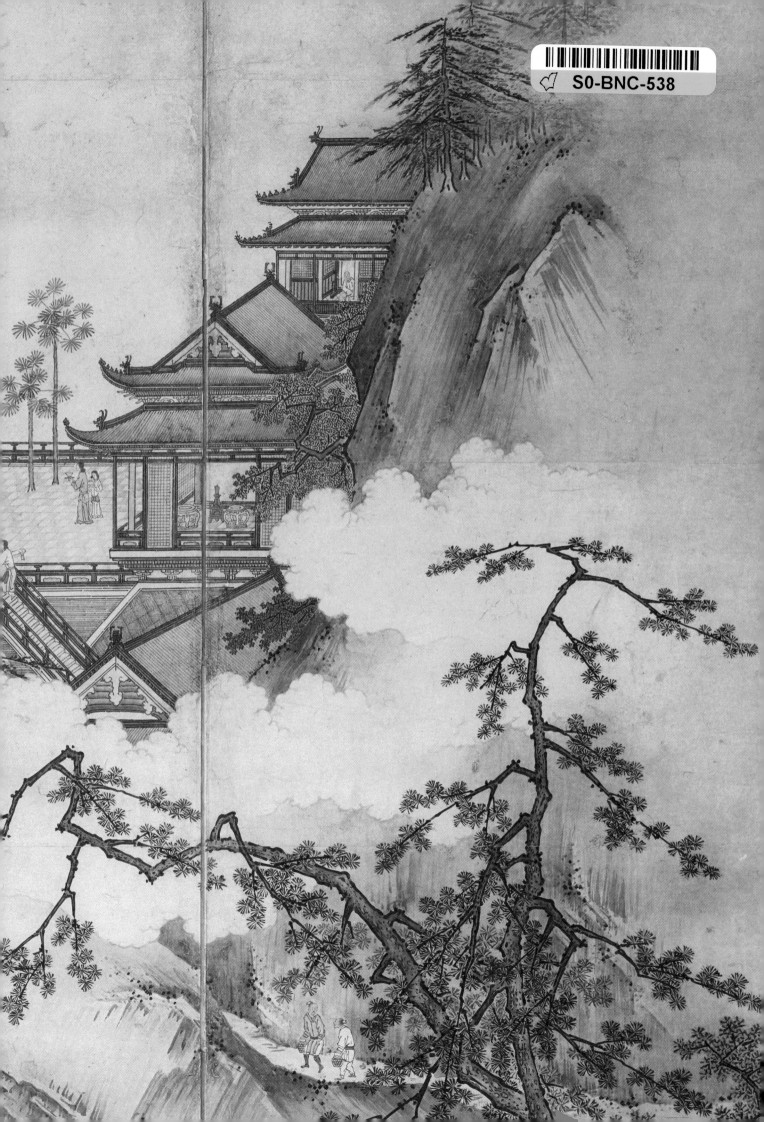

TREASURES OF
ASIAN ART

TREASURES OF
ASIAN ART
THE ASIA SOCIETY MUSEUM COLLECTION

Denise Patry Leidy

Adriana Proser

Michelle Yun

ASIA SOCIETY MUSEUM

NEW YORK

DISTRIBUTED BY

DELMONICO BOOKS • PRESTEL

MUNICH LONDON NEW YORK

Support for Asia Society Museum is provided by the Asia Society Global Council on Asian Arts and Culture, Asia Society Friends of Asian Arts, Arthur Ross Foundation, Sheryl and Charles R. Kaye Endowment for Contemporary Art Exhibitions, Hazen Polsky Foundation, New York State Council on the Arts, and New York City Department of Cultural Affairs.

Published by
Asia Society
725 Park Avenue
New York, NY 10021
www.AsiaSociety.org

Distributed worldwide by DelMonico Books • Prestel

DelMonico Books, an imprint of Prestel, a member of Verlagsgruppe Random House GmbH

Prestel Verlag
Neumarkter Strasse 28
81673 Munich

Prestel Publishing Ltd.
14-17 Wells Street
London W1T 3PD

Prestel Publishing
900 Broadway, Suite 603
New York, NY 10003

www.prestel.com

Project Manager: Marion Kocot
Curators: Adriana Proser and Michelle Yun
Production Coordinator: Leise Hook
Copy Editors: Deanna Lee and Linda Truilo
Indexer: Kathleen Friello

Designer: Rita Jules, Miko McGinty, Inc.
Typeface: Fakt
Printing: Trifolio S.R.L., Verona, Italy

Library of Congress Control Number: 2016951770

A CIP catalogue record for this book is available from the British Library.

ISBN 978-3-7913-5616-7 (hardcover)
ISBN 978-0-692-74304-1 (softcover)

The paper in this book meets the requirements of ANSI/NISO z39.48-1992 (Permanence of Paper).

Cover illustrations: (front) Detail of Fig. 313; (back) Detail of Fig. 10
Endpapers: Details of Fig. 245
Frontispiece: Fig. 69
Pages 14–15: Maps designed by Anandaroop Roy
Pages 16–19: "The Mr. and Mrs. John D. Rockefeller 3rd Collection: A Personal Recollection" by Sherman E. Lee is reprinted from Denise Patry Leidy, *Treasures of Asian Art: The Asia Society's Mr. and Mrs. John D. Rockefeller 3rd Collection* (New York: The Asia Society Galleries, 1994).
Page 25: Detail of Fig. 229
Page 319: Detail of Fig. 331

Contents

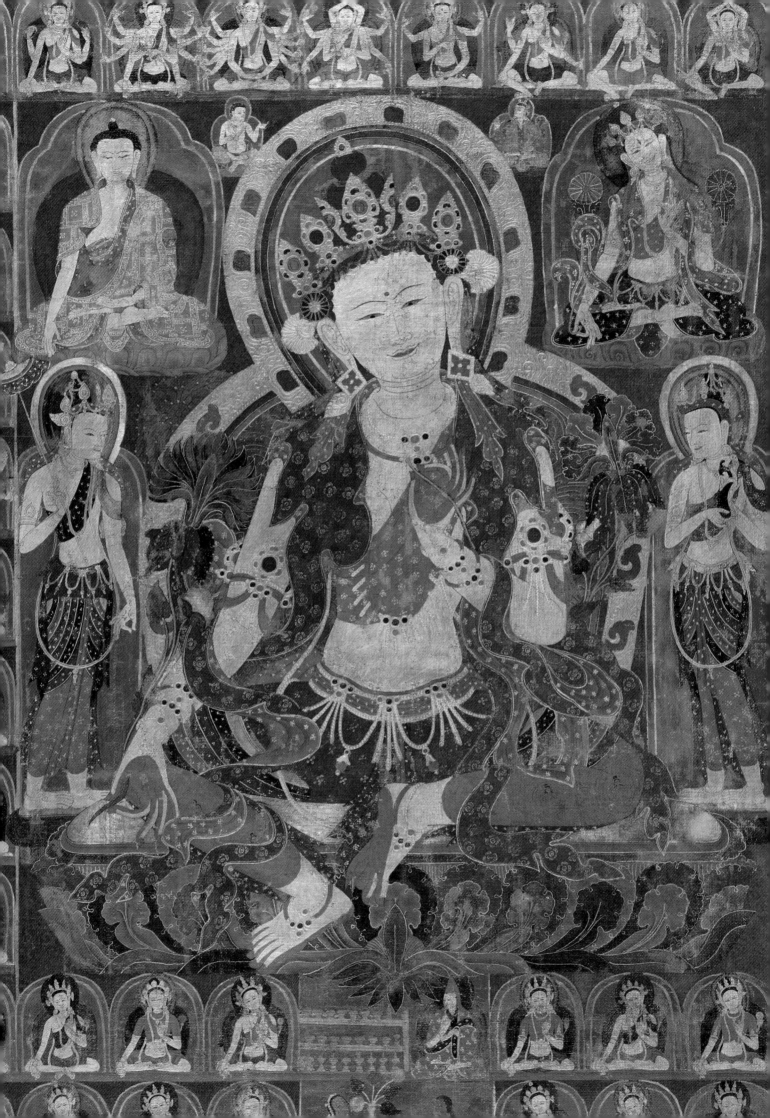

FOREWORD

It is entirely appropriate that, in a year in which we celebrate the sixtieth anniversary of the founding of Asia Society by John D. Rockefeller 3rd, we also celebrate the legacy of art collecting he and wife Blanchette Hooker Rockefeller established, with a revised and expanded edition of *Treasures of Asian Art*. As early as 1956, JDR3 understood that an appreciation of the arts of the countries and peoples of Asia is crucial to promoting better understanding between Asia and the United States. His vision, perhaps even more relevant today than sixty years ago, acknowledged the significance of arts and culture within larger social, economic, and political contexts and without hesitation, he encouraged a schedule of diverse programming for the Society which would prove to be the basis of its mission to the present day.

In an extraordinary speech in New Delhi, India, Rockefeller spoke at length about the importance of building understanding.

Understanding seems like a simple word and idea. Yet we all know it to be, in fact, far from simple. It is the most subtle and delicate, difficult and elusive, bond that can link continents and nations and even men. It strikes deeper than mere "tolerance." It reaches further than mere acquaintance or formal association. It is that of equality of mind and spirit whose existence is essential to true peace between nations and men—and without which all designs of partnership can crumble to nothing.

This statement underlines the continued importance we place on art and culture as a facilitator in the search of understanding.

The program of exhibitions that began soon after the Society was established provided added incentive for the Rockefellers' collecting and culminated in the extraordinary gift of their collection to Asia Society, which came to us with his untimely passing in 1978. The Mr. and Mrs. John D. Rockefeller 3rd Collection is the foundation of the Asia Society Museum Collection, which today includes additional traditional works of Asian art, as well as the beginnings of an important, ever-expanding collection of painting, sculpture, photography, and new media work by contemporary Asian and Asian American artists.

The Asia Society Museum Collection is small but notable for the consistent and extraordinary number of acclaimed masterpieces it comprises: 285 objects made up the Rockefeller bequest plus several additional gifts from Blanchette Hooker Rockefeller. The condition applied to the consideration of subsequent acquisitions includes the founder's directive that works acquired be of the same quality as those in the original bequest. With the judicious addition of twelve works since the original Rockefeller gifts, the Collection continues to be described as "gemlike" and one of the most important collections of Asian art in the United States.

The decision in 2007 to begin to collect contemporary art was initiated again through the generosity of an individual collector, and continued the legacy of the Rockefellers. The Harold and Ruth Newman New Media Collection itself forms the basis for the contemporary collection, which now includes ninety-one works in various mediums. We are indebted to the generosity of the Newmans and other collectors and donors who are committed to our work in the arts and whose gifts enable us to continue the Rockefeller legacy.

Asia Society has grown and expanded in the breadth of the mission originally set forth by John D. Rockefeller 3rd. From its modest beginnings, we have developed to become a global organization with centers in Hong Kong, Houston, Los Angeles, Manila, Mumbai, New York, San Francisco, Seoul, Shanghai, Sydney, Washington, DC, and Zurich. Throughout our evolution, we have remained consistent with and committed to our founder's vision and generosity that continue to inspire us.

JOSETTE SHEERAN
President & CEO
Asia Society

Opposite: Detail of **FIG. 60.**

PREFACE

The arts and culture have been an integral, if not the most prominent and important aspect of Asia Society's work in the sixty years since its founding by John D. Rockefeller 3rd. It is our great pleasure, in this auspicious sixtieth anniversary year, to be able to publish a revised and expanded catalogue of the Museum's Collection and underscore the intensified relevance of the arts to the mission of Asia Society as we move forward into the next stages of the organization's development.

The arts and culture go deeply into what define us as a species and bind us together in communities, societies, and nations. Indeed, culture is what makes us human. Perhaps no one understood more completely than Asia Society's founder, John D. Rockefeller 3rd, that the arts are indispensable to the development of mutual understanding among Asians and Americans, and it was therefore imperative to him that arts and culture, and particularly art exhibitions should be a central platform of his new organization. To ensure this focus in the future of the Society, he and his wife, Blanchette Hooker Rockefeller, decided early on that the exquisite collection of Asian art works they had begun to collect, would eventually be their bequest to the Society. He had a discerning eye, and with the guidance of the noted art historian and curator Sherman Lee, the Mr. and Mrs. John D. Rockefeller 3rd Collection of Asian Art, which forms the basis of the Asia Society Museum Collection, is known to arts professionals and specialists the world over as one of the most exquisite collections assembled, despite its relatively small scale.

It has been more than twenty years since the Collection—which at the time, essentially comprised the original gift of John D. and Blanchette Rockefeller to Asia Society—was first published, and in the years since Asia Society and Asia Society Museum have grown in terms of both size and global vision. Equally important, Asia itself has changed dramatically in that time, as has its place in the world and how the nations of Asia are perceived by the rest of the world. The Museum Collection has expanded to reflect some part of that change, encompassing not only the traditional arts of South, East, and Southeast Asia that formed the core of the Rockefeller bequest, but which now includes contemporary and new media work from those areas, as well as the Americas.

Asia Society Museum—and indeed, museums across the world—occupies a critical place in terms of protecting the cultural legacies of Asia, particularly in its role as custodian of the objects and ideas that embody those legacies. The acts of collecting, caring for, and creating an environment for meaningful experiences with art objects effectively safeguard our heritage for contemporary and future generations. The Museum in the twenty-first century becomes the thread connecting the millennial civilizations of Asia with our collective futures and is part of the process inaugurated by our founder six decades ago of building deep appreciation for the arts and cultures of Asia.

Thanks are due to the many individuals, in addition to the Rockefellers, who have made it possible to maintain and expand the Collection. We appreciate the generosity and guidance of the members of our collection committees, past and present: Carol and David Appel, Susan Beningson, Max N. Berry, Stephen R. Blair, Max and Monique Burger, Gina Lin Chu, Willard G. Clark, Katharine B. Desai, Anne Ehrenkranz, George J. Fan, Michael Figge, T. Richard Fishbein, Ken Hakuta, Susan Hayden, Roya Heidari, Sunil Hirani, Lisina Hoch, Joey Horn, Michael Jacobs, Joleen and Mitch Julis, Dow Kim, Yung Hee Kim, Ann R. Kinney, H. Christopher Luce, Marie Lippman, Dipti Mathur, Harold and Ruth Newman, Christopher Olofson, Cynthia Hazen Polsky, Amy Robbins, Denise Saul, Jerome Silbergeld, Guy F. Ullens, Jack and Susy Wadsworth, Robert and Ann Walzer, Roger L. Weston, James R. Woods, and Robert Youngman.

I also sincerely thank the Museum staff for their commitment to this publication and for their dedicated care of the Collection.

BOON HUI TAN
Museum Director and Vice President for Global Arts & Cultural Programs

STATEMENT FROM THE GLOBAL COUNCIL ON ASIAN ARTS AND CULTURE

As co-chairs of the Global Council on Asian Arts and Culture, a group that passionately supports Asia Society's vision and mission in the arts, we are delighted with the publication of the updated and expanded Treasures of Asian Art. Asia Society Museum's robust collection of traditional and contemporary art represents the work of extraordinary Asian artists over millennia and exemplifies connoisseurship at the highest level. The study and contemplation of art objects is one of the most powerful ways with which we can learn about and develop a connection to cultures that are different from our own. Members of the Global Council recognize the critical role of the arts in bringing people together and celebrating the human spirit. Through its activities, the Council inspires its members to engage with and champion the arts of Asia—from ancient to contemporary, from performing to visual—and we are pleased that this book encompasses an ambitious scope. The myriad ideas represented by the works in the Collection and in this catalogue reflect the institution's larger mission to educate, forge meaningful relationships, and promote a greater understanding of ourselves and of the world around us.

ANNE BICK EHRENKRANZ
AGNES HSU-TANG, PhD
Co-Chairs, Global Council on Asian Arts and Culture, Asia Society

ACKNOWLEDGMENTS

On the occasion of the sixtieth anniversary of the founding of Asia Society, we celebrate the legacy of collecting and exhibiting Asian art that John D. Rockefeller 3rd (1906–78) and Blanchette Hooker Rockefeller (1909–92) set in motion for Asia Society with this revised and expanded edition of *Treasures of Asian Art*. The first edition, written by Denise Patry Leidy and published in 1994, featured the masterworks of the Mr. and Mrs. John D. Rockefeller 3rd Collection of Asian Art, which had been donated to Asia Society fifteen years earlier. Since the initial publication of *Treasures*, the collection has expanded to include additional antiquities as well as contemporary artworks.

As the art historian Sherman E. Lee (1918–2008) explains in his essay written for the first edition and reprinted in this volume, John D. Rockefeller 3rd firmly believed that the presentation of art and culture from Asia was an indispensable tool for understanding its societies and thus made these programs central to Asia Society, a multidisciplinary organization that would encompass all aspects and parts of Asia. From 1963 to 1978, Lee worked with the Rockefellers as an advisor for their collection. Spectacular historical works, including sculpture, painting, and decorative arts from East, Southeast, and South Asia, and the Himalayas, became the core of the Asia Society collection of traditional art, which has been supplemented by subsequent gifts and acquisitions of treasures from Asia's impressive artistic heritage.

As a complement to these holdings, Asia Society inaugurated a contemporary collection, of Asian and Asian American new-media art, in 2007. The impetus for this collection was to broaden the understanding of Asia's artistic production through the inclusion of works that demonstrate advances in new technologies, ones often developed in Asia. Using video, photography, and other new media, contemporary artists from Asia and the Asian diaspora have responded to the shifts in sociopolitical, economic, and cultural conditions that are occurring across the region.

As in the first edition of *Treasures of Asian Art*, artworks in this volume are grouped by region and country based on time period, medium, or both, an approach that emphasizes the strengths of the collection and allows for broader discussions of background issues and for making connections. With this edition's inclusion of historical and contemporary works from the Collection, readers may find new ways to understand these works. Presented together, they may express the talents, skills, imaginations, and deep histories of the artworks' creators to both students of Asian art and the general public.

For greater ease of reading, footnotes with citations have been omitted from this edition. Sources for information about each grouping of artworks are listed in the selected bibliography (page 402), and translations of inscriptions, colophons, and seals are included in the essays.

We would like to thank Boon Hui Tan, Museum Director and Vice President of Global Arts & Cultural Programs, and Marion Kocot, Museum Deputy Director, for supporting our work and this project. For continued institutional support, we thank Josette Sheeran, President and CEO of Asia Society. We would also like to acknowledge the support of the colleagues who assisted Denise Patry Leidy directly and indirectly with the research and scholarship for the initial publication of *Treasures*, which forms the foundation of this expanded edition. They include: Sherman E. Lee, Louise Allison Cort, James Lally, Martin Lerner, Miyeko Murase, Clarence Shangraw, Hiram W. Woodward, Jr., James C.Y. Watt, Tom Chase and Leslie Gat, Robert L. Brown, Vidya Dehejia, Vishakha Desai, Elizabeth ten Grotenhuis, Deborah Klimburg-Salter, Janice Leoshko, and Sarah Thompson. Former and current Asia Society staff provided expertise and assistance, including: Mirza M. Burgos, Mary Christian, Deepali Dewan, Karen L. Haight, Merantine Hens-Nolan, Alexandra Johnson, Hongnam Kim, George LaVoo, Mary Linda, Amy V. McEwen, Chana Motobu, Robert D. Mowry, Joseph N. Newland, Richard A. Pegg, Nicolas G. Schidlovsky, Mary Smith, and Gen Watanabe. Their contributions live on in the pages that follow. In the original edition, Denise Patry Leidy also expressed her gratitude to her husband John and son Alex for their patience and support.

Asia Society is grateful to these Getty Museum Leadership Fellows for their research efforts between 2006 and 2010: Niharika Dinkar, Jacquelin Ganem, Lara Netting, Kristy Philips, Daisy Yiyou Wang, Xiaojin Wu, and Yang Yingshi. We would like to thank Julia Meech, John Miksic, Sonia Quintanilla, and Takayuki Seki for their help. We also thank our more recent curatorial predecessors at Asia Society: Melissa Chiu, Colin Mackenzie, Caron Smith, Miwako Tezuka, and of course Denise Leidy, without whom this volume would not exist.

Our sincere gratitude is extended to Clare McGowan, Senior Registrar and Collections Manager, and Jennifer Patrick Lima, Associate Registrar, for their expert care of the objects in the collection; Leise Hook, Museum Publication Coordinator, who shepherded the production of this book; Museum Interns Akasya Benge, Shengnan Dong, Jiete Li, and Louis Soulard for their assistance; and Miko McGinty and Rita Jules for the beautiful book design.

Last but not least, we offer our appreciation to our husbands, Raphael Falco and Edward Mapplethorpe, for their support, patience, and fortitude.

ADRIANA PROSER, John H. Foster Senior Curator for Traditional Asian Art
MICHELLE YUN, Senior Curator of Modern and Contemporary Art

NOTE TO THE READER

All works illustrated are in the Asia Society Museum Collection. The first section of the catalogue focuses on the traditional objects, including those from the Mr. and Mrs. John D. Rockefeller 3rd Collection of Asian Art, organized by region and theme. The second section of the catalogue features the contemporary objects, organized first by region and then alphabetically by country and artist.

Because this book was designed for a general readership, English is used whenever possible. Words in foreign languages requiring transcription in the Roman alphabet appear in a simplified form, without diacritical marks, in a manner that approximates their pronunciation—for example, "Shakyamuni" and "Chandi Reja"—with the following exceptions: Chinese appears in *pinyin*; the macron is used in Japanese words to indicate a long vowel (Hōryūji) except in Japanese names or terms that have entered the English lexicon (Tokyo); and Korean is rendered in Revised Romanization of Korean. Terms have been standardized whenever possible: Buddhist terms are in Sanskrit rather than the language of the country of a work's origin; hence "Bodhisattva Avalokiteshvara" is used throughout (rather than "Guanyin Pusa" for Chinese works and "Kannon Bosatsu" for Japanese ones).

For Asian artist names the surname appears first, except in cases of individual preference, or if the artist is best known with his or her given name first.

Whenever possible, an object's measurements—height (H.), width (W.), depth (D.), or diameter (Diam.)—are given. Dimensions of paintings and prints are given as height by width. Durations of videos are given as minutes and seconds. For sculptures, the terms *right* and *left* should be interpreted from the sculpture's perspective. For paintings, these directions are described from the spectator's point of view. Single stills are used to represent videos, unless otherwise noted.

Opposite: Detail of **FIG. 374.**

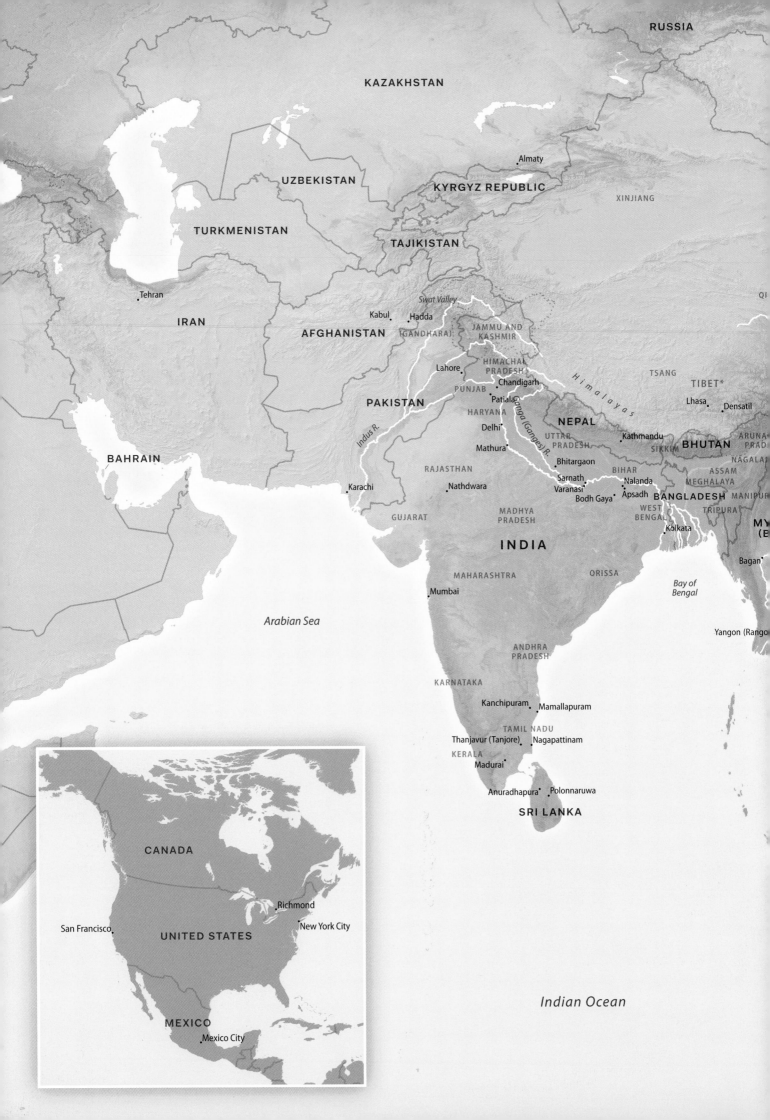

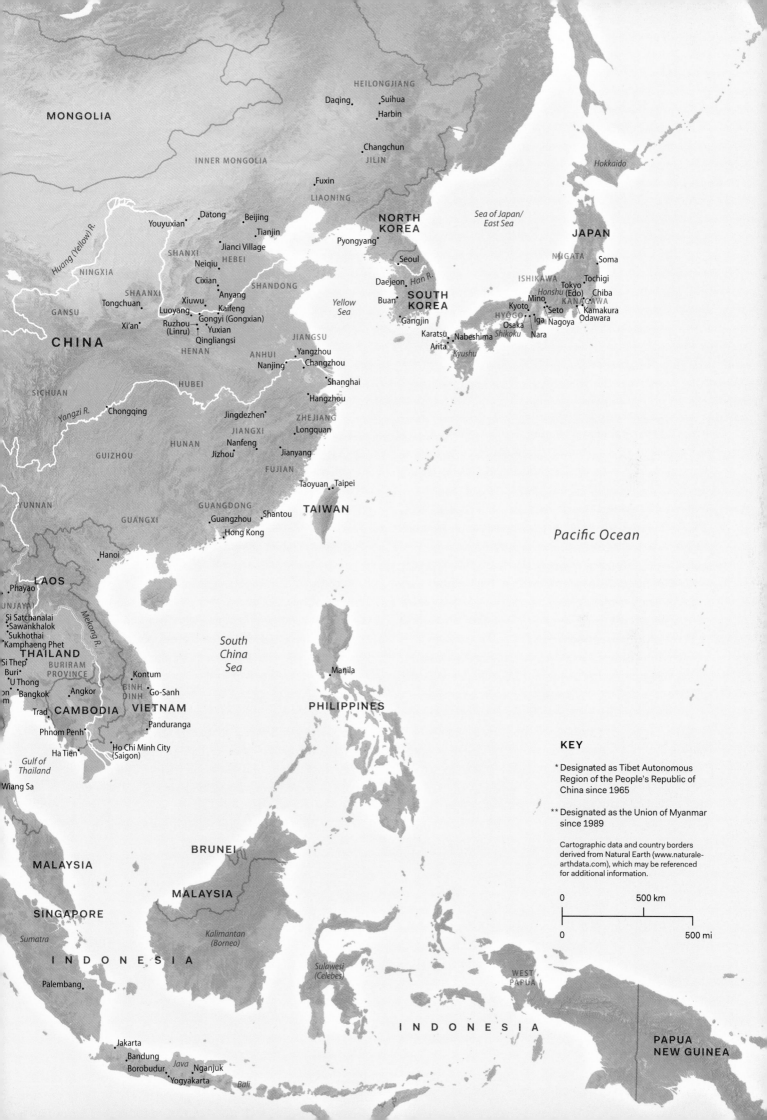

MONGOLIA

INNER MONGOLIA

HEILONGJIANG

Daqing
Suihua
Harbin

Changchun

JILIN

Fuxin

LIAONING

Youyuxian
Datong
Beijing

Tianjin

Jianci Village

SHANXI
HEBEI

Neiqiu

Cixian
Anyang

SHANDONG

Xiuwu
Kaifeng

Tongchuan
Luoyang
Gongyi (Gongxian)

SHAANXI

Xi'an
Ruzhou
(Linru)
Yuxian

Qingliangsi

CHINA

HENAN

ANHUI
Nanjing

JIANGSU

Yangzhou
Changzhou

Shanghai

HUBEI

Hangzhou

SICHUAN

Yangzi R.
Chongqing

Jingdezhen

ZHEJIANG

JIANGXI

Longquan

HUNAN
Nanfeng
Jizhou
Jianyang

GUIZHOU

FUJIAN

Taoyuan
Taipei

YUNNAN

GUANGDONG

TAIWAN

GUANGXI
Guangzhou
Shantou

Hanoi
Hong Kong

LAOS

Phayao

UNJAYA?

Si Satchanalai
Sawankhalok
Sukhothai
Kamphaeng Phet

THAILAND

BURIRAM
PROVINCE

Si Thep

Buri

U Thong

Bangkok
Angkor

Kontum
Go-Sanh

BINH
DINH

Trad

CAMBODIA
VIETNAM

Phnom Penh
Panduranga

Ha Tien

Ho Chi Minh City
(Saigon)

Wiang Sa

Gulf of
Thailand

South
China
Sea

Manila

PHILIPPINES

NORTH
KOREA

Pyongyang

Seoul

Daejeon
Han R.

SOUTH
KOREA

Buan

Gangjin

Karatsu
Nabeshima

Arita

Kyushu

Yellow
Sea

Sea of Japan/
East Sea

JAPAN

Hokkaido

NIIGATA

Soma

ISHIKAWA
Tokyo
Tochigi
(Edo)
Chiba

Mino
KANAGAWA

Kyoto
Kamakura

HYŌGO
Osaka
Seto
Iga
Nagoya
Odawara

Shikoku
Nara

Honshu

Pacific Ocean

BRUNEI

MALAYSIA

MALAYSIA

SINGAPORE

Sumatra

INDONESIA

Palembang

Kalimantan
(Borneo)

Sulawesi
(Celebes)

WEST
PAPUA

INDONESIA

PAPUA
NEW GUINEA

Jakarta
Bandung
Borobudur
Java
Nganjuk
Yogyakarta
Bali

KEY

* Designated as Tibet Autonomous
Region of the People's Republic of
China since 1965

** Designated as the Union of Myanmar
since 1989

Cartographic data and country borders
derived from Natural Earth (www.naturale-
arthdata.com), which may be referenced
for additional information.

0 500 km

0 500 mi

THE MR. AND MRS. JOHN D. ROCKEFELLER 3RD COLLECTION: A PERSONAL RECOLLECTION

SHERMAN E. LEE

For John and Blanchette Rockefeller, collecting works of art was inevitable. His parents, John and Abby Aldrich Rockefeller, had been notable collectors of American, European, and Asian art. The house that J. D. Rockefeller 3rd grew up in was full of fine Old Master paintings, including works by Duccio, Piero della Francesca, and Perugino. His mother had formed an outstanding assemblage of American folk art, and both parents avidly collected Chinese porcelains and Iranian glazed pottery, as well as sumptuous Islamic textiles. The Chinese ceramics were almost wholly those usually collected by Westerners in the years immediately surrounding World War I—Kangxi, Yongzheng, and Qianlong porcelains, ranging from monochromes to the blue-and-whites to the rich polychrome wares, *famille rose*, *famille verte*, and the rarest of all, the now-unfashionable *famille noire*. The question for the younger couple was not whether to collect, but what and, more important, why and how to collect.

In forming their Asian art collection, John and Blanchette were very much complementary to each other. In this area and in the collection of American painting, John was the senior partner, just as Blanchette was for modern art. Her position as a trustee and officer of The Museum of Modern Art as well as her innate sensitivity gave her an unparalleled opportunity to develop a keen knowledge of the modern field. Further, it enhanced an interest in the unusual and innovative aspects of art— which she carried over to her judgments in the field of Asian art.

John's interest in Asian art certainly began as an intellectual one. His major commitment to improving awareness and knowledge of East Asian political,

social, and economic affairs in the United States, symbolized by his support of the Japan Society and his founding of The Asia Society in New York, led him to extend his purposes to the acquisition of the art of East Asia[1]: India, Nepal, Southeast Asia, China, Korea, and Japan. He was much concerned with the future public use of such a collection, realizing that its possibilities for public education and delectation were part of his aim to improve and increase the American understanding of the Orient, past and present.

His strong interest in the problems of world population and his work immediately after World War II in Japan as a part of the United States Government's study of ways and means to rebuild a democratic Japan led to his annual trips to East Asia and to his acquaintance with at least one major collector of Chinese and Korean ceramics: Takakichi Aso, the son-in-law of Japan's first postwar prime minister, Shigeru Yoshida. Aso's collection was superb and quite famous in "ceramic circles," and it did its part to stimulate John Rockefeller's incipient collecting instincts, sufficiently so that he began to wonder how and what to acquire.

In view of the nature of his parents' collection and of the stimulus given by the Aso collection, it is not surprising that John, and Blanchette, turned to ceramics and that many of the early acquisitions were in that area. A further incentive was the ceramics' usefulness as decorative adjuncts to the small but distinguished number of Impressionist and Post-Impressionist paintings in their collection. At the time the growing Asian art market was still far from its recent exaggerated levels. The enormous rise in the European art market, especially for Impressionist and Post-Impressionist paintings, had

confirmed John's growing conviction that it was unwise to collect in that area, and he shifted his attention to East Asian art and American painting.

By 1963 John felt the need for a professional advisor for his East Asian collecting activities and asked me to perform that task. I was honored and pleased by his choice but also realized that such a position would be difficult and might pose a conflict, in view of my more demanding duties as director and chief curator of oriental art at the Cleveland Museum of Art. He faced this problem with characteristic wisdom and thoroughness, and we worked together to achieve a solution beneficial to both the Rockefellers and the museum. It was both simple and direct: whatever he saw or was offered first was automatically at his option; whatever I or any other museum official saw or was offered was at the option of the museum. Should there be any confusion or simultaneity of offer, it would be decided by chance—in the only case that developed, by a flip of a coin. The agreement was unanimously approved by the museum's board of trustees and lasted until John's tragic death in July of 1978.

One of our very first meetings at the Rockefeller duplex apartment at One Beekman Place was a long examination and discussion of the philosophy and justification for the development of a major collection of Asian art. John and Blanchette were united in their desire that the collection be based upon artistic merit and that it represent the finest accomplishments in the arts of East Asia, but that it be representative of the breadth of those cultures. In this they escaped the prison of the "unified" and specialized collection, whether of ceramics, lacquer, or one particular period. This approach may well be out of fashion in today's relativistic climate of scientistic and anthropological assemblages, independent of aesthetic judgements, of the artifacts of a given culture, but it was the rationale for some of the most rewarding and important collections of modern times—The Frick Collection in New York, the Freer Gallery of Art in Washington, The National Gallery in London, and the National Gallery of Scotland in Edinburgh. It is also a rationale close to the conceptions behind some of the finest private collections made public in Japan—the Hatakeyama, Gotoh, and Nezu museums in Tokyo. In aiming for a representation of the highest level of achievement in any of the arts of a given period, country, or region, the Rockefellers chose an ultimately unattainable goal, but one worth striving for.

In their collecting efforts, John was ever the rational, demanding, and patiently reflective element while Blanchette provided the adventurousness born of the modern movement in Western art combined with a fine intuitive aesthetic judgement. The combination was irresistible. Their overriding concern was that the collection become a source for public education and delight, and I, for one, cannot imagine a better goal. Neither Rockefeller was prone to the "I must have it" syndrome that confuses personal self-gratification with aesthetic judgment.

Since we were in agreement as to purpose, all that remained was to practice, and this for only fifteen years. It was soon evident that both Rockefellers were then more interested in objects than in oriental paintings. It was difficult to transfer Blanchette's love for modern painting and John's for American nineteenth-century painting to the scroll and screen formats of China, Korea, and Japan. In objects, John was much interested in technology and finish, while Blanchette was drawn to the earlier wares and tomb figurines. Sculpture proved to be the means of "breaking the barrier," for in the Western mind, that medium is inseparably associated with painting in the concept of "fine art." In the West historically one couldn't consider sculpture without the complement of painting, though in China sculpture had never achieved the status of painting.

A degree of balance was achieved in the collection, more in Japanese art than in that of China. The Dainichi Nyorai of the Kamakura period is the earliest such work in the collection, and it is followed by the excellent *shuyado*, a monochrome ink hanging scroll of Zen inspiration with important inscriptions by priests Myotaku and Yoka Shinko of Tōfukuji. From the great Rinpa school of decorative painting is the poem scroll with bamboo by Sōtatsu and Kōetsu. Large-scale screen painting in Japan is represented by a well-preserved pair of sixfold screens representing the Four Seasons, by Kanō Motonobu or an artist very close to him.

Only two major works represent the great Chinese painting tradition: a fine late Song landscape by Lou Guan with stylistic links to early Song; and a hanging scroll by Kuncan (Shiqi) dated 1661, *Temple on a Mountain Ledge*, a relatively quiet work related in composition to the famous dramatic landscape of 1664, *Bao'en Monastery*, in the Sumitomo Museum, Kyoto.

Both John and Blanchette were particularly sensitive to the compassionate ideals expressed in Buddhist art. Even the Fudō in the collection is benign when compared with the great horrific registered images in Japan. The masterpiece of Japanese sculpture in the collection is the small Jizō Bosatsu (ca. 1223—1226) by Zen-en, with additional inscriptions by Jisson and Han'en of Kōfukuji. The marvelous state of preservation of color and cut gold (*kirikane*) and the appropriate youthful and compassionate

expression of the face make the work one of the best of all Kamakura-period images in the West. No persuasion was necessary on my part for this acquisition, for the concept expressed by the image was precisely congruent to the collectors' ideal of Buddhist art.

The Japanese ceramic collection ranges from Jomon and Kofun to the porcelains of Edo. Many of the Edo wares were acquired in Europe, especially in London and Paris, during the sixties, when very special examples of Kakiemon and Imari exported from Japan in the seventeenth and early eighteenth centuries began to appear at dealers and at auctions. It was a wonderful opportunity for all, and the Rockefellers were able to acquire the hexagonal Kakiemon vases with covers like those at Hampton Court, the covered bowl like the registered example formerly in the Shiobara collection and the one in the MOA Museum, as well as the bold Imari octagonal vase with a design of ladies in a garden. But pride of place must surely go to the well-known tea-leaf jar with quarreling crows by Ninsei[2]—one of his finest Rinpa designs.

Chinese art is largely represented in metalwork and porcelain, media in which China made significant technological and artistic contributions. The very late Shang bronze *you* is an outstanding transitional bronze of great precision and with rich decoration. The Western Han gilt and inlaid *pan* is deservedly famous, along with its Eisai Bunko counterpart. The band on the interior with birds, animals, and earth spirits, clearly visible because of the excellent preservation of the bronze, is one of the liveliest of such representations, significant for both its technical excellence and its evidence of Han pictorial art. The *tong wenjiazun* (bronze *zun* for warming wine) of about 26 BCE is another fine example. Particularly rich are the hunting and animal motifs in a mountainous landscape, including hunters, warriors, lions, bears, griffins, tigers, and earth and wind spirits.

Two silver-gilt vessels are of signal rarity and quality: the repoussé dish of the late Six Dynasties period (or early Liao?) and the Tang silver-gilt "lotus bowl" dish. The former demonstrates the importance of Northern Qi and Sui art in the formulation of the Tang international style (especially in the dish's floral borders in high relief) and in the development of landscape painting toward its first great age in the tenth century. The lotus bowl uses animal and floral motifs on a smaller scale with exquisite detail. In Japan the famous bowl at the Hakutsuru Museum, Ashiya, is a splendid counterpart to the Rockefeller bowl. Mention must also be made of the stone tympanum with incised and raised relief of Shakyamuni Buddha Preaching at Vulture Peak. This sculpture displays the complexity

and sophistication achieved by the Northern Qi artists of this reign. Sui and Tang achievements are very much indebted to the culture of Northern Qi.

The Tang dynasty produced decorative arts of the highest interest and quality in an almost bewildering variety of techniques—whether textiles, woodwork, metal, ceramics, or lacquer. The oblate mirror in the collection represents one of the rarest and most demanding techniques, called by the Japanese *heidatsu*. The back of this silver-bronze mirror displays a design of flower sprigs, flying cranes, and mandarin ducks as well as a central medallion boss with a ribbon and floral arabesque, cut from gold and silver sheets, engraved, and then inlaid in the still-soft lacquer coating of the mirror back. After polishing down to the metal design, the visual effect is remarkable and provides a fine representation of the Tang international style adopted also in contemporary Korea and Japan.

Chinese ceramics were particular favorites of the Rockefellers and the numerous examples from Tang through Qianlong constitute the strongest single holding in the collection. The variety is wide and ranges from lead-glazed earthenware figurines through the monochromatic subtleties of the classic Song wares to both monochrome and richly decorated porcelains characteristic of the Ming and Qing dynasties. In this area, the Rockefellers were on very familiar ground, not only because of his parents' activities, but because of their familiarity with British collectors and their collections. Mrs. Alfred Clark and Mrs. Walter Sedgwick certainly influenced the Rockefellers' predilections, but so did the late Peter Vaughan of John Sparks, Ltd. In any case the subtle and direct qualities of the Song wares were particularly loved by Blanchette Rockefeller, while John was keenly appreciative of the technical finesse and restrained decoration of the Ming imperial wares.

Four major works, all remarkable for the strength and quality of their decoration, may well epitomize the Rockefeller taste in Chinese ceramics. The Cizhou *meiping* with carved and inlaid slip decoration is matched by only one other similar piece in a Japanese collection. The Yuan-dynasty blue-and-white dish with a *qilin* running amid rich vegetation of bamboo, banana, melon, and morning glories is comparable only to the famous dish in the Ashmolean Museum, Oxford. The large underglaze red jar with its decoration of the Three Friends (pine, bamboo, and plum) must be the best-drawn example of this eminently pictorial subject. The acquisition of this large and bold example was one of the few occasions when I tried all my powers of persuasion to

convince John that the cut-down rim of the vessel was an acceptable imperfection for such a rare and beautiful ceramic. Finally, the covered water jar with decoration of *koi* and aquatic plants is doubly impressive since in this case the survival of the lid is most unusual and, further, admirably completes the harmony and boldness of the decoration. The other imperial porcelains in this group, ranging from Yongle through Jiajing, make it one of the most impressive in America.

If the Rockefellers' acquisitions began with Chinese and Japanese works, those from India and Southeast Asia very quickly became major temptations for the two collectors. John Rockefeller's penchant for "uplifting" and compassionate Buddhist works necessarily led back to the source of Buddhism—India—and particularly to the culture that produced the classic Buddha image, the Gupta period (about 320–647). To possess one fine Gupta bronze image is the dream of every curator and collector of Indian art; but to possess three is quite remarkable. The Rockefeller collection's triad reveals three different aspects of Gupta style: the seated bronze image is a Sarnath type with plain drapery; the large standing figure with "string folds" is closely related to the Mathura school of image making; and the smaller standing image seems more properly related to North Indian types known in stone.

The Nepalese icons in both stone and bronze are typically graceful and elegant with an acceptable degree of sweetness that appealed greatly to both Rockefellers. Although the miniature Myanmarese masterpiece of stone carving with its forty-eight figures seems immediately appealing, some persuasion was required to secure its entry into the collection. John Rockefeller and I had been visiting a dealer in Tokyo when I saw the miniature stone in a showcase; recognizing it because of another one in the Cleveland Museum of Art's collection, I urged its acquisition. John could not at first accept that so inexpensive and small a work could be important, but when I insisted that it rated an A on our "grading" system

of A to D, he began to pay attention, then humored his advisor, and finally came to admire the quality of the work.

On the other hand, he was the one who first saw in London the great early Cambodian bronze Maitreya from Prakhon Chai and immediately seized the once-in-a-lifetime opportunity. In doing this, he ensured the quality and fame of the collection that bears his name, for the Maitreya is surely his single most appealing image, and one that sets a standard for early Cambodian bronze sculpture, even among the larger sculptures known from the same site.

The bronze material of the Maitreya was fascinating to both collectors, and they pursued south Indian bronzes of the classic image types, including a rare Chola Brahma, a famous Krishna Dancing on Kaliya from the Clermont collection in Switzerland, and a very complete and spirited Chola Nataraja. One of my favorite stone sculptures in the collection is the eighth-century stone Ganesha from central India, one of the early representations of the Hindu deity associated with happiness and good fortune. His presence, usually in the entrance lobby of The Asia Society, is an auspicious one.

The Ganesha is particularly appropriate as a symbol of the relationship between the donors and the institution they made possible. Such generous and unselfish contributions are rare at any time, but the record of John and Blanchette Rockefeller as friends and students of East Asian art and culture can be sensed, even understood, through the knowledge and delight offered by this collection, which they labored long and hard to build.

Editor's notes
1. In his first edition of *A History of Far Eastern Art*, the author defines East Asia as "India and Nearer India—that is, Nepal and Ceylon; Farther India—that is, Cambodia and Siam; and Indonesia—that is Java and Sumatra; and China, Korea, and Japan" (Sherman E. Lee, *A History of Far Eastern Art* [Englewood Cliffs, NJ: Prentice-Hall, Inc.; New York: Harry N. Abrams, Inc., 1964], 19).
2. The birds on this jar recently have been identified as mynah birds.

INTRODUCTION

ADRIANA PROSER
MICHELLE YUN

At a recent exhibition of Kamakura-period sculpture at Asia Society Museum, a conversation with a new visitor and lover of western art illustrated the basic challenges faced by Museum visitors with little familiarity with Asian art and Asia in general. When asked if he enjoyed the exhibition, he replied, "Well, it is so very different from western art. It is hard to know how to look at it." When encountering any work of art without contextualization, viewers may find it challenging, if not impossible, to know what to look at or look for. For those encountering Asian art for the first time, a point of entry—for example, the use of a familiar medium, like porcelain—can help the viewer toward appreciation and lead to deeper understanding of the art in question. An object like the large, underglaze cobalt-blue, Yuan-dynasty dish **(FIG. 167)** may have immediate visceral appeal for many visitors: everyone can distinguish its floral and animal imagery, and blue-and-white dishes can still be found in shops and department stores in most places in the world today. The recognition of this kind of object means that it is easier to approach and understand. Moreover, this is a large object. Its size piques the viewer's interest and draws him or her closer. A desire to identify the strange animal depicted on the platter may steer the viewer's attention to the object label, where more information is provided. Conversely, when a viewer approaches a work of art in new media, seemingly familiar in our age of modern technology, he or she often relies on the label's supplementary information to begin to understand the nuanced ideas put forth in the work by the artist. Furthermore, even though moving imagery—viewed in a theater or on a television, computer, or mobile device—has become a ubiquitous part of popular culture in many societies around the world, contemporary artists working with new-media formats often use culturally specific imagery that may not be familiar to all audiences. For example, with Song Dong's single-channel video, *Burning Mirror* **(FIG. 325)**—which features images of places around Beijing to explore the social implications of gentrification preceding the 2008 Olympic games—viewers may at first find the imagery alienating and walk away without taking time to absorb and understand the artist's message or discover how the ideas being explored in the work may relate to themselves.

The Asia Society Museum Collection has grown considerably since it was founded in 1978. It now includes not only the works given in the original John D. Rockefeller 3rd and Blanchette Hooker Rockefeller bequest but also later acquisitions and a number of objects bequeathed from the estate of Blanchette Hooker Rockefeller. These traditional art objects are complemented by a selection of contemporary Asian and Asian American new-media artworks that the Museum began acquiring in 2007. This combination of historical and contemporary holdings allows for the presentation of pairings or groupings that can help make unfamiliar works of Asian art more approachable. Moreover, the breadth and depth of the collection represents art production over centuries across Asia and can encourage viewers to reflect on their own experiences and how these influence their approaches to appreciating and understanding Asian art and culture.

Asia Society Museum is committed to providing cultural context as a critical tool to understanding Asian artistic production. With this in mind, we have brought together the Museum's historical and contemporary artworks in one volume to present the permanent

Collection to specialists, Asian-art enthusiasts, and general readers who may have never thought about Asian art before. In this essay, we highlight several groups of ancient and contemporary works from the Collection to reveal common themes over time and across regions and to demonstrate how technology and social change are revealed through art. These juxtapositions also illustrate how Asia's rich history and artistic traditions have continued to evolve and inspire artists.

The Asia Society Museum Collection, like many western collections of Asian art, includes a number of heads that originally topped statues of Buddha. Among them is a large eighth-century limestone head from Thailand (**FIG. 84**). Separated from the rest of its body, its temple context, and its country, the religious icon is transformed into an object to covet or study in a secular space. Fundamentally, this out-of-context experience is not so different from what Araya Rasdjarmrearnsook, a leading video artist from Thailand, captures in her 2011 work *Village and Elsewhere: Artemisia Gentileschi's Judith Beheading Holofernes, Jeff Koons' Untitled, and Thai Villagers* (**FIG. 306**). This work takes reproductions of paintings created for secular spaces and considers them in a religious context. To make the video, Rasdjarmrearnsook invited a group of children from the Thai countryside to a local Buddhist temple for a lecture by one of the residing monks about the two western paintings noted in the title. In this context, the works take on new meanings as a monk proceeds to use the reproductions of the paintings as visual aids for a lesson on Buddhist teachings. The video explores how looking at objects out of context may transform our appreciation or interpretation of them while leading us to reassess our criteria for understanding art and the world around us.

By considering works in the Collection thematically, one can bring to light connections between past and present art. In East Asia, for example, the theme of the flowers of the four seasons has existed for centuries. Several pieces in the Collection exemplify Japanese artists' mastery in depicting this subject and its continuing inspiration for contemporary artists, who have used new technologies to explore it. *The Four Seasons*, a mid- to late-sixteenth-century pair of six-panel folding screens, attributed to the Odawara Kanō school, demonstrates the artistic convention of painting the seasons as a progression, with spring and summer on the right screen and autumn and winter on the left screen (**FIG. 245**). Japanese painters adopted this popular theme from eighth-century Chinese prototypes, and this example

reveals the blending of Chinese and Japanese aesthetics to create a bold yet sensuously detailed landscape.

Inspired by the history and format of traditional Japanese screen paintings, Mami Kosemura created the three-channel video animation, *Flowering Plants of the Four Seasons* (2004–6; **FIG. 356**). This work brings the cycle of seasons to life using contemporary media that asserts the theme's historical role as a rumination on the passage of time as well as death and renewal in nature and art. Similarly, the artist collective teamLab used new media to address this subject in their 2011 video rendition *Life Survives by the Power of Life* (**FIG. 367**). In this work, the seasonal cycle is imbued with poignant allusions to ecological and social vulnerabilities and the fallibility of modern technology, exemplified by the 2011 Fukushima nuclear disaster.

However, the links to art of the past are not simply thematic, as illustrated by a comparison to Hon'ami Kōetsu's 1626 poem scroll with selections from the *Anthology of Chinese and Japanese Poems for Recitation* (*Wakan Rōei shū*) (**FIG. 247**). The poems in this literary compilation are organized seasonally, and the fourteen-foot-long handscroll, like all such works, was designed to provide a moving image: to view the scroll as intended, one would simultaneously roll and unroll it, moving from right to left. This temporal form of viewing is a precursor to the video-animation format used by teamLab centuries later. Moreover, the calligrapher Kōetsu has been recognized as what we would today call an art director; he coordinated collaborative works with fellow artists in a similar manner to how teamLab's interdisciplinary collective of artists, software designers, and mathematicians pool their respective areas of expertise to create complex projects. In this case, the collaborator who painted the bamboo was likely a disciple of Kōetsu's talented associate, Tawaraya Sōtatsu.

For religious traditions, intellectual thought, and vernacular folklore, the natural world has also been a source for complex symbolic associations; these often have specific ethical and philosophical connotations. In particular the Chinese literati, or educated elite, established a longstanding tradition of retreating from urban society and politics during times of turmoil. Consequently a painting of or reference to a particular mountain or idyllic mountain setting may communicate the desire for withdrawal, in search of a more natural order. In the painting *Xie An at East Mountain* (**FIG. 209**), the Daoist subject matter of a recluse in the mountains alludes to a response by the educated elite to intolerable political conditions: Xie An has gone into reclusion to

escape an official career serving a corrupt government. Social alienation is also the source for inspiration in Yang Fudong's *Seven Intellectuals in a Bamboo Forest*, a series of five single-channel videos, filmed from 2003 to 2007 **(FIGS. 335–339)**. The title and content of the series are direct references to the Seven Sages of the Bamboo Grove (*zhulin qixian*), a group of Chinese intellectuals from the third century CE, who are said to have spent their time engaged in Daoist-inspired discussions, poetry, and music, sometimes while inebriated. At least one member of the group abandoned his government position after becoming disheartened by corruption, and the group as a whole became associated with a retreat from public life. Yang Fudong's protagonists too are idealistic and enlightened Chinese youths who reject the corruption found in conventional society and search for a lifestyle that is more in balance with nature. The notion of the estrangement between nature and contemporary society is underscored in Part I of the series, which was filmed on Yellow Mountain, located in China's southern Anhui Province; the picturesque setting is evocative of a traditional landscape painting, reinforcing an association with literati values.

Nature also has been closely associated with spiritual or divine power. Mount Kumano, long revered by devotees as one of the most sacred locations in Japan, has attracted pilgrims since the eighth century. Such sacred sites have been popular subjects for Japanese artists of the past and present; like them, Mariko Mori has been inspired by its natural environment, spirituality, and associated rituals. In her innovative new-media work *Kumano* **(FIG. 357)**, the site serves as the backdrop for the artist, who assumes the persona of three spiritual deities: a forest fairy, a shaman performing a Shinto ritual dance, and a futuristic hostess performing a traditional tea ceremony in a Buddhist temple.

In this work, Mori appears in the guise of a Shinto deity at the Nachi Waterfall on Kumano, a depiction borrowed from traditional Buddhist imagery of Avalokiteshvara (Kannon in Japanese), as seen in a painting of the Bodhisattva of Compassion seated on a rocky outcrop overhanging turbulent water **(FIG. 238)**. This kind of Avalokiteshvara image appeared in China about the tenth century, inspired by textual references to his abode on Mount Potalaka, said to be located off the southern coast of India. In China, Buddhists came to believe that Guanyin (as Avalokiteshvara is known in China) resided on Putuo Shan, an island off the coast of Zhejiang Province. In the twelfth century, Chan (known in Japan as Zen) monks brought this imagery to Japan. Religious literature developed after the introduction of Buddhism appropri-

ated local Japanese deities (*kami*) by describing their Buddhist origins. According to such attributed origins, the Shinto deity associated with the Nachi Waterfall, Fusumi or Musubi no Kami, is identified as Kannon in his eleven-headed, thousand-armed form.

Notions of sanctity and ritual are also indicated through Mori's portrayal of a futuristic being who clearly conducts a tea ceremony but uses uniquely styled implements. Many philosophies of tea practice have evolved since powdered green tea was brought from China to Japan in the twelfth century. In the early development of the tea ceremony, men played the critical role, but with the turn of the twentieth century, women increasingly began to study the practice, and today more Japanese women than men have studied how to perform this art. Mori has studied tea practice for years, and her adaptation of the tea ceremony in *Kumano* reflects her knowledge of the evolution of the ritual. Two objects in the Museum Collection represent the historical range of tea schools and taste. One is an Iga water jar (*mizusashi*) **(FIG. 255)** that exemplifies the *wabi* aesthetic championed by the tea master Sen no Rikyū (1521–1591). The other is a tea leaf storage jar **(FIG. 285)** created by Nonamura Ninsei that reflects the taste advocated by the tea master Kawamori Sowa (1585–1656) known as refined beauty (*kirei*).

In art produced across Asia, as worldwide, historical narratives resonate over time. For example, fantastic legends of arduous journeys, battles, or missions surround the plethora of deities that populate the Hindu traditions of India. The *Ramayana* is one of a number of narrative tales that spread with the religion from India to Southeast Asia, transmitted over time through text, image, and the performing arts. As this epic has permeated Asian cultures across generations, it has been adapted by local inhabitants to take on new nuances, styles, and forms. One early-nineteenth-century painting, in a style associated with Himachal Pradesh in India, combines scenes that take place just before the attack on Lanka to rescue the goddess Sita from the demon Ravana's clutches **(FIG. 54)**; the hero, Rama, is the focal point of the figural grouping on the left-hand side of the composition. In her contemporary treatment of the *Ramayana* theme, the Indonesian artist Arahmaiani makes reference to her country's popular tradition of storytelling through shadow play (*wayang kulit*). Like other artists today, she uses a traditional story as a vehicle to illuminate and critique contemporary social and political issues. Her single-channel video, *I Don't Want to be a Part of Your Legend* (2004; **FIG. 297**), relates another major *Ramayana* episode from the perspective of Sita: as Rama's wife, she is

subjected to a trial by fire to prove her purity and ensure her survival. Arahmaiani presents this tale using shadow puppets made of cut leaves, and her experience as a woman in contemporary Indonesian society frames how she tells the story. With this context, the story acquires new resonance, serving as a metaphor for female resiliency and self-preservation in the face of oppressive male patriarchy. The video's accompanying lyrics, written and sung by the artist, underscore the lament of existing under such conditions.

As the preceding examples show, artists have often looked not only to historical themes but also to artistic traditions for inspiration. The influence of the past can take many forms: in some cases as an aesthetic reference to earlier works, in other cases as an internalization and implementation of traditional processes or ideas. The photographs in Cang Xin's *Communication Series* **(FIG. 314)** link China's present and rich cultural past through representing the artist's physical encounters with traditional objects, such as ancient Chinese bronzes. By documenting his actions, Cang Xin represents a desire to better understand history through a literal interaction with the past.

The practice of borrowing or appropriating traditional art forms is executed comprehensively in the work of Ah Xian, another Chinese contemporary artist. Drawing inspiration from ancient art, Ah Xian's yellow-glazed porcelain bust, from his *China China* series **(FIG. 313)**, was fabricated at China's famous Jingdezhen porcelain kilns in Jiangxi Province. The techniques, style, designs, and glazes used to create the bust recall Ming- and Qing-period ceramics from Jingdezhen. Two Ming-period dishes, one

with a six-character Hongzhi reign mark on its base and the other with a six-character Zhengde reign mark on its base, display the glaze color that Ah Xian employs on the bust **(FIGS. 196 AND 197)**. Altar vessels such as stem cups and censers, which originated from ancient bronze forms, were often made of porcelain during the Ming and Qing dynasties. Monochrome ware like these plates were specially produced for the four altars used for imperial ceremony and sacrifice; yellow ceramics were used at the Altar of Earth (*diqitan*). In China, yellow is a cardinal color representing earth, and the use of yellow-glazed roof tiles was limited to royal palaces, mausoleums, gardens, and temples. Moreover, the word for yellow in Chinese (*huang*) is a homonym of the word for emperor. The landscape features in the porcelain body of the bust evoke other elements of China's past. Created in relief, the mountains, trees, architecture, and small figures recall the Chinese tradition of creating and copying landscape paintings, exemplified by a set of four album leaves from *Landscapes in the Manner of Old Masters* **(FIG. 211)**.

These juxtapositions illustrate the rich and nuanced layers of meaning that become accessible when one considers both the traditional and contemporary works in the Asia Society Museum Collection. We encourage readers to consider relationships like the examples above as they peruse the objects presented in this publication. It is our hope that readers will reflect on the relevance of context and that this perspective will encourage other enlightening connections in future encounters with artworks from Asia and beyond.

TRADITIONAL COLLECTION

Denise Patry Leidy and Adriana Proser

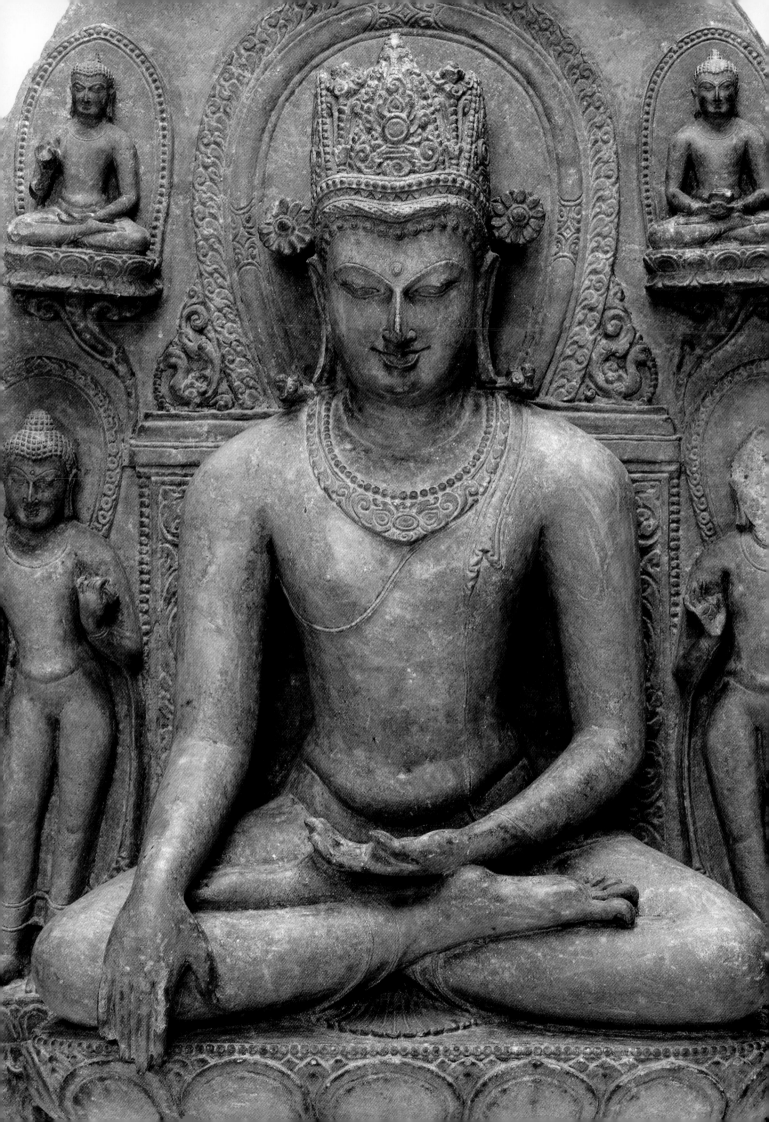

Indian Sculptures of the Kushan Period

Most of the earliest-known images of buddhas and other Buddhist deities were produced in northwest India during the Kushan period, about six hundred years after Buddhism was founded. The Kushans, descendants of nomads from various parts of Central Asia, had settled in parts of Bactria to the northwest of India and ultimately used this stronghold to form an empire that included eastern Parthia, the Kabul Valley, the Gandhara region of present-day Pakistan, and parts of Kashmir and North India.

Although the exact dates of the Kushan period remain controversial, it is now generally agreed that the first through the third century of the Common Era (CE) encompass the height of their rule. There were two major centers of Kushan culture, each with its distinctive style: art from the region of Gandhara shows the impact of Hellenistic and Roman sculpture, owing in part to the sustained effect of Alexander the Great in that part of the world, while art from the city of Mathura in Uttar Pradesh displays a traditional Indian aesthetic. Whereas Gandharan art had a strong influence on early Buddhist art in Central Asia and is also briefly reflected in the earliest Chinese Buddhist material, Mathuran art had a more profound impact on the development of Buddhist art in India and Southeast Asia.

A large standing buddha **(FIG. 1)**, which can be dated to the late second or early third century, typifies the art of Gandhara. The buddha wears the traditional garments of an Indian monk: a long cloth, known as a *dhoti*, is wrapped around his waist and covered by a large shawl draped over his shoulders, a portion of which he holds

in his left hand. The hem of the skirtlike *dhoti* is lower than that of the shawl, helping to distinguish the two garments. Western prototypes are evident in the representation of these garments—a series of thick, heavy folds that obscure the underlying physique—as well as in the treatment of the buddha's facial features and his wavy hair. Similarly, his posture, with its slight sway to the left, is reminiscent of the *contrapposto* position often found in the art of ancient Greece and Rome.

At the same time, well-established Indian traditions are also visible. These include superhuman physical marks (*lakshanas*) that convey the advanced spiritual state of a buddha. Some of these marks are used exclusively in representations of the historical Buddha, Shakyamuni, while others are also found on other Buddhist deities. *Shakyamuni* is the name given to the historical person Siddhartha Gautama (about 563–483 BCE) after he achieved enlightenment and became a buddha ("one who has awakened"). The name *Shakyamuni* is generally translated as "sage of the Shakyas," the name of his clan. Because he is the person responsible for teaching Buddhism during this age (one among countless past and future ages), Shakyamuni is referred to as "the Buddha" to distinguish him from the other buddhas in the pantheon. Over one hundred physical marks are listed in texts describing the perfect form of the Buddha, however, far fewer are shown in the visual arts. These marks include the Buddha's broad shoulders and long legs that are equated with the shoulders of a lion and legs of a gazelle. The Buddha also has webbed fingers, and his full lips are intended to appear as if they have just been stung by bees. Such marks in

Opposite: Detail of **FIG. 16**

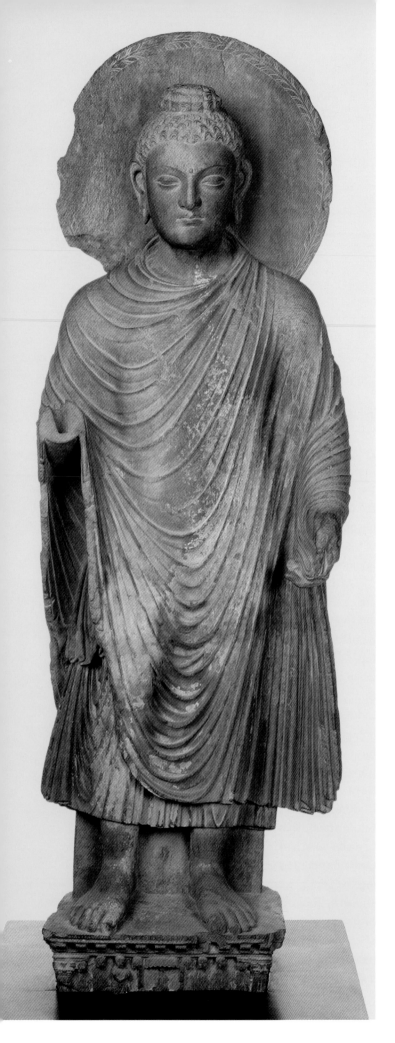

conjunction with hand gestures and postures help discern the identities of these figures in Buddhist art.

The marks on the Buddha's head and face are the most important. The bump at the top of his head is known as an *ushnisha,* which refers to his supernal wisdom, as does the mark in the center of his forehead, called an *urna.* The latter mark, originally considered to be a tuft of hair, is sometimes referred to as the "third eye," and after the ninth century it is at times shown as an eye. The Buddha's downcast eyes symbolize his understanding and mastery of meditation. Finally, his elongated earlobes—which refer to his early life as a prince, when he wore heavy earrings that stretched his earlobes—are a reminder to the faithful that in order to seek enlightenment they must surrender their attachment to worldly goods and pleasures.

This statue's right hand, now broken off, was most likely raised in the gesture of reassurance (Sanskrit: *abhayamudra).* In this gesture, the hand is raised to shoulder height and shown with the palm out and fingers pointing up. This distinguishes a buddha engaged in activity from one whose hand gesture (*mudra*) would indicate meditation.

It is difficult to determine which buddha is portrayed in this life-size statue, although it likely represents Shakyamuni Buddha, the founder of Buddhism. The small figures on the pedestal may once have provided some additional iconographical information. Standing in adoring positions, they are placed to either side of a niche. Although the image that once filled this niche has disappeared, it is likely that it represented either the Buddha preaching or a moment in the life of the founder of Buddhism, even if only by a conventional symbol for Shakyamuni, such as a wheel (a symbol of the acts of preaching and ruling).

Representations of buddhas and other deities in human form first appeared in Indian art in the first century CE, a dramatic change in iconography that reflects equally important changes in the religion. Prior to the Kushan period, such symbols as a footprint, a tree, a wheel, or a burial mound of stone or earth known as a stupa were used to signify the person of the Buddha. There is still much speculation about the change from aniconic to iconic images of the Buddha and about the rationale underlying this change.

FIG. 1. Buddha. Kushan period, late 2nd–early 3rd century. Pakistan, Gandhara area (Reportedly from Naogram, Pakistan). Phyllite. H. 72 x W. 23½ x D. 11½ in. (182.9 x 59.8 x 29.2 cm). Asia Society, New York: Mr. and Mrs. John D. Rockefeller 3rd Collection, 1979.3

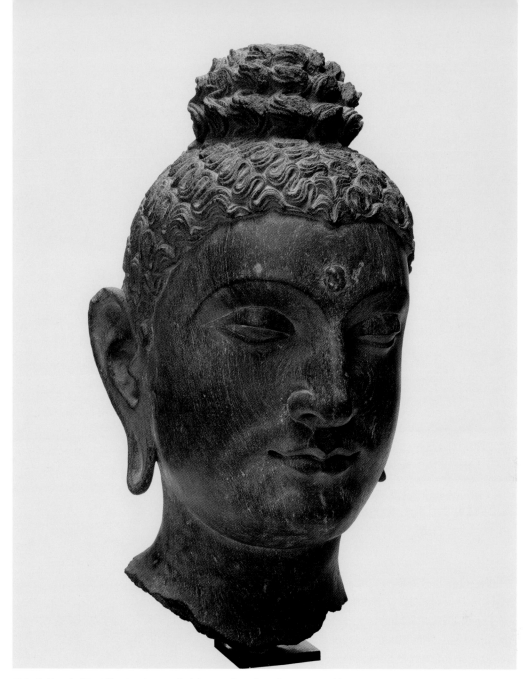

FIG. 2. Head of Buddha. Kushan period, late 2nd–early 3rd century. Pakistan, Gandhara area. Schistose phyllite. H. 14½ x W. 7¾ x D. 9¼ in. (36.8 x 19.7 x 23.5 cm). Asia Society, New York: Mr. and Mrs. John D. Rockefeller 3rd Collection, 1979.2

Many of the aniconic symbols were used as part of narrative scenes, and it is clear from their context that they were intended to represent Shakyamuni.

The Buddhism that Shakyamuni taught was austere, stressing status of monks over the laity and focusing on self-reliance in the search for enlightenment. As the religion developed and diversified, new deities such as bodhisattvas were introduced, and in some schools the worship of Shakyamuni, who had been revered more as a self-perfected and enlightened person, began to stress his transcendence rather than his humanity. It is within this context that images of the Buddha and other deities in human form, such as this sculpture, were made and used.

A comparison of the face of this large standing buddha with that of others, including the head from a Gandharan-style sculpture of a buddha that also dates to the late second or early third century (FIG. 2), shows that the standing figure's head was recently recarved: the chin of the standing buddha is much narrower, the nose is flatter, and the lips are smaller and pursed. The recarving was probably an attempt to improve the appearance of the sculpture, which had been damaged.

Once part of a full statue, a small head of a man (FIG. 3) illustrates an interest in portraiture in the art of Gandhara. Portraits of the Kushan rulers are found on coins and free-standing sculptures; individuals are also depicted as donors or attendants in narrative scenes

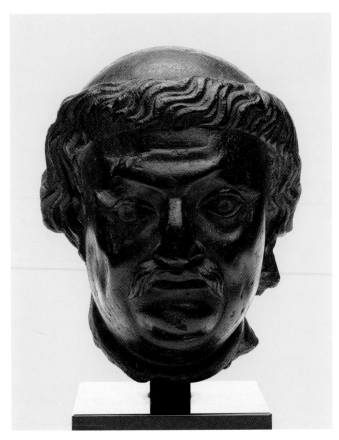

FIG. 3. Head of a Man. Kushan period, 2nd–3rd century. Pakistan, Gandhara area. Schist. H. 6 x W. 5 x D. 5 in. (15.2 x 12.7 x 12.7 cm). Asia Society, New York: Estate of Blanchette Hooker Rockefeller, 1993.1

from the life of Shakyamuni and in those representing worship of the Buddha. It seems likely that this head was once part of such a scene. The fleshiness and maturity of the face and the accurate depiction of his receding hairline reflect the Roman interest in nonidealized portraiture and attest to the continuing influence of western traditions on the art of Gandhara.

The thickness of the tunic and skirt worn by a kneeling figure **(FIG. 4)** and the interest in the folds of the drapery illustrate the continuation of the Gandharan style in the northwest of the subcontinent during the fourth and fifth centuries. This sculpture, which most likely represents a female donor, was once part of a larger scene. Her clothing identifies her as a laywoman and member of the ruling warrior class known as the *kshatriyas*. She holds a large sash, probably made of an expensive material, and a piece of fruit. It is likely that she was once shown offering gifts to an image of the Buddha. Stucco sculptures such as this one, which probably would have been attached to the exterior of a building, have been excavated in large numbers around the city of Hadda in present-day Afghanistan. The use of stucco, which also reveals western influence, appears to have been most common from the third through the fifth century.

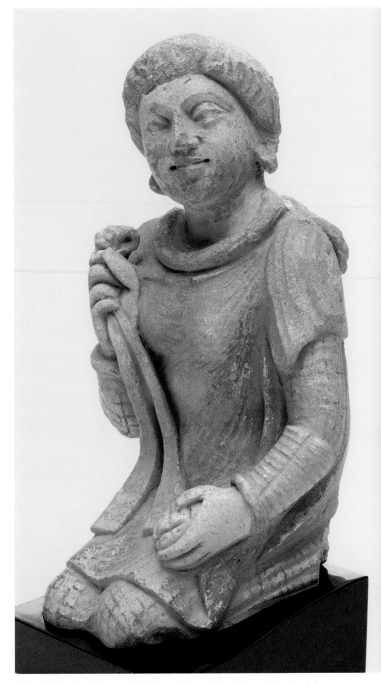

FIG. 4. Kneeling Figure. 4th–5th century. Afghanistan. Stucco with traces of pigment. H. 12⅞ x W. 5¾ x D. 5 in. (32.6 x 14.6 x 12.7 cm). Asia Society, New York: Mr. and Mrs. John D. Rockefeller 3rd Collection, 1979.4

Such sculptures were first modeled in clay and covered with a thin layer of gypsum plaster. Then a thinner, finer stucco was applied and modeled to form the facial features and other delicate details. These sculptures were also often covered with a gluey plaster called gesso and painted. Traces of a red checkered pattern are visible on the tunic and skirt of this kneeling woman. This technique for making stucco sculptures to decorate buildings is believed to have originated in Alexandria, in part to replace the more expensive and labor-intensive

marble sculptures common in the Greco-Roman world. It has been suggested that the popularity of stucco in northwest India resulted from the lack of stone there. However, stone is widely available in the region around Hadda, and it seems more likely that the medium was a novelty that had been imported from regions to the west.

The distinctive red color of a sandstone sculpture of a woman standing beneath a tree **(FIG. 5)** is typical of works made in or near the city of Mathura. The proportions of the woman's figure, in particular her full breasts and hips; her physiognomy; her active pose; and the scantiness of her drapery are characteristics of sculpture from Mathura, where western art exerted little influence.

Fertility figures such as this one play an important role in Indian art. They are among the first images known from India, and beautiful, young, fertile women are found in the religious art of all regions of India from all periods. Such images are often called *shalabhanjikas,* although other terms are also used. In general, a *shalabhanjika* consists of a tree and a woman, and this motif has been depicted in endless variations. The woman's youth, her voluptuous figure, and her elaborate hairstyle and jewelry characterize *shalabhanjika* motifs, which represent the eternal procreative forces of nature. The fertility implicit in this type is reiterated by the pose of this figure, as she touches the trunk of the tree with her left foot, a posture that is called *dohada.* This is a reference to an ancient Indian belief that the touch of a woman can cause a tree to burst into bloom—just as flowers and fruit have burgeoned in the tree above this young woman's head.

This example of a *shalabhanjika* decorates a pillar that was once part of a circular railing used to create a sacred space around a monument such as a stupa, or such religious symbols as a throne or a tree. The indentations on the sides of the pillar indicate where railings would originally have been inserted. The earliest Indian stupas and other objects of worship were generally undecorated, and most of the imagery associated with these sites are carvings on the railings and pillars that surrounded them. This figure holds a long object, probably an expensive cloth, to offer to the deity worshiped at the sacred space within. It is not known whether this railing pillar was from a Buddhist, Hindu, or Jain site, as sacred sites and *shalabhanjikas* were common to all of the religions practiced in Mathura.

FIG. 5. Railing Pillar With a Female Figure (*yakshi*) Standing Under an Ashoka Tree (Shalabhanjika). Kushan period, 2nd century CE. India, Uttar Pradesh, Mathura area. Red sandstone. H. 32⅛ x W. 7⅝ x D. 6 in. (81.6 x 19.4 x 15.3 cm). Asia Society, New York: Mr. and Mrs. John D. Rockefeller 3rd Collection, 1979.1

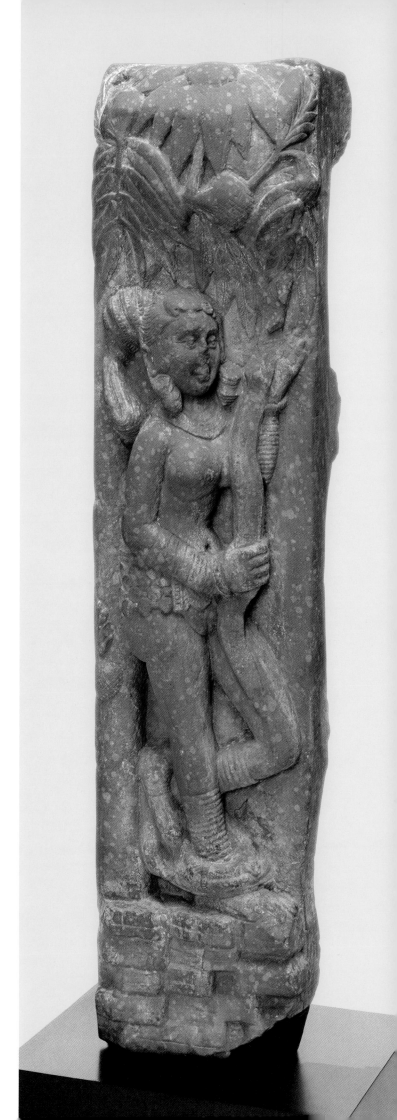

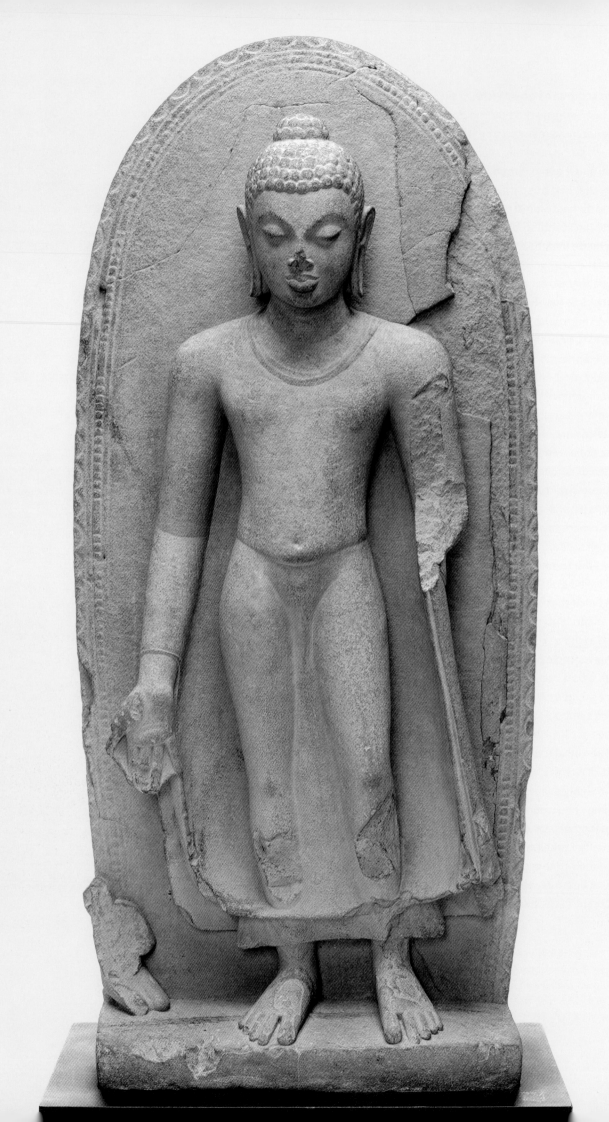

Sculptures from North India, 5th–7th Century

Sculptures made in North and north-central India during the rule of the Gupta kings are often considered to represent one of the high points in Indian art. The Gupta period, which lasted from about 319, when the name of the dynasty was first announced, to about 500, the year of the death of King Buddhagupta, was a period of enormous prosperity and flourishing of the arts. A relatively uniform style is found in sculpture produced throughout the Gupta empire. This "classic" style spread through much of India, and proceeded to influence the art of places as diverse as Sri Lanka, Thailand, and Java, contributing significantly to the development of religious art, both Buddhist and Hindu, in Southeast Asia.

The city of Sarnath, located in Uttar Pradesh in north-central India, was one of the major centers for the production of sculpture during the Gupta period, and it is the style of sculpture produced in this city during the last quarter of the fifth century that best exemplifies the art of the imperial Gupta period. The elegant proportions and strong physique of a standing buddha made of sandstone **(FIG. 6)** typify the art of the Sarnath school. Sculptures from Sarnath are characterized by their graceful bodies, relaxed postures, downcast eyes, slight introspective smiles, and by their refined details, such as those seen along the sides of the oval-shaped mandorla behind the figure in this piece. Like the halos often found behind the heads of Buddhist, Hindu, and Christian deities, mandorlas are symbols of light, and hence divinity. The clinging drapery worn by this buddha, most evident in the hemlines and necklines, also typifies this style. His garments, which consist of a long skirtlike *dhoti* and a full shawl, are the usual habit of a Buddhist monk.

The interest in fully covering the body seen here reflects the influence of earlier sculptures such as those produced in and around the city of Mathura in Uttar Pradesh during the second and third centuries under the rule of the Kushans. The emphasis on the human figure rather than the robes, the proportions of the buddha's body, and the treatment of his facial features also derive from traditions associated with the city of Mathura. In addition, the use of superhuman physical marks, such as the *ushnisha* on the buddha's head, the snail-shell shape of his curls, and his elongated earlobes, are long-standing Indian traditions. The first two of these marks distinguish the spiritually advanced buddha from other Buddhist deities.

It is difficult to identify which buddha is represented in this sculpture. His right hand is lowered with the palm out in the gesture of charity *(varadamudra),* and it appears from the position of his left elbow that his missing left hand was raised with the palm open to the viewer in the gesture of reassurance *(abhayamudra).* In Indian Buddhist art, the latter is often understood as a reference to a certain event in the life of Shakyamuni—his taming of a drunken elephant named Nalagiri that had been sent to harm him—and therefore it is possible that this sculpture may represent the founder of Buddhism. The small kneeling figure to the buddha's right, little of which remains, represents the donor of the sculpture.

An architectural panel **(FIG. 7)** used to decorate a brick temple is a charming example of a terra-cotta in the fifth-century Gupta style. Terra-cotta, a coarse clay fired at a low temperature, makes for fragile sculptures. It was an important medium in Indian art for centuries, and examples have been preserved from some of India's earliest periods.

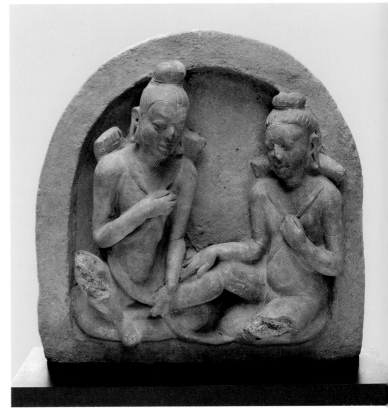

FIG. 7. Two Figures, probably Rama and Lakshmana. Gupta period, 5th century. India, Uttar Pradesh. Terra-cotta. H. 17½ x W. 16¾ x D. 5¼ in. (44.5 x 42.5 x 13.3 cm). Asia Society, New York: Mr. and Mrs. John D. Rockefeller 3rd Collection, 1979.6

Opposite: **FIG. 6.** Buddha. Gupta period, about 475. India, Uttar Pradesh, Sarnath area. Sandstone. H. 34⅛ x W. 17⅝ x D. 6 in. (86.7 x 44.8 x 15.2 cm). Asia Society, New York: Mr. and Mrs. John D. Rockefeller 3rd Collection, 1979.5

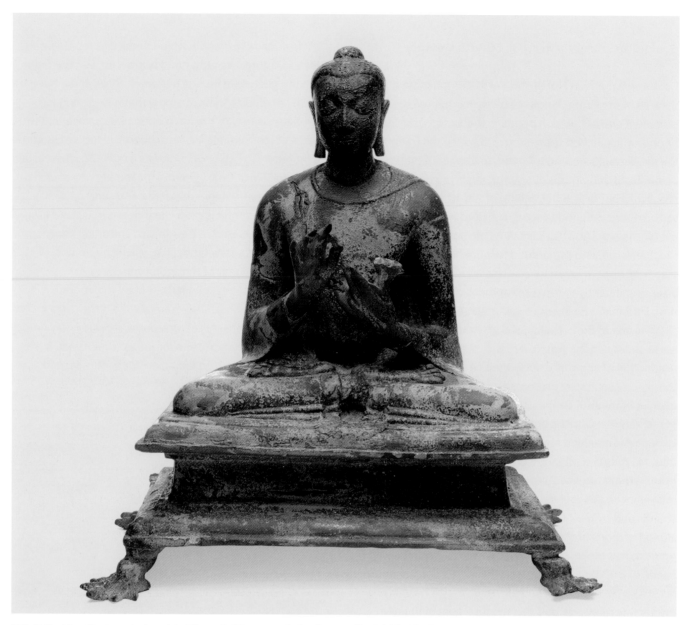

FIG. 8. Buddha. Gupta period, ca. late 5th–early 6th century. India. Copper alloy inlaid with silver and copper. H. 14⅛ x W. 14 x D. 9 in. (35.9 x 35.6 x 22.9 cm). Asia Society, New York: Mr. and Mrs. John D. Rockefeller 3rd Collection, 1979.7

This panel shows two lightly clothed men seated in conversation. Because of their clothing and the quivers they carry, these figures have tentatively been identified as the Hindu god Rama—a form of Vishnu—and his brother Lakshmana. Rama is the hero of the great Hindu epic poem *Ramayana,* which tells the story of the loss of Rama's throne; his exile from his kingdom Ayodhya; and his life in the woods with Lakshmana, his wife Sita, and the monkey-king Hanuman. Here Rama, who holds a bow, is shown slightly larger than Lakshmana.

The shape of this architectural panel and the style of the two figures suggest that they were made in the vicinity of the city of Bhitargaon in Uttar Pradesh. This city was the site of an early Hindu brick temple with terra-cotta decoration that is widely considered one of the finest of

its type. The three-quarter view used in the representations of Rama and Lakshmana in this relief were also commonly employed in the decoration of architectural panels from Bhitargaon. In addition, the cascading loops of hair, full lips, slightly bulging eyes, and distinctive long, flat earlobes also have parallels in the art of Bhitargaon. The treatment of the eyes and the slight elongation of the torso and limbs distinguish sculptures produced in the area of Bhitargaon from those made at Sarnath and illustrate one variant within the classic style associated with the Gupta empire.

Three bronze sculptures (**FIGS. 8, 9, AND 10**) exemplify the importance of the Gupta style, particularly in northeastern India, during the sixth and seventh centuries. All three sculptures depict a buddha (most likely Shakyamuni).

One of the buddhas is seated and the other two are standing. These sculptures also illustrate the growing importance of bronze as a medium during the sixth and seventh centuries. Although the reasons for this growth in bronze casting remain obscure, bronze sculptures such as these three examples are often linked to the better-known bronze-casting traditions in northeastern India from the eighth through the twelfth century, when this region was largely under the rule of the Pala kings and was the most important center in India for the production of Buddhist art.

The seated buddha **(FIG. 8)** has been dated to the late fifth or early sixth century largely on the basis of the paleography of the inscription carved on the pedestal. This inscription consists of a standard Buddhist creed that is often found on Indian sculpture that loosely translates as "all those phenomena which are born of causes, Thathagata [that is, Buddha] spoke indeed of all those causes, and their cessation [was also preached by him]." This consecratory formula is written on the sculpture in the North Indian Brahmi script, which was commonly used in the late fifth and early sixth centuries.

The buddha holds his hands in the preaching gesture (*dharmachakramudra*). His broad shoulders, full torso, and the clinging drapery continue stylistic traditions found in the city of Sarnath during the imperial Gupta period. However, the proportions of the face and physique of this bronze buddha are more elongated than is common in buddhas from Sarnath and other sites in Uttar Pradesh. This is most evident in his folded legs, which are noticeably long in proportion to his torso. A similar subtle elongation is found at such sites as Bhitargaon and in northeastern India, making it difficult to suggest a provenance for this piece.

A standing buddha **(FIG. 9)** also follows the conventions established at Sarnath in the last quarter of the fifth century. Both this bronze sculpture and the sandstone sculpture of a buddha discussed earlier **(FIG. 6)** stand in the *abhanga* position, in which one leg is slightly bent to give a feeling of potential movement to the image. Both buddhas wear monk's robes that are almost transparent in order to emphasize the perfection of the buddha's physical form. They have the same oval face, with almond-shaped eyes, a broad nose, and full lips. This bronze buddha holds his right hand in the gesture of reassurance. He grasps a piece of unattached cloth in his left hand; this cloth may reflect a misunderstanding of an earlier visual tradition in which the buddha holds the end of his shawl in his left hand.

Subtle differences distinguish this bronze buddha from the sandstone example: his shoulders are marginally

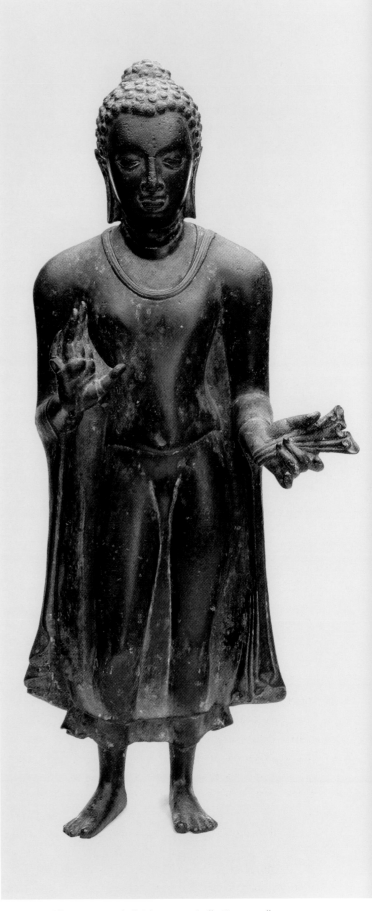

FIG. 9. Buddha. Gupta period, 6th century. India. Copper alloy. H. 19⅜ x W. 7 x D. 5 in. (49.2 x 17.8 x 12.7 cm). Asia Society, New York: Mr. and Mrs. John D. Rockefeller 3rd Collection, 1979.9

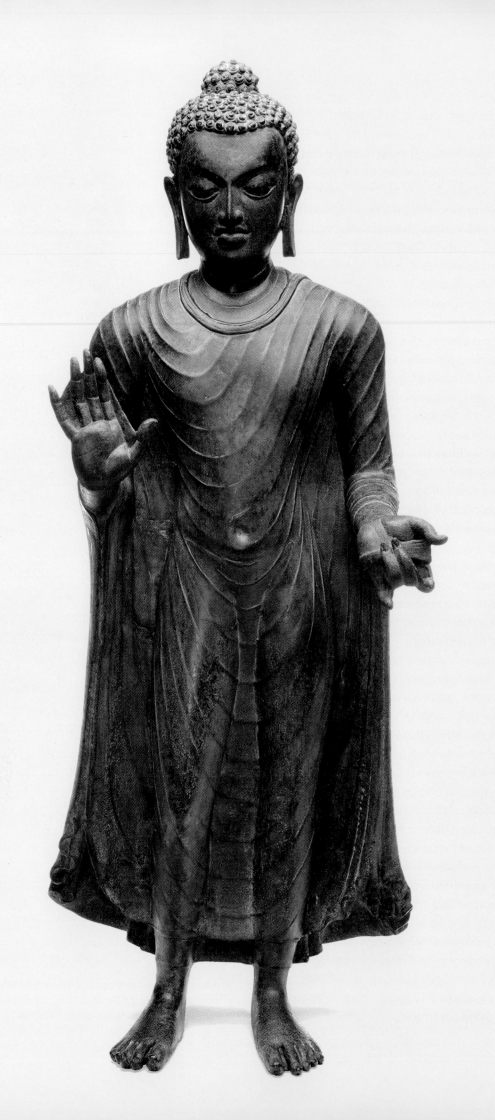

broader in proportion to the overall physique, his facial features are slightly blunter, and the center of his hairline is more pointed. Moreover, his posture is slightly more rigid than that of the Sarnath-type buddha. This rigidity, the fuller thighs of the bronze buddha, and the greater attention paid to the edges of his *dhoti* and shawl help date this image to the sixth century. Similar characteristics are found on stone sculptures produced in the areas around Bodh Gaya in Bihar Province to the east of Uttar Pradesh, and it is possible that this powerful bronze sculpture is an early example of the Buddhist art of that region.

A striking late-sixth-century bronze statue of a standing buddha **(FIG. 10)** provides another link between the art of the Gupta period and later traditions in East India. Elements of Gupta prototypes are evident in the body type of the buddha and the treatment of his drapery as a series of folds that cling to and reveal his form. Once again, the unattached piece of cloth in the buddha's left hand reflects earlier prototypes.

The stylization of the drapery folds and the attention given to the hemlines of the garment point to the statue's origins in East India. The slightly elongated proportions of the buddha, his stiff pose, and thicker thighs are also typical of sculpture produced in Bihar and West Bengal. Further links to East India are seen in the treatment of the buddha's features—in particular his long, narrow nose—and the somewhat square shape of his face.

A stone sculpture of the Hindu god Vishnu **(FIG. 11)** also illustrates the evolution of Gupta styles in East India in the sixth and seventh centuries. Although the sculpture's hands, which would have held identifying attributes, are missing, the figure is identified as Vishnu because of his crown and the treatment of his hair, which is neatly coiffed and which distinguishes Vishnu from Shiva, whose hair is generally shown as matted. The god stands frontally with his legs slightly apart and has the same slight stiffness in his pose, often associated with early sculptures from northeastern India, seen in the two standing bronze buddhas. Vishnu wears a long skirt that has been pulled between his legs and is covered with a belt decorated with jewel cabochons, two hanging pendants, and a rosette. The pleats of his garment are depicted as a series of regular concentric lines, and this slight stylization of the drapery is reminiscent of the treatment of the folds of the garments worn by one of the standing buddhas mentioned earlier **(FIG. 10)**.

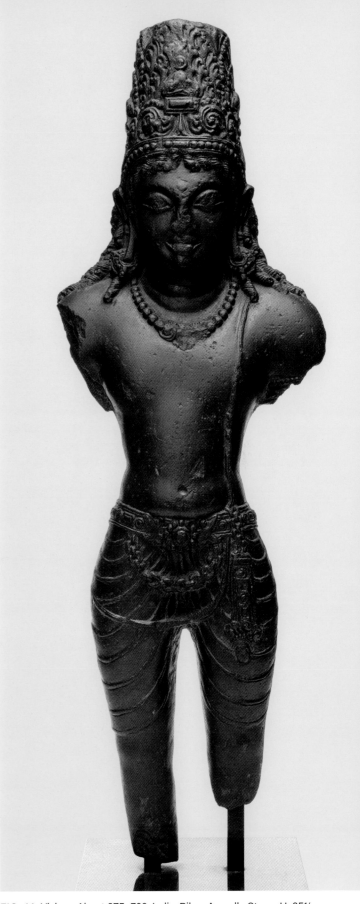

FIG. 11. Vishnu. About 675–700. India, Bihar, Apsadh. Stone. H. 35½ x W. 12 x D. 6 in. (90 x 30.5 x 15.2 cm). Asia Society, New York: Gift from The Blanchette Hooker Rockefeller Fund, 1994.1

Opposite: **FIG. 10.** Buddha. Late 6th century. India, probably Bihar. Copper alloy. H. 27 x W. 10¾ x D. 7 in. (68.6 x 27.3 x 17.8 cm). Asia Society, New York: Mr. and Mrs. John D. Rockefeller 3rd Collection, 1979.8

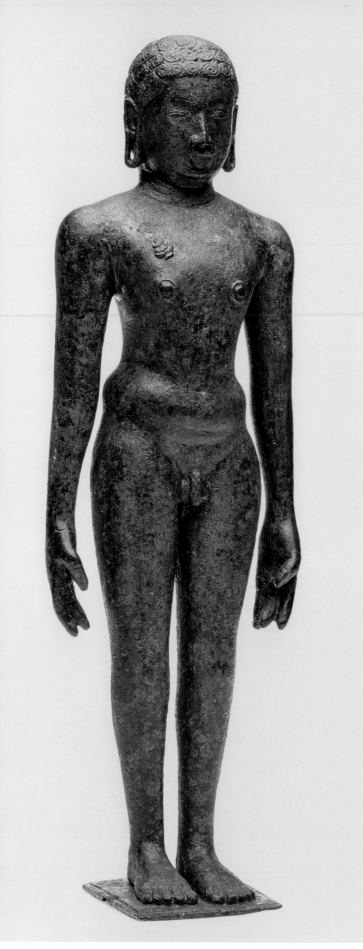

FIG. 12. Tirthankara. 7th–early 8th century. India, Karnataka or Tamil Nadu. Copper alloy. H. 10½ x W. 3½ x D. 3½ in. (26.7 x 8.89 x 8.89 cm). Asia Society, New York: Mr. and Mrs. John D. Rockefeller 3rd Collection, 1979.11

This sculpture has generally been attributed to the city of Apsadh, located to the southeast of Nalanda in Bihar Province, because of the similarities between the body of this Vishnu and those of other sculptures that are attributed to this area. This sculpture of Vishnu and other pieces in the same style are often associated with the rule of King Adityasena (7th century CE), who was a member of the Later Gupta dynasty that ruled parts of North and northeastern India in the third quarter of the seventh century. The Later Guptas are also known as the Guptas of Magadha. Little is known about their relationship, if any, to the earlier imperial line.

Some scholars have associated this Vishnu and stylistically similar works with the city of Apsadh. This conclusion is based on the discovery of an inscription in Apsadh that gives a genealogy for Adityasena and his family and records the building of a temple dedicated to Vishnu. The inscription also states that Adityasena's mother established some type of religious college in the city, while his wife supported the excavation of a tank for ritual bathing. Although neither the college nor the tank has been found, a large mound in the center of the city has been partially excavated and is believed to be the temple dedicated to Vishnu. This temple was apparently decorated with a large number of stucco sculptures that are thought to illustrate scenes from the *Ramayana*. It is not certain whether or not this particular sculpture of Vishnu was originally housed in the temple built by Adityasena; however, given the king's interest in Vishnu and the quality of this sculpture, it seems likely that this statue may once have been prominently displayed in either this temple or somewhere else in the city.

Two Jain Sculptures

Jainism is a religious faith that was founded at approximately the same time as Buddhism, and both religions can be understood as reflections of the cultural and philosophical changes that characterized Indian society in the sixth and fifth centuries before the Common Era. The founder of Jainism was Vardhamana Mahavira (about 540–468 BCE), who was slightly younger than Siddhartha Gautama, the founder of Buddhism. Jainism, which today is practiced primarily in western and North India, stresses nonviolence toward all living things and the practice of austerities. Jainism is not as widespread as Buddhism and Hinduism, both of which traveled to other lands, but its influence on the thought and actions of Mohandas Gandhi extended through his writings to Martin Luther King, Jr.

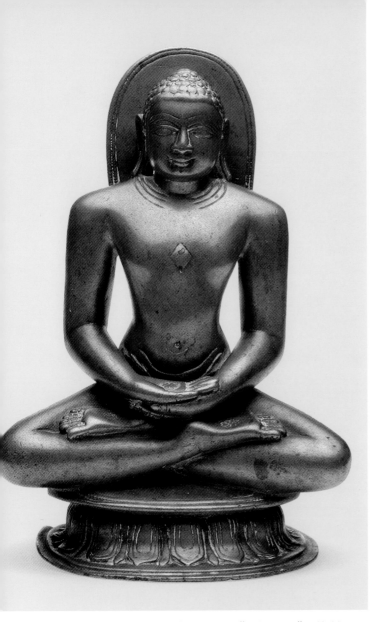

FIG. 13. Tirthankara. 9th–10th century. India. Copper alloy. H. 11 x W. 8 x D. 5 in. (27.9 x 20.32 x 12.7 cm). Asia Society, New York: Mr. and Mrs. John D. Rockefeller 3rd Collection, 1979.12

The term *Jainism* is derived from *jina,* the name given to twenty-four principal adepts and teachers of this religion. These figures, who are also known as *tirthankaras* or "river-forders," are the principal focus of Jain art, which also incorporates some of the semidivinities found in Buddhist and Hindu art. The nakedness of the images of two *jinas* in the Collection indicates that they belonged to the Digambara or "sky-clad" sect of Jainism, which is the more austere of the two primary branches of this religion. The other sect is known as the Svetambara or "white-clad" sect.

The erect, motionless stance of an image of a *tirthankara* (**FIG. 12**) and his elongated arms and earlobes are physical marks that indicate his spiritual advancement. His posture and downcast eyes show that he is in meditation. The *jina* has the same idealized body used for Buddhist and Hindu divinities, however the depiction

of a roll of flesh at the waistline appears to be more common in Jain sculpture. The small leaflike mark on the upper right of his chest may have been intended to distinguish this *tirthankara* from the other twenty-three, however, it is not possible to identify this figure without further information. The full, compact, and somewhat fleshy physique of the *tirthankara* dates this sculpture to the seventh or early eighth century. Moreover the shape of the face and the treatment of the features suggest that this bronze was cast in South India, making it an important example of an early Jain image from that area. In particular, the oval face and fleshy cheeks and his small, rounded features are typical of works cast in and around Tamil Nadu, a region that was famous for its bronze casting during the ninth through the twelfth century. The treatment of the *jina's* hair as a cap of loose but full curls is also characteristic of early sculptures from that part of India.

The broader and less articulated body of a seated *tirthankara* (**FIG. 13**) dates this work to the ninth or tenth century, while the flatter and fuller features suggest origins in north-central rather than South India. The posture of this *tirthankara*, in which each foot is placed on the opposite thigh—the lotus posture (*padmasana*)—is a meditative pose also used in Buddhism. The hand gesture (*dhyana-mudra*) also symbolizes meditation, and both indicate the *tirthankara's* advanced spiritual development. The lack of motion or activity in each of these figures embodies the Jain emphasis upon living carefully and inflicting no harm.

Pala-Period Sculptures

One of the longest lasting and most important Buddhist cultures of India developed and flourished in East India from the eighth to the twelfth century. During this period, Bihar and Bengal—present-day West Bengal State and the nation of Bangladesh—were primarily under the control of the Pala family. However, various other families, in particular the Senas, also controlled smaller sections of the region at different times. Monks from all over Asia traveled to East India to study Buddhism at the famous monasteries there. As a result, the influence of Pala-style art spread throughout Asia. Pala contributions to Buddhist art include the developments of a new figural type, which was loosely based on prototypes developed during the Gupta period (about 320–about 500) in North and north-central India, and the evolution of more complicated iconography that illustrates contemporary changes in Buddhist thought.

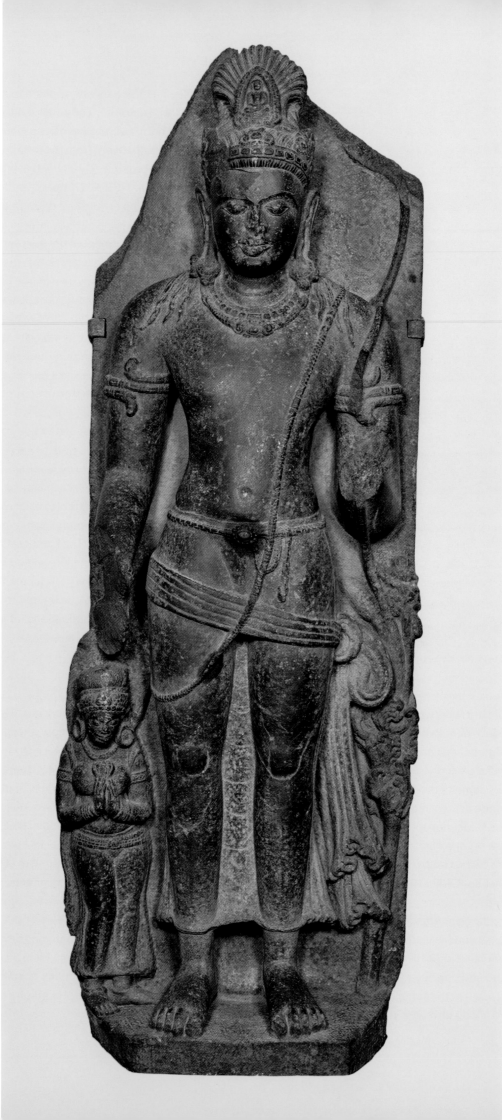

A monumental sculpture of the Bodhisattva Avalokiteshvara **(FIG. 14)** provides an important link between the fifth- and sixth-century style of art associated with the Gupta empire and traditions found in East India. While after attaining enlightenment a buddha transcends mortal concerns and the cycle of reincarnation, a bodhisattva is as spiritually advanced, but he vows to help all sentient beings become enlightened and chooses to remain accessible to the devout in their daily lives. The development of the cult of the bodhisattvas is part of a series of changes that led to the emergence of the Mahayana branch of Buddhism. Worship of bodhisattvas and the belief in multiple buddhas of the past, present, and future ages are among the main elements that distinguish Mahayana, the "Great Vehicle," from the more austere branch of Buddhism based on an earlier group of scriptures and known as Theravada, the "Way of the Elders," which emphasizes the historical Buddha rather than a complex pantheon.

Avalokiteshvara, the Bodhisattva of Compassion, is the most popular deity in the Buddhist pantheon and is worshiped in a wide array of forms. Avalokiteshvara is identified by the small sculpture of Amitabha Buddha in his headdress. Amitabha is the head of Avalokiteshvara's spiritual family; his image was first used regularly to identify sculptures of Avalokiteshvara in India in the sixth century, and it soon became one of the most constant features in the imagery of this bodhisattva. The stem that this Avalokiteshvara holds was once part of a lotus and further identifies this form of Avalokiteshvara as the Lotus Bearer (*Padmapani*), one of the most common and simplest forms of this bodhisattva. The small female attendant may represent the donor of the image; she has also been interpreted as a symbol of Avalokiteshvara's ability to grant children to barren women.

The contrast between the powerful form of the bodhisattva and the serene expression on his face continues an aesthetic established during the Gupta period. Avalokiteshvara wears a long skirtlike garment and has a full sash tied around his hips. As befits his status as a bodhisattva, he also wears earrings, a necklace, and armlets. Similar clothing and jewelry are worn by Gupta-period representations of Avalokiteshvara, and the smoothness of the body and the clinging drapery also reflect earlier prototypes. This piece is distinguished from the Gupta-period sculptures, however, by the heaviness and fullness of the figure, the slight rigidity in his pose, and

the more elaborate treatment of the jewelry. Moreover, Avalokiteshvara's straight nose and the somewhat square shape of his face differentiate it from earlier works. These features characterize the beginnings of the Pala style and help to date this piece to the late seventh or early eighth century.

Elaborate details coupled with the long bodies, with well-defined waists, and the long, thin facial features of the Buddha figures seen in two reliefs **(FIGS. 15 AND 16)** exemplify the style of Pala sculpture of the tenth and eleventh centuries. Sculptures of this type, among the most common produced during the Pala period, were placed in niches within architectural monuments or shrines. Both show Shakyamuni under a *pippala* tree (*Ficus religiosa*) seated in the posture of meditation on a lotus pedestal atop a base decorated with lions and other figures; the Buddha's left hand is in the gesture of meditation and his right hand is making the gesture of touching the earth (*bhumisparshamudra*).

In Buddhist art, the earth-touching gesture is used to represent the story of Shakyamuni's defeat of the demon Mara. This occurred while the Buddha-to-be was meditating in his quest for enlightenment. Because the forces of evil in the world did not want him to become enlightened or lead the way for others, the demon Mara attempted to distract Siddhartha, as Shakyuamuni was known before attaining enlightenment, by tempting him with beautiful women, pummeling him with natural forces, and attacking him with demon hordes. In response to Mara's final challenge to his right to seek enlightenment, the meditating figure reached down to touch the ground, calling upon the earth to validate his quest. The earth responded thunderously and Mara was vanquished.

In the earlier of the two reliefs **(FIG. 15)**, the Buddha is attended by the bodhisattvas Avalokiteshvara and Maitreya, who stand to his right and left, respectively. The traditional Buddhist consecratory formula is inscribed around a lush halo that encircles Shakyamuni's head. Two stupas are shown to either side of this inscription, but the precise meaning of these stupas, which are also found on other Pala-period pieces, remains elusive. One possibility is that they represent the existence of buddhas in past and future ages, signifying the continuation of Buddhism over time. This concept is symbolized by the imagery of Shakyamuni's triumph over Mara, because this triumph was immediately followed by his enlightenment and his decision to share his

Opposite: **FIG. 14.** Buddha Avalokiteshvara. Late 7th–early 8th century. India, Bihar. Schist. H. 101 x W. 37 x D. 27 in. (256.5 x 94 x 68.6 cm). Asia Society, New York: Mr. and Mrs. John D. Rockefeller 3rd Collection, 1979.10

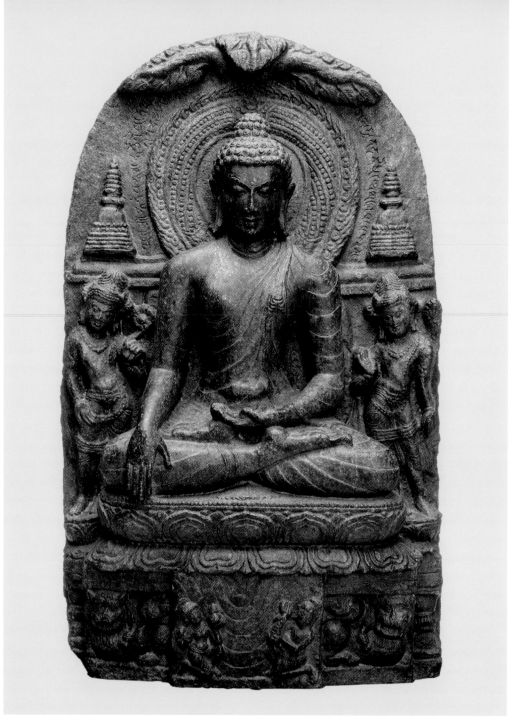

FIG. 15. Buddha Shakyamuni. Pala period (8th–12th century), late 9th–early 10th century. India, Bihar. Schist. H. 28¼ x W. 17¾ x D. 7¼ in. (71.8 x 45.1 x 18.4 cm). Asia Society, New York: Mr. and Mrs. John D. Rockefeller 3rd Collection, 1979.37

understanding with others. The small female figure holding a pot depicted at the base of the relief represents the earth goddess, while the accompanying male figure shown offering a flower garland to the Buddha portrays the donor of the artwork.

An interest in detail and a greater iconographic complexity distinguish the eleventh-century example **(FIG. 16)** from the earlier relief. The central Shakyamuni Buddha figure is seated on an elaborate throne, and around him are arrayed four smaller buddha images. Each of these five major figures has a nimbus with a decorated

border encircling his head or body. In addition to two branches of the *pippala* tree, under which he achieved enlightenment, Shakyamuni also has a canopy above his head. As was true of the earlier relief, the earth goddess and a male donor are depicted on the pedestal, and the sculpture includes the Buddhist consecratory formula, although in this example it is inscribed along its base rather than around the nimbus. The crouching lions on the base symbolize the Buddha's role as an earthly ruler or king, as well as the process of enlightenment, which is sometimes described as a lion's roar.

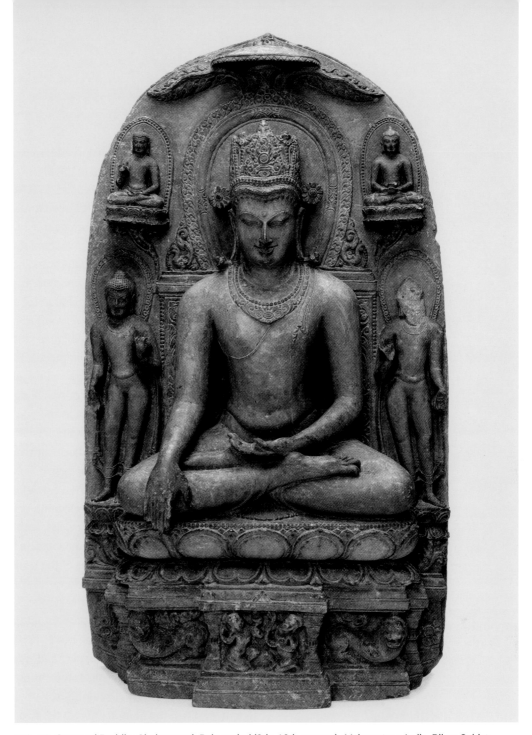

FIG. 16. Crowned Buddha Shakyamuni. Pala period (8th–12th century), 11th century. India, Bihar. Schist. H. 27¾ x W. 16¼ x D. 6½ in. (70.5 x 41.3 x 16.5 cm). Asia Society, New York: Mr. and Mrs. John D. Rockefeller 3rd Collection, 1979.36

Unlike the earlier image, in this representation the Buddha wears a crown and jewelry, adornments that first appear in Pala-period sculptures dating to the eleventh century. These can be interpreted in many ways. The crown, jewelry, and throne indicate that Shakyamuni is both a teacher and a universal ruler. The importance of crowns in the representations of Shakyamuni and other buddhas has been linked to the development of the esoteric branch of Buddhism, which is known as Vajrayana, the "Diamond Vehicle or Path." Characterized by an expanded pantheon of divinities and by the practice of certain mental and physical exercises, Esoteric Buddhism stresses the importance of rites and ceremonies in the quest for enlightenment. The crowned buddhas often associated with Esoteric Buddhism can be linked to the belief in the transcendence of the buddhas in later Buddhist thought and to initiation ceremonies during which monks were crowned to signify their attainment of certain levels of spiritual development.

The four smaller images of the Buddha on this slab illustrate scenes from the life of Shakyamuni. Moving clockwise from the lower left are Shakyamuni's descent

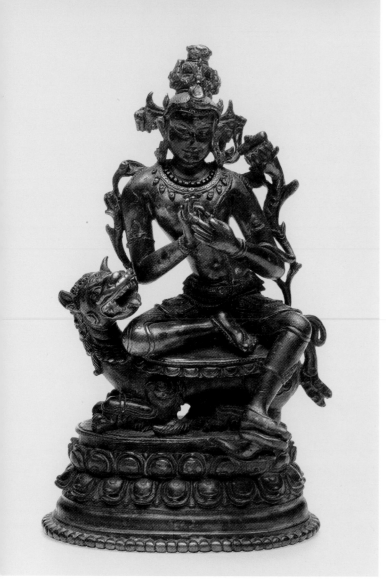

FIG. 17. Bodhisattva Manjushri Seated on a Lion. Pala period (8th–12th century), mid-11th century. India, Bihar or Bengal. Gilt copper alloy with inlays of silver and copper. H. 5½ x W. 3½ x D. 2 in. (14 x 8.89 x 5.08 cm). Asia Society, New York: Mr. and Mrs. John D. Rockefeller 3rd Collection, 1979.35

India where each event took place; as such, they also indicate the importance of pilgrimage to the sacred sites of Buddhism.

The elegant proportions and attenuated waistlines of these buddhas are also found in the physique of a bronze sculpture of the Bodhisattva Manjushri **(FIG. 17)**. Such details as the flower-shaped ties used for his crown date the sculpture to the mid-eleventh century. Often depicted as a youth, Manjushri is the Bodhisattva of Wisdom and symbolizes the transcendent understanding and knowledge that are required to attain enlightenment. He is identified by the small book (a manuscript of one of the *Prajnaparamita* [*Perfection of Wisdom*] *Sutras*) placed on the lotus that he holds in the crook of his left arm and by the lion he rides. Unlike stone sculptures, which were used in public settings, small bronze images such as this one were intended primarily for personal devotion in monasteries and homes. Known as the posture of relaxation (*lalitasana*), Manjushri's position is often seen in Pala-period images of princely bodhisattvas, probably to symbolize their activity and accessibility.

This same posture is seen in two reliefs **(FIGS. 18 AND 19)** that can be dated to the late eleventh or early twelfth century because of their rich carvings, elaborate details, and pointed tops. They depict Khasarpana Lokeshvara, one of the most important forms of the Bodhisattva Avalokiteshvara, who takes a wide variety of forms to help the faithful and spread his compassion to the world. The Khasarpana or "Sky-Gliding" form is youthful, has two arms, and wears his hair in a tall matted coiffure with an image of Amitabha Buddha on his headdress. The five directional buddhas are represented sitting on lotus pedestals at the top of the sculptures. Female deities stand to either side of the central figures: the two-armed figure to the bodhisattva's right represents Tara, and the four-armed figure with a stupa in her headdress is Bhirkuti.

Tara, who represents the active form of compassion and is often linked to Avalokiteshvara, is one of the most popular deities in Esoteric Buddhism. Bhirkuti is also worshiped as a manifestation of compassion, but she is rarely worshiped as an independent deity and is also often associated with Avalokiteshvara.

Esoteric Buddhism includes an astonishing number of deities in a mind-boggling array of forms, and a precise identification of each and every figure is often necessary to identify the main image in a sculpture or painting.

from the heaven of thirty-three gods, which he visited to preach to his mother; the first sermon; the story of a monkey's offering of honey to the Buddha; and the taming of the mad elephant Nalagiri sent by his evil cousin to kill him. These identifications are based on the postures of the figures, their hand gestures, and the objects they hold in their hands; they are four of a standardized group of scenes called the Eight Great Events. These events can be interpreted as both historical records and as paradigms for the process of enlightenment. For example, the taming of the elephant can be understood as a symbol of the mastery of certain aspects of the self that must be disciplined. The scenes also evoke the actual location in

Opposite: **FIG. 18.** Bodhisattva Avalokiteshvara in the Form of Khasarpana Lokeshvara. Pala period (8th–12th century), late 11th–early 12th century. India, Bengal. Phyllite. H. 54¾ x W. 30 x D. 13 in. (139.1 x 76.2 x 33.02 cm). Asia Society, New York: Mr. and Mrs. John D. Rockefeller 3rd Collection, 1979.39

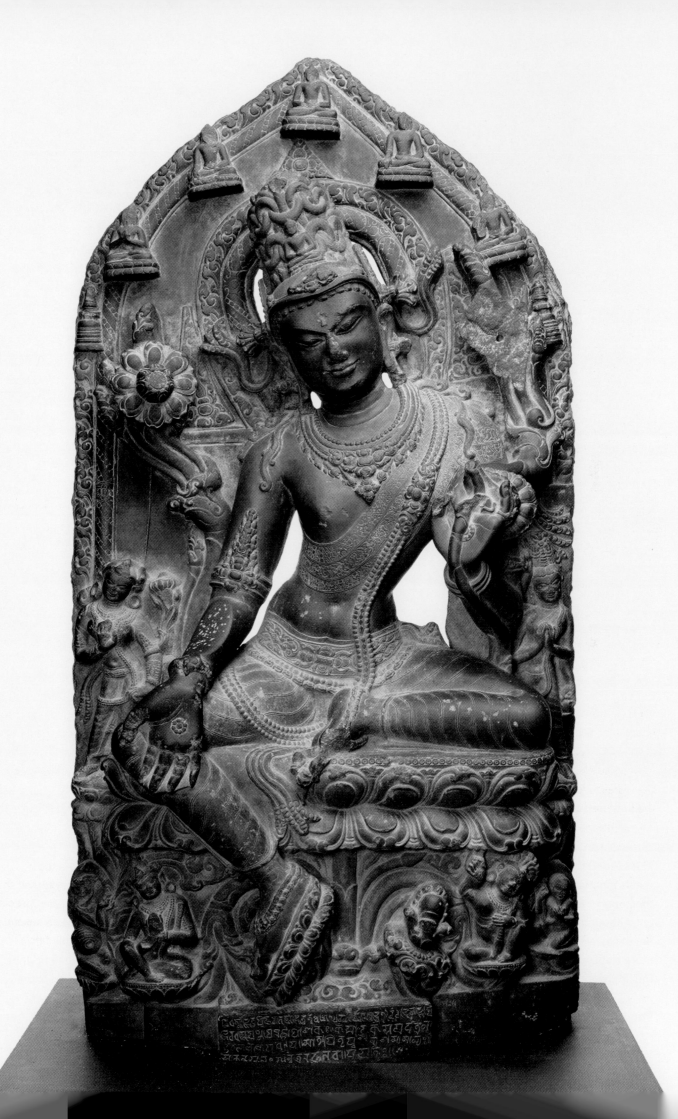

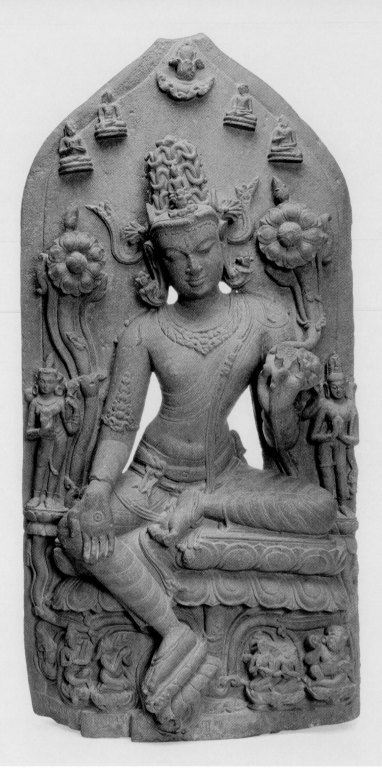

FIG. 19. Bodhisattva Avalokiteshvara in the Form of Khasarpana Lokeshvara. Pala period (8th–12th century), late 11th–early 12th century. India, Bihar or Bengal. Schist. H. 37½ x W. 18½ x D. 6¾ in. (95.3 x 47 x 17.2 cm). Asia Society, New York: Mr. and Mrs. John D. Rockefeller 3rd Collection, 1979.40

The secondary figures in compositions such as these two reliefs function as symbols reinforcing the theme—here the importance of compassion—and help in identification.

Although the principal figures and their iconography are the same, one of the reliefs stands out as being more elaborately carved and decorated **(FIG. 18)**, and the figures on the two bases are arranged slightly differently. The figures on the base of the relief in figure 18, from left to right, are a *preta* or "hungry ghost" named

Suchimukha, whose name means "needle-nosed"; Sudhana; a young protective deity named Hayagriva; and a donor. Hayagriva, "horse-necked," is sometimes shown as having a horse head and sometimes a human head. He belongs to a class of protective deities that signify the terrifying but benign powers of the buddhas. In addition, there is a long inscription engraved at the bottom of the base.[1]

The figures on the base of the relief in figure 19, from

left to right, represent Sudhana, Suchimukha, two donors, and Hayagriva.[2] In both works, Suchimukha is seated beneath Avalokiteshvara's outstretched right hand, which is held in the gesture of charity or offering. This composition illustrates the belief that Avalokiteshvara feeds nectar to the hungry ghosts as a symbol of his infinite compassion for all living beings. Hayagriva is often associated with Avalokiteshvara and accompanies many of the forms taken by the bodhisattva, and his and Suchimukha's presence help to elaborate the meaning of these two reliefs more clearly. The incorporation of the young pilgrim Sudhana within the iconography of this form of Avalokiteshvara, however, is more difficult to comprehend. It may reflect the popularity of the *Gandavyuha*, the text that features Sudhana, in Pala-period Buddhist thought.

A stone image of Shakyamuni Buddha with scenes from his life **(FIG. 20)** highlights the importance of Bodh Gaya as a center of Buddhist pilgrimage and study in the eleventh and twelfth centuries. The central image shows the Buddha seated in the lotus posture (*padmasana*) with his right hand in the earth-touching gesture (*bhumisparshamudra*). The pyrophyllite stone used in the manufacture of this sculpture is found locally in places as far apart as northeastern India and Myanmar. Similar small sculptures sharing stylistic characteristics with the art of Pala-period India and carved in pyrophyllite have been found primarily in the art of Tibet and Myanmar. The stone is also found in Yunnan Province in China. It is likely that pilgrims from Tibet and Myanmar to Bodh Gaya, as well as craftsmen or Buddhists from India traveling to Tibet and Myanmar, transported the style of carved pyrophyllite buddhas with them.

The central image represents the defeat of Mara and the forces of illusion by the founder of Buddhism prior to his enlightenment. Shakyamuni sits on a lotus pedestal that rises from a two-tiered base filled with small images of animals and people. Two serpent-headed *nagas* crouch on either side of the central lotus stalk, from which spring all of the small lotus pedestals depicted. The outermost figures represent the Eight Great Events of Shakyamuni's life. The inner figures illustrate the life of the Buddha during the first seven weeks after his enlightenment. The central image represents the first week, during which he remained in meditation beneath the tree where he had attained enlightenment. The remaining figures represent the Buddha during the following six weeks, although not all the figures have been identified.

While the events preceding Shakyamuni's enlightenment were often represented in early Buddhist art, particularly in India, those after the enlightenment are less

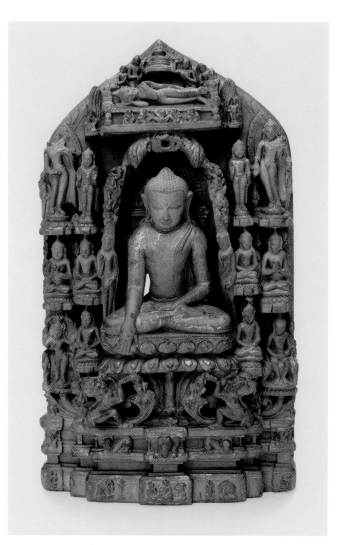

FIG. 20. Scenes of the Buddha's Life. 11th–12th century. Possibly Bodh Gaya, East India. Pyrophyllite with gilding. H. 7¾ x W. 4½ x D. 2 in. (19.7 x 11.4 x 5.08 cm). Asia Society, New York: Mr. and Mrs. John D. Rockefeller 3rd Collection, 1979.90

commonly seen. The depiction of these events may reflect the influence of Sri Lankan Buddhism. These seven phases, sometimes called the Seven Stations, play an important role in contemporary Sri Lankan practices, and their presence here may reflect the introduction of a type of Theravada Buddhism from Sri Lanka during the reign of King Kyanzittha (about 1084–1113). Avalokiteshvara and Maitreya flank the Buddha in this sculpture. The only works describing these two bodhisattvas as attendants to Shakyamuni are esoteric meditation texts known as *sadhanas*. This suggests that the scenes represented here can be interpreted as both historical references and paradigms for the process of enlightenment.

An inscription in Tibetan script of the syllable *om* on the back of the carving suggests that it was used by a Tibetan patron, reinforcing an association with Esoteric Buddhism. Were this and other similar examples with Tibetan inscriptions carried from India to Tibet by a Tibetan

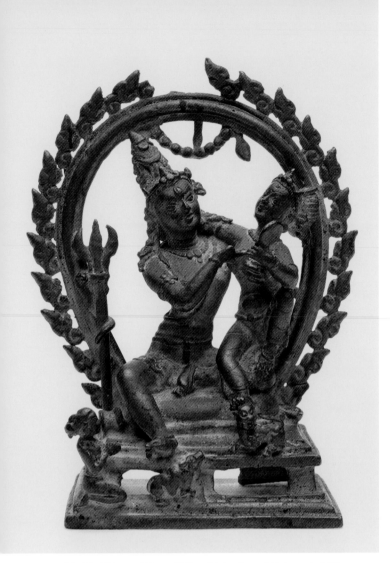

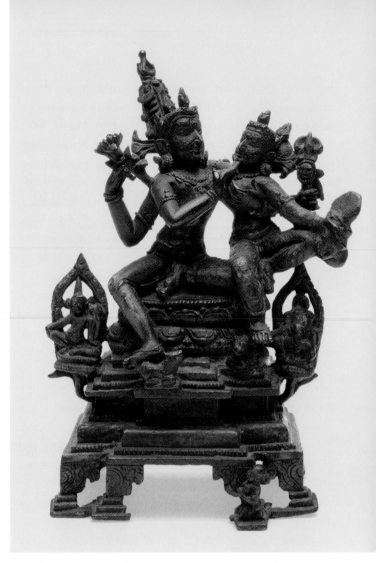

FIG. 21. Shiva and Parvati (Uma-Maheshvara). Pala period, 9th century. India. Copper alloy. H. 5⅜ x W. 4⁵⁄₁₆ x D. 2¼ in. (13.7 x 11 x 5.7 cm). Asia Society, New York: Mr. and Mrs. John D. Rockefeller 3rd Collection, 1979.14

FIG. 22. Shiva and Parvati (Uma-Maheshvara). Pala period (8th–12th century), late 10th–11th century. India, Bihar or Bengal. Copper alloy. H. 5½ x W. 3⅞ x D. 3⅛ in. (14 x 9.8 x 7.9 cm). Asia Society, New York: Gift from The Blanchette Hooker Rockefeller Fund, 1994.2

pilgrim? It is difficult to determine since sculptures of this type were also made in Tibet.

Although Buddhism was an important religion in the Pala kingdom, Hinduism, which at that time was the principal religion in other regions of India, was also practiced in East India, along with Jainism. Two charming small bronze sculptures depicting the god Shiva and his wife Parvati illustrate the stylistic similarities between Pala Hindu and Buddhist art. In the earlier of the two sculptures **(FIG. 21)**, which can he dated to the ninth century, Shiva and Parvati are seated on a soft cushion above a rectangular base that is probably intended to represent their heavenly home on Mount Kailasa. They are framed by a flaming halo. Shiva is identified by his vehicle, the bull Nandi; the crescent moon in his headdress; the tiger skin around his thighs; and by the drum and the trident encircled by a snake that are placed to his right side. Parvati, who embraces Shiva with her right arm and holds a mirror in her left hand, is identified by her vehicle,

the lion. The kneeling woman on the base represents either a generic devotee or the donor of this sculpture. Although it is more complicated iconographically, the same theme—Shiva and Parvati embracing while Parvati holds up a mirror for her spouse—is also represented in the second bronze **(FIG. 22)**, in which Shiva and Parvati are seated on a lotus pedestal placed above a high tiered base. They are accompanied by their two sons, the elephant-headed Ganesha seated to Parvati's left, and Karttikeya (or Skanda or Kumara) seated to Shiva's right. In this sculpture, Shiva has four arms and is identified by the crescent moon in his hair, the bull Nandi, and the trident and skull that he holds in his back left hand. Parvati's right foot rests on her lion. The postures of Shiva and Parvati are less relaxed in this sculpture than in the previous example, and the garments, coiffures, and jewelry are more detailed. The stylistic character-istics help to date the sculpture to the late tenth or eleventh century.

Sculptures of this theme, which is commonly called Uma-Maheshvara after two other names for Parvati and Shiva, emphasize the more benign and playful aspects of Shiva as well as his loving relationship with his wife and children. It is interesting that, as in both these bronzes, depictions of female donors are included in numerous Pala-period representations of this theme. Moreover, small bronze Uma-Maheshvara images appear to have been more common than larger works in bronze or stone. Although little is known about the practice of Hinduism in East India during the Pala period, the predominance of female donors on small bronzes of this type suggests that the theme of Shiva and his family may have held some special significance for women and may have been a focus of private devotion rather than of temple worship.

1. This inscription begins with the traditional Buddhist consecratory formula and contains the name of a donor (which has been read as either Kamsadlaka or Kasyanagaka). It also offers pious wishes for the enlightenment of all beings.
2. There is also a short inscription beneath these figures, which remains to be translated.

Stone Sculptures from Hindu Temples

Many Hindu practices can be traced back to India's earliest civilizations, and the amazing array of deities and semidivinities worshiped today in Hinduism reflects the amalgamation of traditions and beliefs from all parts of India. Despite its ancient roots, Hinduism did not become pervasive in Indian culture until the seventh century CE, largely owing to competition from newer religions such as Buddhism and Jainism. Hinduism flourished throughout India from the eighth through the thirteenth century, when Islam also became important. During this time, different regions of India were ruled by various dynasties, and the boundaries between kingdoms shifted frequently. As a result, this period in Indian art history is marked by the development of regional styles in different parts of the subcontinent.

Temples are important in Hindu worship, and a staggering number, ranging from undecorated brick buildings to enormous temple complexes, were built from the seventh through the fourteenth century. Each Hindu temple is dedicated to a specific god and functions as a symbol for the cosmos. The interiors and the exteriors of the more elaborate temples are decorated with stone sculptures, each with a precise iconographic meaning, which played a role in identifying and celebrating the principal deity housed in the temple as well as in symbolizing the Hindu cosmos. Most of the deities and semi-

divinities represented in the sculptures share similar, idealized physical features and must be distinguished from one another by the objects they hold, their clothing and ornaments, and sometimes their position in relation to other deities.

The large size and frontal posture of a sculpture of a ten-armed dancing Ganesha **(FIG. 23)** indicates that this representation of the elephant-headed god was placed in a prominent position on the exterior wall of a temple. Such walls are generally subdivided into a series of horizontal areas, some projecting and some recessed. The most important images on a temple wall are placed on the projecting areas.

Ganesha is the son of Shiva, one of the three most important deities of the Hindu pantheon, and his placement in a prominent location on a temple wall generally indicates that Shiva is its principal deity. Ganesha's lion-skin skirt (barely visible on this sculpture), the snake in his headdress, his matted hair, and his dancing posture all signify his relationship to Shiva, who also bears these attributes. In this sculpture, Ganesha is accompanied by several musicians, playing cymbals or drums, who are placed to either side and above his head. Seven of his ten hands are in gestures commonly used in dance, while the other three hold a rosary, a snake, and a broken tusk that alludes to a well-known tale in which the portly Ganesha hurls a tusk at the moon in embarrassment after the moon sees his stomach burst from overeating.

The relaxed postures of Ganesha and his attendants; the three-dimensional, fleshy treatment; and the restrained use of ornament date this sculpture to the eighth century. The naturalism of such details as the lotus pedestals or the floral motif that decorates Ganesha's crown and jewelry also characterize sculptures from that time. The full, rotund bodies of Ganesha and his attendants, together with their round faces and soft features lovingly rendered by craftsmen in sandstone, place the origins of this sculpture in north-central India.

Sandstone is also a wonderful medium with which to work the exaggerated pose of a celestial entertainer **(FIG. 24)**. Her flat face and broad features suggest this sculpture's origin in Rajasthan or Uttar Pradesh and a date in the tenth century. The large amount of jewelry worn by the musician and her attendant and the flamboyant flutter of the musician's scarves provide additional evidence for this date. Entertainers, particularly beautiful women, are among the most common images on Hindu temples. They entertain the gods and designate the area within as a special palace or a heaven, where music and dance are readily available.

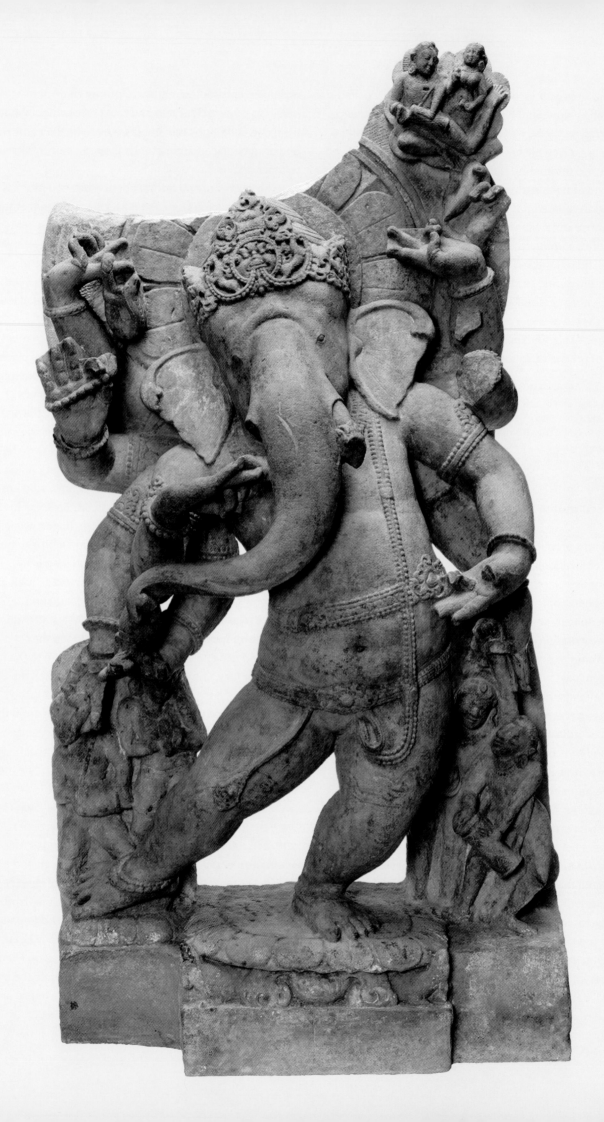

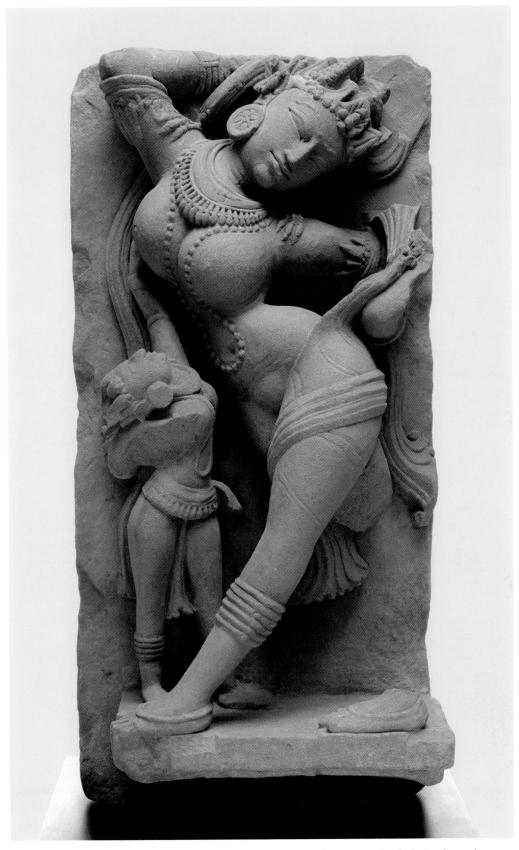

FIG. 24. Celestial Entertainer. Pala period, 10th century. India, Rajasthan or Uttar Pradesh. Sandstone (quartz arenite). H. 19½ x W. 10 x D. 9 in. (49.5 x 25.4 x 22.86 cm). Asia Society, New York: Mr. and Mrs. John D. Rockefeller 3rd Collection, 1979.32

Opposite: **FIG. 23.** Ganesha. 8th century. India, Uttar Pradesh. Sandstone, quartz/quartzose arenite variety. H. 49½ in. (125.7 cm). Asia Society, New York: Mr. and Mrs. John D. Rockefeller 3rd Collection, 1979.13

FIG. 25. Celestial Entertainer. 11th century. India, Rajasthan or Uttar Pradesh. Sandstone. H. 21¼ x W. 12 x D. 6 in. (54 x 30.48 x 15.24 cm). Asia Society, New York: Mr. and Mrs. John D. Rockefeller 3rd Collection, 1979.33

Figures such as this were placed in subsidiary locations on the temple walls, where they functioned as attendants to the principal images, which are representations of the gods. In this sculpture the woman, who holds a tambourine above her head, seems to be just beginning or finishing a performance. The smaller female attendant, who reaches up to touch the performer's breast, adds a touch of humor and an erotic element to the scene.

An image of another celestial female **(FIG. 25)** characterizes the style of sculptures produced in the region of Rajasthan and Uttar Pradesh in the eleventh century. She twists dramatically, lifting one hand above her head while placing the other (now missing) at her side. Her clothes and ornaments are similar to those worn by the tambourine player: a crown, armlet, earrings, and two heavy necklaces, one long and one short. However, this heavenly figure also wears a girdle of beads around her waist and legs, and the treatment of her jewelry and clothing is more elaborate—seen, for example, in the use of more wavy incised lines to represent the folds of her

skirt and in the lavish amount of beads used to make her jewelry.

The tree above the woman's head bears fruit, which two small monkeys are eating. The *shalabhanjika,* the combination of a tree and a woman, is one of the most enduring images in India and is used in Buddhist, Hindu, and Jain art, primarily as a symbol of fertility. The three-dimensionality of this figure suggests that the sculpture may once have served as a bracket figure for a pillar, probably in the interior of a temple.

The tenon on the top of a late-eleventh- or early-twelfth-century sculpture of a celestial entertainer who plays the cymbals while dancing beneath a tree **(FIG. 26)** indicates that this sculpture was once a pillar bracket. The woman's broad shoulders, tiny waist, and full thighs suggest that this sculpture was carved in the region of Mysore in South India. As is true in sculpture from North and northwestern India, this entertainer is depicted as an idealized beauty, and her proportions are exaggerated and elongated. These proportions, her oval face, and her delicate features distinguish this dancer from her northern counterparts.

The jewelry on this figure is the most elaborate worn by any of these entertainers. She wears three necklaces of varying lengths, enormous hoop earrings (now broken), armlets, and anklets. A jeweled girdle from which are suspended several lengths of interwoven beads—one reaching to her ankles—encircles her hips. Finally, garlands of beads decorate her shoulders, with one length of beads falling to her knees. The staggering complexity and three-dimensionality of this decoration attest to the sheer technical virtuosity of sculptors working in India at the height of Hinduism and temple building.

Early Sculptures from South India

One of the most intriguing issues in the study of Indian art history is the relative scarcity of known examples of architecture or sculpture from the southern part of the subcontinent prior to the seventh century CE. Most of the sculptures and monuments that date from the seventh through the ninth century are associated with one of the two most important dynasties in South India during this period: the Pallavas, centered on the eastern coastline

FIG. 26. Celestial Entertainer. Western Chalukyan period, late 11th–early 12th century. India, Karnataka. Schist (metasiltstone). H. 39¾ x W. 13½ x D. 6½ in. (101 x 34.3 x 16.5 cm). Asia Society, New York: Mr. and Mrs. John D. Rockefeller 3rd Collection, 1979.31

FIG. 27. Vishnu. Pallava period, 8th century. India, Andhra Pradesh or Tamil Nadu. Copper alloy. H. 13¼ x W. 5½ x D. 4¾ in. (33.7 x 13.97 x 12.06 cm). Asia Society, New York: Mr. and Mrs. John D. Rockefeller 3rd Collection, 1979.17

around the cities of Kanchipuram and Mamallapuram, and the Pandyas, centered further south in the vicinity of Madurai. Both families were ultimately supplanted by the Cholas, who controlled most of the southern tip of India from the tenth through the thirteenth century.

A bronze representation of the Hindu god Vishnu **(FIG. 27)** provides one example of the style of sculpture made during Pallava rule. Vishnu stands on a square pedestal with a socle to his left that may have been used to drain the liquids poured over the sculpture during worship. Iconographically, it depicts Vishnu in his supreme or *para* aspect. Shown standing in a frontal and somewhat rigid position, Vishnu wears a long skirtlike garment that falls to just above his ankles and is tied with a sash at his waist. A full scarf is tied over this skirt, its ends extending to either side at his hips. The four-armed Vishnu is identified by his attributes—the conch, the wheel, and the club—and he holds a small lotus flower in his outstretched lower right hand. The god's hair is arranged in a tall coiffure, and he wears an elaborate cylindrical crown. He is adorned with earrings, necklaces, armlets, bracelets, a belt around his upper waist, and a sacred thread. This thread is worn by members of the high-ranking Brahmin caste that was traditionally responsible for the performance of rituals. It is a standard attribute of all Hindu gods.

Although this iconography is found throughout India, several details, however, help to classify this sculpture as an example of South Indian art. These include the unusual belt around his midriff, the placement of the sacred thread over his lower right arm, and the stylized treatment of the hems of his garment. Vishnu's round face with soft, youthful features and his lithe figure and long, thin waist are also typical of works made in the Pallava territories of South India.

The powerful physicality and more oval face of a monumental sculpture of a seated woman **(FIG. 28)** suggest that this piece may have been produced farther south, in the regions controlled by the Pandya family. The figure, seated in a relaxed position against a slightly damaged throne, wears a long skirt that is fastened at the waist and has an additional scarf tied over her hips. A tall crown that enhances the oval shape of her face, a sacred thread that runs from her left shoulder to her right hip, and her simple jewelry are characteristic of early South Indian sculptures.

Both the function and iconography of this sculpture remain uncertain. The Pandyas are noted for their construction of rock-cut temples created from natural caves. The façades of these structures were often decorated with sculptures, and it seems likely, given the weathered

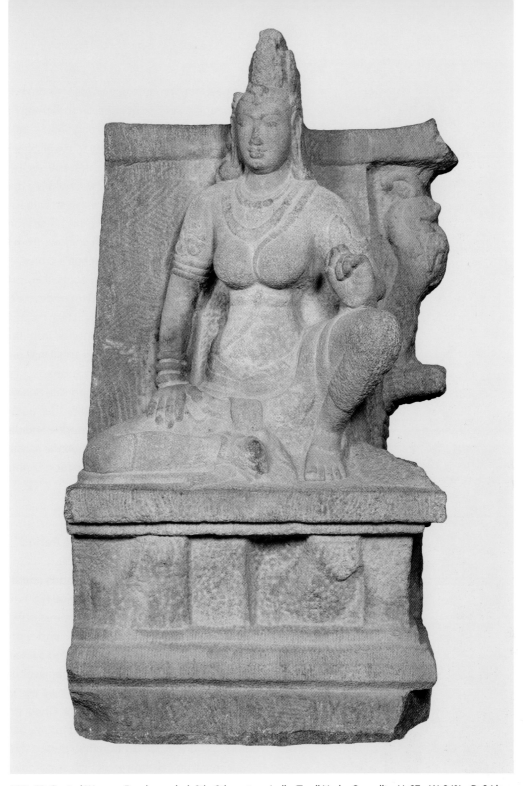

FIG. 28. Seated Woman. Pandya period, 8th–9th century. India, Tamil Nadu. Granulite. H. 67 x W. 34¾ x D. 34 in. (170.2 x 88.3 x 86.4 cm). Asia Society, New York: Mr. and Mrs. John D. Rockefeller 3rd Collection, 1979.16

condition of this piece, that it once may have graced the front of such a temple. The clothing, jewelry, and confident posture of the figure suggest that she might represent a queen. This identification is supported by the importance of women as patrons and the fairly early use of idealized portraits of rulers in the imagery of South Indian temples. However, it was unusual for women to wear the sacred thread, and so it is also possible that this sculpture is a representation of a Hindu goddess. The position of her right hand and the remnants of a stem and flower indicate that she was once shown holding a lotus, a gesture commonly used in representations of the goddess Parvati, Shiva's wife. The Pandyas were devoted to Shiva and, if this striking sculpture were to represent a goddess, it would likely be Parvati.

Although different in size and material, some similarities between this magnificent stone sculpture and an extremely abraded bronze image of a woman **(FIG. 29)**

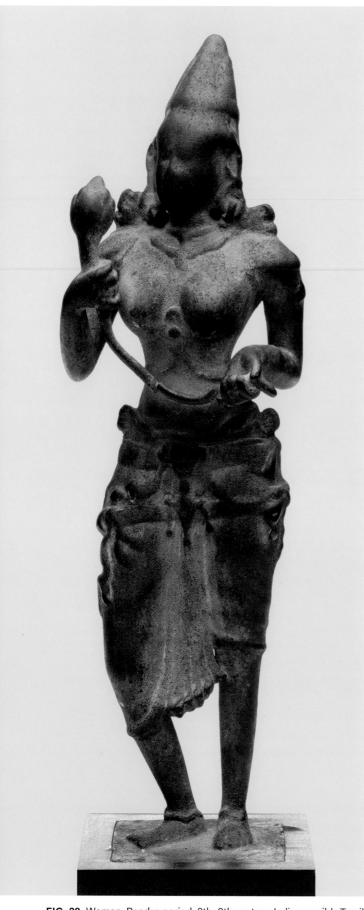

FIG. 29. Woman. Pandya period, 8th–9th century. India, possibly Tamil Nadu. Copper alloy. H. 12 x W. 4 x D. 3¾ in. (30.5 x 10.16 x 9.52 cm). Asia Society, New York: Mr. and Mrs. John D. Rockefeller 3rd Collection, 1979.18

suggest that the bronze was also produced in the Pandyan regions of South India. Both women have oval faces and tall, pointed crowns; strong shoulders; full breasts; long, narrow torsos with very thin waists; wide hips; and long tapering legs. Both are dressed similarly, with a full skirt that hangs longer over the right leg than the left, and each woman's skirt is tied by a sash with full, long ends that fall over the center of the skirt. The woman in bronze holds a lotus, the stem of which flows from her right hand to her left. Although she also has a crown, she does not wear a sacred thread; and it seems likely that this piece once functioned as an attendant or devotee in a larger series of images.

South Indian bronze sculptures from the seventh to the ninth century are relatively small in scale, particularly when compared with the large bronze sculptures cast during the subsequent Chola period, and were probably used for personal devotion rather than as the focus of temple rituals. In addition to pouring liquids over sculptures, devotees also often rubbed the faces; such practices were probably responsible for effacing the features of this statue.

Bronze Sculptures of the Chola Period

The bronze sculptures of Hindu gods and Buddhist deities cast during the Chola period (880–1279) are among the most renowned sculptures in world art. The Cholas came to power in the late ninth century, and until the late thirteenth century they ruled a large part of South India from their homeland near Thanjavur on the southeastern coast, maintaining diplomatic ties with countries as distant as China and Indonesia. Chola rulers were active patrons of the arts, and literature, dance, and the other performing arts flourished during their rule. They also constructed enormous temple complexes decorated with stone representations of the Hindu gods.

While stone sculptures were created to beautify and empower the exterior and interior walls of the temples, large bronze images were kept within the temple complexes for individual devotion and for use in rituals and festivals. In order to carry them in processions, poles were placed through the round lugs found on the bases of many of these sculptures. To further embellish a sculpture and glorify the god, streamers and garlands were wrapped around the vertical metal pieces rising up from either side of some bases (for example, **FIG. 37**). Smaller bronze sculptures were used in homes and private shrines for worship as well as protection and good luck.

Admired for the sensuous depiction of the figure and the detailed treatment of clothing and jewelry, Chola-period bronzes were created using the lost wax technique, commonly known by its French name, *cire perdue.* Because each sculpture made in this fashion requires a separate wax model, each is unique; but because they are religious icons, Chola-period sculptures also conform to well-established iconographic conventions and can often look similar at first glance, even though they may date from different centuries.

Although bronze casting has a long history in South India, it appears that a much greater number of bronze sculptures was cast during the Chola period than before. Chola-period bronze sculptures are also generally larger than earlier pieces, further attesting to the importance of bronze sculpture during this period.

One possible reason that the production of bronze sculptures flourished was the development of the *bhakti* tradition from the sixth through the tenth century. A popularizing movement within Hinduism, *bhakti* valued intense devotion to an individual god above adherence to religious tenets or the performance of rituals. One means for the spread of this devotional movement was a group of historical figures known as "slaves of the lord," a term that is also sometimes translated as "saints" and refers to devout Hindus who were analogous in many respects to Roman Catholic saints. Some of these Hindu saints were devoted to Shiva and others to Vishnu, and they traveled to sites in South India associated with their deity and wrote poems and songs praising the gods in the popular language of Tamil rather than in the liturgical Sanskrit. Their emphasis on stories recounting the daily activities and family lives of the gods, as well as their belief in the presence and beneficence of these deities in daily life, did much to humanize and spread Hinduism.

Another important catalyst for the development of Hindu images was the patronage of the Chola rulers. The Cholas, who were devout Hindus, chose Shiva as the primary focus of their worship and revered Shiva in his role of Lord of the Dance as their tutelary deity. The development of the best-known form of Shiva as Lord of the Dance, or Nataraja, can be attributed to Chola patronage. Although painted and sculpted representations of Shiva performing his many dances are found as early as the fifth century CE, under Chola patronage the concept of Shiva Nataraja became closely associated with the performance of one particular dance, the dance of bliss or *ananda tandava,* and with one particular pose— a four-armed Shiva standing on the back of a dwarf with

his left leg poised dramatically in front of his body. The contrast between the serenity of Shiva's face and his dramatic movement is integral to the meaning of this type of sculpture.

Dating to about 970, an early Chola-period image of Shiva as Lord of the Dance **(FIG. 30)** illustrates the complexity and sophistication of this icon, which can be read and understood from many perspectives. The position of Shiva's hands, the objects he holds, and the ornaments he wears are intended to explain the significance of his dance and narrate the events surrounding his performance.

It is believed that Shiva first performed the dance of bliss in order to redeem a group of sages who were practicing an unorthodox form of Hinduism. In an attempt to resist Shiva, the sages challenged him with a tiger, a snake, and a dwarf-demon. Shiva subdued all three. As a result, the Lord of the Dance often wears a snake belt and an animal-skin loincloth, and he usually stands on the back of a dwarf. These three creatures symbolize the untamed minds, egotism, and ignorance that Shiva had to destroy in order to guide the sages to a more developed spiritual state.

Indicated by his striking pose, the power inherent in Shiva's furious dance also symbolizes his role as the creator-destroyer of the universe. Hinduism presupposes that everything in the cosmos changes constantly: on a small scale, each individual passes through endless rebirths and the goal of the devotee is to escape that cycle; on a larger scale, the cosmos passes through cycles of destruction and creation. Unlike human rebirth, however, cosmic re-creation occurs only after an almost immeasurable period of time has passed. Shiva's dance of bliss, which is the catalyst for the destruction of one universe and the creation of a new cosmos, symbolizes both processes.

The two-sided drum in Shiva's back right hand provides accompaniment to his dance and symbolizes movement, which in turn signifies creation. The fire in his back left hand and the fiery halo that surrounds him symbolize the destruction that occurs during the dance and leads to the re-creation of the cosmos. The god's two front hands show the salvation that is inherent in his dance: his front right hand is held in the gesture of reassurance and his front left hand points to his lifted foot to signify that his activities are intended to provide deliverance.

Earlier Chola-period representations of Shiva as Lord of the Dance reveal some experimentation in the creation of the classic icon, but by the eleventh century the iconography was codified and it remained essentially

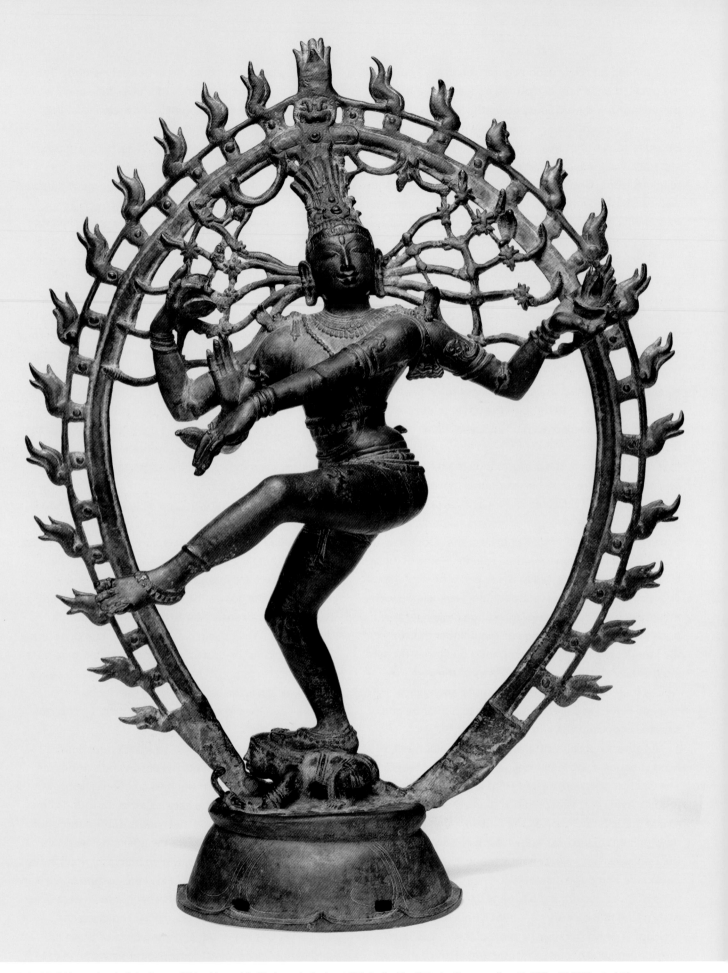

FIG. 30. Shiva as Lord of the Dance (Shiva Nataraja). Chola period, about 970. India, Tamil Nadu. Copper alloy. H. 26¾ x W. 21½ x D. 10 in. (67.9 x 54.6 x 25.4 cm). Asia Society, New York: Mr. and Mrs. John D. Rockefeller 3rd Collection, 1979.20

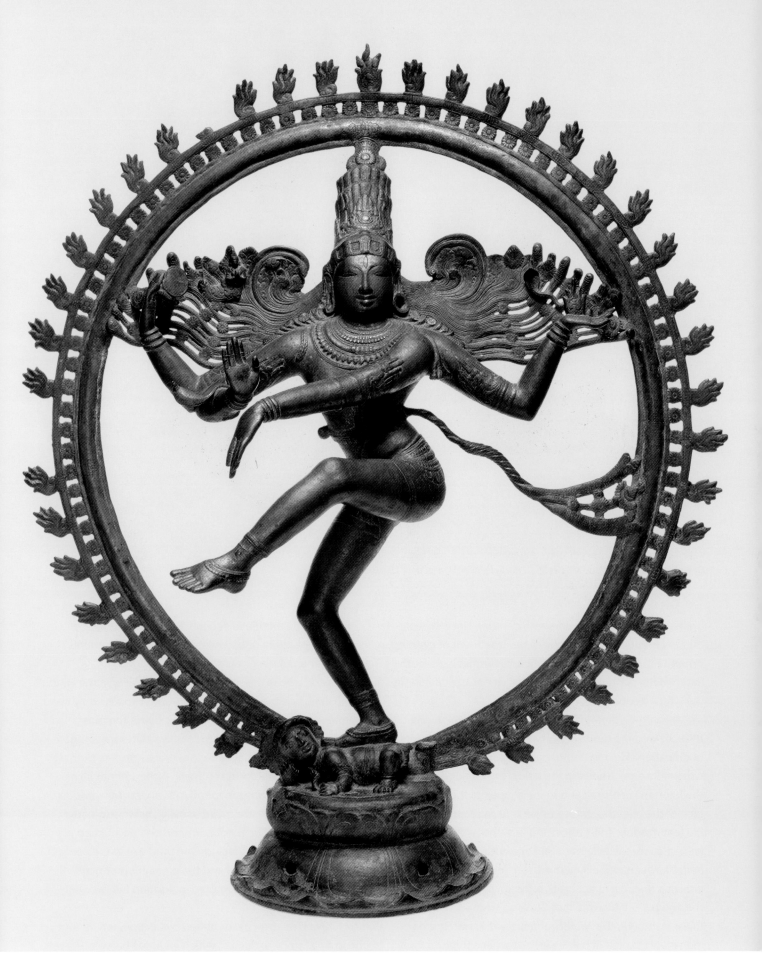

FIG. 31. Shiva as Lord of the Dance (Shiva Nataraja). Chola period, 12th century. India, Tamil Nadu. Copper alloy. H. 29¼ x W. 26½ x D. 8 in. (74.3 x 67.3 x 20.3 cm). Asia Society, New York: Mr. and Mrs. John D. Rockefeller 3rd Collection, 1979.29

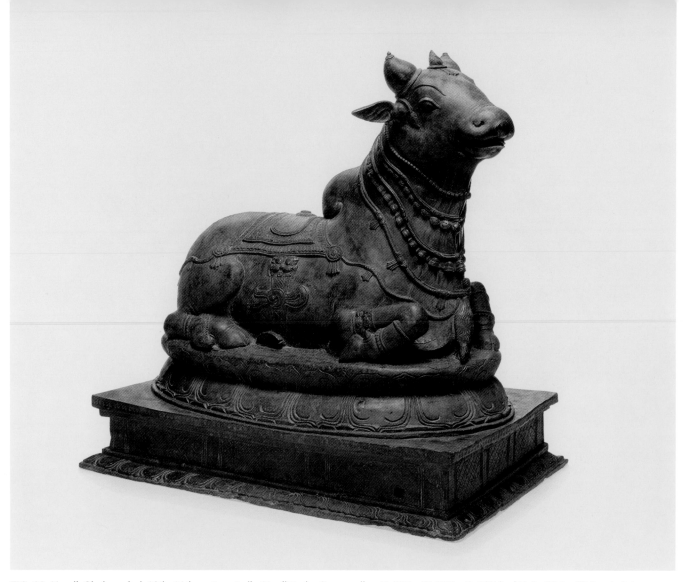

FIG. 32. Nandi. Chola period, 10th–11th century. India, Tamil Nadu. Copper alloy. H. 20¼ x W. 20½ x D. 13¼ in. (51.4 x 52.1 x 33.6 cm). Asia Society, New York: Mr. and Mrs. John D. Rockefeller 3rd Collection, 1979.30

unchanged until the seventeenth century. Nonetheless, minor variations of this type—in the treatment of clothing, ornaments, and proportions—help distinguish eleventh- and twelfth-century sculptures from those cast earlier in the Chola period.

A comparison of a twelfth-century Shiva Nataraja **(FIG. 31)** with the tenth-century sculpture illustrates this codification. The most noticeable changes between the two works can be seen in the halos: the earlier halo is oval, the later one is round; and in the shapes of the faces: the face of the twelfth-century Shiva is broader and flatter, his features less full. Other details of the twelfth-century work also reveal its later date. For example, the flaming halo has been embellished with an interior rim of flowers, a device that, while decorative, diminishes the power of the image. The treatment of Shiva's flowing locks is also more stylized in the twelfth-century work: rather than individual strands of hair as in the earlier sculpture, they now form a single curvilinear shape embellished with curlicues and flowers. Finally, in the later work, Shiva's

front left arm and his raised left foot have been lifted marginally higher, unbalancing the sculpture and inter- rupting the movement of the dance.

Shiva, who is the most complicated deity in the Hindu pantheon, has the most manifestations, and is worshiped in many guises. While the dancing pose is the most important identifying feature of Shiva Nataraja, images of this type also display other general attributes that are shared by different forms of Shiva. Although not all of these characteristics are found in every representation of Shiva, enough of them are usually shown to clearly identify the god. The most common characteristics associated with Shiva include the third eye in the center of his forehead, the skull and the crescent moon in his headdress, his long matted locks, and his two different earrings.

Shiva can often be identified by his position as the head of a family of deities, which includes his wife Parvati, and their two sons, Ganesha and Karttikeya (or Kumara or Skanda). All four have vehicles or mounts, and Shiva's is

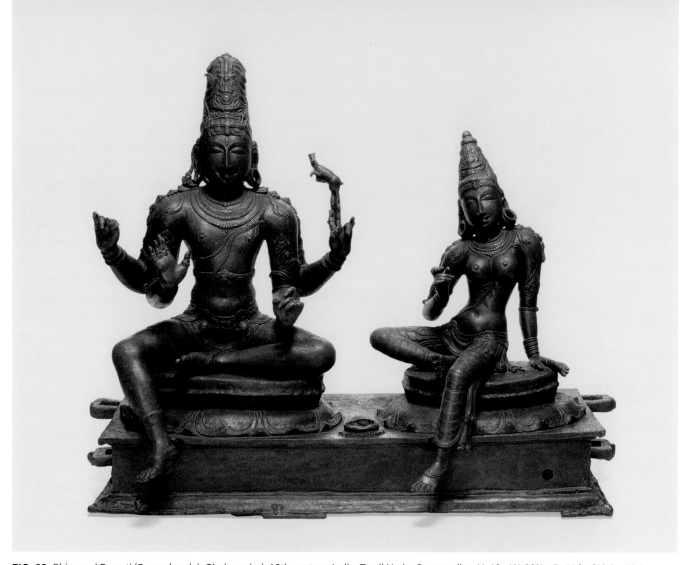

FIG. 33. Shiva and Parvati (Somaskanda). Chola period, 12th century. India, Tamil Nadu. Copper alloy. H. 19 x W. 23¾ x D. 11 in. (48.3 x 60.3 x 27.9 cm). Asia Society, New York: Mr. and Mrs. John D. Rockefeller 3rd Collection, 1979.28

the bull, today commonly referred to as Nandi. In addition to their association with sculptures of Shiva, stone images of Shiva's bull are usually placed in prominent positions in temples dedicated to Shiva, either in separate shrines within the larger complex or in front of the primary temple and directly aligned with its principal Shiva image. Individual bronze sculptures of Shiva's bull, such as this appealing example **(FIG. 32)**, are fairly rare. Although this unusual work has often been dated later, the sensuous modeling of the bull's form, the detailed three-dimensional treatment of his jewelry, and the organic relationship between the bull's body and his jewelry and saddle all point to a date in the tenth or eleventh century. The imprecise and sketchy treatment of the base—in particular the mismatched lotus petals—presents a problem in dating this sculpture because this sketchiness is often found in later works. It is possible that this base was created later, however, because a thin break encircles the figure of the bull, suggesting that it may have been placed into the base rather than cast at the same time.

Representations of Shiva with members of his family are among the most common images associated with his worship. Images of Shiva and Parvati seated side by side on the same pedestal with their son Karttikeya between them, a representation known as Somaskanda, were among the more popular icons produced during the Chola period. In this twelfth-century example **(FIG. 33)**, from which the figure of Karttikeya is now missing, Shiva can be identified by some of his more characteristic attributes, including the antelope in his back left hand and the crescent moon and the snake in his matted headdress. The antelope refers to his role as the Lord of Animals; the snake and the crescent moon to his asceticism. The empty circle on the base between Shiva and Parvati would once have held a small figure of their son Karttikeya, who is worshiped as both a divine child and a god of war. Such small sculptures of Karttikeya are easy to remove and are often missing from images of this type.

Parvati, the daughter of the Himalayan Mountains, is worshiped as both Shiva's wife and an independent deity.

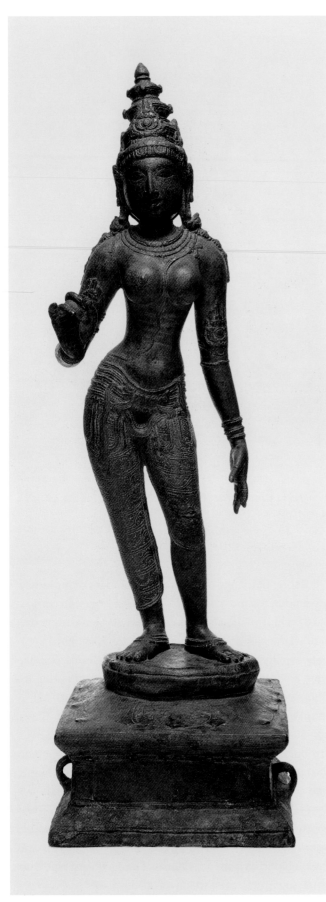

FIG. 34. Parvati. Chola period, 11th century. India, Tamil Nadu. Copper alloy. H. 21¼ x W. 7 x D. 6¼ in. (54 x 17.8 x 15.9 cm). Asia Society, New York: Estate of Blanchette Hooker Rockefeller, 1992.5

She can assume many forms, some of them ferocious and others benign.

Two of the more important forms, Durga and Kali, represent her ferocity. As Shiva's wife, Parvati is often shown as gentle and loving. In family portraits such as this sculpture, she is smaller than Shiva and holds her right hand in a distinctive gesture in which the hand is curved and the thumb and the forefinger touch or almost touch.

The use of the same gesture and a conical crown with mountainlike tiers (*karandamukuta*) identify three standing sculptures as images of Parvati (**FIGS. 34, 35, AND 36**). The goddess stands in a triple-bend (*tribhanga*) pose with a pronounced sway and holds one arm and hand down in a dramatic fashion and the other hand in a manner that represents holding a flower. The gestures and posture suggest that these sculptures were once part of sets of images in which Parvati accompanied Shiva as Lord of the Dance. Parvati is one of the few beings privileged to have watched Shiva perform the dance of bliss, and, despite the fact that most pairs of this type have been separated, an attendant statue of Parvati is an integral part of the Shiva Nataraja imagery. Such sculptures of Parvati show her with her left hip thrust out and her left hand down and it appears these sculptures were placed to the left side of the god. One Parvati in the Collection (**FIG. 34**) has her right hip thrust out, which means that this sculpture was probably not part of a set of images in which Parvati accompanied Shiva as Lord of the Dance.

All three Parvati images date to the eleventh century; however, one of them (**FIG. 35**) dates to the early part of that century and the other two were made later. Each of the three statues of Parvati wears a long garment that clings to her legs in a stylized fashion. The garment of the earlier sculpture is shown with a series of gentle pleats. On the later sculptures, the pleats are not shown as folds of cloth, but have become patterned lines that form the decoration of the skirt, which also includes conventionalized flowers. The earlier Parvati thrusts her hip out in a more dramatic fashion, thereby resting more weight on the opposite leg. In the later sculptures, this position has shifted slightly and the weight is distributed more evenly between both legs.

Worshiped as the god of good luck and remover of obstacles, Ganesha, the elephant-headed son of Shiva and Parvati, is one of the most popular gods of the Hindu pantheon. The rotund body and short legs of an eleventh-century sculpture (**FIG. 37**) typify representations of this deity. Ganesha's elephant head is the result of a quarrel between Shiva and Parvati. Angered by Ganesha's refusal—at Parvati's behest—to let him see his wife while

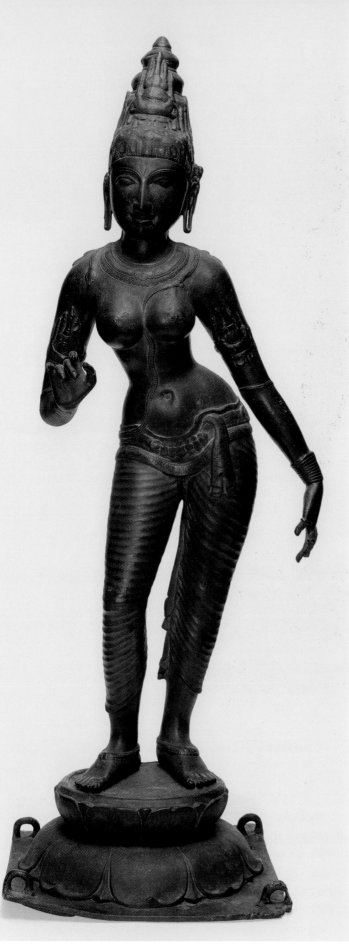

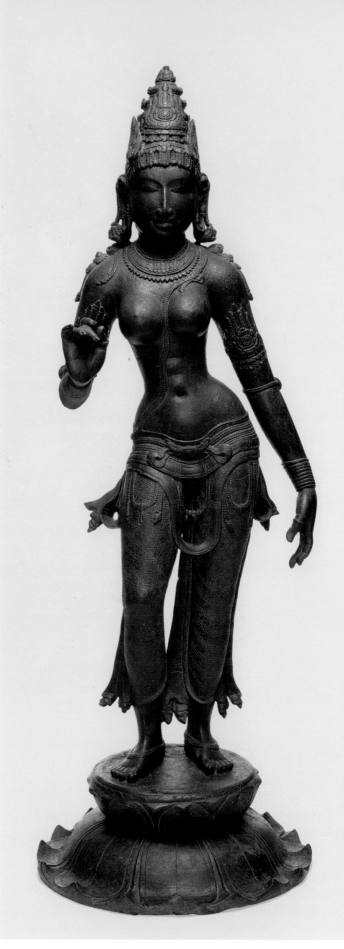

FIG. 35. Parvati. Chola period, early 11th century. India, Tamil Nadu. Copper alloy. H. 35 x W. 10¾ x D. 10¾ in. (88.9 x 27.3 x 27.3 cm). Asia Society, New York: Mr. and Mrs. John D. Rockefeller 3rd Collection, 1979.19

FIG. 36. Parvati. Chola period, 11th century. India, Tamil Nadu. Copper alloy. H. 31¾ x W. 12 x D. 12 in. (80.6 x 30.48 x 30.48 cm). Asia Society, New York: Mr. and Mrs. John D. Rockefeller 3rd Collection, 1979.21

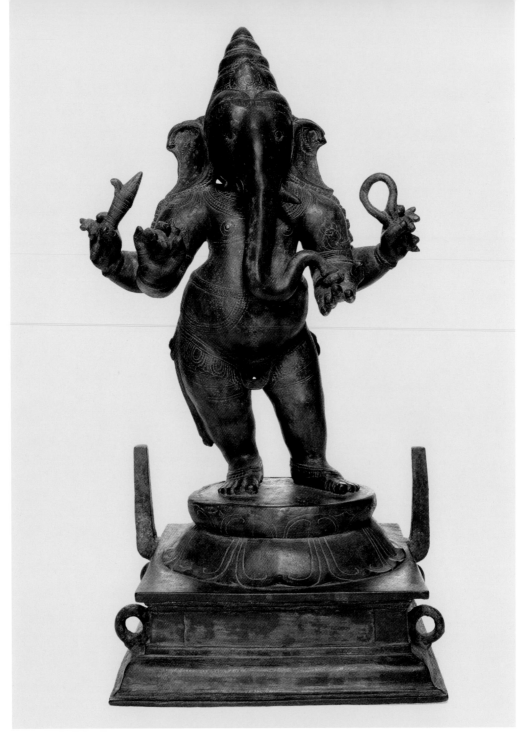

FIG. 37. Ganesha. Chola period, 11th century. India, Tamil Nadu. Copper alloy. H. 21¼ x W. 10¾ x D. 10⅞ in. (54 x 27.3 x 27.6 cm). Asia Society, New York: Mr. and Mrs. John D. Rockefeller 3rd Collection, 1979.26

she was bathing, Shiva cut off Ganesha's head, and Parvati was devastated with grief. In order to soothe her, Shiva replaced the head with that of the first creature he saw, which happened to be an elephant. Ganesha holds a broken tusk in his front right hand, connecting the sculpture to the story of how Ganesha threw his tusk at the moon after it witnessed the rupture of his stomach from overeating; in addition, he holds a mace and a lasso, which are symbolic respectively of his position as a god of war and his ability to advantageously ensnare a devotee.

Statues of the sixty-three saints dedicated to Shiva also played an important role in the imagery of temple complexes and were usually placed in halls surrounding the main sanctum of a temple. As is true of sculptures of the major divinities worshiped at any given temple, those of the saints were also worshiped daily.

The tauter forms of the bodies of two sculptures of Shaiva saints, one of Mannikkavachaka (FIG. 38) and the other of the child-saint Sambandar (FIG. 39), date these pieces to the twelfth century. The stylized treatment of the hair and ornaments of each figure is also characteris-

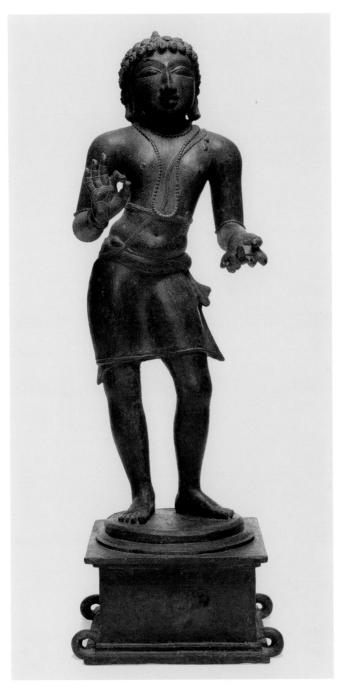

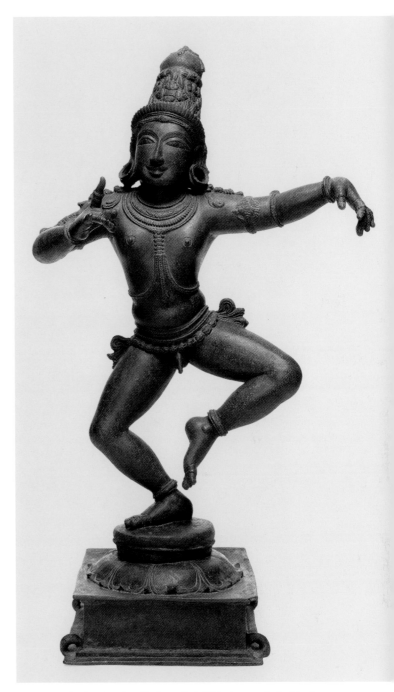

FIG. 38. Saint Mannikkavachaka. Chola period, 12th century. India, Tamil Nadu. Copper alloy. H. 19¼ x W. 6¾ x D. 4⅝ in. (48.9 x 17.2 x 11.8 cm). Asia Society, New York: Mr. and Mrs. John D. Rockefeller 3rd Collection, 1979.27

FIG. 39. Saint Sambandar. Chola period, 12th century. India, Tamil Nadu. Copper alloy. H. 18⅞ x W. 11¼ x D. 6¼ in. (47.9 x 28.6 x 15.9 cm). Asia Society, New York: Mr. and Mrs. John D. Rockefeller 3rd Collection, 1979.24

tic of twelfth-century pieces and is seen in the sculpture of Shiva and Parvati discussed earlier. Both statues of these saints are reputed to have been excavated from the Tiruvan Vanpanalur Temple, and their similar sizes suggest that they were once part of the same set. The stylistic similarities between the two pieces—seen, for example, in the shapes of the straight noses and the full lips—suggest that they may have been made at the same atelier.

Mannikkavachaka, who is generally shown wearing only a loincloth, is identified by the manuscript that he

holds in his hand. This book is the *Tiruvachakam*, a set of fifty-one hymns to Shiva written by the saint. Mannikkavachaka lived in the middle of the ninth century and was added to the group of sixty-three Shaivite saints during the twelfth century, when worship of these saints was most popular. Before he dedicated his life to Shiva, Mannikkavachaka had been the trusted minister of the kings of the Pandyas. While en route to purchase horses for the king, Mannikkavachaka encountered Shiva disguised as a sage. He was so moved by the sage's teachings that he forgot his original errand and used the

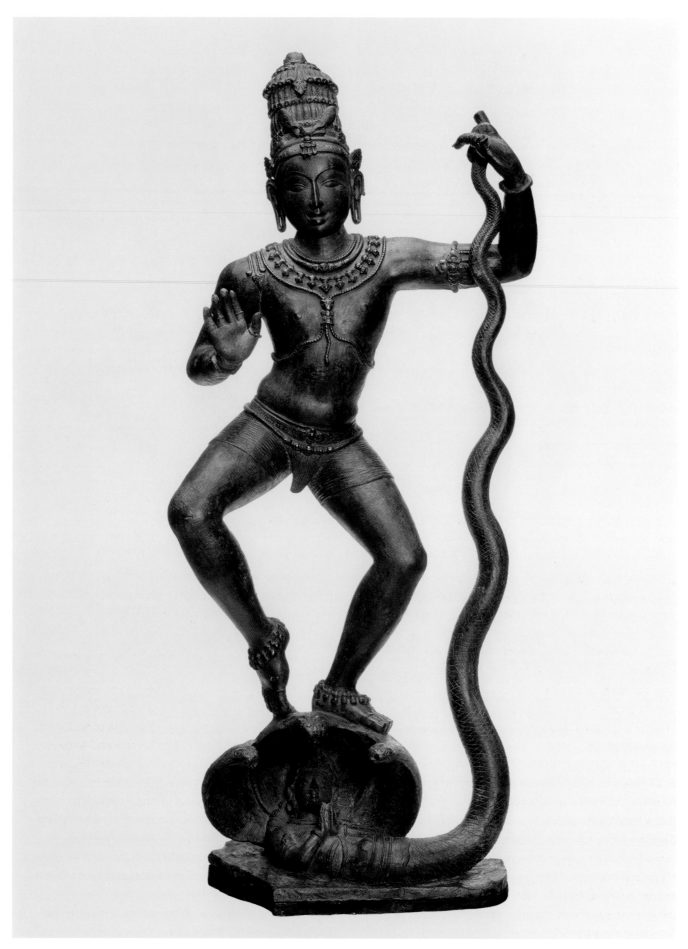

FIG. 40. Krishna Dancing on Kaliya (Kaliyahimarddaka Krishna). Chola period, late 10th–early 11th century. India, Tamil Nadu. Copper alloy. H. 34½ x W. 13¾ x D. 10¼ in. (87.6 x 35 x 26 cm). Asia Society, New York: Mr. and Mrs. John D. Rockefeller 3rd Collection, 1979.22

vast amount of money with which he had been entrusted to build a shrine to Shiva at Peruntai. Shiva rescued Mannikkavachaka after he was thrown into prison by the enraged king, and the saint spent the rest of his life in devotion to his lord.

The child-saint Sambandar is often identified by his joyous dancing pose. According to legend, the three-year-old Sambandar became hungry while he was visiting a temple with his father and was fed milk by a statue of Shiva and Parvati. He immediately became their devotee and spent the rest of his life singing their praises. Sambandar's poems were instrumental in reviving a type of Tamil-language poetry known as "musical poems" because they are easily set to music. Sambandar's dancing pose is not a reference to his own performances but to the dances performed in his honor or as part of the worship of Shiva.

In addition to representations of Shiva and members of his family, other prominent Hindu deities are depicted in Chola-period bronzes. It is assumed that each individual is at a different point of spiritual development, and Hinduism accepts that each will pursue her or his religious life in the most appropriate manner. Most Hindus venerate several deities, choosing gods or aspects of gods that are appropriate to different situations and life passages. Moreover, Hinduism can be broadly categorized into three branches, each of which is focused on one of three major deities. In addition to Shiva, these are Vishnu, who is called the Preserver and has often appeared in the world as a savior, and Devi or the Goddess, who is called by many names and takes many forms, some of them benign and some of them ferocious.

According to Hindu beliefs, Vishnu descends to earth in different manifestations known as avatars in order to save the world and restore the balance of the universe. Vishnu appears as a man-lion, a giant boar, the gods Krishna and Rama, and in several other guises. Vishnu's manifestation as Krishna is one of the most popular, and the life and activities of this beloved god—often as a child—are a favorite theme in Indian literature and art. A powerful sculpture of Krishna dancing on a multiheaded cobra (FIG. 40) depicts his encounter with the serpent-demon Kaliya. Kaliya had been living in a whirlpool in the sacred river Yamuna, terrifying everyone and spreading his poison throughout neighboring lands. Krishna was caught by the serpent when he chased a ball that inadvertently went into the whirlpool. To the amazement of the onlookers he grabbed the central head of the serpent, forced Kaliya to bow, danced upon his head, and sent him back to his native environment, which was the ocean.

This magnificent sculpture of Krishna dancing on the head of Kaliya illustrates the difficulties of dating Chola-period bronze images. The god's broad shoulders and full torso are characteristic of sculptures dating to the late eleventh and twelfth centuries. Yet, this body type was also often used in Indian art to depict a child, as in the sculpture of Sambandar discussed earlier; thus, here it might illustrate iconography rather than style. Moreover, several of the details in this sculpture of Krishna also point to an earlier date: the sense of volume and fleshiness in the sculpture of Krishna and the organic relationship between the figure and his clothing and ornaments are comparable to those found on the tenth-century image of Shiva as Lord of the Dance (FIG. 30); the shape of Krishna's face and his full, slightly pouting lips are also similar to those of the image of Shiva Nataraja; the precise and three-dimensional treatment of Krishna's hair and ornaments and the distinctive fan-shaped fold at the back of his skirt point to a date in the late tenth or early eleventh century. There are other features—such as the coppery color of the metal used in making this statue and the greater three-dimensionality seen in the treatment of the jewelry—that suggest this sculpture may have been cast in a region different from that of the majority of Chola-period bronzes, which are believed to have been produced in the vicinity of Thanjavur.

Dating to the eleventh century, a striking sculpture of Rama (FIG. 41) was once part of a larger group of images representing the principal characters in the great Indian Hindu epic poem the *Ramayana*. Loosely based on events in early Indian history, the *Ramayana* tells the story of Rama's life, of the abduction of his wife Sita by the evil demon-king Ravana, and of her rescue by Rama and the beloved king of the monkeys, Hanuman. Originally an oral poem, the *Ramayana* was recorded long after it was first recited and exists today in several recensions. This figure can be identified as Rama by the position of his hands, which indicates that he is holding a bow and arrow, and by the details of his jewelry and hairstyle that help to differentiate him from other divinities. In addition to this sculpture of Rama, the set would have included images of Sita, Lakshmana, and Hanuman.

A more unusual form of Vishnu is represented in a small bronze (FIG. 42) in which Vishnu is shown striding (on two lotus pedestals) in front of a large flaming wheel. The god has sixteen arms, each of which once held an attribute. Many of these attributes are difficult to see and a few are missing in areas where Vishnu's hands have been broken off. It is clear, however, that Vishnu holds a wheel and a conch shell in his uppermost, back hands

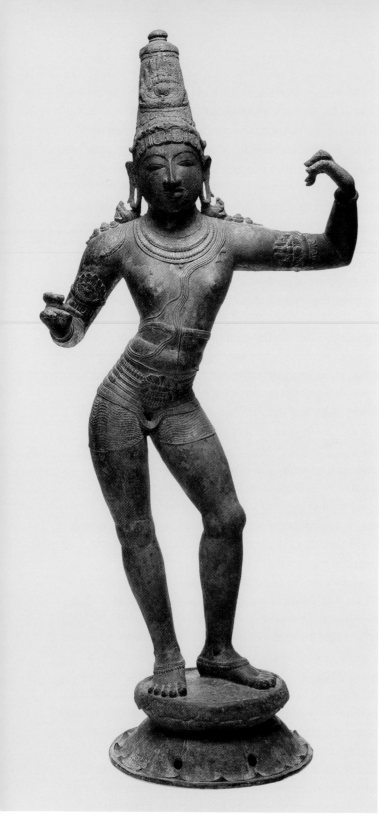
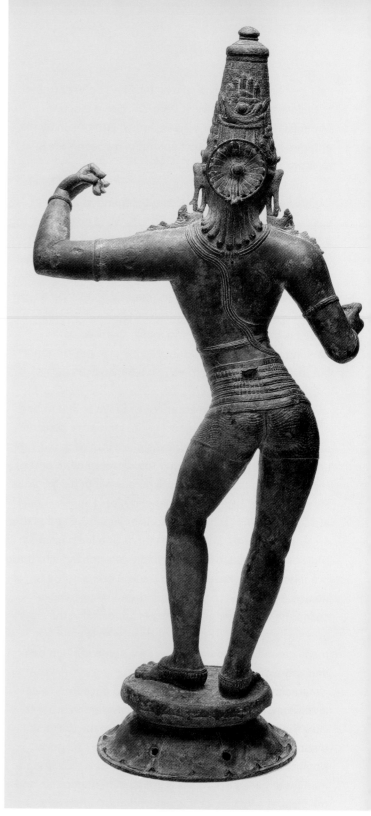

FIG. 41. Standing Rama. Chola period, early 11th century. India, Tamil Nadu . Copper alloy. H. 37¾ x W. 17½ x D. 9½ in. (95.9 x 44.5 x 24.1 cm). Asia Society, New York: Mr. and Mrs. John D. Rockefeller 3rd Collection, 1979.23

and a mace and a lotus in two extended front hands. The wheel is a symbol for the act of teaching, the practice of rulership, and the passing of time. In Vishnu's iconography, it signifies the god's important role in the preservation and re-creation of the universe. In this small bronze, the large wheel and many hands of Vishnu illustrate the god's function as a universal protector. This sculpture is

not as exquisitely cast as the larger images of Vishnu, Shiva, and the other deities that are discussed in this chapter. The strong, full physique of the god and his oval face point to a date in the eleventh century.

The lack of plasticity in the treatment of the body helps to date a sculpture of the god Brahma **(FIG. 43)** to the twelfth century. Despite his theological importance

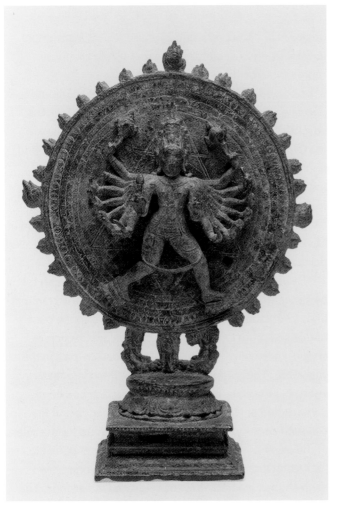

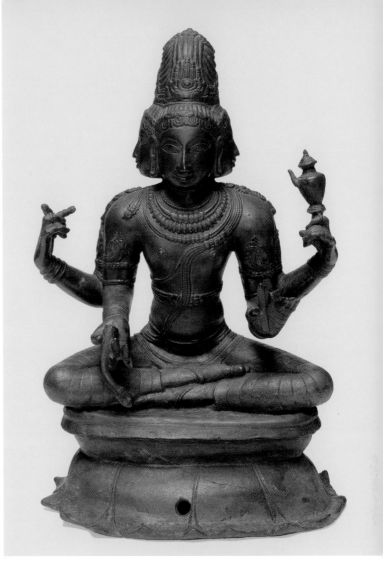

FIG. 42. Vishnu. Chola period, 11th century. India, Tamil Nadu. Copper alloy. H. 7¼ x W. 5⅛ x D. 2⁵⁄₁₆ in. (18.5 x 13 x 6 cm). Asia Society, New York: Gift from The Blanchette Hooker Rockefeller Fund, 1994.3

FIG. 43. Brahma. Chola period, 12th century. India, Tamil Nadu. Copper alloy. H. 15⅝ x W. 10¼ x D. 9¾ in. (39.7 x 26.03 x 24.76 cm). Asia Society, New York: Mr. and Mrs. John D. Rockefeller 3rd Collection, 1979.25

in Hinduism as a symbol of the generation of the cosmos, Brahma is not often represented in the visual arts. He is identifiable by his four faces and the attributes he holds in his hands: a lotus stem in the lower right, a bundle of grass in the upper right, a vase in the upper left, and a book in the lower left.

The incised eyebrows and wide, staring eyes found on Brahma's four faces are later recuttings. The eyes are considered one of the most important elements of a Hindu sculpture, serving as a link between the god and the devotee who views it. The chiseling of the eyes or "eye-opening" ceremony is one of the last stages in the consecration of an image in a temple and is accompanied by elaborate ceremonies and rituals.

Both the ritual bathing of images and lustrations of water, milk-rice, molasses, and other liquids are important parts of Hindu ritual. Because the eyes of the sculptures receive the full impact of these poured offerings, they often become abraded over time, and so those on

older images were sometimes recarved to preserve the potency and appearance of the deity. The four faces on this sculpture of Brahma show different degrees of recutting. Stylistically, the eyes of this figure compare with those found on works from the fourteenth to the seventeenth century, dating the recarvings to a later period than that of the original image.

Unlike the famous bronze sculptures of Hindu gods, Chola-period representations of Buddhist deities are scarcer and much less known. Probably cast in or near the town of Nagapattinam, a sculpture of a standing Buddha **(FIG. 44)** illustrates the continuation of Buddhism in South India after the rise of Hinduism. The Buddha holds his right hand in the gesture of reassurance and his left in the gesture of charity, and this combination (known as the *abhayavaradamudra*) can be read as a statement of the Buddha's active presence. This combination of gestures is generally used by the Buddha Shakyamuni, the founder of the religion. Because of the use of these

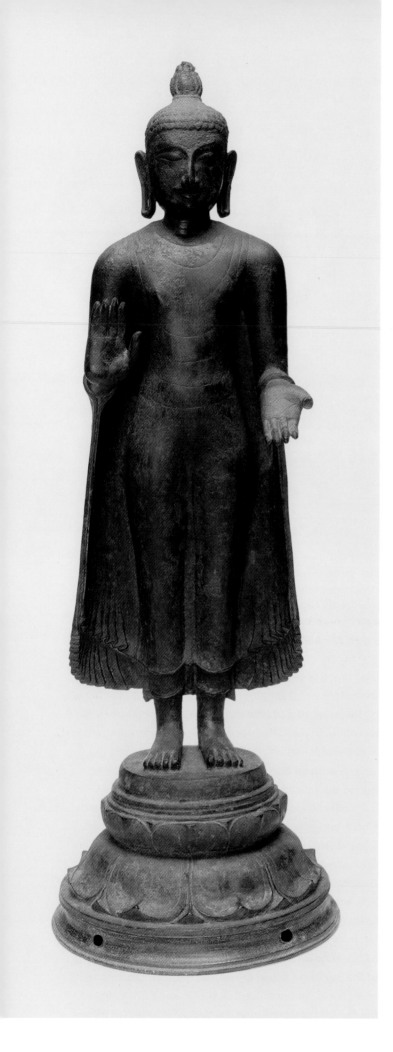

gestures and the preference for images of Shakyamuni in Chola-period sculptures, it seems likely that he is represented by this statue.

Located on India's southeastern coast, Nagapattinam had been a major Buddhist center from as early as the seventh century, when it was mentioned in the diary of the Chinese pilgrim Yijing. Nagapattinam had close and continuous ties with the Sri Lankan, Myanmar, East Indian, and Indonesian Buddhist communities; and an eleventh-century flowering of Buddhism in this coastal city was spurred at least in part by the arrival of a group of colonists from the kingdom of Shrivijaya, which controlled parts of Sumatra and of the Thai/Malay Peninsula.

Buddhist bronzes dating from the ninth through the seventeenth century have been attributed to the Nagapattinam workshops. The inscription carved into the base of this sculpture links the piece to the construction of a chapel known as the Rajendra-chola-perum-palli in the year 1090.[1] This chapel was located within a monastery known as the Cula-mani-varma-vihara that had been constructed at Nagapattinam in the earlier part of the eleventh century. The monastery was named for the ruler of the Javanese dynasty that was partially responsible for its construction. The chapel, though, is one of two such chapels named after the reigning Chola kings. The aforementioned later chapel, constructed in 1090, is named for Kulottunga I, who was also known as Rajendra. The inscription's reference to this king, whose rule lasted from 1070 to 1120, indicates that this sculpture was cast in the late eleventh or early twelfth century; and the Buddha's body, the shape of his face, and his strong features are comparable to those found in Hindu sculptures produced at that time. The fairly long inscription also states that this image of the Buddha was commissioned by members of the guild of metalworkers, and was to be used in processions for a sacred festival, suggesting that—as was true of Hindu images from the Chola period—Buddhist bronzes were also publicly displayed during festivals.

This sculpture of a standing Buddha also shows several characteristics common to Buddhist images from South India, in particular his rigid stance, the heaviness of his garment's hemline, and the flame-shaped *ushnisha* at the top of his head. A symbol of the Buddha's superhuman knowledge, the *ushnisha* is often represented as

FIG. 44. Buddha. Chola period, about 1070–1120. India, Tamil Nadu. Copper alloy. H. 27¼ x W. 9½ x D. 9½ in. (69.2 x 24.13 x 24.13 cm). Asia Society, New York: Mr. and Mrs. John D. Rockefeller 3rd Collection, 1979.15

FIG. 45. Throne for the Image of a Deity. Circa 1880. India, Gujarat or Maharasthra. Gold, glass. H. 4 x W. 4.25 x D. 3.25 in. (10 x 11 x 8 cm). Asia Society, New York: Given by Susan L. Beningson to Asia Society Museum in honor of the appointment of Vishakha N. Desai as President of the Asia Society, 2007.1

a rounded bump. During the sixth through the ninth century, however, the flame-shaped *ushnisha* became common in South India. Early examples show three flames, whereas later versions have five, sometimes understood to symbolize the five types of knowledge acquired by the Buddha. This tradition of the flame-shaped *ushnisha* spread from India to Sri Lanka, Myanmar, and Thailand.

1. This inscription has been translated by Vidya Dehejia as "Well-being [and] prosperity. The *nayakar* [Buddha], of all the eighteen countries, of the metalworkers. / The procession image, for the sacred festival of the *alvar* temple, which was caused to be taken in procession by the respected one [*utaiyar*] endowed of the four *gunas* from Cirutavur; [in] the *perum-palli* [great place of worship or great *vihara*] of the metalworkers, [in] the *perum-palli* of Rejendra Chola."

A Throne for the Image of a Deity

In the Hindu tradition, entertainment is part of the act of worship, performed along with feeding, bathing, and adornment of a deity. Icons are clothed, crowned, and otherwise adorned according to the time of day and season. Sacred texts describe the heavens aglow with precious gems and metals, an environment replicated in the temple's inner shrine where the principal deity is surrounded with gold and gems. Devotees believe they will reap merit by presenting gifts to the gods, including jewelry, crowns, and other accoutrement for images of gods, goddesses, and mythical beings.

The path of *bhakti*, or intense personal and emotional devotion, stresses the ability of any devotee, regardless of caste or the assistance of a priest, to embrace a god. In families of means, devotional icons are offered gifts that include utensils for worship, swings, and miniature thrones. A miniature gold throne **(FIG. 45)** for a household shrine—ornamented with lotus petals below the railing, an openwork back with a repoussé design of a floral spray, and a suspended umbrella—is a late-nineteenth-century example. A small figure of Krishna adorned as king would likely have been seated on the throne.

Two Mughal Sandstone Screens

Much of North India was ruled by the Mughals, a dynasty of Central Asian origins that had entered North India from Afghanistan in 1526. Construction of palaces was widespread under Mughal leadership, which lasted until 1858, and was particularly prolific between the second quarter of the sixteenth century and the first half of the seventeenth century. India has a long tradition of elaborate stone carving for temples and palaces. Red sandstone was one of the most popular materials in the region of Mathura, south of New Delhi. Two seventeenth-century

Top: **FIG. 46.** Screen. 17th century. India, Mughal. Sandstone. H. 31 x W. 42¾ x D. 2½ in. (78.7 x 108.5 x 6.4 cm). Asia Society, New York: Gift of Arthur Ross, 1995.2

Bottom: **FIG. 47.** Screen. 17th century. North India, Mughal. Mottled red sandstone. H. 19½ x W. 25⅞ x D. 4⅞ in. (49.5 x 65.7 x 12.4 cm). Asia Society, New York: Gift of Arthur Ross, 1995.3

Mughal-period screens are carved from this material **(FIGS. 46 AND 47)**.

Carved stone screens or panels like these two examples would have been used as decoration. They would have been placed over and set into the rough stone masonry of what was likely part of a palace struc-ture. Both red sandstone screens derive in part from the tradition of ceramic tile decoration in fifteenth-century Iranian and Central Asian architecture. Craftsmen carved one screen with an overflowing vase of flowers in a cartouche flanked by tall-stemmed blossoms growing from the earth, imagery also found in contemporary Indian examples and in the Persian art of the Mughals' Timurid ancestors **(FIG. 46)**. The carvings of the throne area of the Diwan-i Amm (Hall of Public Audience) at the Lal Qal'ah (also known as the Red Fort) in Old Delhi has floral forms in a similar composition. The red sandstone walls and architectural elements of the throne area were completed in 1648 under the rule of Shah Jahan.

The second architectural fragment has been carved with interlocking forms ornamented with rosettes often seen in Islamic art **(FIG. 47)**. Similar decorative panels appear in the form of frames, which sometimes contain writing or excerpts from the Quran. Cartouches of this nature appear in carpets and other decorative arts of the period.

Paintings for Mughal, Rajput, and Western Himalayan Courts

Illustrations in books and small-scale paintings grouped in albums or sets are among the most important art forms that were produced in India from the sixteenth through the nineteenth century.

While much of North India was ruled by the Mughals, different regions of the northwestern part of the subcontinent were under the control of native Rajput kings, who enjoyed varying degrees of authority within the larger Mughal empire. Much of the history of the era concerns the many and varied ways in which the relationships between the Mughal and Rajput rulers were established and redefined.

During this time a tradition of painting developed that was closely linked to the art of the book. Paintings were created for vertically oriented books from Iran and, to a certain extent, Turkey and Central Asia. Prior to the introduction of paper to India in the thirteenth century, most Indian paintings were either murals or illustrations in religious texts written on a type of palm leaf and horizontally oriented. Most of the palm-leaf illuminations were in Buddhist or Jain texts and were painted in the eastern and western regions of India. The earliest group of illustrated manuscripts dealing with nonreligious themes comes from North India, generally consisting of histories of Iran or Islam. The development of the related tradition of painting may be linked to encounters with Muslims and the continuous assaults on North India that began in the eighth century with the annexation of areas in present-day Pakistan and that continued until most of the northern regions came under the sway of the Mughals.

By the late fifteenth century, illustrated books dealing with Hindu themes and stories were also produced in northwestern India. These books were generally commissioned by lay devotees, often as acts of religious merit. Although they are painted on paper, these books were often made in a horizontal format, as can be seen in a folio from an illustrated manuscript of the *Bhagavata Purana* (FIG. 48), that reflects the shape of earlier palm-leaf manuscripts (compare FIG. 57). This folio is from a manuscript in which most of leaves have the name *Sa. Nana* or *Sa. Mitharam*

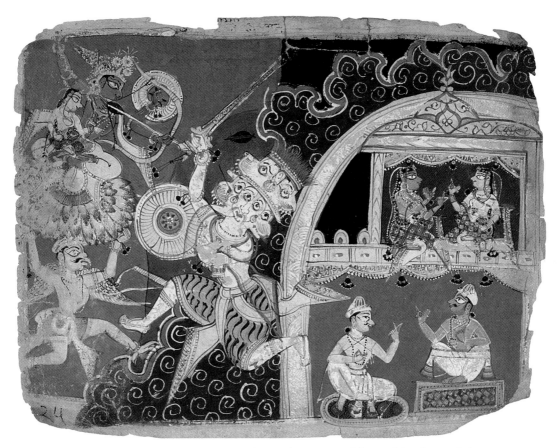

FIG. 48. Folio from a *Bhagavata Purana* Manuscript: Battle Between Krishna and the Fire-Headed Demon Mura. About 1500–1540. India, Rajasthan or Uttar Pradesh. Opaque watercolor and ink on paper. H. 7 x W. 9 in. (17.8 x 22.9 cm). Asia Society, New York: Mr. and Mrs. John D. Rockefeller 3rd Collection, 1979.55

written on them; the name *Sa. Nana* is inscribed at the top left of this page. The manuscript is believed to have been commissioned by two brothers who were merchants. The name *Sa. Nana* is usually found on paintings from the second half of the book, while *Sa. Mitharam* is found on works from the earlier section.

Compiled before the ninth and tenth centuries, the *Bhagavata Purana,* featuring the exploits of the Hindu god Vishnu, is one of the best-known and best-loved works of Indian religious literature. Book Ten, which focuses on Vishnu's manifestation as the god Krishna, is the most popular portion of this classic, and incidents in it are often depicted in Indian painting. This manuscript page illustrates Krishna's ferocious battle with the five-headed demon Mura, who sleeps under the water surrounding the city of Pragyyotishapura. Here Krishna, carried aloft by the bird-man Garuda, is fighting the demon, as shown at the upper left of the page. The domestic scenes at the right show inhabitants of the city who seem unaware of the combat that is shown raging to the left.

The compartmentalization of these two scenes is typical of Indian painting prior to the importation of Persianate styles and techniques to the Islamic courts of India during the sixteenth century. The juxtaposition of areas of bold colors within the painting, the unrealistic proportions of the figures with regard to the architecture, and the exaggeration of body parts—for example, the depiction of the eyes—are common in nonimperial paintings from northwestern India. The pulsating energy found in the treatment of the figures in this painting is also typical.

The greater sense of depth and the more naturalistic treatment of figures within architectural or landscape settings seen in the illustrations on a page from a manuscript of the *Ta'rikh-i Alfi* (*History of a Thousand Years;* **FIG. 49**) exemplify the style of painting produced in the sixteenth century at the court of the third Mughal emperor, Akbar (reigned 1556–1605). Akbar and his successors were active patrons of the arts, and painting flourished at the Mughal court from the sixteenth through the eighteenth century. As was often true of Muslim rulers, the Mughal emperors were deeply interested in history—their own, that of their illustrious forebears such as Timur (Tamerlane), and that of Islam. Paintings produced at the Mughal court often illustrated either historical themes or the activities and achievements of the emperors.

The *Ta'rikh-i Alfi* is one of the many works of history and literature commissioned by Akbar and illustrated at his court. A new history of the Islamic world, the manuscript was intended to encompass everything that had happened in Islam since the birth of the prophet Muhammad. Akbar commissioned the book in about 1581/82, and it is believed to have been completed between 1592/93 and 1594/95. Most of the work involved in the production of this manuscript was done in Lahore. The text is infused with Akbar's liberal religious sentiments and implies that Akbar was *Iman Mahdi*, a reformer whose appearance at the end of Islam's first millennium would forestall the apocalypse. Many verses in the *Ta'rikh-i Alfi* were considered heretical, and it is believed that one of the individuals who wrote the text was murdered. The complete manuscript is unusual among the books produced at Akbar's court, both for its relatively large size and for the prominence given to the written text. On this folio the text fills most of the center of this page and all of the verso.

The long text of this page records events that occurred during the caliphate of al-Ma'mun, focusing on the struggles for political power that occurred between 815 and 816.[1] Among the events mentioned are the rebellion of Ibrahim al-Jazzar (whose name means "the butcher") in the province of Yemen, the ambiguous end of this rebellion, the journey of the forces of Ibrahim al-Jazzar and Zaya al-Nar (who originally had been sent to control the battle in Yemen) to fight a rebellion in Iraq, the killing of King Leo, and the ascension of King Michael in Byzantium. The text also mentions that al-Ma'mun had his opponent Yahya b. Amir stoned to death for insubordination during this period. It is possible that this last incident is alluded to in the scene in the center of the painting, which shows a barely clothed prisoner with shackled legs lying in a courtyard. The prisoner appears dead, but there is no evidence of the means of his death. The vignettes along the border of the painting may also be intended to refer to the political unrest that plagued this period of al-Ma'mun's caliphate. Numerous figures are shown talking agitatedly and meeting in doorways and gardens, suggesting intrigue and unrest.

Akbar's wide-ranging interests are reflected in the paintings produced at his court, which often reveal a compelling amalgamation of sources. For example, the theme this painting illustrates is derived from Iranian examples, but the poses of the figures and their somewhat exaggerated gestures reflect the influence of early Indian styles such as those seen in the *Bhagavata Purana* illustration discussed earlier. Finally, the use of a type of atmospheric perspective in the background at the top of the page illustrates the influence of European prints on the art of Akbar's court.

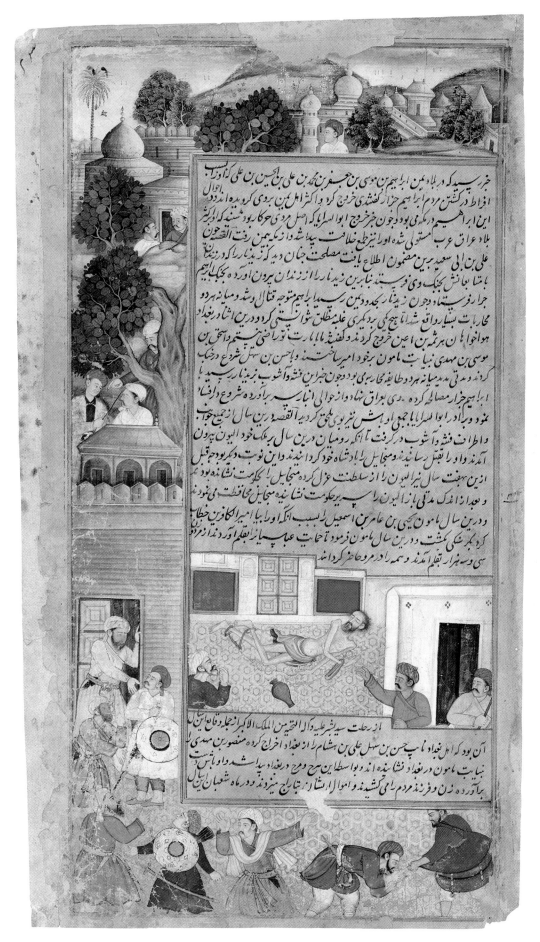

FIG. 49. Folio from a *Ta'rikh-i Alfi* Manuscript: Death of a Prisoner. Mughal period, reign of Akbar (1556–1605), about 1585. India, Uttar Pradesh, Lahore area. Opaque watercolor and ink on paper. H. 16 x W. 8⅝ in. (40.6 x 21.9 cm). Asia Society, New York: Mr. and Mrs. John D. Rockefeller 3rd Collection, 1979.56

FIG. 50. Kesu Das. Mother and Child. Mughal period, reign of Jahangir (1605–27), 1589. India. Brush and ink on paper. Image: H. 3¾ x W. 2 in. (9.5 x 5.2 cm); page: H. 10½ x W. 6⅞ in. (26.7 x 17.5 cm). Asia Society, New York: Mr. and Mrs. John D. Rockefeller 3rd Acquisitions Fund, 2002.1

An even stronger influence of European prints is evident in the Mughal painting of a mother and child **(FIG. 50)**. Christian iconography had made its way into the Mughal ateliers through European missionaries located largely in West India, who had brought prints, painting, and sculpture along with them for proselytizing. In keeping with sixteenth-century European techniques, the Mughal artist has created a receding architectural setting and has painted the drapery to create a sense of volume. This painting was produced in the atelier of the Mughal emperor Jahangir (1569–1627), who was particularly predisposed toward the works of European artists. Christian themes, particularly of the Virgin and Child, were abundant during the Mughal period in the sixteenth and seventeenth centuries. The artist, Kesu Das, signed his name on the finished piece—an unusual practice within Mughal painting.

Two Rajput paintings produced in the region of Malwa, located in north-central India, illustrate some of the differences between the Mughal and Rajput painting traditions. Both Malwa paintings date to the seventeenth century. The earlier one **(FIG. 51)**, which can be dated to about 1650–60, is a folio from a manuscript of the *Amaru Shataka (One Hundred Verses by Amaru)*, while the second folio **(FIG. 52)**, which dates to about 1660–80, is an illustration of the musical mode *Madhu Madhavi Ragini* from a *Ragamala* series. The compositions of these paintings and their use of space and color reflect the conceptual differences between the Rajput and Mughal worldviews and pictorial styles. Mughal paintings are usually particularized, stressing a specific individual, moment, or event. Although Rajput paintings dealing with courtly themes and subjects can also be imbued with a historical specificity, many Rajput pictures, especially those dealing with literary or religious themes, do not adhere to empirical reality. Mughal paintings show an interest in spatial depth, which helps to place a scene in a setting, while Rajput narrative paintings often place figures and architecture within a flat picture plane. The colors used in Rajput paintings are brighter and bolder than those used in contemporaneous Mughal works, and the gestures and postures used in Rajput paintings are more stylized than those found in the art of the Mughal court.

Malwa painting is noted for its conservatism within the Rajput tradition; compared with most other schools of painting in Rajasthan, it betrays little awareness of or influence from the predominant Mughal style and insistently harks back to such pre-Mughal conventions as seen in the *Bhagavata Purana* picture of more than one hundred years earlier. This can be seen in the conventionalized figures and architecture in both these paintings. The blues, reds, and yellows; the relatively simple backgrounds; and the figures' sweet faces and delicate gestures are characteristics shared by Malwa paintings of the later seventeenth century. The ornate detailing of the architecture in the page from the *Amaru Shataka* manuscript, though, helps to date this painting to the second quarter of the seventeenth century. The majority of the paintings from this set are in the Prince of Wales Museum, Mumbai, and the set has been dated to about 1650 on the basis of style and inscriptional evidence. The greater simplification and elongation of the figures in the *Ragamala* picture are more typical of works painted later.

Illustrations of texts dealing with aspects of love are among the most popular images in Malwa paintings of the seventeenth century, and the *Amaru Shataka* is one

such text. Written by the Sanskrit poet Amaru (active ca. 7th century), the hundred verses in this lyrical book describe the various forms of love. In this painting, the seated woman is depending on the services of her confidante to explain her anguish to her lover. Although this painting refers to the specific verse from the poem written above (now somewhat damaged), such illustrations of lovers, or so-called heroes (*nayakas*) and heroines (*nayikas*), are quite generalized in Malwa painting of the seventeenth century.

Love is also the theme of the charming painting of a woman rushing through the rain to meet her lover (**FIG. 52**). *Ragamala* paintings, or illustrations to a "Garland of Ragas," represent a uniquely Indian amalgamation of music, poetry, and painting. Often translated as "modes" or "melody types," ragas are tonal frames that provide a set structure—including scales, center tone, and progressions—for a piece of music that can then be used to improvise according to the style of the musician. In literature, each musical mode is personified in a male

(*raga*) or female (*ragini*) form, referring to earlier classifications of lovers and heroes and heroines. Moods and seasons associated with musical modes were incorporated into literary descriptions, which in turn formed the basis for paintings.

In *Madhu Madhavi Ragini*, the sense of joyous anticipation is heightened by the time of day—early evening—and by the rain and lightning that characterize the monsoon season. The sense of drama is intensified by the woman's startled reaction to the bolt of lightning and the birds flying in the sky above her head. In love-themed literature throughout India, all of these characteristics are commonly associated with the literary archetype Abhisarika Nayika, the one who braves all obstacles to be with her lover.

A moonlit night with bright stars is the setting for an illustration of Krishna and Balarama in pursuit of the demon Shankashura from a beautifully illustrated manuscript of the *Bhagwat Purana* (**FIG. 53**). It was painted in the seventeenth century in the Rajput court of Bikaner, a powerful kingdom in northwestern Rajasthan, which

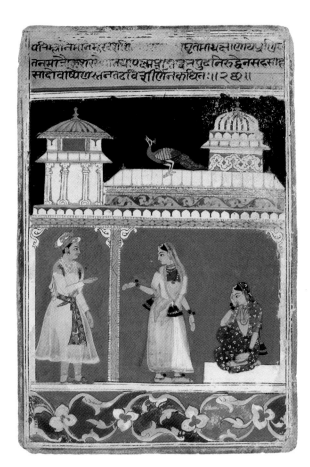

FIG. 51. Folio from an *Amaru Shataka* Manuscript: Heroine Confiding in Her Attendant. About 1650–1660. India, Madhya Pradesh, Malwa region. Opaque watercolor and ink on paper. H. 8¼ x W. 5¾ in. (21 x 14.6 cm). Asia Society, New York: Mr. and Mrs. John D. Rockefeller 3rd Collection, 1979.58

FIG. 52. Folio from a *Ragamala* Series: Madhu Madhavi Ragini. About 1660–1680. India, Madhya Pradesh, Malwa region. Opaque watercolor and ink on paper. H. 9 x W. 6⅝ in. (22.9 x 16.8 cm). Asia Society, New York: Mr. and Mrs. John D. Rockefeller 3rd Collection, 1979.57

FIG. 53. Krishna and Balarama In Pursuit of the Demon Shankashura. Ca. 1690. India, Rajasthan, Bikaner. Gouache, gold, and silver on paper. H. 9 x W. 5⅛ in. (23 x 13.3 cm). Asia Society, New York: Mr. and Mrs. John D. Rockefeller 3rd Acquisitions Fund, 2002.2

had developed close relations with the Mughal court, primarily through matrimonial alliances. Seventeenth-century paintings, like this one from Bikaner, exhibit the influence of Deccani painting—the lush style associated with the plateau in south-central India—as well as Mughal influences. The local semibarren landscape is featured in this painting.

The illustration depicts Krishna and his elder brother Balarama chasing the shell demon, Shankasura, who Krishna eventually kills in the *Bhagwat Purana*. Following a popular narrative strategy, Krishna is depicted twice within the same frame. In the lower-right corner of the painting Krishna appears as the eternal lover, as he plays his flute for his beloved Radha surrounded by *gopis* (cowherds) on a moonlit night. In contrast, in the upper left-hand corner Krishna, in his heroic aspect, chases Shankasura along with Balarama. The artist has made attempts to draw the *gopis* from all perspectives, a clear departure from the prototypical profile that usually dominates Bikaner painting.

Rama, the protagonist of the *Ramayana*, is the subject of another narrative illustration **(FIG. 54)**. The instability of the Mughal courts between the seventeenth and eighteenth centuries forced many painters to seek patronage from the courts of rulers in the Western Himalayas. While working for these courts, the painters evolved a style of painting art historians call *Pahari* (of the mountains) that

uses a stylized vocabulary for the depiction of religious and sentimental subject matter. An illustration to the *Ramayana* displays the slender, elegant physical forms and graceful, flowing drapery that characterize *Pahari* painting. As is typical of the style, the faces of Rama and his brother Lakshmana are depicted in profile and their figures are set against beautiful, idealized landscapes.

The painting uses a novel compositional strategy to depict Rama, who is seated on the left side with a vast expanse of water separating him from the abode of the demon Ravana (Lanka) in the upper-right corner. This scene depicts the moment just before the Pandavas, the sons of Pandu, launched their attack on Ravana to rescue the goddess Sita from his clutches. Rama and Lakshmana are surrounded by the monkey armies.

1. The full text as translated by Habibeh Ramih is summarized here.

Temple Hangings

Large painted temple hangings known as *pichhavais* (literally, those that hang at the back) are among the most distinctive types of textiles produced in India. Intended to be hung behind sculptures of Krishna, a manifestation of the Hindu god Vishnu, these hangings are painted with images of Krishna or scenes from his life. The use of these

temple hangings developed as part of the evolution of a special sect of Krishna worship known as Vallabhacharya, after the name of the founder of this sect, Vallabha (1478–1532). This sect was noted for its distinctive fusion of abstract metaphysical concepts derived from Vedanta philosophy and human love and pleasures. It was also characterized by its elaborate rituals that required altarpieces decorated with textiles, sculptures, metal-work, and flowers.

The eight women flanking a flowering tree on two examples of this type of temple hanging (FIGS. 55 AND 56) represent the theme of Krishna and the female cowherds, or *gopis.* An enormously popular theme in Indian litera-ture and art, this motif features Krishna's life as a cowherd and his magnetic appeal to the women he encounters. In such themes, Krishna is often shown playing with the *gopis* or hiding from them, and such is his power that each woman believes that she is the only one whom

Krishna loves. This enduring motif is generally inter-preted as a metaphor for the soul's longing for union with the divine.

In both these wall hangings, the women hold objects that would have been offered to the statue of Krishna (placed before the hanging) during religious ceremonies. These include peacock feather and other fans, fly whisks, betel boxes, garlands, and lamps for *arati,* a ceremony performed during worship in which lamps are waved in a circular motion before the head of the image. The cows presumably tended by Krishna and his female consorts are shown at the bottom of each composition. A river teeming with fish, turtles, crabs, and other water creatures and the placement of many small figures in the border distinguish the more elaborate textile (FIG. 55). The small figures probably represent the devout who commissioned this temple banner. In both hangings, the sun and moon are shown at the top of the painting in a

FIG. 54. Illustration to the *Ramayana*—Preparations before the Attack on Lanka. Ca. 1820. India, Himachal Pradesh, Perhaps Hindur. Opaque watercolor and gold on paper. Image: H. 11¼ x L. 16½ in. (28.6 x 41.9 cm). Asia Society, New York: Mr. and Mrs. John D. Rockefeller 3rd Acquisitions Fund, 2002.3

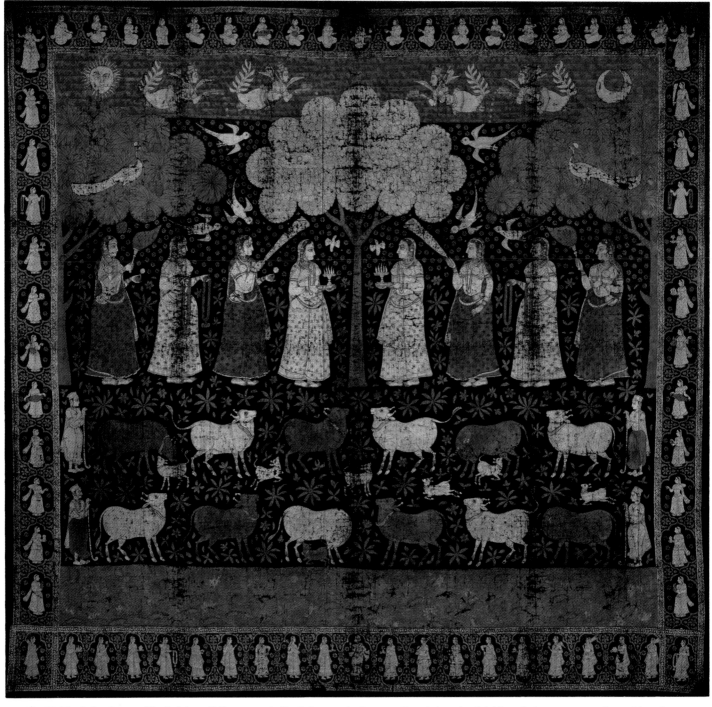

FIG. 55. The Rainy Season (Varsha). Late 17th century. India, Gujarat or the Deccan. Temple hanging (*pichhavai*); opaque watercolor, gold, and silver on dyed cotton. H. 80¾ x W. 86½ in. (205.1 x 219.7 cm). Asia Society, New York: Mr. and Mrs. John D. Rockefeller 3rd Collection, 1979.59

band of dark color that represents thunder clouds, indicating that these scenes take place during Varsha, the rainy season.

Temple hangings of this type were generally produced for special festivals related to the seasons and to specific events in Krishna's life. They were usually changed twice a month in accordance with the annual cycle of religious ceremonies. The precise function and meaning of these two temple hangings is difficult to determine. However, an important festival known as Janmasthami, which

commemorates the birth of Krishna, falls during the rainy season, and it is possible that these hangings were intended to be used at that time.

Both are painted on cotton that was dyed dark blue, the color of Krishna's skin. Silver and gold pigments were used in addition to other colors in one, suggesting a seventeenth-century date for this hanging, while the simpler composition and palette of the other piece point to the eighteenth century. Rajasthan, in northwestern India, was the center of the Vallabacharya sect, which had

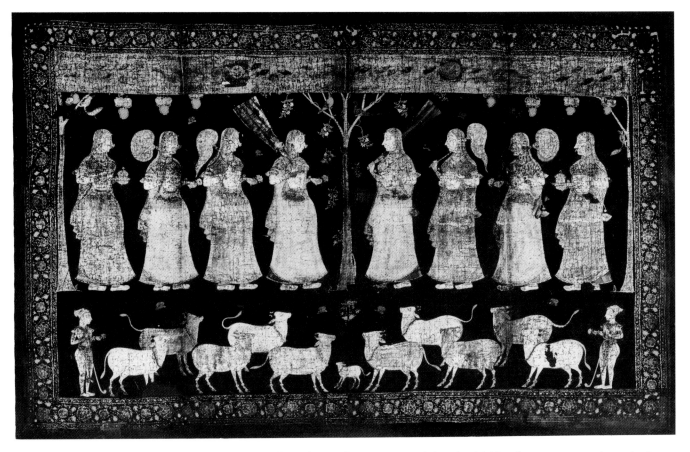

FIG. 56. The Rainy Season (Varsha). Late 18th century. India, Gujarat or the Deccan. Temple hanging (*pichhavai*); opaque watercolor on dyed cotton. H. 74 x W. 118 in.(188 x 299.7 cm). Asia Society, New York: Mr. and Mrs. John D. Rockefeller 3rd Collection, 1979.60. Black-and-white photograph by Otto E. Nelson.

been established in the city of Mathura. In 1671 the sect was proscribed by the Mughal emperor Aurangzeb (reigned 1658–1707), and the center of the sect was moved to the city of Nathdwara in the Rajput kingdom of Mewar, farther south in Rajasthan. Temple hangings such as these two were produced in Rajasthan, Gujarat, and the Deccan, however it remains difficult to determine the origin of such pieces. Scholarship from the late twentieth century has suggested that hangings with dark blue backgrounds such as these two were produced farther south in Gujarat or the Deccan rather than in Rajasthan.

Buddhist Paintings from India, Nepal, and Tibet

Buddhist paintings are found in cave temples, halls of worship and meditation, and scriptural texts. The production of Buddhist manuscripts from leaves of the talipot palm strung together with cord and illustrated with images of various Buddhist deities, scenes from the life of Shakyamuni, or both of these motifs, flourished in Bihar and Bengal (the latter now divided between West Bengal State and Bangladesh) under the rule of the Pala kings during the eleventh and twelfth centuries. During the

same period, similar manuscripts dedicated to the Jain religion were also produced in smaller numbers in west India. It is interesting that no illustrated Hindu manuscripts that date to this period exist even though, by this time, Hinduism was the predominant religion in India.

Four leaves from a manuscript from East India of the *Ashtasahasrika Prajnaparamita Sutra* (*Perfection of Wisdom in Eight Thousand Lines*) dated to about 1073 **(FIG. 57)** are illustrated with scenes from the life of the Buddha interspersed with images of deities. The *Ashtasahasrika Prajnaparamita Sutra* is one of the earliest known texts of Mahayana Buddhism; sections of it may have been formulated as early as the second century BCE and it is believed to have been completed by the second century CE.

Several inscriptions, in Sanskrit and Tibetan, written on another leaf (E) provide a rare history of the origin of this book. The Sanskrit colophon records the donation of the manuscript by a devotee named Nae Suta Shoha Sitna and lists the name of the scribe as Ananda, of the famous Nalanda monastery in Bihar. The offering was made in the fifteenth year of the rule of King Vigrahapala, who was the son of Nayapala. Nayapala ruled from about 1042 to 1058, and his son's reign lasted from about 1058 to

FIG. 57. Five of the Leaves from an *Ashtasahasrika Prajnaparamita* Manuscript. Pala period (8th–12th century). India, Bihar, Nalanda monastery. Ink and opaque watercolor on palm leaf. Each approx., H. 2⅞ x W. 22⅜ in. (7.3 x 56.8 cm). Asia Society, New York: Mr. and Mrs. John D. Rockefeller 3rd Acquisitions Fund, 1987.1

Prajnaparamita (detail of A)

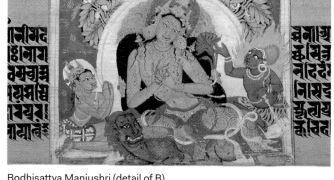

Bodhisattva Manjushri (detail of B)

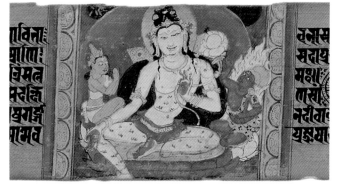

Bodhisattva Avalokiteshvara (detail of C)

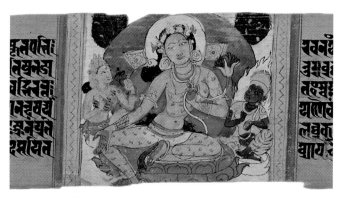

Tara (detail of D)

1085; the fifteenth year of King Vigrahapala's rule would have been around 1073, thereby giving a date for the production of this manuscript. A second Sanskrit inscription records a rededication of the manuscript in 1151. Manuscripts such as this were considered to be sacred objects and were used for teaching and possibly as the focus of meditation. As a result, rededications and repairs were common.

The first of the three Tibetan inscriptions translates the Sanskrit, while the second and third trace the history of this Indian book in Tibet. Once owned by the Kashmiri monk Mahapandita Shakya Shri, who was active in Tibet from 1204 to 1213, the manuscript was then used by the famous Butön (1290–1364), the compiler of the first Tibetan canon of Buddhism. The last inscription documents the use of this book and its dedication for the benefit of an otherwise unknown nobleman as part of his funeral rites. The provenance recorded in these inscriptions illustrates how Buddhist manuscripts may have functioned in the spread of Buddhist thought and imagery from India to other parts of Asia.

As it generally true in manuscripts of this type, the illustrations do not relate directly to the text, which is primarily a philosophical treatise on the nature of wisdom and compassion. An important Buddhist deity is depicted in the center of each leaf while a scene from the life of the Buddha is placed to each side. Reading leaves A to D, the central images represent the Buddhist goddess Prajnaparamita, the Bodhisattva Manjushri, the Bodhisattva Avalokiteshvara, and the Buddhist goddess Tara. The illustrations of scenes from the life of the Buddha depict the birth of Shakyamuni, the temptation of Mara, the preaching of the first sermon, the miracle at Shravasti, the descent from the Heaven of Thirty-three Gods, the taming of the elephant Nalagiri, the offering of honey by a monkey, and the *parinirvana*, or death of Shakyamuni. Known as the Eight Great Events, these standard scenes are often used in Buddhist sculpture of the Pala period both to encapsulate the Buddha's biography and to provide a spiritual life path for the devotee. In addition, the Eight Great Events are often found in *Prajnaparamita* manuscripts. However, the insertion of images of different Buddhist deities such as Prajnaparamita and Manjushri between the scenes from the life of the Buddha interrupts the relationships among these various scenes, suggesting that the role of these images is more iconic than narrative.

The differences in style found between the paintings on the first two leaves and the second two leaves of the manuscript indicate that the second group was most likely added to the book when it was rededicated in the twelfth century. A comparison between the image of Manjushri on leaf B and that of Avalokiteshvara on C illustrates this difference: Manjushri is painted with a greater sense of depth and movement than is Avalokiteshvara; this same comparison can also be made for the attendant figures and additional details in each of these scenes. Manjushri and the other figures on leaves A and B are painted with more delicacy and precision and with a broader range of colors than the figures on C and D. In addition, the white background used in the second group gives an unfinished appearance to these illustrations that is not present in the first two leaves.

Four leaves from another East Indian manuscript of the *Ashtasahasrika Prajnaparamita Sutra* (FIG. 58) can be dated to about 1151–1200 by the more static and stylized positions of the deities, the sketchy treatment of their faces, and the decorative details of the backgrounds. As is true of the previous example, the ends of the leaves of this manuscript, as well as areas around the string holes, are decorated with geometric patterns or small images of lotuses, stupas, and animals. The deities illustrated are Manjushri, Prajnaparamita, Tara, and a *dharmapala*, or guardian of the law. The last named deity is blue, wears a tiger skin, and has four arms. He holds a ritual implement known as a *vajra* and a lasso in two of his hands. These implements and the tiger skin are attributes generally associated with Mahakala; it is possible that this is an early image of this important deity.

Such protective deities as Mahakala, as well as such female divinities as Prajnaparamita and Tara, play important roles in the branch of Buddhism known as Tantric Buddhism or Vajrayana. This school, which is best known today as the religion practiced in Tibet and other Himalayan regions, flourished in East India under the rule of the Pala kings, and it has been suggested that the development of illustrated manuscripts during this period may reflect the growing influence of Vajrayana Buddhism, which makes greater use of images in its practices and has a more complicated pantheon that includes female deities. Since the images of deities in manuscripts such as this one have no illustrative relationship to the written text, they may have been intended for use in meditation as well as for protecting the manuscript and its owner. The commissioning of such manuscripts was a meritorious act intended to enhance the spiritual well-being of the donor of the manuscript, the artist and the scribe who created it, and all who saw and used the book.

Illustrated Buddhist manuscripts were produced in Nepal by at least the early eleventh century, and the rounder faces and longer, thinner physiques of the figures

A Dharmapala (detail of **FIG. 58**, D)

illustrating four leaves from a manuscript of the *Ganda-vyuha* **(FIG. 59)** indicate that this is a Nepali rather than an Indian work. Unlike the figures in the Indian manuscripts that evoke movement through their stylized or exaggerated poses, those in the Nepali manuscript twist and turn within the picture plane. In addition, the Nepali palette favors red and blue while that used in Indian paintings features red and yellow. The sketchy treatment of the figures in these leaves and the style of calligraphy of the text help to date the manuscript to the late eleventh or early twelfth century.

The *Gandavyuha* is part of an influential text known as the *Avatamsaka Sutra (Flower-Ornament Sutra)*. The *Gandavyuha* narrates the pilgrimage of a young boy named Sudhana as he travels from teacher to teacher in search of enlightenment. Sudhana's journey illustrates his growing mastery of Buddhist wisdom, and it also loosely parallels the life of Shakyamuni. In these four leaves, Sudhana is shown either walking under trees or seated

FIG. 58. Four Leaves from an *Ashtasahasrika Prajnaparamita* Manuscript. About 1151–1200. India, Bihar or Bengal. Ink and opaque watercolor on palm leaf. Each H. 3 x W. 17¼ in. (7.6 x 43.8 cm). Asia Society, New York: Mr. and Mrs. John D. Rockefeller 3rd Collection, 1979.53.1-4
A—Manjushri; B—Prajnaparamita; C—Tara; D—A Dharmapala.

FIG. 59. Four Leaves from a *Gandavyuha* Manuscript. Thakuri period, late 11th–early 12th century. Nepal. Ink and opaque watercolor on palm leaf. Each H. 2 x W. 21½ in. (5.1 x 54.6 cm). Asia Society, New York: Mr. and Mrs. John D. Rockefeller 3rd Collection, 1979.54.1-4
A—Sudhana; B—Sudhana visits a teacher; C—Sudhana visits a teacher; D—Sudhana.

before the various initiates whom he visits. On leaf B, the small red tower located between the small figure of Sudhana and the larger image of the bodhisattva he visits suggests the painting may represent Sudhana's visit to Maitreya, during which the bodhisattva presents the young pilgrim with a vision of his paradisiacal tower. The lack of any identifying characteristics, on the other hand, makes it impossible to determine which teacher Sudhana is visiting in the scene on leaf C.

The single Tibetan painting in the Collection is not from a manuscript but is a larger painting on cloth. The slight sway in this fourteenth-century representation of Tara **(FIG. 60)**, the position of her legs, her garments, and details in the background such as the two trees behind her ultimately derive from Buddhist painting traditions that spread from East India to Kashmir, Tibet, Nepal, Myanmar, and other regions. Often known as the savior-ess, Tara is one of the most widely revered deities in Tibet, where she is worshiped in many guises. It is believed that the monk Atisa (982–1054), one of the most significant figures in Tibetan Buddhism, who is credited with the renaissance of Buddhism in that country, brought the cult of Tara to Tibet with him in the mid-eleventh century, and this would help to account for the importance awarded to Tara in Tibetan Buddhism. The fact that in this painting she is attended by two standing bodhisattvas suggests her portrayal as a buddha, embodying enlightenment and

Sudhana visits a teacher (detail of **FIG. 59**, B)

understanding. Tara makes the gesture of charity with her right hand and holds a lotus in her left. These gestures are commonly used in representations of Tara, and this image is identified as a form of Green or Syama (or Khadiravani) Tara by her color and her posture, in which one leg rests on the pedestal and the other is pendant. Another of her manifestations, White Tara, is represented in a small figure above the principal figure's left shoulder. Above her right shoulder, Shakyamuni Buddha is depicted in the earth-touching gesture. The two extremely small figures

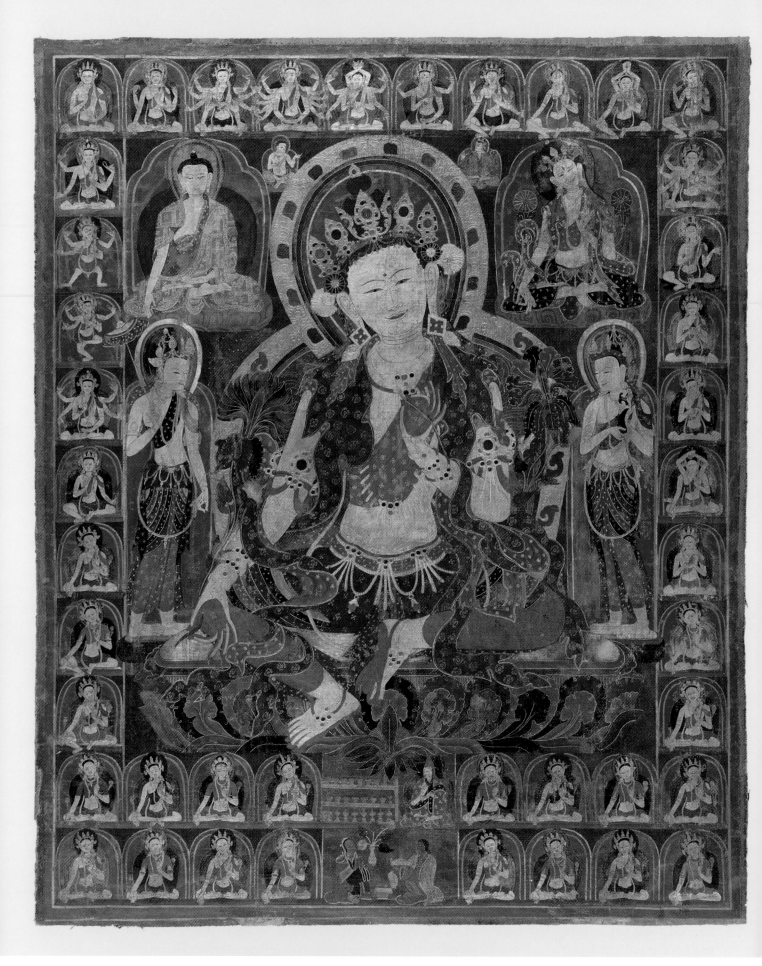

FIG. 60. Green Tara. 14th century. Tibet. Opaque watercolor with gold on cotton. H. 30¾ x W. 25 in. (78 x 63.5 cm). Asia Society, New York: Mr. and Mrs. John D. Rockefeller 3rd Acquisitions Fund, 1991.1

above the Green Tara's head represent a *mahasiddha* (great sage) and a kingly person, possibly a famous devotee, while the numerous small figures surrounding the image illustrate the many manifestations of Tara. The male and female donors of the painting and the monk who consecrated it are depicted in the center of the lower registers. The red hat worn by the monk indicates that he was a member of the Sakya order of Tibetan Buddhism, often called the "Red Hat" sect in western scholarship. The presence of the monk and the donors and the painting's iconography suggest that it was used for meditation and initiation into practices centered on the many aspects and energies of Tara.

Several features indicate that this painting was created in the western part of central Tibet in an area that was known as Tsang. This area is renowned for a style of Tibetan painting that flourished from the thirteenth through the sixteenth century and that was strongly influenced by the art of Nepal because of the many Newari artists then working in central Tibet. The emphasis on blue and red in this painting and the treatment of the faces and figures reflect Nepali prototypes.

The structured composition of spaces in the painting and its rich and abundant detailing—for example, in the small figures—are typical of the art of Tsang. Additional details include the elegant designs on Tara's clothing, the rich and varied depictions of her lotus pedestal and the lotus flowers, the embossing of the halo and the crown, and the elaborate flowerlike pieces used to tie her diadem. The fact that her armlets are shown facing the insides rather than the outsides of her arms also helps to place this painting in the Tsang tradition.

An image of a Tibetan-style stupa known as a *chorten* is drawn in black and red ink on the verso of the painting. The only inscription on this painting is found within this stupa, directly behind the main image of Tara. Written in Tibetan in the *dbu can* script, it reads *om a hum*. This traditional mantra, or sacred saying, is used in many aspects of Tibetan Buddhism, but provides no further information regarding this particular painting.

Sculptures from Kashmir

Kashmir's apparent seclusion in a valley in northwestern India—now in the state of Jammu and Kashmir—belies its importance as a crossroads linking North India with parts of Central Asia, China, and Tibet. Consequently, there is a range of influences in Kashmiri art, which has in turn had a significant impact on the art of other places.

Early Kashmiri sculpture contains several distinctive iconographic types that are not found in contemporaneous art from India or the Himalayas. Many of these images maintain iconographic types popular in India as early as the second and third centuries; the preservation of this imagery is crucial for understanding the development of religious thought in India and elsewhere in Asia from the sixth through the tenth century.

Architecture, sculpture, and painting flourished in Kashmir during the eighth and ninth centuries. The development of the arts at this time is often attributed to the patronage of King Lalitaditya of the Karakota dynasty (reigned about 724–750), who expanded Kashmir's borders and acquired the great wealth needed to support the large-scale production of art. Lalitaditya's predecessors and successors also supported the arts, however, and the large number of extant works from the eighth and ninth centuries reflects the power and influence of Kashmir during this time.

A standing sculpture of the Hindu god Vishnu **(FIG. 61)** illustrates the amalgamation of styles that distinguishes Kashmiri sculpture of this period. While the idealized proportions, smooth body, and simple garments and jewelry of the god reflect the style of art that was widespread in North India from the fourth through the sixth century, the interest in musculature derives from northwestern Indian traditions of the first and second centuries that were influenced by Hellenistic and Roman art.

One of the two most important gods of the Hindu pantheon, Vishnu appears on earth in many avatars or forms—some human, some animal, and some hybrid. Two of these forms, a lion and a giant boar, are symbolized by the two additional heads on this sculpture. As the man-lion (Narasimha), Vishnu is believed to have saved his devotee Prahlada from the wrath of his father, who worshiped Shiva. As Varaha the giant boar, Vishnu rescued the earth from drowning during a great flood. Both forms signify Vishnu's function as a preserver of individuals, the world, and the cosmos.

Images such as this one that combine two of Vishnu's manifestations are called Vishnu Vaikuntha. However, the fangs seen in the central face link this representation of Vishnu Vaikuntha with a four-headed form that was very popular in Kashmir owing to the presence of a certain sect devoted to Vishnu. Known as Vishnu Chaturmurti, this four-headed form includes a demonic head at the back as well as the three faces of the Vaikuntha form. The Vishnu Chaturmurti type is interpreted as a representation of Vishnu's powers as well as a reference to some of his more famous and beloved descents. Images of Vishnu

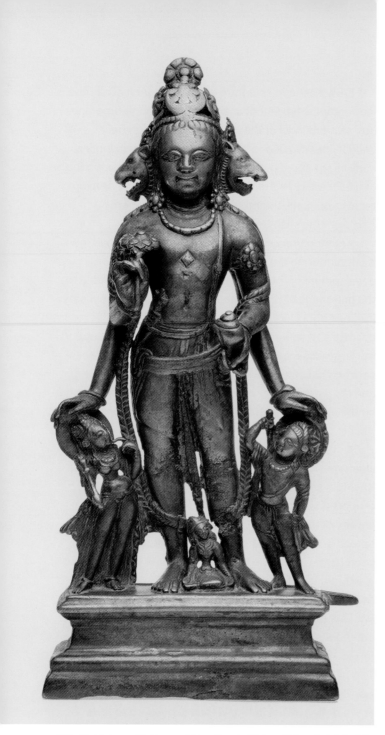

An eighth-century representation of the Bodhisattva Avalokiteshvara **(FIG. 62)** also illustrates the preservation of North Indian types of images in the art of Kashmir. Bodhisattvas were represented in such relaxed and pensive poses with the right hand touching the right cheek in early Buddhist art from North India, Central Asia, and China; the type continued in East Asian Buddhist art until the seventh century. The precise meaning of the iconography of these figures remains uncertain, though it seems likely that they represent a bodhisattva seated in paradise, possibly the Tushita Pure Land, waiting for rebirth on earth. This bodhisattva is identified as Avalokiteshvara by the lotus he holds in his hand, the seated Buddha Amitabha in his headdress, and the antelope skin that is wrapped across his back and left arm. The skin is a reference to ascetic practices and may be linked to the

FIG. 61. Vishnu with Lion and Boar Heads (Vishnu Vaikuntha). 8th–9th century. Kashmir. Copper alloy. H. 13½ x W. 7⅟₁₆ x D. 3⅛ in. (34.3 x 18 x 8 cm). Asia Society, New York: Mr. and Mrs. John D. Rockefeller 3rd Collection, 1979.43

in the form of the four-headed Chaturmurti were also popular in the area around the Indian city of Mathura during the first centuries of the Common Era; the importance of this type of image in later Kashmiri art is one example of the preservation of iconographic types for which Kashmir is noted. Vishnu holds a lotus and a conch shell. The figures standing to either side of Vishnu are personifications of the club and the wheel; the anthropomorphic depiction of these attributes also continues early Indian practices.

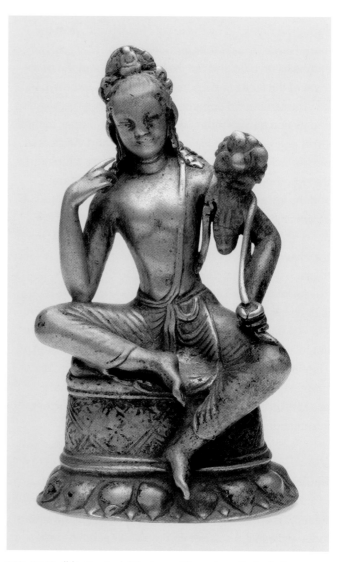

FIG. 62. Bodhisattva Avalokiteshvara. 8th century. Kashmir. Copper alloy with inlays of copper and silver. H. 7⅞ x W. 5 x D. 2¾ in. (20 x 12.7 x 6.98 cm). Asia Society, New York: Estate of Blanchette Hooker Rockefeller, 1993.2

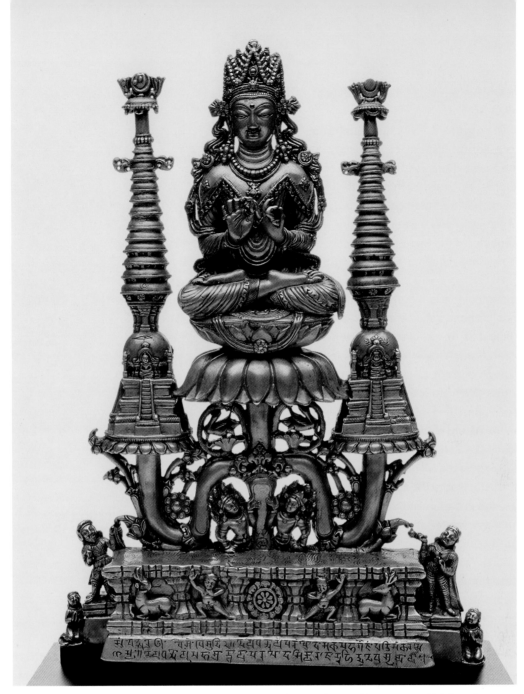

FIG. 63. Crowned Buddha Shakyamuni. 8th century. Kashmir or northern Pakistan. Brass with inlays of copper, silver, and zinc. H. 12¼ x W. 9 x D. 3½ in. (31.1 x 22.86 x 8.89 cm). Asia Society, New York: Mr. and Mrs. John D. Rockefeller 3rd Collection, 1979.44

interest in bodhisattvas as ascetics that is found in Indian art from the fourth through the sixth century and subsequently in Southeast Asian Buddhist art.

The thick, heavily pleated garments worn by the Buddha seated in the center of an elaborate sculpture **(FIG. 63)** derive from sculptural traditions that predominated in northwestern India from the second to the fourth century. The Buddha, his hands in the gesture of turning the wheel of the law, or preaching, is seated on a lotus that rises from a pond inhabited by serpent deities known as *nagas.* A stupa with a long staircase that leads to a buddha seated before a niche is on either side, supported on lotus flowers rising from the central stalk. Layered to

resemble a rocky mountain ledge, the base of the sculpture has images of a wheel, two guardians, and two deer that help to identify the primary image as Shakyamuni, since their presence in Indian Buddhist art often refers to the Buddha's first sermon at the Deer Park in Sarnath. On the right and left of the base are images of donors and their attendants, their costumes reminiscent of Turkic dress, which was worn by members of the Sahi group who ruled in Kashmir and other northern regions. A long Sanskrit inscription on the front of the base lists the donors as Sankarasena, a government official, and Princess Devashriya. Although the numbers in this inscription are difficult to decipher, a recent study of inscriptions from

Kashmir has shown that the sculpture could date to either 714/15 or 733/34.[1]

The distinctive costume worn by the Buddha connotes the consecration (*abhisheka*) of Shakyamuni as the king of the Tushita Pure Land, the abode of all the buddhas before their final rebirth on earth. The five-pointed crown, the three-pointed cape tied at the back with two strings, and the unusual floral decorations on the shoulder of the Buddha have been identified as the primary elements in the iconography of this scene.

The development of this iconography and its emphasis on Shakyamuni's consecration in the Tushita Pure Land has been linked to the rise of the Lokottaravadins, a subsect of the Mahasamghikas influential in the development of Mahayana Buddhism. Unlike earlier sects that defined the Buddha as a historical person who had achieved enlightenment, the Mahasamghikas speculated more broadly on the nature of the Buddha, defining him as a supermundane (*lokottara*) being of unlimited power and longevity. Relying on the *Mahavastu*, a text that was compiled from the first to the fourth century, the Mahasamghikas, and in particular the Lokottaravadin branch, developed a new interpretation of the path to buddhahood that stressed each person's inherent ability to become a buddha. According to this text, each potential buddha passes through ten stages known as *bhumis* during his spiritual career. In the last of these stages, the prospective buddha resides in the Tushita Pure Land to await rebirth on earth. A similar idea is represented in images of bodhisattvas in pensive poses such as the sculpture of Avalokiteshvara discussed earlier.

The broad forehead, narrow chin, and pronounced facial features of this Buddha differ from the oval face and softer features in the representation of Avalokiteshvara **(FIG. 62)**. Some scholars have suggested that images with stronger facial features, such as those of the Buddha and other figures in this sculpture, were produced in northern Pakistan in the region known as the Swat Valley rather than in Kashmir. The difference in facial types may also be the result of different hands or periods of production, or perhaps the coexistence of several ethnic groups in Kashmir.

Such pronounced facial features are also found on the figures in a small ivory relief **(FIG. 64)**. Several sculptures of this type are known, and they are believed to have been used to decorate wooden shrines or stupas. Most are considered to be from eighth- or ninth-century Kashmir, and the attenuated torso and the stylized, nearly vertical drapery folds here suggest a date in the ninth

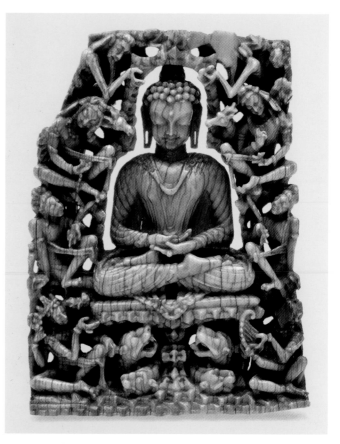

FIG. 64. God Indra visits Buddha Shakyamuni. 8th–9th century. Kashmir or northern Pakistan. Ivory. H. 3⅞ x W. 2⅞ in. (9.8 x 7.3 cm). Asia Society, New York: Mr. and Mrs. John D. Rockefeller 3rd Collection, 1979.42

century. The debate regarding the origins of the bronze Buddha also pertains to this sculpture.

The posture and gesture of the central figure of the Buddha on this deeply carved relief indicate he is in meditation. Two snarling lions stand beneath the Buddha, while numerous small figures are seated to each side. The two figures at the top have the emaciated bodies of ascetics. All of the subsidiary figures sit in relaxed postures, and most of them have a beltlike meditation strap (*yogapatta*) tied around the waist and one knee.

Most reliefs from Kashmir illustrate scenes from the life of the historical Buddha. This carving illustrates in relief the god Indra's visit to the Buddha at the Indrashala cave in Rajgir. The image of Indra is repeated eight times around the meditating Shakyamuni. The emphasis on certain moments in the life of the Buddha found in such ivory sculptures is another example of how earlier themes were preserved in the art of Kashmir.

1. The inscription has been translated:
"This is the pious gift of the devout Sankarasena, the great lord of the elephant brigade, and of the pure-minded and pious Devashriya, made in the second day of Vaishakha in the year 3."

Sculptures from Nepal

Historically, Nepal consisted of a much smaller region than the territory encompassed today by the modern nation, which was formed during the eighteenth century. It included only the section known as the Kathmandu Valley and a few outlying areas. Nepali art was created by artists of Newari descent working within this limited geographic area; this was responsible for a certain conservatism and consistency in Nepali sculpture. Yet because of Nepal's critical location, linking North and East India with such nations of the Himalayas as Tibet, there are also mutual influences Nepali art shares with that of other styles found throughout the Himalayan region.

Three bronze sculptures depicting Avalokiteshvara, the Bodhisattva of Compassion, illustrate the development of Nepali sculpture from the eighth through the thirteenth century. All three sculptures are examples of one of the most common representations of Avalokiteshvara, which was produced in some quantity in Nepal from the sixth through the nineteenth century. The earliest of the three examples (FIG. 65) dates to the eighth or ninth century. Avalokiteshvara, identified by the small seated image of the Buddha Amitabha in his crown, is standing with his right hand in the gesture of charity. He wears a long skirtlike garment, a sash tied around his hips, earrings, a necklace, and bracelets. The long cord that runs from his left shoulder and across his right thigh represents a sacred thread and symbolizes Avalokiteshvara's high social and religious status.

The smooth torso, broad shoulders, long legs, and relaxed posture of this early depiction of Avalokiteshvara reflect the impact of the Gupta style—which prevailed in North India from the fourth through the sixth century—on the art of Nepal. Nepali traditions, however, are seen in Avalokiteshvara's broad face, full cheekbones, and elegant features. Different from the facial features of Indian bodhisattvas, which are small and full, those of this bodhisattva are larger and thinner: the elegant curves of the eyebrows and eyes, and the long thin line of the nose are distinctively Nepali.

The simple yet naturalistic treatment of this Avalokiteshvara's garments and jewelry characterizes early Nepali sculptures. He wears a long piece of cloth that has been wrapped around his waist and between his legs to form a type of skirt. Numerous incised lines describe the garment and illustrate the folds created by its draping. Avalokiteshvara's full sash is wrapped on top of the skirt and neatly tied at his left. The ties used to

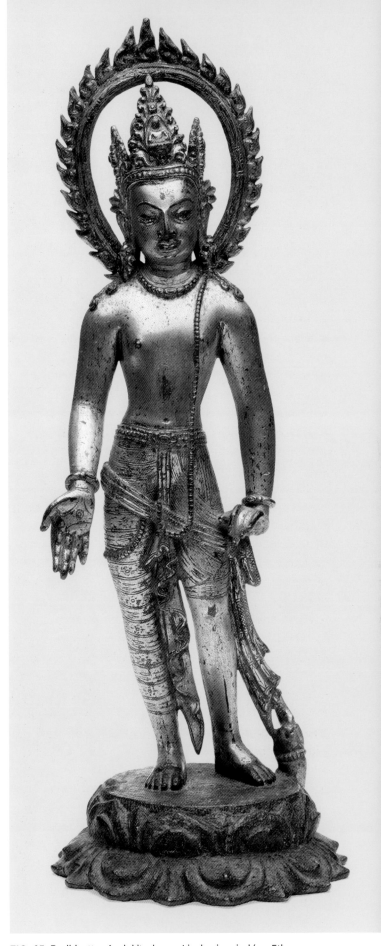

FIG. 65. Bodhisattva Avalokiteshvara. Licchavi period (ca. 5th century–750), 8th–9th century. Nepal. Gilt copper alloy. H. 13¼ x W. 5 x D. 4¾ in. (33.7 x 12.7 x 12.1 cm). Asia Society, New York: Estate of Blanchette Hooker Rockefeller, 1992.3

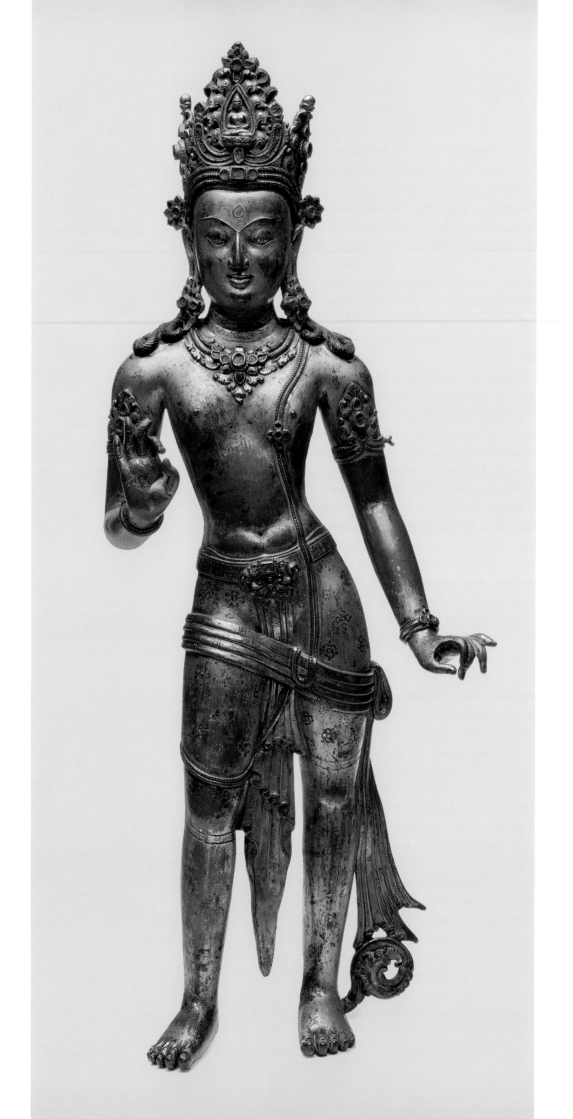

secure the skirt, the cord, and the crown are clearly articulated at the back of the sculpture. They illustrate the interest in naturalistic details that characterizes Nepali sculpture of the eighth and ninth centuries.

A late-tenth- or early-eleventh-century sculpture of Avalokiteshvara (FIG. 66) demonstrates even more elaborate modeling of the entire body, clothing, and jewelry. Although the physique is bulkier, the cheeks and waist of this figure are more accentuated than those of the earlier Avalokiteshvara. His transparent garment is indicated by delicate floral patterns and thin incised lines about the knees that represent the hemline. The sash, cord, and other adornments worn by the bodhisattva are thicker and more elaborate than those in the earlier sculpture.

This is one of the earliest extant examples of the use of semiprecious stone inlays to decorate a sculpture. Originally all the circular depressions in the jewelry on this figure would have been filled with multicolored stones, few of which remain today. The use of inlays spread from Nepal to Tibet, and such decorative inlays are among the most distinctive features of Himalayan sculpture.

Both of the figure's hands are held in the gesture of teaching (*vitarkamudra*), in which the thumb touches the index or middle finger. This suggests that this sculpture may originally have been part of a triad consisting of the Buddha Amitabha and the bodhisattvas Avalokiteshvara and Mahamasthamaprapta. This gesture is used by both Amitabha and Avalokiteshvara when they are shown guiding the souls of the faithful to rebirth in Amitabha's pure land, known as Sukhavati.

A late-thirteenth- or early-fourteenth-century sculpture of Avalokiteshvara (FIG. 67) continues the tradition illustrated by the two earlier sculptures. Here, Avalokiteshvara holds a lotus in his left hand and makes the gesture of charity with his right. While the treatment of the body, clothing, and jewelry in this sculpture is similar to that in the previous example, the greater rigidity of his pose and exaggeration of his waist and thighs date this sculpture to a later period.

The slightly elongated proportions and the exaggerated treatment of the edges and hems of the robe date a seated buddha to the eleventh or twelfth century (FIG. 68). The combination of monastic robes, pendant legs, and the gesture of preaching indicates that this sculpture represents Maitreya in his role of earthly buddha of the

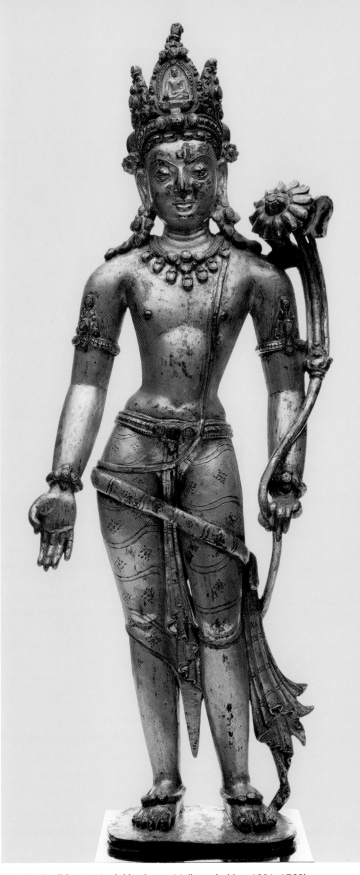

FIG. 67. Bodhisattva Avalokiteshvara. Malla period (ca. 1201–1769), late 13th–early 14th century. Nepal. Gilt copper alloy. H. 17 x W. 7 x D. 4 in. (43.2 x 17.8 x 10.2 cm). Asia Society, New York: Mr. and Mrs. John D. Rockefeller 3rd Collection, 1979.51

Opposite: FIG. 66. Bodhisattva Avalokiteshvara. Transitional period, late 10th–early 11th century. Nepal. Gilt copper alloy with inlays of semiprecious stones. H. 26¾ x W. 11½ x D. 5¼ in. (67.9 x 29.2 x 13.3 cm). Asia Society, New York: Mr. and Mrs. John D. Rockefeller 3rd Collection, 1979.47

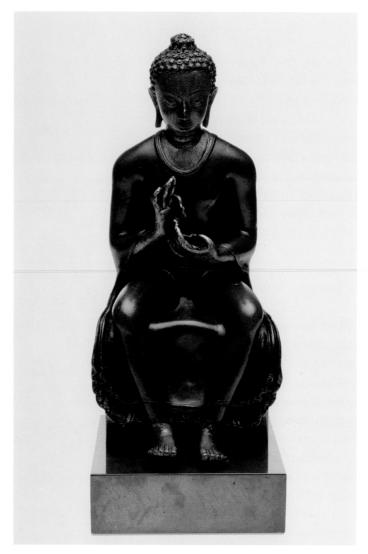

FIG. 68. Ketumati Maitreya. Transitional period, 11th–12th century. Nepal. Copper alloy with copper overlay, traces of gilding, and trace of blue pigment. H. 8¾ x W. 4⅜ x D. 5½ in. (22.2 x 11.1 x 14 cm). Asia Society, New York: Mr. and Mrs. John D. Rockefeller 3rd Acquisitions Fund, 1983.1

next age. Maitreya's position in the Buddhist pantheon is unique because he is worshiped both as a bodhisattva in this age and as the buddha of the next. As a bodhisattva he presides over the Tushita Pure Land; as a buddha he rules over the Ketumati Pure Land, an earthly paradise sometimes associated with the Indian city of Banaras in Uttar Pradesh. The cult of Maitreya is somewhat messianic, for it is believed that his rebirth as a buddha will herald a utopian age in which the circumstances of a devotee's daily life will be more conducive to achieving enlightenment. As a result, devotees sometimes pray for rebirth in the Tushita Pure Land to await rebirth in Ketumati.

The combination of a relaxed and somewhat playful pose—seen, for example, in the whimsical upturn of the toes—and elaborate jewelry dates a sculpture of a seated bodhisattva **(FIG. 69)** to the thirteenth century. It is possible that this sculpture may represent Avalokitesh-vara, although there is no seated Amitabha Buddha in his headdress. The antelope skin, complete with its head, that is wrapped around the bodhisattva's left forearm is sometimes cited as an attribute of the Bodhisattva of Compassion. The bodhisattva's left hand is in the gesture of teaching, commonly found in images of Avalokiteshvara when he is shown in conjunction with those of Amitabha. In this case, however, the seated posture would suggest that this sculpture may represent Avalokiteshvara in the Pure Land of Sukhavati rather than as a guide for souls.

A seated image can be identified as Avalokiteshvara in the form of Amoghapasha Lokeshvara **(FIG. 70)** by the Amitabha image in his headdress and the attributes in his six hands. Amoghapasha Lokeshvara, Lokeshvara of the Infallible Noose, is named for the rope that this figure holds in his bottom right hand. Once ensnared in this sacred noose, the devotee must tell the truth about

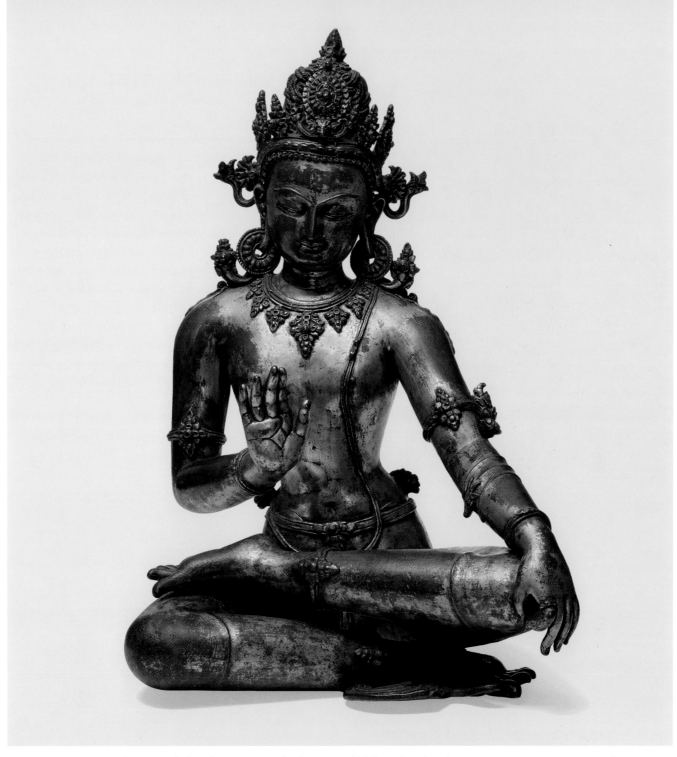

FIG. 69. Bodhisattva. Early Malla period, 13th century. Nepal. Gilt copper with inlays of semiprecious stones. H. 18¾ x W. 12¼ x D. 10 in. (47.6 x 31.1 x 25.4 cm). Asia Society, New York: Mr. and Mrs. John D. Rockefeller 3rd Collection, 1979.49

himself, which can break the bonds of illusion and help a practitioner achieve enlightenment. The middle and top right hands hold a ritual instrument known as a *vajra,* or thunderbolt, and a fly whisk. The left hands of the bodhisattva hold, from back to front, a ritual scepter, a water pot, and a lotus.

In this sculpture, Amoghapasha Lokeshvara is accompanied by two snake-headed semidivinities known as *nagas.* He is seated in the posture of royal ease (*maharajalilasana*) on a lotus pedestal that rises from a pond. The leaves and buds of the lotus are flamboyantly represented as a series of swirling forms, and two lions decorate the stem. Amoghapasha Lokeshvara is one of the tutelary deities of the Kathmandu Valley, and this form was frequently represented in sculpture and painting. A special rite, performed on the eighth day of the bright fortnight of each month, was dedicated to this manifestation of the Bodhisattva of Compassion, and it is possible that sculptures such as this one were the focus of this ritual.

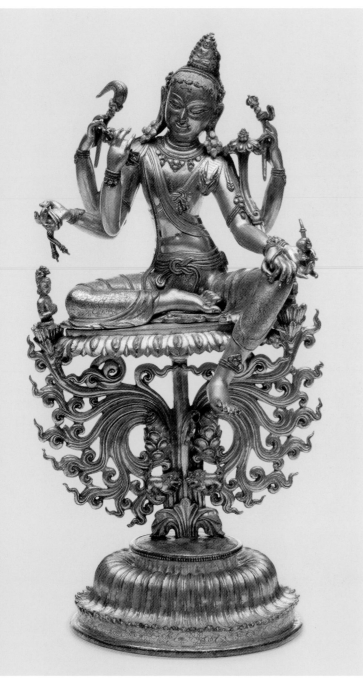

FIG. 70. Bodhisattva Avalokiteshvara in the Form of Amoghapasha Lokeshvara. Three Malwa Kingdoms, 16th–17th century. Nepal. Gilt copper alloy. H. 11 x W. 5⅝ x D. 5⅞ in. (27.9 x 14.29 x 14.92 cm). Asia Society, New York: Mr. and Mrs. John D. Rockefeller 3rd Collection, 1979.50

The oval shape of this figure's face, compared with faces of other Nepali sculptures, and the depiction of his hairline as a series of loose curls link this work to Buddhist sculptures made in Tibet and China. On the other hand, the flamboyant treatment of the lotus leaves and the style of garments worn by the attendant *nagas* indicate a provenance in Nepal. The lack of volume in the treatment of the physique, the interest in design seen in the cloth and the lotus, and the rigidity of the figure—

compare, for instance, the toes to those in figure 69—typify sculptures made in the sixteenth and seventeenth centuries.

Buddhism and Hinduism were both practiced in Nepal, and the same artists made sculptures for both religions. The elegant proportions, relaxed postures, and simple garments and jewelry worn by the figures of Shiva and Parvati in a small bronze **(FIG. 71)** date this sculpture to the late tenth or early eleventh century. Such Uma-Maheshvara images were popular in Nepal, and many variants on the theme were produced in bronze and stone. In general, such sculptures are identified by the deities' attributes—such as Shiva's trident or mismatched earrings or Parvati's flower—and the presence of Shiva's bull and Parvati's lion. In the case of this charming bronze, however, the combination of the man and woman and their affectionate postures are enough to identify the divine couple.

A striking tenth-century stone sculpture **(FIG. 72)** provides a more complicated image of Shiva and his family relaxing in their heavenly home on Mount Kailasa.

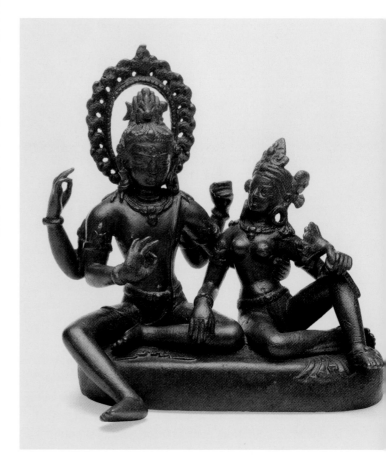

FIG. 71. Shiva and Parvati (Uma-Maheshvara-murti). Transitional period (750–1200), late 10th–early 11th century. Nepal, Kathmandu Valley. Copper alloy. H. 6⅛ x W. 6¼ x D. 4¾ in. (15.5 x 15.9 x 12 cm). Asia Society, New York: Mr. and Mrs. John D. Rockefeller 3rd Collection, 1979.48

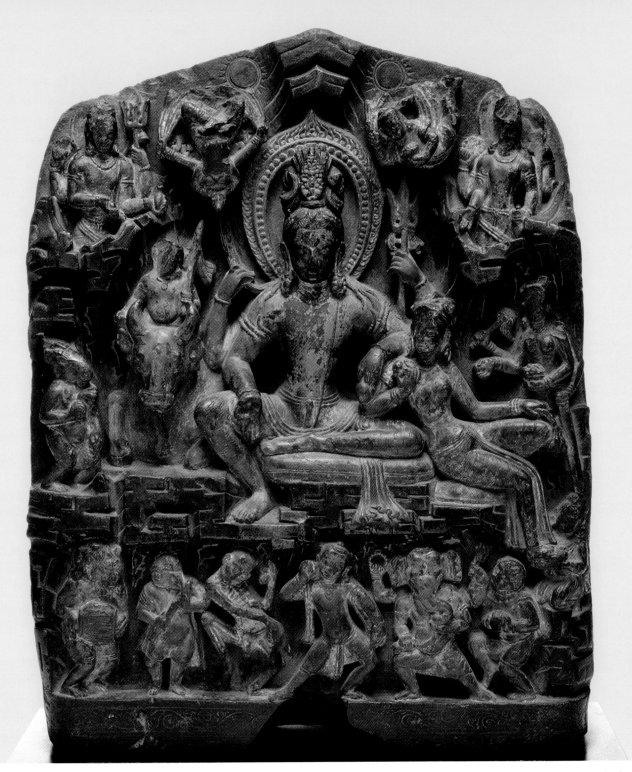

FIG. 72. Shiva and Parvati (Uma-Maheshvara). Thakuri period, 10th century. Nepal. Stone with traces of gold leaf. H. 16 x W. 13¾ x D. 3½ in. (40.6 x 33.7 x 8.9 cm). Asia Society, New York: Estate of Blanchette Hooker Rockefeller, 1992.2

The rocky ledges depicted above and below the primary images symbolize the mountain abode. Parvati leans lovingly against Shiva's left leg in the center of the composition; her smaller size is typical of Uma-Maheshvara iconography. The four-armed Shiva holds a trident with one of his left hands and with a right hand lifts a lock of his hair, which is being offered to the woman flying above his right shoulder, who represents the goddess Ganga. This is a reference to the tale in which Shiva allows the

mighty river Ganga to flow from the heavens onto the earth through his hair to soften the cascade's destructive potential.

The divine couple is attended by several members of their family. The young boy seated on Shiva's bull represents their son Karttikeya. Ganesha, their elephant-headed son, is depicted at the bottom of the relief dancing with the *ganas*, a host of benevolent dwarfs associated with Shiva and his family. A cow-headed *gana*

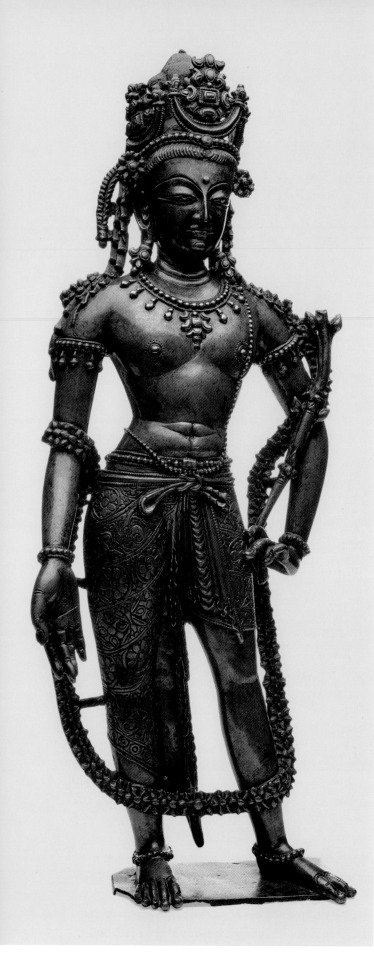

FIG. 73. Bodhisattva. Late 10th–early 11th century. Western Tibet. Brass with inlays of copper and silver. H. 27¼ x W. 11½ x D. 4½ in. (69.2 x 29.2 x 11.4 cm). Asia Society, New York: Mr. and Mrs. John D. Rockefeller 3rd Collection, 1979.45

is also shown offering food to Karttikeya. The two figures at the relief's top corners represent Shiva's attendants, known as *pratiharas*, who are depicted in his likeness and as personifications of his powers. Parvati is attended by a four-armed goddess named Vijaya and by another figure who supports her right foot.

Striking family tableaux such as this one were very popular in Nepal, and the earliest stone examples date from the sixth century. The iconography of this and related sculptures has been identified as a scene of the birth of Karttikeya, when in delight Shiva and Parvati commanded their heavenly hosts to sing and dance in celebration of their new son.

Sculptures from Tibet

The art and culture of Tibet are best known for the practice and preservation of Esoteric Buddhism (Vajrayana), which emphasizes the performance of rituals and the worship of a staggering array of divinities, long after this form disappeared in India. Tibet's vast geographic area and its many adjacent neighbors—ranging from India and Kashmir in the northwest to the northern regions of Myanmar and to China—are reflected in the rich stylistic diversity of Tibetan art. Tibetan sculpture is characterized by its combination of a conservative and complicated iconography with the acceptance and adaptation of figures, facial types, and clothing that are associated with many other cultures and various eras.

A striking image of a standing bodhisattva **(FIG. 73)** is distinguished by the detailed rendering of the lush floral patterns on the skirtlike garment. This magnificent image illustrates the impact of Indian, particularly Kashmiri, traditions on the art of western Tibet in the late tenth and early eleventh centuries. The idealized figure of the bodhisattva and his long garment derive from the art of India, while the interest in musculature—evident in the powerful articulation of the torso, the exaggerated waistline, the shape of the face, and the strong facial features—closely parallels the art of Kashmir; indeed, until very recently this sculpture was considered to be Kashmiri. The pose of the figure and the long garland of flowers encircling him generally characterize works made in areas of western Tibet.

The influence of Kashmiri art on Tibetan sculpture reflects Kashmir's importance as a source of Buddhism and Buddhist art traditions during the second propagation of this religion in the late tenth and early eleventh centuries. By the seventh century both Indian and

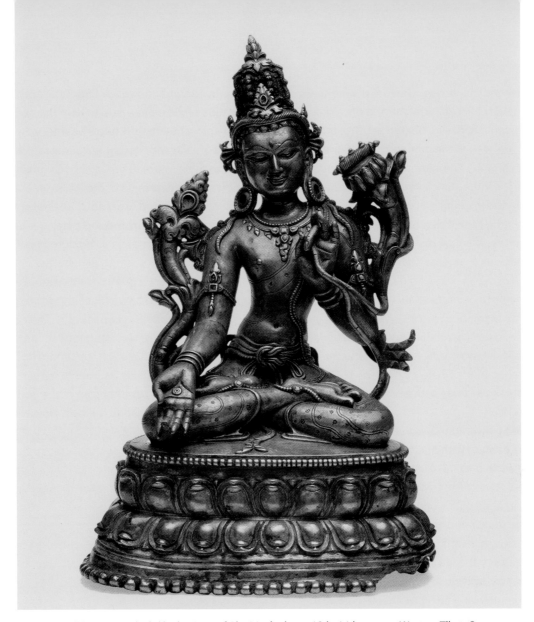

FIG. 74. Bodhisattva Manjushri in the Form of Sita Manjughosa. 13th–14th century. Western Tibet. Copper alloy with inlays of turquoise. H. 12⅜ x W. 8⅜ x D. 6⅛ in. (31.4 x 21.27 x 15.56 cm). Asia Society, New York: Mr. and Mrs. John D. Rockefeller 3rd Collection, 1979.46

Chinese forms of Buddhism had been known and practiced in Tibet, and by the eighth century Buddhism had been made the state religion. Buddhist influence waned, however, during persecutions initiated by China's Tang Emperor Wuzong (reigned 840–46) that occurred between 840 and 842. In the late tenth century, changes in political power led to the resurgence of the religion, and monks from several areas, notably Kashmir to the west and the Pala Kingdom of East India, were invited to Tibet to teach and practice.

The importance of Kashmiri aesthetics in this sculpture suggests that it may have been made by a Kashmiri artist working in Tibet. Several Kashmiri artists are known to have traveled to western Tibet with the teacher Rinchen Zangpo (958–1055), who had gone to Kashmir in search of texts and images. Rinchen Zangpo is known to have lived and taught in the Guge region of western Tibet, where members of the royal family were housed during the disintegration of the Tibetan empire during the ninth to the eleventh century. Yet, the elegantly elongated proportions, the elaborate jewelry, and the large lotus seen in this sculpture of a bodhisattva are common in the art of all of the countries in the western Himalayas during the tenth and eleventh centuries, attesting to the impact of traveling monks and artists during this period.

The large lotus stalk that this bodhisattva holds in his left hand and his relaxed posture suggest that this sculpture may represent Avalokiteshvara. A positive identification is difficult, however, because this sculpture lacks the image of a small seated Buddha Amitabha in the headdress, a defining attribute of Avalokiteshvara.

A seated image of Manjushri, the Bodhisattva of Wisdom **(FIG. 74)**, illustrates the continuation of Kashmiri influence in western Tibetan sculpture during the thir-

teenth and fourteenth centuries. Manjushri's pronounced facial features, fleshy cheeks, and a strong physique characterize Kashmiri styles in Tibetan art. Tibetan characteristics are seen in the immediacy and directness of this sculpture and the complex and detailed treatment of the pedestal, the lotus stalks, and the crown and jewelry. This interest in detail is also found in the naturalistic treatment of the sash that ties Manjushri's skirt.

In this sculpture, Manjushri is identified by the image of a small book that rests on top of the lotus held in his left hand. Manjushri often holds a sword, but its absence here helps to distinguish this as an image of Manjushri as Sita Manjughosa, a form of the bodhisattva that stresses the role of meditation in attaining transcendental wisdom. This form of Manjushri reflects the teachings of Mahapandita Shakya Shri (1127–1225), a monk from Kashmir who was active in Tibet in the early thirteenth century.

An image of Shakyamuni Buddha seated in the meditative lotus posture with his right hand in the gesture of touching the earth **(FIG. 75)** illustrates the impact of the iconography and style of Pala-period Indian sculpture on Tibetan art. Images of the Buddha with this pose and gesture were the most important icons in the art of the Pala period. Shakyamuni sits on a cushion decorated with flowing vines and the face of a lion. Two lions, two standing elephants, and two small figures are depicted on the base of the sculpture. The figure holding the vase represents the earth goddess whom Shakyamuni invoked in his battle with Mara and his demonic hoards. The figure seated in the posture of relaxation probably represents the donor of the sculpture.

The more abstract figure and face of the Buddha—which do not show the interest in musculature and fleshiness found in the Kashmiri-influenced sculptures cast in western Tibet—derive from traditions common in the art of the Pala period. The distinctive use of two colors of metal in this piece may reflect a practice recorded in the writings of the Tibetan scholar and teacher Padma Dkarpol (1524–1592), in which sculptures are described as being made of both white and red brass. The darker color used for the Buddha's robe has been linked to the metals found in western Tibetan sculpture that are characterized by that area's long-standing ties to Kashmir. It has also been suggested that this robe may refer to the red robes worn by monks of the Sakya order, which was prominent in central Tibet.

A charming image of a seated goddess **(FIG. 76)** also illustrates Pala influence on the art of Tibet: the elongated proportions of the goddess, the oval face and eyes, and

the long, straight nose derive from the art of East India. Parallels to Pala pieces help to date this sculpture to the late eleventh or early twelfth century. Seated in the posture of relaxation on a lotus pedestal, she holds her hands in the gesture of preaching. Originally a figure was placed on each side of the lotus pedestal, but only one remains clearly discernable. Several smaller figures, some of whom are dancing and playing musical instruments, and two lions are also depicted on the base of the pedestal.

The main figure's posture and gesture are used in representations of the two most important goddesses in Buddhism, Tara and Prajnaparamita. Their attributes help to distinguish them: Prajnaparamita holds a *pundarika* lotus upon which sits a book, while Tara holds the blue lotus. Unfortunately only fragments remain of the two lotuses once found to either side of the goddess depicted here, making identification difficult. However, since

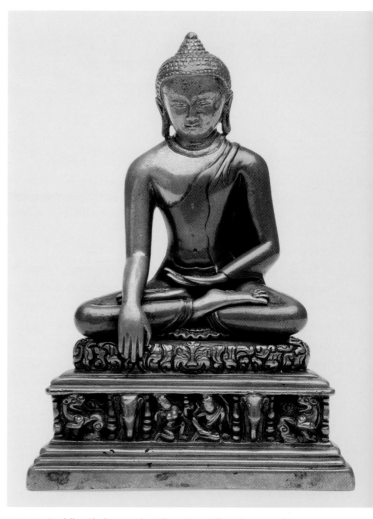

FIG. 75. Buddha Shakyamuni. 11th century. Tibet. Copper alloy with copper overlay and inlays of silver. H. 5⅝ x W. 4¼ x D. 2¼ in. (14.3 x 10.8 x 5.72 cm). Asia Society, New York: Mr. and Mrs. John D. Rockefeller 3rd Collection, 1979.89

several similar metal sculptures are identified as Tara, who is much more commonly represented in the art of Tibet, this statue has also been identified as an image of that goddess.

This sculpture is made of an ivory-toned stone that is known as pyrophyllite. Stone sculptures are rare in Tibet, and only a few other examples made of an ivorylike stone are known. These stone sculptures are quite small, and their scale and rarity suggest that they may have had a specific ritual or religious function. As is common in Tibet, the hair of this goddess was painted blue. In addition, the entire figure (but not the base) is gilt; some scholars have suggested that this may be a later addition.

Like Kashmir, Nepal shares borders with Tibet and its influence can be found in much of the Buddhist sculpture created for temples, monasteries, and private practitioners. The exquisite craftsmanship of a Dhumavati Shri Devi **(FIG. 77)** is stylistically linked to images fashioned for one of the *tashigomang*, or special stupas, belonging to Densatil Monastery in central Tibet and suggests it was designed by a Newari craftsman. This monastery has long been considered one of the great treasures of Tibet. Constructed at the end of the twelfth century in a remote, rocky area, it was most famed for its *tashigomang* (Many Doors of Auspiciousness), reliquaries that housed the remains of venerated Buddhist teachers. They were multitiered, sculptural gilt copper structures that stood more than ten feet tall and were resplendent with inlays of semiprecious stones.

Prior to the destruction of Densatil Monastery during China's Cultural Revolution (1966–76), eight *tashigomang*, dating between 1208 and 1432, stood in its main hall. Followers of the charismatic Phagmo Drupa Dorje Gyalpo (1110–1170) constructed the Densatil Monastery. There are many schools of Buddhism in Tibet; however, his school, which came to be known as the Phagmo Drupa Kagyu School, was one of the four primary schools of the Kagyu lineage of Tibetan Buddhism. One of Phagmo Drupa Dorje Gyalpo's former students, Jigten Gonpo (1143–1217), experienced a marvelous vision that inspired the iconography and design of the *tashigomang*.

The early fifteenth-century Dhumavati Shri Devi would have been located on the lowest tier of a *tashigomang*, known as the Tier of Protectors of the Teachings. Believers expected concrete help and assistance from the guardians on this tier. These powerful guardians of the faith are considered part of the world of *samsara*, the cycle of life and death. They can grant wealth and help eliminate negative influences in a believer's life, but they cannot offer enlightenment. Shri Devi sits on a recumbent mule

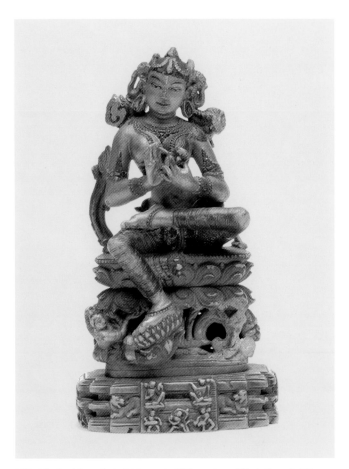

FIG. 76. Goddess. Late 11th–early 12th century. Tibet. Pyrophyllite with gilding and blue pigment. H. 3¾ x W. 2⅛ in. (9.5 x 5.4 cm). Asia Society, New York: Mr. and Mrs. John D. Rockefeller 3rd Collection, 1979.38

while holding swords in two of her four hands. She holds a skull-cup in her lower right hand. Ten small deities in her retinue each sit on a lotus flower in a posture similar to hers. Each is enclosed within winding tendrils from the lotus plant. They have only two arms and hold curved knives in their right hands and skull-cups in their left. They appear to be a representation of the ten goddesses holding curved knives and skull-cups who, according to *tashigomang* stupa inventory charts, attended Dhumavati Shri Devi. Her jewelry includes a necklace of human heads.

An Avalokiteshvara from western Tibet seated on a lotus pedestal **(FIG. 78)** offers a compassionate contrast to the Shri Devi and provides another example of the intermingling of styles and imagery in the art of Tibet. He holds an elegant lotus in his left hand, and a tenon on the back of his right arm and a small cup on the right side of the base indicate that a second lotus was placed on that side as well. He wears a long skirtlike garment that wraps around his waist and is secured with a sash. The skirt is decorated with delicately incised patterns of flowers and circles that alternate in vertical rows. Floral

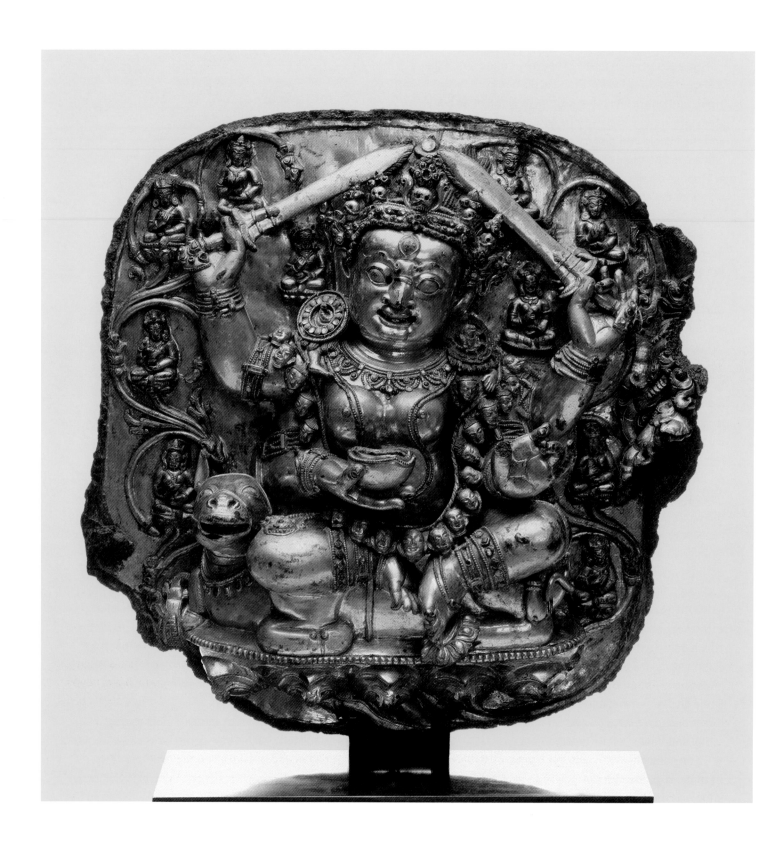

FIG. 77. Dhumavati Shri Devi. Early 15th century. Central Tibet, Densatil Monastery. Gilt copper alloy with inlays of semiprecious stones. H. 18 x W. 19 x D. 7 in. (45.7 x 48.3 x 17.8 cm). Asia Society, New York: Gift of Mr. and Mrs. Gilbert H. Kinney in honor of Vishakha Desai, 2012.4

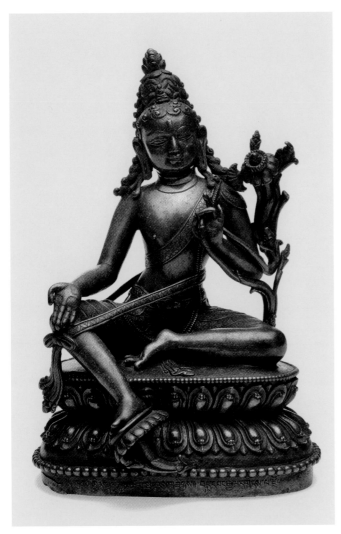

FIG. 78. Bodhisattva Avalokiteshvara. 15th–16th century. Western Tibet. Copper alloy. H. 7½ x W. 5¼ x D. 4¾ in. (16.5 x 13.34 x 12.07 cm). Asia Society, New York: Gift from The Blanchette Hooker Rockefeller Fund, 1994.4

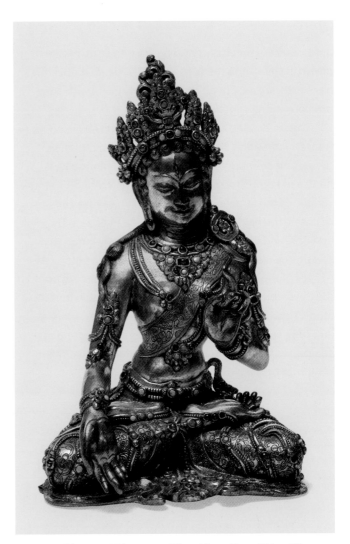

FIG. 79. White Tara. 17th century. Tibet, Mongolia, or China. Silver with gold and inlays of semiprecious stones. H. 6¾ x W. 4³⁄₁₆ x D. 3½ in. (17.1 x 10.64 x 8.89 cm). Asia Society, New York: Mr. and Mrs. John D. Rockefeller 3rd Collection, 1979.52

patterns are also incised into the sash, and leaflike forms decorate the meditation or yoga strap over his pendant right leg. Avalokiteshvara has long hair that is worn in a chignon with the exception of the three braids at the back of his head and the two braids to either side of his face. A small seated buddha and two flowers are placed among the soft curls on his forehead. The bodhisattva's form and features are continuations of the Pala style.

The meditation strap may illustrate the continuation of earlier Kashmiri practices in Tibetan Buddhism. Such meditation straps are found in Kashmiri sculptures dating to the seventh and eighth centuries and in Tibetan paintings of the sixteenth century and later. There were some sectarian differences between the type of Esoteric Buddhism practiced in Kashmir, which focused on the worship of Vairochana and four other buddhas, and that practiced in the Pala Kingdom, which centered on such texts as the *Kalachakra Tantra*.

The long inscription written along the base of the lotus suggests that this sculpture was either commissioned by or made by a Nepali living in Tibet.[1] The inscription refers to Padma Bangrgyal (1497–1542), implying that this type of image reflects the teachings of this monk. It also suggests a date in the fifteenth or sixteenth century, which is in keeping with the dense treatment of the lotus pedestals on the base.

The interest in ornamentation often seen in later Tibetan sculpture is illustrated by the blue hair, elaborate jewelry, and two types of metal in a sculpture of the Goddess Tara **(FIG. 79)** that can be dated to the seventeenth century. Her pose and hand gestures identify this image as White Tara, an embodiment of infinite compassion. The eyes in the center of her forehead and on the palm of each hand symbolize Tara's vigilance on behalf of all sentient beings.

Made of silver, this sculpture is decorated with gold and inlaid semiprecious stones. Tara's silver skirt and

gold scarf are precisely carved with rich floral motifs. Her crown, jewelry, and the astonishing girdle that covers her skirt were cast in gold and lavishly inlaid with semi-precious stones, including turquoise.

The silver used to make this statue may have come from China, which at the time had strong cultural, religious, and economic ties with Tibet and Mongolia. It has been suggested that this sculpture might be a smaller version of the large silver images of White Tara used to decorate the halls of the Potala Palace in Lhasa. The construction of this temple and of its many large-scale sculptures was one of the most important events in the history of the seventeenth century, and its impact on the development of Tibetan art remains a topic for future study. However, the type of jewelry the goddess wears and the use of turquoise inlay are commonly found in sculptures from Mongolia, and it is possible that this sculpture may have been made there.

1. The inscription has been translated by John C. Huntington as: "*Om Svasti* all seeing best god of gods Avalokiteshvara / At the ceremony of the Chomo Sheep miracle the learned (or skillful) Nepali, Aphajyoti, made / The consecrated offering of this beneficial deva under [the direction of] the perfected Tibetan Padma Bangrgyal/Because of this virtuous [action] [may] all beings quickly receive enlightenment / Mangalam [benefaction.]"

Two Bodhisattvas from Sri Lanka

The dating of early sculptures from Sri Lanka remains problematic and only two broad stylistic categories exist. Earlier sculptures are classified as in the style of Anuradhapura, named after the city that was the capital from the second through the tenth century; later works are categorized as Polonnaruwa style, also named for the location of the capital (993–1235), which was moved after Sri Lanka was attacked by the powerful Chola empire of South India.

Two sculptures—one representing an unidentified four-armed bodhisattva and the other the Bodhisattva Avalokiteshvara—show some of the stylistic and iconographic variation in Anuradhapura-style sculptures and suggest that there were complex interrelationships between the many regional styles and iconographic usages in South and Southeast Asian Buddhist art during this period.

The unidentified bodhisattva **(FIG. 80)** belongs to a group of images generally dated to the seventh and eighth centuries. His relatively rigid pose, his long waist and short legs, the shape of his head, his full features, and the manner in which his hair is pulled up to form a

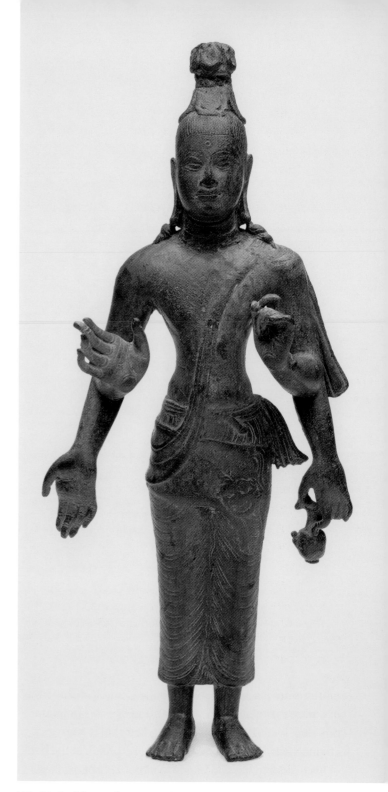

FIG. 80. Bodhisattva (Four-armed Lokeshvara, Avalokiteshvara, or Maitreya). 7th–8th century. Sri Lanka. Copper alloy. H. 8¾ x W. 4 x D. 2 in. (22.2 x 10.2 x 5.1 cm). Asia Society, New York: Mr. and Mrs. John D. Rockefeller 3rd Collection, 1979.41

bundle at the top of his head are characteristics often found in one of the most prominent types of early Sri Lankan sculpture.

This four-armed bodhisattva presents a distinctively Sri Lankan version of the ascetic-bodhisattvas found in art beyond the Indian mainland from the seventh through the ninth century. The bodhisattva wears a long skirtlike

garment, around which is wrapped an animal skin, probably that of a tiger. The spouted bottle (kundika) that he carries, his long matted hair, his relative lack of jewelry, and the animal skin indicate his asceticism. The importance awarded to ascetic bodhisattvas in Indian art from the fourth through the sixth century illustrates changes in Buddhist thought during that period, and their appearance slightly later on in Sri Lanka, Java, Thailand, and Cambodia reflects the spread of these new religious tenets outside India.

The spouted bottle is an attribute of both Avalokisteshvara and Maitreya, the two most important and widely revered bodhisattvas, and it is likely that this sculpture was intended to represent one of them. However, Avalokiteshvara generally has a seated buddha in his headdress and Maitreya a stupa in his: the lack of such a symbol hinders the positive identification of this bodhisattva.

The second sculpture (FIG. 81) can be identified as Avalokiteshvara by the image of a seated buddha in his headdress and the flask for ambrosia (amrta kalasha) in his left band. Such features as the double necklace, the looped cord that runs over his left shoulder and around his right hip, and the rosettes on his armbands point to a date in the eighth or ninth century. The necklace and other jewelry mark this as a princely rather than an ascetic bodhisattva.

Avalokiteshvara's more relaxed posture is typical of a second type of sculpture produced during the Anuradhapura period. Sculptures of this type are also characterized by their round forms and the stylized treatment of their drapery, in which the lower garment hugs the legs and thighs, emphasizing the folds between the legs and the flaring sides of the garment. The largeness of the hands, also seen in the sculpture of the four-armed bodhisattva, is shared by many types of Sri Lankan sculpture.

The close ties between Sri Lankan and Southeast Asian sculpture are illustrated in the scholarship on this Avalokiteshvara, for which several provenances have been suggested. The figure's relaxed pose and the shape of his face are comparable in some respects to works made in peninsular Thailand while it was controlled by Shrivijaya; as a result, this sculpture has been published as an example of Shrivijayan sculpture. The exaggerated sense of relaxation in this figure and his fleshy form, however, set this sculpture apart from the majority of works that are accepted as examples of the Shrivijayan style.

A second origin that has been suggested for this sculpture is the Panduranga kingdom that was located in parts of southern Vietnam. Very little is known about this

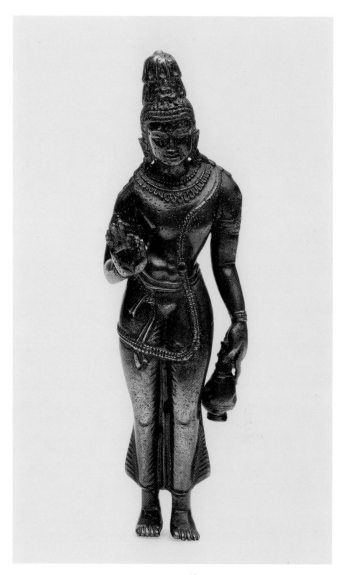

FIG. 81. Bodhisattva Avalokiteshvara. 8th–9th century. Sri Lanka. Copper alloy. H. 4⅝ x W. 1⅝ x D. 1 in. (11.7 x 4.1 x 2.5 cm). Asia Society, New York: Mr. and Mrs. John D. Rockefeller 3rd Collection, 1979.81

kingdom or the art produced there, but there are some similarities between the armlets and necklace worn by this Avalokiteshvara and the jewelry found on sculptures that have been associated with the region. Nonetheless, the majority of sculptures that are attributed to Vietnam have much tauter physiques and more rigid poses.

Finally, comparisons between some of the features of this sculpture and those of images from northeastern Thailand and the adjacent regions of Cambodia are also possible but not conclusive. For example, the treatment of the hair as a series of overlapping curls is to some extent a simplification of the hairstyles seen in sculptures from such sites as Prasat Hin Khao Plai Bat II in Thailand. Further research is needed to help define the cultural interactions between Sri Lanka and Southeast Asia in order to explain the nature of these intriguing stylistic relationships.

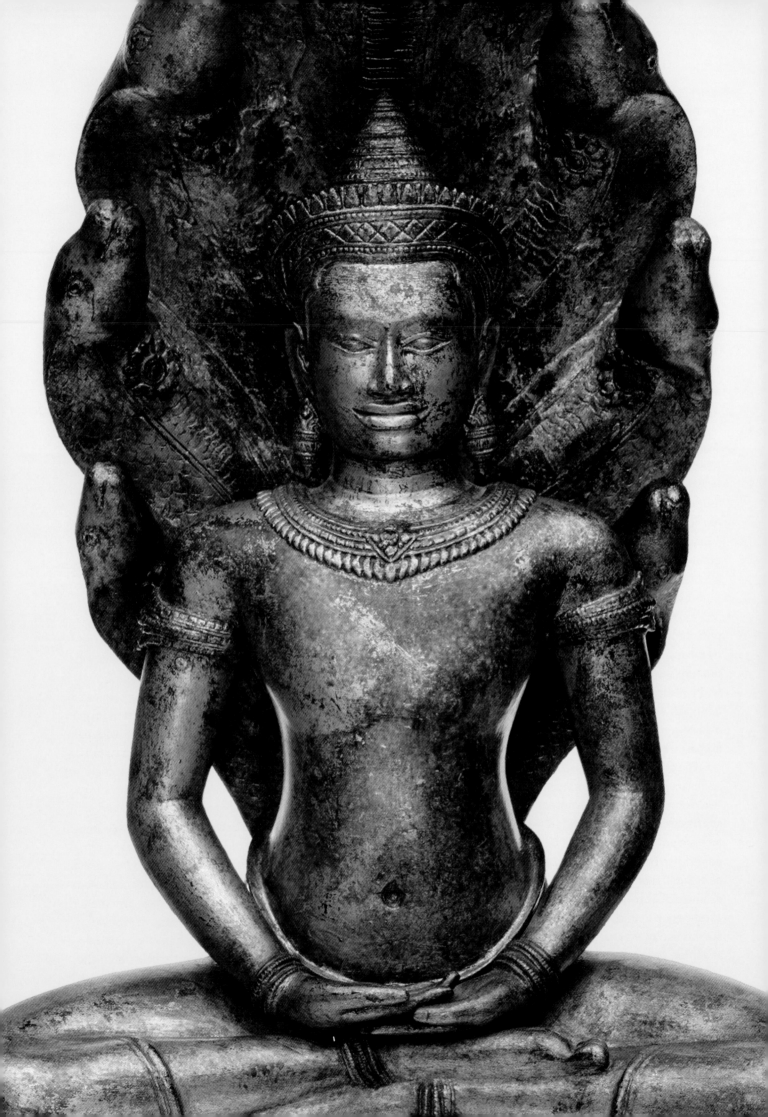

SOUTHEAST ASIA

A Buddha from Myanmar

The art of Myanmar (formerly Burma), largely inaccessible for decades to much of the world due to political restrictions until recently, remains the least studied among the traditions of Southeast Asia. Focused scholarship, however, is increasing and more is becoming available regarding the art and artistic developments of this country that has for centuries been a majority population of Theravada Buddhist practitioners. An austere branch of Buddhism based on early scriptures in the Pali language, Theravada or the "Way of the Elders" has predominated in Myanmar since the thirteenth century. The best-known Myanmar art is from the Pagan period (11th–13th century), when Myanmar was a major political and economic force in Southeast Asia and an important center for the practice of Buddhism.

A bronze sculpture dating to the fourteenth or fifteenth century depicts the Buddha holding his right hand in the gesture of touching the earth (*bhumisparsha-mudra*) and his left hand in the gesture of meditation (*dhyanamudra*) **(FIG. 82)**. By the Ava period in Myanmar, when this sculpture was produced, the earth-touching mudra had become the most popular gesture for the Buddha to be depicted with. The position and posture of this Buddha and the stylized depiction of his drapery—in particular the way in which the shawl is draped twice over the left shoulder—continue visual traditions from the art of the Pagan period, but several details help to date this sculpture to the Ava period. These include the Buddha's short neck, slim waist, and broad shoulders.

His long fingers and toes, each of equal length, the elongated earlobes touching the shoulders, the casting of the pedestal in two parts, and the dense geometric decoration incised into the central part of this pedestal also help to give the image a later date. The form of the pedestal—a waisted lotus throne for the Buddha image—refers to Mount Meru, the central axis or cosmic mountain at the center of the Buddhist universe.

Two lions and an image of the earth goddess wringing her hair to wash away Mara's hordes are on the base. Two small figures of monks, each of whom holds a piece of cloth between folded hands, are attached to the base. These monks are Mogallana and Shariputra, two of Shakyamuni's most important disciples, who symbolize the importance of using skillful means and knowledge in the search for enlightenment. Historical disciples such as Mogallana and Shariputra are more important in Theravada than in other branches of Buddhism, and the prominence given to such images in later Myanmar art reflects the influence of this branch.

Early Sculptures from Mainland Southeast Asia

The diversity of style and iconography in sculptures produced in mainland Southeast Asia from the sixth through the ninth century reflects the many regional cultures then thriving in that part of the world. During the ninth century, much of this area came under the control of the Khmer empire, which was based in present-day Cambodia and lasted until the mid-fourteenth century.

Opposite: Detail of **FIG. 99**

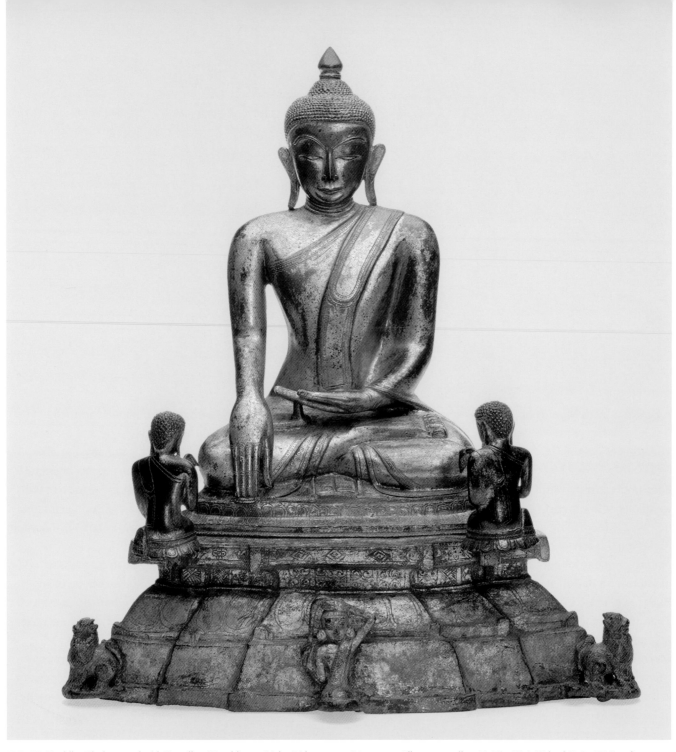

FIG. 82. Buddha Shakyamuni with Kneeling Worshipers. 14th–15th century. Myanmar. Gilt copper alloy. H. 16 x W. 14¾ in. (40.6 x 37.5 cm). Asia Society, New York: Mr. and Mrs. John D. Rockefeller 3rd Collection, 1979.91a-c

In general, two systems of classification are used to help define the regional styles found in this material: one relies on political terms, such as "Dvaravati" and "pre-Angkor," while the more recent system groups sculptures by language and/or ethnic types such as the "Mon" and "Khmer." Neither system, however, satisfactorily or accurately describes the astonishing variety found in the sculpture of this region.

Some of the earliest sculptures from mainland Southeast Asia represent Buddhist deities, while others depict Hindu gods. A standing image of a buddha **(FIG. 83)** illustrates the best-known type of sculpture produced in central Thailand from the sixth through the ninth century, which is often called "Dvaravati'" after the name of a city or kingdom. The term comes from the transliteration of a name in Chinese sources and from

Opposite: **FIG. 83.** Buddha. Mon style, late 7th–8th century. Thailand. Limestone with traces of gilding. H. 36½ x W. 12 x D. 5½ in. (92.7 x 30.5 x 14 cm). Asia Society, New York: Mr. and Mrs. John D. Rockefeller 3rd Collection, 1979.75

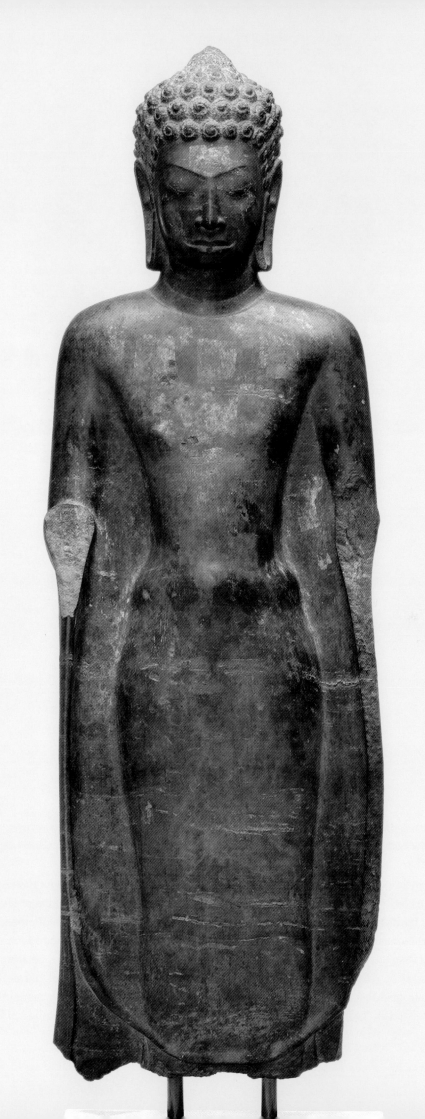

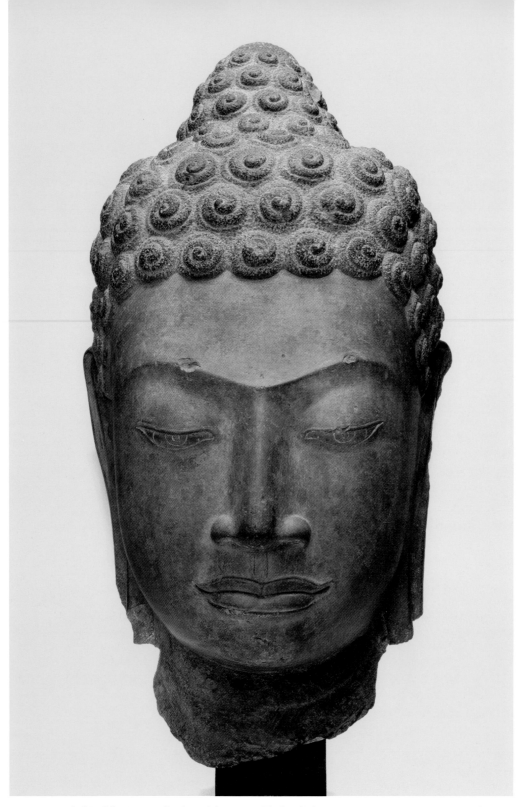

FIG. 84. Head of Buddha. Mon style, about 8th century. Thailand. Limestone. H. 24⅞ x W. 13¾ x D. 11⅝ in. (63.1 x 34.9 x 29.5 cm). Asia Society, New York: Mr. and Mrs. John D. Rockefeller 3rd Collection, 1979.76

a version of this name inscribed on several medals excavated at sites such as Nakhon Pathom and U Thong. The actual geographic boundaries of Dvaravati remain unclear, as does the relationship between the various towns that, because of their similar layouts and architecture, are believed to have been part of this realm. As a result, some scholars suggest that sculptures such as this buddha should be classified as "Mon" after the language

of the people who from about the sixth through the tenth century controlled the regions of Thailand (as well as some of the southern parts of present-day Myanmar) where the sculptures were produced.

This standing buddha is wearing a long skirt-like robe covered by a full shawl. Both garments are thin and cling to the body; the most visible distinction between the two pieces of clothing is seen at the bottom hems. Traces of

gold leaf—probably applied fairly recently during worship—remain on the hair, face, and upper body of the buddha. The broad shoulders, tapering body, and downcast eyes of the Buddha derive from Indian art of the Gupta period (about 320–about 500). The use of superhuman physical marks such as the snail-shell-shaped curls and cranial protuberance (*ushnisha*) reflects Indian prototypes, while the frontality of the figure, his squarish face, broad lips and nose, and prominent joined eyebrows characterize sculptures of the Mon style.

The Mon practiced Theravada Buddhism, which focused on the worship of Shakyamuni, whom this sculpture might represent. Although the hands, now missing, would be crucial to a more precise identification of the figure, it is possible that both were held in the *vitarkamudra,* in which the hand is held up with the thumb and the forefinger touching. This gesture signifies teaching and appeasement and is often used in early representations of Shakyamuni from Thailand.

The high cheekbones, broad nose, and full lips of a sculpture of the head of a buddha **(FIG. 84)** are common characteristics of Mon-style buddha images. Mon-style art was fairly conservative, changing little over the centuries, and a precise chronology for sculptures in this style has yet to be established. Nonetheless, the slight elongation of the shape and features suggest that this head might date somewhat later than the buddha figure.

Assigning a date and provenance to a bronze sculpture of a standing buddha **(FIG. 85)** is also challenging. This Buddha wears the same garments as the stone Buddha **(FIG. 83)**, however, his shawl is draped over only one shoulder, and his torso is longer and his features more pronounced. This sculpture might date slightly later than the stone Buddha, since elongated torsos typify sculptures of the tenth and eleventh centuries, and strong features are found in Mon-style sculpture made at Haripunjaya from the middle of the tenth to about the thirteenth century. During this period, Haripunjaya remained a Mon stronghold while much of Thailand was under the control of the Khmers. This modest sculpture may represent a rare example of the later Mon style and provide a link between these traditions and those of Haripunjaya.

The iconography of a stone sculpture showing Buddha standing on a lotus pedestal with two attendants above a mythical winged creature **(FIG. 86)** is one of the most distinctive and intriguing Mon contributions to Buddhist iconography. The Buddha on the relief is a classic Mon-style representation and is attended by two figures: the figure to the Buddha's left wears a short shirt-like garment and holds a lotus and another object

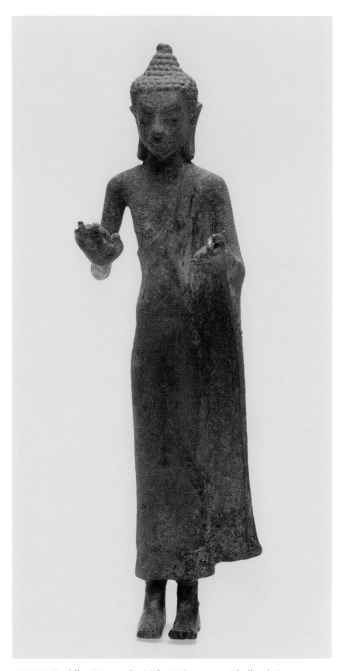

FIG. 85. Buddha. Mon style, 10th–11th century. Thailand. Copper alloy. H. 9⅛ x W. 3½ x D. 3½ in. (23.2 x 8.89 x 8.89 cm). Asia Society, New York: Mr. and Mrs. John D. Rockefeller 3rd Collection, 1979.74

in his hands, while the figure on the Buddha's right wears a skirt and a sacred thread and holds an unidentified attribute in one hand.

The discussions surrounding the precise meaning of such sculptures center on the possible identification of these two attendant figures and the strange creature at the base. The two figures are generally identified either as bodhisattvas or as the Hindu gods Brahma and Indra. The latter identification assumes that both hands of the Buddha, missing in this example, would have been held in the gesture of teaching. In Buddhist art, this gesture is often used to symbolize the descent of Shakyamuni

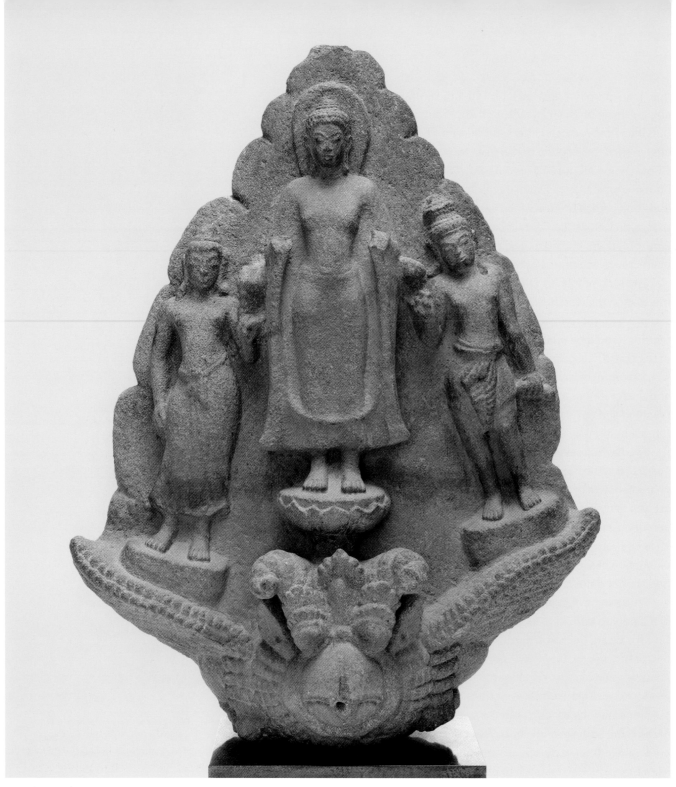

FIG. 86. Buddha and Two Attendants. Mon style, 8th century. Thailand. Sandstone. H. 16⅝ x W. 13 x D. 5¾ in. (H. 42.2 cm). Asia Society, New York: Mr. and Mrs. John D. Rockefeller 3rd Collection, 1979.77

Buddha from the Trayastrimsha Heaven (heaven of thirty-three gods), which he had visited to preach to his mother. Some texts suggest that these two Hindu gods accompanied the Buddha on his descent, and they appear in earlier Indian representations of the subject, so it has been assumed that if the central buddha in these sculptures represents Shakyamuni descending from the Trayastrimsha Heaven, the two figures must be depictions of Brahma and Indra. However, the texts describing

Shakyamuni's visit to the Trayastrimsha Heaven generally state that he descended from that paradise on a jeweled ladder, and a ladder or stair is often depicted in representations of this event. A ladder is noticeably absent from the iconography of this and similar works, making it difficult to confirm their identification.

Reliefs of this type are often called Banaspati plaques after the name given to the winged and horned beings at their bases. This creature is sometimes associated with

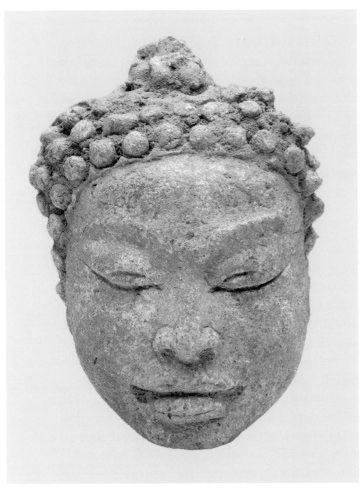

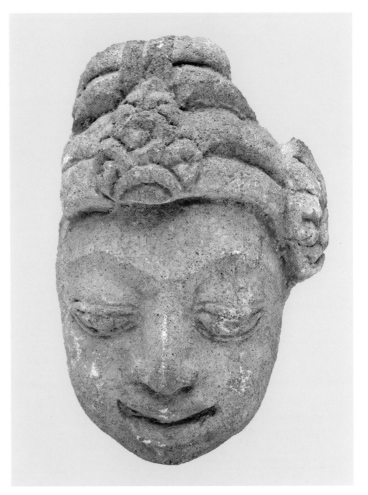

FIG. 87. Head of Buddha. Mon style, late 8th–9th century. Thailand. Stucco. H. 6 x W. 4¾ x D. 3¾ in. (15.2 x 12.07 x 9.53 cm). Asia Society, New York: Mr. and Mrs. John D. Rockefeller 3rd Collection, 1979.78

FIG. 88. Head. Late 8th–9th century. Thailand. Stucco. H. 7¼ x W. 4¾ x D. 2 in. (18.4 x 12.06 x 5.08 cm). Asia Society, New York: Mr. and Mrs. John D. Rockefeller 3rd Collection, 1979.79

Garuda, a bird-man who functions as the vehicle of the Hindu god Vishnu; such a conflation of Buddhist and Hindu iconography is not unusual in Southeast Asia.

It has also been suggested that the Banaspati creature represents a theriomorphic transformation of the Indian concept of the marvelous life-giving and life-sustaining lotus root or *padmamula*, which is often used as a generative symbol in Buddhist art. The marvelous lotus root is sometimes associated with flying horned creatures and has also been associated with Garuda. While it is not impossible that this being could have ultimately derived from the symbolism of the lotus root, this explanation of the Banaspati does not help to determine the iconography of images such as this one. It seems likely that an understanding of this distinctive Mon type will not be possible until there is further research on the exact nature of early Buddhist practices and beliefs in Thailand and Southeast Asia.

Stucco heads represent another characteristic and relatively unstudied tradition of Mon art. The snail-shell curls of one such head **(FIG. 87)** show it to represent

Buddha, and the bejeweled headdress of a second head **(FIG. 88)** indicates it might be a male figure, perhaps of fairly high rank. The relatively bold features in both might reflect the ease of modeling inherent to the medium of stucco, and this stylistic feature could also help to date these heads to the late eighth or the ninth century.

Although a number of heads of this type survive, it is difficult to determine their function. Mon-style stucco statues also exist, and the heads may once have been parts of standing figures. The backs of the heads are unfinished, and it is possible that these sculptures were once attached to the sides of wood or brick buildings as architectural decorations. Similar works in stucco and terra-cotta are known to have been used in friezes narrating the life of Siddhartha and other Buddhist tales. In general, terra-cotta pieces, which date to the seventh century, seem to predate the use of stucco in the eighth or ninth century.

A compelling seated figure **(FIG. 89)** illustrates the complexity and richness of art made in regions of Thailand that appear to have been influenced by Mon and

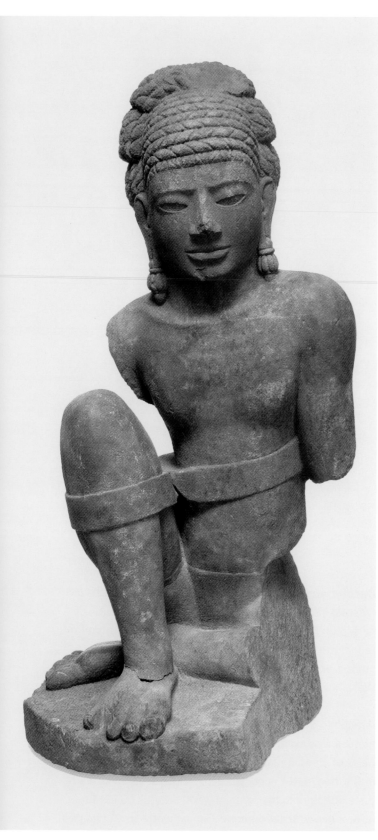

Khmer cultures. The figure is badly damaged and has been repaired. A portion of the left hip and the right leg, from mid-thigh to ankle, are modern restorations. It is clear from the position of his feet that he was once seated with his right leg bent up over his left, which was laid on the ground, The figure is lightly clothed and has a meditation or yoga strap (*yogapatta*) around his torso and his right leg. He is distinguished by an interest in anatomy that is seen in the depiction of the bones in his upper chest and by his long, matted hair.

This sculpture has been tentatively identified as Aiyanar, one of the disciples of Shiva, the Hindu god worshiped in South India and Sri Lanka. The name *Aiyanar* is Tamil, meaning "he who commands." Aiyanar was a huntsman who was believed to protect travelers and guard reservoirs, particularly at night. Comparisons with other known sculptures of this deity suggest that the right arm of this figure was resting on his knee while his left hung down.

This sculpture is reputed to have been discovered at Si Thep, in the north-central part of Thailand, and it is made of graywacke, a variety of sandstone often used in sculptures attributed to this site. Si Thep is located between what are known to have been two centers of Mon power and a region that is believed to have been an important center of Khmer culture prior to the development farther south of the Khmer empire during the tenth century. There is some textual evidence for the role played by the Khmers in the establishment of Si Thep. Moreover, the prevalence of Hindu imagery in the sculpture from this site also points to the Khmer rather than Mon tradition.

Sculptures from Si Thep are characterized by their strong, clearly delineated physiques, dramatic poses, and by the minimal attention paid to their garments. For example, the thin line at his waist indicates that this figure wore a short skirt-like garment. This style of sculpture is found both at Si Thep and at sites that in fact are associated with some of the earliest traditions of Cambodian sculpture—Khmer as opposed to Mon sculpture. The relationship between these two strong traditions is one of the more perplexing and unresolved issues in the history of art in Thailand and Cambodia.

An exquisitely cast bronze sculpture of the Bodhisattva Maitreya (**FIG. 90**) provides another illustration of the tangled relationship between Mon and Khmer styles in the seventh and eighth centuries. This Maitreya is widely

FIG. 89. Male Figure (Aiyanar?). First half 7th century. Thailand, reportedly from Lop Buri Province, Si Thep. Graywacke. H. 26⅞ x W. 13½ x D. 12⅞ in. (68.3 x 34.3 x 32.7 cm). Asia Society, New York: Mr. and Mrs. John D. Rockefeller 3rd Collection, 1979.73

Opposite: **FIG. 90.** Bodhisattva Maitreya. 8th century. Thailand, Buriram Province, Prasat Hin Khao Plai Bat II. Copper alloy with inlays of silver and black stone. H. 38 x W. 14¼ x D. 10¾ in. (96.5 x 36.2 x 27.3 cm). Asia Society, New York: Mr. and Mrs. John D. Rockefeller 3rd Collection, 1979.63

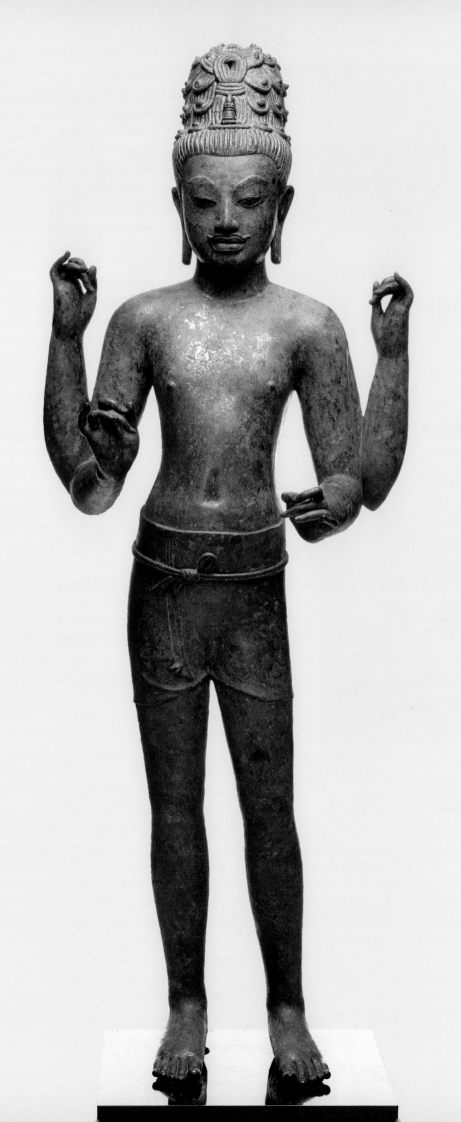

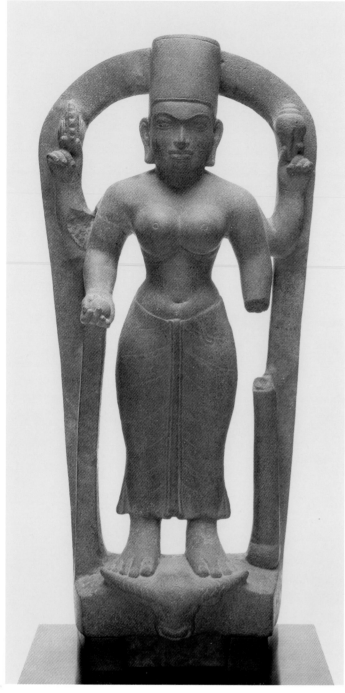

FIG. 91. Durga as the Slayer of the Buffalo-Demon (Durga Mahishasura-mardini). Pre-Angkor period, 7th century. Cambodia. Sandstone. H. 15 x W. 7⅜ x D. 3¾ in. (38.1 x 18.7 x 9.5 cm). Asia Society, New York: Mr. and Mrs. John D. Rockefeller 3rd Collection, 1979.61

finds in mainland Southeast Asia. Representations of the bodhisattvas Maitreya (who in this sculpture is identified by the presence of a small stupa in his headdress) and Avalokiteshvara were the most numerous icons unearthed at Kho Plai Bat. In addition, a few sculptures of standing buddhas were found. The buddhas are closely related to the Mon-style Buddha image discussed earlier. The bodhisattvas, however, show affinities to both Mon- and Khmer-style art. For example, this Maitreya's minimal clothing parallels that of the skirt worn by the aforementioned stone image of Aiyanar. Moreover, Maitreya's facial features, the fact that this sculpture was cast in the round, and the use of inlay for the eyes parallel characteristics found in early Khmer-type sculpture. On the other hand, Maitreya's lean and elegant proportions, his air of introspection, and his relaxed pose are closer to Mon than to Khmer prototypes. This combination of features suggests that the craftsman who created the work was working in the style associated with the Korat Plateau in northeastern Cambodia, which was under political and trade influence from the Mon Devaravati Kingdom.

A sculpture of the Hindu goddess Durga **(FIG. 91)** is an example of the Khmer-style sculptures carved in Cambodia during the seventh century. Durga's face is rectangular and the flesh on her cheeks is smooth and taut. Her eyes, nose, and mouth are broad and full and have been carefully delineated. She wears a tall, unadorned crown and a long garment tied together at the front that hugs her hips and thighs. Thin lines have been incised into the surface of this garment to indicate pleats.

Durga's frontal and upright posture and squat, powerful physique are typical of Khmer-style sculptures, as is the use of the mandorla to support the sculpture. Such support may be needed when stone sculptures are fully carved in the round. The sense of musculature in this image, the interest in the taut surfaces of her skin, and the sketchy depiction of drapery also relate this sculpture to both Buddhist sculptures from the area around Kho Plai Bat, such as the Maitreya, and later Hindu works produced under the rule of the Khmer empire.

Durga is one of the more powerful forms taken by the Hindu goddess Parvati. In this sculpture, Durga is in the form known as Durga Mahishasuramardini, which shows Durga vanquishing the buffalo-demon Mahisha. Mahisha, who had achieved great powers through the practice of austerities and was tormenting the world, could not be stopped by Shiva, Vishnu, or any of the other Hindu gods. In order to defeat him, the other gods lent their powers to Durga to augment her own. Durga's assumption of Vishnu's powers is shown by his attributes that she holds

acknowledged to be one of the finest sculptures from a group of bronzes unearthed in 1964 at a location first recorded by Jean Boisselier as Prakhon Chai, a site located to the south and the east of Si Thep. In 2002, Emma C. Bunker corrected the record, identifying the find site as an old temple on Kho Plai Bat, a hill forty kilometers southwest of Prakhon Chai city. The discovery of this cache in the base of the abandoned temple remains one of the most spectacular and challenging archaeological

in her hands: the conch shell, the wheel, and the ball symbolizing the earth. Vishnu's club is below her missing lower left hand. After a fierce battle she subdued Mahisha and saved the world; her defeat of the demon is indicated by the head of the bull upon which she stands.

The crown worn by a sculpture of the god Vishnu **(FIG. 92)** is similar to that worn by the goddess Durga. Known as a *kiritamukuta*, this type of headdress is

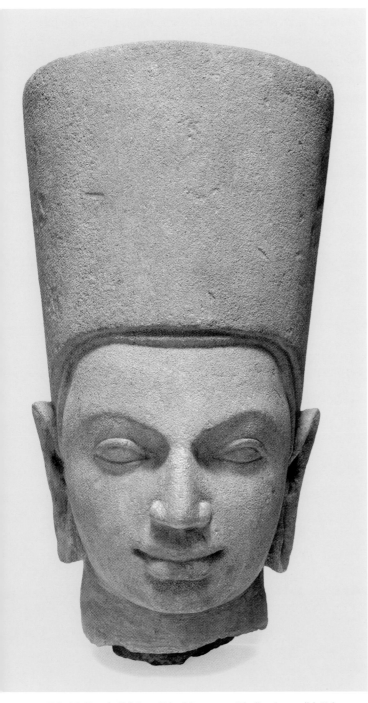

FIG. 92. Head of Vishnu. 7th–8th century. Thailand, possibly Wiang Sa area. Sandstone. H. 16¾ x W. 8½ x D. 9 in. (42.5 x 21.6 x 22.9 cm). Asia Society, New York: Mr. and Mrs. John D. Rockefeller 3rd Collection, 1979.62

commonly worn by the Hindu god Vishnu, and the identification of this head is based on its presence. However, several characteristics suggest that this sculpture may have been produced in the central part of the Thai/Malay Peninsula, possibly around the city of Wiang Sa, where several other images of Vishnu have been found. These include the minimally flared shape of Vishnu's crown, the small edges of the hairline seen beneath the crown, and the slightly round face and full features of the god. In addition, sculptures from this part of Thailand generally have the same overlarge crown and ears found on this head. The sculptures found at Wiang Sa are generally dated to the seventh and eighth centuries, providing a timeframe for dating this sculpture of Vishnu as well. The shape of Vishnu's face and his type of features do not closely parallel the well-known Mon types found in other parts of peninsular Thailand. It is not certain what ethnic group may have been responsible for the production of sculptures in this style.

The oval face, fleshy cheeks, small features, and flexed posture of an image of the Bodhisattva Manjushri and of an unidentified bodhisattva are found among another group of sculptures made in the southern or peninsular part of Thailand. Manjushri, the Bodhisattva of Wisdom **(FIG. 93)**, is identified by the sword and book that are placed atop the lotus whose stem he holds in his left hand. The gesture of bestowal (*varadamudra*) further defines the figure as the Sita Manjughosa or "Gift-Bestowing" form of Manjushri. The five tiny images of seated buddhas in the bodhisattva's headdress represent the five transcendent buddhas of the esoteric pantheon, linking this sculpture with the practices of that branch of Buddhism.

The sculpture of the unidentified bodhisattva **(FIG. 94)** is slightly smaller than that of Manjushri. However, the striking similarities between the two pieces suggest that they may have been produced in the same region. Both bodhisattvas sit in the posture of relaxation (*lalitasana*) and both hold their right hands in the gesture of bestowal. The remnants of a lotus stem in the left hand of the unidentified bodhisattva indicate that this sculpture was probably once characterized by attributes such as Manjushri's sword and book. The hole found at the back of the lotus pedestal indicates that the unidentified bodhisattva would once have had a mandorla behind him. It is possible that this mandorla would have been capped by a parasol similar to that seen in the Manjushri sculpture.

Both of these last two figures wear thin diadems and have jeweled and flowered hair, some of which falls in the long corkscrew-shaped curls often found in early

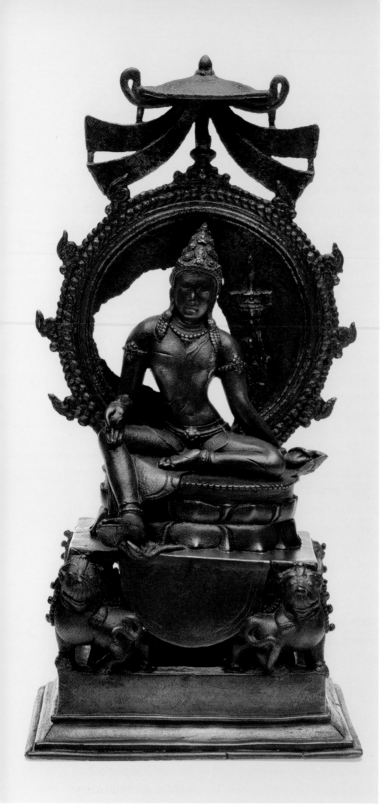

FIG. 93. Bodhisattva Manjushri in the Form of Sita Manjughosa. Shrivijayan style, late 8th century. Thailand. Copper alloy. H. 12¼ x W. 6⅛ in. (31.1 x 15.6 cm). Asia Society, New York: Mr. and Mrs. John D. Rockefeller 3rd Collection, 1979.82

Buddhist sculpture from peninsular Thailand. Manjushri's hair contains images of seated buddhas, and flowers fill the hair of the unidentified bodhisattva. They wear nearly identical necklaces and armlets, and there are large floral ornaments in the center of the belts that tie their long skirts. Both bodhisattvas are seated on similarly

decorated lotus pedestals, which are placed on two-tiered square bases with pudgy, squat-faced lions at the four corners. A pendant oval shape, probably intended to represent some type of draped cloth, is found on the front of Manjushri's base but is lacking in the other sculpture.

Both bodhisattvas belong to the Shrivijayan tradition of sculpture, so named for the kingdom of Shrivijaya, which, from its capital at Palembang in Sumatra, controlled large parts of southern Thailand. This seafaring kingdom may also have controlled other regions in Indonesia such as parts of Java. As a result, sculptures made under Shrivijayan rule exhibit a wide diversity in style, making them difficult to classify. Sculptures produced on the Thai/Malay Peninsula, such as these two images of bodhisattvas, are classified as either peninsular Thai, Chaiya, or Shrivijayan.

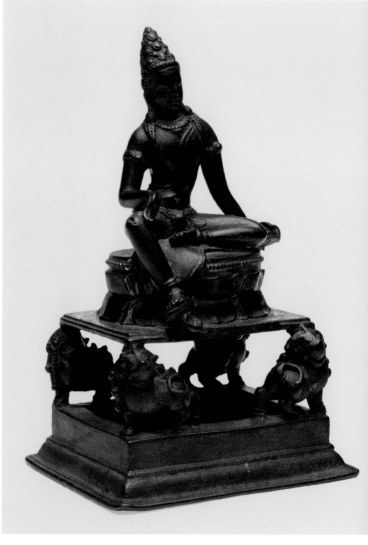

FIG. 94. Bodhisattva. Shrivijayan style, 8th century. Thailand. Copper alloy with traces of gilding and pigment. H. 8¾ x W. 5½ x D. 4⅜ in. (22.2 x 13.97 x 11.11 cm). Asia Society, New York: Gift from The Blanchette Hooker Rockefeller Fund, 1994.5

Sculptures of the Khmer Empire

The study of Cambodian and Thai sculptures dating from the tenth to the fourteenth century is to a large extent the study of the civilization and culture of the Khmer empire. The Khmers are one of the largest groups of people known to have inhabited and controlled parts of mainland Southeast Asia from the sixth century on. Historically, they are best known for the era called the Angkor period, after the name of the capital that was established at the end of the ninth century by King Yashovarman I (reigned about 877–899). The Angkor period spans from about 802, when King Jayavarman II established the foundations of the great empire that would rule large portions of mainland Southeast Asia, to about 1431, when the Thai people conquered the capital city of Angkor.

Angkor remains one of the most remarkable capitals in world history and is noted for the vast number of breathtaking monuments that were constructed in and around it from the tenth to the thirteenth century. These structures range from relatively small temples dating to the earlier years of the Angkor period to the gigantic temple mountains of Baphuon and Angkor Wat—temples built up in the form of a cosmic mountain—which date from the eleventh and the twelfth centuries. Most of the temples are profusely decorated with sculptures, and the study of Cambodian art has relied on the study of works in situ to provide a chronology. As a result, even those works that predate the founding of the capital at Angkor are generally dated by reference to the monuments following a classification into styles paralleling those found on these temple mountains, giving names such as "Koh Ker style" and "Baphuon style."

Prototypes for the art of the Khmer empire are found in certain sixth- through eighth-century sculptures that were carved in Cambodia and parts of Thailand. These earlier works are generally classified as either "pre-Khmer type," "Khmer type," or "pre-Angkor style." Early works and the classic examples of the art of the Khmer empire produced during the tenth and eleventh centuries are characterized by strong, forceful bodies and faces, and by an interest in depicting the warmth and tautness of flesh.

The smooth body and finely detailed treatment of clothing and crown date a sculpture of the Hindu god Shiva **(FIG. 95)** to the early eleventh century. Shiva's powerful upper torso and his headdress follow those of sculptures carved during the time that the temple mountain of Koh Ker was constructed, from 921 to about 945, while there are also parallels with the headdress in examples associated with Banteay Srei, which dates to

the late tenth century. The double outlining of his lips and the shape of his eyebrows also parallel details found on sculptures at Koh Ker. The hint of slim elegance in his physique and the use of low-relief decoration to depict his garments, however, are more indicative of sculptures dating to the eleventh century, the period of construction of the great temple mountain complex at Baphuon.

Shiva wears a short skirtlike garment known as a *sampot* that is wrapped around his waist, pulled between his legs, and tied in the front. The excess material falls in stylized folds over the garment, which is depicted as a series of very thin folds. The god also wears a lavish cloth belt, under which an additional piece of fabric has been placed. The depiction of the back of the waist of the garment as higher than the front is typical of late-tenth-century sculptures, as is the thickness of the legs (and presumably the ankles) that would have allowed the carved figure to stand without additional support. The contrast between the textured garment and the apparent softness of his skin is often found in Cambodian sculptures, particularly those dating from the tenth to the twelfth century.

Identified by the diamond-shaped third eye in the center of his forehead, this four-armed representation of Shiva has an intriguing iconographic history. The shape of an abraded image in the center of the headdress suggests that it once represented a stupa or a seated buddha, emblems used to identify respectively the bodhisattvas Maitreya and Avalokiteshvara. The apparently deliberate abrasion of the image suggests that this was a Buddhist sculpture that was recarved for use as a Hindu image, at which time the third eye was probably added.

The slim yet sensuous proportions of a figure of a woman **(FIG. 96)** and the touch of elongation in her body are typical of works in the Baphuon style carved in the early decades of the eleventh century. She wears a long skirt known as a sarong that has been wrapped around her waist and tied at the front. Additional folds of cloth fall in the center of the skirt in a stylized pattern often called a "fish-tail" motif. The skirt is higher at the back than at the front, but the difference is not as great as in the sculpture of Shiva. The woman wears a simple belt tied around her hips. The delicate contrast between her cloth skirt and soft skin continues the qualities found in the sculpture of Shiva. The style of her skirt, in particular the use of low-relief decoration, is comparable to that in works from the Baphuon period. The fact that it is unpleated, however, is unusual for pieces found at that monument, suggesting that this piece might have been made either in a workshop that was not involved in the building of Baphuon or at the beginning of the

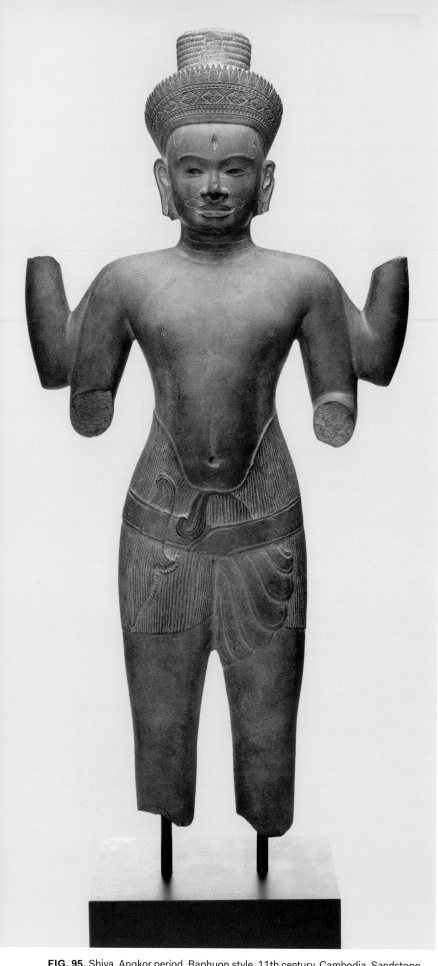

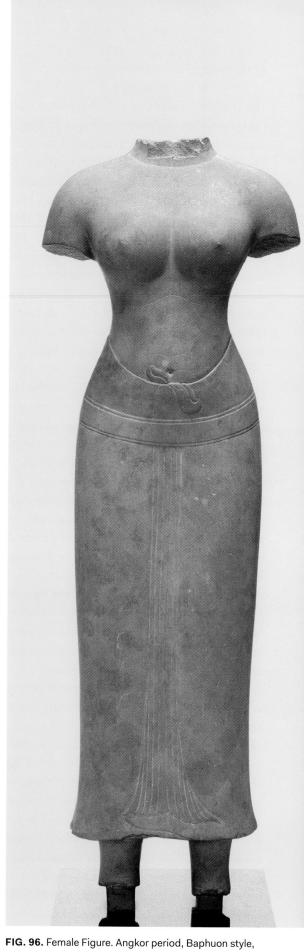

FIG. 95. Shiva. Angkor period, Baphuon style, 11th century. Cambodia. Sandstone. H. 41 x W. 20¼ x D. 6¾ in. (104.1 x 51.4 x 17.2 cm). Asia Society, New York: Mr. and Mrs. John D. Rockefeller 3rd Collection, 1979.64

FIG. 96. Female Figure. Angkor period, Baphuon style, Early 11th century. Cambodia. Sandstone. H. 38 x W. 13 x D. 6½ in. (96.5 x 33 x 16.5 cm). Asia Society, New York: Mr. and Mrs. John D. Rockefeller 3rd Collection, 1979.65

construction of that site. It is also possible that this sculpture was made as a replacement for an earlier work and was carved in a deliberately archaized style.

It is not possible to determine whom this sculpture is intended to represent. The Hindu god Shiva was the patron deity of most of the rulers of Cambodia in the eleventh century. As a result, it has sometimes been suggested that this sculpture represents Shiva's consort, Parvati (also known as Uma).

The identity of a standing male figure **(FIG. 97)** is also difficult to determine. He wears a garment that is identical to that worn by the Shiva discussed earlier and has the same piece of cloth under his belt. The simplification of the garments—such as the less exaggerated treatment of the front and the back of the waistline and the fact that there are fewer additional folds of cloth—help date the male figure to the Baphuon period. The lack of vertical pleating in the treatment of the *sampot* and the youthful and serene face of the figure indicate that this piece was also probably carved early in the period of the construction of the Baphuon, which is believed to have lasted from about 1010 to about 1080.

A date toward the end of the Baphuon period in the third quarter of the eleventh century can be given to another sculpture of a male figure **(FIG. 98)** because of the greater interest shown in depicting his garments. For example, eight-petaled flowers are incised into the excess folds of his *sampot,* and the vertical pleats used to depict this garment are more numerous than those found in earlier sculptures. Jeweled pendants filled with cabochons hang from the belt, which may represent metal rather than cloth. It has been suggested that elaborate metal belts were a symbol of royalty; this sculpture then may well have commemorated a royal figure. However, this type of belt is sometimes found on sculptures of guardians, which were generally part of the complicated iconographic programs found in the temple mountains such as Baphuon, and it seems likely that the identity of a figure such as this one was determined as much by its placement as by its clothing and ornaments.

Beginning with the reign of Jayavarman II (802–850), the Cambodian kings ruled by divine right as god-kings or *devarajas;* it is believed that this Indian concept was transmitted to Cambodia via Java, where Jayavarman II had spent some time in exile before establishing his control over Cambodia. Sculptures of gods such as Shiva

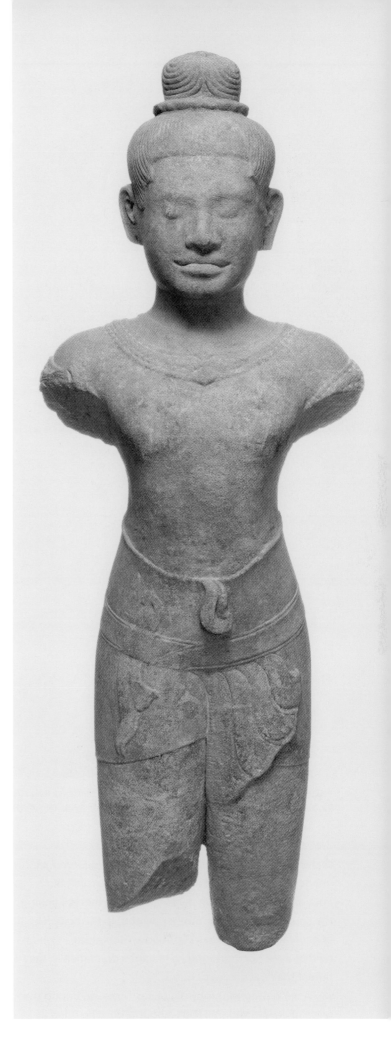

FIG. 97. Male Figure. Angkor period, Baphuon style, 11th century. Cambodia. Sandstone. H. 50 x W. 19 x D. 11¾ in. (H. 127 cm). Asia Society, New York: Gift of Arthur Ross, 1981.1

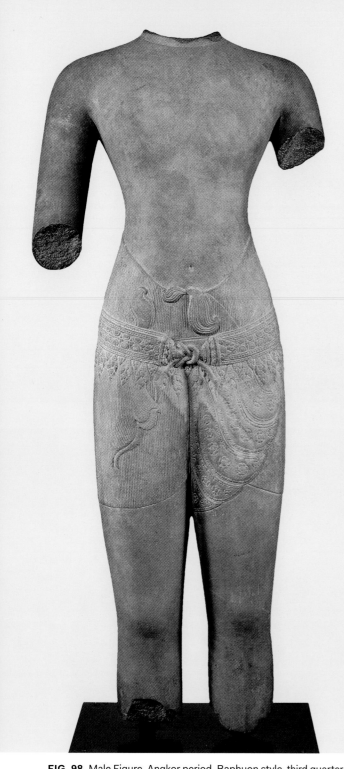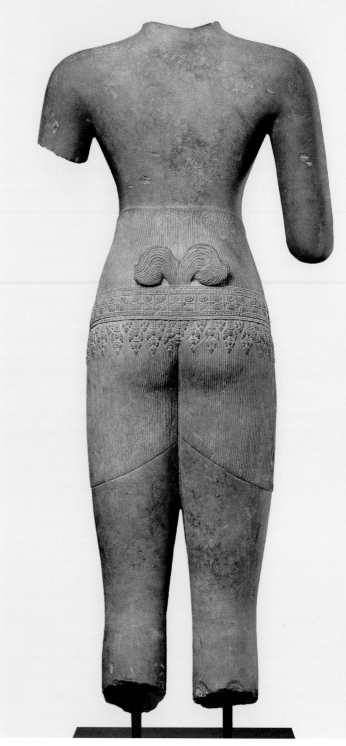

FIG. 98. Male Figure. Angkor period, Baphuon style, third quarter 11th century. Cambodia. Sandstone. H. 41½ x W. 17 x D. 9 in. (105.4 x 43.2 x 22.9 cm). Asia Society, New York: Mr. and Mrs. John D. Rockefeller 3rd Collection, 1979.66

therefore served two functions: they were regarded as images of both the god and symbols of the ruler. Such images were often given personal names, thereby linking the soul of the ruler (or another person) to the deity. The conservatism that marks Cambodian sculpture, in which neither style nor iconography changes dramatically, may reflect the dual nature of this art.

A shift in iconography did occur, however, during the reign of Jayavarman VII (1181–about 1218), who ruled as a buddha-king rather than as a Hindu god-king, and thus dedicated his monuments to Buddhist rather than to Hindu divinities. The emphasis placed on a new type of Buddhist image, that of a crowned Buddha seated on the coils of the cobra Muchilinda, is one of the many changes in Buddhist art as well as thought fostered by Jayavarman VII. Images of the Buddha without a crown and protected by the hood of Muchilinda have a long history in Buddhist art. They illustrate how Buddha Shakyamuni was sheltered

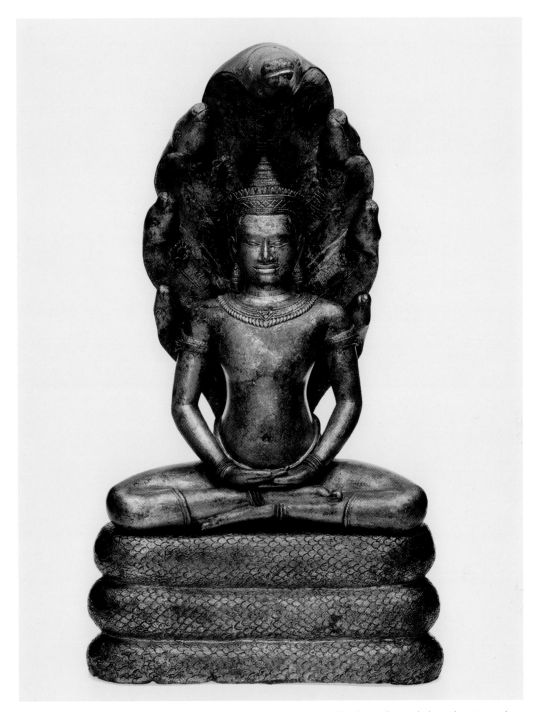

FIG. 99. Crowned Buddha Seated in Meditation and Sheltered by Muchilinda. Angkor period, Angkor Wat style, possibly 12th century. Cambodia. Copper alloy with recent covering of black and gold lacquer and gold leaf. H. 28¾ x W. 16½ x D. 10 in. (73 x 41.91 x 25.4 cm). Asia Society, New York: Mr. and Mrs. John D. Rockefeller 3rd Collection, 1979.68a-c

from a storm by this serpent within the first six weeks after Shakyamuni attained buddhahood, a moment often represented in the visual arts.

The crown and jewelry worn in two twelfth-century examples, one cast in a copper alloy **(FIG. 99)** and the other carved of sandstone **(FIG. 100)**, add several layers of meaning to this iconography. These adornments represent both the omnipresence of the Buddha and the legitimacy of the ruler. In these two sculptures, the

serpent, who helps to identify the iconography and represents the powers of water, is also a long-standing emblem of royalty throughout South and Southeast Asia. As it is associated with healing, the serpent may also have had a personal meaning for Jayavarman VII, whose reign brought about the construction of many hospitals, though it has also been suggested he was physically disabled.

The jewelry also links these sculptures of Shakyamuni with the traditions of Esoteric Buddhism, in which deities

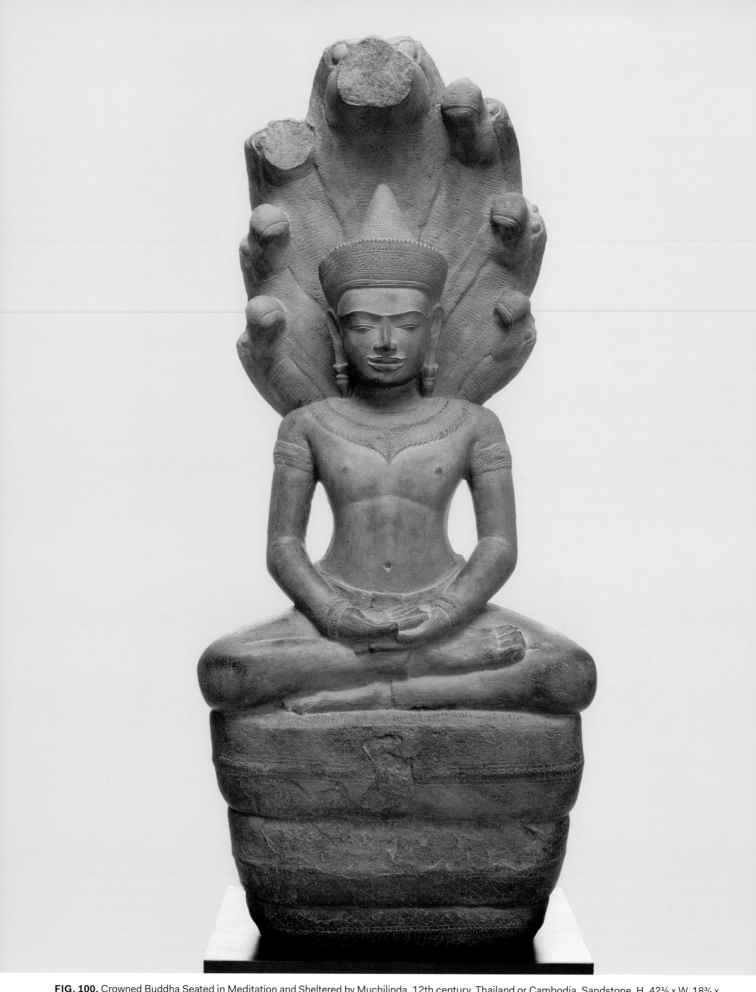

FIG. 100. Crowned Buddha Seated in Meditation and Sheltered by Muchilinda. 12th century. Thailand or Cambodia. Sandstone. H. 42½ x W. 18¾ x D. 11½ in. (H. 108 cm). Asia Society, New York: Gift of Mrs. John D. Rockefeller 3rd, 1982.1

wear jewelry. Jayavarman VII's preference for this particularly complicated branch of Buddhist thought may have had political implications as well; it has been suggested that the shift to Buddhism during the twelfth century was a result of the search for a more potent religion after a disastrous Cham attack on the Khmers in 1117.

Each of the bronze and sandstone Buddhas is seated in a meditation posture and holds his hands in the gesture of meditation. Each wears a long skirtlike garment with thick waist and hemlines, a crown, earrings, a necklace, armlets, and bracelets, and is seated on the coils of the seven-headed cobra. The floral decoration on the crown of the sandstone Buddha and his shorter and broader features indicate that this piece is earlier than the bronze Buddha, who has geometric decoration in his crown. The exaggeration of the waistline edge of the garment worn by the bronze Buddha also points to a somewhat later date. The two treatments of the serpent coils suggest that these sculptures may have different origins. The coils in the sandstone sculpture are smaller at the bottom and larger at the top, while those in the bronze sculpture are the reverse. Smaller lower coils are often found on sculptures that were produced in the regions of Southeast Asia that today are part of Thailand when much of the territory of that contemporary nation was under Khmer control. Finally, it should be pointed out that the base and serpent's hood of this bronze are of nineteenth- or twentieth-century manufacture.[1]

A standing sculpture of the Buddha (FIG. 101) provides an additional illustration of the impact of the art of the Khmer empire in Thailand from the late eleventh to the early thirteenth century. The Buddha wears a skirtlike *dhoti* and a long shawl. He is crowned and wears earrings, a necklace, and a thick belt. His hands are held in the gesture of reassurance *(abhayamudra)* and on each palm is a wheel symbolizing the Buddhist teachings.

The style of buddhas of this type is often classified as Lop Buri, after the name of a city in Thailand that was a viceregal Khmer city in the eleventh and twelfth centuries. Lop Buri also appears to have been an important center for the production of stone and bronze images of the Buddha. Bejeweled buddhas of this type are found in the decoration of Phimai, a temple dedicated to Esoteric Buddhism constructed at the beginning of the twelfth century in the southeastern part of central Thailand. Image types developed for this site were influential in Thai and Cambodian art during the late twelfth and early thirteenth centuries. The crown and other jewelry in these twelfth-century examples may both refer to Jayavarman VII as the Buddha-King and illustrate the belief in the

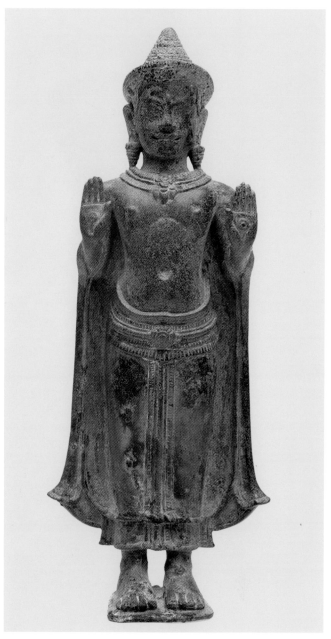

FIG. 101. Crowned Buddha. 11th–12th century. Thailand. Copper alloy. H. 9¼ x W. 3¾ x D. 2½ in. (23.5 x 9.52 x 6.35 cm). Asia Society, New York: Mr. and Mrs. John D. Rockefeller 3rd Collection, 1979.80

transcendence rather than the historicity of the Buddha that is typical of Esoteric Buddhist thought.

A charming bronze figure of a kneeling woman (FIG. 102) further illustrates the art of the Khmer empire in the late eleventh and early twelfth centuries. The woman's taut figure, the detailed carving of the pleats in her skirt, the articulation of the waist of her garment, and the type of jeweled belt that she wears all typify Cambodian sculpture produced during this period. In particular, this piece is in the style associated with the temple mountain of Angkor Wat, constructed between about 1100 and about 1175, which is the largest of the Cambodian complexes and one of the world's wonders.

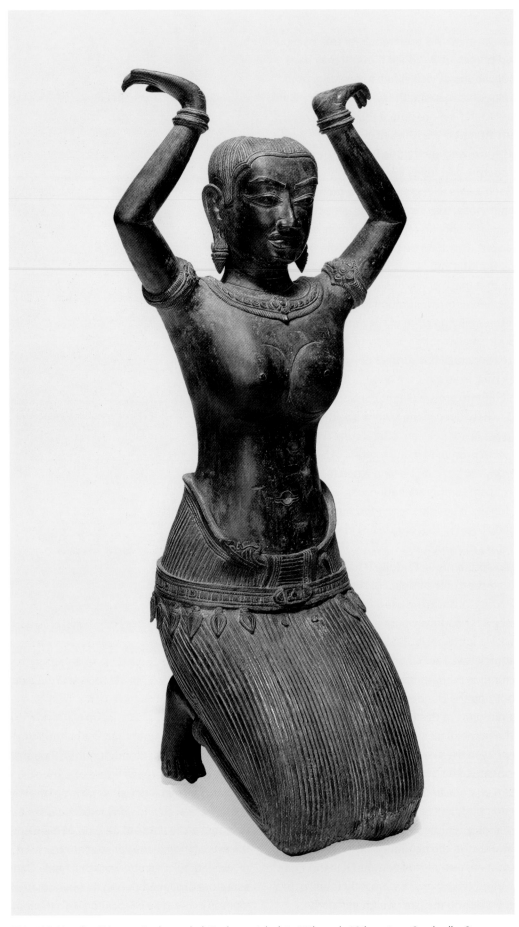

FIG. 102. Kneeling Woman. Angkor period, Baphuon style, late 11th–early 12th century. Cambodia. Copper alloy. H. 18¾ x W. 9¼ x D. 7¾ in. (47.6 x 23.5 x 19.7 cm). Asia Society, New York: Mr. and Mrs. John D. Rockefeller 3rd Collection, 1979.69

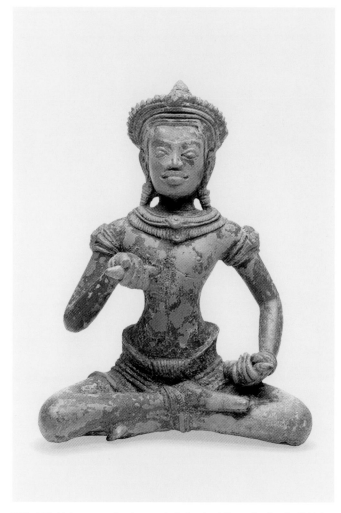

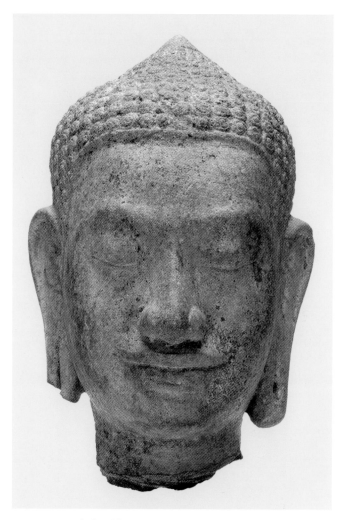

FIG. 103. Vajrasattva. Angkor period, Angkor Wat style, first half 12th century. Cambodia. Copper alloy. H. 5 x W. 4½ x D. 2¾ in. (12.7 x 11.43 x 6.98 cm). Asia Society, New York: Mr. and Mrs. John D. Rockefeller 3rd Collection, 1979.67

FIG. 104. Head of Buddha. Angkor period, Bayon style, 12th–13th century. Cambodia. Sandstone. H. 13 x W. 8½ x D. 9½ in. (33 x 21.6 x 24.1 cm). Asia Society, New York: Mr. and Mrs. John D. Rockefeller 3rd Collection, 1979.71

The iconography and function of this sculpture are perplexing. Kneeling figures, either in bronze or stone, from the eleventh and twelfth centuries are common, and some of them have been identified as royal figures. The figure's gracefully upturned hands—together with a large, cupped indentation in the top of her head—suggest that this kneeling woman may once have held something, probably offering it to a statue of a divinity, and it is tempting to speculate that she was originally part of a larger group of devotees and deities.

A small sculpture is identified as the Buddha Vajrasattva by the bell and thunderbolt that he holds **(FIG. 103)**. This deity was worshiped both as a Buddha and as an attendant figure in Southeast Asian Buddhism and symbolizes the triumph of Buddhist wisdom over human ignorance.

This image of Vajrasattva is comparable in style to works found in the temple mountain of Angkor Wat. Although the sculpture was modeled in the round, Vajrasattva's form is more linear and less fleshy than those of the earlier works discussed. Sculptures dating to the twelfth century typically have more attention given to the clothing and jewelry, as is seen in the heavy ornaments worn by this Vajrasattva and the exaggerated treatment of the waistline of his skirt.

The large area of unfinished stone at the back of a head of a Buddha **(FIG. 104)** indicates that it is a fragment from a larger work. Cambodian sculptors worked almost exclusively in the round, and the back of the head would have been carved unless attached in front of another piece of stone. One possible explanation is that the head was once part of an image of an uncrowned Buddha Shakyamuni sheltered under the hood of the giant cobra Muchilinda. The hooded cobra would have been attached to the head at the unfinished area.

The oval shape of the Buddha's head and the mild elongation of his features are characteristic of works dating to the end of the Angkor period. In particular, this style is common at Angkor Thom, Jayavarman VII's

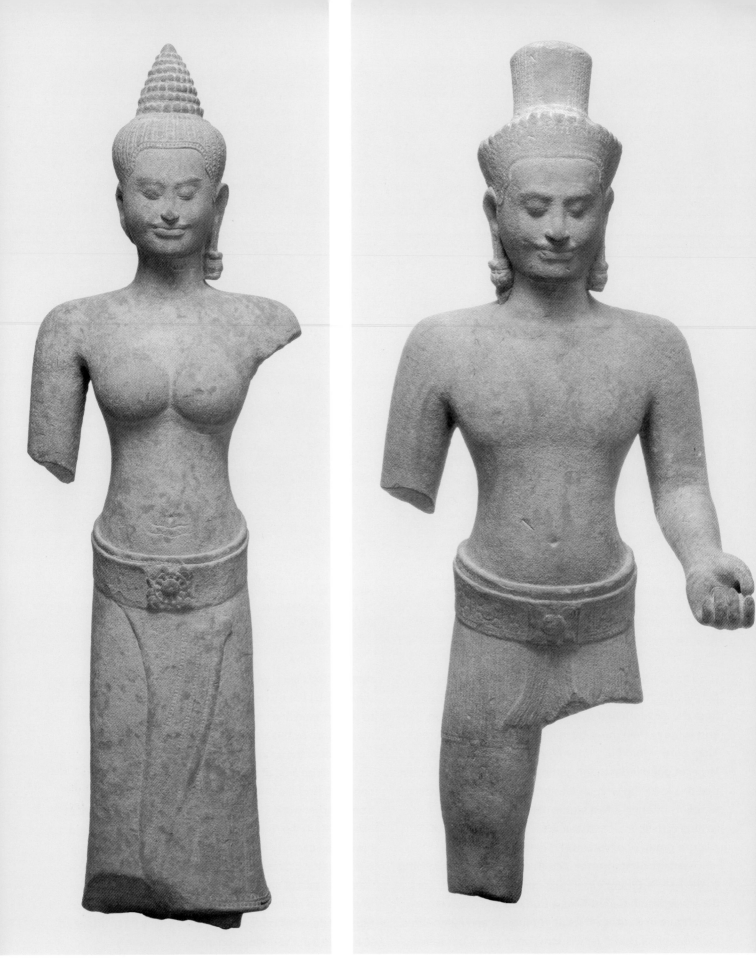

FIG. 105. (Left) Female Figure (one of a pair). Angkor period, Bayon style, late 12th–early 13th century. Cambodia. Sandstone.
H. 55 x W. 18 x D. 9½ in. (139.7 x 45.7 x 24.1 cm). Asia Society, New York: Mr. and Mrs. John D. Rockefeller 3rd Collection, 1979.72.2
(Right) Male Figure (one of a pair). Angkor period, Bayon style, late 12th–early 13th century. Cambodia. Sandstone. H. 54 x W. 25 x D. 15 in.
(137.2 x 63.5 x 38.1 cm). Asia Society, New York: Mr. and Mrs. John D. Rockefeller 3rd Collection, 1979.72.1

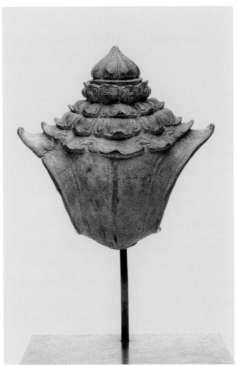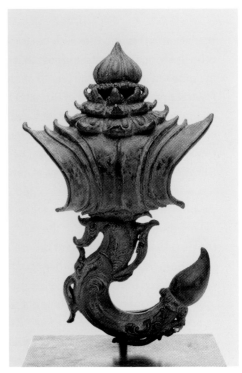

FIG. 106. Palanquin Fittings. Angkor period, 12th century. Cambodia. Copper alloy. Hooks, H. 9 x L. 4¾ x W. 6¼ in. (22.9 x 12.07 x 15.88 cm); rings, H. 6 in x L. 3⅛ x W. 6 in. (15.2 x 7.94 x 15.24 cm). Asia Society, New York: Mr. and Mrs. John D. Rockefeller 3rd Collection, 1979.70.1-3

city-within-a-city, with the temple mountain Bayon (constructed from about 1180 to 1230) at its center.

Similar facial features are found in a pair of sculptures, one male and one female **(FIG. 105)**, that date to the late twelfth to the early thirteenth century. The man wears a short *sampot* and a large belt decorated with an incised floral pattern. The woman wears a longer sarong and also wears a prominent belt. Both wear heavy earrings and have elongated earlobes. The statues are slightly worn; however, the stylized detailing of the woman's hair and the man's crown indicates that the garments probably also had more detailing than is now evident. These figures have often been identified as a royal couple, probably owing to the lack of distinguishing characteristics that could be associated with Hindu deities. Nevertheless, the Cambodian custom of paralleling gods and rulers often makes it difficult to distinguish one from the other, and so it is equally possible that these sculptures represent divinities who are as yet unidentified.

Although stone and bronze sculptures are the best-known forms of Cambodian art, evidence exists for a well-developed and highly sophisticated art of metalwork that served the functional and decorative needs of the court and aristocracy. Three bronze fittings, most likely used to embellish a wooden palanquin **(FIG. 106)**, are each made of a shell-like section topped with a stylized flower, probably a lotus. Two of the fittings have hooks that resemble the stalks and leaves of the lotus; comparison

with other objects of this type suggests that these hooks may once have held rings. The lack of volume in the floral decoration found on these fittings parallels the linearity found on twelfth-century sculptures; these pieces follow the style of decoration found on Angkor Wat.

1. The use of a mortise and tenon secured with screws through drilled holes to attach the hood to the base is not found during the Khmer period. This method suggests nineteenth- or twentieth-century manufacture.

Sculptures from Indonesia

Indonesia comprises more than thirteen thousand islands and is home to many different ethnic groups. Java, one of the largest of the Indonesian islands, is the site of some of the most spectacular architectural monuments in the world, such as the famous Borohudur. The study of Javanese material, however, is hampered by the complexity of the history of Indonesia, the intricate relationships among the different islands and peoples in this part of the world, and the large number of other Southeast Asian countries, along with India, whose art and culture influenced those of Indonesia.

Questions surrounding the seafaring kingdom of Shrivijaya provide one example of the many complexities found in the study of Indonesian art history. Shrivijaya was one of the greatest powers in Southeast Asia from

the seventh through the ninth century; inscriptions and other historical records suggest that it continued to exist in some form until the thirteenth century. The city of Palembang on the island of Sumatra is generally accepted as the capital of Shrivijaya, which also controlled parts of central and western Java and some of the Thai/Malay Peninsula. The relationship, if any, between the rulers of Shrivijaya and the Hindu rulers of central Java—who traced their lineage to a ruler named Sanjaya who was a devotee of the god Shiva—remains unclear. These historical enigmas are reflected in the many issues surrounding the provenance and dating of bronze and stone sculptures from Indonesia and other countries in Southeast Asia between the seventh and the ninth century.

The treatment of the details of the hairstyle and headdress of a sculpture of a seated goddess with eight arms (FIG. 107) suggests that this piece may be an example of bronze sculpture from Sumatra. The depiction of her hair as a series of diagonal ribbon-like lines with corkscrew curls running along the sides of her topknot and falling over her shoulders is strikingly similar to that found in three ninth-century bronzes discovered in the Komering River at Palembang in 1930, works that continue to be linchpins for the study of sculpture from Sumatra. The representation of her diadem as a thin band with

triangular shapes and the three-dimensionality of her armlets are also comparable to those of sculptures excavated in Sumatra. Finally, the static yet relaxed pose of the goddess and her high and extremely thin waist also point to a Sumatran provenance.

With the exception of the thunderbolt or *vajra* in her upper right hand, the attributes held by this goddess are too damaged to recognize easily, making the identification of the figure difficult. Her eight arms indicate that she is a goddess, likely a Buddhist one. Very little is known about the religion that was practiced in Shrivijaya, but we do know that Sumatra was once a major center for the study of Esoteric Buddhism, a branch noted for its worship of female divinities.

The depiction of the locks of hair as a series of parallel ribbon-like lines suggests that an intriguing sculpture that is tentatively identified as a standing bodhisattva may also have been made in Sumatra (FIG. 108). In addition to the type of hair, this sculpture also shares the large cylindrical bump at the top of the head that is seen in the sculpture of the aforementioned goddess and on other sculptures believed to come from Sumatra. However, the thickness and rigidity of the legs, the lack of volume in the torso, the simplicity of the detailing, and the figure's strong features differentiate this piece from other Sumatran examples. A possible explanation for these differences may be a ninth- or tenth-century date for the piece. It is also possible that this sculpture was produced in an area of the Indonesian archipelago that is less well known than either Sumatra or Java; or it might be both provincial and later in date.

This sculpture has long been identified as an image of the bodhisattva Maitreya, although the rationale for this identification is unclear. The figure's headdress does not feature a stupa, Maitreya's most frequently represented attribute. The identification might derive from the long hair that runs down the figure's back, a style of hair often found on images of Maitreya that illustrates his origins as an ascetic figure in early Buddhist art. This feature alone is not sufficient for the identification, however, because long hair is also found on representations of other bodhisattvas, particularly on works dating from the seventh through the ninth century, when the bodhisattva-ascetic played an important role in Southeast Asian Buddhist imagery. Moreover, the identification of this figure is further complicated by the disk that he holds in his back right hand, an attribute most commonly associated with the Hindu god Vishnu. However, similar wheel-shaped objects are also held by Buddhist attendant figures known as *vajra*-deities. Given the importance of Buddhism in

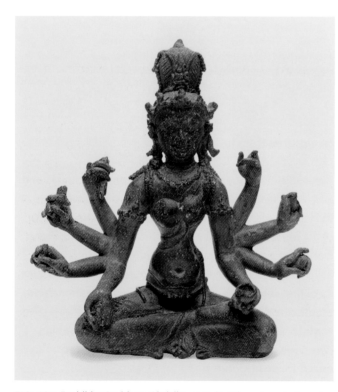

FIG. 107. Buddhist Goddess. Shrivijayan style, 9th century. Indonesia, Sumatra. Copper alloy. H. 6¼ x W. 6¼ x D. 3 in. (15.9 x 15.9 x 7.6 cm). Asia Society, New York: Mr. and Mrs. John D. Rockefeller 3rd Collection, 1979.84

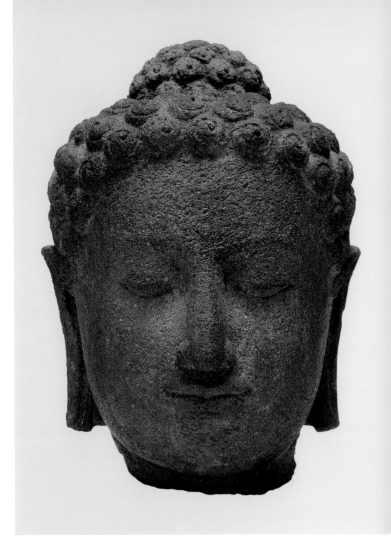

FIG. 109. Head of Buddha. 9th century. Indonesia, Central Java. Andesite. H. 13 x W. 11 x D. 10 in. (33 x 27.9 x 25.4 cm). Asia Society, New York: Mr. and Mrs. John D. Rockefeller 3rd Collection, 1979.85

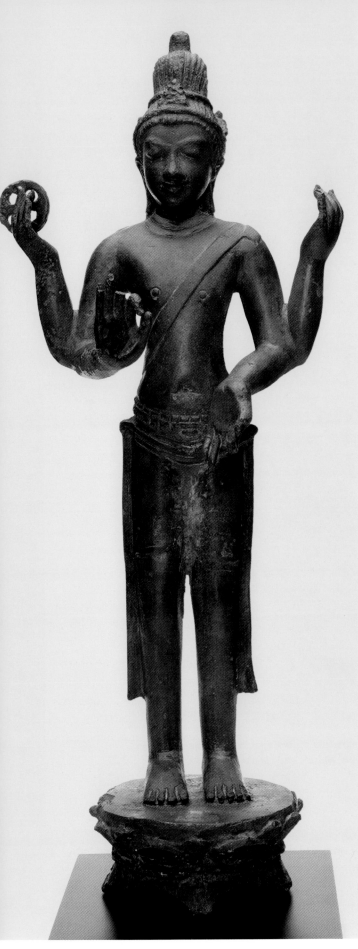

FIG. 108. Standing Figure, probably a Bodhisattva. Shrivijayan style, 8th–9th century. Indonesia, possibly Sumatra. Copper alloy. H. 18 x W. 7 x D. 6 in. (45.7 x 17.8 x 15.2 cm). Asia Society, New York: Mr. and Mrs. John D. Rockefeller 3rd Collection, 1979.83

Indonesia, it seems likely that this figure does represent a bodhisattva or some other Buddhist deity.

An introspective and serene head from a sculpture of a buddha **(FIG. 109)** illustrates the distinctive commingling of Indian prototypes that characterizes the style of art found in Central Java during the ninth century. The proportions of the face, the slight smile, and the downcast eyes can be traced back to the type of Buddha image developed in India during the Gupta period (about 320–about 500), while the spherical shape of the head and the full, round features are typical of slightly later works from eastern India.

There are several large temple mountain complexes that were constructed in Central Java during the rule of the Shailendra dynasty and dedicated to Buddhism. The ninth-century temple mountain Borobudur, the most famous of these complexes, is renowned for the beauty and majesty of its more than five hundred seated sculptures of the Buddha. Many of the seated buddhas from this site have lost their heads, thus it has been common to assign a provenance of Borobudur to works, such as this head, that are close in style to the sculpture at this famous

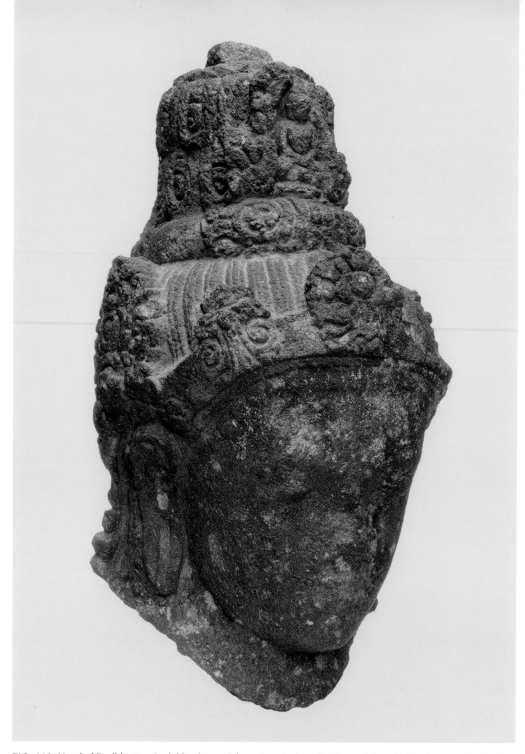

FIG. 110. Head of Bodhisattva Avalokiteshvara. 9th century. Indonesia, Central Java. Volcanic stone. H. 21¼ x W. 12½ x D. 13¼ in. (54 x 31.8 x 33.7 cm). Asia Society, New York: Mr. and Mrs. John D. Rockefeller 3rd Collection, 1979.86

monument. However, certain features—for example, a minimally higher forehead and a marginally narrower jaw—distinguish this head from those of the buddhas at the site, suggesting that while this head may have been produced during the construction of Borobudur, it was made for a lesser-known site.

A head of the Bodhisattva Avalokiteshvara (FIG. 110) was also once optimistically attributed to Borobudur. Avalokiteshvara is identified by the small image of a seated Amitabha Buddha in his headdress. His hair is styled into an elaborate coiffure and he wears a diadem decorated with five plaques. The size of this head indicates that it came from a large sculpture. Because of its size, it has also been suggested that this head came from Chandi Plaosan, a ninth-century temple mountain noted for its monumental sculptures. However, this provenance is also speculative, and it is more accurate to consider this head simply as an example of sculpture from Central Java rather than as a fragment from any particular monument.

Four *vajra*-deities **(FIG. 111)** from a large set of small bronze sculptures discovered in 1913 in the village of Chandi Reja, in Nganjuk in East Java, further illustrate the importance of Esoteric Buddhism in Java. These four figures were once part of a larger set of perhaps as many as ninety sculptures that formed a three-dimensional mandala, or cosmic diagram. While the precise textual basis for the arrangement of the entire Nganjuk group has not been established, scholars generally agree that these sculptures, which are now scattered in collections around the world, were part of a Diamond World, or *Vajradhatu,* mandala. The transcendent Buddha Vairochana is the central deity of the Diamond Realm. In Esoteric Buddhist thought, mastery of both the Diamond Realm, which symbolizes wisdom, and the Womb World (*Garbhadhatu*), which symbolizes practice, is necessary to achieve enlightenment. The small size of these figures and their iconography suggest that they were placed in the outer rings of the mandala, where they functioned as attendants and guardians for the more important deities in the inner part of the cosmic diagram.

Although the sculptures from the Nganjuk mandala were the first of this type to be discovered, other examples have been found over the past seventy years. A stunning set that can be dated to the early tenth century was excavated in 1976 in Bantul to the southwest of Yogyakarta, and additional single examples dating from the tenth and eleventh centuries are in many public and private collections worldwide. The abundance of these small statues attests to the importance of the creation of such three-dimensional mandalas in the form of Buddhism practiced in East Java. The figures' slenderness and their elaborate jewelry characterize sculptures made in East Java during the late tenth and early eleventh centuries. The move of the palace from Central to East Java in about 929 is one of the most perplexing events in the history of the island. While the reason for this move remains unclear, it is possible that it was linked to a natural disaster such as a volcanic incident involving Mount Merapi, which is still active and has erupted numerous times over the past 400,000 years, as determined through geological evidence.

A stone figure of Vajrasattva **(FIG. 112)** is a monumental example of the East Java style seen in the small bronzes discussed above. Vajrasattva is seated on a thin lotus pedestal with his right foot placed on his left thigh in a posture known as s*attvaparyanka.* The protruding teeth identify this to be one of the ferocious representations of the deity. His left hand holds a lotus that supports a *vajra,* while his right hand holds a priest's bell. He wears a full skirtlike garment that is tied with thick bows at both hips, and has an elaborate crown, heavy earrings and armlets, and several necklaces. A sacred thread crosses from his left shoulder to his right leg. Several pendant ribbons flow from the belt around his hips over his skirt and onto the lotus pedestal. The greater bulk of this figure and the

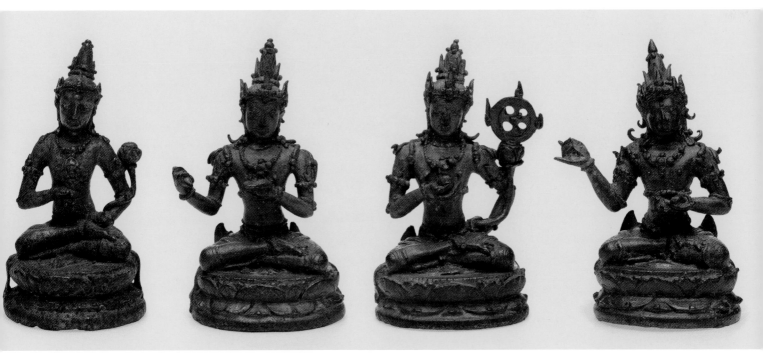

FIG. 111. Four Vajra-Deities. Late 10th–early 11th century. Indonesia, East Java, Nganjuk, Chandi Reja. Copper alloy. Each approx., H. 3¼ x W. 2 x D. 2 in. (8.3 x 5.1 x 5.1 cm). Asia Society, New York: Mr. and Mrs. John D. Rockefeller 3rd Collection, 1979.87.1-4

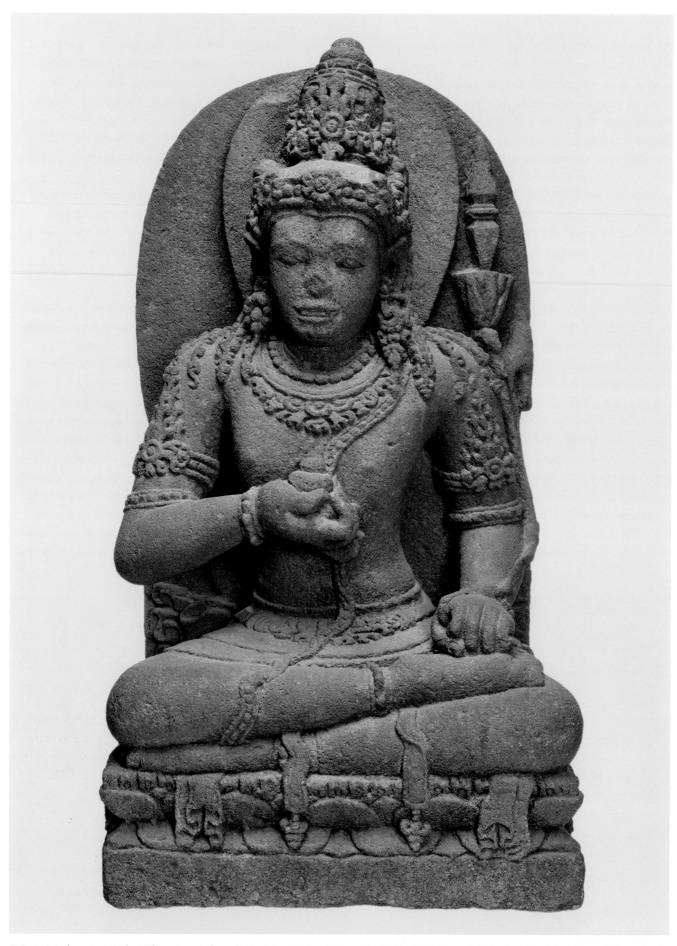

FIG. 112. Vajrasattva. 12th–13th century. Indonesia, East Java. Volcanic stone. H. 41½ in. (105.4 cm). Asia Society, New York: Mr. and Mrs. John D. Rockefeller 3rd Collection, 1979.88

rigidity of the posture help date it to the twelfth or thirteenth century.

Two forms of Vajrasattva were worshiped in Indonesia: Vajrasattva as the Adi or primordial Buddha, who is worshiped as the supreme Buddha in certain sects, and Vajrasauva as one of the sixteen *vajra*-deities. Since images of Buddha Vajrasattva are generally shown with their legs crossed in the posture of meditation called *vajraparyanka,* this sculpture represents Vajrasattva as one of the *vajra*-deities. Given this iconography, this sculpture may once have been part of a large assembly of stone deities grouped together to form a monumental version of the mandala-based arrangements of which the smaller bronze *vajra*-deities were a part.

Ceramics from Southeast Asia

The history of pottery in Southeast Asia reflects complicated interrelationships among the region's different countries and peoples as well as, to a certain extent, connections with the ceramics of China to the north. Manufacturing and decorative techniques, shapes, and designs were shared by various regions at different times. Sometimes this commonality was the result of the introduction of new technologies or designs from one region to another, while in other instances such similarities might have been a result of economic competition. The study of the ceramic traditions of Southeast Asia is an area that has been growing. The discovery of new kilns and studies on previously little known types, such as the ceramic art of the Khmer empire (about 879–1431), are helping to define the field and raise questions pertinent to the understanding of this material.

A stunning jar in the Collection **(FIG. 113)** dating from the fifteenth to the sixteenth century illustrates some of the similarities and differences between Chinese and Southeast Asian ceramics. The shape of the jar, and in particular the presence of four lugs on the shoulders, may be loosely related to several traditional Chinese forms such as the so-called martaban jars that were used to export pickles and wine from South China to Southeast Asia. The lugs were most likely used to tie down some type of cover, suggesting that this jar was used for storage as well. In addition, the decoration of chrysanthemums incised beneath the glaze is a long-standing motif in Chinese art, often used as a symbol of longevity. The free-flowing treatment of the flowers and leaves, however, is distinctive and has no parallels in Chinese art.

This jar has generally been classified as Vietnamese because of its brown glaze, as a considerable number of ceramics covered with this type of glaze are made in some number in that part of mainland Southeast Asia. The flowers and leaves incised underneath this glaze, however, do not commonly appear on other examples of early Vietnamese ceramics, most of which are believed to have been produced in the northern parts of the contemporary nation of Vietnam. In addition, works from northern Vietnam have heavier bodies and thicker glazes than this jar.

Shards discovered in 1974 near the unexcavated kiln site at Go-Sanh and in other nearby villages in central Vietnam, provide interesting parallels to the body and method of decoration of this jar. Very thinly potted stoneware with reddish bodies and translucent caramel-colored glazes—characteristics possessed by this jar—were among the type of ceramics found at the Go-Sanh site. Some of these ceramics also have very indistinct decoration that parallels the flowers incised into the body of this jar. These parallels suggest that the jar may be an example of ceramics produced in central rather than northern Vietnam. From about the third century to 1471, this area was controlled by the kingdom of Champa, one of the most important but little-studied kingdoms in the history of mainland Southeast Asia.

The strategic location of Champa along the southeastern Vietnamese coast made it an important part of the trade route for luxury goods that linked mainland Southeast Asia with the islands of Indonesia, China, and other parts of the world from at least the eighth century on. Ceramics similar to fragments found at the Go-Sanh site have been found in the Philippines and Indonesia, linking this kiln site to international trade; they are also known to have been treasured family heirlooms, passing through generations as ritual objects in some areas of Southeast Asia. Champa was defeated by its northern Vietnamese neighbors in 1471, but the production of the distinctive Go-Sanh wares appears to have continued for some time afterward.

The evolution of a tradition of stoneware painted with underglaze blue in northern Vietnam during the late fourteenth or early fifteenth century is closely tied to the histories of China and Vietnam. It is generally acknowledged that the technology needed to control painting with underglaze cobalt blue on a white porcelain body had been mastered in China by the mid-fourteenth century, a period when China was under the foreign rule of the Mongol Yuan dynasty (1279–1368). The first Chinese ceramics produced using this technique were often

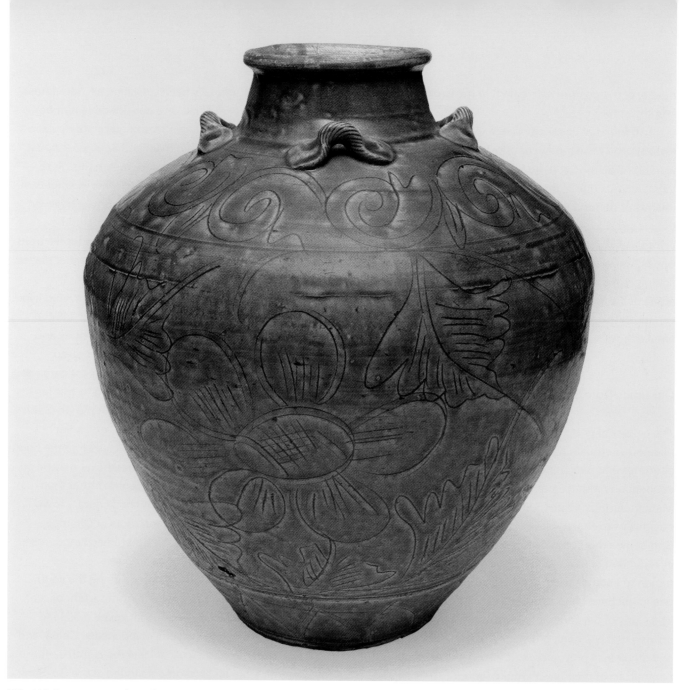

FIG. 113. Storage Jar. 15th–16th century. Vietnam, possibly Champa. Stoneware with incised design under glaze (Go-Sanh ware). H. 13⅛ x Diam. 12 in. (33.3 x 30.5 cm). Asia Society, New York: Mr. and Mrs. John D. Rockefeller 3rd Collection, 1979.96

intended as trade goods, though excavations have unearthed examples of imperial wares and objects for domestic use as well.

The Ming-period Chinese annexation of Vietnam from 1407 to 1428 and the imperial Chinese prohibition of the ceramic trade from 1436 to 1465 spurred the development of the Vietnamese ceramic industry in the fifteenth century. The introduction of blue-and-white technology is the most noticeable effect of these two historical events and has led to much speculation regarding the possibility of Chinese potters immigrating to Vietnam. Originally used in Vietnam to replace the underglaze iron decoration common on ceramics made during the thirteenth and fourteenth centuries, underglaze cobalt-based pigment

quickly became the most common pigment for painting Vietnamese ceramics. Close ties exist between these fifteenth-century wares and Chinese prototypes of the late fourteenth and early fifteenth centuries. For example, a large fifteenth-century Vietnamese storage jar **(FIG. 114)**, with a lush and rhythmic peony scroll encircling the body, and with lions and deer on the shoulder, derive exclusively from Chinese prototypes. The heavier body and greater freedom in the painting of designs, however, differentiate Vietnamese pieces from their Chinese counterparts.

Although the Chinese annexation of Vietnam may have provided the technology for blue-and-white wares, economic competition was an important stimulus in their development. By the fifteenth century, blue-and-white

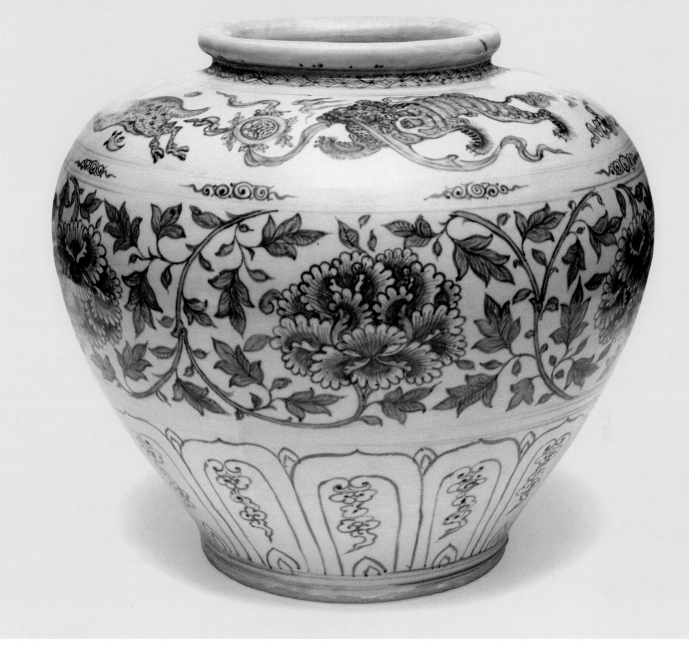

FIG. 114. Storage Jar. 15th century. Vietnam. Stoneware painted with underglaze cobalt blue. H. 13⅛ x Diam. 14 in. (33.3 x 35.6 cm). Asia Society, New York: Mr. and Mrs. John D. Rockefeller 3rd Collection, 1979.98

wares were the most popular ceramics in the world. Active markets for them existed in East Asia, throughout Southeast Asia, and in the Middle East. The Chinese prohibition of exporting ceramics for almost thirty years during this time of high demand provided an ideal opportunity for the Vietnamese ceramic industry to expand, and the Vietnamese reliance on Chinese prototypes was most likely a deliberate attempt to capitalize on the contemporary desire for Chinese-style wares.

Chinese prototypes provided the motif and composition painted on a bowl with cobalt blue **(FIG. 115)**, particularly the peony in the interior. The base of this bowl is covered with a chocolate-brown slip. Examples of ceramics with this type of base have been found in Thailand as

well as Vietnam. There is no technical explanation for covering the base in this fashion, and though this practice may have been the result of aesthetic taste, it may also have served some practical function. For example, a brown-glazed base may have been employed to differentiate vessels used in religious or other types of ceremonies from those used in more mundane settings. It may also have been a type of potter's mark or a counting symbol. The discovery of Thai as well as Vietnamese ceramics with this distinctive coating of the base suggests that while the purpose of this device is unclear now, it may have once been widely recognized in Southeast Asia.

A charming duck-shaped vessel **(FIG. 116)** also attests to the internationalism of Vietnamese traditions during

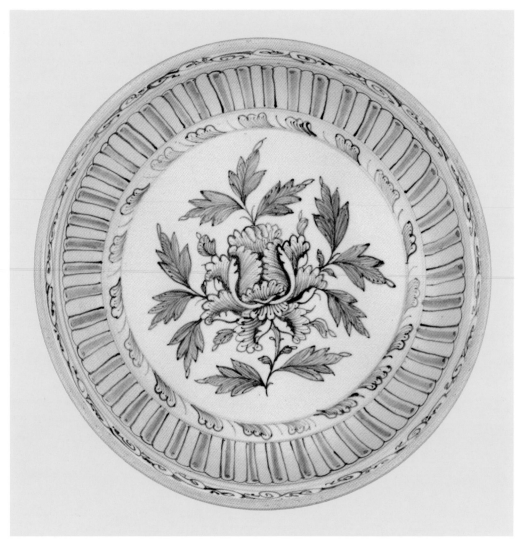

FIG. 115. Bowl. 15th century. Vietnam. Stoneware painted with underglaze cobalt blue. H. 2⅝ x Diam. 9⅝ in. (6.7 x 24.4 cm). Asia Society, New York: Mr. and Mrs. John D. Rockefeller 3rd Collection, 1979.97

this period. The motif of a single or a pair of mandarin ducks often symbolizes marital bliss in China, however duck-shaped vessels were not common in Chinese ceramics. It is possible that the impetus behind the development of this vessel comes from the Indonesian tradition of the *kendi* **(FIG. 117)**. Still used as a drinking vessel in Indonesia today, ceramic and bronze *kendi* were used earlier for pouring libations in Buddhist ceremonies. Vessels of this type were produced in both China and Southeast Asia, primarily for export to Indonesia. Many forms of the *kendi* are known: they are generally distinguished by their spherical bodies and by the use of the neck as a handle as well as for filling the vessel. Vietnamese potters often modified the *kendi* by transforming the spout into the head of an animal or fish and painting scales, fins, or feathers on the sides; the appealing duck-shaped vessel clearly belongs to that tradition.

Duck-shaped containers such as this one are often identified as water droppers because of their small spout

FIG. 116. Duck-Shaped Vessel. 15th century. Vietnam. Stoneware painted with underglaze cobalt blue. H. 5¾ x L. 8 in. (14.6 x 20.3 cm). Asia Society, New York: Mr. and Mrs. John D. Rockefeller 3rd Collection, 1979.99

openings. The four lugs on the vessel are unusual. Perhaps used to secure a cover or to suspend the vessel, lugs of this type are not found on *kendi*, suggesting that this vessel was intended for secular rather than ritual use.

As was true in Vietnam, the flourishing of a ceramic industry in north-central Thailand during the fourteenth through the sixteenth century, and possibly later, has been attributed to Chinese trade policies. Thai ceramics were exported to Indonesia and other lands. The best-known Thai ceramics are green-glazed wares. Often called celadons in the West (after a character in a seventeenth-century French play who wore a green costume), ceramics of this type can be traced back to early periods in Chinese history. Highly prized during the Northern and Southern Song dynasties (960–1279), ceramics with different hues of green glazes were produced in all parts of China. While some of these wares were reserved exclusively for the court, others were manufactured specifically for export throughout Asia.

The most famous of the Thai green-glazed ceramics are known both as Sawankhalok wares and as Si Satcha-nalai and were exported widely. Sawankhalok is the current name of the region where they were produced. During the time of the Sukhothai empire (about 1350–1451), this area was known as Si Satchanalai, a designation now commonly used for these works. Archaeological findings suggest that several hundred kilns were active in this region, producing many types of ceramics in addition to the famous green-glazed wares.

A small covered jar **(FIG. 118)** and the aforementioned *kendi* vessel **(FIG. 117)** are characteristic of Si Satchanalai pieces, particularly those intended for export to Indonesia and the Philippines. Both are covered with an olive-colored glaze and potted using a fairly grainy, dark buff-colored clay that contains traces of red.

A stunning jar **(FIG. 119)** may provide a rare example of ceramics produced in the northern part of Thailand. More than two hundred kilns have been discovered in this area, many of them grouped together and often within close range of major cities. The mountainous terrain in this part of Thailand, which made transportation of materials and products difficult, contributed to the development of local centers of ceramic production. One of the most important kiln areas was Kalong, which was ideally situated to provide ceramics to populated areas such as Wiang Pa Pao and Wang Nua. Ceramics from Kalong are highly esteemed and are considered among the best examples of wares from northern Thailand.

Possibly because of its minimal decoration—just a series of wavy incised lines found along the shoulders—this large green-glazed jar has often been attributed to the kilns at Kalong. However, the pale gray body of this jar distinguishes it from Kalong wares, which were generally made of a pale, buff-colored clay. Shards with a gray body and a pale green glaze, similar to those of this piece, were found in 1979 at Phayao to the east of Kalong, leading some to suggest that this jar is an example of Phayao ware.

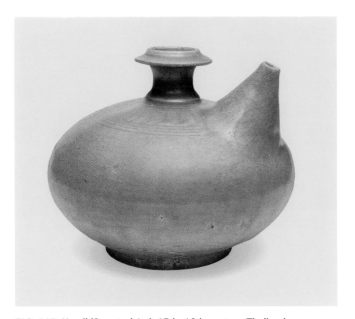

FIG. 117. Kendi (Spouted Jar). 15th–16th century. Thailand. Stoneware with incised design under glaze (Si Satchanalai ware). H. 5¾ x Diam. 6¼ in. (14.6 x 15.9 cm). Asia Society, New York: Mr. and Mrs. John D. Rockefeller 3rd Collection, 1979.94

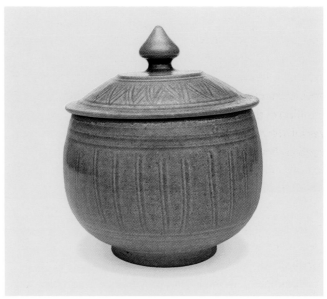

FIG. 118. Covered Jar. 15th–16th century. Thailand. Stoneware with incised design under glaze (Si Satchanalai ware). H. 6 including cover x Diam. 4½ in. (15.2 x 11.4 cm). Asia Society, New York: Mr. and Mrs. John D. Rockefeller 3rd Collection, 1979.93a,b

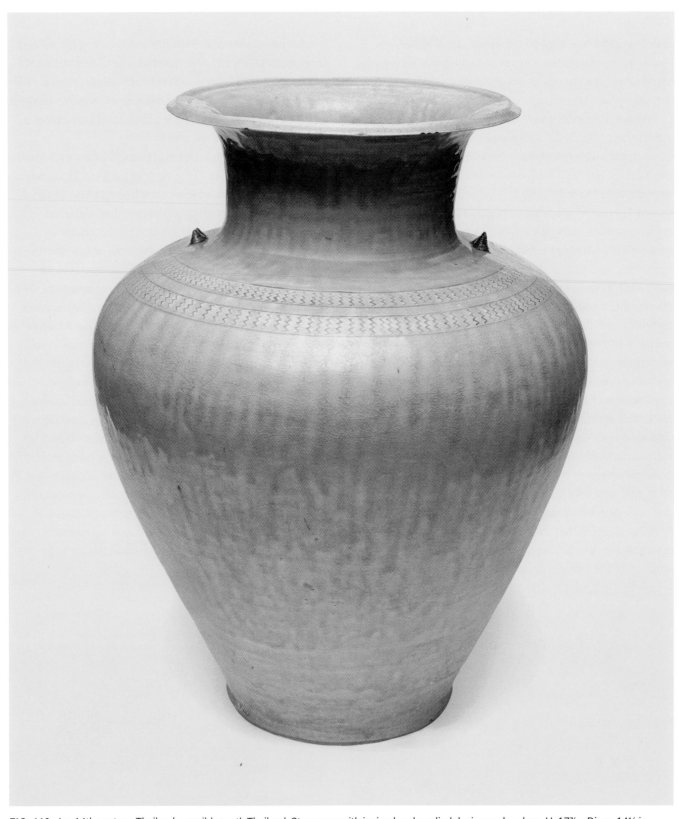

FIG. 119. Jar. 14th century. Thailand, possibly north Thailand. Stoneware with incised and applied design under glaze. H. 17⅞ x Diam. 14¼ in. (45.4 x 36.2 cm). Asia Society, New York: Mr. and Mrs. John D. Rockefeller 3rd Collection, 1979.95

Identification of this jar's provenance is complicated by its having been excavated from a thirteenth- or fourteenth-century stupa in the north-central city of Kamphaeng Phet, which is closer to the better-known ceramic centers that produced Si Satchanalai wares.

Moreover, ceramics made farther north in Thailand were intended primarily for local consumption, and few examples have been found in other regions of the country. When it was unearthed, the jar was filled with a large number of metal and terra-cotta votive tablets. It is

possible that it was brought to Kamphaeng Phet from some other part of Thailand for a specific purpose.

The shape of this jar is similar to that of other examples that have been found in north and north-central Thailand. Funerary urns produced during the eleventh and twelfth centuries at kilns controlled by the Khmer empire of Cambodia provide one possible prototype for this widespread form. The Khmer and the Mon are two of the most important ethnic groups in mainland Southeast Asia, and the differences and interrelationships between Khmer and Mon sculpture are among the most important research areas for the study of the art of mainland Southeast Asia. Scholars have begun engaging in similar studies on the prototypes for Si Satchanalai and other Thai ceramics, and the field awaits further insights into this subject.

An Indonesian Ceremonial Bronze

Early and widespread trade existed in Southeast Asia by the middle of the second millennium BCE. Evidence of this interaction has been through excavations and finds of Dongson bronzes in South China, the Malay peninsula, Vietnam, Thailand, Cambodia, and throughout Indonesia. An ax head with a dramatic curved blade in the shape of a bird from Indonesia is identified with the Dongson culture **(FIG. 120)**. In Indonesia the majority of Dongson axes have been found in the southern part of Sumatra and in Java, although the culture extended throughout the whole Indonesian archipelago up to Western New Guinea.

Bird imagery is common to Dongson objects. In this instance, the entire blade is in the shape of a bird leaning downward, with an eye and beak defined on one side of cast bronze through raised lines. In the belly of the bird are raised linear forms, among which a crested bird can be seen, as well as a shape resembling the ax head itself. On the opposite face, raised lines suggest a feathered creature, but not one conforming to the full shape of the ax head. Images of birds are pervasive throughout the Dongson cultural area. The object was lost-wax cast and has a hollow interior. The symbolism of the avian motifs on this ax may relate to solar cults, clan identifications, or notions of transition and change, but scholars have yet to come to a consensus. The ax was most likely mounted on a pole, but the combination of decoration and lack of heavy wear suggests that this was likely a ceremonial piece rather than a functional weapon or tool.

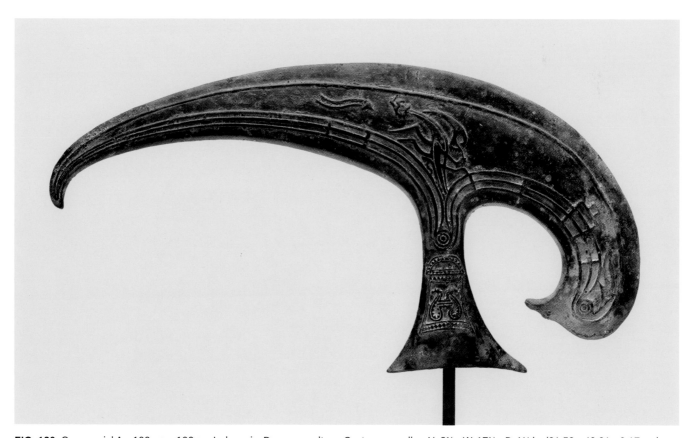

FIG. 120. Ceremonial Ax. 100 BCE–100 CE. Indonesia, Dongson culture. Cast copper alloy. H. 8½ x W. 17¼ x D. 1¼ in. (21.59 x 43.81 x 3.17 cm). Asia Society, New York: Mr. and Mrs. John D. Rockefeller 3rd Collection, 1995.1

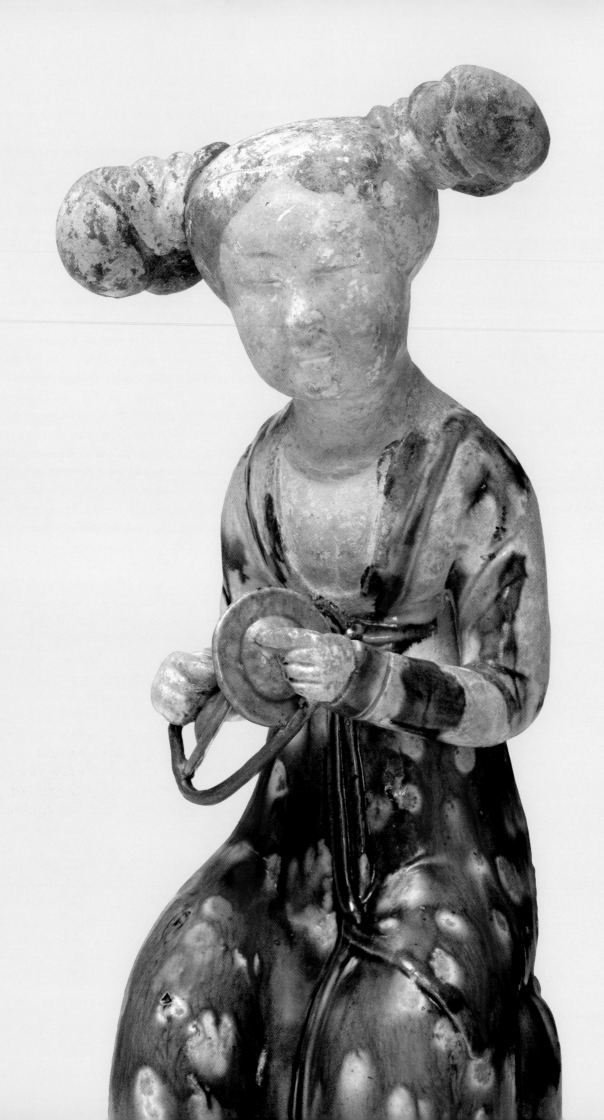

EAST ASIA: CHINA

Chinese Bronzes of the Shang and Zhou Periods

The description of the Shang and Zhou periods in Chinese history as a "Great" Bronze Age stems from both the astonishing variety of shapes and motifs found in the ritual vessels cast during these periods and the sheer technical complexity involved in producing the vessels. The use of bronze is one of the hallmarks of the culture that controlled a large part of northern China during the Shang period, from about 1700 to about 1050 BCE. The Shangs' importance in Chinese history is partially due to their writing system, which was one of the first variants of the Chinese script. Many of the inscriptions dating from this period are recorded on bronze vessels and oracle bones, which played a formative role in Shang-dynasty culture.

The use of oracle bones is one of the links connecting the Shang to earlier Neolithic cultures in China, particularly that of the Longshan, which is known to have flourished along China's northeastern coast. Late-twentieth-century archaeological research in China unearthed bronze vessels that have been attributed to a pre-Shang culture of the Xia period, which may provide a missing link between the Neolithic era and the Shang. Whether these objects are Xia-period evidence remains controversial, however, and at present the study of the development of China's Great Bronze Age remains, in many respects, that of the evolution of Shang culture.

Anyang, the capital city of the late Shang period (1300–1050 BCE), was located in Henan Province in north-central China. The excavation of this site over the past eight decades has revealed large palace buildings, workshops for bronze-casting and other trades, important burials, and numerous spectacular bronze vessels. These provide a wealth of new material and help to define the stylistic evolution of early Chinese bronzes. Moreover, the discovery of the workshops has helped determine that bronze casting during the Shang period was the work of many specialized artisans, each of whom was assigned a very specific task.

A *zun* vessel, which was used for storing and serving wine (**FIG. 121**), typifies the art of the late Shang period. This wine container was cast using several ceramic piece molds, a method that has no parallel elsewhere in the world. In this technique, ceramic molds carved with complicated, multilayered designs were assembled around an interior clay core. Molten bronze was then poured in the space left between the mold and the core. After the bronze had cooled and hardened, the ceramic molds were broken to reveal the vessels. Time and precision were required to make bronze vessels in this fashion, and the control of the raw materials, labor, and technology needed to make such objects was one of the prerogatives of the ruling elite during the Shang period.

Bronze vessels were used in cult rituals, particularly those in which the rulers communicated with their ancestors, and were often buried as part of the grave goods in elaborate tombs. Drinking and eating played an important role in Shang-period ceremonies; the majority of the vessels cast during this time were intended for this purpose. Vessels were often cast in sets whose number of pieces increased according to the owner's rank.

Opposite: Detail of **FIG. 142**

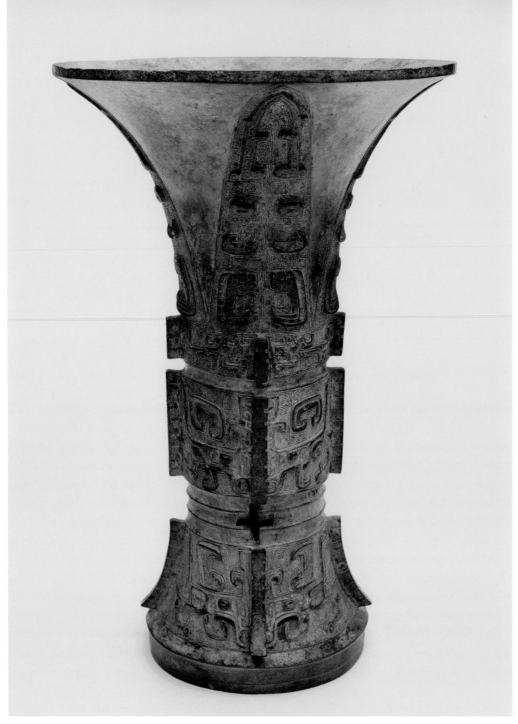

FIG. 121. Wine Vessel: *Zun*. Shang period, 13th–11th century BCE. North China. Copper alloy. H. 13 x Diam. 8¼ in. (33 x 21 cm). Asia Society, New York: Estate of Blanchette Hooker Rockefeller, 1993.3

This *zun* was probably part of a large and complicated group used by the highest-ranking members of society. The striking designs on this *zun* vessel typify the imagery that decorates ritual bronzes of the late Shang period. Interlocked spirals known as thunder-cloud motifs (*leiwen*), executed in a low relief, fill the background of all the decorated areas. A triangular form, alternately identified as a cicada or a plantain leaf, decorates the neck of the *zun* and is filled with C-shaped horns and eyes cast in high relief. Small curvilinear dragons fill a narrow band directly beneath these triangles. The body and foot of the vessel are decorated with a design that consists of

the horns, eyes, and snout of a mythical creature known as the *taotie*.

This *taotie* design is one of the most common images in the decoration of Shang-period bronze vessels. It is also one of the most controversial. The exact meaning of the *taotie* continues to be a source for intense scholarly debate. Some specialists believe that decoration such as the *taotie* evolved as a result of the complicated technique used to make bronzes and insist that the designs have no iconographic or symbolic function. Others point to the importance of bronze vessels as ritual objects, arguing that given such use, their significant and ubiqui-

tous motifs must have some purpose or meaning. The scholars who argue that Shang motifs have meaning outnumber those who disagree; the current trend in scholarship is toward the interpretation of these motifs and symbols.

Debate over the interpretation of the *taotie* began as early as the Song period (960–1279), when the study of these early ritual vessels was part of a broader interest in antiquarianism fostered by the court. Some Chinese texts describe the *taotie* as a type of monster mask, suggesting that it may have been intended to serve as a warning against gluttony and overindulgence. Modern scholarship has reiterated the significance of the masklike quality of this motif, stressing the critical role that masking plays in the rituals of shamanism. One of the earliest religious systems in the world, shamanism is named for the role of the priest or shaman, an individual who either through her or his own powers, or by assuming the powers of an animal or bird, is able to transcend the mortal sphere and ascend to the heavens to communicate with gods or ancestors.

Early shamanistic motifs have been identified on examples of painted pottery as well as carved jades produced in some of the earliest Neolithic cultures of China; these motifs may provide a source for the role of such imagery in Shang culture. The differences between the shamanistic imagery depicted on Neolithic pottery and that of symbols such as the *taotie* may reflect the changes in religious practices that occurred between the Neolithic and Bronze ages. By and large, the imagery found on bronze vessels is much more static than the freer motifs painted on earlier pottery. This static quality may be a result of the way Shang-dynasty bronzes were created. On the other hand, it may also reflect the rigidity and hierarchical structure of Shang society, in which the ruler also functioned as a priest or shaman, and changes in shamanistic imagery over time may have reflected subtle changes in religious practices.

In addition to ritual vessels, bronze was used to make weapons such as axes, halberds, spearheads, and arrowheads during the Shang and Zhou periods. The extremely narrow point of a spearhead **(FIG. 122)** and the articulation where the shaft joins the head is typical of pieces made during the Shang dynasty. Spearheads dating to later periods are generally broader. The decoration of this spearhead is cast along the top and bottom of the shaft. There are two registers of decoration; at the top of the shaft loose thunder-cloud motifs are cast in low relief, while at the bottom, granulation provides the background for the decoration. The curving forms cast in

high relief against these two backgrounds bear some resemblance to the small images of dragons that decorate the *zun* vessel, but they have become too abstracted to identify.

The gradual disappearance of the *taotie* and other Shang-period motifs in the bronze art of the subsequent Zhou period can perhaps be understood as a result of the changing worldview and the new uses of bronze vessels that mark this period. The Zhou, one of a number of peoples who inhabited parts of northwestern China, were alternately allied and in conflict with the Shang. Around 1050 BCE, the Zhou had enough power to defeat the Shang, thereby becoming the mightiest of the many different groups of people living in China during the Bronze Age. After conquering the Shang, the Zhou established a capital in Xi'an in Shaanxi Province. This early part of the Zhou's rule is known as the Western Zhou period, after the location of the capital. Pressures from rivals ultimately forced the Zhou to move the base of their power farther east to Luoyang in Henan Province. The second half of their rule is known as the Eastern Zhou period and was one of the great ages of Chinese culture, probably best known for being the age during which Confucius lived. The Eastern Zhou period is further subdivided into two eras, the Spring and Autumn (770–475 BCE), and the Warring States (475–221 BCE); as its name suggests, the latter was marked by frequent conflict.

FIG. 122. Spearhead. Shang period, 13th–11th century BCE. North China. H. 6¼ x W. 1½ in. (15.9 x 3.8 cm). Copper alloy. Asia Society, New York: Estate of Blanchette Hooker Rockefeller, 1993.4

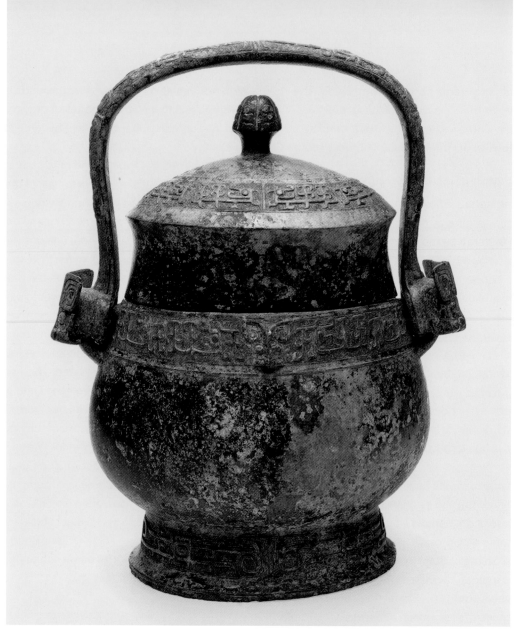

FIG. 123. Wine Vessel: *You*. Western Zhou period, about late 11th–early 10th century BCE. North China. Copper alloy. H. 12⅝ including handle x W. 9½ across handle attachments in. (32.1 x 24.1 cm). Asia Society, New York: Mr. and Mrs. John D. Rockefeller 3rd Collection, 1979.101a,b

Bronze vessels were items of luxury and power prized throughout the entire Zhou period, and the changes in the types and decoration of these vessels illustrate the many cultural and political shifts that characterize this long and complicated era of Chinese history. Bronzes made in the early part of the Western Zhou period illustrate a reliance on Shang prototypes, as well as subtle changes in shape and imagery that reflect the culture of the Zhou and of those with whom they had ethnic or political ties.

The placement of the handles of a *you* vessel (FIG. 123)—on either side rather than on the front and back—and its simple form help date this vessel to the early part of the Western Zhou dynasty in the eleventh to early tenth century BCE. The shape of the bucket, the horned animals that mark the joint between the handle and the vessel, and the decoration of writhing narrow

dragons against a background of thunder-clouds found on the handle, the lid, and along the top and bottom of the vessel derive from the art of the late Shang period. The words "father Gui" (*fu gui*) are cast into both the cover and body of this bronze vessel and may be a reference to the person who commissioned the piece.

A similar inscription is cast into the cover and interior of a *you* vessel (FIG. 124) of slightly different shape. There are three characters, the first two of which are inside a symbol known as a *yaxing*. *Fu ding* has been suggested as a possible reading of the first two characters; the third remains undeciphered. Traditional *taotie* motifs, set against a background of thunder-clouds, decorate the cover and two registers on the body of this *you*, which was used for storing or serving wine. The vessel's tall shape and the band of circles enclosing the main register

FIG. 124. Wine Vessel: *You*. Western Zhou period, about late 11th century BCE. North China. Copper alloy. H. 14⅞ including handle x W. 8¾ across flanges in. (37.8 x 22.2 cm). Asia Society, New York: Mr. and Mrs. John D. Rockefeller 3rd Collection, 1979.100a,b

FIG. 125. Food Vessel: *Gui*. Western Zhou period, about late 11th–early 10th century BCE. North China. Copper alloy. H. 7½ x W. 12¼ across handles in. (19.1 x 31.1 cm). Asia Society, New York: Mr. and Mrs. John D. Rockefeller 3rd Collection, 1979.102

derive from the bronze art of the Shang period. The addition of realistic horns to the *taotie* motif on the lid and lower register transforms the motif into an image resembling an animal, perhaps a buffalo.

An interest in depicting real animals, a recurring feature in the art of the Western Zhou, is often associated with the art and cultures of groups living in the southern parts of China, and its evidence in the art of the Western Zhou reflects Zhou ties to them. The elaboration of the flanges along the edges of this wine vessel into distinct yet abstract forms typifies the slightly baroque quality of decoration that is also associated with the Western Zhou period. The combination of Shang-inspired decoration and Western Zhou innovations help to date this *you* to the earlier part of the Western Zhou period.

The forceful cow heads decorating the tops of the handles on a *gui* food vessel **(FIG. 125)** are another example of the interest in animals found in early Western Zhou art. Yet the decoration of this bronze, in particular the *taotie*, continues the Shang decorative repertory. An inscription reading "made this precious vessel" (*zuo baoyi*) is cast into the base of the interior of the vessel. As can be seen by comparison with other examples, such as the later *gui* discussed next, this vessel once had a cover that may have been turned over and used as a serving plate.

The addition of a square podium to a *gui* food server **(FIG. 126)** is typical of the changes that occurred in the shapes of vessels during the late Western Zhou period. The wavelike patterns decorating the vessel, its cover, and base; the dragon-shaped handles embellished with a small figure of a curly tailed tiger crawling up and biting the dragon; and the elaborate articulation of the top part of the cover all exemplify this style. The continuing political importance of bronze vessels is illustrated by the fact that this vessel, despite having a late–Western Zhou shape and design, can be dated to the sixth century BCE, during the Eastern Zhou dynasty. This later date is based on the discovery of a *you* vessel with the same pattern and similar handles on the slope of Mount Mang close to the Eastern Zhou capital of Luoyang in Henan Province. The inscription inside that *you* indicates that it was commissioned by the duke of Qi in honor of the marriage of his second daughter. Qi, one of the most important states of the Eastern Zhou period, had its base in Linzi in the heart of Shandong Province. The excavation of the inscribed *you* farther west in Henan suggests a marriage alliance between Qi and the royal Zhou clan. Two such marriages, one in 603 BCE and the other in 558 BCE, are recorded and provide a range of dates for the *you*, as well as for related pieces such as this *gui*.

Both the Asia Society's *gui* and an identical piece in the collection of the Palace Museum in Beijing are said to have been unearthed at Linzi, a similarity that, together with the prominence of the wave pattern and the dragon-tiger handles on the two vessels, further strengthens their association with the state of Qi. Vessels commissioned by the Qi are noted for their conservative shapes and designs. Their continuation of Western Zhou styles can be interpreted as both a matter of the taste of the Qi and a statement about their continuing alliance with the Zhou.

The experimentation with shapes and abstraction of designs seen in the latter part of the Western Zhou period continues throughout the entire Eastern Zhou. The shape of a canteen **(FIG. 127)** now often called a "pilgrim's flask" (*bian hu*) became popular around 400 BCE. New methods were used to decorate this flask: the primary embellishment consists of square panels filled with an abstract interlaced design, a motif often called the "hook and volute." These decorative panels were created using molds that had been stamped rather than hand carved. In addition, the raised areas between these panels and the triangular forms decorating the neck were inlaid with a reddish copper; the use of this inlay helps to date this vessel to the fourth century BCE.

The use of copper inlay on this canteen heralds the importance of inlay as the primary decorative technique in Chinese bronzes made from the fifth through the third century BCE. Although this type of decoration differs from that found in earlier Chinese bronzes, the methods of manufacture remained unchanged. The bronzes were cast with depressions that were later inlaid with several materials. Turquoise was the earliest material used as an inlay, and examples dating to the Shang period have been unearthed. Copper was the most commonly used material

FIG. 126. Food Vessel: *Gui.* Eastern Zhou period, about 6th century BCE. China, reportedly found in Shandong Province. Copper alloy. H. 12¾ including cover x W. 15½ across handles in. (32.4 x 39.4 cm). Asia Society, New York: Mr. and Mrs. John D. Rockefeller 3rd Collection, 1979.103a,b

FIG. 127. Flask. Eastern Zhou period, 4th century BCE. North China. Copper alloy inlaid with copper. H. 14½ x W. 13¾ in. (36.8 x 34.9 cm). Asia Society, New York: Mr. and Mrs. John D. Rockefeller 3rd Collection, 1979.104

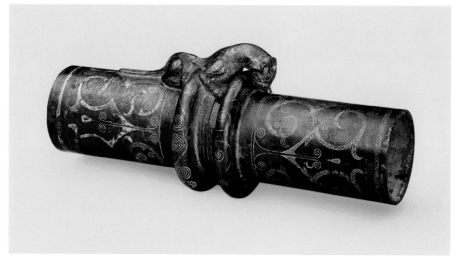

FIG. 128. Pole Fitting. Eastern Zhou period, 3rd century BCE. North China. Copper alloy inlaid with silver. H. 2¾ x L. 7⅛ x W. 2¼ in. (7 x 18.1 x 5.7 cm). Asia Society, New York: Mr. and Mrs. John D. Rockefeller 3rd Collection, 1979.105a,b

at the beginning of the Warring States era, while gold and silver became popular in the second half of the era.

Silver inlay was used to create the flowing spirals and curves that embellish a pole fitting with a clasp in the shape of a crouching tiger (FIG. 128). The fluidity and openness of the inlay decoration help to date this piece to the third century BCE, because the design of earlier bronzes with this method of decoration is generally denser and more static.

Also called "tube couplers," pole ornaments such as this were most likely used to join two parts of a wooden pole. The elegance of this example suggests that is was used as a decorative element for a chariot, a palanquin, or some other extravagance.

The appearance of abstract designs and inlaid decoration and the use of bronze to make luxurious and beautiful items for everyday consumption illustrate the shifting roles of bronze items during the last part of the Zhou dynasty. Bronzes were no longer a privilege of the ruling class, as vessels once reserved primarily for rituals were now used at state banquets, in family festivities, as diplomatic gifts, and in dowries. Despite this transformation that occurred in the use of bronzes during the Shang and Zhou dynasties, the forms and decoration of the vessels cast during these periods had a continuing impact on the development of Chinese art. Shapes such as the *zun* appeared in Chinese ceramics that for hundreds of years played important roles as ritual objects on family altars; likewise, the ubiquitous *taotie* motif endured for centuries—as a decorative motif on rings, door handles, and ceramics.

Han Dynasty Bronzes

During the Han dynasty bronze was used to make a wide range of vessels as well as weights, tallies, sculptures for tombs, lamps, censers, coins, mirrors, and other objects. The Han dynasty, which lasted over four hundred years, completed the reunification of China begun at the end of the Warring States period by the Qin dynasty. The Han dynasty is divided into two eras: the Western Han, which lasted from 206 BCE to 9 CE, when the capital was at Xi'an, and the Eastern Han, which ruled from Luoyang between 25 and 220 CE. (The period from 9 to 23 CE is known as the Wang Mang interregnum, after the usurper who briefly assumed the mantle of the ruling Liu family.)

A cylindrical vessel supported on legs (FIG. 129) is one of the most common forms that was used during the Han dynasty. Numerous examples were made in bronze and

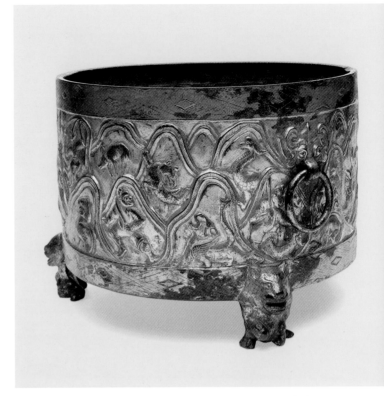

FIG. 129. Wine-Warming Vessel: *Wenjiazun*. Western Han period, 1st century BCE. China. Gilt copper alloy. H. 6¼ x Diam. 8¼ at mouth in. (15.9 x 21 cm). Asia Society, New York: Mr. and Mrs. John D. Rockefeller 3rd Collection, 1979.107

clay, and works made of jade are also known. The 1963 excavation of two bronze vessels in this cylindrical shape from a tomb in Youyuxian in Shanxi Province provided useful evidence for determining the function of the type. One of the excavated pieces had an inscription that gave the date of its production as 26 BCE and described its function as a wine-warming vessel (*wenjiazun*). Such an identification of footed cylindrical vessels helps to distinguish these pieces from a type of flat-bottomed vessel also used during the Han dynasty as a container for cosmetics (*lien*). Both wine-warming vessels and cosmetic containers have been found with decorations painted in the interiors. The presence of such decorations, which would be covered by any contents, probably indicates that at least some of these pieces were not intended to be functional and instead were most likely used as tomb goods.

The legs of this vessel are bear-shaped and the populated mountain scape on the body exemplifies the type of decoration often found on clay and bronze wine warmers and cosmetic containers. Hunters and anthropomorphic figures with bearlike heads pursue tigers, lions, bears, and griffins among the rolling hills. Two figures walk through the mountains carrying long poles and wear distinctive hats that are astonishingly similar to the

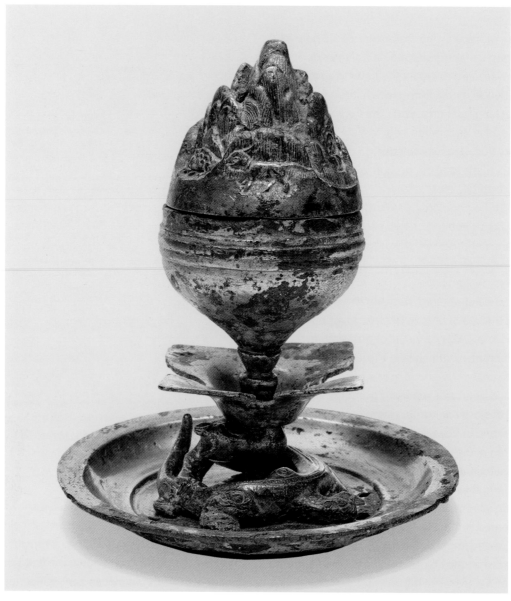

FIG. 130. Censer in the Shape of Mount Bo (*Boshanlu*). Eastern Han period, 1st–2nd century. North China. Gilt copper alloy. H. 5½ x Diam. 4⅝ saucer in. (14 x 11.7 cm). Asia Society, New York: Mr. and Mrs. John D. Rockefeller 3rd Collection, 1979.109a,b

conical straw hats worn in China in the nineteenth and twentieth centuries. Spritelike creatures also inhabit this world.

Landscape and hunting scenes were common in the art of the Western Han dynasty, and many different meanings have been attributed to this type of imagery. The scenes of hunting illustrate the importance of this sport for royalty.

Images of mountains are also often interpreted as representations of the mythical land of Penglai, an imaginary mountain paradise inhabited by immortals and other semidivine creatures, said to be located in either the western mountains or the eastern seas. Belief in magical worlds such as Penglai began as early as the fourth century BCE. By the Western Han period interest in the

land of the immortals had become more widespread and more concrete. It was believed that such a paradise could be found and that an elixir of immortality could be obtained there.

The numerous humanoid and animal mythical beings exemplify the intense interest in auspicious omens (*xiangrui*) found in Han thought and culture. Many of the more common motifs in the visual arts—such as dragons, unicorns, winged horses, and other composite creatures, as well as images of beings that are not entirely human— are examples of the amazing variety of fortuitous signs cited in Han literature and historical records. The names and descriptions of many of the mythical beasts and other auspicious creatures are cited in literature from the Warring States–period Chu culture, and the popularity of

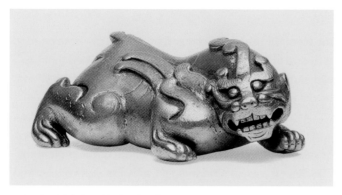

FIG. 131. *Bixie* (Mythical Animal). Western Han period, 206 BCE–9 CE. North China. Gilt copper alloy. H. 1½ x L. 3⅝ x W. 2¼ in. (3.8 x 9.2 x 5.7 cm). Asia Society, New York: Mr. and Mrs. John D. Rockefeller 3rd Collection, 1979.111

these motifs has been interpreted as a reflection of the continuing impact of the early southern civilization on the art and thought of the Han dynasty. The spritelike beings depicted on this wine-warming vessel were common images in the southern part of China once ruled by the state of Chu and are believed to represent immortals (*xian*) or transformed beings that subsist on dew and jade.

The sense of movement in the rolling shapes of the mountains and the lively depiction of the figures and animals in the landscape help date this cylindrical vessel to the first century BCE. By contrast, the more static composition of the landscape and the animals (dog, tortoise, and monkey) depicted in the upper part of an incense burner **(FIG. 130)** help to date it to the first or second century CE. Cast in the shape of a mythical mountain, this censer rises from the body of a flower that is supported on the back of a coiled dragon, which rests on a small plate. In earlier examples, dragons are often incised into the plate rather than fully carved; the sculptural treatment of this dragon helps date the piece to the Eastern Han period.

Made in both ceramic and bronze, incense burners in this shape are now commonly known as Mount Bo or *boshan* incense burners. The use of these censers can also be traced to the prevailing interest in magical paradises and immortality. The mountaintops of these censers were made in two parts and open in the center to allow for the placement and lighting of incense. The smoke from the incense escapes through small holes cleverly hidden in the top part of the mountains. This smoke was believed to represent cloud-breath or *yunqi*, an auspicious omen that was generally depicted in the visual arts as trailing wisps of smoky clouds. The sight of the smoke rising from a censer such as this one would have been interpreted as a tangible manifestation of cloud-breath, making such censers invaluable tools for

adepts in the various cults of immortality. Such censers were also used, however, to mask odors in bathrooms and to perfume the air at banquets.

A small bronze sculpture of a mythical animal known as a *bixie* may also reflect the Han-period fascination with auspicious portents and magical animals **(FIG. 131)**. Believed to appear during eras of good government, the vaguely feline *bixie* is winged and has two horns. The animal's crouching position and sense of menace help to date the sculpture to the Western Han period. It is difficult to determine the intended function of this intriguing sculpture; similar smaller pieces were weights for floor coverings, but this large example might have been sculpted for a tomb.

The function of a small bronze image of a standing horse **(FIG. 132)** is also unclear. Horses made of either ceramic or bronze were commonly used as tomb sculptures through the entire Han period, and their popularity reflects the role of the horse as a luxury. The short legs, stubby body, knotted tail, and arched neck of this horse are typical of sculptures of horses during the Eastern Han dynasty, helping to date this work to the first or second century CE.

By the Eastern Han period, the preeminence awarded to bronze as a material favored in early Chinese culture had diminished, and clay became the most common material for tombs, sculptures, and everyday objects. Metalwork, whether in bronze or other materials, did not become dominant again until the Tang dynasty (618–906), when the importation of Persian and Central Asian goods and techniques spurred the development of a new metalwork tradition in China.

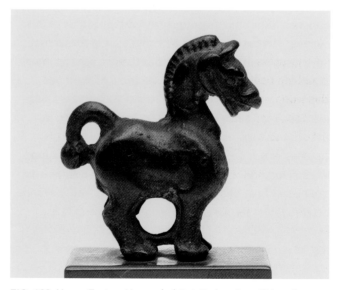

FIG. 132. Horse. Eastern Han period, 1st–2nd century. China. Copper alloy. H. 2⅜ x L. 2⅛ x W.⅝ in. (6 x 5.4 x 1.6 cm). Asia Society, New York: Mr. and Mrs. John D. Rockefeller 3rd Collection, 1979.106

Early Chinese Ceramics

The production and decoration of ceramics are inseparable from the development of Chinese culture. Made throughout Chinese history, ceramics have been used as ritual and utilitarian objects, as furnishings for tombs, as marks of imperial status, as luxuries for display and for trade, and for use in daily life.

Ceramic vessels are associated with most of China's Neolithic civilizations. The most striking and numerous are those produced by the Yangshao culture that flourished in north-central and northwestern China from about 5000 to 1500 BCE. The Yangshao culture is generally divided into six phases, each of which is named for an archaeological site and characterized by the creation of earthenware painted in shades of black, red, and brown. The shapes and decorations of these ceramics, however, vary from phase to phase.

The density and complexity of the decoration painted on a large storage jar (**FIG. 133**) are characteristic of ceramics from the Gansu Yangshao culture (about 3000–1500 BCE). Yangshao culture flourished in Gansu and Qinghai provinces in the northwest, after the earlier nuclear Yangshao culture (about 5000–3000 BCE) located farther east in Henan and Shaanxi provinces. The swirling curvilinear patterns that decorate the upper half of this jar and the serrations along the edges of the lines used to paint these forms typify ceramics made during the Banshan phase of the Gansu Yangshao, generally dated to the early third millennium BCE.

Both decorated and undecorated ceramics were produced during the Yangshao culture. It is generally assumed that painted ceramics such as this jar were used either as ritual objects or to show the high status of their owners. The two large lugs on either side of the jar may have been used for carrying, while the two smaller ones at the top could have helped to secure a cover. It has also been suggested that the lower half of such vessels were left unpainted since they would be partially buried in the ground, providing some stability.

This enormous jar was made of earthenware using the coil method. Earthenware is a coarse and somewhat grainy clay fired at a fairly low temperature. Vessels made of it are rather fragile and fairly porous. Coiling is a method associated with only the earliest Chinese ceramics, as most later pieces were thrown on the wheel. During the Neolithic period, mats and other objects were used to turn and shape the clay. It is generally accepted that the wheel used to form ceramics had been invented in China by the end of the Yangshao period.

After shaping the vessel, the designs were painted on, and then both the form and the decoration were burnished, or rubbed down, using a stone or some other implement. The design was painted with slip, a thin mixture of clay and water and, in this instance, colored using mineral pigments.

A covered jar dating to the late third or early fourth century (**FIG. 134**) illustrates two important technical developments: the use of stoneware for the body and the application of glaze. Created from a more refined clay that is fired at a higher temperature than earthenware, stoneware is stronger than the former. First produced in some quantity in South China during the Shang dynasty, high-fired wares were commonly used in China from the second through the thirteenth centuries.

A glaze is a mixture of water and substances containing silica, which vitrifies or turns glassy during firing, and often other ingredients for color or texture. Glazes were known in China as early as the Shang dynasty (about 1700–1027 BCE); it has often been speculated that the development of glaze technology was spurred by the accidental production of a glaze when kiln ash that had fallen on the ceramics fused with the bodies. Glazes can be colored by the addition of pigments such as iron oxides, as a result of different methods of firing, or through a combination of both. The first Chinese glazes were generally green, gray, or yellowish because this range of colors was easily produced during firing by the addition of an iron oxide. The gray-olive glaze that coats this covered jar makes it an early example of the type of green-glazed wares, commonly known as celadons, for which China remains justly famous—although the better-known green-glazed wares date later in Chinese history.

This charming jar is an example of Yue ware, a type of ceramic produced for several centuries in a region known as Yue in southeastern China in Zhejiang and Jiangsu provinces. It was not until the Tang dynasty (618–906), however, that the term *Yue* was applied to early ceramics produced in this region of China. Yue wares were first produced in some quantity during the Eastern Zhou period (771–221 BCE), and they make up the majority of tomb goods found in burials dating to this period. Production of these wares continued until the ninth century,

Opposite: **FIG. 133.** Storage Jar. Neolithic period (ca. 10,000–2,000 BCE), Gansu Yangshao culture, Banshan type (ca. 2700–2300 BCE), about 3rd–2nd millennium BCE. China, Gansu or Qinghai Province. Earthenware painted with red and black slips. H. 15⅝ x Diam. 13¾ without handles in. (39.7 x 34.9 cm). Asia Society, New York: Mr. and Mrs. John D. Rockefeller 3rd Collection, 1979.125

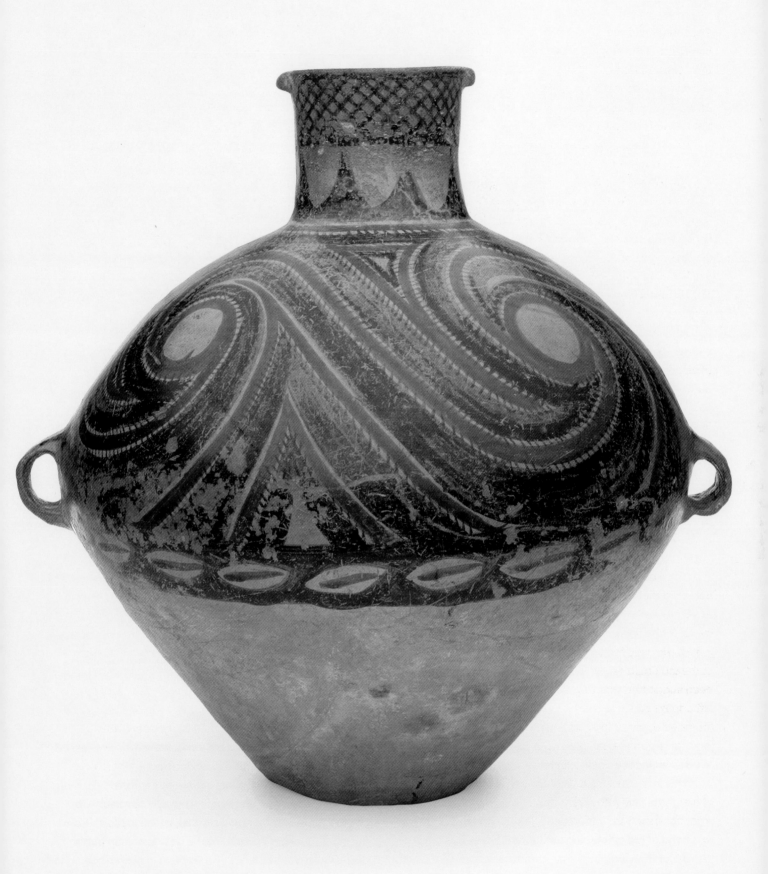

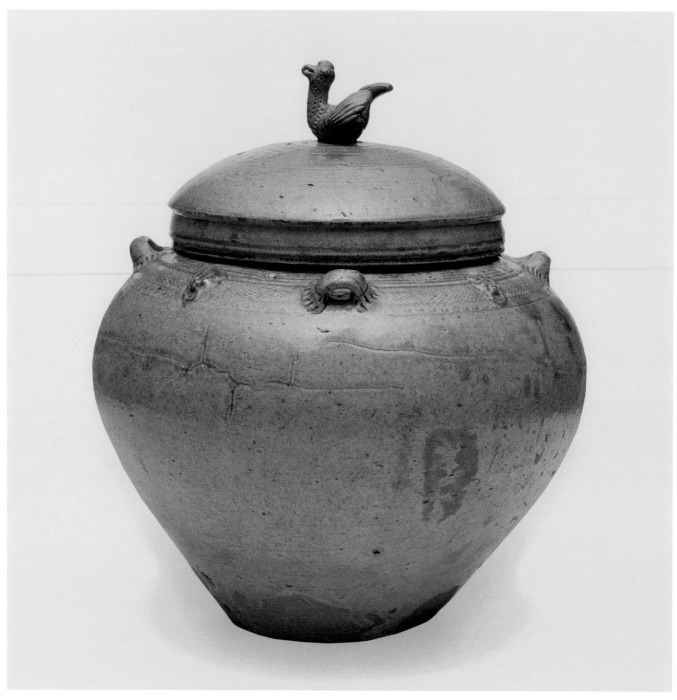

FIG. 134. Covered Jar. Western Jin period, about late 3rd–early 4th century. China, Zhejiang Province. Stoneware with impressed and applied design under glaze (Yue ware). H. 10⅞ including cover x Diam. 10 in. (27.6 x 25.4 cm). Asia Society, New York: Mr. and Mrs. John D. Rockefeller 3rd Collection, 1979.126a,b

and Tang-period examples were traded with nations as diverse as Indonesia and Egypt.

This jar dates to the Western Jin dynasty (265–316). A delightful bird with outstretched wings serves as the knob for the cover. Impressed into the shoulders of the jar is a band of crosshatching with borders. The evenness of the decoration indicates that it was made using a tool with a raised pattern, as incised decoration that is carved freehand into the clay presents a more irregular pattern. Four lugs and four *taotie* faces with false handles dan-

gling from their mouths were applied over the impressed pattern after the body had been formed.

Applied decoration was also used for the designs on a large earthenware storage jar partially covered with a green-colored lead glaze **(FIG. 135)**, made in North China during the Sui period (581–618). The use of lead in the glaze, which makes it highly refractive, can be traced back to the third century BCE. The animal masks and floral medallions that were affixed to the sides were covered by this glaze. Like the *taotie* masks used to decorate the

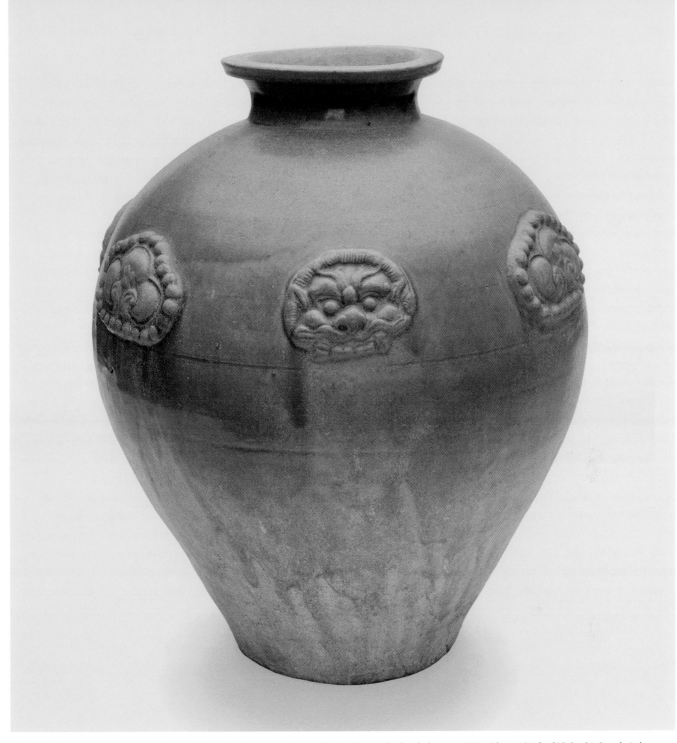

FIG. 135. Storage Jar. Sui period. North China. Earthenware with applied design under lead glaze. H. 16⅝ x Diam. 13½ in. (42.2 x 34.3 cm). Asia Society, New York: Mr. and Mrs. John D. Rockefeller 3rd Collection, 1979.127

Western Jin–period covered jar, the animal masks represent a traditional Chinese motif that can be traced back to the Shang and Zhou dynasties. The floral medallions, on the other hand, provide evidence of the interest in Central Asian decoration that is found in the ceramics produced in northeastern China during the sixth century CE; the use of relatively large applied decorations is also attributed to that source.

The sixth-century interest in Central Asian decorative motifs was in part the result of the political and economic ties between the different kingdoms in China and the various peoples of Central Asia. Motifs inspired by Central Asian imagery are also found on Buddhist and funerary sculpture dating to this period. This use of foreign motifs, particularly from Central and West Asia, continued and intensified during the Tang dynasty, and such exoticism is one of the most important aspects of Tang art during the seventh and early eighth centuries.

The shape of a three-legged dish decorated with a design of clouds and flowers **(FIG. 136)** was derived from

similar shapes used in the metalwork of Iran and western Central Asia. While the clouds are a traditional Chinese motif, the stylization of the flower into a geometricized shape reflects foreign aesthetics. The multicolored lead glazes used to decorate this piece are known as three-color or *sancai* glazes.

Several techniques were used to decorate this earthenware dish: the design of flowers and clouds was first stamped into the clay, then portions of the design were covered with glazes of different colors. The clouds and part of the stylized flower were covered with a blue glaze, while another part of the flower was covered with a green glaze, as was the outer rim of the plate. Areas on the inside of the dish were covered with some type of glaze-resistant material, possibly wax, before golden brown glaze was used to coat the inner part of the dish and most of the base. The resist material prevented the glaze from adhering and allowed unglazed areas to become part of the overall decoration. Three-color or *sancai* pieces are among the best-known ceramics of the Tang dynasty, and some of the finest examples are found among the many sculpted ceramic tomb furnishing figures made during this period.

Although *sancai* pieces are the most numerous of extant Tang-period ceramics, several other types of wares were also produced. Among these, green-glazed wares were the most important for the future development of Chinese ceramic technology. Stoneware covered with

black, dark brown, or very dark blue glazes were also produced throughout North China during the Tang period. Black glazes appear to have been used primarily to decorate common objects rather than those intended for court or as burial goods. Similar glazes continued to be used for household goods during the Northern Song period (960–1127), and stoneware of this type remain difficult to date precisely.

The very bulbous body of a wide-mouthed jar **(FIG. 137)** that was probably used for storage suggests that it dates to the eighth or ninth century, because many smaller jars of a similar shape date to the Tang period. In comparison, Song-dynasty examples of this type of jar generally have much straighter sides.

Remnants of an inscription written in black ink on the base of a cuspidor-shaped jar **(FIG. 138)** help to date this piece to about 835 CE, as it provides the year the piece was purchased. Written with a brush in a calligraphic style common during the Tang period, the inscription is badly abraded and difficult to read; both 835 and 855 have been suggested as possible readings of the date, although the former is generally accepted by scholars.[1]

The glaze on this jar is thicker, blacker, and more elegant than that partially covering the storage jar. Moreover, the fact that the piece was inscribed suggests that it might have been considered important. However, the function of this small jar remains elusive. Although it is in the shape of a cuspidor, or spittoon, it is possible that

FIG. 136. Footed Dish. Tang period, 8th century. North China. Earthenware with stamped design under multicolored lead glazes (*sancai* ware). H. 2⅛ x Diam. 9½ in. (5.4 x 24.1 cm). Asia Society, New York: Mr. and Mrs. John D. Rockefeller 3rd Collection, 1979.128

FIG. 137. Jar. Tang period, 8th–9th century. North China. Stoneware with glaze. H. 9⅜ x Diam. 11 in. (23.8 x 27.9 cm). Asia Society, New York: Mr. and Mrs. John D. Rockefeller 3rd Collection, 1979.130

this jar may have been used in the drinking of tea, possibly as a receptacle for the leaves that are left behind. Tea drinking was popular in China during the Tang dynasty, and this elegant vessel might be an early example of an object that was dedicated to this practice. Most of the well-known tea bowls and other ceramics associated with the drinking of tea in China date to the Song period.

1. The inscription has been read as *taihe jiu nian* [or *i mao*] *san yue (?) ri ma*, which is translated as "purchased on the (?) day of the third month, the ninth year of the Taihe."

Right: **FIG. 138.** Jar. Tang period, about early 9th century. North China. Stoneware with glaze. H. 4⅜ x Diam. 6¼ in. (11.1 x 15.9 cm). Asia Society, New York: Mr. and Mrs. John D. Rockefeller 3rd Collection, 1979.129

Sculpture for Tombs

The use of clay to make sculptures and other furnishings for tombs is one of the most distinctive aspects of Chinese ceramic history, and some of China's most endearing sculptures were produced in this medium. The Chinese belief in and desire for an afterlife that continued the pleasures and activities of the world is reflected in the use of ceramics to make models (known as spirit goods or *mingqi*) of attendants, entertainers, pets, domestic animals, and a host of worldly goods, all of which would be needed and used by the deceased in his or her after-life. Tomb furnishings also reflected the wealth, status, and interests of the deceased, while equipping tombs with such items was often understood as an act of homage on the part of one's family and descendants. Although certain tomb goods were made of bronze, jade, and other materials, clay was most commonly used.

Large retinues of warriors and attendants, as well as models of architecture and household goods, have been excavated from some of the sumptuous burials that date from the Han dynasty (206 BCE–220 CE). The elegant slimness, quiet pose, clothing, and hairstyle of a standing attendant **(FIG. 139)** are comparable to those found in recently excavated tombs dating to the early part of the Western Han dynasty; it is likely that this figure was once part of a larger retinue of attendants buried in the tomb of a high-ranking person. The position of the figure's joined hands suggests that they may once have held some type of object, further helping to identify this figure as an attendant.

Determining the gender of this sculpture is an interesting study in assumptions about this topic. Figures like this were once considered to be males because of their costumes: two robes worn over a pair of trousers. Figures wearing similar clothing that have been excavated in tombs such as that of Renjiaopo in Xi'an in Shaanxi Province are identified in the Chinese excavation reports as female, although with no accompanying explanation. Additional female figures from the Renjiaopo tomb kneel and wear full-length robes and long hair. The presence of two different types of female attendants suggests that each may have served a different function. The bun at the back of the head of this standing attendant appears on both male and female figures from the Western Han dynasty and may have been a sign of rank rather than gender.

Made of earthenware, this standing female was formed using a mold. Before firing, the entire figure was covered with a white slip; the traces of red pigment on the face and

FIG. 139. Female Attendant. Western Han period, 2nd century BCE. North China. Earthenware with slip and traces of pigment. H. 21½ x W. 6 x D. 5 in. (54.6 x 15.24 x 12.7 cm). Asia Society, New York: Mr. and Mrs. John D. Rockefeller 3rd Collection, 1979.110

black pigment on the hair suggest this figure may once have been painted, giving it a more naturalistic effect than it now has. The figure's stillness most likely reflects its position as an attendant, for warriors and entertainers from the same time are generally shown in livelier postures and with more animated features.

From the third to the early seventh century, China was subdivided under the rule of several different dynasties, many of which were of foreign origin. Fewer tomb sculptures were produced during this period, in part because of the warfare in China, and in part because of the different religious practices of the rulers of different states. Tomb sculptures became popular again under the Sui and Tang dynasties, when large parts of a relatively wealthy China were under the control of the Han-Chinese. Although tomb sculptures continued to be used in China after the Tang dynasty, they were not as prevalent after the Song period as they had been in earlier periods.

Many tomb sculptures from the Tang period (618–906) are coated with the vibrant lead glazes known as three-color or *sancai*. A large standing figure of a civil official **(FIG. 140)** illustrates this technique. His outer robes were tinted amber-brown by adding an iron oxide to the glaze, while the green used to trim the sleeves of the inner and outer robes was derived from copper. The cream color also used to trim the sleeves of the robes is the third of the three colors for which these glazes are named. Although they were not used in this example, blue and black were sometimes used in the coloring of *sancai* glazes, making this term somewhat more poetic than accurate. As is often true of this type of ceramic, certain areas were deliberately left unglazed, and the color of the earthenware body adds another element to the decoration, as did the painting of the face and hat, although very little trace of those pigments remains.

Three kilns have been associated with the production of this type of glaze: the Tongchuan kilns in Shaanxi Province, the Neiqiu kilns in Hebei, and the Gongxian kilns in Henan. Both the Tongchuan kilns and the Gongxian kilns are known to have produced goods for imperial use, and it has been suggested that the development of three-color wares may also have been supported by imperial patronage.

The earliest known examples of ceramics covered with *sancai* glazes date to the reign of Tang Emperor Gaozong (reigned 649–683). They have been excavated from the 675 tomb of Li Feng, the fifteenth son of the Emperor Gaozong. Ceramics decorated with this colorful glaze were also made in some number during the reign of the usurper Empress Wu, who ruled from 690 to 704.

FIG. 140. Civil Official. Tang period, 8th century. North China. Earthenware with multicolored lead glazes and traces of pigment (*sancai* ware). H. 40¾ in. (103.5 cm). Asia Society, New York: Mr. and Mrs. John D. Rockefeller 3rd Collection, 1979.114

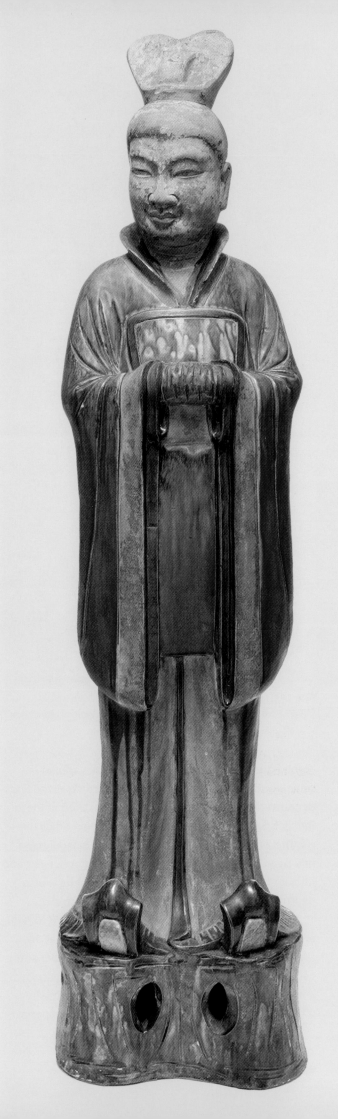

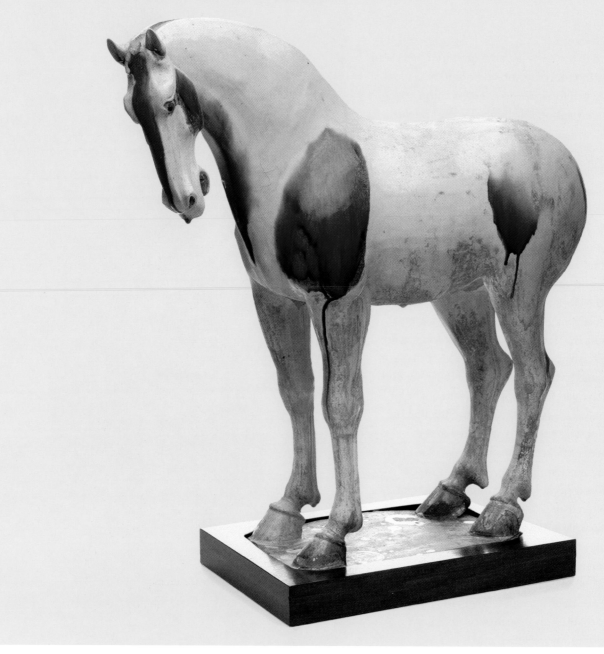

FIG. 141. Horse. Tang period, early 8th century. North China. Earthenware with multicolored lead glazes (*sancai* ware). H. 23 x L. 24¼ x W. 8 in. (58.4 x 61.6 x 20.3 cm). Asia Society, New York: Estate of Blanchette Hooker Rockefeller, 1992.1

Tomb figurines covered with *sancai* glazes appear in vast quantities in Tang imperial tombs dating to the first decades of the eighth century. The restoration of the Li family's control of the Tang empire was marked by the reburial of several members of the imperial family who had been killed by Empress Wu, and the immediate need for a large number of tomb sculptures must have also contributed to the development of *sancai* wares.

The large size of this figure of a civil official **(FIG. 140)** and the use of a contoured pedestal suggest that this sculpture may have been in the tomb of a member of the court, if not of the imperial family itself. Such pedestals are found on tomb sculptures of both civil and military officials excavated from the grave of Prince Zhuanghai,

the second son of Emperor Gaozong, who was reinterred in 706. It is unlikely, given the rigid structuring of tomb sizes and burial goods in the Tang period, that a figure of a civil official would have been placed in any tomb but that of a member of the court. This official's folded hands indicate that he was in a subservient position to the deceased; only someone of considerable status would have had any authority over a civil official.

Lively horses standing in a wide array of poses are among the most famous examples of Tang-dynasty *sancai* wares. Horses were an important part of the funerary regalia of high-ranking officials and members of the imperial family. Many of these horses have saddles, bridles, and other ornaments that illustrate the manner in

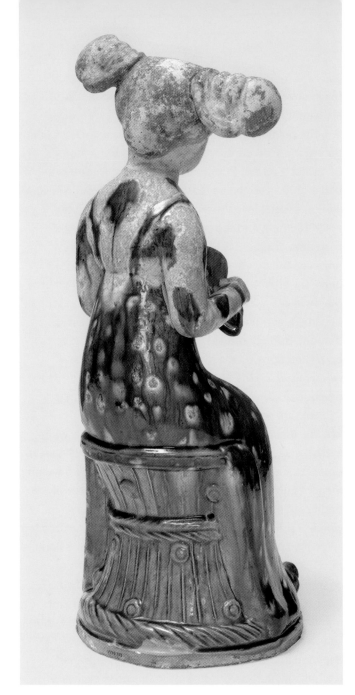
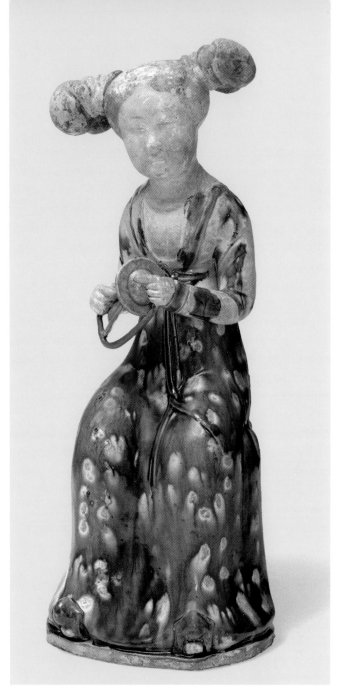

FIG. 142. Court Lady. Tang period (618–906), 8th century. North China. Earthenware with multicolored lead glazes and traces of pigment (*sancai* ware). H. 14⅛ x W. 5¾ x D. 5⅛ in. (35.9 x 14.6 x 13 cm). Asia Society, New York: Mr. and Mrs. John D. Rockefeller 3rd Collection, 1979.113

which horses were outfitted during the Tang dynasty; the type and degree of adornment on a horse also reflected the status of the deceased.

Sancai ceramic sculptures were made of earthenware using molds, and in most Tang-period examples the horse and its saddlery were made in one piece from a single mold. An unadorned horse **(FIG. 141)** that also lacks a tail and a mane illustrates a second type of Tang horse that appears to have been made during the early decades of the eighth century. Unlike the more colorful version of the *sancai* glazes used in making horses that have saddlery, the coloring of this horse is very subtle, consisting of a cream body with amber-brown markings. It has been suggested that the tails and manes of this type were

made of perishable materials such as hair, while their saddles, bridles, and other fittings may have been made of bronze or even some more precious metal.

Horses of this type have been found in pairs: usually one horse has a lowered head, as seen in this example, while the other raises its head to neigh. The pairing of horses, the possible use of metalwork to make the saddlery, and the dating of this type of horse to the early eighth century suggest links between the production of such horses and the use of *sancai* figurines in the imperial reburials of that period.

The abundant use of a glaze colored with cobalt blue in the dress worn by a seated figure of a court lady holding cymbals **(FIG. 142)** helps to distinguish this piece

as a luxurious example of Tang *sancai*. Imported to China from Iran, cobalt was expensive and used sparingly.

Both the high-waisted dress worn by this figure and her youthful charm typify sculptures of women produced during the late seventh century, as fuller-figured beauties became popular in the early eighth. The two-tone decoration of her high-waisted dress was fashionable in the second half of the seventh century. In this case, both the amber and the blue parts of the gown are decorated with various-sized spots of unglazed clay created by a resist process. There are traces of pigment on her face and hair.

The warfare that accompanied the rebellion of the Sogdian general An Lushan in 756 had a negative effect on Tang ceramic production since several important kilns, including the Tongchuan kilns in Shaanxi, were destroyed during the fighting. As a result, the production of three-colored ceramics and other wares slowed considerably after the mid-eighth century. Some *sancai* wares were produced under the Liao dynasty, which ruled parts of northeastern China from 907 to 1125, however the vast majority of *sancai* wares appear to have been made during the late seventh and the early eighth centuries. They are vivid reminders of the vibrant tastes of the cosmopolitan culture of China during the Tang period.

Chinese Buddhist Sculptures

The acceptance of the Indian religion of Buddhism in China, which was marked by persecutions as well as by substantive adaptations of doctrines, remains one of the most interesting dialogues in religious history. The style and iconography of Chinese Buddhist art, particularly from the fifth through the eighth century, provides a visual record of the many ways in which the beliefs, customs, and aesthetics of India and China were accommodated to each other to form a distinctive, sinicized tradition of Buddhist thought and art—one that would spread from China to Korea and Japan.

The development of paradise cults and imagery is a hallmark of East Asian Buddhism. The belief that multiple buddhas and bodhisattvas inhabit different paradises or pure lands (*kshetriyas*) is common in Buddhism and is discussed in much Buddhist literature. Despite a strong textual tradition, images of these heavenly spheres are relatively rare in India and Southeast Asia. Much of the East Asian iconography of this type can be traced to the images that evolved in China beginning in the sixth century.

The political instability and economic chaos in China during the sixth century had a profound impact on Buddhist thought. Prior to this time, most Buddhist sects had emphasized the necessity of working through several lifetimes to achieve the ultimate goal of Buddhism—enlightenment and the subsequent release from the problems of everyday life. During the sixth century, however, the desire for rebirth in a Buddhist pure land, generally either the Tushita Pure Land of the Bodhisattva Maitreya or the Western Pure Land of Amitabha Buddha, became a prominent feature of Chinese Buddhist thought. Such paradises were generally understood to be way stations on the road to enlightenment, ideal worlds in which the believer had the time and luxury to practice Buddhism and then attain enlightenment in a subsequent earthly lifetime.

The iconography of the two bodhisattvas in a white marble sculpture dated by an inscription to 570 (**FIG. 143**) presents some of the complexities that mark the development of pure land imagery in China.[1] The two central bodhisattvas are seated in what is generally known in western scholarship as the pensive pose, in which one leg is crossed over the other and the forefinger of one hand is raised as if to gently touch the cheek in a thoughtful gesture. This pose has often been said to identify the Bodhisattva Maitreya seated in his Tushita Pure Land awaiting his rebirth on earth as the Buddha of the Future. However, the Bodhisattva Avalokiteshvara is often depicted in the same pose in images from India and Kashmir. In fact, several figures in this pose excavated in China have been variously identified as Maitreya, Avalokiteshvara, or more generally as bodhisattvas or pensive figures. This uncertainty suggests that images of this type can best be understood as representations of bodhisattvas seated in a paradise, probably the Tushita Pure Land. The belief that every bodhisattva inhabits the Tushita Pure Land before his final rebirth on earth is found in several early texts, such as the *Dashabhumika Sutra*, that were influential in early Chinese Buddhist thought.

The images at the top of this relief can also be understood as early examples of pure land imagery. The pagodalike building being carried aloft by dragons and heavenly beings may represent the ascent of a deceased person's soul to a pure land for rebirth. The presence of the standing bodhisattvas accompanied by monks

Opposite: **FIG. 143.** Pair of Bodhisattvas in the Pensive Pose. Northern Qi period, dated 570. China, Hebei Province. Marble. H. 24½ x W. 14⅞ x D. 5½ in. (62.2 x 37.8 x 14 cm). Asia Society, New York: Estate of Blanchette Hooker Rockefeller, 1992.4

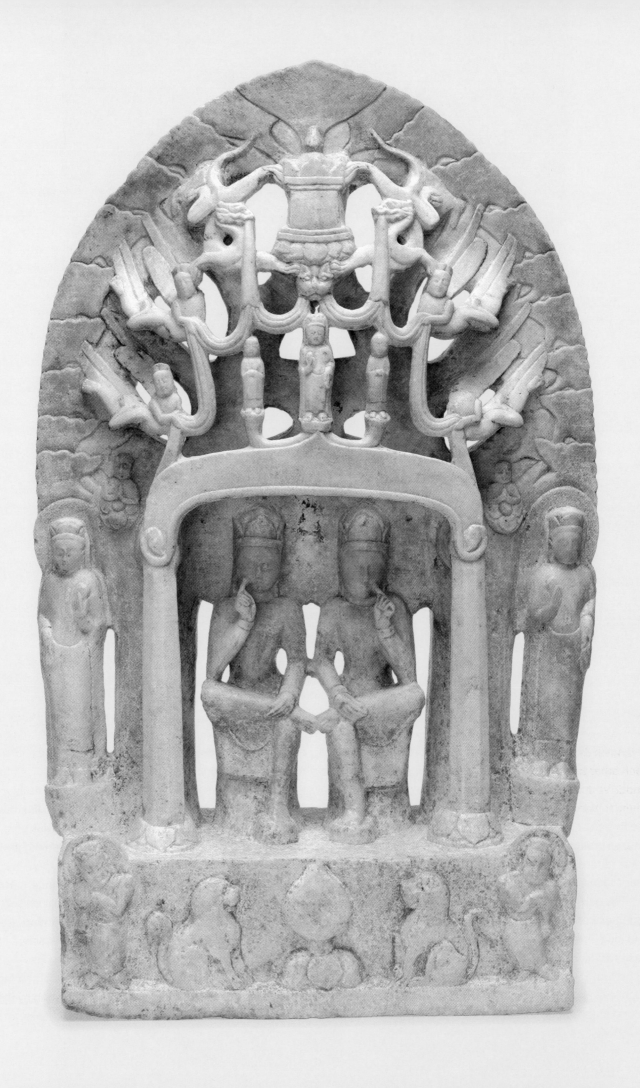

FIG. 144. Head of a Bodhisattva, Perhaps Mahasthamaprapta. Tang period, early 8th century. North China. Limestone with traces of pigment. H. 13 x W. 7 x D. 9½ in. (33 x 17.78 x 24.13 cm). Asia Society, New York: Mr. and Mrs. John D. Rockefeller 3rd Collection, 1979.115

presage the numerous images of buddhas (particularly Amitabha) and their attendants descending to earth. Such images are common themes in Pure Land Buddhism and several other East Asian sects. Finally, the two small figures with clasped hands seated on lotuses prefigure the use of such images to represent souls reborn in Amitabha's Western Pure Land in the art of China, Korea, and Japan.

The garments worn by the seated bodhisattvas, together with their broad shoulders, elegant torsos, and long legs, are typical of sculptures made in north-eastern China during the second half of the Northern Qi period (550–577). The ultimate prototypes for such lean physiques can be found in the art of Gupta-period India (about 320–about 500), and it is possible

that this style entered China through a Central Asian intermediary.

The fuller cheeks and plump features on an early-eighth-century head of a bodhisattva **(FIG. 144)** illustrate one of the most important and long-lasting styles of Buddhist imagery to develop in China. The flaming jewel in the bodhisattva's headdress suggests that this head may have come from a sculpture of Mahasthamaprapta. This bodhisattva is rarely depicted alone, and it is likely that this head was once part of a triad representing Amitabha Buddha with two attendant bodhisattvas, Mahasthamaprapta and Avalokiteshvara.

Carved in the eighth century at the height of the Tang dynasty, sculptures in this style are distinguished by their interest in the softness and plumpness of the cheeks, arms,

stomach, and other parts of the body. They differ noticeably from earlier works, such as the sculpture of the pensive bodhisattvas, which were influenced to a certain extent by Indian aesthetics and therefore emphasized the idealized lines of the bones of the body rather than its flesh.

During the Tang dynasty, China was a major world power, and in addition to trading ceramics and luxury goods to many parts of Asia, it was the source of Buddhism for Korea and Japan, where eighth-century Chinese Buddhist art had a profound influence. As a result, sculptures in the style seen in this charming head were produced throughout Korea and Japan.

1. A long inscription runs form the proper left side, along the back, and to the right side of the base. Although the inscription is quite abraded, it dates the sculpture to the third day of the fifth month of the year equivalent to 570, and it is clear that the sculpture was commissioned by a religious society. Much of the inscription is a list of names of the donors, who call themselves *yizi*, a term often used by members of early Buddhist groups in China.

FIG. 145. Stem Cup. Tang period, about late 7th–early 8th century. North China. Silver with embossing, chasing, engraving, and microscopic traces of gilding. H. 1⅞ x Diam. 2½ in. (4.8 x 6.4 cm). Asia Society, New York: Mr. and Mrs. John D. Rockefeller 3rd Collection, 1979.118

Tang and Liao Dynasty Metalwork

The renewed interest in metalwork and the use of gold and silver in Tang-period China illustrate the impact of foreign ideas and art forms on the culture. During the Tang dynasty, which lasted from 618 to 906, China was the economic, political, and cultural center of Asia, with ties extending from Japan to the Mediterranean world. Diplomatic emissaries, Buddhist monks, and traders flocked to China, fostering a cosmopolitan and eclectic culture that united China, Korea, and Japan in the eighth century. This cosmopolitanism is reflected in the arts of the Tang dynasty: the inclusion of foreigners among tomb figurines, the prominence of Central Asian dance and music, and the rise in the number of metal objects made in its territory resulted from the Tang-period fascination with the foreign and the exotic.

Although gold and silver in the form of hammered fragments had been used as inlay on bronzes as early as the Shang and Zhou dynasties, during the subsequent Han and Northern and Southern dynasties these metals were only occasionally used for jewelry and other types of ornament. It was not until the Tang dynasty that a large number of functional objects made of or decorated with gold and silver were produced. The close contacts among China, Central Asia—particularly Sogdiana (centered in present-day Uzbekistan), which had long-standing mercantile ties with China—and Sassanian-period Iran played a critical role in the evolution of metalwork during the Tang period.

A stem cup **(FIG. 145)** and an elegant bowl **(FIG. 146)**, both of which date to the late seventh or early eighth century, typify the use of Sassanian and Sogdian motifs and techniques. The bowl was shaped by hammering, or "raising" a sheet of silver into this form, then additional hammering produced the designs, including the embossing of the lobed lotus petals that decorate the sides and the chasing of the ring matting, that is, the background of small circles seen on the exterior. Not found in Chinese art prior to the Tang period, both raising and ring matting were techniques commonly used in Sassanian and Sogdian metalwork, suggesting a likely source for their introduction to China.

The lotus petals on the sides of the bowl are decorated with floral arabesques inhabited by birds: the symmetrical treatment of these motifs and the static, face-to-face birds probably stem from West and Central Asian sources. The decoration on the rim, in which a wide variety of animals race through stylized flora, derives from Chinese prototypes. Scrolling floral vines amid running animals also decorate the foot ring and the bottom of the interior of the bowl. The freer, more calligraphic, and more sinicized treatment of these vines contrasts with the stylization of motifs on the outside of the bowl and further attests to the sophisticated interplay of native and foreign elements in Tang metalwork.

The vines, flowers, birds, and animals on this bowl were covered with gilding (usually gold leaf or some

FIG. 146. Bowl. Tang period, about late 7th–early 8th century. North China. Silver with embossing, chasing, engraving, and gilding. H. 2¾ x Diam. 6⅞ in. (7 x 17.5 cm). Asia Society, New York: Mr. and Mrs. John D. Rockefeller 3rd Collection, 1979.117

gold-colored pigment), much of which has worn away over time. It is possible that the interior of this bowl was once covered with a liner that hid the tool marks from the hammered designs.

Similar techniques of manufacture and motifs were used in the small stem cup. In the embossed lobes, flowering vines alternate with birds in a stylized landscape. The stem cup has often been traced to the metalwork of Iran or Sogdiana. Unlike most of the shapes associated with Tang-dynasty metalwork, though, the stem cup was to remain in constant use in Chinese culture, and ceramic examples were often used in shrines and on family altars.

The decoration of the back of a mirror **(FIG. 147)** illustrates another use of gold and silver during the Tang dynasty. Cut from individual pieces of gold and silver foil, the birds, flowers, insects, plants, and decorative motifs that embellish the back of this bronze mirror were inlaid into a lacquer base and then covered with an additional layer of lacquer to keep them in place. While this method of inlaying can be traced to the Han period, the plants and birds in this design are typically Tang.

The seventh and eighth centuries marked the height of Tang power and prestige. They also saw a flowering of the arts and an increase in the number of gold and silver objects created. The production of precious-metal objects diminished in the second half of the Tang dynasty, partially as a result of the waning interest in a broader

Asia, owing to the internal strife and external pressures that beset China from the mid-eighth through the ninth century.

Ceramics of the Song and Jin Periods

Ceramics made in China during the Song period (960–1279) are among the most influential and revered in the world. They are noted for their elegant, simple shapes, their lush glazes, and their lively designs. These ceramics are highly admired in part because of the complicated and varied technologies used in their manufacture. Since the late twelfth and early thirteenth centuries, five of the wares produced during this period—Ding, Ru, Jun, Guan, and Ge—have been classified as the "five great wares" of China. The widespread importation of Song ceramics throughout Asia and to places as far away as Africa, and their strong influence on the art of Korea and Japan, also helped to spread the knowledge and appreciation of these ceramics.

Many internal factors contributed to the expansion of the ceramic industry during the Song period. For example, governmental support of trade and the funding of protection for the northern frontier that was under siege from several aggressors encouraged both the growth of a large domestic industry and the concomitant rise of a merchant class. Members of this class not only

FIG. 147. Mirror. Tang period, about 8th century. North China, reportedly found in Henan Province. Copper alloy with gold and silver inlays in lacquer. H. 5⅞ x W. 5⅞ in. (14.9 x 14.9 cm). Asia Society, New York: Mr. and Mrs. John D. Rockefeller 3rd Collection, 1979.119

exported ceramics but also used them in their homes. The development of a court bureaucracy responsible for the administration of the country also led to the ascent of a class of scholar-gentlemen with a deep interest in art, and the refined tastes of this group were instrumental in the development of many types of art. Court sponsorship of the arts and the court-led interest in antiquarianism also encouraged the Song ceramic industry. It was during this time that ceramics were first collected and preserved as art objects, and much of the later Chinese scholarship on ceramics is based on judgments and classifications begun in the Song period.

Song ceramics are categorized into wares that often take the names of their areas of production. Much of the scholarship on Chinese ceramics from this period has stressed the distinction between the aristocratic wares, such as Ru and Guan that were known to have been used at the court, and more popular types, such as Cizhou and Jian wares. Over the past two decades, a combination of archaeological discoveries and new scholarship has challenged this rigid distinction between court and popular wares. It is now believed that many if not most of the kilns operating in China sent the very best examples of their work as tribute to the court, while less fine pieces

were available for domestic consumption and trade. Nonetheless, a distinction can still be made between the taste of the court and that of other segments of society; this distinction is illustrated in the astonishing variety found in Song ceramics.

Ding wares are among the first wares known to have been used at the Chinese court during the Northern Song period (960–1127), when the capital was located at present-day Kaifeng in Henan Province. The kilns that produced these wares are located in present-day Jianci Village in Quyang County in Hebei Province, known during the Song dynasty as Ding Prefecture. A delicate bowl decorated with an incised design of lotus flowers and leaves (FIG. 148) exemplifies Ding wares of the eleventh and early twelfth centuries: it has a thinly potted, extraordinarily light, buff-colored body; a warm ivory-colored glaze; and lively and precise incised decoration. Examples of Ding ware from this period are considered the high point in the development of this ceramic type, which was produced from the eighth through the thirteenth (or fourteenth) century. Until the tenth century, Ding wares were often undecorated, with the exception of a few pieces incised with leaves and lotus flowers, a symbol of purity in Buddhism. In this regard, it is interesting that some of the largest groups of early Ding wares were recovered from Buddhist monuments, suggesting a tie between the production of the earliest decorated Ding wares and the practice of Buddhism.

The kilns that produced Ding are generally credited with several important innovations in ceramic technology. These include stepped saggars for firing vessels, the upside-down (*fushao*) firing technique, and reusable ceramic molds to impress designs on the pieces. A saggar is a clay box that is used to hold a ceramic piece while it is being fired, both to prevent dirt from blemishing ceramics while they are in the kiln and to help control the temperature during the firing process. At first, each ceramic was fired in an individual saggar. The Ding invention of stepped saggars, however, allowed potters to place ceramics one on top of the other in a single saggar, thereby increasing the number of pieces that could be produced in a firing. The upside-down technique used in the stepped saggars also helped prevent the ceramics from warping during the firing. This was particularly important in the production of Ding wares, which are among the thinnest ceramics produced in China. In order to prevent them from sticking to the saggars, the mouths of pieces were not glazed; the copper band fitted to the mouth of this bowl covers the unglazed rim. Finally, the introduction of molds that could be reused to make more than one object also helped the Ding potters to produce more and more pieces.

The increase in production and the wider availability of Ding wares as a result of these technical innovations has sometimes been cited as one of the reasons for their loss of court favor in the late eleventh century. Despite all

FIG. 148. Bowl. Northern Song period, 11th–early 12th century. China, Hebei Province. Porcelain with incised design under glaze, the rim bound with copper (Ding ware). H. 2½ x Diam. 8¾ in. (6.4 x 22.2 cm). Asia Society, New York: Mr. and Mrs. John D. Rockefeller 3rd Collection, 1979.139

FIG. 149. Dish. Northern Song period, early 12th century. China, Hebei Province. Porcelain with molded design under glaze (Ding ware). H. 2 x Diam. 9 in. (5.1 x 22.9 cm). Asia Society, New York: Mr. and Mrs. John D. Rockefeller 3rd Collection, 1979.140

the technical advances that occurred at the Ding kilns, the glaze on these pieces was not applied perfectly but had a tendency to run in drops that are known in Chinese as tear drops; it has been suggested that this slight flaw was responsible for diminishing court patronage. Interestingly, the word used to describe these "tear drops," *mang*, can also be interpreted to mean "popular" or "vulgar." It is also possible that the new style of design that resulted from the use of molds was one reason for the change of patronage.

The design of a dragon chasing a pearl among swirling clouds found on the interior of a dish dated to the early twelfth century **(FIG. 149)** exemplifies the style of decoration made using molds: it is both denser and more complex than the elegant lotuses that were hand carved on the eleventh-century bowl. The clarity of the design on this dish suggests that it may have been one of the first pieces made from a mold, for after a mold has been used, its impression is not as precise.

The changes in technology and taste illustrated in the ceramics produced at the Ding kilns coincided with several political changes that marked the history of the twelfth century. In the early part of the century, the Song

FIG. 150. Brush Washer. Northern Song period, early 12th century. China, Henan Province. Stoneware with glaze (Jun ware). H. 2¾ x Diam. 6¾ in. (5.7 x 17.1 cm). Asia Society, New York: Mr. and Mrs. John D. Rockefeller 3rd Collection, 1979.138

rulers joined forces with the Ruzhen Tartars to defeat the Qidan state of the Liao, located on China's northeastern frontier, which threatened Song control of China as well as the autonomy of the Ruzhen. After the joint Song-Ruzhen victory, the latter turned against the Song, establishing the Jin dynasty (1115–1234) in northeastern China. The Jin ultimately took control of all of North China, forcing the Song rulers to flee south. This was the beginning of the Southern Song period (1127–1279), when the capital was at present-day Hangzhou in Zhejiang Province.

The Jin capital was in Beijing, fairly close to the Ding kilns. Some of the changes seen in ceramics produced there after the second decade of the twelfth century may illustrate the taste of the Jin rulers. The use of a four-clawed dragon to decorate an early-twelfth-century dish of extremely high quality is interesting, particularly in light of the changing notions about the role of court patronage in the production of Song-period ceramics. The dragon was often used as a symbol of imperial power in China, and from at least the fourteenth century, five-clawed dragons were used in ceramics and the decorative arts to symbolize the emperor, while four-clawed dragons often decorated objects that were intended to be used as imperial gifts. The high quality of this dish and its decoration suggest that it may have been made for distribution by the court, either in the first decade of the twelfth century during the rule of the Northern Song or a decade later for the Jin court, perhaps as a symbol of their assumption of the mantle of authority.

A small brush washer with a ring handle **(FIG. 150)** exemplifies the court taste that developed in the early

twelfth century under the patronage of the Song emperor Huizong (ruled 1101–25). Huizong is one of the most famous imperial patrons in Chinese history, and the changes that occurred in artistic taste under his patronage had a long-lasting effect on Chinese art. These changes included a shift away from the monochromatic landscapes favored by his predecessors to more colorful paintings and an emphasis on evoking the intangible in paintings and poetry. Huizong was noted for his fascination with the bronzes and jades made during the Shang and Zhou periods and for the development of new types of court ceramics such as Ru and Guan wares. Unlike the Ding wares that had been favored previously by the court, these later pieces are rarely decorated with incised or impressed motifs, but rely instead on the beauty of their elegant shapes and exceptional glazes. The kiln responsible for the production of Ru wares was discovered in 1986 in Qingliangsi, Baofeng County, Henan Province. Ru appears to have been produced from about 1080 to the first years of the twelfth century. An official ware by the name *Guan* may have been produced in the second decade of the twelfth century, after the production of Ru ware had ceased.

Although this brush washer is an example of Jun ware, its subtle, bold shape has an understated elegance that is enhanced by the unctuousness of the very thick, pale blue-gray glaze. The fine lines found in the glaze, known as "crazing" or "crackle," are the result of the shrinking of the glaze in the kiln. Crackle also characterizes Ru and Guan wares, further strengthening the parallels between imperial ceramics and Jun wares such as this brush washer.

Jun wares are named for Jun Prefecture in Henan Province, however, archaeological discoveries have shown that these wares were produced in the area around Linru in the same province. At least eight kilns near Linru have been identified for the production of Jun wares. Of these, the Wugongshan kiln is believed to have produced the highest-quality wares and, given its parallels to imperial Ru ware, it is possible that this brush washer is a product of that kiln. The fact that excavations at the Wugongshan kiln site have shown that coins dating to the Xuanhe period of Huizong's reign (1119–25) were produced at this kiln site increases the likelihood of Jun's imperial connections. In addition, the number of shards found at this site indicate that imperfect pieces were discarded. Both the discovery of the coins and the rejection of less-than-perfect ceramics may suggest that some Jun pieces from this particular kiln were intended for the use of the court.

Whether or not Jun wares were used at the court remains an issue of debate. Although Jun is one of the five great wares of China, western scholars have generally disagreed with their Chinese counterparts, who believe that it was an imperial ware. Both the thickness of the bodies of Jun ware, when compared with wares such as Ding and Ru, and the spectacular purple splashes that often decorate it are cited as reasons for Jun being a popular ware.

The bright purple splashes in the glaze on a small bowl (FIG. 151) are characteristic features of Jun ware. These bursts of color were created by adding filings of copper to the glaze before firing. As in the case with this small bowl, the splashes on early Jun wares were applied sparingly and somewhat randomly. In later examples, the copper filings were brushed into the glaze in more structured patterns. While the flamboyance of these splashes is one of the elements that distinguishes some Jun ware from the more understated Ru, both the bubble bowl and the brush washer have elegant shapes covered by a glaze that is blue-gray.

Jun ware, Ru ware, and all other Chinese ceramics with green-blue-gray glazes are often classified in the West as "celadons." Several reasons have been suggested for the popularity of such green-glazed pieces in Chinese ceramic history: green glazes derived from ironoxides are relatively easy to produce and were among the first glazes created in China. The interest in green glaze has also been linked to the Chinese preference for jade, although in Chinese culture white jade is considered more beautiful than green. In addition, an interest in the effect of crazing in glazes has been linked to Huizong's fascination with early Chinese bronzes, as this effect is similar to the patination acquired by early metalwork.

Yaozhou wares are among the most elegant and widespread of the famous Chinese green-glazed pieces. The ware is called by the former name for the Tongchuan region of Shaanxi Province, where the majority of the best of those pieces were made. Noted for their deeply carved designs, Yaozhou wares have light gray bodies and thick, olive-green glazes. Their designs and shapes are closely related to those of Ding wares since, in the late eleventh and early twelfth centuries, both Yaozhou and Ding wares were made at the kilns where the technical innovations took place.

The lush peony carved into the bottom of the interior of a small Yaozhou dish (FIG. 152) is typical of the bold decoration found on wares of this type: the petals and flowers of the peony are so deeply carved that the glaze pools into the recesses, deepening its tone and making the design more prominent. Combed lines further enhance the decoration. Thirteenth-century Chinese records indicate that Yaozhou wares were seen as crude and were used by restaurants because of their durability; they are generally believed to have been used popularly rather than at the court.

The complicated carving of peonies and leaves found on both the exterior and interior of a small cusped bowl dating to the late Northern Song period (FIG. 153) suggests, however, that some examples of this widely distributed ware were reserved for more affluent or

FIG. 151. Bowl. Northern Song period, early 12th century. China, Henan Province. Stoneware with glaze with suffusions from copper filings (Jun ware). H. 1¾ x Diam. 3⅜ in. (4.4 x 8.6 cm). Asia Society, New York: Mr. and Mrs. John D. Rockefeller 3rd Collection, 1979.137

FIG. 152. Dish. Northern Song period, late 11th–early 12th century. China, Shaanxi Province. Stoneware with carved and combed design under glaze (Yaozhou ware). H. 1½ x Diam. 7 in. (3.8 x 17.8 cm). Asia Society, New York: Mr. and Mrs. John D. Rockefeller 3rd Collection, 1979.132

important clients. Such carving is more difficult and time-consuming than decorating only the interior or the exterior of a ceramic. The cuspate shape of this bowl is unusual too, which suggests that it may have been made by special order for an important client. The precise function of this bowl is difficult to determine. Based on a comparison with the use of similar shapes in metalwork, it is possible that it may have once served as a basin for a small ewer.

The Yaozhou kilns continued production during the rule of the Jin dynasty. A large bowl in the Collection **(FIG. 154)** that has a date corresponding with the year 1162 inscribed in black ink on an unglazed ring in the bottom of the bowl provides a linchpin for the style of Jin-dynasty

Yaozhou wares. The date is part of a longer inscription that has been read in various ways.[1] However, the most important information in this inscription is the date. Lotus flowers floating on waves decorate the interior of this bowl, while more stylized floral motifs are incised on the exterior. As was true of the cuspate bowl, the decoration of both the interior and the exterior suggests that the piece was made to order. In this regard, it is interesting that one of the readings of the inscription suggests that the last character, which is very difficult to make out, may be an owner's or a potter's name.

Lotus flowers surrounded by swirling waves also decorate the interiors of two small Yaozhou bowls **(FIGS. 155 AND 156)**, helping to date these works to the

FIG. 153. Cusped Bowl. Northern Song period, about early 12th century. China, Shaanxi Province. Stoneware with combed and incised design under glaze (Yaozhou ware). H. 2¾ x Diam. 6 in. (7 x 15.2 cm). Asia Society, New York: Mr. and Mrs. John D. Rockefeller 3rd Collection, 1979.131

FIG. 154. Bowl. Jin period, 12th century. China, Shaanxi Province. Stoneware with incised design under glaze (Yaozhou ware). H. 4½ x Diam. 8 in. (11.4 x 20.3 cm). Asia Society, New York: Mr. and Mrs. John D. Rockefeller 3rd Collection, 1979.136

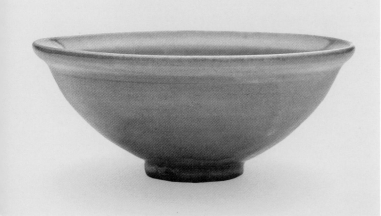

mid-twelfth century. As was true of the design on the interior of the dated bowl, the lotus flowers were carved and the wave patterns were combed. The sketchy treatment of the lotuses and the reliance on the time-saving comb are typical of the twelfth-century practice of mass production, evidenced also by the use of molds at the Ding kilns. A more structured and somewhat abstract design was quickly carved on the exterior of a slightly rounded bowl (FIG. 157), common in the denser and more static decoration found on ceramics made in northern China during the twelfth century.

Like Yaozhou wares, Cizhou wares are thickly potted, boldly decorated ceramics that were produced for popular consumption. The name *Cizhou* derives from Ci Prefecture, or Cixian, in Hebei Province, though examples of this type of ware were produced in many kilns throughout Hebei, Henan, and Shaanxi provinces. The most common decoration of Cizhou wares consists of bold black-and-white patterns. These designs were created using many techniques, including carving and painting.

The powerful peony flowers and leaves decorating a sturdy bottle (FIG. 158) were produced using the sgraffito technique, which is one of the most complicated methods of decoration in ceramic technology. The light gray body of the vessel was first coated with a white slip, which was then covered with a black slip. After the outlines of the design were incised into the black slip, portions of this top slip were shaved away to reveal the white one underneath.

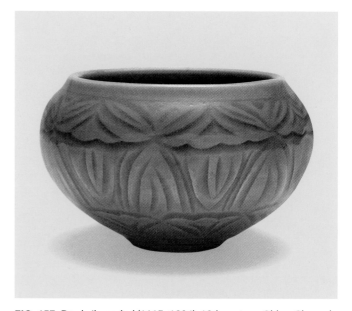

FIGS. 155 (top and middle) AND 156 (bottom). Two Bowls. Jin period, mid-12th century. China, Shaanxi Province. Stoneware with carved and combed design under glaze (Yaozhou ware). Each H. 2⅛ x Diam. 5⅜ in. (5.4 x 13.7 cm). Asia Society, New York: Mr. and Mrs. John D. Rockefeller 3rd Collection, 1979.133 (top and middle) and 1979.134 (bottom)

FIG. 157. Bowl. Jin period (1115–1234), 12th century. China, Shaanxi Province. Stoneware with carved and combed design under glaze (Yaozhou ware). H. 2½ x Diam. 4 in. (6.4 x 10.2 cm). Asia Society, New York: Mr. and Mrs. John D. Rockefeller 3rd Collection, 1979.135

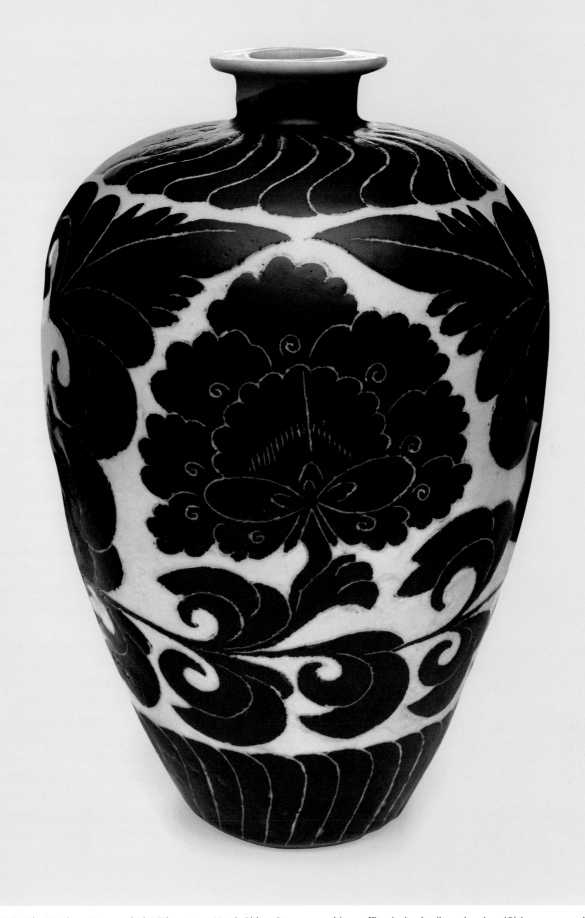

FIG. 158. Bottle. Northern Song period, 12th century. North China. Stoneware with sgraffito design in slip under glaze (Cizhou ware, probably from Xiuwu or Cizhou). H. 12½ x Diam. 8½ in. (31.8 x 21.6 cm). Asia Society, New York: Mr. and Mrs. John D. Rockefeller 3rd Collection, 1979.141

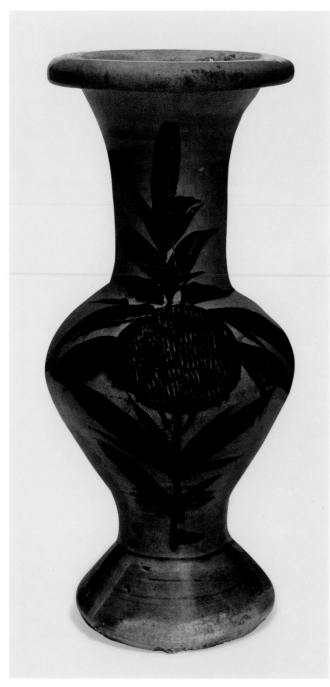

FIG. 159. Vase. Jin period, 12th century. North China. Stoneware with slip and with painted and incised design in black pigment under lead glaze (Cizhou ware, probably from Xiuwu or Cizhou). H. 8⅛ x Diam. 3⅝ in. (20.6 x 9.2 cm). Asia Society, New York: Mr. and Mrs. John D. Rockefeller 3rd Collection, 1979.142

Additional lines were then incised into the flowers and leaves to help articulate the design. Finally, the entire body (except for the foot) was coated with a thin, slightly whitish transparent glaze. Most of the vessels made using this technique were created in the late eleventh and early twelfth centuries. Archaeological research suggests that this technique was most popular at the kilns at Xiuwu and Cizhou in Henan Province. The shape of this bottle, which is known as a *meiping*, is one of the most popular

forms in the history of Chinese ceramics and was used for centuries. Although western scholars have generally described vessels in this shape as vases, they were most likely bottles used for storing and serving wine.

By the twelfth century, potters making Cizhou wares began to paint directly onto the slip covering the body, a technique that both saved time and enabled a more fluid design. The peony design on a *zun*-shaped vase **(FIG. 159)** was painted with a black pigment on a white slip background. The vase was then covered with a transparent green glaze. The *zun* shape of this vessel derives ultimately from bronze wine vessels produced during the Shang and Zhou periods (see **FIG. 121**), and the reappearance of this shape in the popular ceramics of the twelfth century most likely reflects the antiquarianism popular during the Northern Song period. Ceramic and bronze vessels in this shape were commonly used as furnishings for family altars, and the revival of this form during the Song period coincides with a resurgence of Confucianism, which emphasized ancestor worship.

The appearance of the antiquarian *zun* shape in Cizhou wares illustrates the enormous variety of techniques, shapes, and designs in Song-period ceramics. The kilns producing Cizhou wares were also responsible for the production of ceramics distinguished by their dark brown, dark blue, and black glazes. These wares are generally known as "northern black wares" or "Henan black wares" to distinguish them from similar but more famous ceramics made in the south of China. These northern black wares, like Cizhou wares, were widely distributed and used.

The unctuousness of the dark glaze covering a bottle **(FIG. 160)** dating to the late eleventh or early twelfth century is typical of the glaze used to cover northern black wares. The truncated shape of this bottle is unique to Song-period ceramics and is found in many types of wares. The method of decorating this bottle is similar to that found in other Cizhou wares: the light gray body was first covered with a brown slip, then decorative ribs were added by trailing lines of thick, white slip down the surface of the vessel. Finally, the bottle was covered with a thin, light brown glaze that appears almost black where it is densest.

This blackness, the result of the iron in the glaze, can be seen with a different appearance in the spectacular "oil spot" effect on a brush washer **(FIG. 161)** that was also made at a kiln producing so-called Cizhou and northern black wares. During the firing, the excess iron in the glaze rose to the surface, creating the spots. This technique was also used at the Jian kilns in Jianyang in Fujian Province

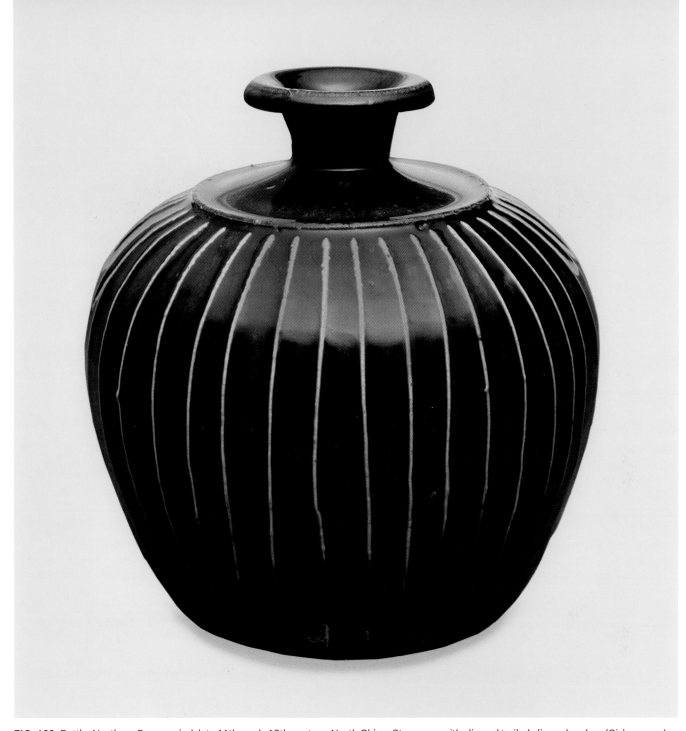

FIG. 160. Bottle. Northern Song period, late 11th–early 12th century. North China. Stoneware with slip and trailed slip under glaze (Cizhou ware). H. 8⅛ x Diam. 7¾ in. (20.6 x 19.7 cm). Asia Society, New York: Mr. and Mrs. John D. Rockefeller 3rd Collection, 1979.143

in southeastern China, and it has been suggested that the northern black wares were produced in response to the popularity of ceramics from Fujian, which were used throughout China at all levels of society. Because of their use in southern China's Buddhist monasteries, Fujian wares became extraordinarily popular and influential in Japan, where they were known as *tenmoku* after the Japanese reading for Mount Tienmu in Zhejiang Province. Mount Tienmu housed many Buddhist monasteries that were visited by Japanese monks, and it was there that Japanese monks used and began to collect the ceramics made in nearby Fujian Province.

A small tea bowl with a "hare's fur" glaze effect is a classic example of Jian ware **(FIG. 162)**. The same method is used to achieve both the so-called oil-spot and hare's fur effects. The oil-spot pattern elongates into the hare's fur if slightly more heat is used in firing. This particular tea bowl is unusual because plum blossoms have been painted over the glaze in a brown slip. This extra level of decoration is not common in Jian wares and, as has been pointed out, suggests that the bowl was produced for an important patron.

The enormous popularity of Jian wares during the Song period may reflect the importance of tea drinking at

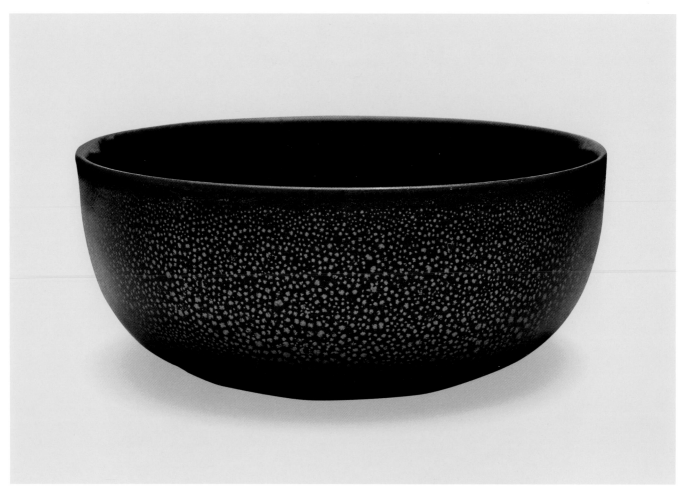

FIG. 161. Brush Washer. Northern Song period, late 11th–early 12th century. North China. Stoneware with glaze with iron "oil spots." H. 2⅝ x Diam. 6½ in. (6.7 x 16.5 cm). Asia Society, New York: Mr. and Mrs. John D. Rockefeller 3rd Collection, 1979.144

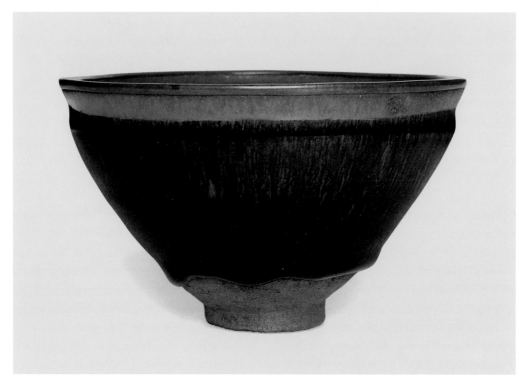

FIG. 162. Tea Bowl. Southern Song period, 12th–13th century. China, Fujian Province. Stoneware with glaze with iron "hare's fur" and painted with overglaze iron brown slip, the rim bound with silver (Jian ware). H. 2⅞ x Diam. 4⅞ in. (7.3 x 12.4 cm). Asia Society, New York: Mr. and Mrs. John D. Rockefeller 3rd Collection, 1979.145

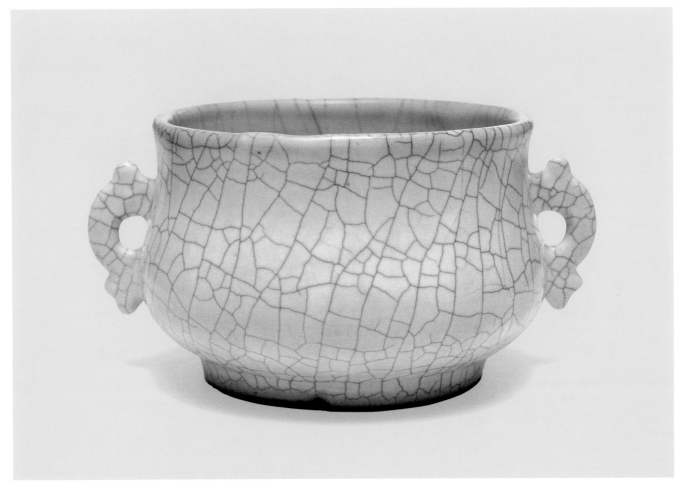

FIG. 163. Censer. Yuan period, 13th–14th century. China, Zhejiang Province. Stoneware with glaze (Ge ware). H. 3¼ x Diam. 4⅝ at mouth in. (8.3 x 11.7 cm). Asia Society, New York: Mr. and Mrs. John D. Rockefeller 3rd Collection, 1979.146

this time. Tea drinking had become popular during the Tang dynasty and continued to be throughout the Song period. Both the author of the eleventh-century *Notes on Tea* (*Cha Lu*) and the twelfth-century ruler Huizong are known to have preferred black tea bowls over white or green ones because they better displayed the white color of whisked tea. This type of tea, made from powder rather than leaves, was popular in Song China, and its use spread to Japan, where it was incorporated into the Japanese tea ceremony.

Northern Song imperial taste, particularly the interest in undecorated, delicately colored blue-gray or blue-green wares that was fostered by Emperor Huizong, was extremely influential in the production of blue-green glazed wares in southern China during the twelfth and thirteenth centuries. Guan wares, included among the five great wares of China, were produced at the Southern Song court to imitate the wares said to have been produced at the earlier Northern Song court. No examples of Northern Song Guan wares are extant today. *Guan* means "official," and Guan ware was purportedly produced within the precincts of the northern and southern capital

cities under the direction of the official bureau responsible for provisioning the court. The excavation of the site of the Wuguishan kiln near the Southern Song capital of Hangzhou has provided much useful information regarding the development of Southern Song Guan wares and their influence on other southern ceramic traditions.

This influence is seen in an elegant incense burner **(FIG. 163)**, produced in the thirteenth or fourteenth century. The delicate gray-green glaze on this censer reflects the development of this type of glaze in the Northern Song period. The incense burner's shape is based upon the form of *gui* vessels produced during the Western Zhou period. Ceramics such as this censer that have dark bodies and very thick glazes with prominent crazing enhanced by rubbing ink, or some other substance, into the cracks are called Ge wares in current publications. Ge ware was first mentioned in the fourteenth-century publication *Faithful Record of the Zhizheng Era* (*Zhizheng Zhiyi*), written by Kong Qi, and it was continuously discussed in later Ming- and Qing-period works. According to these later literary sources, the term *Ge ware*, which can be translated as "older

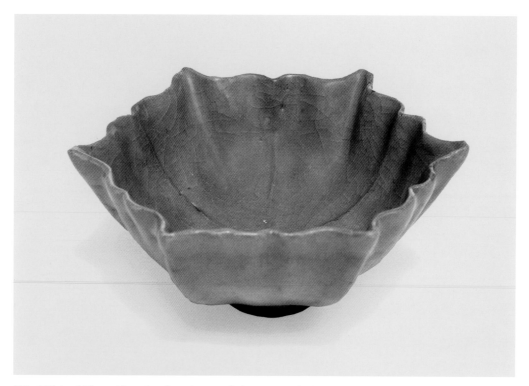

FIG. 164. Leaf-Shaped Cup. Southern Song period to Yuan period, 13th century. China, Zhejiang Province. Stoneware with glaze (Longquan ware). H. 1⅜ x Diam. 3⅝ across points in. (3.5 x 9.2 cm). Asia Society, New York: Mr. and Mrs. John D. Rockefeller 3rd Collection, 1979.147

brother ware," refers to ceramics produced under the supervision of a man called Zhang Son One (Zhang Shengyi), whose younger brother Zhang Son Two (Zhang Shenger) was responsible for the production of a yet unidentified ware known as Di, or "younger brother," ware.

Archaeological excavations at the Longquan kilns located in Zhejiang Province suggest that this intriguing incense burner and other examples of Ge ware may have been produced there. These kilns are noted for their production of thick, gray-bodied ceramics covered with a glassy, dense, olive-green glaze. In 1956 excavations at the Dayou and Xikou kilns, two of the over fifty Longquan sites, uncovered black-bodied wares with pale gray-green glazes very similar to the body and glaze of this incense burner. It is possible that potters working at these two kilns created such dark-bodied wares in an effort to re-create the dark purplish-colored clay sometimes used in the production of Guan wares. The Jiaotanxia kilns located near the Longquan area are known to have produced Guan wares to supplement those pieces made at Wuguishan, and it is not impossible that the kilns at Longquan also made Guan-style pieces for the use of the court bureaucracy.

The quiet shape, elegant glaze, and crazing of an unusual leaf-shaped cup **(FIG. 164)** provide further evidence for the existence of close ties between some of the Longquan kilns and the Guan wares produced for the court. The gray stoneware body of this piece is typical of Longquan wares, while the grayish green of its glaze differs from the more olive tone common in these ceramics. Moreover, crazing is unusual on Longquan wares, which are noted for their rich, even, glasslike glazes. The shape of the cup is distinctive and its function is difficult to determine. This cup has also been dated to the Yuan dynasty (1279–1368) when similarly shaped silver vessels were made. On the other hand, the close ties between the taste manifested in this charming ceramic and that of the Southern Song period under the influence of the court suggest a date in the first half of the thirteenth century. It seems likely that this cup presents an example of how the court influenced the production of Longquan wares during the Southern Song period.

Production of Longquan wares began in the twelfth century and continued until the fifteenth century. Mainly used domestically, Longquan wares were also exported in large numbers to Southeast Asia, Korea, and Japan. The thick body and stylized decoration of a Ming-period platter **(FIG. 165)** are typical of later Longquan wares. The large size of the platter indicates that it was made for export, probably to Southeast Asia, Iran, or Turkey. Such large platters were in demand in those parts of the world as food servers.

Qingbai wares, which were produced in Jizhou, Nanfeng, and Jingdezhen in Jiangxi Province, were also

manufactured for a long period of time, often for export. Qingbai wares are named for the color of their glaze rather than after the places where they were made. *Qingbai* can be translated as "blue-white" while *yingqing*, the other name for these wares, means "shadow blue."

As can be seen in an elegant Southern Song-period jar **(FIG. 166)**, Qingbai wares are admirable for the delicacy and translucency of their glazes and for the way the glaze pools in areas created by the shape and decoration of the ceramic. The bulbous shape of this jar is unusual for Qingbai wares. It is enhanced by the lotus, peony, iris, and mallow sprays carved against a background of combed patterns on the body.

The use of porcelain to make this jar is the result of technical developments in the production of Qingbai wares. The earliest Qingbai wares, produced during the tenth and eleventh centuries, were made using local clay with a fine white body that lacked a certain plasticity. Beginning in the twelfth century, a type of clay known as *kaolin* was mixed with local clay to create the body of Qingbai wares, giving a much greater plasticity to the material. This development during the Southern Song period paved the way for the evolution of porcelain in China during the fourteenth and fifteenth centuries and for the eventual spread of this technology throughout the world, securing one more contribution of Song-period China to the history of ceramics.

1. The seven-character inscription has been read by Wang Qingzheng as *Dading renwusui zhixia*, "container made in the *renwu* year of Dading." James C.Y. Watt has proposed as possible readings *Dading renwusui Zhi* or *Dading renwusui Gong*, in which the last character refers to a name.

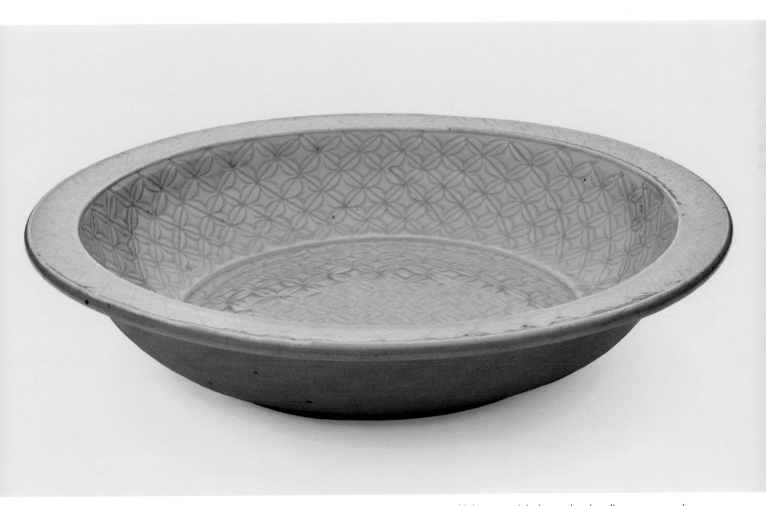

FIG. 165. Platter. Ming period, 14th–15th century. China, Zhejiang Province. Stoneware with impressed design under glaze (Longquan ware). H. 3½ x Diam. 16½ in. (8.9 x 41.9 cm). Asia Society, New York: Mr. and Mrs. John D. Rockefeller 3rd Collection, 1979.148

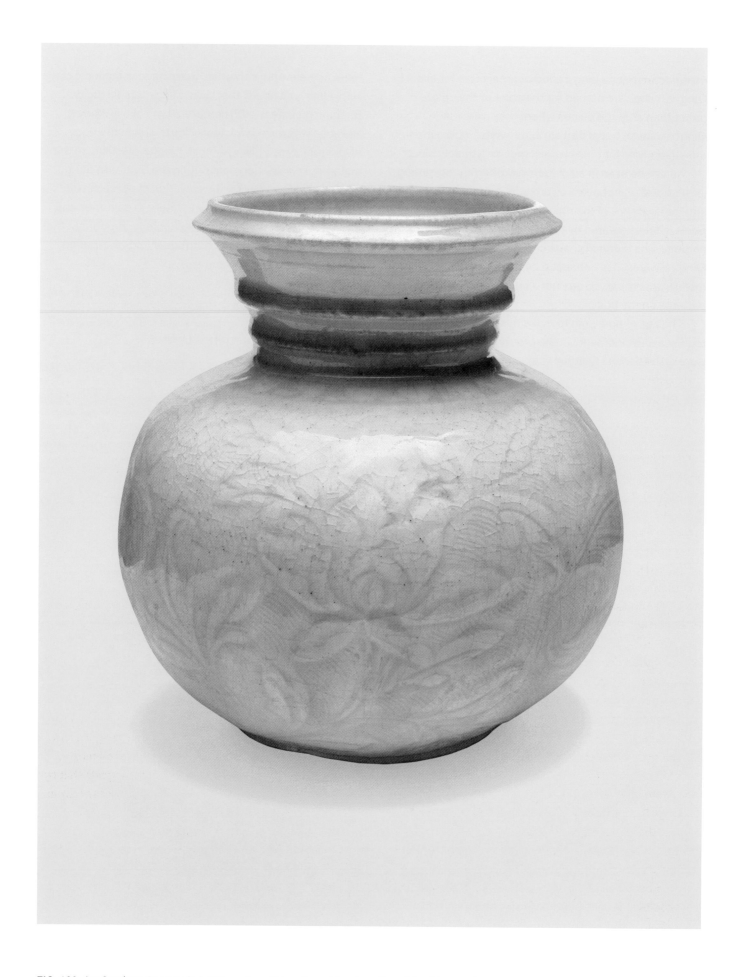

FIG. 166. Jar. Southern Song period, 13th century. China, Jiangxi Province. Porcelain with carved and combed design under glaze (Qingbai ware). H. 6½ x Diam. 6⅛ in. (16.5 x 15.6 cm). Asia Society, New York: Mr. and Mrs. John D. Rockefeller 3rd Collection, 1979.149

Porcelains of the Yuan and Early Ming Periods

The history of the Chinese ceramic industry from the late thirteenth to the early fifteenth century is one of constant innovation in both technology and taste. From 1279 to 1368, China was controlled by Mongols such as Chingiz (Genghis) Khan, who conquered the Jin dynasty in the north and the Southern Song dynasty in the south, and reunited China under the rule of the Yuan dynasty. In 1368, Han-Chinese control was reestablished and lasted until 1644. This period is known as the Ming, after one of the ruling dynasties during this time, which was one of the longest-lasting dynasties in Chinese history.

Trade played an important role in Chinese ceramics during both the Yuan and the Ming periods, and the ceramics reflect the impact of the growing demand for these wares throughout the world. The development of imperial patronage during the early Ming dynasty is recorded in the evolution of the shapes of and decorations on Chinese porcelains made during that time.

Unlike the earlier Song period, during which a wide range of types was produced in kilns throughout China, the majority of ceramics made during the Yuan and Ming dynasties were produced at the Jingdezhen kiln complexes located in Jiangxi Province. Some of the earliest porcelain in the world was manufactured at this complex, the site of some of the most important technical innovations and refinements in the history of ceramics. The most important and far-reaching of these was the perfection of the technique for painting decoration under the glaze using a blue pigment derived from cobalt. This technology led to the creation of the famous blue-and-white wares of China and eventually to the production of them around the world.

Despite the popularity and importance of blue-and-white wares, the history of the development of this technology remains elusive. Until the end of the twentieth century, the oldest known examples of blue-and-white wares were believed to be pieces produced in the third quarter of the fourteenth century. The cobalt blue used to decorate these fourteenth-century examples was imported from Iran, where it had long been used in ceramic glazes. Because the fourteenth-century ceramics decorated with imported cobalt were produced during a period of foreign rule, scholars had formerly believed that the earliest Chinese blue-and-white wares were intended primarily for export, particularly to Iran and Turkey. It also had been suggested that the impetus for the development of these wares stemmed from the use of cobalt blue, in a very different technique, in the Middle East.

Several significant archaeological excavations in China during the past forty years, however, yielded shards and ceramics decorated in underglaze cobalt blue that are substantially earlier than the well-known fourteenth-century examples, thus the history of the development of this important technology is under extensive revision. The earliest excavated examples of ceramics painted with underglaze cobalt blue date to the Tang dynasty. Numerous shards of ninth-century ceramics decorated with this pigment have been found in the port city of Yangzhou in Jiangsu Province on China's southeastern coast. In addition, a shipwreck discovered near Belitung Island in the Java Sea in 1998 included Tang-dynasty dishes with underglaze cobalt blue patterns among its cargo. Exported examples have also been found in sites such as the city of Samarra in Iraq and the site of the old city of Suhar in Oman, on the Persian Gulf.

The bodies of these ninth-century shards are very similar to those of ceramics produced at the Gongxian kilns in Henan Province, and it is generally accepted that the shards excavated in Yangzhou are fragments of ceramics that were produced in the north. Unlike other ceramics manufactured at Gongxian, examples of wares painted with underglaze cobalt blue are not found in tombs dating to the Tang dynasty. This suggests that these wares were produced primarily for trade with the Middle East. The blue used in the production of Tang blue-and-white wares was derived from absolite—an ore native to China—and not from the imported Iranian cobalt that was used in the fourteenth century and later; the blue pigment derived from absolite is grayer in tone than that which comes from cobalt.

Several examples of blue-and-white wares dating to the late thirteenth and early fourteenth centuries have also been excavated. These early Yuan pieces have been excavated from many regions of China, including Jiangsu, Zhejiang, Anhui, and Shandong provinces, and Inner Mongolia. This wide-ranging distribution suggests that by this time blue-and-white wares were used domestically as well as exported. The shapes of these discovered pieces and the fact that some of them are inscribed with the term for ancestral altar (zong wei) indicate that during this period, blue-and-white wares were often used in religious, ceremonial, or funerary settings. The discovery of several pieces painted with five-clawed dragons suggests that some fourteenth-century blue-and-white wares may have been intended for imperial use.

The evidence provided by Chinese archaeology indicates that both the development of underglaze blue technology and the domestic use of such ceramics

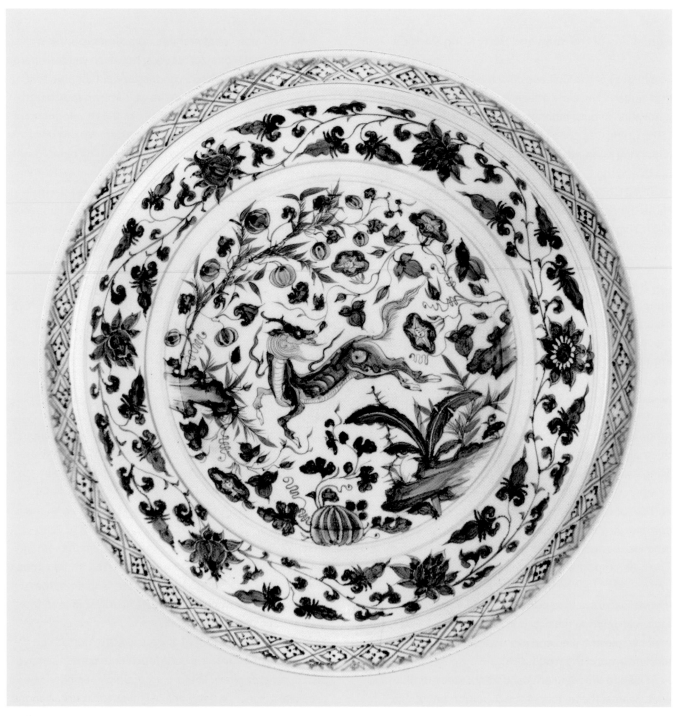

FIG. 167. Platter. Yuan period, mid-14th century. China, Jiangxi Province. Porcelain painted with underglaze cobalt blue (Jingdezhen ware). H. 3 x Diam. 18⅜ in. (7.6 x 46.7 cm). Asia Society, New York: Mr. and Mrs. John D. Rockefeller 3rd Collection, 1979.151

occurred earlier than was previously thought. Nonetheless, the full development of underglaze blue painting and the widespread exportation of ceramics decorated in this technique can still be dated to the mid-fourteenth century. Iran, Turkey, and India were the primary patrons for blue-and-white wares during the Yuan and early Ming dynasties. As a result, some of the most extensive collections of fourteenth- and fifteenth-century Chinese blue-and-white wares are preserved today in the Topkapi Saray Museum in Istanbul and the Ardebil Shrine in Tehran.

Inscription on foot ring of Yuan-period platter (**FIG 167**).

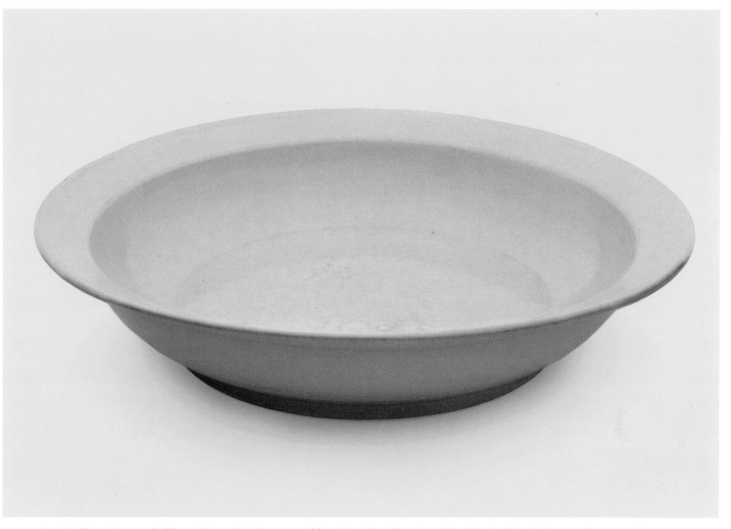

FIG. 168. Platter. Yuan period, late 14th–early 15th century. China, Jiangxi Province. Porcelain with glaze (Jingdezhen ware). H. 3½ x Diam. 17⅜ in. (8.9 x 44.1 cm). Asia Society, New York: Mr. and Mrs. John D. Rockefeller 3rd Collection, 1979.150

Decorated with traditional Chinese themes such as the mythical *qilin* (a unicornlike creature), bamboo, morning glories, melons, and plantains, a large mid-fourteenth-century platter **(FIG. 167)** exemplifies the type of ceramics exported to the Middle East during the Yuan period. All of these motifs are considered auspicious and convey wishes for good fortune and blessings. The style of the composition, particularly its density and complexity and the lack of empty space, is characteristic of blue-and-white wares made for export. The large size of the platter also reflects its intended market: it was most likely used to serve food to a large group of people. This custom differs from the Chinese tradition, in which numerous smaller bowls and plates are offered individually to each person sharing a meal.

An inscription engraved on the outside of the foot ring of this platter documents it as one of the few examples of Yuan-period porcelain known to have been preserved for some period of time in India. Written in Farsi, the language of the Persian and Mughal courts, it cites the name of the Mughal emperor Shah Jahan (reigned 1627–58) and gives a date that corresponds to 1652/1653 in the western calendar.[1] Similar inscriptions dating to the period of Shah Jahan's reign are found on some other ceramics from the late Yuan and early Ming periods. For example, a large glazed porcelain platter **(FIG. 168)** that can be dated to the late fourteenth or early fifteenth century has Shah Jahan's name inscribed in the glaze on the exterior (and the weight inscribed on the base). Although this platter has no decoration, it has been suggested that a gold pigment once may have been painted over the glaze, as similar platters with this type of decoration are known.

Inscriptions on exterior side (left) and bottom (right) of Yuan-period platter **(FIG 168)**.

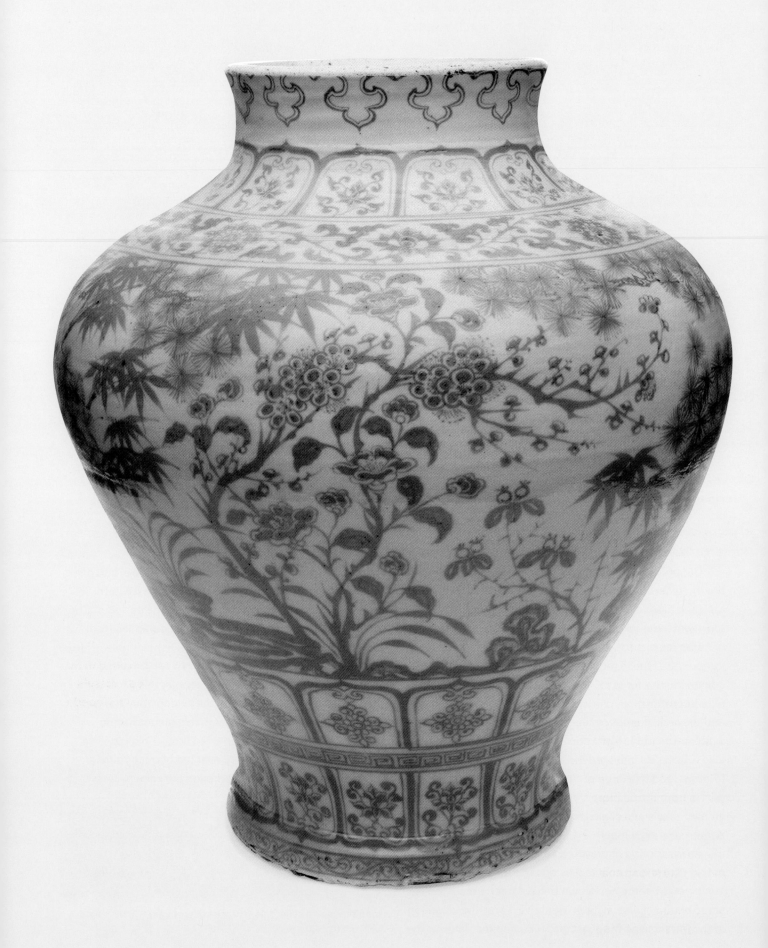

Shah Jahan is famous for his patronage of the arts—in particular, the building of the Taj Mahal—and he is also known to have been a collector of ceramics. However, there are no extant imperial collections from either the Mughal or the Rajput courts of India that are comparable to those found in Turkey and Iran, and much less is known about the nature of imperial collecting in India. Chinese porcelains are depicted in Indian paintings, and references to Chinese porcelains found in imperial Mughal memoirs and European accounts of this court make it clear that Chinese porcelains were held in high regard. Several known Chinese porcelains are inscribed with the name of Shah Jahan; his predecessor, Jahangir; and his successor, Aurangzeb. It is not clear why certain pieces, such as these two platters, were inscribed with the names of these emperors. It is possible that both the blue-and-white platter and the plain-glazed example had been in Shah Jahan's family for generations and that he had them engraved as marks of ownership or lineage. Or, the ceramics might have been gifts from his Persian or Turkish counterparts, inscribed to record Shah Jahan's appreciation of these rare and precious presents.

In addition to ceramics painted with underglaze blue, pieces decorated with a combination of this pigment and an underglaze red, colored using a copper oxide, have also been excavated from early Yuan sites. The red color of the underglaze copper pigment is notoriously difficult to achieve during firing, and pieces decorated exclusively with this color are scarcer than the well-known blue-and-white examples. Nonetheless, underglaze copper-red wares became popular and were made in some number during the reign of the first Ming emperor, Hongwu (reigned 1368–98). Shards from such wares were discovered at the Hongwu palace site in Nanjing, which suggests that they were used at the court. The presence of several copper-red decorated wares from the late fourteenth century in the palace museums in Beijing and Taipei also supports this presumption. Some ceramics decorated with a copper-based pigment were found in the Philippines, indicating this type of ware was also exported.

A large jar in the *guan* shape provides an outstanding example of a late-fourteenth-century porcelain painted with a copper-red pigment (**FIG. 169**). This jar, which once had a cover and a slightly longer neck, was probably used for storage. Although the copper-red decoration retains the density and complexity characteristic of Yuan-period design, its strong spatial organization helps to date this

example to the early Ming period. The painting on this jar is carefully divided into several registers: curvilinear shapes called *ruyi* (after the name of a Chinese scepter) form designs that encircle the truncated neck, while leaf-shaped designs filled with flowers and a horizontal band containing a floral arabesque are on the shoulder. Two rows of similar leaf-shaped images divided by a small band filled with a key-fret motif encircle the base.

The central section is painted with a traditional Chinese theme called the Three Friends of Winter (*suihan sanyou*): pine, plum, and bamboo, which flourish even under adverse conditions and are symbols of longevity, perseverance, and integrity, the innate virtues of the ideal scholar-gentleman. Although it has a long history in Chinese literature, the theme did not become popular in Chinese art until the fourteenth century.

The emergence of the theme of the Three Friends of Winter in fourteenth-century painting has often been interpreted as a subtle Chinese response to Mongol domination. It is possible that a similar rationale underlies its appearance in the decorative arts at the time. On this jar the overall theme is reiterated by the presence of the orchid— another symbol of the scholar-gentleman—which has been added to the principal motifs. The camellias, roses, plantains, and strangely shaped Taihu rocks on the jar indicate that the Three Friends are growing within the confines of a traditional scholar-gentleman's garden. The high quality of the painting on this jar and its large size indicate that it was an expensive item, probably made for a wealthy scholar-gentleman or possibly for the court.

A small dish (**FIG. 170**) and a saucer (**FIG. 171**) decorated in underglaze copper red illustrate a more standard use of this pigment. They are decorated with scrolling flowers, probably chrysanthemums, but on both pieces, the copper pigment fired to a dull gray, demonstrating the difficulties inherent in working with this color. Saucers such as this one were often used to hold tripod vessels made of bronze or ceramic; it is possible that this lobed saucer once served as a cup stand on an altar or family shrine.

A large bowl (**FIG. 172**) painted with images of fruits and flowers in underglaze cobalt blue illustrates the imperial taste in Chinese ceramics of the early fifteenth century. Scrolling lotus vines are painted on the exterior of this bowl, while camellias, litchis, peaches, pomegranates, peonies, and chrysanthemums decorate the interior. The careful placement of these motifs, their calligraphic

Opposite: **FIG. 169.** Jar. Ming period, late 14th century. China, Jiangxi Province. Porcelain with underglaze copper red (Jingdezhen ware). H. 20 x Diam. 16¾ in. (50.8 x 42.5 cm). Asia Society, New York: Mr. and Mrs. John D. Rockefeller 3rd Collection, 1979.153

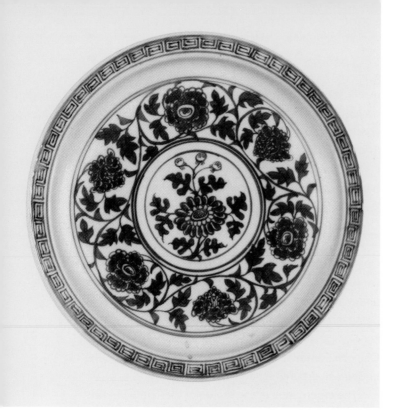

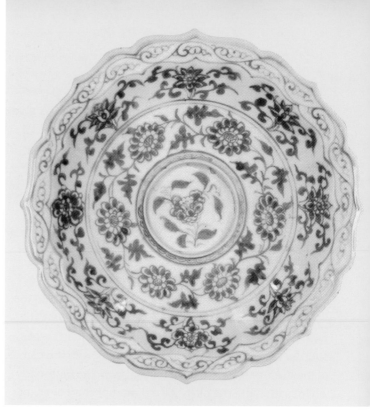

FIG. 170. Dish. Ming period, early 15th century. China, Jiangxi Province. Porcelain painted with underglaze copper red (Jingdezhen ware). H.¾ x Diam. 7½ in. (1.9 x 19.1 cm). Asia Society, New York: Mr. and Mrs. John D. Rockefeller 3rd Collection, 1979.154

FIG. 171. Saucer. Ming period, late 14th century. China, Jiangxi Province. Porcelain painted with underglaze copper red (Jingdezhen ware). H. 1 x Diam. 7¾ in. (2.5 x 19.7 cm). Asia Society, New York: Mr. and Mrs. John D. Rockefeller 3rd Collection, 1979.152

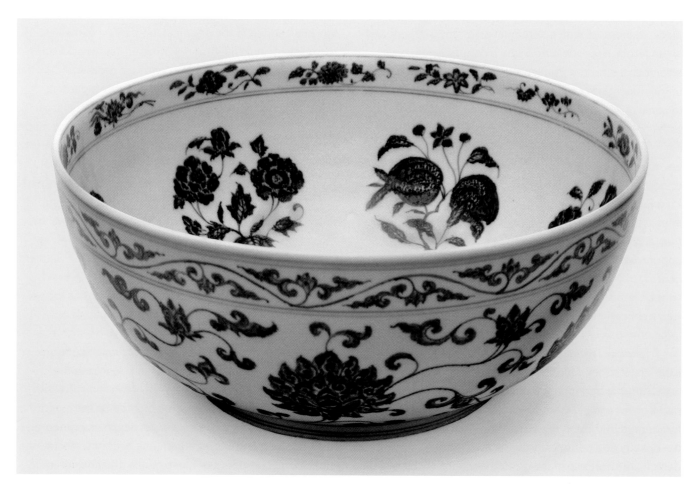

FIG. 172. Bowl. Ming period, early 15th century (probably Xuande era, 1426–1435). China, Jiangxi Province. Porcelain painted with underglaze cobalt blue (Jingdezhen ware). H. 5⅝ x Diam. 13⅜ in. (14.3 x 34 cm). Asia Society, New York: Mr. and Mrs. John D. Rockefeller 3rd Collection, 1979.169

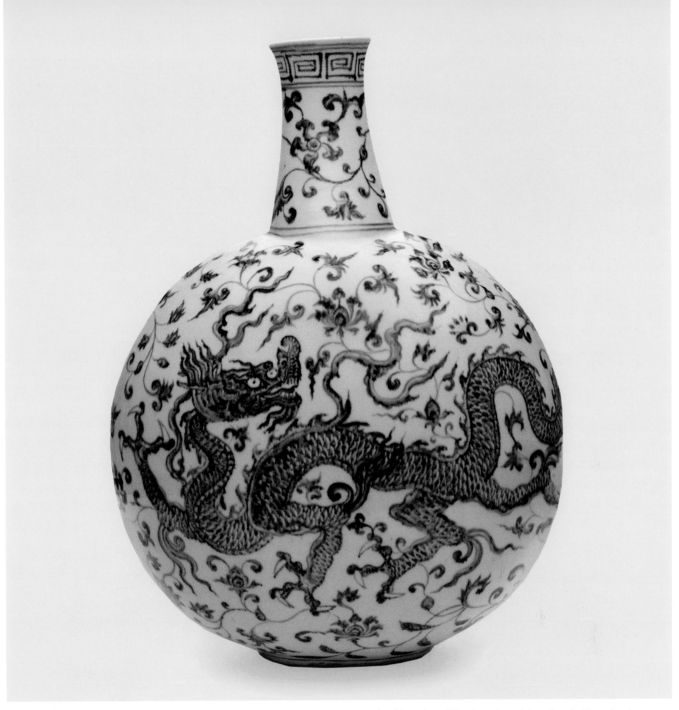

FIG. 173. Flask. Ming period, early 15th century (probably Yongle era, 1403–1424). China, Jiangxi Province. Porcelain painted with underglaze cobalt blue (Jingdezhen ware). H. 18½ x W. 14⅜ x D. 5⅞ in. (47 x 36.5 x 25 cm). Asia Society, New York: Mr. and Mrs. John D. Rockefeller 3rd Collection, 1979.160

treatment, and the openness of the composition characterize the style of the early fifteenth century.

The same fluidity of design is seen in the scrolling lotus arabesques surrounding the two striding dragons that decorate the front and back of a large flask that also dates to the early fifteenth century **(FIG. 173)**. These alert dragons share the powerful form, large scales, massive head, and upturned nose characteristic of early Ming depictions. The background of lotus scrolls is typical, however, of the early Ming interest in decorative pattern rather than in the naturalism of the sea and the sky, which are more often depicted as the habitat of the dragon in

Chinese ceramics. During this period images of five-clawed dragons were again reserved for ceramics intended for imperial use. Works decorated with three- or four-clawed dragons, such as this one, were used at the court as gifts from the emperor to his attendants and were also presented to foreign rulers and dignitaries. The large size of this flask suggests that it may have been intended for use in countries such as Iran or Turkey, and similar examples are found in the famous collections in Tehran and Istanbul.

The black spots found in the underglaze pigment used to paint this flask are typical of fourteenth- and

FIG. 174. Foliate Dish. Ming period, early 15th century (probably Yongle era, 1403–1424). China, Jiangxi Province. Porcelain with incised design under glaze (Jingdezhen ware). H. 1 x Diam. 7⅞ in. (2.5 x 20 cm). Asia Society, New York: Mr. and Mrs. John D. Rockefeller 3rd Collection, 1979.157

FIG. 175. Dish. Ming period, early 15th century (probably Yongle era, 1403–1424). China, Jiangxi Province. Porcelain with impressed and incised design under glaze (Jingdezhen ware). H. 1⅜ x Diam. 6⁷⁄₁₆ in. (3.5 x 16.3 cm). Asia Society, New York: Mr. and Mrs. John D. Rockefeller 3rd Collection, 1979.158

fifteenth-century blue-and-white wares. They are caused by the precipitation of the cobalt into the overlying glaze during firing. Chinese scholars and connoisseurs have labeled this effect as "heaped-and-piled." Also characteristic of ceramics made during this period is a slight wrinkling in the glaze, called "orange-peel." The bluish tinge found in the otherwise transparent glaze is also typical.

The style of painting on both the underglaze copper-red dish **(FIG. 170)** and the large blue-and-white flask are characteristic of ceramics produced during the rule of the Yongle emperor (reigned 1403–24). Yongle, the third emperor of the Ming dynasty, usurped the throne from his nephew, the designated successor to Hongwu.

Recent excavations of the imperial kilns at Jingdezhen have determined that porcelain covered with a warm white glaze, often known as "sweet white wares" (*tian bai*), were among the most popular ceramics produced during Yongle's reign. Over 95 percent of the ceramics unearthed from the strata dating to this period are white wares, suggesting that imperial taste contributed substantially to the production of this type of ceramic. Moreover, Yongle is known to have patronized the construction in 1412 of a nine-story pagoda at the Bao'en temple in Nanjing, and the choice of white bricks to cover this structure further attests to his preference for these plainer wares.

A small dish with a foliate rim **(FIG. 174)** typifies the white wares produced during Yongle's reign. A highly refined porcelain body was used to make this dish, which has a clear glaze. An extremely delicate pattern of grapes was incised into the interior of the dish, and flowers and clouds decorate the exterior of the rim. Difficult to see at first glance, decoration of this type is often called hidden decoration (*anhua*). Hidden decoration was very popular in the early Ming period, at least in part because of Yongle's taste for plain white wares.

The decoration of two dragons among three clouds impressed under the glaze in the interior of a thin dish **(FIG. 175)** is also very difficult to see. Just a few dishes of this type, which are noticeably thinner than the majority of Yongle porcelains, have survived to the present day. A few examples of eggshell porcelain with impressed decoration have the Yongle reign mark in archaic characters incorporated into their design; the attribution of these very thin dishes to the Yongle period is based on the existence of this mark. It should be noted that the foot ring on this dish is not as precisely rendered as those found on most pieces that date to Yongle's reign. The long, thin body and face and the short legs of the two dragons impressed into the body of this dish are comparable to early-fifteenth-century depictions of this mythical creature.

Yongle's preference for white wares is quite different from the taste for brightly colored underglaze blue and copper-red wares of the late fourteenth century; several reasons have been proposed to explain this change in imperial taste. White is the color of filial piety and mourning, and it is possible that Yongle's choice of ceramics was partially intended to mitigate the circumstances under which he came to rule. Yongle spent the first four years of his reign publicly grieving for the father whose wishes he had ignored when he usurped the throne. However, white wares had also been esteemed during the Tang and Song dynasties, and Yongle may have fostered their production to claim a link to this illustrious past.

The worldwide export of ceramics during the Yuan dynasty was temporarily slowed by the warfare that led to the establishment of the Ming dynasty. The official reopening of trade during the Yongle period had an impact on the form and decoration of ceramics produced during the first half of the fifteenth century. For example, the flattened gourd shape of a bottle **(FIG. 176)** ultimately derives from metalwork and ceramic flasks of Iranian, Syrian, and Turkish origins. Several variants of this form were common to ceramics in the Yongle and subsequent Xuande (reigned 1426–35) eras. The ends of the handles are formed into curvilinear shapes, or *ruyi*. The stylized lotus medallion lightly incised in the center of this bottle is often found as decoration on early-fifteenth-century ceramics. Unlike the more naturalistic Chinese designs, this geometric treatment also reflects renewed interest in the Middle East.

A pear-shaped ewer **(FIG. 177)**, which also derives its form from Middle Eastern metalwork, would once have had a small lid. The body, spout, and handle of this ewer are decorated with a peony spray that has been lightly incised under the glaze. The innovative combination of foreign shapes with Chinese designs suggests the two-way influences of the Chinese ceramic trade from the fourteenth to the fifteenth century. Since export ceramics produced during the Yuan dynasty catered specifically to foreign tastes, it is often possible to determine whether a particular piece was made for the domestic or the export market. During the first half of the fifteenth century, however, foreign forms were also used domestically, and the large number of new shapes that appeared during this period suggests a taste for exotic forms both at the court and in the domestic market.

A comparison of two white porcelain bowls, each decorated with hidden designs, helps to illustrate the subtle changes that occurred in ceramics produced during the Yongle period and those made in the Xuande

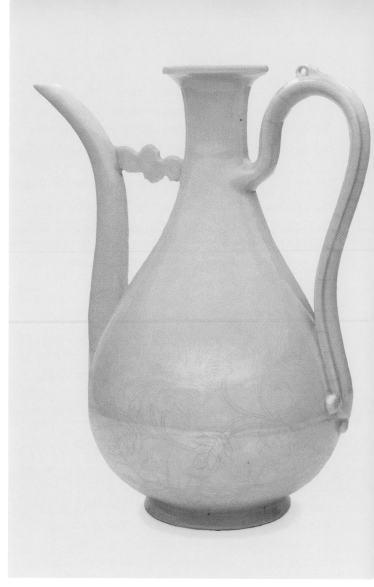

FIG. 176. Bottle. Ming period, early 15th century (probably Yongle era, 1403–1424). China, Jiangxi Province. Porcelain with incised design under glaze (Jingdezhen ware). H. 12½ x W. 8½ x D. 6 in. (31.8 x 21.8 x 15 cm). Asia Society, New York: Mr. and Mrs. John D. Rockefeller 3rd Collection, 1979.156

FIG. 177. Ewer. Ming period, early 15th century (probably Yongle era, 1403–1424). China, Jiangxi Province. Porcelain with incised design under glaze (Jingdezhen ware). H. 13 x W. 11 x D. 7⅞ in. (33 x 28 x 19.8 cm). Asia Society, New York: Mr. and Mrs. John D. Rockefeller 3rd Collection, 1979.155

era. Both the interior and the exterior of a bowl probably made during the Yongle era **(FIG. 178)** are decorated with incised motifs: plantain leaves and chrysanthemum flowers are incised on the interior, while a chrysanthemum spray and the geometric keyfret design decorate the exterior. Plantain leaves decorate the exterior of the Xuande-period bowl **(FIG. 179)**, while the interior is plain except for chrysanthemum flowers in the bottom.

The Xuande bowl has a higher foot rim and marginally straighter sides than the bowl from the Yongle period. In addition, the Xuande bowl is heavier and more thickly potted than the earlier piece, and its glaze has a somewhat more noticeable blue-green tinge. This color becomes apparent where the glaze pooled into the incised decoration, making the designs on the Xuande piece easier to see.

A six-character mark, written in underglaze blue, is inscribed in a double circle on the inside of the foot ring of the Xuande bowl. Marks of this type, which appear frequently on Chinese ceramics manufactured at Jingdezhen, attest to the extent of imperial patronage and control of the ceramic industry from the early fifteenth through the mid-sixteenth century and extending through the late seventeenth, eighteenth, and nineteenth centuries. Although such marks first appeared during the Yongle era, they did not become common until the Xuande era; the widespread use of reign marks in the mid- and late fifteenth century denotes the elevated status of ceramics, which during this period became even more important as objects of imperial patronage and symbols of imperial taste.

1. The inscription reads *Shah Jahan ibn' Jahangir Shah, 1063,* with the A.H. date 1063 corresponding to 1652/1653 CE.

FIG. 178. Bowl. Ming period, early 15th century (probably Yongle era, 1403–1424). China, Jiangxi Province. Porcelain with incised and impressed design under glaze (Jingdezhen ware). H. 4 x Diam. 8¼ in. (10.2 x 21 cm). Asia Society, New York: Mr. and Mrs. John D. Rockefeller 3rd Collection, 1979.159

FIG. 179. Bowl. Ming period, Xuande era, 1426–1435. China, Jiangxi Province. Porcelain with incised design under glaze (Jingdezhen ware). H. 4 x Diam. 8⅛ in. (10.2 x 20.6 cm). Asia Society, New York: Mr. and Mrs. John D. Rockefeller 3rd Collection, 1979.161

FIG. 180. Carinated Bowl. Ming period, Xuande era, 1426–1435. China, Jiangxi Province. Porcelain painted with underglaze cobalt blue and copper red (Jingdezhen ware). H. 3 x Diam. 6⅞ in. (7.6 x 17.5 cm). Asia Society, New York: Mr. and Mrs. John D. Rockefeller 3rd Collection, 1979.167

Imperial Chinese Ceramics of the 15th Century

Noted for their refined bodies and elegant shapes, porcelains made during the reigns of the Xuande (1426–35) and Chenghua (1465–87) emperors are ranked among the finest examples of imperial Chinese wares. Many of the characteristics of fifteenth-century porcelains resulted from increased imperial interest in ceramics. Ceramic production during this time is noted for the widespread use of reign marks to date pieces, the development and refinement of techniques for making and decorating wares, and the creation and variation of designs.

Reign marks are inscriptions that identify the name of the dynasty and the reign name of an emperor. (Emperors' given names are rarely mentioned in Chinese history and are not used in inscriptions.) While reign marks occasionally appear on porcelains produced in the first quarter of the fifteenth century during the rule of the Yongle emperor, they became widespread under Xuande's reign, and by the mid- to late fifteenth century they were often used to distinguish ceramics made exclusively for the court. The six-character mark on the interior of the base of a small bowl **(FIG. 180)** reads "made during the Xuande reign of the great Ming dynasty" (*da Ming Xuande nian zhi*). Xuande reign marks were variously written on the interiors, exteriors, or bases of bowls, dishes, and other vessels. After the Xuande era, reign marks were almost invariably inscribed on the base of the ceramic.

This bowl originally had a cover, and its shape suggests that it once may have been part of a larger set of dishes used for dining. According to the book *Talks on Pottery* (*Tao Shuo*), written by Zhu Yan in 1774, ceramics were first used for imperial dining in the early fifteenth century. The wealth of new shapes created during this period and the large number of porcelains produced illustrate the higher status awarded to this art form.

Two different underglaze colors were used to paint the motif of dragons chasing flaming pearls among waves on the exterior of this bowl. The waves, pearls, and clouds are in cobalt blue, while the powerful dragons are in copper red. Here, the design of the dragons was lightly stamped into the clay before the design was painted, possibly in an attempt to control the flow of the notoriously difficult copper red during firing.

The combination of copper red and cobalt blue indicates that this bowl was considered a particularly luxurious piece, while the depiction of the dragons as having five claws shows that it was intended for the use of the emperor. Although dragons had long been used as symbols of imperial power in China, in the fifteenth century the motif of a dragon chasing a pearl became a prominent imperial symbol in the arts. The flaming pearl might represent the sun or the moon—either would be an appropriate symbol of the power of the emperor. It also has a close affinity to the so-called wish-granting jewel—*chintamani*, "jewel of wisdom," which is also in flames—that is often held by Buddhist deities. Just as this type of pearl is popularly believed to be able to grant material or spiritual wishes to the devout, so could it have been used to illustrate the power and benevolence of the emperor.

While objects decorated with five-clawed dragons were reserved for the use of the imperial family, those with four claws, such as the powerful and assured dragon painted in underglaze blue on a small stem cup **(FIG. 181)**, were used by nobility of lower rank. A six-character Xuande reign mark is written in the bottom of the interior of this cup made of a refined porcelain clay. This stem cup is neither very thick nor thin. The black spots in the cobalt and the pale sea-green tinge in the otherwise transparent glaze are typical of Chinese blue-and-white wares of the Yongle, Xuande, and Chenghua eras.

The flowers and fruit painted in underglaze blue on the interior and exterior of an elegant bowl **(FIG. 182)**, inscribed on the exterior of the base with a six-character Xuande reign mark, illustrate another theme common in Xuande-era porcelains. The combination of flowers and fruits, sometimes as symbols of the four seasons or the twelve months, and sometimes for purely decorative purposes, began to be used during the Yongle era and is frequently seen on porcelains of the subsequent Xuande and Chenghua eras.

Three lotuses and a chrysanthemum, a peony, and a camellia spray are painted around the interior of this bowl, while an unidentified flowering branch is at the center. Litchi, peach, loquat, pomegranate, grape, camellia, cherry, and chrysanthemum sprays decorate the exterior. The delicate sense of vitality of these fruits and flowers as well as the ease of their careful placement over the

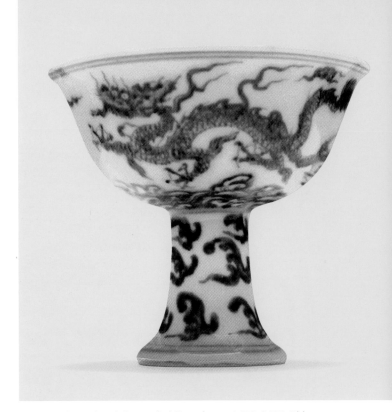

FIG. 181. Stem Cup. Ming period, Xuande era, 1426–1435. China, Jiangxi Province. Porcelain painted with underglaze cobalt blue (Jingdezhen ware). H. 3½ x Diam. 4 in. (8.9 x 10.2 cm). Asia Society, New York: Mr. and Mrs. John D. Rockefeller 3rd Collection, 1979.163

surface of the bowl, giving the design a subtle sense of movement and naturalness, characterize the decoration of porcelains during the Xuande era and help to distinguish pieces like this from earlier examples.

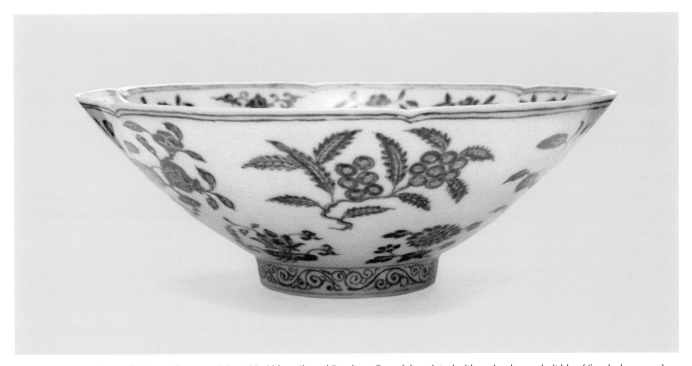

FIG. 182. Bowl. Ming period, Xuande era, 1426–1435. China, Jiangxi Province. Porcelain painted with underglaze cobalt blue (Jingdezhen ware). H. 3⅛ x Diam. 8¾ in. (7.9 x 22.2 cm). Asia Society, New York: Mr. and Mrs. John D. Rockefeller 3rd Collection, 1979.162

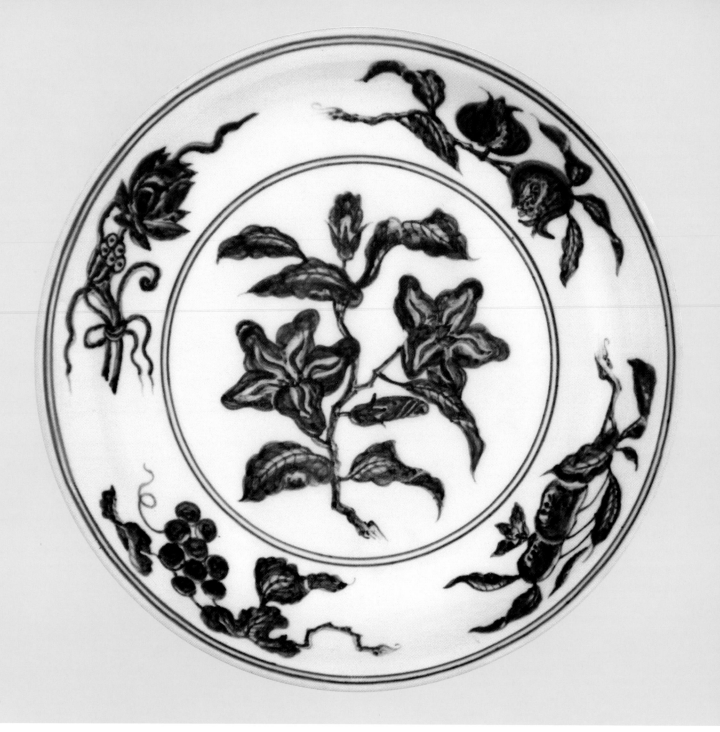

FIG. 183. Dish. Ming period, Xuande era, 1426–1435. China, Jiangxi Province. Porcelain painted with underglaze cobalt blue (Jingdezhen ware). H. 1⅞ x Diam. 10¼ in. (4.8 x 26 cm). Asia Society, New York: Mr. and Mrs. John D. Rockefeller 3rd Collection, 1979.165

The similarities found in the compositions of two dishes in the Collection suggest that potters relied on pattern books created at the court for the decoration of porcelains. While the designs on one dish are painted in underglaze cobalt blue **(FIG. 183)**, in the other the decoration is reserved in white against a dark blue background **(FIG. 184)**. In the latter technique, the design of flowers was incised into the porcelain body, the surrounding areas were painted in with the blue pigment, and the entire piece was then covered with a transparent glaze. Both dishes are inscribed with a six-character

Xuande reign mark: it is on the base of the blue-on-white piece and on the side of the other dish. Both are decorated with a composition that consists of a single large floral spray in the center of the interior of the dish and four different floral sprays along the interior rim, or cavetto.

These two dishes show some of the numerous variations of flowers and fruits found in the decoration of Xuande-era porcelain, and the bountiful array of fruits and flowers from different seasons of the year may be understood as allusions to the passage of time. Crepe myrtle is painted in the center of the blue-and-white bowl, and a

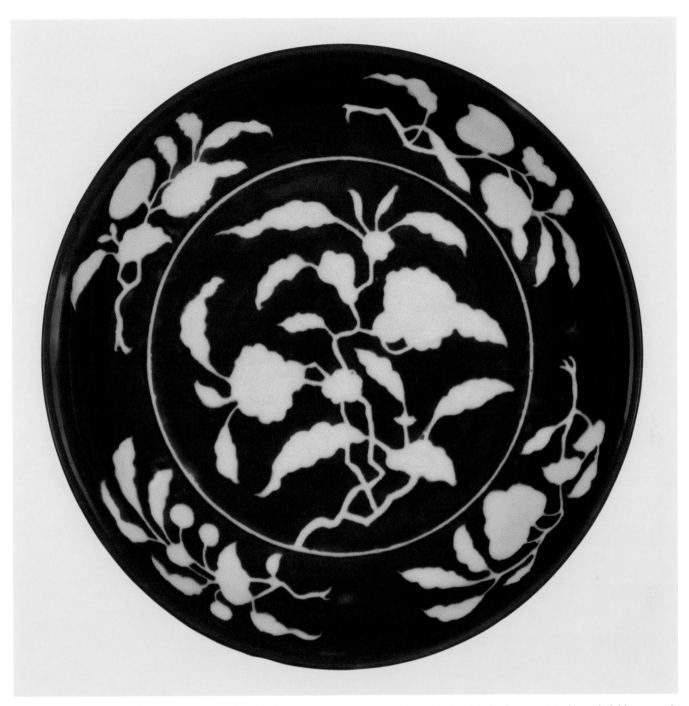

FIG. 184. Dish. Ming period, Xuande era, 1426–1435. China, Jiangxi Province. Porcelain with incised design in reserve against cobalt blue ground under glaze (Jingdezhen ware). H. 2¼ x Diam. 11½ in. (5.7 x 29.2 cm). Asia Society, New York: Mr. and Mrs. John D. Rockefeller 3rd Collection, 1979.166

lotus, pomegranate, apple, and cherry decorate the rim. On the blue-ground dish, a spray of camellias is encircled by peaches, pomegranates, crab apple, and litchi. A continuous floral scroll is painted on the exterior rim of the white-background dish, while four sprays decorate the same area on the ceramic with reserve decoration. As is characteristic of dishes from the Xuande era, the designs are larger, more forceful, and more focused than was typical in earlier works with similar motifs.

Although the groups of fruits and flowers on these two dishes were chosen primarily for their decorative possibilities, it is important to remember the numerous symbolic associations of many of these motifs. For example, the pomegranate often symbolized the desire for children. The peach represents immortality, and the Chinese word for apple (*ping*) is a homonym of that for peace. In addition, both the cherry and the camellia are sometimes understood to refer to young women. The combination of these auspicious motifs and their constant reuse has led to the suggestion that dishes with such decoration were intended to be used by women. Commissioned throughout the Ming dynasty, dishes decorated

FIG. 185. Lobed Vase. Ming period, early 15th century (probably Xuande era, 1426–1435). China, Jiangxi Province. Porcelain painted with underglaze cobalt blue (Jingdezhen ware). H. 7½ x Diam. 5¼ in. (19.1 x 13.3 cm). Asia Society, New York: Mr. and Mrs. John D. Rockefeller 3rd Collection, 1979.170

FIG. 186. Jar. Ming period, early 15th century (probably Xuande era, 1426–1435). China, Jiangxi Province. Porcelain painted with underglaze cobalt blue (Jingdezhen ware). H. 9¼ x Diam. 11¼ in. (23.5 x 28.6 cm). Asia Society, New York: Mr. and Mrs. John D. Rockefeller 3rd Collection, 1979.168

FIG. 187. Bowl. Ming period, Xuande era, 1426–1435. China, Jiangxi Province. Porcelain painted with underglaze cobalt blue (Jingdezhen ware). H. 4⅜ x Diam. 12 in. (11.1 x 30.5 cm). Asia Society, New York: Estate of Blanchette Hooker Rockefeller, 1993.5

FIG. 188. Bowl. Ming period, Xuande era, 1426–1435. China, Jiangxi Province. Porcelain painted with underglaze cobalt blue (Jingdezhen ware). H. 3½ x Diam. 10½ in. (8.9 x 26.7 cm). Asia Society, New York: Mr. and Mrs. John D. Rockefeller 3rd Collection, 1979.164

with this type of motif were made in several color schemes, including blue and white, yellow and white, and more rarely, brown and white. If they were indeed made for women, it is possible that the variety in color schemes and decoration may have reflected the different statuses of the many women at the Chinese court. Court regulations from the subsequent Qing dynasty indicate that certain color combinations were specifically assigned to court ladies of different ranks. For example, yellow porcelains were used by the empress and empress dowager, while those with white interiors were assigned to concubines of the first rank. It is possible that some version of this system was already in use during the Ming dynasty, just as many of the imperial symbols used by the Qing, such as the five-clawed dragon, had been developed earlier.

Floral motifs were also used in the designs of blue-and-white and other wares that were not produced for the court, for example, in the unusual pomegranate shape of a vase **(FIG. 185)** and the four peony sprays that form the primary decoration of a wide-mouthed jar **(FIG. 186)**. While the overall compositions of their decoration show the accomplished use of space that characterizes Xuande porcelains, the quality of the painting does not match that found on imperial wares. In general, the outlines of the motifs on nonimperial pieces are not as carefully delineated and the brush strokes are less deliberate, giving the motifs a more blurred appearance than is found on court

ceramics. A similar haphazardness is also apparent in the decoration along the necks and bases of these vessels.

The Xuande era also saw the development of themes that reflect the interests of the scholar-gentleman class. The imagery painted on the sides of two large shallow bowls belongs to this category: one bowl is decorated with the Three Friends of Winter **(FIG. 187)** and the other with the Four Gentlemanly Accomplishments **(FIG. 188)**. Both designs are exquisitely painted in underglaze blue in compositions that cover the entire body of the bowl. The six-character Xuande reign mark is written on the exterior just below the rim of the Three Friends of Winter bowl and on the base of the other bowl.

Because pine, plum, and bamboo flourish even under adverse conditions, they are grouped together as the Three Friends of Winter, symbols of the upstanding character of a scholar-gentleman when faced with hardship. The grouping also has seasonal overtones, as the blossoming plum and green bamboo are among the first plants to bud when winter, marked by the evergreen pine, turns to spring. On this bowl, each of the three motifs is repeated twice in order for the design to fill the entire surface.

Calligraphy, painting, music, and chess are the Four Gentlemanly Accomplishments. On the bowl depicting this theme, the four activities are practiced by figures in a garden set against a background of distant mountains

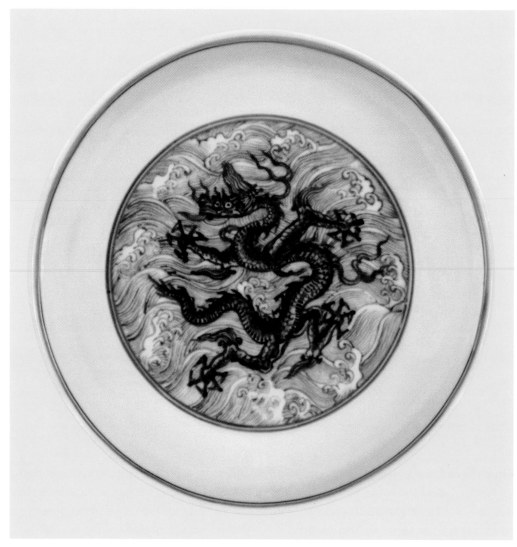

FIG. 189. Dish. Ming period, mid- to late 15th century (probably Chenghua era, 1465–1487). China, Jiangxi Province. Porcelain painted with underglaze cobalt blue (Jingdezhen ware). H. 1½ x Diam. 7⅞ in. (3.8 x 20 cm). Asia Society, New York: Mr. and Mrs. John D. Rockefeller 3rd Collection, 1979.174

that skillfully suggests the view from a terrace. Each of the accomplishments is represented as a vignette within the overall composition, with plants, rocks, and trees separating the scenes from one another. Although the theme reflects the activities of the educated male elite, the clothing and hairstyles of the figures on this bowl indicate that they are women, which gives an unusual twist to a standard theme.

Bowls of this shape are generally called dice bowls in the West, presumably because they were believed to have been used for throwing dice, however, some questions remain regarding their actual use. They are generally more thickly potted than other porcelains bearing the Xuande reign mark. While the thicker body may reflect the intended function of the piece—whether or not this was the rolling of dice—other explanations are also possible. For example, this thickness is similar to that found in Xuande-period porcelains produced for use outside the

court. It is possible that thicker porcelains with imperial marks were made to be given as gifts by members of the court, which could explain the combination of a reign mark and a thicker body. In this case, the use of popular themes with scholarly overtones such as the Three Friends and the Four Accomplishments might reflect the taste of the scholar-gentlemen and other bureaucrats who were employed at the court.

The three emperors who ruled in quick succession between the reign of the Xuande emperor and that of the Chenghua emperor did not have any major influence on the development of porcelains. Many of the shapes and designs found in Xuande-era ceramics were repeated until the Chenghua era, when the refinements of the porcelain body and the experimentation with shapes and designs begun under Xuande were resumed.

The five-clawed dragon writhing against a sea of storming waves on the interior of a porcelain dish

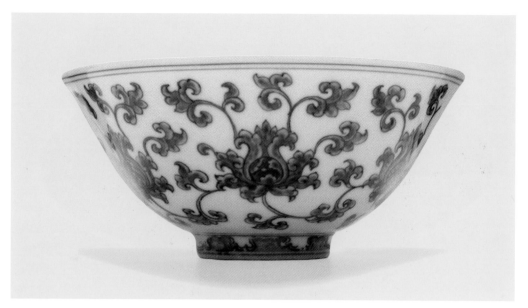

FIG. 190. Bowl. Ming period, Chenghua era, 1465–1487. China, Jiangxi Province. Porcelain painted with underglaze cobalt blue (Jingdezhen ware). H. 2½ x Diam. 6 in. (6.4 x 15.2 cm). Asia Society, New York: Mr. and Mrs. John D. Rockefeller 3rd Collection, 1979.171

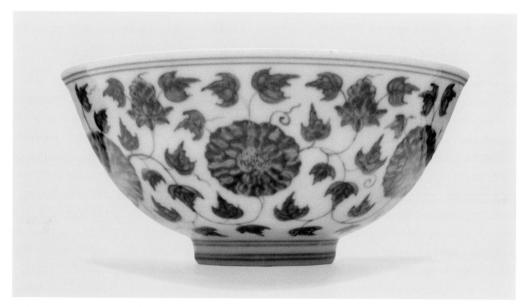

FIG. 191. Bowl. Ming period, Chenghua era, 1465–1487. China, Jiangxi Province. Porcelain painted with underglaze cobalt blue (Jingdezhen ware). H. 2¾ x Diam. 6 in. (7 x 15.2 cm). Asia Society, New York: Mr. and Mrs. John D. Rockefeller 3rd Collection, 1979.172

(FIG. 189) painted in underglaze cobalt blue has the same powerful, long, thin body and strong face and jaws that characterize Xuande interpretations of this mythical creature. Five similar dragons decorate the porcelain body, and the delicacy and control of the painting indicate that this dish was intended for imperial use. Moreover, the same design of five-clawed dragons against waves is found on pieces bearing the six-character Chenghua mark.

Some of the thinnest porcelain bodies made during the Ming period were produced during the reign of the Chenghua emperor and are considered some of the finest Chinese porcelains ever made. Bowls with thin porcelain bodies and precisely rendered designs, such as one painted with stylized lotuses **(FIG. 190)** and another with chrysanthemums **(FIG. 191)**, belong to a category known as palace bowls and are regarded as some of the most outstanding examples of Chenghua porcelain. The decoration on these bowls is exquisitely painted, and they are covered with a thinner and smoother glaze than that used on earlier porcelains. Such bowls, which have subtly rounded sides and small, high foot rims, appear to have been produced exclusively during the reign of the

FIG. 192. Dish. Ming period, mid- to late 15th century (probably Chenghua era, 1465–1487). China, Jiangxi Province. Porcelain with copper-red glaze (Jingdezhen ware). H. 1⅜ x Diam. 6½ in. (3.5 x 16.5 cm). Asia Society, New York: Mr. and Mrs. John D. Rockefeller 3rd Collection, 1979.177

Chenghua emperor. Both these examples have the six-character reign mark written on their bases.

As was true of imperial Xuande wares, the decoration on Chenghua pieces such as these palace bowls was usually based on paintings by artists working at the Imperial Painting Academy. On both of these bowls, the flowers and scrolling leaves have been carefully placed both to cover the exterior of the bowl and to suggest the organic movement and growth of actual plants. The flowers and leaves flow together in one continuous pattern with no clear beginning or end. This enhances the rounded shape of the bowl and continues the skillful use of the shape of a ceramic as a pictorial plane that was begun in the Xuande era.

The bright red color of a small monochrome dish **(FIG. 192)** also employs technology that was developed during Xuande's reign. The bright red glaze of this bowl is often called sacrificial red (*jihong*) and ceramics covered with this glaze are thought to have been used as ceremonial wares during the Xuande era. The surname of the imperial Ming family, Zhu, can be translated as *red*, and it has been suggested that this was one reason why red was chosen as the banner color for that dynasty. In addition, historical records indicate that red was used as a symbol for the sun and that red bricks and vessels with red glazes were used at the Altar of the Sun (*Chaoritan*), one of the four main altars designated for imperial sacrifices and ceremonies. The names of the vessels listed for use at

imperial altars are those used to describe the shapes of bronze vessels, particularly those of the Shang and Zhou dynasties. However, recent research has shown that during the Ming dynasty, more common shapes such as bowls, plates, and dishes were substituted for vessels in archaic shapes, and thus it seems likely that this small bowl was used for rituals and ceremonies.

The red color of the glaze was achieved by mixing a finely ground copper oxide into the glaze and by firing the porcelain so as to fix this color. Because copper red was so difficult to fire, the creation of a beautiful monochrome glaze was a major advancement. Very few vessels of this type were successfully manufactured during the Xuande period, and it seems that the technology used to make this particular glaze may have been guarded by one group of potters. The glaze of Chenghua examples such as this piece is blacker than the strong red found in Xuande examples, suggesting that the precise technology had somehow been lost. It was not until the eighteenth century that a red close to the Xuande red was again produced. The mottled effect found on the glaze of this piece (and of the Xuande examples) helps to distinguish it from the Qing-dynasty red, which is much smoother in appearance.

The use of the joined colors (*doucai*) technique to decorate a small wine cup with a design of dragons in floral medallions **(FIG. 193)** also illustrates technology that was developed in the Xuande era. In the *doucai* method,

the outline of a design is drawn under the glaze using a cobalt blue. The vessel is then fired, and enamels are carefully painted over the glaze to color in and finish the designs. A second, lower-temperature firing then fixes the enamels. On this cup, delicate shades of blue, green, red, and yellow have been used to paint the dragons, flowers, and leaves. The overglaze colors match the underglaze outlines perfectly; the precision needed for this type of decoration made them very difficult and expensive to produce. Most ceramics decorated in the *doucai* method are small, perhaps owing to their costliness.

Since most of the examples of ceramics using this complicated technique date to the Chenghua era, *doucai* was formerly believed to have been invented then. The discoveries in a Tibetan monastery and in the Jingdezhen excavations of *doucai* pieces that have Xuande-era reign marks provide evidence, however, that this technique must have originated earlier. Still, the large number of pieces made with this technique during the Chenghua era attest to its importance then. Some scholars have suggested that it may reflect the taste of the emperor's favorite concubine Wan Guifei, who is thought to have been involved with the production at Jingdezhen.

Other forms of and motifs on fifteenth-century porcelains can be interpreted as reflections of broader cultural or historical concerns. For example, the flying-fish dragon (*feiyu*) on a small jar marked with a six-character Chenghua mark **(FIG. 194)** and the many mythical creatures on a stem cup probably from the same era **(FIG. 195)**

FIG. 193. Wine Cup. Ming period, Chenghua era, 1465–1487. China, Jiangxi Province. Porcelain painted with underglaze cobalt blue and overglaze enamels (Jingdezhen ware). H. 1⅞ x Diam. 2⅞ in. (4.8 x 7.3 cm). Asia Society, New York: Mr. and Mrs. John D. Rockefeller 3rd Collection, 1979.175

can be interpreted in several different ways. The jar is painted with underglaze blue, while underglaze blue and overglaze red enamel were used to decorate the stem cup. Both the flying-fish dragon and the many winged animals flying over the waves on the stem cup often have been interpreted as references to China's position as the world's most important seafaring empire in the fifteenth century.

The flying-fish dragon depicted on the jar is a rare motif that seems to have been used in Chinese ceramics briefly during the middle of the Ming period; its appearance has also been related to the tightening of Ming regulations regarding what types of dragons and how many claws were permitted to different categories of officials and other groups at court. Identified by his wings, fins, and fishtail, this dragon has sometimes been associated with the legend of the wondrous fish-dragon who saved a drowning Tang-period scholar and bore him to the heavens for rebirth as the chief star in the Big Dipper. That an image of a flying-fish dragon also was used to decorate a small incense burner modeled after a *gui*—a squat bowl-shaped vessel, often with two handles, on a raised foot—found in a temple dedicated to the God of the Northern Skies suggests a link between the image and some type of religious practice.

The shape of this jar also distinguishes it from the majority of jars made during the fifteenth century. It is one of a small group of jars made between the last years of the Xuande era and the opening years of the Chenghua era that are characterized by the distinctive treatment of their bases and foot rims: on all of these pieces, the underside of the vessel has been cut into small steps leading from the edge of the foot ring to the center of the base. The reasons for this unique form of base remain unclear; however, it is tempting to speculate that such vessels were made for a group of patrons associated with some religious or secular institution.

The flying-fish dragon also appears on the stem cup, whose decoration includes winged fish, elephants, horses, deer, and other creatures. Motifs of this type are found on ceramics bearing reign marks of the Xuande, Chenghua, and Wanli (1573–1620) eras, providing a fifteenth-century date for the development of this theme. The appearance of this type of motif has also been linked to the renewed interest in the *Classic of the Seas and Mountains (Shanhai Jing)* during the Chenghua era. Many of the animals depicted can be identified by reference to this source. For example, it mentions both celestial horses and flying fish. Although the better-known and more current recensions of the *Classic of the Seas and Mountains* date

FIG. 194. Jar. Ming period, Chenghua era, 1465–1487. China, Jiangxi Province. Porcelain painted with underglaze cobalt blue (Jingdezhen ware). H. 3¼ x Diam. 4¾ in. (8.3 x 12.1 cm). Asia Society, New York: Mr. and Mrs. John D. Rockefeller 3rd Collection, 1979.173

FIG. 195. Stem Cup. Ming period, mid- to late 15th century (probably Chenghua era, 1465–1487). China, Jiangxi Province. Porcelain painted with underglaze cobalt blue and overglaze red enamel (Jingdezhen ware). H. 4 x Diam. 6⅛ in. (10.2 x 15.6 cm). Asia Society, New York: Mr. and Mrs. John D. Rockefeller 3rd Collection, 1979.176

to the Qing period, much of this text is earlier and can be traced back in some form to the Eastern Zhou period (771–221 BCE). Moreover, several of the Xuande-era examples of this motif have Sanskrit inscriptions written on the interiors of their bases—a detail that suggests a link between this type of imagery and the practice of Buddhism. Because the motif of mythical and quasi-mythical creatures flying over the waves appears to have been used primarily on stem cups and on bowls of high quality, it is tempting to link the development of this theme to a sect of Buddhism and religious practices.

Ceramics of the Late Ming Period

A change from delicate shapes and elegant designs to larger, bolder forms and new decorative motifs distinguishes Chinese ceramics produced from the late fifteenth through the mid-seventeenth century. The changes reflect both the lessening of imperial control during this time and the development of new domestic and foreign markets that was a response to the loss of imperial patronage. Imperial ceramics were produced during the reigns of the Hongzhi (1488–1505), Zhengde (1506–21), Jiajing (1522–66), Longqing (1567–72), and Wanli (1573–1620) emperors. By the end of the reign of the Wanli emperor, however, the production of imperial ceramics was officially halted, largely because money had to be raised to cover the expense of resisting the Manchu armies, who would eventually conquer all of China. Imperial patronage did not resume again until 1683, when China was under the rule of the Manchu Qing dynasty.

The ceramics produced at the Jingdezhen kilns in the late fifteenth and early sixteenth centuries for imperial use continued the shapes and decorations of earlier Ming porcelains. The rounded forms and brilliant yellow glazes of two dishes, one dating to the Hongzhi era **(FIG. 196)** and the other to the Zhengde era **(FIG. 197)**, rely on prototypes established in the early fifteenth century. Both dishes are dated with six-character reign marks written on their bases. Ceramics that are glazed with a single color appear to have been used primarily as ceremonial vessels. Yellow pieces like these two dishes are known to have been used to decorate the Altar of Earth (*Diqitan*), one of the four main altars used in imperial ceremonies and sacrifices.

Very subtle differences help distinguish these dishes from each other: the porcelain body of the earlier Hongzhi-era dish is slightly thinner than that of the Zhengde piece; the color of the yellow glaze is more mustard-brown on the earlier piece and brighter on the later one; and the foot ring on the Hongzhi dish is marginally higher than that supporting the later dish. The striking similarities between these two pieces and their reliance on earlier shapes may also reflect their use as ritual vessels, as they may have been made as replacements for some earlier ceramic used in the same context.

The decoration of fruit and flowers found on a Zhengde-era dish with a six-character mark on its base **(FIG. 198)** re-creates motifs, compositions, and a color scheme common in the early part of the fifteenth century. Five floral sprays embellish the interior of this bowl: a camellia in the center of the dish and a cherry, a pomegranate, a peach, and a litchi on the cavetto. These are painted in underglaze blue, while the yellow ground consists of an enamel pigment that was applied over the glaze. Although it is based on earlier prototypes, the floral decoration on this dish fills a greater amount of space than do similar compositions on early- to mid-fifteenth-century dishes. The style of the painting also distinguishes this early-sixteenth-century dish from its fifteenth-century predecessors. In the sixteenth-century work, the outlines of the flowers and leaves are not as precise, and the different hues of blue are not as skillfully blended. For example, two tones of blue are used to paint the leaves of the camellias in the center of the dish—a darker blue outlines the leaves while a lighter blue colors their forms. This strict demarcation between the tones creates a flat image that does not have the organic sense of movement found on examples painted earlier.

The bold treatment and lively movement of the fish and aquatic plants painted on a large covered jar **(FIG. 199)** typify a new aesthetic in early-sixteenth-century ceramics inscribed with imperial reign marks. This jar, which has often been described as a water jar, has the six-character Jiajing mark on its base. Jars of this type are much more heavily potted than other pieces that bear imperial marks, probably because of their relatively large size and perhaps also because of their function, as they are generally believed to have been used as outdoor decoration in gardens. Nonetheless, both the thickness and the size characterize ceramics made in the sixteenth century.

Eight goldfish among various aquatic plants decorate the jar, while four goldfish and plants are on the cover. The theme of fish swimming in their natural habitat can be understood as a symbol of harmony. In addition, this motif is a rebus or visual pun for "vast fortune," as the pronunciation of the Chinese words for "eight fish" is similar to that of this term. The stylized plants depicted in this aquatic

FIG. 196. Dish. Ming period, Hongzhi era, 1488–1505. China, Jiangxi Province. Porcelain with overglaze yellow enamel (Jingdezhen ware). H. 1¾ x Diam. 8½ in. (4.5 x 21.6 cm). Asia Society, New York: Mr. and Mrs. John D. Rockefeller 3rd Collection, 1979.179

FIG. 197. Dish. Ming period, Zhengde era, 1506–1521. China, Jiangxi Province. Porcelain with overglaze yellow enamel (Jingdezhen ware). H. 1¾ x Diam. 8⅝ in. (4.5 x 21.9 cm). Asia Society, New York: Mr. and Mrs. John D. Rockefeller 3rd Collection, 1979.180

scene include lotuses, water chestnuts, sweet flag, water plantain, Ceratophyllum, Myriophyllum, and Potomogeton.

This style of painting in which overglaze enamels and underglaze blue are combined is known as "five-color" (*wucai*) decoration. Both the five-color decoration and the more complicated joined-colors technique, known as *doucai*, began to be used in the fifteenth century. *Wucai* decoration can consist either of a combination of underglaze blue and overglaze enamels (where the enamels

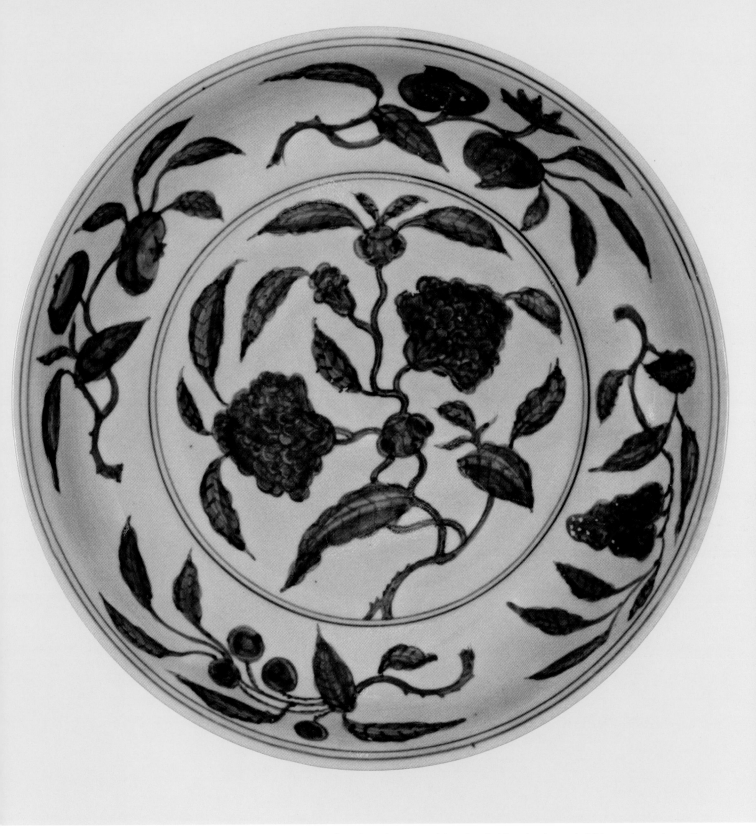

FIG. 198. Dish. Ming period, Zhengde era, 1506–1521. China, Jiangxi Province. Porcelain painted with underglaze cobalt blue and overglaze yellow enamel (Jingdezhen ware). H. 2⅛ x Diam. 11½ in. (5.4 x 29.2 cm). Asia Society, New York: Mr. and Mrs. John D. Rockefeller 3rd Collection, 1979.181

are not necessarily filling in underglaze outlines) or of painting entirely in overglaze enamels. The former technique was used to paint this jar: only the band of leaves on the base of the jar is painted under the glaze.

Thicker bodies, lively paintings, and the addition of themes with narrative content characterize the wares produced at Jingdezhen during the second to the eighth decade of the seventeenth century. Ceramics made during this time are generally classified as "Transitional

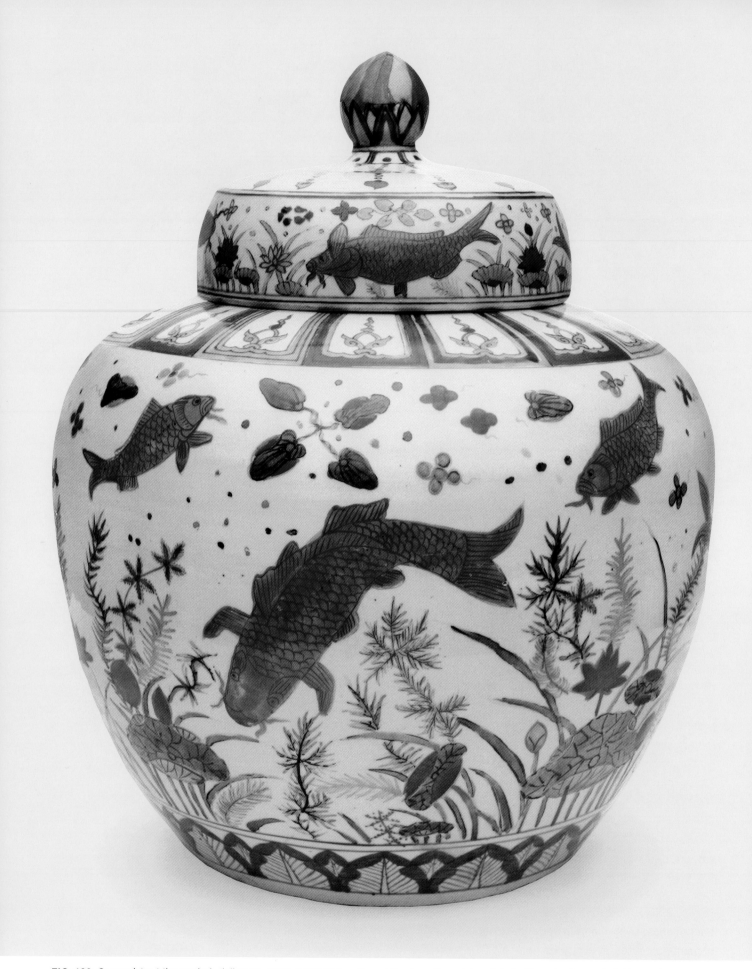

FIG. 199. Covered Jar. Ming period, Jiajing era, 1522–1566. China, Jiangxi Province. Porcelain painted with underglaze cobalt blue and overglaze enamels (Jingdezhen ware). H. 18½ including cover x Diam. 15¾ in. (47 x 40 cm). Asia Society, New York: Mr. and Mrs. John D. Rockefeller 3rd Collection, 1979.182a,b

wares" because they were produced during the transition from imperial Ming patronage to that of the subsequent Qing dynasty.

The rough potting and sketchy painting of two plates **(FIGS. 200 AND 201)** with nearly identical decoration of a Buddhist monk holding a pagoda typify Transitional wares made specifically for the Japanese market in the first three decades of the seventeenth century. Ceramics of this type, known in Japanese as "old blue-and-white" (*ko-sometsuke*), were produced in some number to be used in one version of the Japanese tea ceremony (*wabicha*). Plates such as these were used during a meal served prior to the tea ceremony. Such small individual plates would have been used to hold various delicacies served to each participant from a larger dish.

The choice of each object used in the meal and the tea ceremony was an important aspect of each event. Ceramics decorated in underglaze cobalt blue were appreciated for their sense of coolness. Plates like these two were admired for their ungainliness, which was believed to convey the moment of their production or the personality of the anonymous potter who made them. They were also admired for the roughness of their glaze and for the way the glaze often eroded away from their edges. This trait was termed "insect-nibbled" (*mushikui*) by Japanese tea masters.

A large *zun*-shaped vase painted with a design of squirrels and grapes **(FIG. 202)** may represent an important link between Transitional wares and the early imperial Qing ceramics. Smaller porcelains in this shape (which derives from bronze vessels used during the Shang and Zhou dynasties) produced during the reign of the Kangxi emperor (1662–1722) are common, but the lively and painterly manner in which the squirrels and grapes are painted over the surface of the vase is more comparable to the type of painting found on Transitional wares than to the structured compositions and precise images on Kangxi porcelains. In addition, the thick glaze that appears not to have melded with the porcelain during firing is also typical of Transitional wares.

The theme of squirrels and grapes is painted in underglaze cobalt blue with accents in underglaze copper red. Although grapes were used as a decorative motif in Tang-dynasty metalwork, the theme of squirrels and grapes did not appear in Chinese painting until the Yuan or early Ming dynasties, and it was most popular from the sixteenth through the nineteenth century, when it also spread to Korea and Japan. The motif is a rebus wishing the viewer and the owner of the jar longevity: in Chinese, the words for squirrel and for pine tree are pronounced

FIG. 200. Plate (one of a pair). Ming period, early 17th century (probably Tianqi era, 1621–1627). China, Jiangxi Province. Porcelain painted with underglaze cobalt blue. H. 1⅜ x Diam. 8¾ in. (3.5 x 22.2 cm). Asia Society, New York: Mr. and Mrs. John D. Rockefeller 3rd Collection, 1979.183

FIG. 201. Plate (one of a pair). Ming period, early 17th century (probably Tianqi era, 1621–1627). China, Jiangxi Province. Porcelain painted with underglaze cobalt blue. H. 1⅜ x Diam. 8¾ in. (3.5 x 22.2 cm). Asia Society, New York: Mr. and Mrs. John D. Rockefeller 3rd Collection, 1979.184

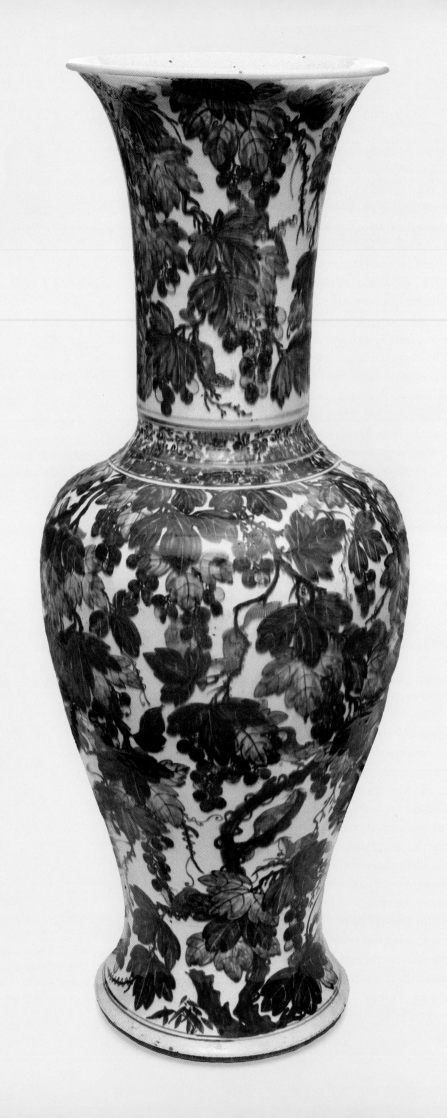

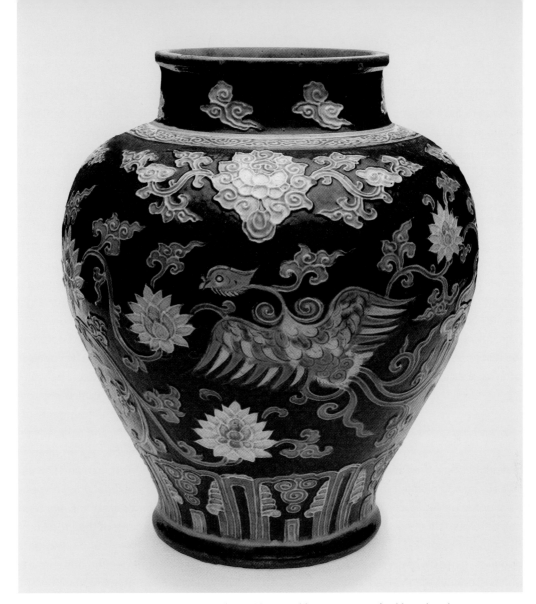

FIG. 203. Jar. Ming period, late 15th century (probably Hongzhi era, 1488-1505). China, Shanxi or Henan Province. Stoneware with trailed slip under glaze and overglaze enamels (Jingdezhen ware). H. 13⅞ x Diam. 11⅞ in. (35.2 x 30.2 cm). Asia Society, New York: Mr. and Mrs. John D. Rockefeller 3rd Collection, 1979.178

the same, and in this motif, the squirrel replaces the pine tree as a symbol of old age. In addition, the words for peach and for grape are also homonyms, and here grapes replace the peach as a symbol of immortality. The use of this theme and of the traditional *zun* shape suggest this vase was made for domestic consumption, although it is not clear exactly who the patron would have been.

The circumstances that led to the development of the liveliness of late Ming and Transitional wares and to the production of ceramics for use in the Japanese tea ceremony also spurred the production of ceramics at other kilns besides the famous complex at Jingdezhen, which had dominated the production of Chinese ceramics in the fifteenth and sixteenth centuries. For example,

fahua stoneware, which were produced from the fourteenth century on at kilns mostly in Shanxi Province, became popular in the late Ming period and were even imitated at Jingdezhen.

The liveliness and sense of movement seen in the decoration of a phoenix and scrolling lotus flowers on a *fahua* jar **(FIG. 203)** that can be dated to the late fifteenth century typifies the decoration that would become popular at Jingdezhen in the next century. Loosely translated as "ruled" or "bound design," the term *fahua* is often understood as a reference to the technique used in making these wares in which the primary motifs were first outlined with slip and then filled in with overglaze enamels. Two firings—one for the body, slip, and glaze; and another,

Opposite: **FIG. 202.** Vase. Ming period to Qing period, 17th century. China, Jiangxi Province. Porcelain painted with underglaze cobalt blue and copper red (Jingdezhen ware). H. 39½ x Diam. 15 in. (100.3 x 38.1 cm). Asia Society, New York: Mr. and Mrs. John D. Rockefeller 3rd Collection, 1979.185

lower-temperature firing for the enamels—were required. The bright green glaze in the interior was added during the second firing. However, it is also possible that *fahua* refers to the term *falang*, the Chinese word for the cloisonné technique that inspired this type of ceramic decoration. The character *fa* is often used in Chinese to transliterate foreign terms, and it has been suggested that the cloisonné technique was imported to China from an area to the west.

Produced for domestic, nonimperial consumption, *fahua* wares were used primarily as sculptures and altar vessels in temples and funerary complexes. The phoenix, which in the early part of the Ming dynasty was often used as a symbol for the empress, was also a symbol of rebirth in Buddhism, and it seems likely that this jar was once part of a set of altar vessels in a Buddhist temple.

Qing-Dynasty Porcelains

During the eighteenth century, the Chinese ceramics industry, which was once again under stringent imperial control, was noted for the perfection of its porcelain bodies and for the development of new techniques for their decoration. From 1644 to 1912, China was under the control of the Manchus, a people of northeastern Central Asian origins, who had conquered the Han-Chinese Ming empire. Known as the Qing dynasty, the period of Manchu rule was one of relative peace and economic prosperity. It was also a time of close ties with Europe: Chinese porcelains were traded in increasing numbers to different nations in Europe, helping to spur changes in the ceramic industry in the West.

The Qing rulers were both sinicized and sinophiles. They were also avid patrons of the arts, which flourished in many forms during their reign. In 1677 the Kangxi emperor (ruled 1662–1722) rebuilt the imperial kilns and factories at Jingdezhen, which had been destroyed during the fighting that had led to the establishment of the dynasty, and in 1683 the production of imperial ceramics resumed. In the seventeenth century, at least six kilns and twenty-three workshops were dedicated to the production of imperial wares. Marks on early Qing ceramics are often symbols such as a conch shell, an artemisia leaf, or one of various flowers, because at first the emperor's reign name was considered too sacrosanct to be used on porcelains.

The creation of a range of opaque overglaze enamel colors was one of the most important contributions made to ceramic technology during the Qing period. The

enamels used to paint ceramics in earlier periods had been transparent and of limited hues. The development of opaque colors allowed painters to blend the tints together to create the varied gradations of shades and hues used to decorate Qing-period porcelains. Development of these enamels began during the reign of the Kangxi emperor and continued into that of the Yongzheng emperor (1737–95). The colors developed in the early part of the Qing period were used throughout the dynasty and continue to be used today in the decoration of porcelains.

An important element in Qing painted porcelains is the addition of shades of pink to the overglaze enamel palette, as can be seen in several porcelains in the Collection. An opaque white derived from a lead arsenite and a pale pink were among the last opaque overglaze enamels to be developed, possibly because they are very difficult to manufacture. The pink overglaze enamels were tinted with colloidal gold (fine fragments of metal in suspension in the enamel), and scholarly debate continues regarding the possibility of European contributions to this technology. Both European and Chinese pink enamels are colored using colloidal gold; however, the Chinese pink, at least in the first part of the eighteenth century, has a much lower tin content than the European version. Moreover, a similar pink is found on seventeenth-century Chinese cloisonné, suggesting that metal technology may have provided the prototype for later ceramic innovations.

The combination of beautiful shapes, refined bodies, sophisticated colors, and elegant paintings that characterize Qing-period porcelains helped to spur the fascination with and desire for these ceramics in the West. One result of the seventeenth- and eighteenth-century western fascination with Qing porcelain was the development of a series of French terms to classify these wares. Of these, *famille verte,* for porcelains that are painted primarily in shades of green, and *famille rose,* for porcelains that have shades of pink in their design, are the most common. Both were coined by Albert Jacquemart, a nineteenth-century French collector who wrote one of the earliest western books on porcelains. Neither term is used in Chinese scholarship, and there is no precise Chinese equivalent for them. Instead, Chinese scholars use such terms as "foreign colors" (*yangcai*), "powdered colors" (*fencai*), "soft colors" (*ruancai*), or "enamel colors" (*falangcai*) to describe porcelains with opaque overglaze enamel decoration.

The range of colors used to paint a dish (**FIG. 204**) and a bottle (**FIG. 205**) dating to the reign of the Yongzheng emperor illustrates the *famille rose* palette. The bottle is decorated with images of peaches, pomegranates,

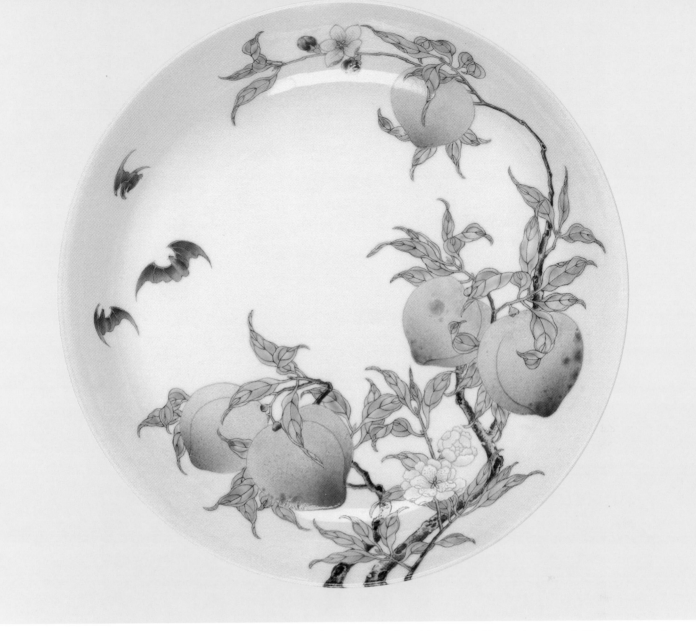

FIG. 204. Dish. Qing period, Yongzheng era, 1723–1735. China, Jiangxi Province. Porcelain painted with overglaze enamels (Jingdezhen ware). H. 1½ x Diam. 8⅛ in. (3.8 x 20.6 cm). Asia Society, New York: Mr. and Mrs. John D. Rockefeller 3rd Collection, 1979.188

loquats, and other auspicious motifs; images of five bats and eight peaches embellish the dish and flow from the exterior to the interior. In these pieces, colors such as the blue-green on the lichen, the white-pink and pale green of the peaches, and the bright yellow of the loquats were possible only because of the expanded palette made available by the development of the opaque enamels.

The delicate painting of two quail standing in a rocky landscape that decorates a small bowl **(FIG. 206)** also illustrates the versatility possible with the opaque enamel colors developed at Jingdezhen in the late seventeenth and early eighteenth centuries. As are the two previous examples, this bowl is marked on the base with the six-character reign mark of the Yongzheng emperor. The delicacy of painting and the combination of opaque

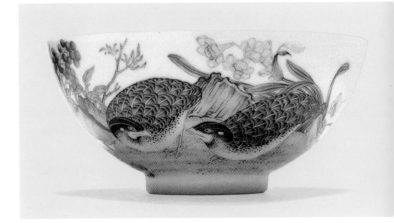

FIG. 206. Bowl. Qing period, Yongzheng era, 1723–1735. China, Jiangxi Province. Porcelain painted with overglaze enamels (Jingdezhen ware). H. 1¾ x Diam. 3⅞ in. (4.4 x 9.8 cm). Asia Society, New York: Mr. and Mrs. John D. Rockefeller 3rd Collection, 1979.186

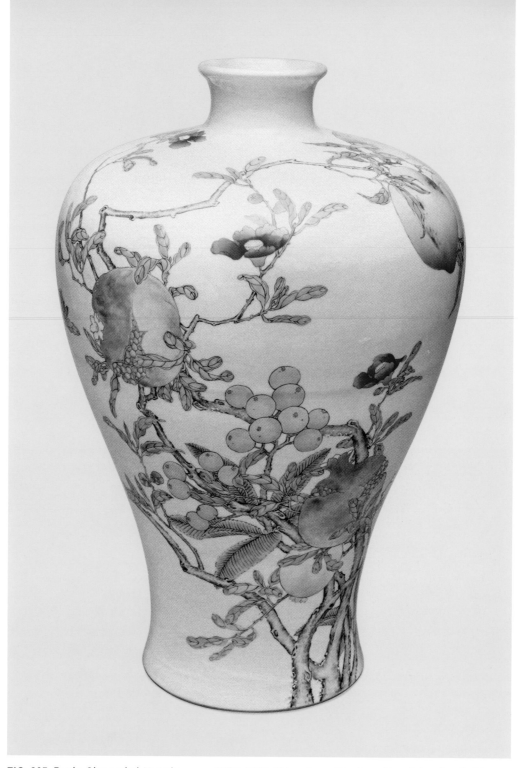

FIG. 205. Bottle. Qing period, Yongzheng era, 1723–1735. China, Jiangxi Province. Porcelain painted with overglaze enamels (Jingdezhen ware). H. 13½ x Diam. 8¾ in. (34.3 x 22.2 cm). Asia Society, New York: Mr. and Mrs. John D. Rockefeller 3rd Collection, 1979.189

and translucent enamels is typical of the finest examples of eighteenth-century porcelains.

The nandina, narcissus, rocks, and sacred fungus in the landscape on this bowl help identify its theme as a pun that can be loosely translated "fungus fairy bestows birthday greetings" (*zhixian zhushou*). This theme was often used for birthday greetings or New Year's wishes. As is often the case with Qing-dynasty porcelains, these wishes are combined with another auspicious theme:

the paired quails can be read as a rebus for peace and prosperity. The theme of good wishes is also found on other ceramics dating to the Yongzheng era, and it is possible that this bowl was once part of a larger set of dishes produced for a specific occasion at the court. The same argument can also be made for the bats, peaches, and other auspicious motifs that were used to decorate the dish discussed earlier **(FIG. 204)**. In Chinese, the words for bat and for happiness are pronounced *fu*,

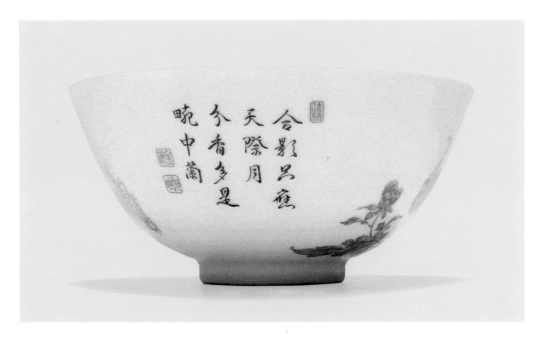

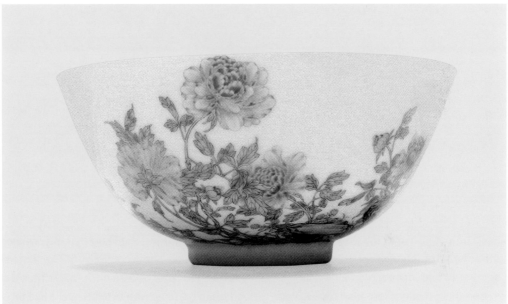

FIG. 207. Pair of Bowls. Qing period, early 18th century (possibly Yongzheng era, 1723–1735). China, Jiangxi Province. Porcelain painted with overglaze enamels (Jingdezhen ware). Each, H. 2½ x Diam. 5½ in. (6.4 x 14 cm). Asia Society, New York: Mr. and Mrs. John D. Rockefeller 3rd Collection, 1979.187.1-2

and peaches are a symbol for longevity. A very similar motif, in which the bat and peaches are combined with a cliff and waves, is often used to symbolize birthday greetings.

Porcelains with exquisite paintings combined with a poem are often termed *gu yue xuan* or "old moon pavilion" style wares. The term *gu yue xuan*, which remains problematic, is generally believed to refer to ceramics that may have been painted at the court rather than in the workshops of Jingdezhen and to be derived from decoration on glass. By and large, *gu yue xuan*-type porcelains are also more thinly potted than other eighteenth-century pieces; the slight wrinkling of the glaze called "chicken scratches" found on other Yongzheng porcelains is not as evident in ceramics of this type.

The use of a poem, written in black enamel, as part of the decoration on a pair of bowls with the six-character Yongzheng mark on their bases (FIG. 207) is also characteristic of *gu yue xuan*-style porcelains. This poem contains a play on the word *wan*, which is a homonym for both "bowl" and "field." It can be translated as:

Seen as a whole, it resembles the shadow of the moon in the sky, but its rich fragrance is that of the orchids in the fields.

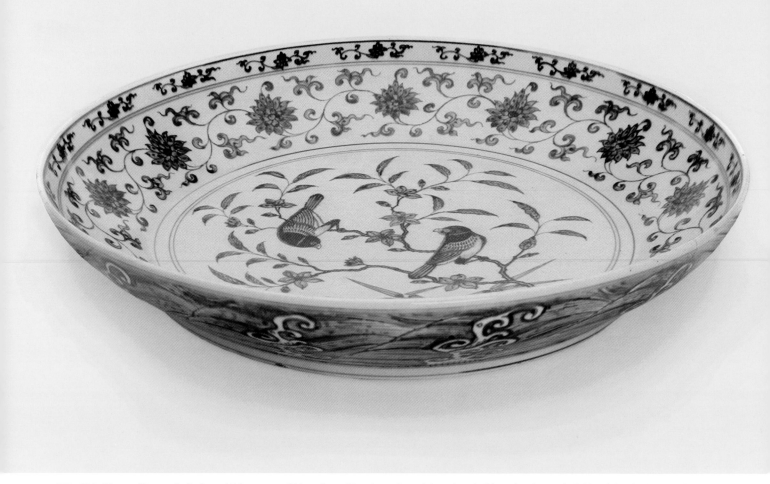

FIG. 208. Platter. Qing period, about 18th century. China, Jiangxi Province. Porcelain painted with underglaze cobalt blue (Jingdezhen ware). H. 3½ x Diam. 19¾ in. (8.9 x 50.2 cm). Asia Society, New York: Mr. and Mrs. John D. Rockefeller 3rd Collection, 1979.190

Seals are placed before and after the poem, a convention used in inscriptions on paintings and calligraphy.[1] Both bowls are decorated with paintings of pink, lilac, green, and yellow peonies growing from blue rocks. Two small insects hover over the flowers. While the general shape and thickness of the bowls is characteristic of the Yongzheng era, the style of the paintings is somewhat stiff. For example, the stems of the peonies do not have the same plasticity that is found in the treatment of the nandina and other flowers on the Yongzheng-era bowl with quails. In addition, the flowers and leaves on these bowls are depicted in a relatively static and frontal manner that lacks the subtle twists and changes of perspective characteristic of the painting on Yongzheng porcelains. The stiffness of the paintings suggests that they may have been applied to the bowls after their production, possibly during the Qianlong era (1716–95) or after.

The re-creation of earlier ceramic shapes and decorative themes typifies the Chinese ceramic industry,

particularly during the Qing dynasty, when many older ceramic traditions were revived. The large size of a platter **(FIG. 208)** and its underglaze blue painting of birds perched on flowering branches are like those of early-fifteenth-century ceramics. The stiffness in the treatment of the birds and branches and in the static quality in the depiction of the peony arabesques encircling the cavetto, however, indicate that this platter was probably made in the eighteenth century. Such re-creations were not intended as forgeries. Rather, they were used by the Qing emperors to show their appreciation and knowledge of earlier traditions and to associate themselves with an important period in the history of the nation they had conquered and ruled.

1. The first seal reads *jia li* (doubled beauty). The other two read *jin cheng* (made of gold), and *xu ying* (reflected brilliance of dawn sunlight). The same seals are found on other *gu yue xuan*-type porcelains, and it has been suggested that the second two are names used by the painter and calligrapher.

Landscape Painting in China

Paintings of landscapes, whether monumental representations or more intimate scenes, are among the most important images in the history of Chinese art. Since at least the Northern Song period (960–1126), landscape paintings have played a critical role in Chinese art, culture, and thought, and they have been imbued with many interrelated levels of meaning. Landscape paintings have been seen as metaphors for religious and personal development, as statements of individual or cultural values, and as political icons. They were an important means of communication among educated individuals, particularly the group of artists who have traditionally been classified as literati or scholar-gentlemen (*wenjen*). The perfection of this art form in the hands of these literati artists has been understood to reflect the self-cultivation and depth of knowledge of this group of painters.

A painting of a towering landscape entitled *Xie An at East Mountain* (**FIG. 209**) and attributed to the late Southern Song– to early Yuan-period artist Lou Guan combines the monumentality and intimacy that typify the Chinese art of landscape painting. The composition of this painting comprises three different points of view, and the use of this system of perspective is one of the salient characteristics of Chinese landscape painting. The foreground is seen from above; the middle ground is seen straight ahead; and the background is seen from below. Use of this tripartite perspective allows Chinese paintings to present images that contain more information than would be available by merely presenting a given landscape from a single viewpoint. In this painting it also helps to enhance the sense of monumentality. A more intimate tradition of Chinese landscape painting is invoked, however, in the placement of the figures in this landscape, one in the left middle ground and the others on a diagonal in the right foreground. This compositional device was used to direct the viewer's attention to a specific area within a broader composition.

The monumental tradition is generally associated with the art of the Northern Song period, while the more intimate style was begun at the Southern Song court (1127–1279). The interplay between these two compositional devices lies at the heart of subsequent Chinese landscape painting, and both were reused and redefined over the centuries.

Little is certain about the life of Lou Guan. He was born in Qiantang in modern-day Hangzhou in Zhejiang Province and is known to have been appointed as an assistant in the Imperial Painting Academy during the Xianchun period of the reign of Emperor Duzong (1265–74). It has generally been assumed that he was active sometime in the second half of the thirteenth century based on his appointment to the court during that period. Lou Guan is believed to have been a student of the famous Ma Yuan (about 1190–1225), who is one of the artists generally credited with the development of the more intimate Southern Song style of landscape painting.

The combination in this painting of the two compositional types associated with the Northern and early Southern Song periods typifies the art of the late Southern Song, providing further evidence that Lou Guan was active in the second half of the thirteenth century. The use of ax-cut strokes—short, chunky, somewhat truncated brushstrokes painted in dark ink—to give depth to the rock and cliffs in this painting continues the style of the early thirteenth century, while the interest in surface textures and the lack of real depth in this painting are typical of the late thirteenth and early fourteenth centuries. These features suggest that this landscape was painted after the fall of the Southern Song dynasty in 1279.

The signature in the upper left hand corner reads Qiantang Lou Guan, "Lou Guan of Qiantang."[1] This signature is more prominent than those found on paintings that the artist created as part of his work for the Imperial Painting Academy, and it has been suggested that the size of the signature indicates that this was a work that Lou Guan painted either for himself or to sell.

The figures in this landscape illustrate the visit of the famous poet and scholar Xie An to a recluse living in a solitary mountain retreat. Here the recluse is shown seated on a ledge beneath a tree in the middle ground of the painting while Xie An and his usual coterie of female attendants walk in the foreground. Xie An, who lived during the fourth century, was renowned in Chinese history for the life he lived in retirement on East Mountain in Zhejiang Province. Unlike most men who withdrew from society, Xie An surrounded himself with women, particularly female entertainers, yet managed to pursue the arts and philosophy despite such obvious distractions.

Xie An's dual nature as a scholar and a hedonist may account for his popularity as a subject in Chinese painting

Page 220 and detail page 221: **FIG. 209.** Attributed to Lou Guan (active mid- to late 13th century). Xie An at East Mountain. Southern Song to Yuan period, late 13th century. China. Hanging scroll; ink and color on silk. Image only, H. 69 x W. 34¾ in. (175.3 x 88.3 cm). Asia Society, New York: Mr. and Mrs. John D. Rockefeller 3rd Collection, 1979.123

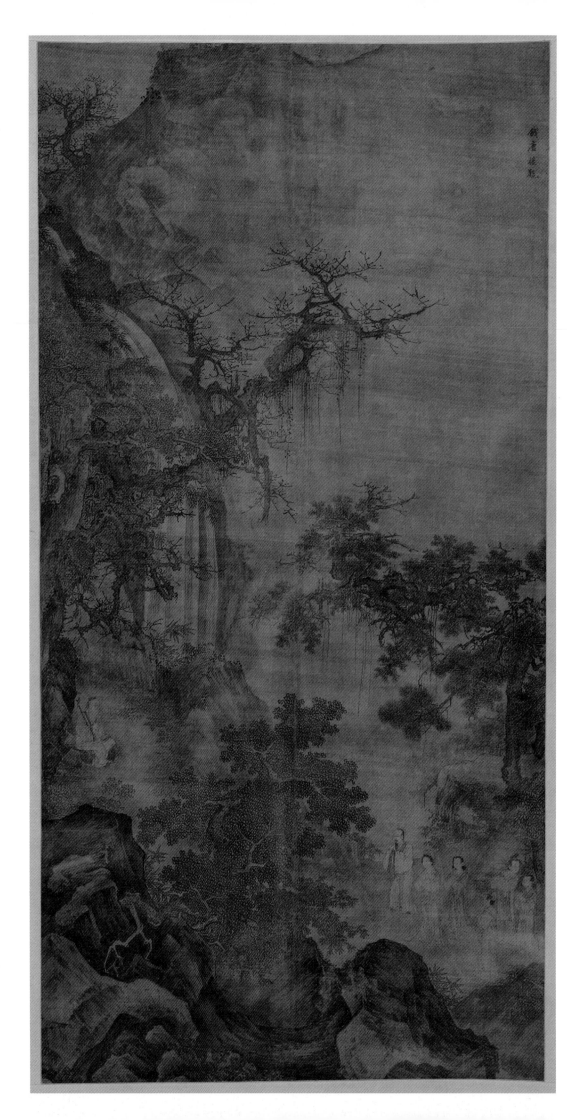

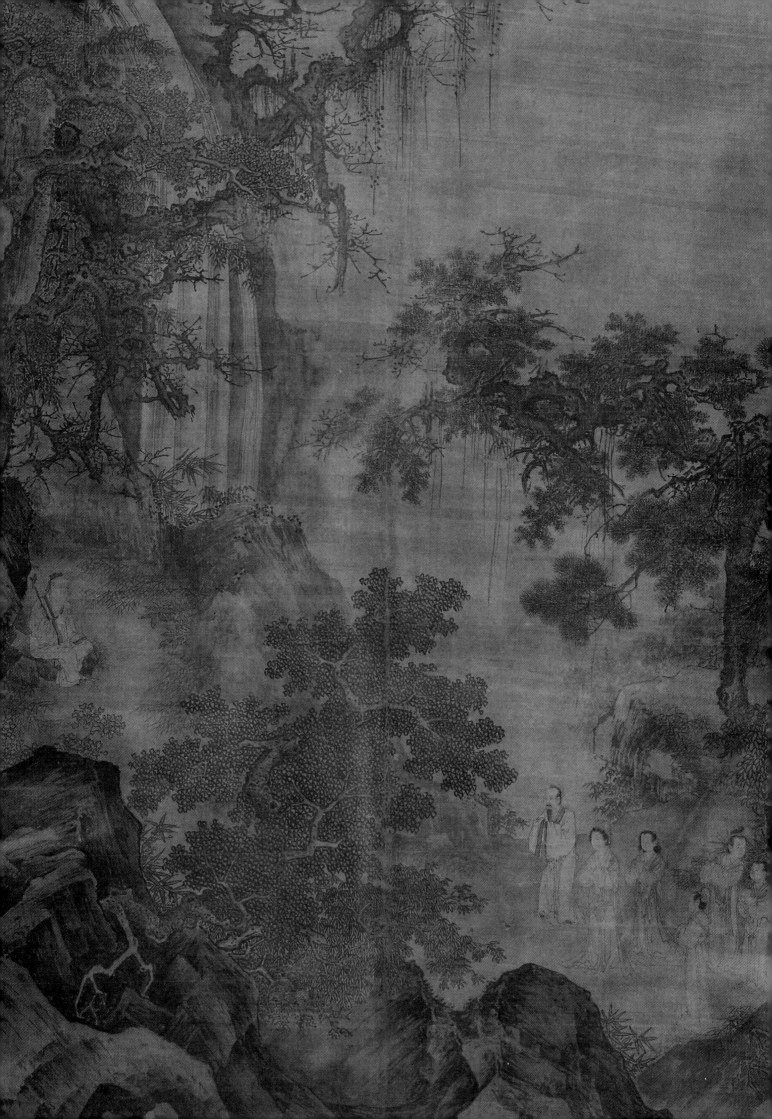

from the thirteenth century on, as paintings of this theme could be enjoyed from different perspectives by diverse patrons. It seems likely, however, given the strong possibility that this work was painted privately rather than for the court, that this painting of Xie An visiting a recluse was intended to glorify his romantic and somewhat hedonistic lifestyle; the prominence given to the figures in this painting also point to the importance of this aspect of the theme.

A towering landscape in the Northern Song tradition also provides the primary theme of *Temple on a Mountain Ledge* (FIG. 210), a painting by Kuncan. Painted during Kuncan's most productive period, from 1660 to 1679, this landscape shows his indebtedness to the compositions and brushwork of such artists as Wang Meng (1308–1385) and Dong Qichang (1555–1636), both of whom were extremely influential for seventeenth-century painters.

The pulsating energy and naturalistic forms seen in *Temple on a Mountain Ledge*, however, typify Kuncan's paintings and distinguish his work from the more abstract compositions favored by his contemporaries. Kuncan's landscape shows a solitary fisherman enjoying the quiet atmosphere surrounding a Buddhist temple. Air and light fill the painting, enhancing both the grandeur of the mountains and the peacefulness of the scene.

Kuncan, also known as Shiqi, is considered one of the four great monk painters of the seventeenth century. Born in Wuling in Hunan Province, he spent his youth studying the Confucian classics before becoming a Chan Buddhist monk. In 1638 he took the tonsure and traveled to Nanjing, where he studied with a disciple of the influential master Zhuhong (1535–1615). Living in Hunan Province at the time of the Manchu invasions of 1644–45, Kuncan spent three months in the wilderness, enduring many hardships. In 1654 he returned to Nanjing. In 1658 or 1659, Kuncan become the abbot of the Yuqi, one of the subtemples of the Bao'en monastery. He remained there until the end of his life, and scenes of this monastery and views of the surrounding area play an important role in Kuncan's art.

The two groups of buildings located in the foreground and the middle ground of this painting must represent some of the complexes at the Bao'en monastery, as they are similar to those in paintings known to depict this site. An eight-line poem inscribed at the top of the painting is dated 1661 and signed with Kuncan's pen name of Jieqiu, the "Stone Daoist." It states that the inscription was written at the Da Xie Hall, Kuncan's quarters in the Bao'en

monastery, which further helps to identify this painting.[2] As is often the case with inscriptions by Kuncan, the poem eludes translation and is somewhat difficult to understand, but it reads as follows:

> I walk on the worldly paths of famous mountains.
> I follow the clouds before me with great regard.
> The void, the mist, and the mountains of
> Creation—high and lofty peaks, like watch
> towers with dignified majesty,
> arranged haphazardly like small bamboo,
> flying off to distant places like the immortals,
> join a multitude of valleys.
> The gourd and the rainhat are united as one.[3]

This poem can be understood as both a reference to his earlier wanderings and as a metaphor for the Buddhist quest for enlightenment to which he dedicated his life.

Both Kuncan's use of a landscape setting as the basis for a personal statement and his references to the works of earlier schools and artists are characteristic of Chinese painting. This interest in the past as a compositional and philosophical prototype is illustrated in an album of ten leaves (FIG. 211), each of which is painted in the style of an earlier master. Albums of this type were produced by many artists from the seventeenth century onward, and they were intended to both pay homage to earlier masters and display the proficiency of the painter. Mastery of the earlier styles and understanding of the underlying conceptual issues would become the basis of the artist's distinctive personal style, just as the ability to refer to or play with the past would add depth to an artist's works.

This fascination with the past has made the study and connoisseurship of Chinese painting a difficult discipline. For example, this album of *Landscapes in the Manner of Old Masters* is inscribed *Guan Si* and dated to 1627 on one of the leaves.[4] Guan Si is the name of a minor artist of the late Ming period, and this date accords with the period of his activity, from about 1590 to 1630. However, very few works are known by this artist, and they differ in style from the ten landscapes painted in this series. Moreover, the variable quality of the painting in this album suggests that it may have been produced by more than one artist. Finally, the style of the brushwork in the album is more in keeping with the painting styles common in China after the eighteenth century, suggesting that this

Opposite: **FIG. 210.** Kuncan (1612–about 1686). Temple on a Mountain Ledge. Qing period, dated 1661. China. Hanging scroll; ink and color on paper. Image only, H. 33½ x W. 19 in. (85.1 x 48.3 cm). Asia Society, New York: Mr. and Mrs. John D. Rockefeller 3rd Collection, 1979.124

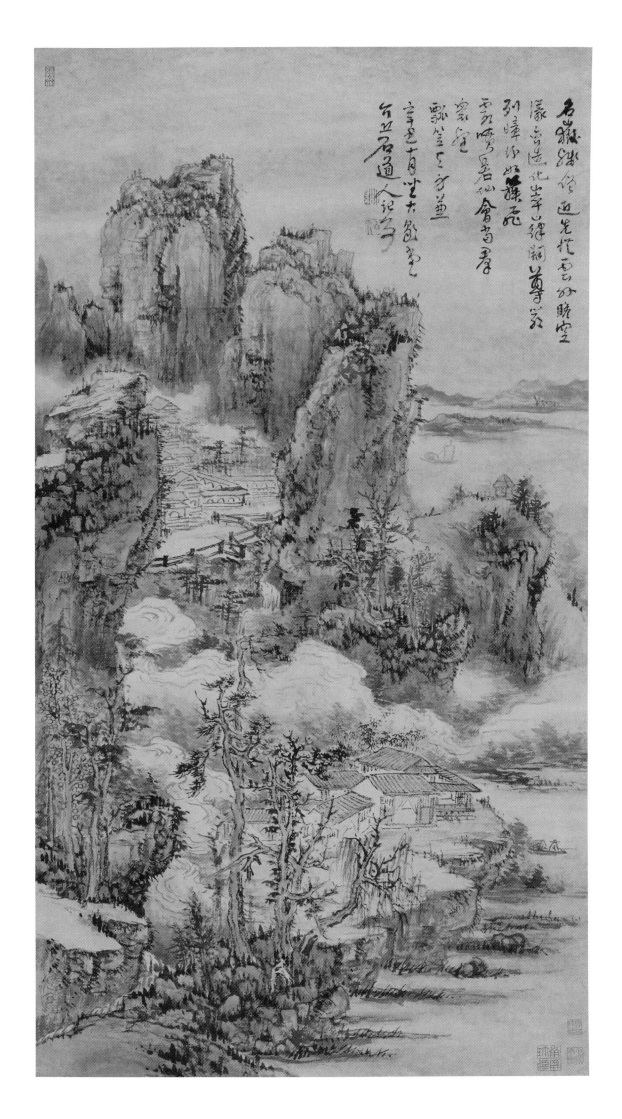

album was painted as a re-creation of a work by a sixteenth-century master, who in turn was reinventing the art of his predecessors.

1. Six seals are impressed along the outer edges of the painting. Reading clockwise from the upper left corner, they are: *qiu bi tang*, a seal of the collector Liang Qingbiao (1620–1691); *jiaolin*, another seal of Liang Qingbiao; *Wang Chi-Ch'ien shi shending zhenji*, a seal of the artist and collector C.C. Wang (born 1907); *yuli shi*, another seal of Liang Qingbiao; *guangi dalue* and *jiaolin biwan*, both of which are possibly seals of Liang Qingbiao; and *jiaolin shuwu*, a seal of Liang Qingbiao.
2. Three artist's seals, *Shiqi*, *paitu*, and *haomeng*, are impressed onto the painting. In addition, two seals of the collector Ho Guanwu and two seals of the collector Wang Nanping appear.
3. Translation by Richard A. Pegg.
4. The inscription as translated by Robert D. Mowry reads like this: "The Daoist Xubai wrote [this] at the cloud-canopied retreat (*xiamu shanfang*) in the middle of the last month of spring in the *dingmao* year of the *tianqi* [reign period]." An artist's seal reading *Guan Si* is impressed on the lower right corner of each leaf. There are several Qing imperial seals as well as collectors' seals on three of the ten leaves, however some scholars have questioned their authenticity.

Jade and Lacquer in China

In the East, objects made of jade and lacquer were displayed in courts and in elegant homes and were considered luxuries, valued as much as objects made of gold and silver were in the West. The many symbolic or auspicious jade and lacquerware images reflect the high esteem in which these materials were held. Much of this value is derived from the complexity of the processes used to carve jade and to produce lacquerware, both of which require sophisticated skills.

Jade was used in ritual and funerary contexts in most of the Neolithic cultures of China and into the Bronze Age. By the time of the Han dynasty, jade objects had become numerous and also served secular purposes; they were still buried in tombs, but were now also displayed as luxuries. Jade's status as a luxury good continued throughout Chinese history. In addition, jade sculptures were among the exotic objects exported to the West in the eighteenth and nineteenth centuries.

The term *jade* is used generally for two different types of stone: true jade, or nephrite, which was imported to China from the area around the Kunlun Mountains located near the city of Khotan in Central Asia, and jadeite, which was imported to China from Myanmar. Nephrite was used in China much earlier than jadeite; the latter does not appear to have been imported until the seventeenth or eighteenth century. Most of the earliest Chinese jades were made from small pieces of nephrite that were collected from river beds; it was not until the supply of this material began to dwindle in the late

Above and opposite: **FIG. 211.** Guan Si (active about 1590–1630). Landscapes in the Manner of Old Masters. Possibly Ming period, 17th century. China. Album of ten leaves; ink and light color on paper. Each, H. 10¾ x W. 7⅛ in. (27.3 x 18.1 cm). Asia Society, New York: Gift of Robert H. Ellsworth in memory of John D. Rockefeller 3rd, 1980.1.1-10

sixteenth century that larger blocks of this stone were quarried from the mountains around Khotan.

The large size of a nephrite sculpture of a mythical *bixie* (**FIG. 212**) helps to date it to the late eighteenth or early nineteenth century. The numerous fractures within the stone (called "cracked ice" fractures) are often found in stones that have been quarried. The brown-black stains found in these fractures were applied after the sculpture had been carved in an attempt to simulate the types of discolorations that naturally occur in stones collected from river beds. This artificial staining, a type of antiquarianism intended to enhance the value of the stone, is typical of Chinese jades carved from the seventeenth through the twentieth century.

The *bixie* first appears in Chinese literature as a creature possessing a deer's agility, grace, and power. In later Chinese art, *bixie* are most commonly represented as leonine creatures with the horns and hooves of a deer,

as in this jade. The *bixie* is a benevolent creature, often a guardian or protector. The precise function of this jade *bixie* is difficult to determine. Its size suggests that it was too large to adorn a scholar's desk or study, as smaller jade objects were often displayed in those locations.

Like that of jade, the use of lacquer can be traced to some of China's earliest civilizations. Lacquer is the resin of the lac tree (*Rhus verniciflua*) that is native to central and southern China and may be indigenous to Japan. Objects coated with lacquer are fairly strong and largely impervious to water and pests. Two basic techniques are used to produce lacquerware; each uses a substructure of wood, bamboo, cloth, or, at times, metal beneath the lacquer coating. In one method, several thin coats of lacquer are applied to the substructure as decoration or protection, revealing the form beneath. In the other technique, multiple coats of lacquer are built up on the substructure, creating an object that consists primarily of these lacquer coatings. The lacquer is then carved to various depths in order to create a decorative motif or pictorial image. Lacquers made in the second fashion are generally termed "carved lacquers."

A wooden sculpture of a horse turning its head toward its tail **(FIG. 213)** was made using the first technique: the shape of the horse was carved in wood and the lacquer was applied to provide color and some protection. The liveliness of this horse, its quivering nostrils, and its twitching tail are comparable to those of jade sculptures

of horses dating to the late Yuan and Qing periods; a comparable date is generally given to this horse, but it could date as late as to the eighteenth century. Both the function and the meaning of this sculpture are unclear. In earlier Chinese art, sculptures of horses were often placed in tombs to serve the deceased as transportation and as indicators of status. However, there is very little symbolism associated with this animal. One exception is the story of the eight horses of King Mu of the Zhou dynasty that carried the ruler throughout the empire. These eight horses are sometimes represented in Chinese art, and it is possible that this single sculpture was once part of a larger set. Groups of horses in a variety of positions were carved on stone slabs dating to the Yuan dynasty and found in Shaanxi Province; it is conceivable that this animal became more important as an art motif during the Yuan dynasty because of its value to the Mongols, who were of nomadic descent and who used horses in warfare.

An elegantly decorated lobed dish provides an example of carved lacquer **(FIG. 214)**. This technique seems to have originated during the Southern Song period and to have flourished during the late thirteenth through the early fifteenth century. A six-character inscription (like a reign mark on a porcelain) incised on the base of the dish dates it to the reign of the Yongle emperor (1403–24), and the style of the decoration and the high quality of carving are in keeping with this date.

FIG. 212. *Bixie* (Mythical Animal). Qing period, late 18th–early 19th century. China. Nephrite. H. 7¾ x L. 12 x W. 7 in. (19.7 x 30.5 x 17.8 cm). Asia Society, New York: Mr. and Mrs. John D. Rockefeller 3rd Collection, 1979.120

FIG. 213. Horse. Yuan to Qing period, about 14th–early 18th century. China. Wood with brushed brown lacquer. H. 8 x L. 14¾ x W. 5½ in. (20.3 x 37.5 x 14 cm). Asia Society, New York: Mr. and Mrs. John D. Rockefeller 3rd Collection, 1979.121

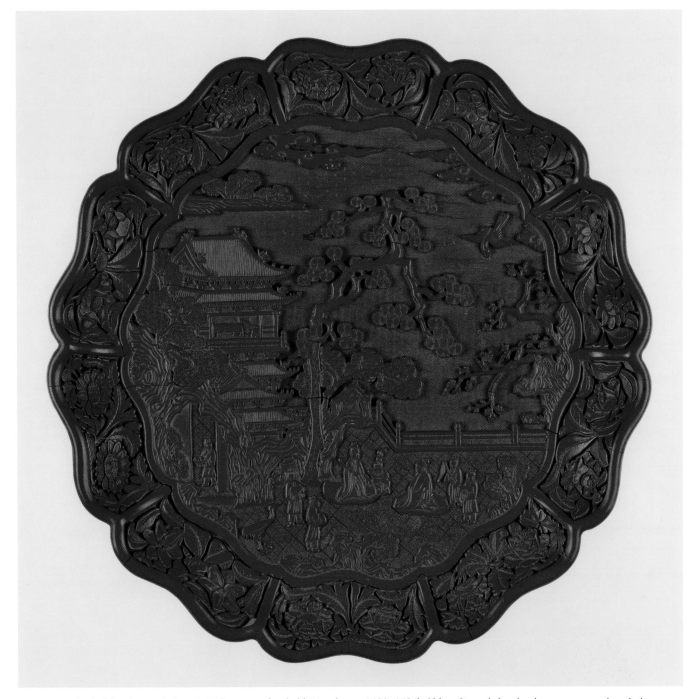

FIG. 214. Lobed Dish. Ming period, early 15th century (probably Yongle era, 1403–1424). China. Carved cinnabar lacquer on wood or cloth. H. 1⅝ x Diam. 13⅝ in. (4.1 x 34.6 cm). Asia Society, New York: Mr. and Mrs. John D. Rockefeller 3rd Collection, 1979.122

The decoration was carved in two layers: three different geometric patterns are used to indicate the sky, water, and paved courtyard, against which a scene of two gentlemen conversing is in relief. The front and the back of each of the lobes of the rim are further decorated with carved flowers.

The two men conversing on the terrace belong to a category of Chinese motifs known as "searching for the truth" (wen dao). Daoist in origin, these scenes usually depict one person asking another for knowledge. Here, the gentleman holding the scepter and seated under a

pine tree in the center of the plate represents one of the manifestations of Laozi, the founder of Daoism. The figure seated before him, whose hands are completely covered by his long sleeves in order to show respect, is the supplicant who has come to request instruction. The close similarities between the composition on this dish and that of a painting of the subject by Shirui in the National Palace Museum, Taipei, suggest that the seeker may be Xuanyuan, a name given to both Confucius and the mythical Yellow Emperor of early Chinese history.

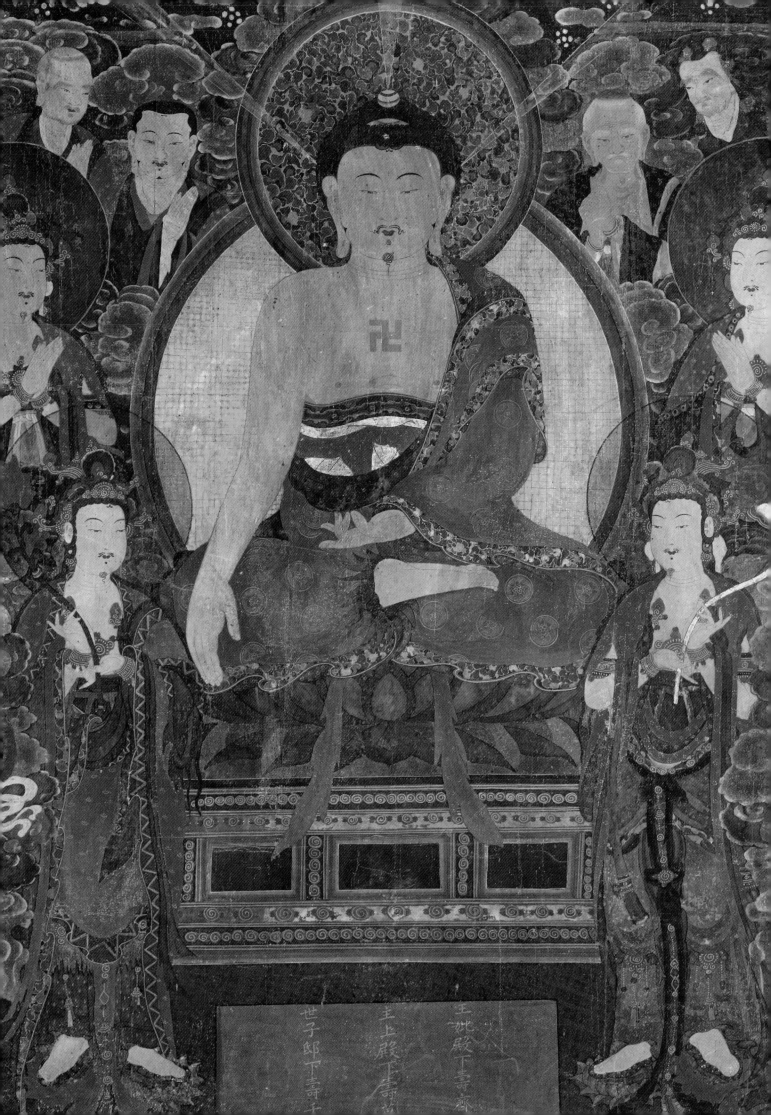

EAST ASIA: KOREA

Korean Ceramics

Although they have long been studied and collected in East Asia, Korean ceramics remain relatively unknown in the West. Stoneware with pale gray-green glazes are among the items listed as "first under heaven" by the twelfth-century Chinese author Taiping Laoren, and these Korean ceramics are the only non-Chinese items on his list. In Japan, Korean ceramics played an important role in both the tea ceremony and the development of stoneware and porcelains. In contrast to China and Japan, Korea never exported porcelains to the West. Rather, despite its position as an entrepôt for Sino-Japanese trade, Korea chose not to enter the international commerce in ceramics in the seventeenth and eighteenth centuries. Western fascination with Chinese and Japanese ceramics can be traced to this early trade in luxury goods, and the relative lack of interest in Korean art in the West may reflect the fact that Korean porcelains and other goods were little known during that period.

The history of Korean ceramics can be traced back to about 5000 BCE, when simple earthenwares were made and used. Some of the most appealing and charming Korean ceramics date to the period of the Three Kingdoms, which lasted from about 57 BCE to 668 CE. During this time, Korea was controlled by three or four different kingdoms: Goguryeo in the north and Silla (or early Silla), Baekje, and Gaya in the south. The presence in this list of Gaya, which appears as a fourth kingdom, reflects the historical fact that this small kingdom was absorbed by Silla in about 592 CE, a century before Silla united the Korean peninsula and established the Unified Silla dynasty (668–935). Although little is known about Gaya, recent archaeological discoveries in the past couple of decades indicate that many of the shapes and types of decoration found in Silla ceramics may have originated in Gaya and were incorporated into the art of Silla during the sixth century.

The strong, taut, bulbous shape of a large storage jar **(FIG. 215)** is found in ceramics that have been attributed to both the Gaya and the Early Silla kingdoms. Jars with very similar shapes have also been excavated from sites dating to the early Iron Age, in about the third and second centuries BCE. This jar is distinguished from earlier pieces by its thinner body, slightly rounded form, undecorated surface (with the exception of a few small areas of ash glaze, further discussed below), and the red and black coloration the clay took on during firing.

The thin horizontal lines on the surface of this jar were probably made when the jar was turned on the wheel. It is possible to smooth away such lines, so their presence attests to the interest in spontaneity and directness that characterizes many Korean ceramics. Similar lines are found on examples of this type excavated from both Gaya and Silla sites, and it seems likely that this jar is one example of the influence of the art of Gaya on that of Early Silla.

The dark color of the fired body and natural ash glaze of a small handled cup **(FIG. 216)** and its articulated shape and decoration typify Gaya ceramics from the fifth and early sixth centuries. The glaze was created during the firing process, when ashes in the kiln melted onto the surface of the ceramic. It is generally believed that such melted

Opposite: Detail of **FIG. 225**

FIG. 215. Storage Jar. Three Kingdoms period, Gaya Federation or Early Silla kingdom, about 6th century. Korea. Stoneware with areas of ash glaze. H. 15¾ x Diam. 16½ in. (40 x 41.9 cm). Asia Society, New York: Gift of Ambassador and Mrs. Richard L. Sneider, 1981.2

ashes, which created an accidental glazing, were partially responsible for the development of glaze technology at a very early date in East Asia. The cup has a stemlike base that has been pierced in several places with small rectangular holes. Crosshatches are incised around the middle of the cup, and the top is carefully shaped. Pierced pedestals such as that on this cup are one of the most distinctive characteristics of early Korean ceramics. Pedestals of this type are ubiquitous in ceramics dating to the Three Kingdoms and Unified Silla periods; they occur as part of some pieces and as freestanding supports for other pottery vessels. The function and meaning of these pedestals is not known. It is possible, however, that they

distinguish ceramics used in rituals or ceremonies from those intended for more mundane tasks.

The more refined body and dense fluted decoration found on a small stoneware bottle **(FIG. 217)** date this piece to the Unified Silla period. The bottle was probably made sometime during the eighth or ninth century, when the Unified Silla production of stoneware was at its height. During this time, Korea was part of an international culture that also included Tang-period China and Nara-period Japan, when strong similarities among styles of painting, ceramics, and sculpture were found across East Asia. While the shape of this bottle has some parallels in contemporaneous East Asian pieces, the

interest in a dark, thick body and heavily incised decoration is uniquely Korean and derives from the art of the Three Kingdoms period.

The dark stoneware body of an elegant spouted ewer **(FIG. 218)** links this eleventh- or twelfth-century piece to the ceramics produced during the Three Kingdoms and Unified Silla periods, but its elegant shape and precise potting typify works made during the Goryeo period (918–1392). The complex gourdlike shape of the ewer and the interest in movement, seen for example in the shapes of the handle and the spout, characterize the aesthetics of Goryeo ceramics and distinguish these works from the bolder and squatter shapes that were preferred in the Three Kingdoms and Unified Silla periods. Unglazed stoneware such as this ewer remain relatively unstudied, as most of the work on Goryeo-period ceramics has concentrated on the development of the famous green-glazed wares.

Besides having been extolled by Taiping Laoren, these wares are also described in *The Illustrated Description of the Chinese Embassy to Korea during the Xuanhe Period* (*Xuanhe fengsi Gaoli tujing*) of about 1124 by the envoy Xu Jing, who was so impressed with the beauty of the glaze that he explained that it shared "the radiance of jade and the crystal clarity of water." Green-glazed stoneware were first made in Korea in the ninth and tenth centuries. By the eleventh and twelfth centuries, they were the most widely produced forms of Korean ceramics. In the twelfth century, a distinctively Korean type of green-glazed stoneware characterized by its inlaid slip decoration was created and remained popular until the fourteenth century. The main centers for the production of greenwares were Buan in North Jeolla Province and Gangjin in South Jeolla Province, which are located on the southwestern coast of the peninsula.

Korea had strong maritime ties with southern China. The development of green-glazed ceramics in Korea is often linked to the prominence of this tradition in China, particularly during the ninth through the thirteenth century. As a result, Goryeo-period greenwares sometimes parallel the shapes and decoration of Chinese wares, particularly such southern wares as Yue and Qingbai. Most of the scholarship on Korean green-glazed ceramics has stressed the importance of Chinese prototypes in their development, however, the inventiveness of the shapes used in Goryeo green-glazed ceramics, many of which do not depend on Chinese prototypes, and the value placed on Goryeo ceramics in China during the late

FIG. 216. Cup with Handle. Three Kingdoms period, Gaya Federation, early 6th century. Korea. Earthenware with incised and pierced design and ash glaze. H. 3⅜ x W. 3¾ including handle in. (8.6 x 9.5 cm). Asia Society, New York: Mr. and Mrs. John D. Rockefeller 3rd Acquisitions Fund, 1989.3

FIG. 217. Bottle. Unified Silla period, 8th–9th century. Korea. Stoneware with carved design. H. 3¾ x Diam. 4¼ in. (9.5 x 10.8 cm). Asia Society, New York: Gift of Mr. and Mrs. Byung and Keum Ja Kang, 1989.1

FIG. 218. Ewer. Goryeo period, 11th–12th century. Korea. Stoneware. H. 12 x W. 7¾ spout to handle in. (30.5 x 19.7 cm). Asia Society, New York: Mr. and Mrs. John D. Rockefeller 3rd Acquisitions Fund, 1989.2

eleventh and early twelfth centuries suggest that the relationships between Chinese and Korean ceramics may be more complex and interactive than has been previously thought.

Two charming bowls illustrate the use of natural forms that typifies Goryeo-period green-glazed wares. The notches in the rim of a bowl decorated with incised peonies **(FIG. 219)** enliven its shape and give it a flowerlike appearance. The foliate-rimmed bowl is decorated with incised outlines of peonies that are filled in with vertical lines that are sometimes called "cat scratched" because of their similarities to the marks made by feline claws.

This type of decoration is also found on Chinese Yue bowls made before the end of the eleventh century. Korean bowls with this type of decoration are generally dated to the late eleventh or early twelfth century, owing to their parallels with Chinese wares of that time.

The lotus petals incised on the sides of a deeper bowl **(FIG. 220)** and enhanced by the pooling of the glaze reflect the importance of this flower in the decorative arts of East Asia. Prototypes for the shape and decoration of this bowl are also found in Chinese Yue ceramics. Korean and Chinese ceramics often exhibit the cracks seen in the glaze of both bowls, known as crackle or crazing. This

FIG. 219. Bowl with Foliate Rim. Goryeo period, late 11th–early 12th century. Korea. Stoneware with incised design under glaze. H. 2½ x Diam. 7¼ in. (6.4 x 18.4 cm). Asia Society, New York: Mr. and Mrs. John D. Rockefeller 3rd Collection, 1979.194

FIG. 220. Bowl. Goryeo period, 12th century. Korea. Stoneware with carved design under glaze. H. 3⅜ x Diam. 6¼ in. (8.6 x 15.9 cm). Asia Society, New York: Mr. and Mrs. John D. Rockefeller 3rd Collection, 1979.195

FIG. 221. Bottle. Goryeo period, late 11th–early 12th century. Korea. Stoneware with glaze. H. 15⅛ x Diam. 9½ in. (38.4 x 24.1 cm). Asia Society, New York: Mr. and Mrs. John D. Rockefeller 3rd Collection, 1979.192

effect, often deliberately achieved, is admired in East Asia.

A crackle pattern much broader than that found on these last two bowls is the only decoration on a large bottle **(FIG. 221)**. Poetically known as a "plum vase" (Chinese, *meiping*; Korean, *maebyeong*), the shape of this bottle originated in China and become one of the

most popular in East Asian ceramics. Bottles of this type were most likely used to store liquid, possibly plum wine, and generally had a small cap.

A broad network of crackle is also seen in the glaze on two foliate bowl-and-saucer sets **(FIG. 222)** that are among the most exquisite examples of Korean greenwares. They are revered for their strong elegant shapes

FIG. 222. Foliate Bowl-and-Saucer Sets. Goryeo period, early 12th century. Korea, South Jeolla Province. Stoneware with glaze. Bowls, H. 3⅝ x Diam. 5¾ in. (9.2 x 14.6 cm); saucers, H. 1⅛ x Diam. 6¼ in. (2.9 x 15.9 cm). Asia Society, New York: Mr. and Mrs. John D. Rockefeller 3rd Collection, 1979.193.1-4

and the translucency and density of their greenish gray glaze. Both the bowls and the saucers have foliate rims; their shapes suggest the forms of a flower such as a lotus or a chrysanthemum. The precise use of such foliate bowls and saucers is unclear, although it has been suggested that these two sets once may have been part of a larger dinner service used to serve meats and vegetables. The bowls and saucers also may have been used as containers for small ewers, in which case hot water in the bowl would have kept wine or tea in the ewer warm during a meal. Larger ewer-and-basin sets in ceramic or metal were produced in China and Korea.

Shards with bodies and glazes comparable to these two sets have been found at the Sadang-ri kiln near Gangjin, providing a possible provenance for them. The high quality of these pieces suggests that they may have been made for use in the palace. It is generally assumed that during the Goryeo period the best ceramics were reserved for the use of the court, and the possible use of these bowls and saucers as part of a larger dining set or as containers for ewers is consistent with the degree of luxury found at court.

The more opaque glazes and straightforward shapes of the peony and lotus bowls discussed earlier **(FIGS. 219 AND 220)** might indicate that these pieces were intended to be used by lower-ranking members of Goryeo society. On the other hand, parallels to Chinese ceramic history suggest that ceramics with incised decoration predate works with spectacular, thick glazes; this may argue for

dating the two decorated bowls earlier than the bottle or the foliate bowl-and-saucer sets. It should also be pointed out that the decorated bowls could be both earlier and less luxurious than the others.

The high quality of the bowl-and-saucer sets provides an interesting possible link to the development of Ru ware in China. One of the most revered and elusive of all Chinese ceramics, Ru wares are largely undecorated, but are noted for their shapes and the beauty of their lush gray-green glazes—slightly bluer than the glaze on these two Korean pieces. Ru wares, which were developed late in the Northern Song period, have long been associated with the patronage of Emperor Huizong (reigned 1101–25), who was one of the most famous emperor-artist-patrons in Chinese history. The comparison of these bowl-and-saucer sets with examples of Ru ware is one of the most common and highest accolades awarded to these Korean ceramics. It has generally been assumed that these pieces could only have been created in response to the development of Ru ware at the Chinese court. However, it has recently been pointed out that Emperor Huizong, whose patronage is often credited for encouraging the aesthetic changes found in Chinese painting and ceramics during the early twelfth century, was deeply interested in Korea and collected examples of Korean fan painting. It has also been speculated that Huizong's knowledge of Korean ceramics may have helped to spur the development of Ru ware.

Two types of ceramics replaced green-glazed stoneware during the Joseon period (1392–1912) in

FIG. 223. Bottle. Joseon period, about mid- to late-18th century. Korea. Porcelain painted with underglaze cobalt blue. H. 15½ x Diam. 8¼ in. (39.4 x 21 cm). Asia Society, New York: Mr. and Mrs. John D. Rockefeller 3rd Collection, 1979.197

Korea: stoneware known as Buncheong wares, which at first were notable for their inlaid decoration; and porcelains, which were primarily decorated with underglaze cobalt blue, iron red, or iron brown. Some porcelains were not painted but merely covered with a transparent glaze. Cobalt blue was scarce in Korea and supplies were often imported from China. The earliest blue-and-white wares were reserved for the use of the court, and it was not until the eighteenth century that this type of porcelain became used more widely in Korea.

Two eighteenth-century works, a long-necked bottle **(FIG. 223)** and a large storage jar **(FIG. 224)**, characterize two different aesthetics that coexisted in Korean art during this period. The long-necked bottle was carefully potted, and its shape is strong and regular. The four lotus flowers and scrolls that decorate it are symmetrically placed and precisely painted. This structuring of the composition is also evident in the pairs of horizontal lines that are painted on the neck and foot of the bottle.

In contrast, the shape of the storage jar is somewhat irregular and a single composition flows over the entire

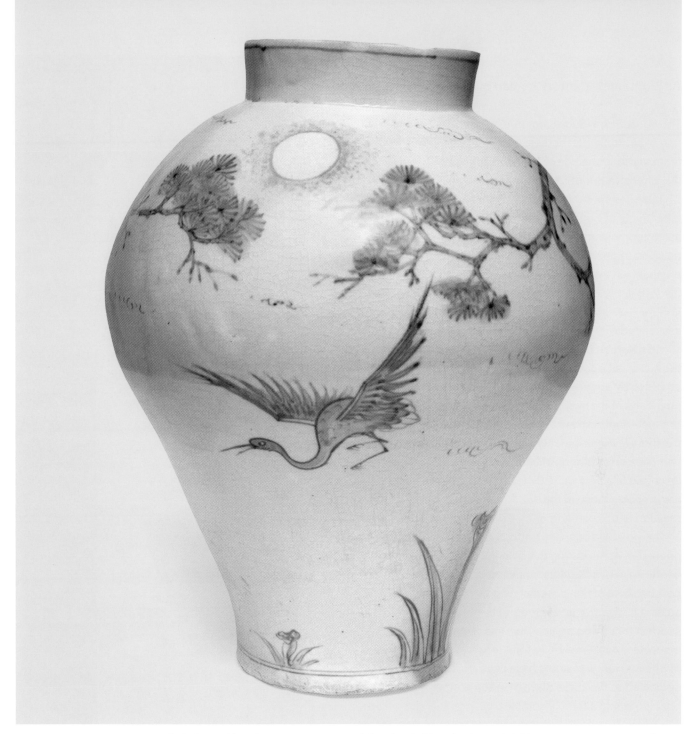

FIG. 224. Storage Jar. Joseon period, about mid-18th century. Korea. Porcelain painted with underglaze cobalt blue. H. 17½ x Diam. 13¾ in. (44.5 x 34.9 cm). Asia Society, New York: Mr. and Mrs. John D. Rockefeller 3rd Collection, 1979.196

surface. The scene of cranes flying among pine trees beneath a moonlit sky is unusual and is not found in other eighteenth-century examples. The crane, pine, and the moon, as well as the *lingzhi* fungus painted at the base of the jar, are traditional symbols of longevity, conveying good wishes to the user. The naturalistic placement and rendering of these motifs give them a narrative quality in keeping with the taste for genre paintings and vernacular themes that is found in other eighteenth-century Korean arts. It is possible that the development of the vernacular reflects the growth of a wealthy, sophisticated, and

self-assured leisure class in Korea who helped to spur the development of the arts in the late Joseon period. There are questions regarding the patrons of the vernacular style, and it is difficult to determine whether aristocrats and high-ranking bureaucrats or a wealthy merchant class predominated. The high quality of both of these ceramics indicates that they could have been used either at the court or in an upper-class home.

An Eighteenth-Century Korean Buddhist Painting

The *Lotus Sutra* (*Saddharmapundarika Sutra*), a compilation of several different texts, some dating as early as the first century CE, is one of the most influential works in the extensive Buddhist canon. The principal text of the Chinese Tientai sect, the *Lotus Sutra* is also revered by other sects of Buddhism, both for its promise of universal enlightenment and because its worship and study are believed to provide the benefits of longevity, health, and prosperity in everyday life. Representations of Shakyamuni, the founder of Buddhism, preaching the *Lotus Sutra* at Vulture Peak are some of the most important images associated with this text.

In a Korean painting of this famous theme **(FIG. 225)**, the historical Buddha is seated on a square throne attended by bodhisattvas, monks, and the four heavenly guardians of the north, south, east, and west. The three groups—bodhisattvas, monks, and guardians—symbolize the three levels of sanctity of the various divinities in the complicated pantheon of later Buddhism. The names inscribed in a cartouche beneath the Buddha's throne are probably those of the donors who contributed to the creation of this painting.

Large-scale banner paintings like this one became popular in Korea during the seventeenth and eighteenth centuries, when Buddhism became widespread, in part because of the loosening of government prohibitions against it. The size and iconography of this painting suggest that it was originally an important image in a monastery. Most likely it was made to hang behind a statue of Shakyamuni and would have been displayed in a hall dedicated to the *Lotus Sutra* or in some other major building within a temple complex.

Several features date this painting to the eighteenth century. The relative two-dimensionality of the deities and the subdued blues and reds are characteristic of Korean Buddhist painting from the seventeenth through the nineteenth century. The perfunctory treatment of details, such as the decoration on the robes of the divinities and the floral scrolls in the halo of the Buddha, is more specific to art of the eighteenth century and reflects the interest in immediacy, spontaneity, and vernacularization that were the hallmarks of Korean art of the time.

FIG. 225. Buddha Shakyamuni Preaching at Vulture Peak. Joseon period, 18th century. Korea. Hanging scroll mounted as a panel; colors, ink, and gold on hemp cloth. Image only, H. 59 x W. 70 in. (149.9 x 177.8 cm). Asia Society, New York: Mr. and Mrs. John D. Rockefeller 3rd Acquisitions Fund, 1990.1

EAST ASIA: JAPAN

Two Early Japanese Sculptures

Some of the most imaginative and intriguing ceramic figures in the world are the products of Japan's earliest cultures. The use of earthenware in Japan began during the Jomon period, about 10,500 to 300 BCE. This period in Japanese history is further subdivided into Incipient, Initial, Early, Middle, Late, and Final phases. *Jomon* is translated as "cord-impressed"; throughout the period ceramics were most commonly decorated by rolling twisted cords and cord-wrapped sticks into the wet clay, and the name of the period is derived from the ubiquity of this practice.

The hatched markings on the surface of a figure of a standing woman **(FIG. 226)** were made using a cord or a rope. Such figurines are one of the most common types of images produced during the Final Jomon period, which dates from about 1000 to 300 BCE. They are classified as the Kamegaoka type after a site in northern Japan where hundreds of such figures were discovered in 1620. Sculptures of this type are sometimes called sun- or snow-goggle figurines (*shakoki dogu*) because their large eyes often resemble goggles, particularly those worn by the Eskimos for coping with blinding sun and snow. The coils of clay piled at the top of the figure's head may have been intended to represent an elaborate headdress or a crown. Some scholars believe the figures were used to ward off evil.

Figures of this type are often said to represent women because the majority of them have visible breasts; they have often been associated with fertility, largely because of the importance awarded to female fertility figures in other Stone Age cultures across the world. However, more recent scholarship has linked these figures to the practice of sympathetic magic in which certain parts of the figure (in this case, the right leg and part of the skirt) were deliberately damaged, presumably in order to help heal injuries in that area of the body. This newer interpretation is based on the fact that the majority of these figures are damaged and that they were often grouped together at a specific site. The traces of red pigment seen in the crown and hair may also have had an amuletic function. It is possible that during the Final Jomon period red was believed to be a protective color and that its use further endowed the sculpture with magical properties.

Cord-impressed designs were also used to decorate the tunic worn by a *haniwa* figure of a man **(FIG. 227)** produced during the Tumulus or Kofun period (258–646). *Kofun* means "tumulus" and the period is named after the enormous tombs that were constructed for the ruling elite. These tombs were generally covered with large mounds of earth and were often in the shape of keyholes and surrounded by moats. A distinctive keyhole-shaped type of tomb spread from the Osaka-Kyoto-Nara or Kansai region on the main island of Honshu to the rest of Japan. Its diffusion is often interpreted as an illustration of the spread of political power from one part of Japan to another. During the Tumulus period, Japan, which had been divided into a series of loosely related domains, was gradually organized into a unified state with a central government located in the Kansai region. The arrival of

Opposite: Detail of **FIG. 251**

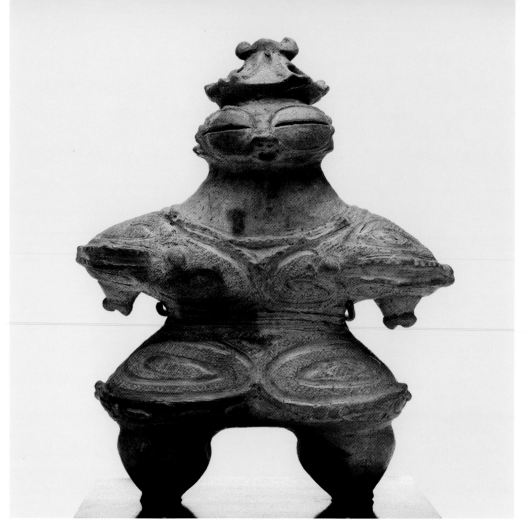

FIG. 226. Female Figure. Final Jomon period, 1000–300 BCE. Japan, Aomori Prefecture. Earthenware with traces of pigment (Kamegaoka type). H. 9⅞ x W. 8½ x D. 5¼ in. (25.1 x 21.59 x 13.33 cm). Asia Society, New York: Mr. and Mrs. John D. Rockefeller 3rd Collection, 1979.198

immigrants from Korea and possibly other parts of mainland East Asia provided one impetus for changes in political organization and related burial practices during the Tumulus period.

Haniwa means "circle of clay"; the earliest examples, dating to the late third century, were simply clay cylinders—larger versions of the base of this figure. *Haniwa* were placed at the top of the burial mound, in the center, along the edges, and at the entrance to the burial chamber. Examples in the shape of houses, animals, weapons, and ceremonial objects appeared in the late fourth century, and figural *haniwa,* such as this sculpture of a man, were created in the fifth, sixth, and early seventh centuries. They are most common in the Kanto region, the area around Tokyo, and were used there for a century longer than in other parts of Japan. Sculptures such as this one functioned both as attendants to the deceased and as symbols of his status and importance.

The traces of red paint found on the earrings and the coronet of this male figure indicate that it was made in the Kanto region, the only area where the pigment was used. The man wears jodhpurlike pants under his long tunic. His beaded necklace and coronet were part of the formal civilian attire worn by high-ranking members of Tumulus-period society.

The function of a comma-shaped object on the front of the tunic of this standing figure remains puzzling. It has been identified both as the hilt of a sword and a sickle. However, the shape of this object is different from that of early Japanese rectangular sword hilts. It is also unlikely that such a high-ranking figure would have used a sickle or that this tool would be a symbol of status. The commalike shape of this object raises another possibility: jade objects in this shape, called *magatama,* were made and used in Tumulus-period Japan. Although the precise meaning of these objects is also debatable, they are believed to have had some ritual or religious significance.

Opposite: **FIG. 227.** Figure of a Man. Tumulus period, 6th–7th century. Japan, Ibaraki Prefecture. Earthenware with traces of pigment. H. 56 x W. 21 x D. 11 in. (142.2 x 53.34 x 27.94 cm). Asia Society, New York: Mr. and Mrs. John D. Rockefeller 3rd Collection, 1979.199

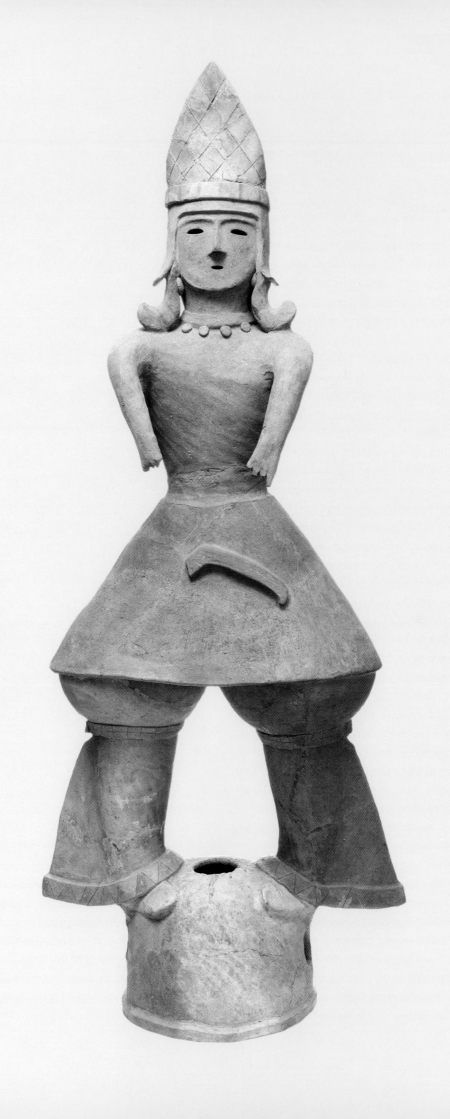

While the object worn by this male figure is much larger than the *magatama,* its similar shape suggests that it may be a representation of some type of regalia, probably an object made of either semiprecious stone or metal.

Japanese Buddhist Art

The introduction of Buddhism to Japan was one of the most important events in Japanese history and had a lasting effect on the development of its thought, art, and culture. According to Japanese sources, Buddhism was introduced from the Korean kingdom of Baekje in either 538 or 552 as part of a series of diplomatic exchanges that also led to a broader awareness of the beliefs and material culture of China and Korea. During the sixth and seventh centuries, a writing system (using Chinese characters) and a highly sophisticated governmental structure also were imported to Japan.

During the eighth century—which is known as the Nara period (710–794) after the modern name of the city then the capital—Japan was part of an international trading network that linked the nations of East Asia to one another and, through China, to places as distant as India and Iran. The city plan of eighth-century Nara carefully followed that of the famous Chinese capital at Xi'an in Shaanxi Province, and the styles of temples, sculptures, and paintings parallel those found on the continent.

An appealing sculpture of a kneeling woman **(FIG. 228)** illustrates the importance of Chinese prototypes in eighth-century Japanese art: her full-sleeved gown, which is tied at the bodice with a long sash, is identical in style to garments seen in Chinese sculptures of women dating from the late seventh and early eighth centuries. Her head is tilted down slightly, and her full sleeves cover her clasped hands. Her hair is parted in the center of her forehead and pulled together in a bun at the back of her head. The sculpture is made of a sandy clay that is supported by an interior wooden frame with wire wrappings. Traces of white slip remain on the woman's face and garments, and it is likely that colors were once painted over the slip. There are remnants of black pigment in her hair.

This sculpture was part of a larger group of small clay figures in the five-story pagoda at the Hōryūji, near Nara, one of the earliest and most important temples in Japan. The pagoda and several other buildings at this site are believed to have been constructed in the late seventh or early eighth century. Four tableaux of clay sculptures illustrating important events in Buddhism are placed in the four directions on the first story of this

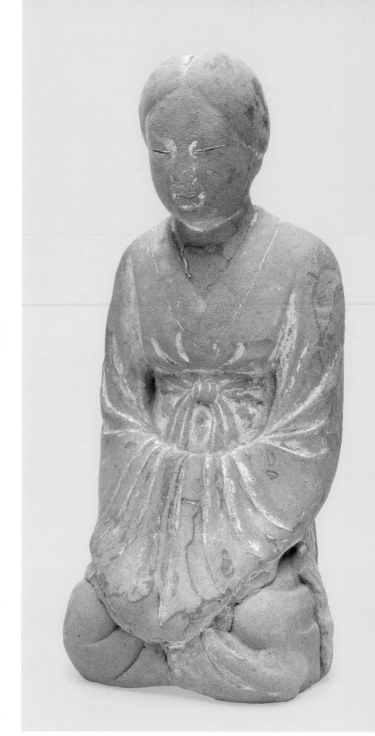

FIG. 228. Kneeling Woman. Nara period, early 8th century. Japan, Nara Prefecture, Hōryūji. Clay with traces of slip and pigment. H. 9 x W. 4 x D. 4¼ in. (22.9 x 10.16 x 10.79 cm). Asia Society, New York: Mr. and Mrs. John D. Rockefeller 3rd Collection, 1979.200

pagoda. The group in the north illustrates the *parinirvana* of Shakyamuni Buddha. At the east the debate between the layman Vimalakirti and the Bodhisattva of Wisdom, Manjushri, an event described in the *Vimalakirtinirdesa Sutra,* is depicted. A landscape believed to represent the Tushita Pure Land of the Bodhisattva Maitreya is placed in the south, while the distribution of Shakyamuni's ashes is illustrated by the group of clay figures at the west.

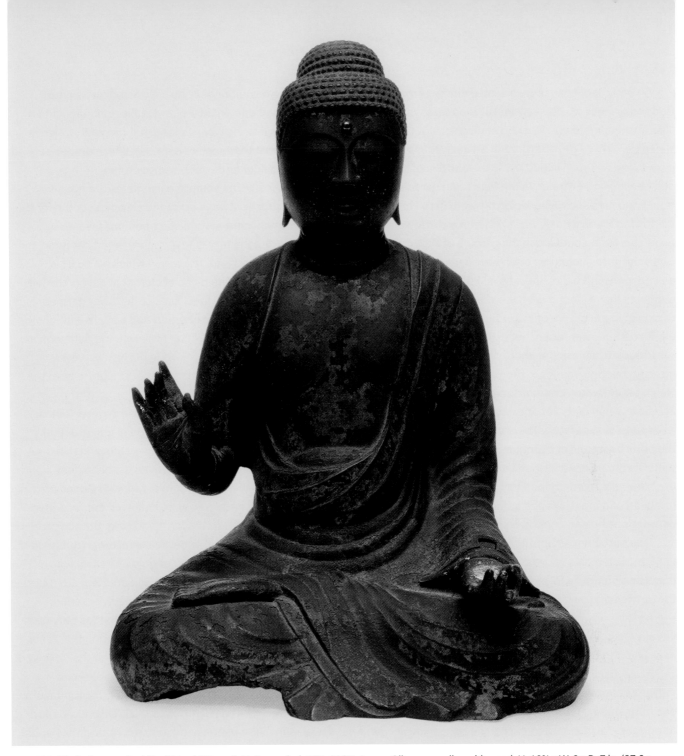

FIG. 229. Bhaisajyaguru Buddha (Yakushi Nyorai). Heian period, 898–1185. Japan. Gilt copper alloy with wood. H. 10¾ x W. 8 x D. 7 in. (27.3 x 20.3 x 17.8 cm). Asia Society, New York: Estate of Blanchette Hooker Rockefeller, 1994.6

It has been suggested that the sculpture of the kneeling woman in the Collection was probably a mourner at the *parinirvana* of Shakyamuni or a member of the audience witnessing the debate between Vimalakirti and Manjushri. This sculpture was registered as an Important Cultural Property on September 5, 1938, at which time it was in the possession of a private collector in Tokyo. It was released from registration on June 16, 1976, when many registered pieces were reclassified.

The Nara period ended when the capital was moved to nearby Heian-kyō, present-day Kyoto, and the subsequent era in Japanese history is known as the Heian period (794–1185). It has often been suggested that the capital was moved to help the court diminish the influence of the Buddhist clergy in Nara, who had at times played an important role in secular affairs. During much of the Heian period, Japan was under the control of powerful families such as the Fujiwara.

An early Japanese bronze seated image of the Buddha of Healing, Bhaisajyaguru (Japanese: Yakushi Nyorai), highlights the rigid and somber characteristics of Heian period sculpture **(FIG. 229)**. Bhaisajyaguru was first introduced to Japan in 680. He is the buddha of medicine and healing and he inhabits the Pure Land paradise. His right hand is raised, palm facing outward in the gesture of bestowing fearlessness, while his left hand is lowered, palm also facing outward in the gesture of wish granting. Bhaisajyaguru sculptures often have a medicine jar placed in the left palm, and a hole in this figure's palm suggests that a jar of this type is now missing. Bronze Buddhist images were popular during the seventh and eighth centuries in Japan, but in the following centuries wood sculptures became more prevalent. A revival of creating buddha images in bronze took place late in the Heian period, when craftsmen created works like this one. The frontal half of this image was cast as one piece with its arms cast separately. The arms were then attached to the body by means of a tongue-and-groove device. The patterns on the head formed by the bosses representing the buddha's spiral-shaped hair are straight above the forehead and are U-shaped at the back of the head. These conventions help to confirm a late Heian period date.

This particular sculpture was created as an image to be mounted on a votive plaque of metal or wood. Two holes behind the head and one centered at the back near the bottom of the sculpture would have been exploited to secure the sculpture to the plaque. Known as *kakebotoke*, literally "hanging Buddha," images of this type hang from eaves near the Image Hall of Buddhist temples.

A late-twelfth-century seated sculpture of Achala Vidyaraja (Japanese: Fudō Myōō) **(FIG. 230)** represents one of the many Buddhist deities introduced to Japan during the Heian period as part of the imagery associated with Esoteric Buddhism. Achala, whose name means "immovable," is one of a group of five wisdom kings or *vidyarajas*, each of whom represents the powers of one of the five buddhas who symbolize the five divisions of the Diamond World (*Vajradhatu*). Achala Vidyaraja, the most important of the five wisdom kings, represents the powers of Vairochana Buddha.

This image of Achala Vidyaraja would have once been placed in the center of a group of five sculptures of wisdom kings. The sculpture follows conventions for the representation of Achala recorded in iconographic texts associated with the teachings of the influential monk Kūkai or Kōbō Daishi (774–835): his body is plump and is generally blue or black; he has long matted hair, a ferocious expression, fangs, and bulging eyes with his left eye

often shown squinting. Achala is seated on a tiered pedestal and once held a sword in his right hand and a lasso in his left. He wears a long, full garment, which is folded over at the waist, and a scarf, which drapes around his left shoulder and over his upper torso.

Stylistically, the sculpture illustrates the transition from the courtly style of art of the eleventh century to the more dramatic and naturalistic traditions favored by the Kamakura military elite. Achala's broad flat torso, his plump hands and feet, the way in which his scarf is tied—in particular the piece of cloth that covers the left shoulder—and the stylized folds of his lower garment typify the art of the late eleventh and early twelfth centuries. The slight articulation at his waist, the definition in his cheeks, and the spiky curls in his hair, however, prefigure the more realistic styles of sculpture from the thirteenth and fourteenth centuries.

The statue was made of Japanese cypress (*hinoki*) using the joined-woodblock method of construction that was developed in the eleventh century. In this technique, different parts— such as the head, feet, hands, and the torso—were carved from separate pieces of wood, the head and torso were hollowed out, and then the pieces were assembled. After joining, the sculptures were often covered with a gessolike material (*gofun*) and painted and decorated with cut gold and silver leaf (*kirikane*). Traces of red pigment and gold leaf are found on this sculpture, although both are badly abraded.

Much destruction occurred due to battles between the warring Taira and Minamoto clans during the transition from the Heian to the Kamakura period that followed. This led to the rebuilding of Buddhist temples and creation of new temple sculptures during the Kamakura period, which lasted from 1185 to 1333. This new period saw Japan in the hands of military rulers, and the capital of the country moved much farther east to Kamakura, the city that gives this era its name.

An elegant and extraordinarily well-preserved statue of the Bodhisattva Kshitigarbha (Japanese: Jizō Bosatsu) **(FIG. 231)**, Bodhisattva of the Earth Womb, represents a deity introduced to Japan in the Heian period that increased in popularity during the Kamakura period. Although he is mentioned in Sanskrit texts, the worship of Kshitigarbha appears to have been more important in China, Korea, and Japan than it was in South or Southeast Asia. Kshitigarbha is worshiped as a savior bodhisattva who helps guide the faithful during the age of the decay of Buddhist teachings—before the coming of Maitreya, the Buddha of the Future. Kshitigarbha is usually depicted as a Buddhist monk with a shaved head and a monk's staff in

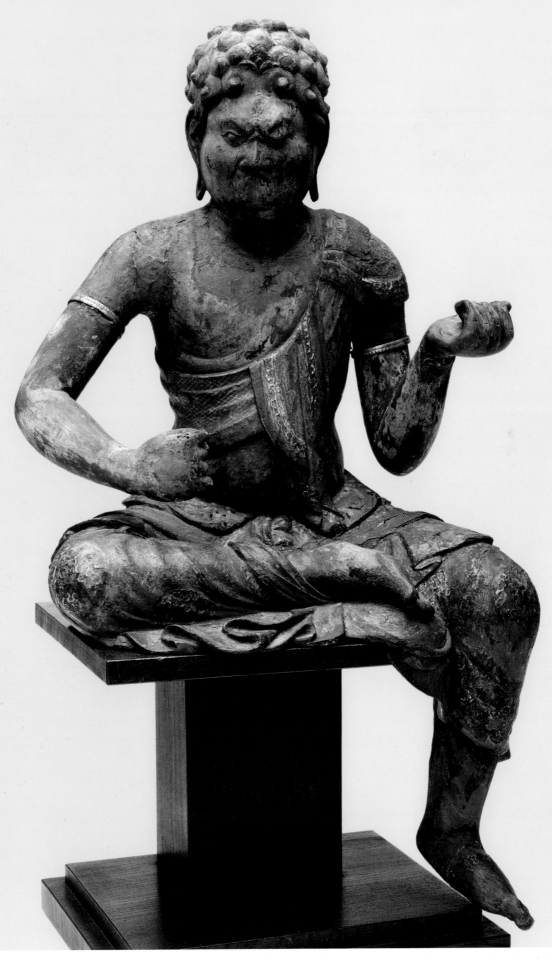

FIG. 230. Achala Vidyaraja (Fudō Myōō). Heian to Kamakura period, late 12th century. Japan. Cypress wood with traces of pigment and cut gold leaf. H. 19¼ x W. 11½ x D. 10 in. (48.9 x 29.21 x 25.4 cm). Asia Society, New York: Mr. and Mrs. John D. Rockefeller 3rd Collection, 1979.201

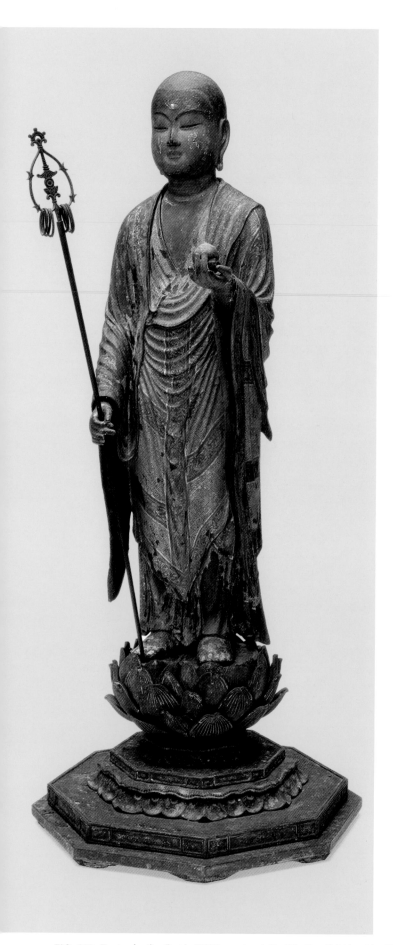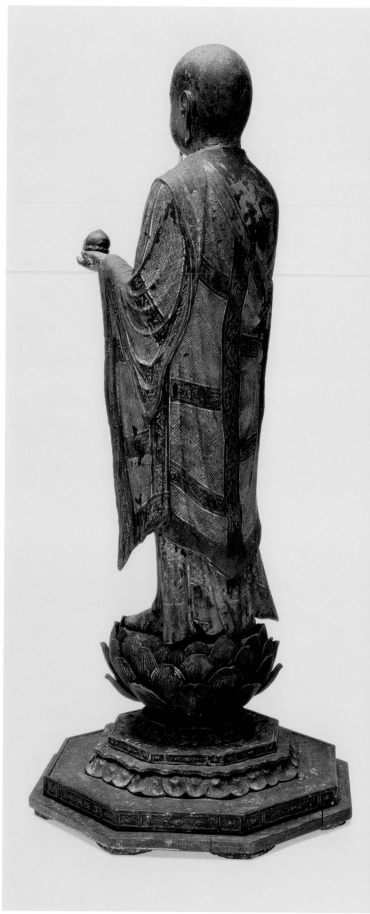

FIG. 231. Zen'en (active first half 13th century). Bodhisattva Kshitigarbha (Jizō Bosatsu). Kamakura period, 1223–1226. Japan. Cypress wood with cut gold leaf and traces of pigment; staff with metal attachments. H. 22¾ x W. 9½ x D. 9½ in. (57.8 x 24.13 x 24.13 cm). Asia Society, New York: Mr. and Mrs. John D. Rockefeller 3rd Collection, 1979.202a-e

his right hand. He holds a jewel of wisdom (*chintamani*), which grants all wishes, in his left hand. In Japan, Kshitigarbha is also worshiped as the protector of women, children, and travelers; stone statues of this bodhisattva are often placed at crossroads.

The careful depiction in this sculpture of the folds of Kshitigarbha's garments, proportions, and the naturalistic rendering of his face, hands, and feet typify the interest in realism that characterizes the art of the Kamakura period. Kshitigarbha wears a vest and a long skirtlike garment. A full shawl covers most of the vest and the upper part of his body. The carving and decoration of his clothing are carefully designed to show the differences between the skirt, vest, and shawl. His skirt is green with a border that has a geometric design made with cut gold leaf. His upper garment, which is draped over his left arm, is also green with a floral border made of cut gold leaf. The same material is used for the geometric pattern that decorates the vest, and for the geometric designs and leaf-scroll borders on the large shawl, which falls from the bodhisattva's left shoulder. The use of borders to divide the shawl into different areas refers to the early practice of piecing together a monk's garment from fragments of cloth.

When this sculpture was repaired in the early 1960s, it was discovered that inscriptions in black ink, mostly the names of the donors or pious wishes, cover the carved-out interior of its body and head. Among them is the name of the sculptor, Zen'en, who was active in Nara in the first half of the thirteenth century. Zen'en is known to have created small elegant sculptures such as this and to have worked for many of the more important temples in Nara, such as the Saidaiji and the Tōdaiji. In addition, he is believed to have taught the sculptor Zenkei (1196–1258). Zen'en, Zenkei, and Zenkei's son Zenshun (active second half of the thirteenth century) are often referred to as the Zenpa school.

The inclusion of the names of two prominent monks at the Kōfukuji among those inscribed in the cavity suggest that this sculpture was made for that temple. The inscriptions refer to Jisson as the abbot and Han'en as the former abbot. Temple records indicate that these positions were held by these monks from 1223 to 1226,

thereby providing a date for this sculpture. This date fits in well with the known activity of Zen'en, whose work includes sculptures that date from 1221 to 1247.

The more mechanical treatment of the folds of the robes and the less fleshy depiction of the face, hands, and feet of a sculpture of Amitabha Buddha (**FIG. 232**) date it to the third quarter of the thirteenth century. Amitabha stands on a lotus pedestal. Inlaid crystals are used to depict his eyes and the *urna* (or "third eye") in his forehead. He wears a skirtlike garment and a long shawl, both of which were painted and then covered with designs in cut gold leaf, such as the geometric designs and floral roundels and leaf arabesques on the borders. The elegance and refinement of this sculpture of Amitabha suggest that it was carved in the region around Kyoto and Nara, where the influence of the courtly traditions of the Heian period continued throughout the Kamakura period.

An interest in Buddhist pure lands, particularly that of Amitabha Buddha, developed in China in the sixth century and worship of Amitabha became widespread in Japan during the Kamakura period as part of a popularization of Buddhism. Amitabha is identified here by the position of his hands, which are held in the gesture of teaching or appeasement (*vitarkamudra*). In East Asia, this gesture is used to depict Amitabha as he descends to earth to guide a deceased practitioner to rebirth in his pure land, Sukhavati, which is also sometimes known as the Western Pure Land.

Images of Amitabha's descent to earth illustrate the nineteenth of forty-eight vows made by this buddha in a previous life, in which he promises to appear at the moment of death to all beings who devoutly desire rebirth in his Western Pure Land. These vows are listed in the *Sukhatvativyuha*, one of the principal texts of the Pure Land tradition. Painted and sculpted versions of this theme, which are known as descent or *raigō* images, became popular in Japan during the eleventh century and are known to have been placed before the deathbed of a devotee in order to help her or him concentrate on Amitabha and his promise.

Amitabha's descent from the Western Pure Land is also illustrated in a late-thirteenth-century painting (**FIG. 233**). Amitabha is standing on two lotuses atop a

Page 250: **FIG. 232.** Buddha Amitabha (Amida Nyorai). Kamakura period, mid- to late 13th century. Japan. Cypress wood with traces of pigment and cut gold leaf, and with inlays of crystal. H. 47 x W. 20½ x D. 20½ in. (119.4 x 52.07 x 52.07 cm). Asia Society, New York: Mr. and Mrs. John D. Rockefeller 3rd Collection, 1979.204a-b

Page 251: **FIG. 233.** Amida Raigō (Descent of Buddha Amitabha). Kamakura period, late 13th century. Japan. Hanging scroll; ink, color, and gold on silk. Image only, H. 38¾ x W. 16½ in. (98.4 x 41.9 cm). Asia Society, New York: Mr. and Mrs. John D. Rockefeller 3rd Collection, 1979.191

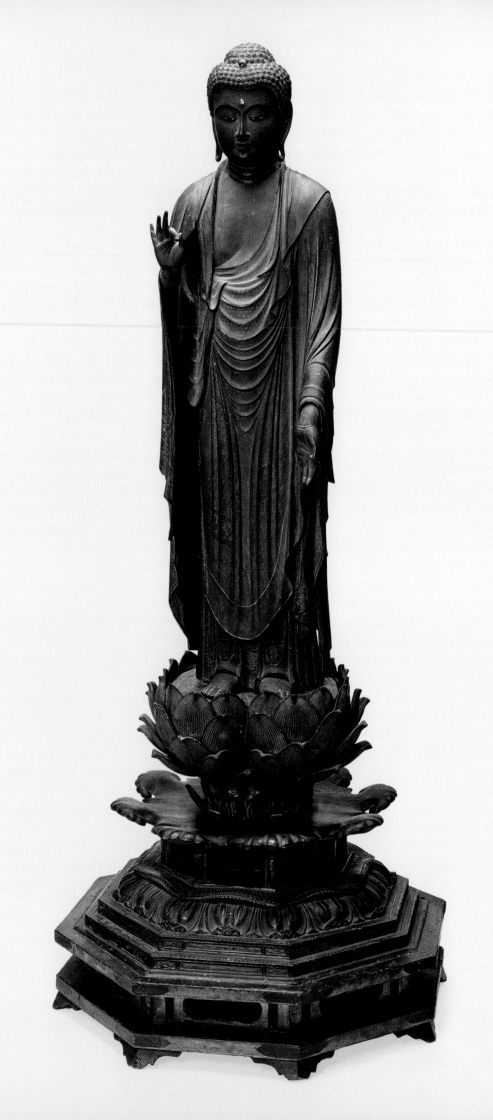

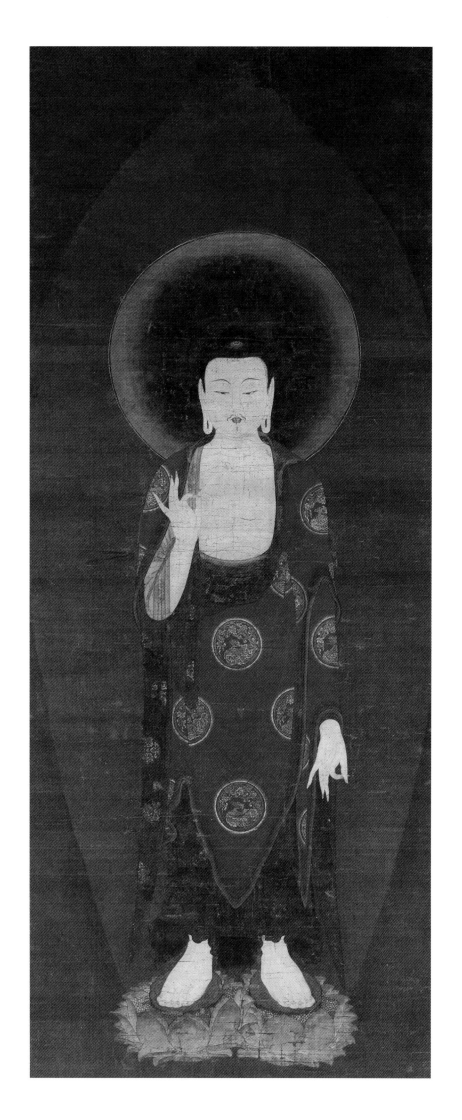

Above and opposite: **FIG. 234.** Two Lion-Dogs (*Koma-inu*). Kamakura period, 13th century. Japan, possibly Wakayama Prefecture. Cypress wood with traces of pigment and gilding. Each, H. 13½ x W. 11½ x D. 6¼ in. (34.3 x 29.2 x 15.9 cm). Asia Society, New York: Mr. and Mrs. John D. Rockefeller 3rd Collection, 1979.206.1-2

lotus pedestal and has a flame-shaped mandorla behind him and a halo around his head. He holds both hands in the gesture of teaching. His upper garment is green and has floral decoration made of cut gold leaf. His shawl is red and filled with cut-gold-leaf floral roundels featuring birds with flowering tails.

This painting of Amitabha's descent illustrates the internationalism of Buddhist art in East Asia. This painting was once thought to be a Korean work because the roundels decorating Amitabha's shawl were common motifs on the garments of Buddhist divinities in Korean painting of the Goryeo period (918–1392). However, similar roundels also appear in Chinese Buddhist painting from

the ninth to the fourteenth century, and they are also found in thirteenth- and fourteenth-century Japanese works. Amitabha's frontal position in the painting and the precise drafting of the delicate outlines indicate the work is by a Japanese rather than a Chinese or Korean artist.

It is likely that the sculpture and the painting of Amitabha were either used individually or as part of a triad with images of the bodhisattvas Avalokiteshvara and Mahasthamaprapta. Eleventh- and twelfth-century representations of Amitabha's descent generally feature a buddha with a large heavenly retinue. The development in the thirteenth century of simple descent images showing Amitabha alone or Amitabha with two attendant bodhi-

sattvas has been attributed to the prominence achieved by the Chinzei branch of the Pure Land sect founded by Shōkōbō Benchō (1163–1238), one of the chief disciples of Hōnen (1133–1212), the founder of the Japanese branch of Pure Land Buddhism. The doctrinal basis of this development can be traced to the *Treatise of the Selected Recitations of the Buddha's Name of the Original Vow* (*Senchaku hongan nenbutsu shū*), one of the most important works by Hōnen. In it he states that single *raigō* images of Amitabha, or those in which he is attended by only two bodhisattvas, were more efficient for visualization of the Amitabha because they focused the devotee's attention more closely on him.

The exaggerated treatment of the chests, waists, and backbones of two lion-dogs with open mouths indicate that these sculptures date to the thirteenth century **(FIG. 234)**. Both were originally painted and gilded, and much of the green and gold pigment remains on their faces, bodies, and tails. Lion-dogs such as these are known in Japan as "Korean dogs" (*koma-inu*). They were generally placed in pairs at the entrances to Buddhist temples or Shinto shrines and functioned as protective images. These Japanese lion-dogs belong to a long tradition in many Asian countries where such animals are found in both religious and secular contexts. Lion-dogs are often said to represent a fusion of the imperial lion of

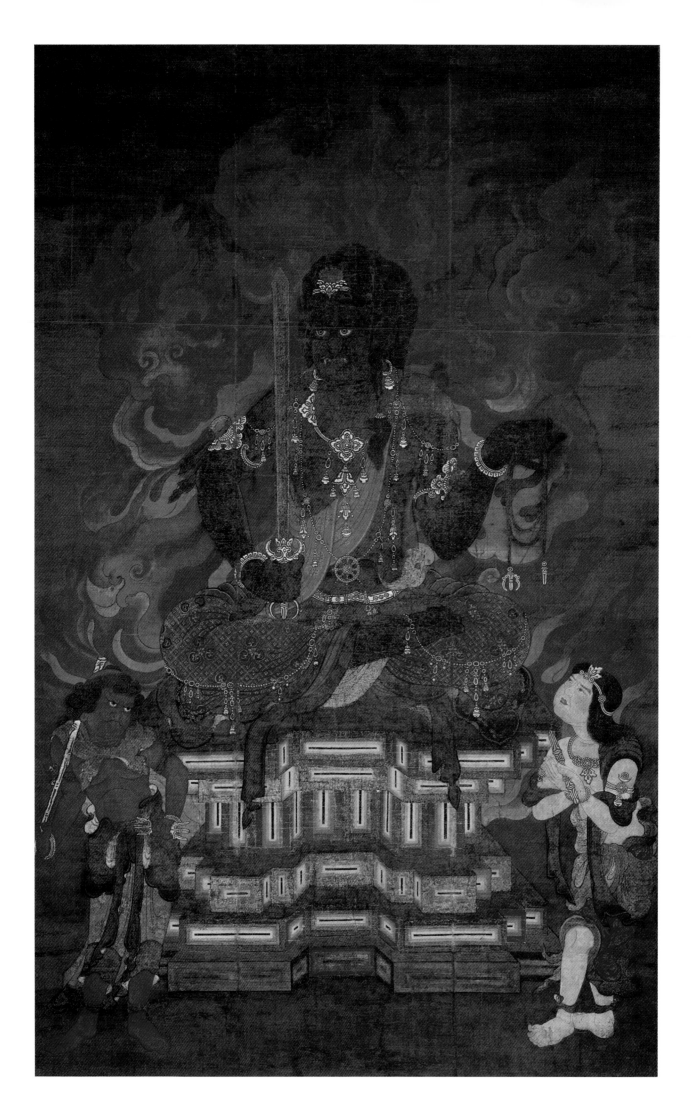

India with the sky-dog of early Chinese mythology. They were introduced to Japan in the eighth century, and the role of lion-dogs appears to have had a place in early *bugaku* drama. The use of lion-dogs in shrines had become common by the early part of the Heian period and continues to this day.

These two lion-dogs were formerly described as being a pair, but it is more likely that each was paired with another because in guardian lion-dog pairs one dog has an open mouth while the other's is closed. The lion-dog with the closed mouth usually also has a horn in the center of his forehead.

A large, powerful painting of Achala Vidyaraja with two young attendants (**FIG. 235**) illustrates the style of art popular in the early fourteenth century, the closing years of the Kamakura period. Achala is seated with one leg folded over the other on an elaborate many-tiered platform and surrounded by swirling flames. He has a blue body, holds a sword with a double-*vajra* hilt and a lasso, and wears elaborate jewelry. He is shown with two of his ten young male attendants.

Achala's form and clothing are full and heavy, and this sense of volume helps to distinguish this painting from earlier Kamakura-period works. The use of broad black outlines to define the form of the wisdom king, the weight of his jewelry, and the treatment of the decoration of his lower garment help date this painting to the early fourteenth century. Achala's red garment is decorated with geometric designs and floral roundels in cut gold leaf that are similar to the designs found on paintings such as that of the Amitabha discussed previously (**FIG. 233**). However, both the geometric designs and the floral roundels are larger in scale than similar motifs on earlier paintings.

A long inscription on the back of this painting states that it was remounted in 1596 and 1780, and that it was once in the collection of the Jizōin at the Kampozan monastery. A Shingon monastery of that name was built in Nagoya in 1728, and it seems likely that this painting was once in the possession of that establishment.

The combination of weightiness and bold decoration also help date a sculpture of the Bodhisattva Avalokiteshvara (Chinese: Guanyin; Japanese: Kannon) to the early fourteenth century (**FIG. 236**). The surface of his skin was covered with a paste of yellow pigment and gold powder (*fundame*), much of which has been lost. His eyebrows and mustache are drawn in black ink, and his lips and chignon were once fully painted red and blue respectively. Kannon's posture and his six arms help identify this as an image of Chintamanichakra Avalokiteshvara. He would originally have held a flaming jewel (*chintamani*) in his middle right hand, and a wheel (*chakra*) would have been balanced on the finger of his upper left hand; the name of this form of the bodhisattva derives from these two attributes. The wheel symbolizes the Buddhist law, while the jewel of wisdom represents the bodhisattva's ability to grant any wish. The bodhisattva's relaxed posture indicates that he is resting in his personal pure land Mount Potalaka, which traditionally is said to be located in the sea, south of India. This form of Avalokiteshvara was introduced to Japan during the Heian period and became one of the six most common forms of the bodhisattva.

The youth's full face and form as well as his heavy garments date a small bronze sculpture (**FIG. 237**) to the early fourteenth century. The iconography of this image is difficult to ascertain, and in the past it has been suggested that the figure might represent Prince Shōtoku (reigned 593–622), but the hairstyle—looped braids to either side of the head—and heavy outer robe and trousers, suggest the representation of a youth (*dōji*), sometimes a prince, of the kind often found as attendants in Buddhist temple tableaux. The gesture and position of the figure suggest it would have held some kind of implement and flanked a sculpture of a major Buddhist deity. The hands of the figure and the box they hold are modern replacements.

Images of Avalokiteshvara, the Bodhisattva of Compassion, seated on a rocky outcrop overhanging turbulent water appeared in China around the tenth century, inspired by textual references to Mt. Potalaka, the abode of Avalokiteshvara located off the southern coast of India. Chinese Buddhists identified this residence with Mt. Putuo, an island off China's southeastern coast, and ultimately Japanese Buddhists identified Mt. Nachi in Southern Kii peninsula as the sacred dwelling of Kannon in Japan. A development of the white-robed Kannon theme, in which the bodhisattva, often in a female guise, is clad in white robes, began to appear in China in the twelfth century and was favored by Chan, or Zen, monks who brought this imagery to Japan. A late-fourteenth- to fifteenth-century white-robed Kannon painting attributed to Gekko (Chinese: Yue Hu), a Chinese painter whose name appears in a fifteenth-century Japanese source, the *Kundaikan Sōchōki* (*Record of the Attendant*

Opposite: **FIG. 235.** Achala Vidyaraja (Fudō Myōō) with Two Attendants. Kamakura period, early 14th century. Japan. Hanging scroll; ink, color, and gold on silk. Image only, H. 72 x W. 45 in. (182.9 x 114.3 cm). Asia Society, New York: Mr. and Mrs. John D. Rockefeller 3rd Collection, 1979.209

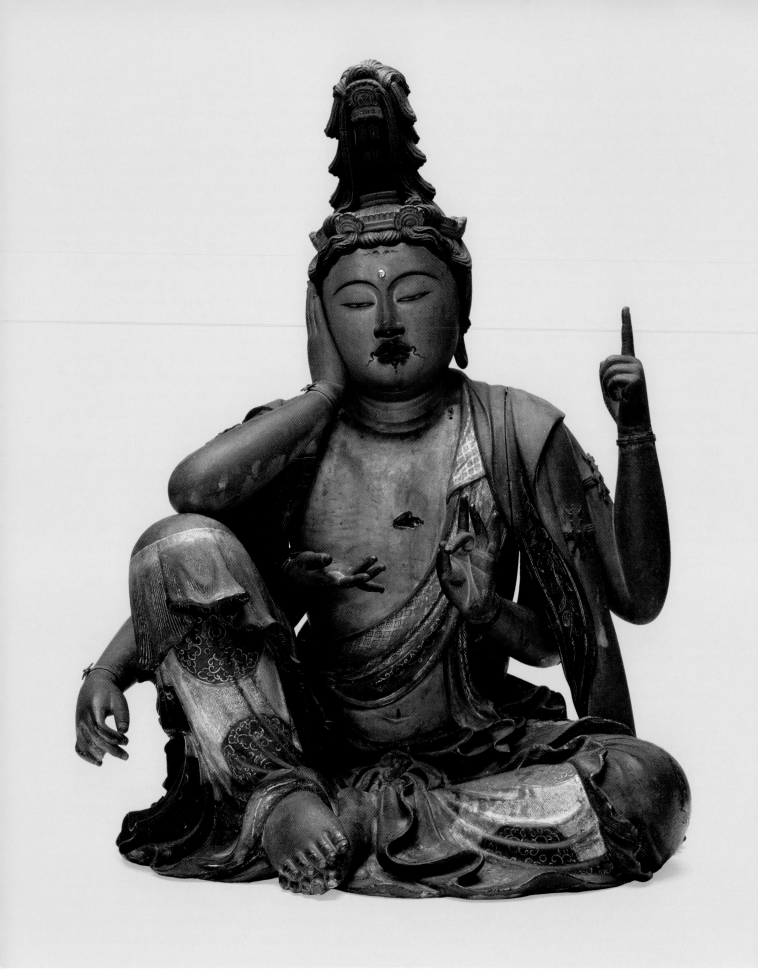

FIG. 236. Bodhisattva Avalokiteshvara in the Form of Chintamani-chakra (Nyoirin Kannon). Kamakura period, early 14th century. Japan. Cypress wood with pigment, gold powder, and cut gold leaf. H. 19½ x W. 15 x D. 12 in. (49.5 x 38.1 x 30.5 cm). Asia Society, New York: Mr. and Mrs. John D. Rockefeller 3rd Collection, 1979.205

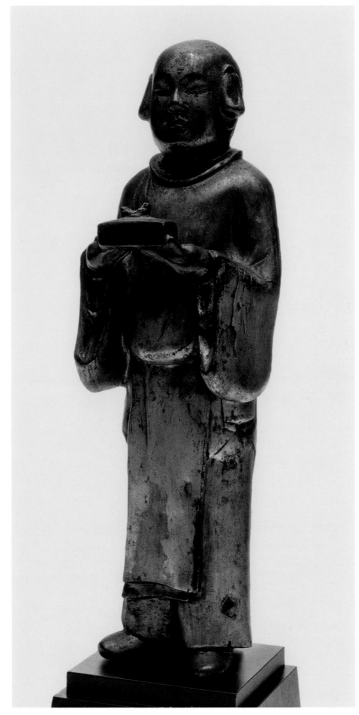

FIG. 237. Male Figure, possibly Prince Shōtoku. Kamakura period, early 14th century. Japan. Gilt copper alloy. H. 9⅝ x W. 3½ x D. 2¾ in. (24.4 x 8.9 x 7 cm). Asia Society, New York: Mr. and Mrs. John D. Rockefeller 3rd Collection, 1979.203a-b

of the Shogun's Residence), is of the monochrome ink type prized by Japanese Zen monasteries during the Muromachi period **(FIG. 238)**. Throughout the thirteenth and fourteenth centuries an interest in Zen Buddhism began to emerge in Japan, and the interest in Zen painting, examples of which Japanese monks had observed in temples in China, coincided with it. The iconography of the white-robed Kannon belongs to the *dōshakuga*

tradition of imagery, which features depictions of Buddhist themes intended to aid the viewer in achieving enlightenment. In this *dōshakuga* painting the washy ink strokes are skillfully applied so that a full moon forms a halo around the head of Avalokiteshvara. The medium lends itself well to the relaxed seated pose of the bodhisattva, the flowing water at his feet, and the cascade of the waterfall to the right.

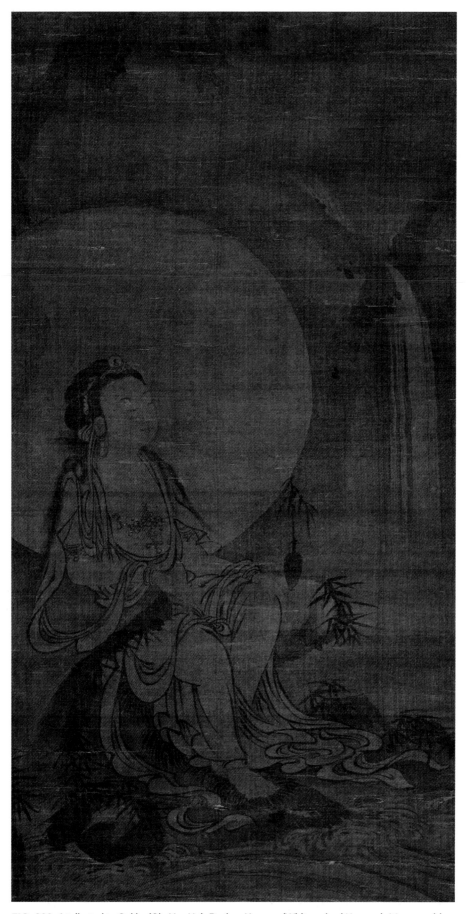

FIG. 238. Attributed to Gekko (Ch. Yue Hu). Byakue Kannon (White-robed Kannon). Muromachi period, late 14th–15th century. Japan. Hanging scroll; ink on silk. Image only, H. 33 x W. 17 in. (83.8 x 43.2 cm). Asia Society, New York: Mr. and Mrs. John D. Rockefeller 3rd Collection, partial gift of Rosemarie and Leighton Longhi in honor of Sherman E. Lee, 1998.1

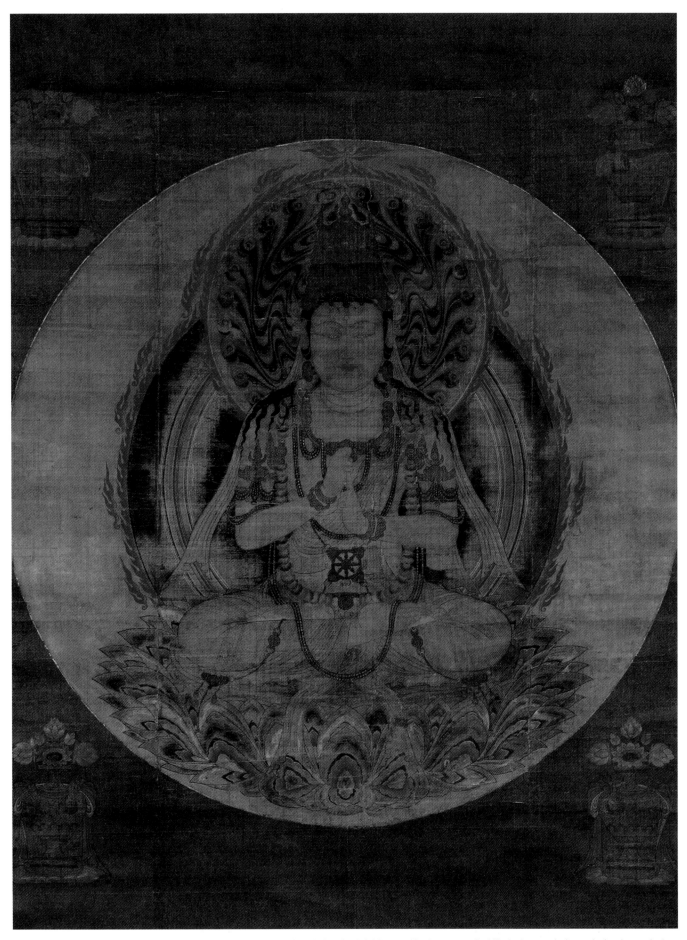

FIG. 239. Buddha Vairochana in the Form of Ekaksara-ushnisha-chakra (Dainichi Nyorai in the Form of Ichiji Kinrin Bucchō). Nanbokucho period, 14th century. Japan. Hanging scroll; ink, color, and gold on silk. Image only, H. 43½ x W. 32⅝ in. (110.5 x 82.9 cm). Asia Society, New York: Mr. and Mrs. John D. Rockefeller 3rd Collection, 1979.207

A painting of Vairochana Buddha as the Buddha of the Golden Wheel (Ekaksara-ushnisha-chakra; **FIG. 239**), may date to the Nanbokucho period. The word *nanbokuchō* means "northern and southern courts," and reflects how the royal family was divided into warring factions during this period, from 1336 to 1392. The Buddha's ovoid face, long narrow eyes, full nose, and pursed lips are typical of fourteenth-century paintings. The figure's shoulders are narrower and the torso less expansive than are those of buddhas in thirteenth-century paintings. The distance between his knees is also shorter. Finally, the stiffness found in details such as the scarves hanging from the buddha's crown or the sash that ties his lower garment as well as the exaggeration of other details, such as the folds of his lower garment or the lotus petals on his pedestal, also point to a date in the Nanbokucho period.

Vairochana, whose name means "infinite light," is worshiped as the primary buddha in the Shingon sect of Esoteric Buddhism. In this painting he is seated in the posture of meditation and holds his hands in a distinctive gesture known as the wisdom-fist (*jnanamushtimudra*). This gesture, in which the index finger of the left hand is extended into the right fist, symbolizes the unity of sacred wisdom and human ignorance. The mandala of the Diamond Realm, one of the two central mandalas of Shingon Buddhism, is the source for this representation of Vairochana. On Diamond Realm mandalas Vairochana's image appears in the top center square of the mandala. The name Buddha of the Golden Wheel refers to the imagery: *ekaksara* refers to the single Sanskrit syllable *bhrum* through which the buddha's spiritual potency is verbalized; the *ushnisha* is the cranial protuberance at the top of a buddha's head, a symbol of wisdom; and *chakra* refers to the golden wheel, a symbol of both the Buddhist law and Vairochana's role as a universal monarch. The stylized flames in Vairochana's halo represent mystical emanations, while the five small buddhas in his headdress indicate his wisdom. Images of Vairochana in this form appear to have been particularly popular in Japan during the Heian and Kamakura periods, and about twenty earlier examples of this theme are extant. The use of religious icons that depict a single deity that was first represented in earlier multifigured mandala paintings is characteristic of Japanese Esoteric Buddhism; and it has often been suggested that this practice may reflect the influence of devotional cults, such as Pure Land Buddhism, on the development of esotericism in Japan.

Landscape and Bird and Flower Paintings of the Muromachi Period

Chinese-style ink painting, which was first introduced to Japan during the Kamakura period, had a profound impact on the art of Muromachi-period Japan (1392–1568). The history of painting during that period is marked by the spread of Chinese techniques and themes from the temples affiliated with Zen Buddhism, where such works were often used in meditative or ritual practices, to the studios of professional painters who were not necessarily associated with a religious institution and who had various patrons. In the fifteenth century, ink painting gained a cultural cachet as it moved out of the religious context and gained a wider audience.

The combination of a long vertical format, a monochromatic landscape, and the two poems of a fifteenth-century painting **(FIG. 240)** characterizes a type known as a "poem-picture scroll" (*shigajiku*), which united word and image. Works of this kind, which were popular in the first half of the fifteenth century, were hung in the residential quarters of priests, and their popularity reflects the large number of such quarters with studies and alcoves that were constructed in Buddhist temples in the fifteenth century. Many of the works in the poem-picture scroll format were painted to celebrate the construction of a study within a subtemple, when the user of the study and his friends gathered to name the studio and to write poetry commemorating its completion.

The union of literature and painting found in poem-picture hanging scrolls reflects the interest in Chinese literature and philosophy that prevailed in Japanese Zen temples during the first half of the fifteenth century. The paintings and their inscriptions often celebrate the joys of seclusion and scholarship, yet it is interesting that most of these paintings were created and enjoyed in prominent, bustling Zen temples by priests who were often deeply involved in the culture and politics of their time.

The three-point perspective and asymmetrical composition used in this landscape derive from Chinese traditions. A thatched hut set against the budding spring trees on the banks of a lake fills one side of the foreground. Riverbanks and the foothills of a mountain are found on the other side, and both scenes are viewed from above. A mountainside path leads the viewer into the middle ground of the painting, which is depicted at eye level. Towering mountains, a cascading waterfall, and distant

Opposite: **FIG. 240.** Pavilion in a Beautiful Field (*Shuyado*). Muromachi period, 15th century. Japan. Hanging scroll; ink and light color on paper. Image only, H. 28¼ x W. 11¾ in. (71.8 x 29.8 cm). Asia Society, New York: Mr. and Mrs. John D. Rockefeller 3rd Collection, 1979.210

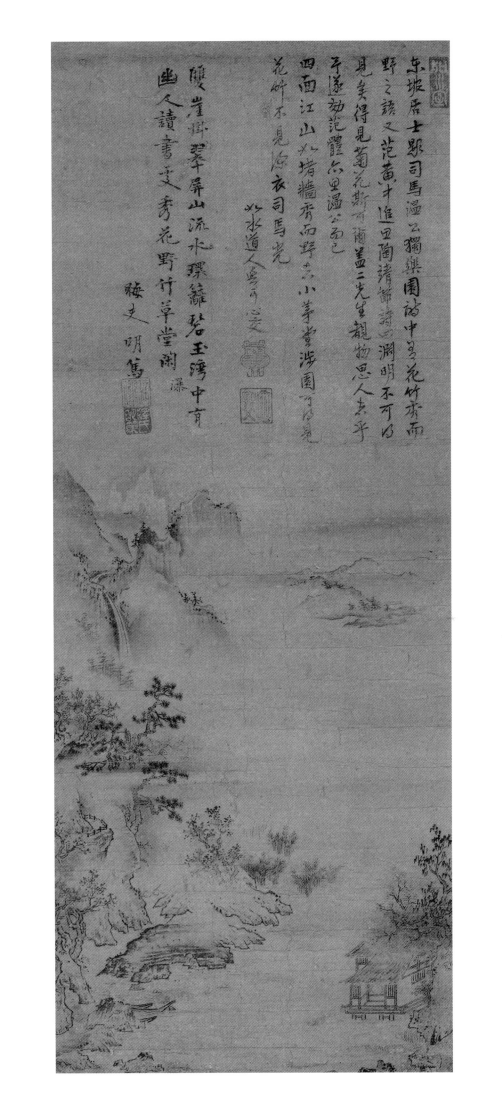

views of the other side of the lake are shown in the background, which is viewed from below.

This landscape is one of five or so early-fifteenth-century paintings called *Pavilion in a Beautiful Field* or *Shuyado*. This title is derived from a recombination of some of the words used in a poem by the famous Chinese author, artist, and scholar Su Dongpo (1036–1101) describing the garden of his colleague, the historian Sima Guang (1019–1086). Su Dongpo's poem and another poem are alluded to in the long inscription and poem written on this painting by Yoka Shinko (died 1437), as well as the shorter inscription by Kaifu Meitoku (died 1451).

Yoka Shinko's inscription and poem can be translated as follows:

Among the works of the retired scholar [Su] Dongpo, there is a poem regarding the Garden of Solitary Delights of Sima Duke Wen. In it are the words *flowers*, *bamboo*, *luxurious*, and *wild*. Also, the poem by Fan Huangzhong in memory of Tao Jingjie [Yuanming] says, "I cannot see Yuanming, but can see the chrysanthemums, which must suffice." As for these gentlemen, they are evoked by seeing certain things. I imitate the form used by Fan and think about Wengong.

The mountains and rivers on four sides are like
* walls;*
the small grass hut is luxurious and wild.
If you step into the garden, you can see the
* chrysanthemums*
but not the patrician-robed Sima Guang.[1]

Kaifu Meitoku's inscription can be read as, "Mount Kingfisher-Green hangs between two cliffs. The mountain waters encircle the wattled fence. In Emerald Jade Bay, there is a place where recluses study writings. Amid the luxurious flowers and rustic bamboo, the thatched hut is now silent."

Both writers of these inscriptions were monks associated with the Rinzai branch of Zen Buddhism and served as abbot of the Tōfukuji in Kyoto: Yoka Shinko was the one hundred twenty-second abbot and Kaifu Meitoku (or Mintoku) was the one hundred thirty-first. Three of Yoka Shinko's seals are affixed to this painting: an oblong seal reading *Josui shitsu*, a tripod-shaped seal reading

Yoka, and a square seal reading *Shinchu*. Kaifu Meitoku's two square seals read *Shinsen* and *Shakushi Meitoku*. The small character for *waterfall* written at the end of the inscription by Meitoku may indicate that the waterfall in the upper-right corner of the painting was added after the composition of the landscape had been completed.

Yoka Shinko wrote colophons on two of the other paintings focused on the *Shuyado* theme, which suggests that this subject may have been important to him and his colleagues at the Tōfukuji. Colophons by both monks are also found on a few other paintings, including a work in the collection of the Masaki Museum in Osaka that is very close in style to this landscape. The Masaki collection painting is dated 1433, and it seems possible, given that Yoka Shinko died in 1437, that the collection's *Pavilion in a Beautiful Field* dates to about the same time.

A painting of a *Bird on a Snow-Covered Plum Branch* **(FIG. 241)** by Saian illustrates one of the styles of ink painting popular in the late fifteenth and early sixteenth centuries. A singing bird perches on a snow-laden plum branch; the blossoms indicate the arrival of spring. A seal reading *Saian* is impressed in the lower-right corner. Very little is recorded about this artist, who is known to have painted bird-and-flower paintings as well as scenes of hermitages nestled in Chinese-style landscapes similar to *Pavilion in a Beautiful Field*. Saian was a Buddhist priest associated with the famous Shōkokuji in Kyoto. The Shōkokuji, which was part of the Five Mountain or *gozan* system of temples, played an important role in the introduction of the Chinese technique of monochrome painting to Japan. Some of the most influential artists of the Muromachi period—including Josetsu (active early fifteenth century), Shūbun (active 1423–60), and Sesshū (1420–1506)—resided, at least for some time, at the Shōkokuji, and the styles of paintings developed by artists associated with this temple had a formative influence on the art of subsequent periods.

The powerful and expressive brushstrokes in this painting—seen for example in the areas of wet (dark black) ink that are used to depict some of the bird's feathers and some of the buds on the plum tree—are characteristics often found in the art of Sesshū and his followers and would indicate that to some degree the elusive Saian was influenced by the most prominent styles found at the Shōkokuji. Sesshū and his followers represent the development of a Japanese ink-painting aesthetic that is charac-

Opposite: **FIG. 241.** Saian (active late 15th–early 16th century). Bird on a Snow-Covered Plum Branch. Muromachi period, early 16th century. Japan. Hanging scroll; ink on paper. Image only, H. 20⅜ x W. 14¼ in. (51.8 x 36.2 cm). Asia Society, New York: Mr. and Mrs. John D. Rockefeller 3rd Collection, 1979.212

FIG. 242. Attributed to Geiami (1431–1485). Bird on a Gardenia Branch. Muromachi period, 16th century. Japan. Hanging scroll; ink on paper. Image: H. 17¼ x W. 12¼ in. (44 x 31 cm). Asia Society, New York: Gift of Mrs. Charles Dreyfus, 1967.4

Opposite: **FIG. 243.** Cho'oku Joki (active late 15th–early 16th century). Birds and Flowers. Muromachi period, late 15th–early 16th century. Japan. Hanging scroll; ink and light color on paper. Image only, H. 28¾ x W. 13½ in. (73 x 34.3 cm). Asia Society, New York: Mr. and Mrs. John D. Rockefeller 3rd Collection, 1979.211

terized by a sense of drama and an interest in strong compositional designs. However, the interest in immediately and intimately capturing a small slice of nature while still suggesting the inevitability of growth and change found in this painting also illustrates the continuing influence of Chinese aesthetics on the art of the Muromachi period.

The same theme and sense of time is also found in an ink painting depicting a *Bird on a Gardenia Branch* (FIG. 242). Once again, the small bird is shown singing while perched on the branch of a flowering tree. In this instance, some of the gardenias have bloomed while others are still buds. Despite the similarities between the two paintings, their styles indicate that they stem from two different traditions of Muromachi ink painting. The branch of the gardenia is placed more obviously to the left of the composition and grows more gently than the thrusting plum branch in Saian's work. A pale wash of ink delicately shapes the head of the bird in this painting, contrasting to the more linear treatment of the bird's head in the work by Saian. Each artist, however, used areas of dark ink to define his bird's tail and certain areas on its wings. The bird and gardenia branch fill the composition more prominently than do the bird and plum branch painted by Saian.

The rise of professional painters during the late fifteenth and early sixteenth centuries also provided a stimulus for renewed Japanese interest in the academic Chinese tradition of bird-and-flower painting. Some Chinese bird-and-flower images were painted in bright colors, while others combined ink and lighter colors. They are noted for their extraordinary realism, in which intimate scenes from nature are captured with sensitivity and precision. Paintings of this type had been known in Japan as early as the Kamakura period, but new examples were introduced to Japan in the fifteenth century as a result of the renewal of official trade between the Ashikaga shoguns and Ming-period China.

A charming painting of *Birds and Flowers* (FIG. 243) exemplifies the combination of Chinese and Japanese aesthetics found in Muromachi bird-and-flower painting. The painting depicts two finchlike birds perched on a branch of a fruit tree while a third bird flies above. The chrysanthemums in the background suggest that this scene may be autumnal, because these flowers are often associated with the fall. The combination of modulated brush strokes and delicate washes in this painting

ultimately derives from Song-period Chinese sources. The sense of vitality and the treatment of flowers, leaves, and other details in a flat, patternlike manner characterizes Japanese art during the fifteenth and sixteenth centuries.

The inscription at the upper right of the painting reads *dai Min yushi Cho'oku Joki shū*, "painted by Cho'oku Joki, who traveled [to Japan] from the great Ming [China]." Two artist's seals, one reading *Joki* and the other reading *Tōson*, are impressed beneath the signature. A third seal, at the bottom left, which was impressed upside down, reads *Gyobu Jiro*.

As is often the case with Muromachi-period artists, very little is known about Cho'oku Joki. His given name was Tomotada, and his personal name is unknown. In addition to Cho'oku and Joki, he used the artist-name Sogei. He is believed to have painted primarily monochromatic ink landscapes and to have been either a Chinese artist who worked with Sesshū or a Japanese artist who traveled to China.

1. Translated by Leidy with the assistance of Sarah Thompson and Gopal Sukhu.

Kanō School Paintings

The Kanō school, a hereditary family of painters employed by the Tokugawa shoguns and other military rulers, dominated Japanese painting from the sixteenth until the nineteenth century. Most other major artists of this period studied with Kanō masters before developing their own styles. The founders of the Kanō school were among the first professional artists to paint Chinese-style ink paintings. Prior to the fifteenth century, this type of painting was primarily the art of Buddhist monks or amateur painters, who were usually scholars of Chinese thought and culture. Kanō mastery of Chinese-style landscape painting also contributed to the success of the school in the fifteenth century, after this theme became popular.

Kanō Masanobu (about 1434–1530), the founder of the Kanō school, was a member of a minor samurai family. Both he and his father served as painters to the Ashikaga shogun Yoshimasa (1436–1490). The rise of the Kanō school, however, is generally attributed to the artistic and organizational genius of Masanobu's grandson, Motonobu

Opposite: **FIG. 244.** Kanō school, possibly by Kanō Shōei (1519–1592). Birds, Ducks, and Willow Tree. Muromachi period, mid-16th century. Japan. Folding screen panels mounted as a hanging scroll; ink on paper. Image only, H. 54 x W. 45 in. (137.2 x 114.3 cm). Asia Society, New York: Mr. and Mrs. John D. Rockefeller 3rd Collection, 1979.213

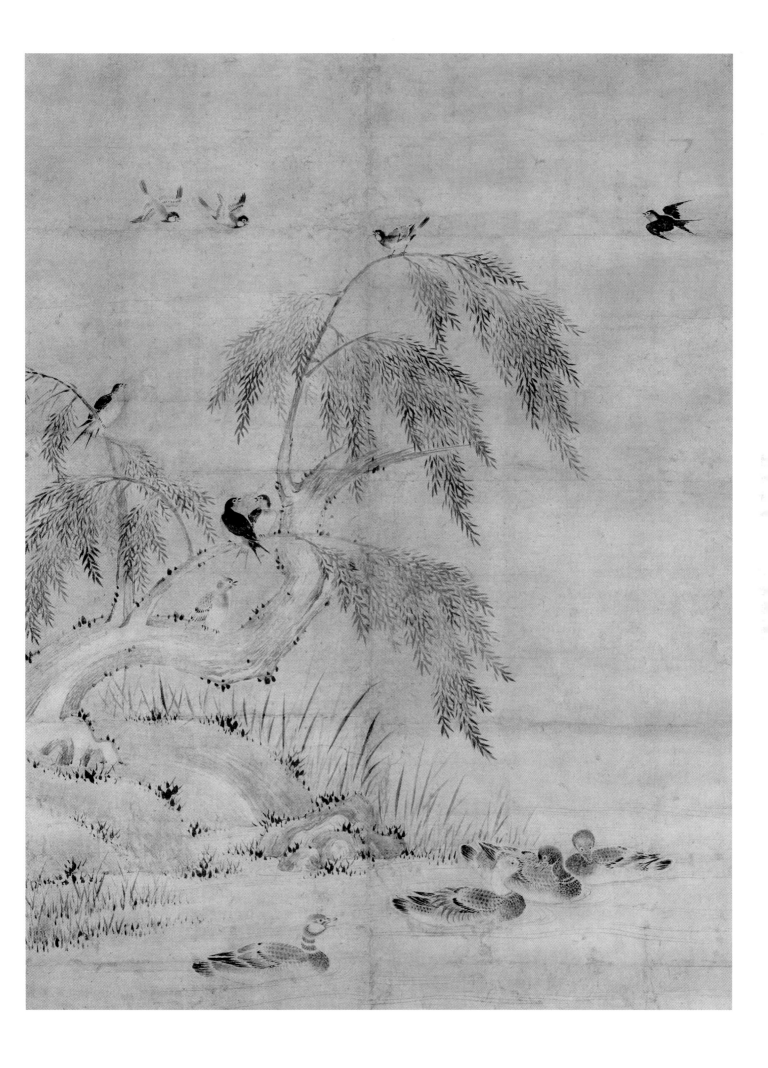

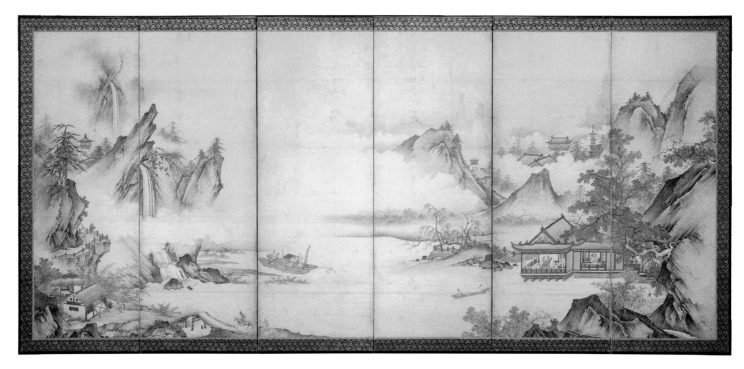

Above and opposite: **FIG. 245.** Attributed to Odawara Kanō school. The Four Seasons. Muromachi period, mid- to late 16th century. Japan. Pair of six-panel folding screens; ink and light color on paper. Each, H. 61 x W. 142⅛ in. (154.9 x 361 cm). Asia Society, New York: Mr. and Mrs. John D. Rockefeller 3rd Collection, 1979.216.1-2

(1476–1559), one of the most influential painters in sixteenth-century Japan. Motonobu developed a distinctive style of large-scale painting that was well suited to the increasing demand for large interior decoration schemes as well as a workshop system that could meet the demands of a growing, wealthy clientele. This combination of style and organization was continued by Motonobu's son, Eitoku (1543–1590), and creative variations and reinterpretations of compositional types and motifs invented by these latter two masters remained the hallmark of the Kanō school for centuries.

A large hanging scroll of *Birds, Ducks, and Willow Tree* **(FIG. 244)** illustrates the use of Chinese prototypes that characterizes the art of the Kanō school. In this painting, four ducks (or small geese) are shown resting in the water near a riverbank while several small birds, including swallows, flit nearby or sit on the branches of a willow tree at the edge of the bank. A larger unidentified bird is resting on the lower branch of the tree. The composition of the painting has been divided into three points of view: a foreground seen from above, a middle ground that is level with the viewer, and a background that is seen from below. This tripartite compositional device was introduced to Japan with the techniques of Chinese ink painting in the twelfth and thirteenth centuries.

The one-corner or diagonal composition of this painting derives from painting traditions that were popular at the Chinese court during the Southern Song period.

The one-corner composition is most often associated with the works of artists such as Ma Yuan (active ca. 1190–1225) and Xia Gui (active about 1180–1224), both of whom were employed by the Chinese court. Works by these artists, which traveled to Japan in the hands of Buddhist monks, played an important role in the development of Japanese painting.

The use of strong outlines to form the trunks of the trees and the shapes of the birds, and the interest in sharply defined details seen in this painting typify the art of the Kanō school and distinguish these works from the softer, more atmospheric Chinese prototypes. The combination of a dominant tree with exposed roots and a variety of flora and fauna is also typical of many Kanō-school works. Paintings such as this, in which Chinese techniques are combined with the Japanese interest in precise yet sensuous detail, are often classified as either *wakan*, "Japanese-Chinese," or *kanga*, "Chinese picture," terms that indicate a blending of Chinese and Japanese aesthetics.

Although now mounted as a hanging scroll, this painting originally formed two panels in a folding screen. Evidence of the change in format can be seen in the area in the center of the painting where the two pieces of paper used for the panels were joined. The composition of the painting, the monochromatic palette, and the cursive brushwork derive from a famous series of paintings by Motonobu and his workshop that were commis-

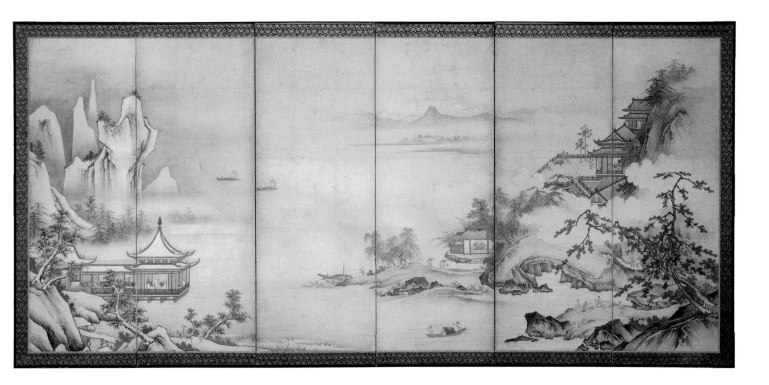

sioned in 1543 for the residential quarters of the abbot of the Reiun'in, a subtemple of the Myoshinji in Kyoto. Such paintings often depict the passage of the four seasons. The combination of elements in this painting alludes to the transition from spring (ducks) to the summer (willow). The lack of depth in the painting and the abundance of detail distinguish it from works that are attributed to Motonobu. These features and the use of short, dry brushstrokes to create rounded shapes are characteristics often found in the art of Motonobu's son, Shōei (1519–1592). It is possible that this painting is from Shōei's atelier.

A pair of mid- to late-sixteenth-century folding screens depicting a landscape of *The Four Seasons* **(FIG. 245)** illustrates the continuing influence of Kanō Motonobu. Reading from right to left, various scenes show changes in foliage and atmosphere from spring to winter. In the opening scene a scholar-gentleman and his attendant walk along a mountain path that winds behind hills in the foreground. Their destination may be the lakeside pavilion, where other scholars are gathered to enjoy a spring day. Scenes of boating, fishing, and other outdoor activities illustrate summer. The foggy mist of summer continues into the autumn section of the painting, where seasonal activities occur in the light of a full autumn moon, seen hovering in the background above distant mountains. The snowy mountains and evergreens suggest the coldness and stillness of winter.

Several of the vignettes scattered through this pair of screens also have additional levels of meaning. For example, the mountain village in the middle ground of the spring section, the distant sails in the middle ground of the autumn section, and the full moon of fall are also part of a popular theme in painting and literature known as the Eight Views of the Xiao and Xiang Rivers (Japanese: *shosho hakkei*). This theme celebrates the scenery found in the area of Hunan Province in southern China where the Xiao and the Xiang rivers flow together.

Other motifs also allude to important images in Chinese poetry and painting. For example, the single figure lounging in the foreground of the autumn section represents "listening to the winds in the pines," while the party on the deck in the middle ground of this section shows figures "watching the mid-autumn moon," a popular pastime that was often the subject of poetry and painting. The scholar riding a donkey and accompanied by the walking attendant in the foreground of the winter section could be a reference to any number of Chinese themes about reclusive scholar-gentlemen, as well as to stories about visiting sick friends.

The clear structure given to the composition of these two screens, the lavish pavilion, the precise rendering of roofs and roof tiles, and details such as the jagged rocks that are filled in with bold, dark, truncated brushstrokes known as ax-cut strokes are all features that reflect the style of Kanō Motonobu. However, the greater rigidity in

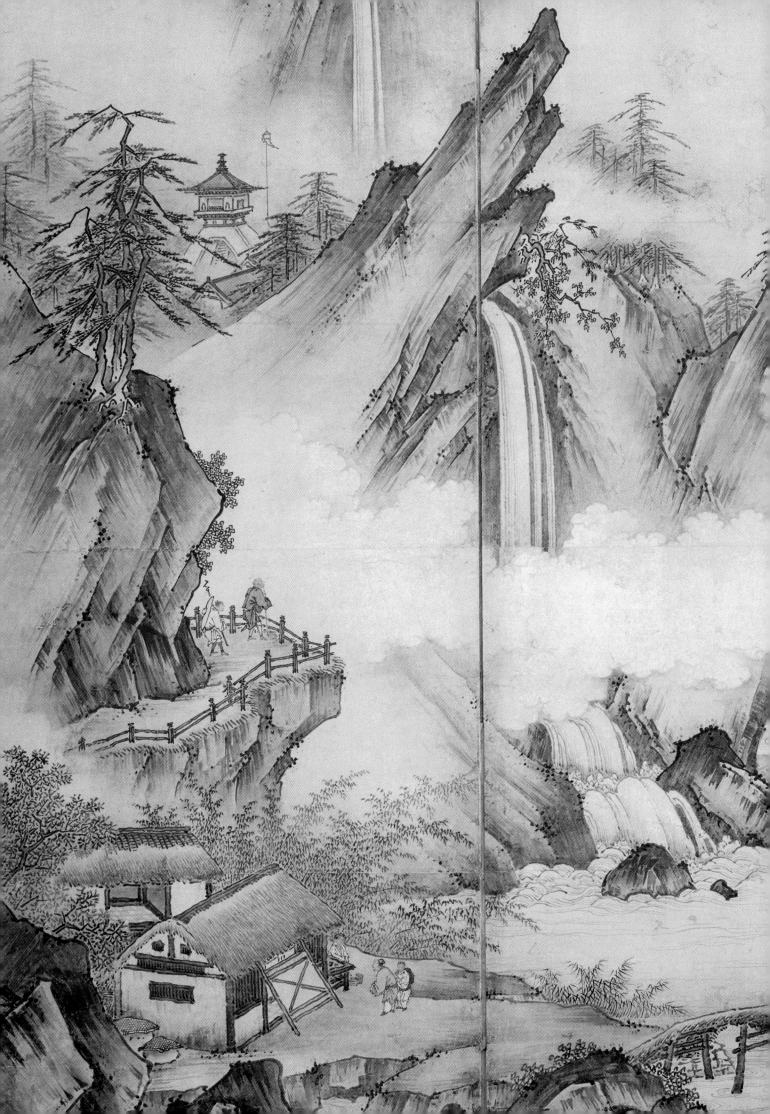

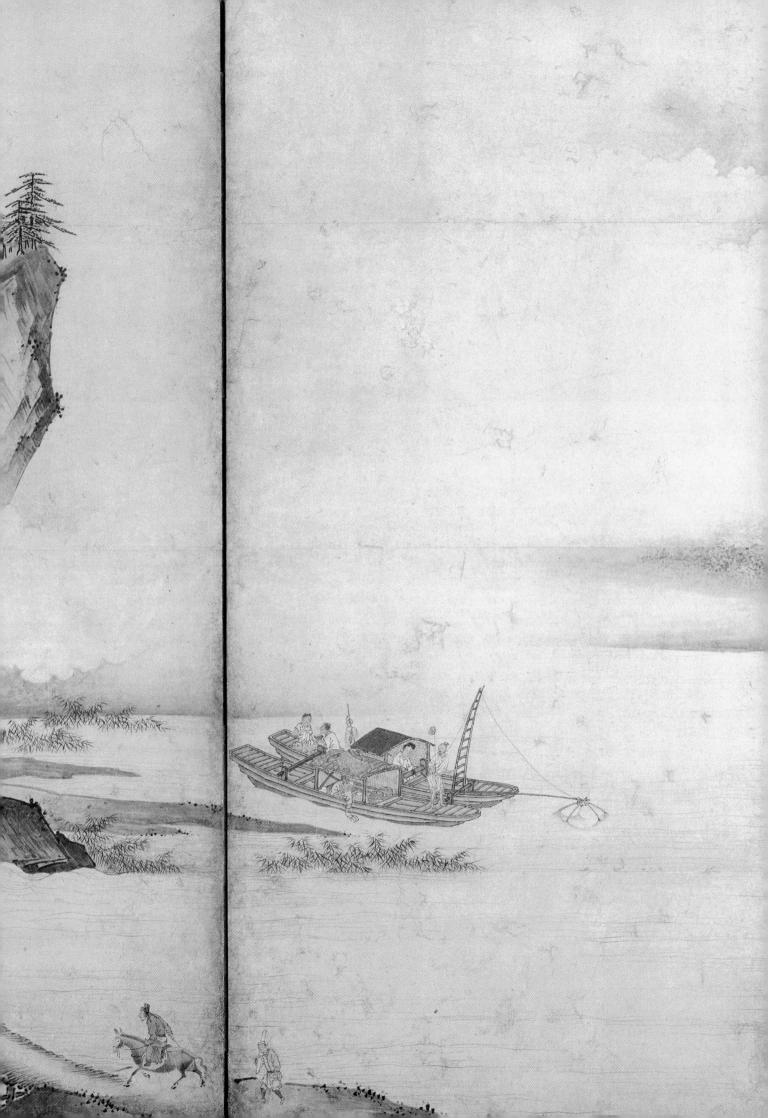

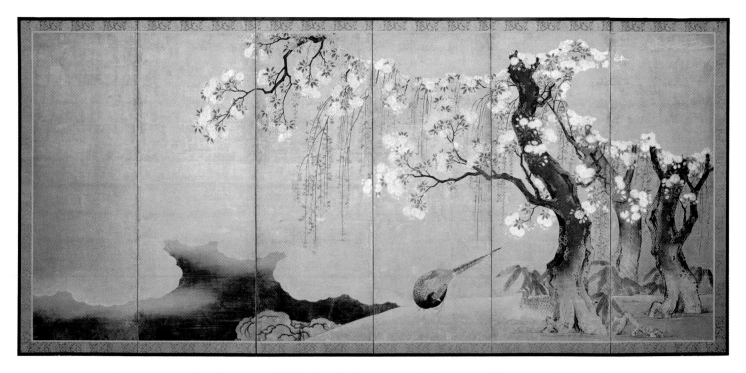

Above and opposite: **FIG. 246.** Attributed to Kanō Ryōkei (died 1645). *Pheasants under Cherry and Willow Trees* and *Irises and Mist*. Edo period, first half 17th century. Japan, Kyoto Prefecture, Nishihonganji. Pair of six-panel folding screens; ink and color on gold leaf on paper. Each, H. 63 x W. 143¼ in. (160 x 363.9 cm). Asia Society, New York: Mr. and Mrs. John D. Rockefeller 3rd Collection, 1979.217.1-2

the brushwork, the dense static mist in the paintings, and the overabundance of stylistic and thematic detail suggest that this pair of screens might be the work of a member or members of the Odawara branch of the Kanō school. Little is known about these artists who worked in the city of Odawara, south of Kamakura. They are called Odawara Kanō to distinguish them from the followers of Kanō Motonobu who were working in Kyoto at the same time. From 1495 to 1590, Odawara was the capital for the Go-Hōjō or Later Hojo clan, which controlled parts of eastern Japan. These feudal lords (*daimyō*) were active supporters of the arts, making the city a major center for the arts in the sixteenth century. The work of the Odawara Kanō is characterized by a strong reliance on Motonobu, which suggests that they were hired by the Go-Hōjō specifically to re-create one of the styles of painting most popular in Kyoto.

A pair of screens, *Pheasants under Cherry and Willow Trees* and *Irises and Mist* **(FIG. 246)**, is attributed to the artist Kanō Ryōkei (died 1645). The three trunks with exposed roots in the foreground of the right-hand screen continue a typical Kanō compositional device. The tripartite composition, the sharply defined forms, and the interest in precise details found in these screens illustrate the traditional style of the Kanō school in the first half of the seventeenth century.

The use of a gold background in this pair of screens, in which the surface of the screen is covered by paper-thin sheets of gold foil, can be traced back to the four-teenth century in Japan. At first, screens covered in this fashion were not painted, but by the late sixteenth century, painted screens with gold backgrounds had become one of the most popular forms of Japanese painting, as they were particularly effective for decorating the heavy stone castles popular in Japan at that time, after firearms were introduced by the Portuguese.

These screens are believed to have once been part of the interior decoration of a room in the Nishihonganji, a prominent temple in Kyoto. Placed together, these two screens illustrate the transition from spring (the budding cherry, willow, and pheasants) to summer (the blooming irises). The cherry, willow, pheasants, and irises are motifs that play an important role in Japanese literature and are often depicted in *yamato-e*, "Japanese picture" paintings. The theme of irises is often associated with the seven-teenth- and eighteenth-century Rinpa school of painting, and the use of this theme in the work of a Kanō artist may represent the influence of this tradition on Kanō artists working in Kyoto.

Both Kanō Ryōkei and his teacher Kanō Mitsunobu (about 1565–1608) worked in Kyoto, while another branch of the Kanō school was based in Edo (present-day Tokyo).

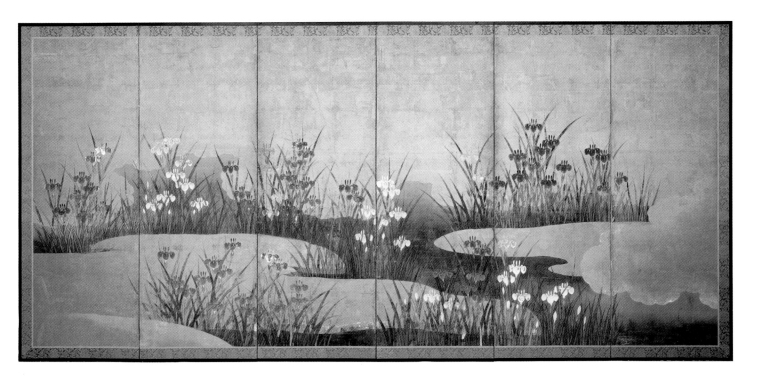

The differences between the art of the Edo branch and that of the Kyoto branch reflect the differing demands of their respective patrons. Ryōkei worked for several temples in Kyoto and was the official painter for the Nishihonganji. Members of the powerful Otani family served as the abbots at this temple. The designs of half-raised bamboo blinds were painted on the backs of these screens and others as a mark by the family to indicate possession.

Rinpa Paintings

Rinpa is the name given to a group of artists whose work is characterized by bright colors, bold forms, lavish surfaces (often enhanced with gold and silver), the frequent use of a bird's-eye perspective, and their reliance on the painting styles and literary themes popular during the late Heian period, when the Japanese court and nobility in Kyoto had been at their political and cultural height. *Rinpa* means "rin school"; the term is derived from the last syllable of the name *Kōrin* in honor of Ogata Kōrin (1658–1716), one of the most influential artists of this school. The Rinpa ancestry is traced back to the painter and calligrapher Tawaraya Sōtatsu (active 1600–1640) and Hon'ami Kōetsu (1558–1637), best known for his calligraphy and pottery. Sōtatsu, Kōetsu, and Kōrin

belonged to the *machishu* class of Kyoto society: wealthy, educated merchants who socialized with and catered to the Kyoto aristocracy, many of whom were impoverished. The interest in reviving early court culture—an interest that permeates the art of the Rinpa school—is a reflection of the close cultural and personal ties between the *machishu* and the aristocracy.

Little is known about the life of Sōtatsu. He began his career as a commercial painter and is known to have owned a fan shop called the Tawaraya. Although Tawaraya is the surname most commonly given to this artist, it is possible that his family name may have been either Kitagawa or Nonomura, names that are found among the lists of those painters who stylistically followed in his footsteps. It has traditionally been accepted that around 1602 Sōtatsu worked on the *Heike nōkyō,* the restoration of the 1164 *Lotus Sutra,* dedicated by the Taira family and owned by the Itsukushima Shrine; it is now classified as a National Treasure. His work on this valuable illustrated scroll indicates that he was already considered an important artist by the early seventeenth century. He was most active in the 1620s, and it is to this decade that most of his major paintings and collaborative calligraphic works are assigned.

Hon'ami Kōetsu, a calligrapher, ceramist, painter, and lacquerer, was one of the most influential artists of the early Edo period. Kōetsu was also known for his

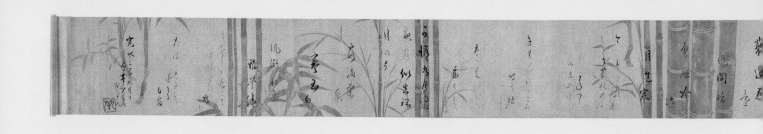

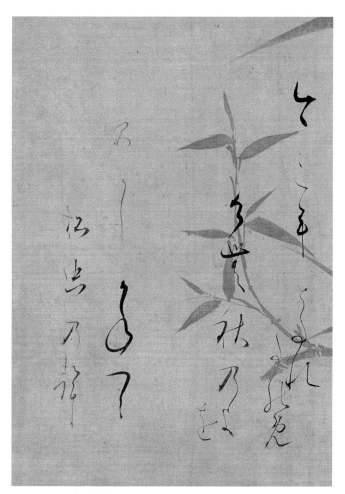
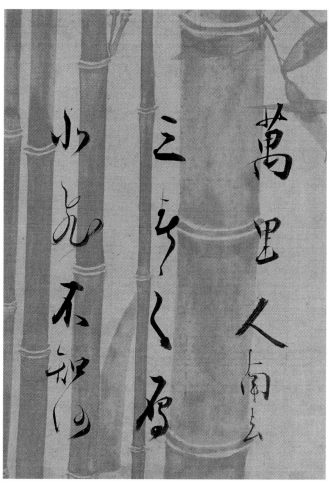

Above and details: **FIG. 247.** Hon'ami Kōetsu (1558–1637). Painting by a follower of Tawaraya Sōtatsu. Poem Scroll with Selections from the *Anthology of Chinese and Japanese Poems for Recitation* (*Wakan Roei Shu*). Edo period, dated 1626. Japan. Handscroll; ink and gold on silk. H. 12⅝ x W. 206½ in. (32.1 x 524.5 cm). Asia Society, New York: Mr. and Mrs. John D. Rockefeller 3rd Collection, 1979.214

designs for metal objects such as sword guards (*tsuba*) and for his mastery of the tea ceremony. He was a member of an important family of craftsmen and cleaned, polished, and appraised swords. Around the time of the restoration of the *Heike nōkyō*, Kōetsu began to collaborate with Sōtatsu to create books and scrolls of calligraphy of classical Japanese poems on decorated papers, re-creating an art popular among the aristocracy during the eleventh and twelfth centuries. Sōtatsu painted the images on the papers and Kōetsu then wrote the calligraphy.

Poem Scroll with Selections from the Anthology of Chinese and Japanese Poems for Recitation (*Wakan rōei shū;* **FIG. 247**) illustrates the type of work

Kōetsu and Sōtatsu produced. In this fourteen-foot handscroll the poems are written against a background of bamboo stalks and leaves painted in gold in a wide array of combinations. The poems are written with full, cursive strokes in which shades of light and dark ink vary, giving a sense of movement to the calligraphy. The Chinese poems are in Chinese characters and the Japanese poems are in Japanese syllabic *kana*. The inscription and seal at the end of this handscroll indicate that Kōetsu was the calligrapher and date the work to 1626.[1]

Despite the similarities between the style of the painting on this scroll and that of works by Sōtatsu, it is unlikely that Sōtatsu painted the bamboo. The collabora-

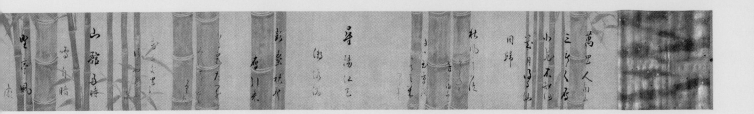

tion between Sōtatsu and Kōetsu appears to have come to an end by about 1620, after Kōetsu moved to Takagamine, where he had established a religious colony on land granted to him by the shogun Tokugawa Ieyasu (1543–1616). Despite their close ties, Sōtatsu did not accompany Kōetsu to Takagamine.

The Anthology of Chinese and Japanese Poems for Recitation was compiled by Fujiwara Kintō (966–1041) in the early eleventh century. It was first written in polished calligraphic form by Fujiwara Yukinari (972–1027) in 1013 and for centuries remained an important source for calligraphers and scholars of literature. The use of silk and gold in the creation of this particular handscroll suggests that it was made for an important patron, possibly a member of a branch of the ruling Tokugawa family.

A striking pair of screens depicting *Flowers and Grasses of the Four Seasons* (FIG. 248) exemplifies the style of painting most closely associated with Sōtatsu's studio and followers from about 1620 to 1650. The screens illustrate the changes from spring to winter through representations of the flowers, grasses, plants, and vegetables that bloom in each of the seasons. Asters, violets, roses, dandelions, thistles, and other seasonal flowers represent spring on the right-hand side of the right screen while the change to summer is shown in plants such as pinks, lilies, honeysuckle, poppies, and irises at left. Hollyhocks, bush clover, and Chinese lantern are combined with other flowers and plants to illustrate autumn on the right-hand side of the left screen. Winter plants, which include flowers and grasses that signify the advent of spring, include bamboo, narcissus, chrysanthemums, and Shasta daisies. The inclusion of vegetables such as the eggplant and taro in the summer section of this screen is unusual and helps to date this pair of screens to the middle of the seventeenth century.

The plants, grasses, and vegetables are painted in the "boneless" or outline-less technique that is often found in the art of the Rinpa school. In this method, shapes are created using color rather than by filling in outlined forms. In some cases, the boneless forms have been painted with thin, translucent pigments that allow the gold background to shine through. In other methods, thick layers of a white gessolike material (*gofun*) have been piled up to give the petals of the flowers, such as those in the large chrysanthemum bush, a dimensionality. Throughout the screen, darker ink has been applied over the lighter colors, wet into wet, to create a smudged and pooled effect. Known as *tarashikomi*, this technique is a hallmark of Rinpa painting. The entire composition of this pair of screens is painted from a bird's-eye perspective that derives from a tradition in early court narrative paintings. This approach is intended to create a sense of intimacy between the viewer and the screens.

A small, round red seal is impressed at the lower-right corner of the right screen and at the lower-left corner of the left screen. The two characters in this seal read *inen*. The seal is frequently found on screens of this type, most of which have no signatures. The *inen* seal appears to have been used by Sōtatsu and by many of the other artists who followed his style. This pair of screens was probably an early work by one or more such artists working in an atelier.

A two-panel screen depicting *Pine and Wisteria* (FIG. 249) is the work of Sakai Hōitsu (1761–1828), one of the two most important artists who worked in the Rinpa tradition in the early eighteenth century. The second son of Lord Sakai of Himeji Castle in Harima Province, Hōitsu had an eclectic education studying literature, poetry, Nō theater, and painting. He also practiced several styles of painting, working with a Kana-school artist as well as with painters in the Maruyama-Shijō, Nanga, and *ukiyo-e* traditions. In 1779 Hōitsu became a Buddhist priest. Shortly after, he devoted himself to the study of the art of Ogata Kōrin, whose works were available to him because of family connections. Hōitsu's interest in Kōrin and in the art of the Rinpa school was responsible in large part for the introduction of this type of painting into artistic and cultural circles in Edo, where Hōitsu worked.

The combination of signatures and seals dates this screen to about 1810 to 1819. The signature in the lower right-hand corner reads *Hōitsu Kishin hitsu*, "painted by Hōitsu Kishin" (*Kishin* is one of his artist-names.) The two seals read *Monsen*, his monk-name, and *Keikyo Dojin*, another artist-name.

The overall composition of this pair of screens, in which the pine tree dominates the right half, may reflect Kana school conventions. The modulated shapes of the

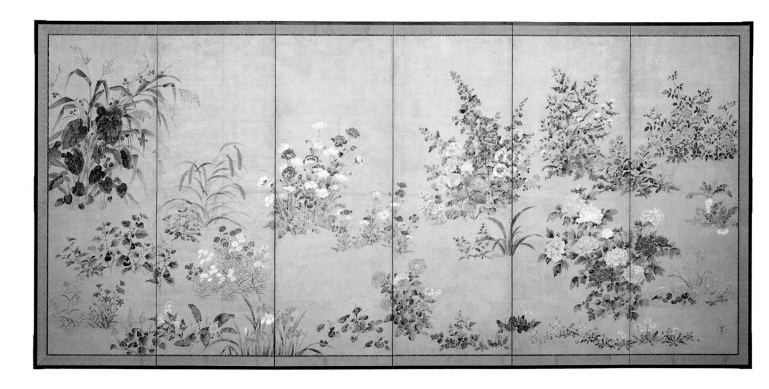

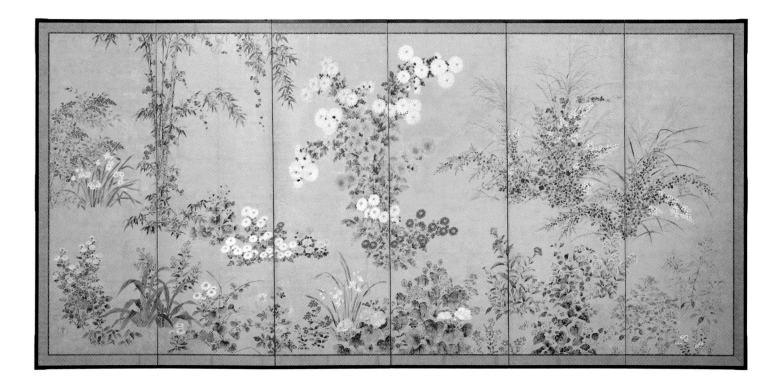

FIG. 248. Attributed to Sōtatsu school. Flowers and Grasses of the Four Seasons. Edo period, about 1620–1650. Japan. Pair of six-panel folding screens; color and ink on gold leaf on paper. Each, H. 63 x W. 143 in. (160 x 363.2 cm). Asia Society, New York: Mr. and Mrs. John D. Rockefeller 3rd Acquisitions Fund, 1985.1.1-2

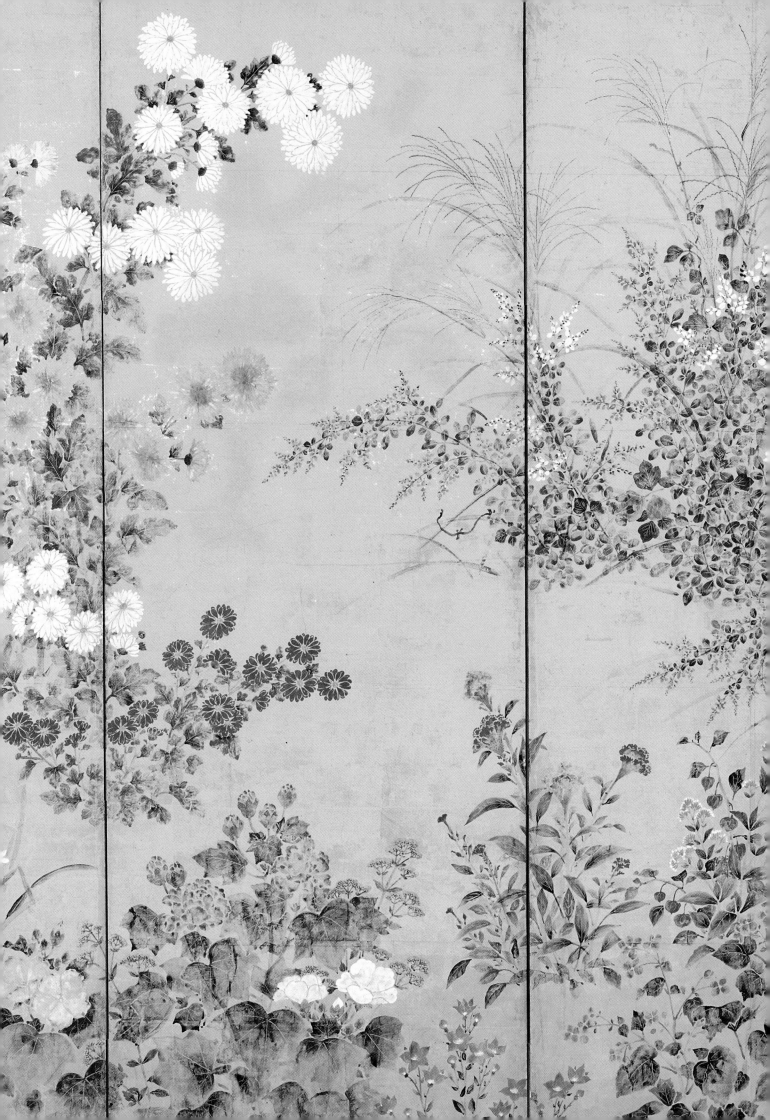

FIG. 249. Sakai Hōitsu (1761–1828). Pine and Wisteria. Edo period, dated 1810–1819. Japan. Two-panel folding screen; ink and color on gold leaf on paper. Image only, H. 60½ x W. 61¼ in. (153.7 x 155.6 cm). Asia Society, New York: Mr. and Mrs. John D. Rockefeller 3rd Collection, 1979.218

trunk and branches, and the representation of the pine needles in cloudlike clusters characterize Rinpa painting. The painterly techniques—for example, the formation of the tree trunk without contour lines and the layering of one color of wet wash into another to create textures— also typify the work of this school.

The union of pine (male) and wisteria (female) is a symbol of love in Japanese art and literature; it is possible that this screen may have been commissioned either for use at a wedding ceremony or as part of a dowry. The sixteen-petaled chrysanthemum motif that has been worked into the metal fittings along the sides of the mount

of this two-panel screen may provide a clue to the owner of this screen. The chrysanthemum was an imperial emblem during the Edo period, however, in the early nineteenth century members of the impoverished court were not active patrons of the arts. It is possible that this screen was desired by a member of the family of a feudal lord (*daimyō*) who was to marry the daughter of a court noble.

1. The inscription is translated as "Kanei [era], third year, ninth month first day. Takagamine, Taikyoan, 69 years." *Taikyoan* is one of Kōetsu's artist-names, and *Takagamine* is the name of the place where the work was created.

Four Japanese Woodblock Prints, 1790–1800

Innovative compositions, an interest in psychological states, and a fascinating interplay of social commentary, satire, and caricature characterize Japanese woodblock prints produced in the last decade of the eighteenth century. These tendencies are evident in the large number of prints produced in the "big head picture" or ōkubi-e format during this period. Concentrating on the faces and upper bodies of their subjects, big head prints present well-known actors and courtesans (as well as anonymous subjects) in an arresting and intimate fashion.

The technique of printing with blocks of wood has a long history in Japan. From the eighth through the six-teenth century, it was primarily used for the mass produc-tion of Buddhist texts and icons. By the mid-seventeenth century, books and single-sheet prints, often featuring scenes of city life based on contemporary literature, were produced to satisfy the demand of a growing and wealthy urban class for arts that reflected their interests and activities. In the teahouses, brothels, and puppet and Kabuki theaters clustered together on the outskirts of Tokyo, Kyoto, and Osaka that constituted their primary amusements, townsmen celebrated a lifestyle free from the constraints of daily life as well as those inherent in the rigid government-dictated social structure of the times. These establishments, and the actors, courtesans, and writers who inhabited them, set the trends for metropoli-tan fashions in literature, art, and clothing. The entertain-ment districts, their art and their fashions, constituted the ukiyo or "floating world," and thus woodblock prints and paintings depicting the localities, activities, and denizens of this world are known as ukiyo-e or "pictures of the floating world."

The first woodblock prints consisted of simple printed black outlines, which later began to be hand colored in shades of red and orange. By the mid-eighteenth century, fully colored prints were produced using a complicated system of multiple blocks. Although the woodblock prints often merely celebrated the actors and courtesans who were the cultural idols of their times, prints from the end of the eighteenth century, which depict a much broader range of subjects, also explored more deeply the personal-ity and psychology of these members of society, hinting at the multiple realities of their public roles and private lives.

A series of prints designed by Kitagawa Utamaro (1753–1806) in the early 1790s, *Ten Studies in Female Physiognomy* (*Fujin sogaku juttai*), exemplifies Utamaro's interest in probing beneath the surface of a subject and his use of subtle clues to create a personality for an imaginary woman who embodies a "type." For example, in the print from the series depicting *The Light-hearted Type* (**FIG. 250**), the alert, somewhat searching expression found on the face of the young woman and her apparent disregard for the state of her clothing help to define her as a fickle woman, one who is easily dissatisfied and constantly looking for new men in her life.[1] The use of the mineral mica in the background of this print further focuses attention on the personality and appearance of its subject.

Utamaro is one of the most renowned Japanese print artists, and he is particularly revered for his skillful and probing depictions of women. He was born in Musashi and studied painting in a Kanō-school atelier. He also studied with the artist Toriyama Sekien (1714–1788), who was noted for his illustrated books of humorous verse. Much of Utamaro's early works features the Kabuki theater. Around 1779, he began to illustrate various types of popular literature. He began to concentrate on beauti-ful women around 1788, at which time he also first used the signature Utamaro.

Facial features, setting, and actions also characterize the subject in a print of an unidentified young woman (**FIG. 251**) designed by Eishōsai Chōki (active about 1786–1808), who is also believed to have studied with Toriyama Sekien. Little is known about him other than that he used two different names, Chōki and Shiko, and it has been suggested that there is a link between his use of a certain style and each name. The signature on this print helps to date it to the period between 1795 and 1796, when the artist used the name Eishōsai Chōki.[2]

Gazing absentmindedly into space, the woman languorously wipes her neck with a handkerchief. Her actions and the view of a mosquito net (presumably covering a bed) to her left illustrate the contemporary ditty written in the cartouche. It tells of a woman who, dreaming of her lover, awakens in the night to find his clothing on her bed. Whether he was actually present or only a dream, her longing for him has aroused her, and she can no longer sleep. It can be translated as follows:

Awakening from a dream in which I rendezvoused
* with my lover,*
I said goodbye to him and was finally freed.
I might have thought it was he beside me, but in
* fact*
I lay beside his night robe.[3]

The immediacy in *okubi-e* style prints of famous courtesans or ideal types is further intensified in repre-sentations of Kabuki actors by the viewer's awareness

婦人相學十躰
浮気之相
相見
歌麿画

FIG. 250. Kitagawa Utamaro (1753–1806). The Light-hearted Type (*Uwaki no sō*) from the series *Ten Studies in Female Physiognomy* (*Fujin sogaku juttai*). Edo period, 1792–3. Japan. Woodblock print; ink, color, and mica on paper. H. 14⅞ x W. 9⅞ in. (37.8 x 25.1 cm). Asia Society, New York: Mr. and Mrs. John D. Rockefeller 3rd Collection, 1979.219

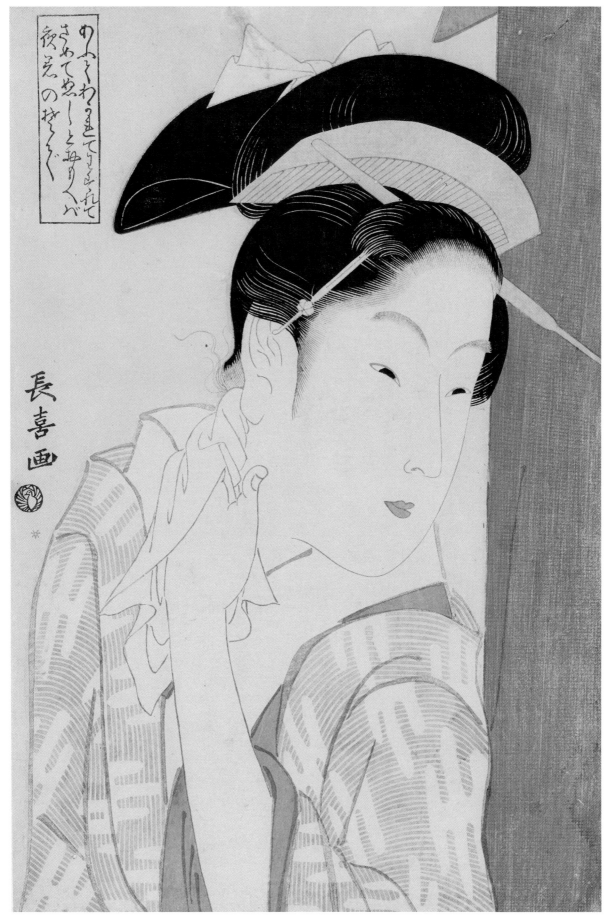

FIG. 251. Eishōsai Chōki (active about 1786–1808). Woman Wiping Her Neck. Edo period, 1795–1796. Japan. Woodblock print; ink, color, and mica on paper. H. 14¼ x W. 9¾ in. (36.2 x 24.8 cm). Asia Society, New York: Mr. and Mrs. John D. Rockefeller 3rd Collection, 1979.222

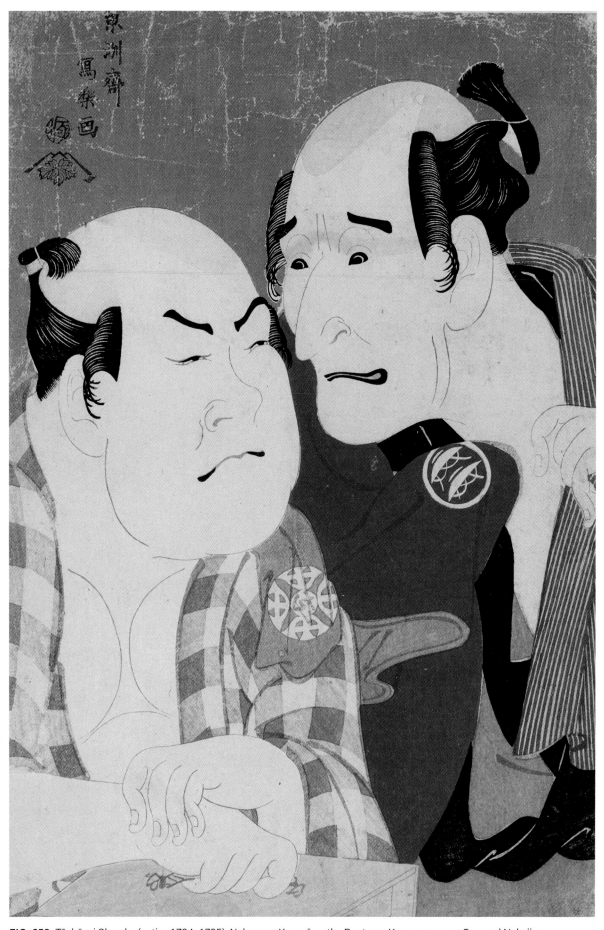

FIG. 252. Tōshūsai Sharaku (active 1794–1795). Nakamura Konozō as the Boatman Kanagawaya no Gon and Nakajima Wadaemon as "Dried Codfish" Chōzaemon. Edo period (1603–1867), 1794–1795. Japan. Woodblock print; ink, color, and mica on paper. H. 14¾ x W. 10 in. (37.5 x 25.4 cm). Asia Society, New York: Mr. and Mrs. John D. Rockefeller 3rd Collection, 1979.220

that the subject of the print is a person whose identity is known playing the role of another (actual or fictional) person. The humor and satire that permeates prints designed by the enigmatic master Tōshūsai Sharaku often derives from an understanding of this tension.

Nothing is certain about the life of Sharaku. All that is reliably known about him is that from May 1794 to the beginning of 1795 he designed and produced about 150 woodblock prints featuring various actors in scenes from contemporary Kabuki performances, creating a visual record of specific moments in the lives of well-known actors and some of the most spectacular and famous woodblock prints in Japanese art.

In one print (FIG. 252), the actors Nakajima Wadaemon and Nakamura Konozō are shown in their roles as two minor characters from a production of *A Medley of Tales of Revenge* (*Katachi-uchi Noriyaibanashi*).[4] This play was presented at the Kiriza in Edo during the 1794–95 season and was recorded by Sharaku in a series of prints. A combination of two popular Kabuki dramas, it tells the story of two sisters' revenge for the death of their father. Sharaku made several prints depicting various actors in scenes from either *The Tale of Shirashi* (*shiraishi-banashi*) section of this play or *The Iris Hair-ornament of Remembrance* (*hana shōbu omi no kanzashi*), a dance that was performed at the same time. Here, the witty comparisons between the facial expressions of the two actors and between Nakamura's bulk and Nakajima's emaciation help distinguish the men within the roles, reminding viewers that actors are real people and not ideal creatures.

Another print designed by Sharaku may provide a clue to the identity of the actor depicted in the *okubi-e* print tentatively called *An Actor, Probably Arashi Ryūzō* (FIG. 253), by Katsukawa Shun'ei (1762–1819), one of the two artists credited with the creation of the big head composition.[5] The other artist credited with this development is Katsukawa Shunchō (active 1780–95), and it is interesting that both artists were members of the Katsukawa tradition of printmaking.[6]

Both this print by Shun'ei and one by Sharaku show a balding actor with one arm bared and extended in a preemptory fashion. The figure in Sharaku's print is identified as the actor Arashi Ryūzō in his role as the moneylender Ishibe Kinkichi in the play *Hana-ayame Bunroku Soga*, a tale of revenge taken by three sons for the murder of their father. It seems likely that the unsympathetic character in this print by Shun'ei represents the same actor in the same role.

The small seal beneath Shun'ei's signature, which is also found on the prints by Sharaku and Utamaro, reads

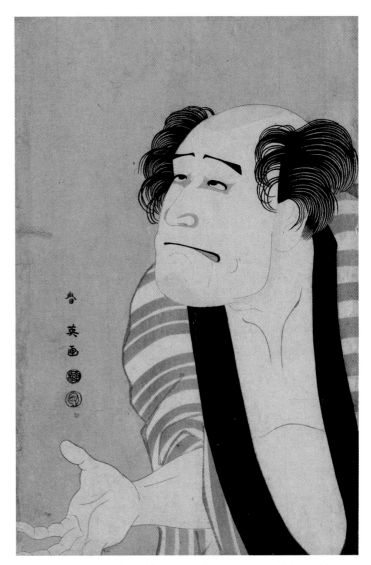

FIG. 253. Katsukawa Shun'ei (1762–1819). An Actor, Probably Arashi Ryūzō. Edo period, late 18th century–early 19th century. Japan. Woodblock print; ink and color on paper. H. 14½ x W. 9½ in. (36.8 x 24.1 cm). Asia Society, New York: Mr. and Mrs. John D. Rockefeller 3rd Collection, 1979.221

kiwame, "inspection concluded." It was the first censor's seal to be used on Japanese woodblock prints. The imposition of official censorship on woodblock prints, and the insistence that the design of every print be approved by government censors, was one of the many ways in which the Tokugawa regime sought to control the lifestyles and the increasing economic and political clout of the urban class.

The merchants and other city dwellers who patronized the floating world, and the actors, courtesans, and other entertainers whose lifestyles and activities were recorded in Japanese woodblock prints, were ranked among the lowest members of society in the traditional Confucian structure promulgated by the Tokugawa shoguns. Its ranking of merchants at the bottom of the four social classes reflected the view that merchants, who

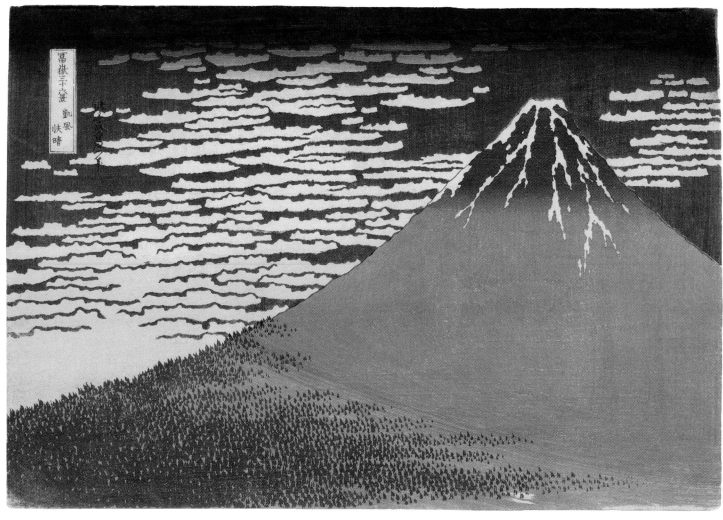

FIG. 254. Katsushika Hokusai (1760–1849). South Wind, Clear Dawn (*Gaifū kaisei*), from the series Thirty-six Views of Mount Fuji (*Fūgaku Sanjūrokkei*). Edo period, early Tempō era, ca. 1831–33. Japan. Woodblock print; ink and color on paper. H. 10 x W. 14⅞ in. (25.4 x 37.8 cm). Asia Society, New York: Asia Society Museum Collection. Purchase, 2015.12

do not produce goods but merely oversee their distribution, contribute less to society than peasants who grow food, artisans who make objects, and the ruling elite who control the government. By the same measure, the performing artists of the floating world were considered outcasts with no place in a rigid social system.

The economic and cultural power of the low-ranking merchants and performers was viewed as a threat by the Tokugawa shogunate (1617–1868), which used censorship and sumptuary laws in an attempt to control members of this group. The censorship of woodblock prints primarily attempted to control the subject matter depicted. In particular, references to recent history, to the rise to power of the Tokugawa family, or to current political events were forbidden. Woodblock prints, which glorified the lifestyles of entertainers and flaunted the growing wealth of the patrons of the floating world, were viewed suspiciously as examples of the excessive luxuriance and growing importance of the urban class, members of which were

often wealthier and better-educated than their samurai overlords. One example of this concern was the banning in 1800 of prints in the big head format because this type of composition was deemed too conspicuous, most likely owing to the scale of the big head print-subjects.

Master woodblock print designer Katsushika Hokusai (1760–1849) excelled at striking landscape compositions and was an innovator in the genre who has enjoyed world renown for over one hundred years. In *South Wind, Clear Dawn* (*Gaifū kaisei*), Hokusai captures the sacred Mt. Fuji as it takes on a red color at dawn, reflecting the rays of the rising sun **(FIG. 254)**. This second-state print is from the printmaker's famed *Thirty-six Views of Mount Fuji* series. The artist features the conical Fuji dominating the composition. Striated, horizontal white clouds appear against the bright blue sky and create a dramatic backdrop for the magnificent mountain. The print is signed *Hokusai aratame Iitsu hitsu* (from the brush of Hokusai changing to [the name] Iitsu) and was published by the great print

producer Nishimuraya Yohachi, whose shop Eijudō was located in central Edo.

1. This printed signature in the cartouche containing the name of the print and the series reads *Utamaro ga*. A *kiwame* seal and the mark for the Tsutaya Jūzaburō publishing house are also included in this cartouche.
2. The printed signature reads *Chōki ga*. The circular seal depicting a bird indicates that the print was published by Tsuruya Kihei.
3. Translation courtesy of Takeuchi Junichi.
4. The printed signature reads *Tōshūsai Sharaku ga*. A *kiwame* seal and the mark used by the publisher Tsutaya Jūzaburō are also included.
5. The printed signature reads *Shun'ei ga*. A *kiwame* seal and the mark of the publisher Tsuruya Kihei are also included in the design of the print. The small, red starlike seal impressed below the publisher's mark indicates that this print was once in the collection of Henri Vever.
6. Shun'ei, who is noted for his actor prints, was a man of diverse interests and also a noted musician. His family name was Isoda; he took the surname Katsukawa from his teacher Katsukawa Shunsho (1726–1792), who was also one of the most influential printmakers in the city of Edo in the closing decades of the eighteenth century.

Japanese Stoneware

The development of certain types of Japanese ceramics, such as Iga and Mino wares, and the use of ceramics for serving food and eating are linked to the evolution of the tea ceremony (*chanoyu*) in Japan. The drinking of powdered green tea (*matcha*) whipped with boiling water came from China to Japan at the end of the twelfth century together with the Zen sect of Buddhism and a certain complex of cultural practices, philosophical pursuits, and artistic styles. This tea was first used in Zen monasteries as an aid to meditation and as a part of formal gatherings. The drinking of this type of tea spread from Zen circles to the Japanese aristocracy, who organized formal tea ceremonies. The tea ceremonies also served as a means of displaying the host's treasures, which at first were primarily Chinese in origin and included refined ceramics as well as paintings, lacquers, and other objects. Over time, as the tea ceremony was redefined under the guidance of different tea masters, new tastes emerged, and everyday Korean ceramics, as well as stoneware produced in Japanese kilns, began to be appreciated for their unpolished charms and were used in the tea ceremony. By the sixteenth century, Japanese ceramics were in great demand for use in both the tea ceremony and the *kaiseki* meal that was served before the more formal type of tea ceremonies. In Japan, wood and lacquer had traditionally been used for dining, and the use of ceramics for the *kaiseki* meal and during the tea ceremony helped to spur their use in homes.

A squarish jar **(FIG. 255)** produced at the Iga kilns illustrates the type of vessel that is used as a fresh water container (*mizusashi*) during the tea ceremony. Water stored in this container is used for replenishing the tea kettle and cleaning the tea bowls. The shape of this jar is unusual among Iga fresh water containers, which are generally round. An unevenly applied glaze was fired green in some places on the jar and brown or black in others; two lattice-patterned rectangles were impressed on two of the sides prior to the application of the glaze. The glazed cover on this jar may not be original—the colors of the glaze do not match those found on the body, and jars of this type generally had black lacquer lids.

Fresh water jars and flower vases were among the two most common products of the Iga kilns, and both were produced primarily for use in the tea ceremony. The Iga kilns were located in Mie Prefecture. Kilns were probably established there in the sixteenth century, possibly under the patronage of Tsutsui Sadatsugu, who ruled the area from 1585 to 1608. Iga wares continued the tradition of stoneware begun at the Seto kilns during the Kamakura period (1185–1333). They are also closely related to the Shigaraki wares that were produced in nearby Shiga Prefecture and that were also used in the tea ceremony.

The influential tea master Sen no Rikyū (1521–1591), who was noted for his understated tea ceremonies (known as *wabicha*), is often credited with the introduction of Iga wares to the tea ceremony. Iga wares are also closely affiliated with the style of tea ceremony favored by Furuta Oribe (1544–1615), a pupil of Rikyū's who developed a more energetic, expressive, and individualistic style of tea. In his tea diary, Oribe, who is often credited with the experimentation in shapes and forms that mark Japanese tea wares in the late sixteenth and early seventeenth centuries, states that he used fresh water containers and flowers pots from Iga. Since the earliest Iga wares were not glazed, the use of glaze on this piece helps to date it to the early seventeenth century.

Until the sixteenth century, only two centers, Seto in Aichi Prefecture and Mino in Gifu Prefecture, produced glazed ceramics, and the complicated and not completely understood relationship between these two regions is crucial to the development of Japanese ceramics. Equally important was the introduction in the late fifteenth century, probably from Korea, of a new and larger type of kiln that facilitated the production of the high-fired, glazed stoneware characteristic of Japanese sixteenth- and early-seventeenth-century ceramics. Production in Mino began in the fifteenth century, probably owing to the influence of technology from the nearby Seto kilns. The close relationship between the two regions is reflected in the names "Black Seto" and "Yellow Seto" used to classify

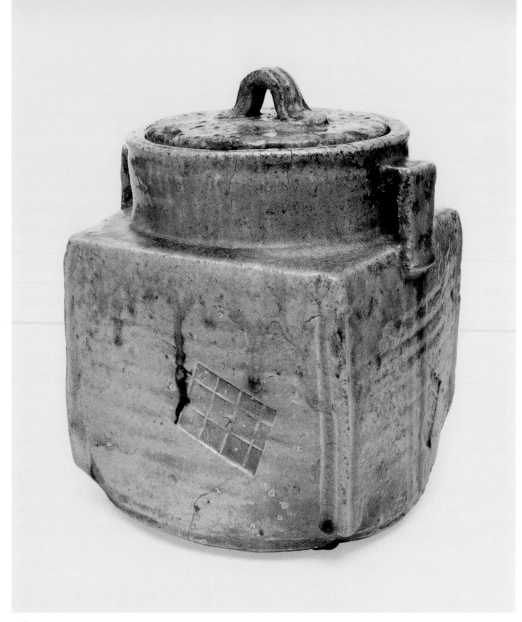

FIG. 255. Water Jar for Tea Ceremony. Momoyama to Edo period, late 16th–early 17th century. Japan, Mie Prefecture. Stoneware with impressed design under glaze (Iga ware). H. 9½ including cover x L. 7¼ x W. 7¼ in. (24.1 x 18.4 x 18.4 cm). Asia Society, New York: Mr. and Mrs. John D. Rockefeller 3rd Collection, 1979.224a,b

glazed wares produced in Mino. Excavations indicate that by the sixteenth century the Mino kilns—which were centered around the modern cities of Tajimi, Toki, and Mizunami—were more influential than those at Seto: over seventy kilns have been discovered in the Mino area in comparison to the twenty-one found at Seto. The fourth quarter of the sixteenth century, a major period of experimentation at the Mino kilns, saw the development of new glazes, forms, and types of wares.

The combination of underglaze painting and a thick, milky white glaze used in the manufacture of a square dish **(FIG. 256)** is typical of the Shino wares produced at the Mino kilns. This dish, which may have been used to serve food during a *kaiseki* meal, has a rough stoneware body and thick, pitted white glaze. The color of this glaze is derived from feldspar, while its opacity is the result of deliberate underfiring. This glaze was perfected around

1585—the height of production for Shino wares—and the finest examples of this type of ceramic date from between 1570 and 1600. Sketchy paintings of half wheels, bamboo and grasses, and flowing lines have been painted under the glaze of this dish with an iron-brown pigment. Shino wares with this type of decoration are often classified as "Decorated" or "Painted Shino" (*e-shino*). The rounded, scalloped corners of this dish are also typical of Shino wares.

The center for the production of Shino wares was Toki, one of the cities with Mino kilns. The use of the term *Shino* to describe these wares is said to derive from their purported association with Shino Sōshin (1440–1552), the founder of the Shino school of incense connoisseurship who was active in court society during the rule of Ashikaga Yoshimasa. Although this term is commonly used today, it is not found in Japanese writings on either ceramics or the tea ceremony until about 1700, and study of the early history of

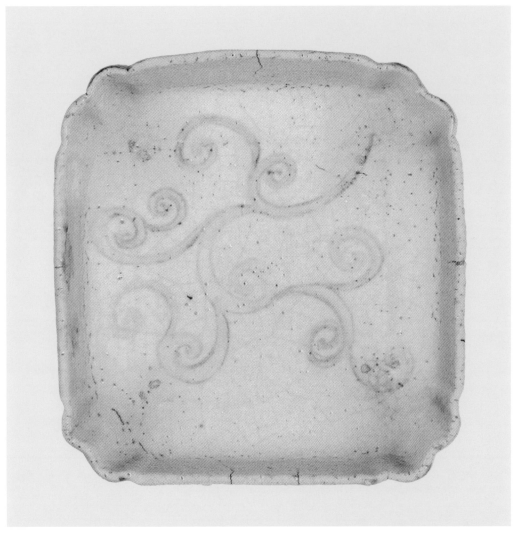

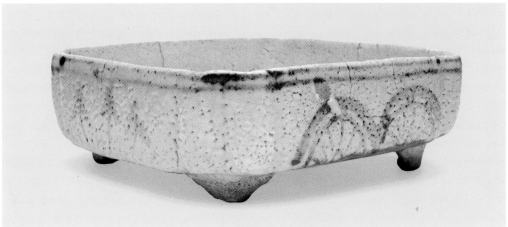

FIG. 256. Square Serving Dish (interior and exterior). Momoyama period, late 16th century. Japan, Gifu Prefecture. Stoneware painted with underglaze iron brown (Mino ware, Shino type). H. 3 x L. 8¾ x W. 8½ in. (7.6 x 22.2 x 21.6 cm). Asia Society, New York: Mr. and Mrs. John D. Rockefeller 3rd Collection, 1979.225

the Mino kilns continues to address the confusing terminology used for some of the earliest products of these kilns.

The development of Oribe wares is another example of the experimentation at the Mino kilns in the late sixteenth and early seventeenth centuries. Oribe wares are named after the influential tea master Furuta Oribe because their

bold, often distorted shapes and powerful decoration are believed to illustrate his taste and the style of his tea ceremony. Recent excavations suggest that production of the famous Oribe wares was centered in a group of seven kilns located in the villages of Kujiri, Ohira, and Ogaya. An additional Oribe kiln has also been discovered in Tsumagi,

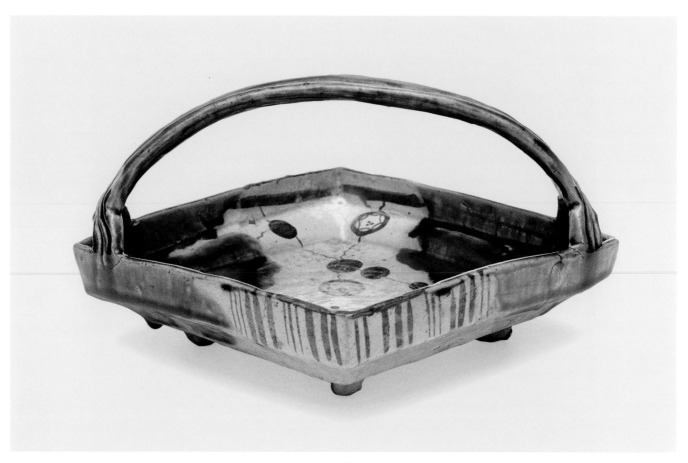

FIG. 257. Square Serving Dish with Bail Handle. Momoyama period, late 16th century. Japan, Gifu Prefecture. Stoneware painted with iron brown on slip under glaze and a partial overlay of copper-green glaze (Mino ware, Oribe type). H. 5½ including handle x W. 8⅛ x D. 8⅛ in. (14 x 20.4 x 20.4 cm). Asia Society, New York: Mr. and Mrs. John D. Rockefeller 3rd Collection, 1979.226

which unlike the other three villages is located to the south of the Toki River. Production of Oribe ware began around 1590 and is believed to have lasted until about 1635.

A square serving dish with a bail-shaped handle (**FIG. 257**), which was most likely used to serve grilled fish, illustrates the style of decoration that is most closely associated with Oribe wares. This type of Oribe ware is often classified as Green Oribe (*ao-oribe*) because of the use of a bright copper-green glaze, which is used here to coat the handle and two of the four corners. The color of the rest of the dish comes from a slip. Interconnected circles, some of which contain patterns, vertical lines, and bamboo shoots, have been painted over the ivory slip in an iron-brown pigment, and then covered with a transparent glaze.

The different areas and colors of glazes and the geometric and naturalistic designs painted on this dish reflect the impact of the textile industry on Mino wares. In particular, this style of decoration derives from the *tsujigahana* textiles that were popular in Japan in the sixteenth and seventeenth centuries. Bold contrasts between brightly dyed areas and lighter parts with hand-painted designs in black ink are the hallmark of

tsujigahana. The close similarities between the designs of Oribe wares and *tsujigahana* textiles have led to the widespread speculation that some of the artists who worked painting the designs on textiles may also have painted Oribe wares. In addition, this type of decoration has an added charm in a serving dish, as it allows the design to appear as each person helps himself or herself to the food.

The decoration on a pleasing sake bottle (**FIG. 258**) also belongs to the Green Oribe type. The neck and shoulder of the bottle are covered with the classic green glaze, often called Oribe green. The body of the bottle was coated with an ivory slip, and autumn grasses were painted over this slip in iron brown. A clear glaze covers the entire piece. The motif of autumn grasses is important in Japanese literature and the visual arts as a symbol for the transitoriness of all aspects of life. Although most of the designs found on Oribe wares generally do not carry symbolic meaning, the use of autumn grasses to decorate a sake bottle is suggestive of the season when new sake is first available for drinking. The likelihood that a bottle such as this one (there are many examples) could have been used during a *kaiseki* meal is increased by the fact that the combination of

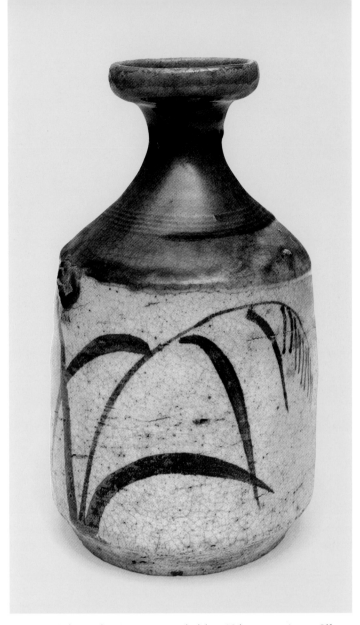

FIG. 258. Sake Bottle. Momoyama period, late 16th century. Japan, Gifu Prefecture. Stoneware painted with iron brown on slip with an overlay of copper-green glaze under glaze (Mino ware, Oribe type). H. 7 x Diam. 3¾ in. (17.8 x 9.5 cm). Asia Society, New York: Mr. and Mrs. John D. Rockefeller 3rd Collection, 1979.227

design and function is at the heart of the tea ceremony's emphasis on the appreciation of a particular moment.

The representation of a scholar riding on a donkey that is incised under the glaze in a small food dish with a foliate rim (FIG. 259) may also have had resonances appropriate to the ambiance of a tea ceremony. However, some Oribe wares were produced on the wheel in large quantities and this dish is most likely of this type and would have been part of a set used for everyday tableware. It is typical of the *Sō Oribe* (allover Oribe) style, in which the pieces are completely covered by green glaze. In early-seventeenth-century Japan, high-fired ceramics like these were still luxury items and likely created for and used by members of the elite. Chinese literature is replete with tales of famous and not-so-famous scholars riding

away on donkeys, often to seek the solitude necessary for a contemplative life. In addition to the central donkey and rider image, motifs such as bamboo shoots, waves, and circles with flowerlike designs are incised under the glaze. Dishes of this type were produced at the Myodo kilns in the Mino region to have been used as sets rather than as individual serving pieces.

Two tall, narrow dishes known as *mukōzuke* (FIG. 260) were placed at the back of the serving tray and used for serving eel and certain other side dishes during the *kaiseki* meal because their shapes hid the tasty but unsightly treats. These small dishes are examples of Karatsu ware, the ceramic produced near the city of Karatsu on the southern island of Kyūshū. Karatsu wares have a refined stoneware body and a thin gray glaze. Pieces such as

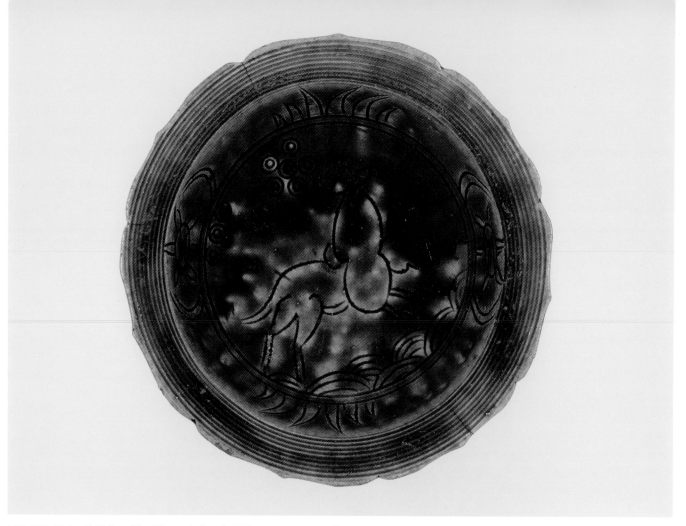

FIG. 259. Dish with Foliate Rim. Edo period, early 17th century. Japan, Gifu Prefecture. Stoneware wtih incised and combed design under copper-green glaze (Mino ware, Oribe type). H. 2 x Diam. 6¾ in. (5 x 17.1 cm). Asia Society, New York: Mr. and Mrs. John D. Rockefeller 3rd Collection, 1979.228

FIG. 260. Two Mukōzuke Dishes. Momoyama to Edo period, late 16th–early 17th century. Japan, Saga and Nagasaki Prefectures. Stoneware painted with underglaze iron brown (Karatsu ware). Each, H. 4¼ x W. 2¼ x D. 2¼ in. (10.8 x 5.7 x 5.7 cm). Asia Society, New York: Mr. and Mrs. John D. Rockefeller 3rd Collection, 1979.229.1-2

these two dishes that are painted with an iron-brown pigment are classified as "Decorated" or "Painted Karatsu" (*e-garatsu*). Bamboo is painted on the front of one of these dishes; water plantain decorates the other. Both have a pattern of overlapping triangles painted on the top part of their backs, a design commonly found on Mino wares, which may reflect the impact of Mino wares on the decoration of those produced in Karatsu. It is sometimes interpreted as an image of textiles drying on a rack, providing another possible link between the textile industry and Mino wares.

The Karatsu kilns were established around the middle of the sixth century, probably by Lord Hata, the provincial ruler of Karatsu who had established strong trade contacts with Korea. It was in Karatsu where a many-chambered climbing kiln and a kick-wheel were first used in Japan; these innovations reflect the impact of advanced Korean technology on Japanese ceramics. Oribe wares were also fired in the more sophisticated kiln, while Shino wares were made in the traditional single-chambered kiln that had long been used in Japan. The new technology is believed to have played a seminal role in the development of the Japanese porcelain industry at Arita in the seventeenth century.

Japanese Porcelains

The rapid development and diversification of the Japanese porcelain industry in the seventeenth century is one of the most fascinating episodes in the history of ceramics. During this period, the city of Arita, located in Saga Prefecture in Hizen Province on the southern island of Kyūshū, became the largest and most important center for the production of porcelain in the world.

Several factors contributed to this development. One was the contributions of the many technically advanced potters brought to Japan from Korea during the late-sixteenth-century Japanese invasions of that country. Another was the prohibitive effects of the civil disarray in seventeenth-century China on its ceramic industry, which led Europeans and other customers in search of highly prized porcelains to turn to Japan. Japanese porcelains then dominated the European market until the mid-eighteenth century, when the official kilns at Jingdezhen in China resumed their major role in trade with the West. Nonetheless, Japanese porcelains continued to influence the decoration of European ceramics, and even now, many patterns on western porcelain can be traced to motifs and styles developed in Japan in the second half of the seventeenth century.

Many questions remain regarding the development of porcelain in Japan. Traditionally, the discovery of the type of clay needed to produce porcelains has been credited to a potter named Ri Sampei, who was one of the Korean artisans brought to Japan. Production of porcelains began around 1610 in the Karatsu stoneware kilns located just to the north of Arita. Karatsu wares also reflected the influence of other Korean advances, such as the use of certain types of kilns and kick-wheels for throwing.

The first Japanese porcelains, which were painted with underglaze cobalt blue, are known as "old blue-and-white" (*ko-sometsuke*). They were often made with a poor-quality clay, and their decoration was sketchy. Blue-and-white wares produced between 1620 and 1630 are generally more elegantly painted with such themes as landscapes and birds and flowers. By about 1640, overglaze enamels or a combination of overglaze enamels and underglaze blue were also used to decorate porcelains. It is generally accepted that overglaze enamels were introduced to Kyūshū from Kyoto rather than from China. One reason for this assumption is the use of a vibrant overglaze blue in both Kyoto ware and Japanese porcelains. This color is not found in Chinese ceramics of that period.

During the second half of the seventeenth century, more than twelve kilns were active around Arita. Many of the porcelains made in the Arita kilns were painted in the enamelers' quarters (*aka-e-machi*), which were founded between 1661 and 1672. Enamels must be fired at a lower temperature than the porcelain body or the glaze, and it is reasonable to assume that glazed porcelain bodies produced at many kilns in Arita were sent to this quarter for painting before refiring.

Japanese porcelains have traditionally been classified in several interrelated categories based on the type and style of their decoration. Porcelains painted with underglaze cobalt blue have been called Arita wares to distinguish them from those decorated with overglaze enamels. Pieces painted with overglaze enamels have been divided into Imari, Kakiemon, and Nabeshima wares; these distinctions are based on the colors used in painting them, the paintings' compositions, and, to a certain extent, the quality of their bodies. Imari wares are named for the port in Kyūshū from which the porcelains were shipped, while Kakiemon wares are named after Sakaida Kakiemon (active mid- to late seventeenth century), the artisan who was once thought to have originated their style of decoration. Nabeshima wares are the distinctive porcelains that were produced exclusively for the Nabeshima lords, who ruled Hizen Province. Finally, Japanese porcelains include a group of wares classified as Kutani wares, which have a

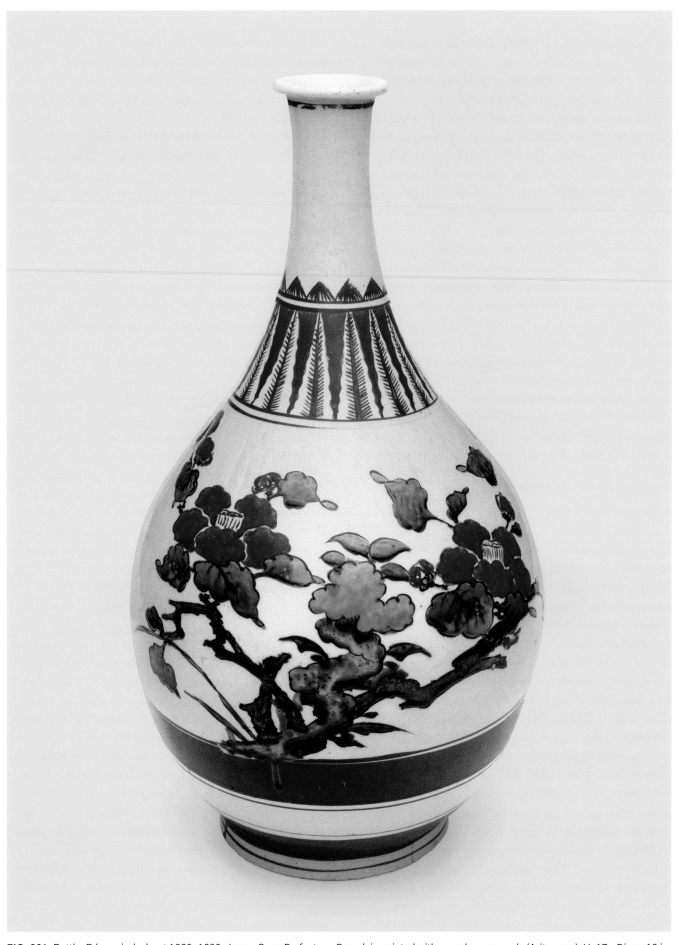

FIG. 261. Bottle. Edo period, about 1660–1680. Japan, Saga Prefecture. Porcelain painted with overglaze enamels (Arita ware). H. 17 x Diam. 10 in. (43.2 x 25.4 cm). Asia Society, New York: Mr. and Mrs. John D. Rockefeller 3rd Collection, 1979.244

relationship to the ceramics produced at Arita—a connection that remains an important research topic. These wares are named for the village of Kutani in Ishikawa Prefecture on the island of Honshu, where they were once thought to have been produced.

The use of many of these terms is under revision. For a number of reasons, it has long been known that there are many examples of Japanese porcelain with overglaze enamel painting that do not conform exactly to the style of either Imari or Kakiemon ware; and the discovery of the enamelers' quarters and the excavation of many kiln sites in Arita indicate that at least in some instances the so-called Kakiemon and Imari wares were produced at the same kiln or painted in the same workshop. The existence of porcelain painted in underglaze blue in the so-called Kakiemon style makes the restricted use of the term *Arita wares* for all blue-and-white porcelains a misnomer. Finally, the unresolved status of production sites for porcelain painted in the Kutani style raises several questions about the evolution of overglaze enamel decoration on mid-seventeenth-century porcelain and the development of later styles of painting. As a result, some Japanese scholars have suggested that the majority of Japanese porcelains be classified as Arita wares based on the location of their production, with no distinction according to the methods or styles of their decoration.

In order to exploit some useful differences indicated by the traditional classifications as well as incorporating ideas in the current literature informed by new discoveries, terms such as *Kakiemon style* and *Imari style* are provisionally used here, primarily to help distinguish between styles of decoration in wares produced at Arita. It should also be pointed out that seventeenth- and early-eighteenth-century porcelains like those discussed in this essay are often called "Old Imari" (*ko-imari*) or "Old Kakiemon" (*ko-kakiemon*) to distinguish them from nineteenth- and twentieth-century works painted in the same style.

A large wine bottle **(FIG. 261)** and a gourd-shaped bottle **(FIG. 262)** that was probably also used for wine typify the early enameled wares produced at Arita. Both pieces can be dated to around 1660 to 1680. They are fairly thickly potted and are painted with lively compositions that are carefully placed to flow across their surfaces. The camellia flowers that encircle the body of the wine bottle are painted in a deep shade of red, the leaves are painted in yellow and green, the branches are purple, and the rock at the base of the bush is bright blue. The leaflike decoration on the neck of this bottle and the two horizontal bands at its base are also in red.

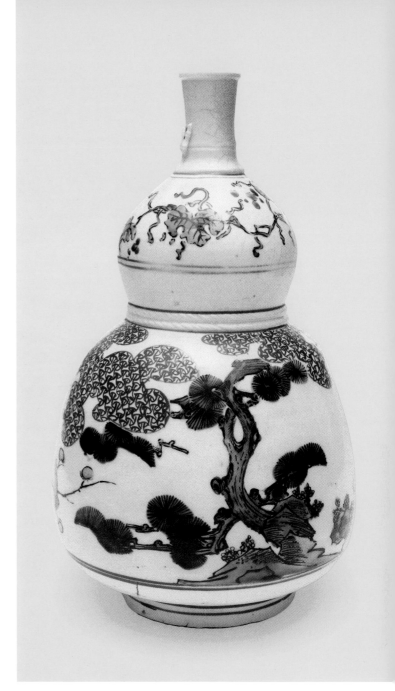

FIG. 262. Gourd-Shaped Bottle. Edo period, about 1660–1680. Japan, Saga Prefecture. Porcelain painted with overglaze enamels (Arita ware). H. 10⅜ x Diam. 5¾ in. (26.4 x 14.6 cm). Asia Society, New York: Mr. and Mrs. John D. Rockefeller 3rd Collection, 1979.243

The gourd-shaped bottle is painted with the same colors. The leaves on the shoulder are yellow and green, the densely packed needles of the pine tree on the body of the jar are dark green, the buds of the plum tree are yellow, and the cloudlike forms decorated with a basket weave-like pattern are red. As is often true of early enameled wares from Arita, the shapes are outlined using a fairly thick black enamel.

An octagonal jar painted with underglaze cobalt blue **(FIG. 263)** and another with underglaze cobalt blue and overglaze enamels **(FIG. 264)** indicate the diversity found in Japanese porcelains. The large size of both jars

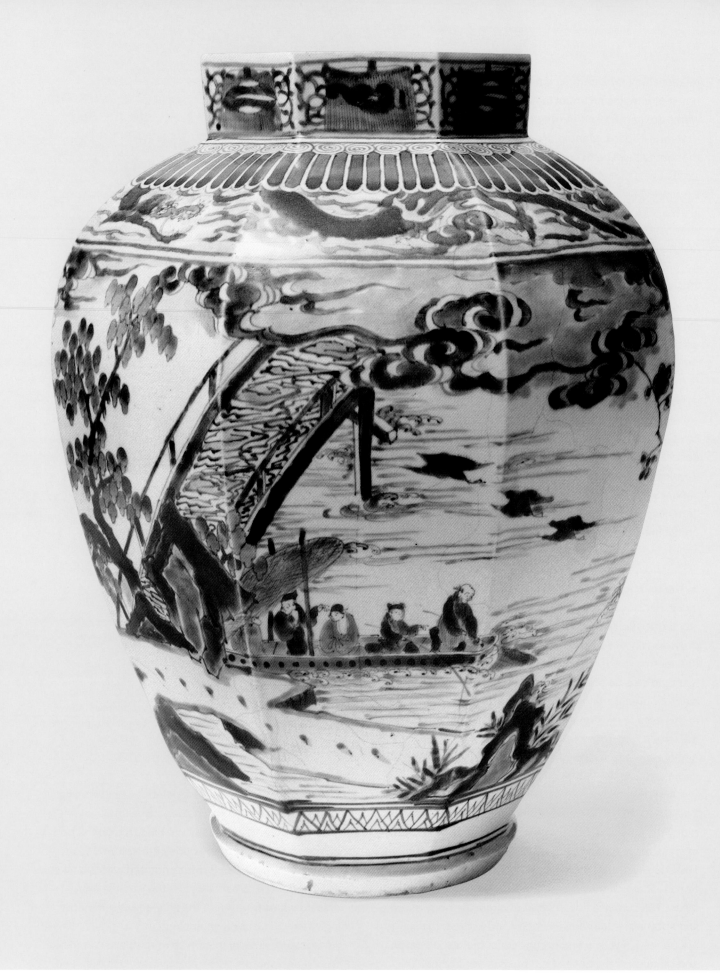

FIG. 263. Octagonal Jar. Edo period, late 17th century. Japan, Saga Prefecture. Porcelain painted with underglaze cobalt blue (Arita ware). H. 20⅛ x W. 15½ in. (51.1 x 39.4 cm). Asia Society, New York: Mr. and Mrs. John D. Rockefeller 3rd Collection, 1979.230

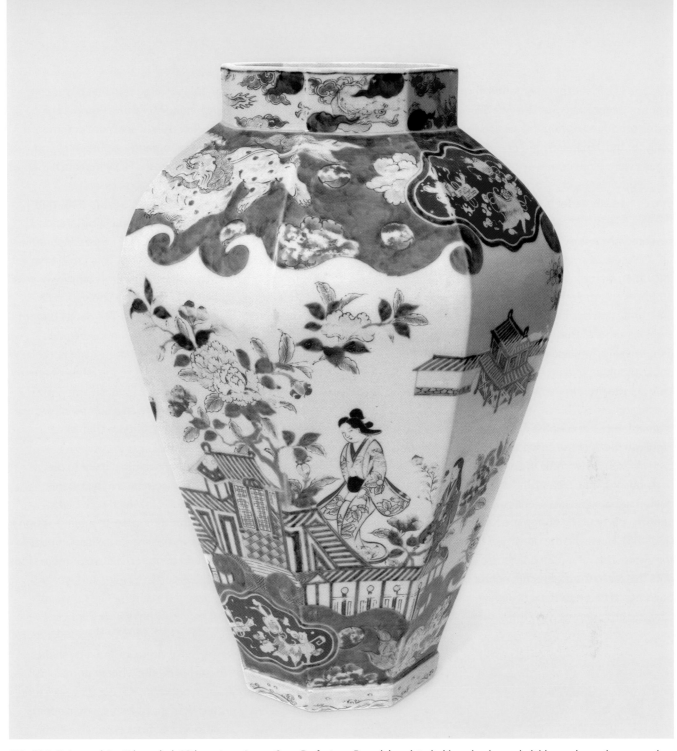

FIG. 264. Octagonal Jar. Edo period, 18th century. Japan, Saga Prefecture. Porcelain painted with underglaze cobalt blue and overglaze enamels, with traces of gold (Arita ware, Imari style). H. 17⅝ x W. 12⅜ in. (44.8 x 31.4 cm). Asia Society, New York: Mr. and Mrs. John D. Rockefeller 3rd Collection, 1979.231

suggests that they were made for export. In each example, the painting is carefully composed to cover the surface of the vessel.

The body of the jar painted only with underglaze cobalt blue **(FIG. 263)** is encircled by a spring landscape; the season is indicated by a blossoming plum tree. Two groups of boaters, consisting of scholar-gentlemen and their attendants, enjoy the balmy weather. The seasonal atmosphere in the painting is enhanced by flying waterfowl and a sense of lushness and verdancy. The eight

stylized images depicted on the neck of the jar represent the eight Buddhist treasures. Stylized flower petals and images of dragons flying through clouds decorate the shoulder of this jar, and triangular patterns fill a narrow band on the base.

Images of scholar-gentlemen play an important role in Chinese art and literature, and landscape themes became popular motifs on Chinese porcelains during the second half of the seventeenth century. Known as the Transitional period in Chinese ceramic history, this era

was one of great experimentation in vessel shapes and types of decoration. Some of the Chinese blue-and-white wares produced during this period were created especially for the Japanese market. Although the Chinese pieces were often commissioned for use in the Japanese tea ceremony, the style of decoration found on those pieces had a broader impact, influencing works such as this large jar, which was most likely made in the late seventeenth century in a Chinese style for export to Europe.

On the body of the jar painted with overglaze enamels (**FIG. 264**), beautifully attired women are depicted walking around a country retreat. A combination of fantastic creatures, flowers, clouds, and cartouches filled with the eight symbols of Buddhism—parasol, canopy, lotus, vase, fish, sea slug, endless knot, and wheel—decorate the neck, shoulder, and area at the base of this jar. Red and blue are the predominant colors used in the painting, and touches of yellow, black, and pink are also present. Gold pigment, most of which has rubbed off, was used to highlight parts of the composition. The hairstyles and type of clothing worn by the women indicate that they are high-ranking courtesans and attendants and reflect customs that were prevalent in Japan in the seventeenth century, particularly during the Kanbun and Genroku eras (1661–88). However, the density of the composition and the complexity of motifs on the neck and shoulder help to date this jar to the eighteenth century. The style of the buildings is characteristic of Japanese representations of Chinese architecture, and the somewhat narrative quality

of the composition on this jar suggests that the scene may be derived from Chinese literature. Parodies of Chinese and Japanese literature were more common in woodblock prints in the seventeenth, eighteenth, and nineteenth centuries, and it seems likely that such themes could have influenced other art forms as well.

A ceramic pillow in the shape of a drum (**FIG. 265**) provides an example of Japanese porcelains intended primarily for domestic consumption. The use of ceramic pillows has a long history in East Asia. This drum-shaped pillow is decorated with white cherry blossoms in reserve against a red background, and gold has been used to highlight the chrysanthemum borders. The dense patterning and the use of dark color in the painting help to classify this pillow as an example of Imari-style porcelain; the structured composition dates it to the late eighteenth or early nineteenth century. At this time, sleeping with the neck resting on such a pillow was a common practice to help preserve the elaborate hairstyles that were so fashionable.

Several factors generally have been used to distinguish Kakiemon-style wares from Imari-style wares: Kakiemon has a lighter palette, in which pale blues, greens, yellows, and reds predominate; the compositions of the paintings are sparser; the motifs in the compositions are more isolated and centered on two or more sides of a vessel rather than covering the entire surface; and the quality of the clay and glaze differs. The bodies of Imari-style porcelains generally have a very light but noticeable blue-gray tinge. The bodies of most Kakiemon-style wares are a warm, milky white, called *nigoshide*, and these are considered to be the whitest porcelains produced in East Asia. In addition, Kakiemon wares tend to be more finely potted than Imari wares, and it seems likely that they were among the most expensive items produced in Arita.

Only one of the twelve kilns known to have been active around Arita is identified with the production of the *nigoshide* body of many Kakiemon-style wares. This kiln, located on the northeast side of the Nangawara Valley, is sometimes identified as the Kakiemon kiln. Evidence from its excavation suggests that it did not begin production until about 1670 or 1680, substantially later than most of the many kilns active in the Arita region. However, a few examples of the *nigoshide* body have been found at other sites, such as an earlier kiln at Otaru, and it is now thought that this body must also have been developed prior to the founding of the Kakiemon kiln.

A large covered bowl (**FIG. 266**) and a wine bottle (**FIG. 267**) are characteristic of Kakiemon-style wares

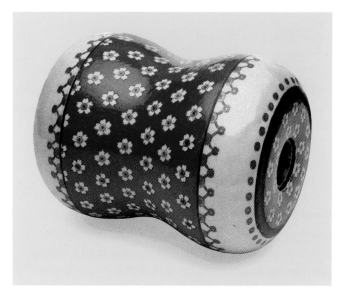

FIG. 265. Drum-Shaped Pillow. Edo period, late 18th–early 19th century. Japan, Saga Prefecture. Porcelain painted with overglaze enamels and gold (Arita ware, Imari style). W. 8¼ x Diam. 6½ in. (21 x 16.5 cm). Asia Society, New York: Mr. and Mrs. John D. Rockefeller 3rd Collection, 1979.233

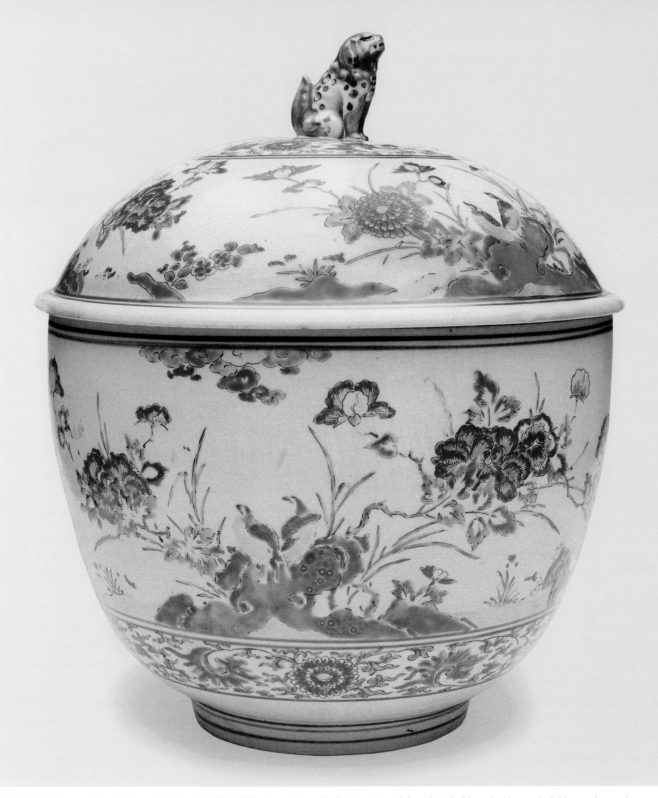

FIG. 266. Covered Bowl. Edo period, about 1670–1690. Japan, Saga Prefecture. Porcelain painted with underglaze cobalt blue and overglaze enamels (Arita ware, Kakiemon style). H. 14⅜ including cover x Diam. 12 in. (36.5 x 30.5 cm). Asia Society, New York: Mr. and Mrs. John D. Rockefeller 3rd Collection, 1979.234a,b

produced from about 1670 to 1690. Two compositions are painted on the body of the bowl. In one, two birds are shown sitting on a gnarly rock in front of a flowering chrysanthemum. The variation on the other side has a peony. The same motifs are repeated on the cover. Bands at the top of the cover and the base of the bowl are filled with a luxuriant, brocadelike floral arabesque. The knob

of the cover is in the form of a lion-dog. The translucence of the pale blue, green, yellow, and red enamels contributes to the delicacy of the painting.

A similar scene in essentially the same palette is painted over three-quarters of the body of the large wine bottle. In this instance, two birds are perched on a rock before a flowering chrysanthemum. The fantastic rocks

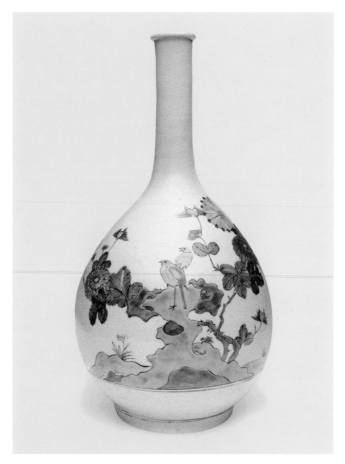

FIG. 267. Bottle. Edo period, about 1670–1690. Japan, Saga Prefecture. Porcelain painted with overglaze enamels (Arita ware, Kakiemon style). H. 15⅞ x Diam. 8½ in. (30.3 x 21.6 cm). Asia Society, New York: Mr. and Mrs. John D. Rockefeller 3rd Collection, 1979.235

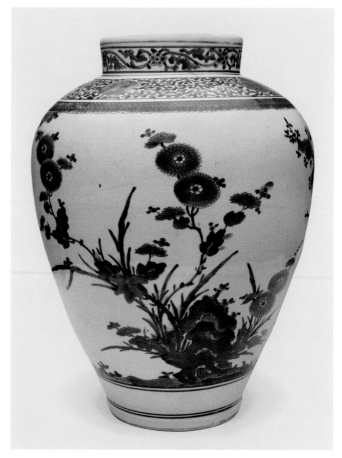

FIG. 268. Storage Jar. Edo period, 1670–1690. Japan, Saga Prefecture. Porcelain painted with underglaze cobalt blue (Arita ware, Kakiemon style). H. 18½ x Diam. 14¾ in. (47 x 37.5 cm). Asia Society, New York: Mr. and Mrs. John D. Rockefeller 3rd Collection, 1979.232

on both pieces are probably intended to represent Taihu rocks, which are found near Lake Tai in China and are often used in Chinese garden designs and depicted in Chinese art. On both the bowl and the bottle, the birds are rather awkwardly painted and have very full chests, a type that appears frequently in the decoration of Kakiemon-style wares. The disproportionately large flowering plants are also a hallmark of this style.

The same characteristics are evident in the decoration of a large storage jar painted in underglaze blue **(FIG. 268)**, which is an example of blue-and-white ware painted in the Kakiemon style. As is typical of this style, two compositions are painted on the jar. In one, two Kakiemon-type birds on a rock are set against a large flowering plum tree. The other composition consists of a large chrysanthemum and a Taihu rock. Different degrees of density are found in the underglaze blue used to paint these compositions, which also show the same interest in empty space found in the better-known Kakiemon-style porcelains that are painted with overglaze enamels. The bands of scrolling flowers on the neck and shoulder of this storage jar are

similar to those found on the cover and base of the covered bowl. The scenes painted on this storage jar, the covered bowl, and the wine bottle all have a ground line.

A deep bowl with the Chinese motif of the Three Friends of Winter **(FIG. 269)** can also be dated to the late seventeenth century. Pine, bamboo, and plum symbolize the integrity of the scholar-gentleman and the arrival of spring. In this depiction of the theme, the plants are placed in a circular composition in the interior of the bowl and are accompanied by birds. A stylized peony arabesque encircles the exterior.

Two clusters comprising a brushwood fence, a Taihu rock, and large flowering plants (including a bamboo and a camellia) with a tiger between them are placed on the sides of the interior of a deep Kaikiemon-style bowl **(FIG. 270)** that dates to the period between 1670 and 1690. A snarling dragon circles the bottom of the interior, and two peony sprays are painted on the exterior. After its arrival in the West, European collectors embellished this bowl with elaborate mounts. This exemplifies how European collectors showed their esteem for East Asian

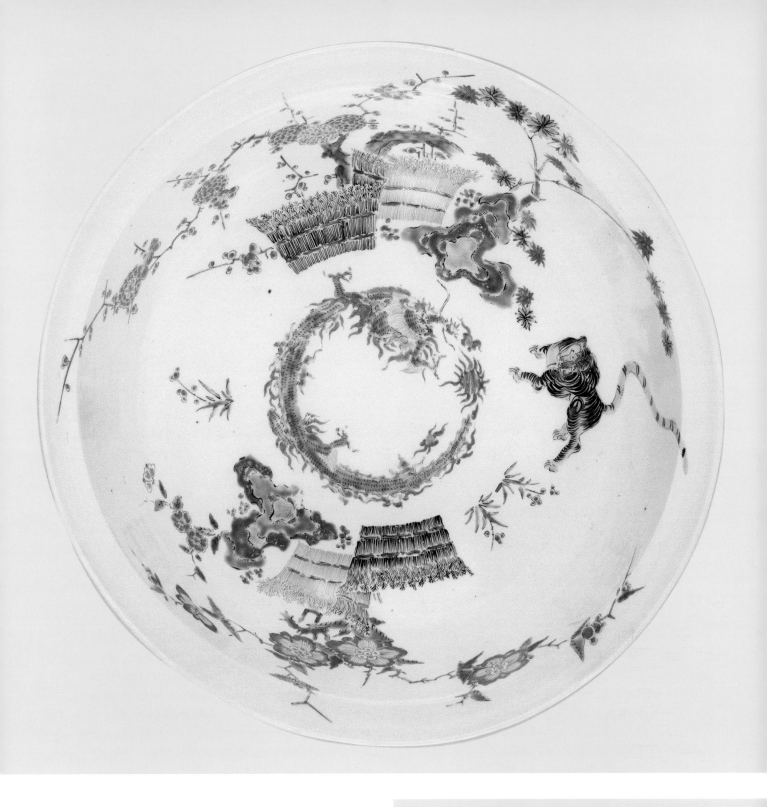

Above and right: **FIG. 269.** Bowl. Edo period, about 1670–1690. Japan, Saga Prefecture. Porcelain painted with overglaze enamels, with traces of gold (Arita ware, Kakiemon style). H. 5½ x Diam. 13¾ in. (14 x 34.9 cm). Asia Society, New York: Mr. and Mrs. John D. Rockefeller 3rd Collection, 1979.236

Above and below: **FIG. 270.** Bowl. Edo period, about 1670–1690. Japan, Saga Prefecture. Porcelain painted with overglaze enamels, with traces of gold (Arita ware, Kakiemon style); with 18th-century gilt copper alloy mounts. H. 5½ x Diam. 12⅞ in. (14 x 32.7 cm). Asia Society, New York: Mr. and Mrs. John D. Rockefeller 3rd Collection, 1979.237

than ten thousand examples of Asian and Meissen porcelain collected by Augustus II (the Strong), King of Poland and Elector of Saxony (reigned 1694–1733). Another rectangular mark, often found on Kakiemon wares in his collection, is also incised into the base. Inventories of the collection indicate that Kakiemon wares, which were often mislabeled as Chinese, were among his favorite ceramics. Not surprisingly, copies of Kakiemon wares were some of the first ceramics produced at the Meissen factories in Saxony that Augustus II founded. At some point in the eighteenth century, gilt bronze mounts were made, probably in Germany, for the display of this bowl. One covers the rim, while the other, which consists of the heads and abstracted legs of three satyrs, supports the bowl. Mounts of this type were often used in Europe to show off Chinese and Japanese porcelains.

A pair of seventeenth-century covered hexagonal jars **(FIG. 271)** exemplifies some of the problems inherent in the use of the term *Kakiemon*. In western scholarship, jars such as these are often called "Hampton Court jars," because their shape is the same as that of two famous jars known to have been in the collection of Queen Mary

porcelains by literally putting them on a pedestal. Kakiemon wares, other Japanese porcelains, and Chinese porcelains are often displayed in the "porcelain rooms" of the European nobility.

Incised into the glaze on the base of this bowl is the mark *N. 116*, which indicates that it was one of the more

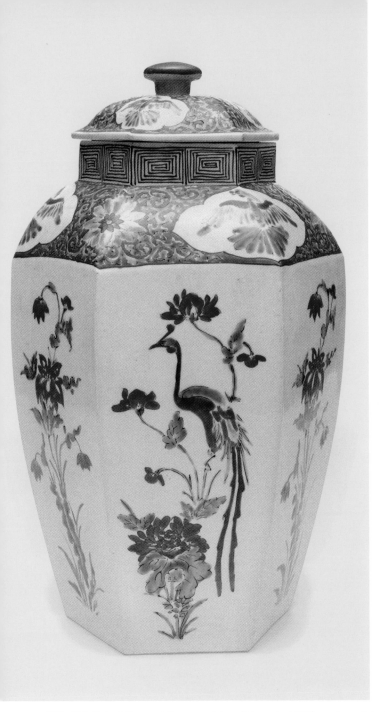

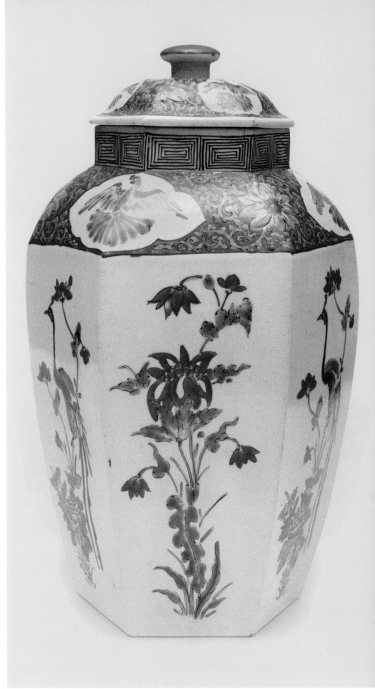

FIG. 271. Pair of Covered Hexagonal Jars. Edo period, 17th century. Japan, Saga Prefecture. Porcelain painted with overglaze enamels (Arita ware). Each, H. 12½ with cover x W. 7½ in. (31.8 x 18.4 cm). Asia Society, New York: Estate of Blanchette Hooker Rockefeller, 1993.6.1a,b-2a,b

(reigned 1689–94) at Hampton Court. The two in the Collection are painted with alternating designs of floral sprays and phoenixes on flowering branches. The translucency of the enamels, the large amount of unpainted space in the composition of each side panel, and the dense floral arabesque used in the decoration of the covers are comparable to those in the decoration on Kakiemon wares.

However, two features are different. One is the use of a brown overglaze enamel, which does not appear in the paintings on the majority of Kaikiemon-style porcelains; another is the body of these jars, which is darker than the milky-white body of most Kaikiemon wares. It seems likely that such jars were made by ceramists and enamelers

who were contemporaries of the Kaikiemon artists and who may have been competitors.

Sculptures of many kinds of figures painted with overglaze enamels in both the Kakiemon- and Imari-style palettes were produced in the seventeenth and eighteenth centuries. Two standing women **(FIGS. 272 AND 273)** and a seated woman **(FIG. 274)**, all dating to the late seventeenth century, represent a popular type of Kakiemon-style sculpture, many examples of which are found in European collections. They are representations of the beautiful woman (*bijin*) theme that was a staple of Japanese *ukiyo-e* paintings and woodblock prints. All three women wear clothing and a hairstyle popular in Japan during the

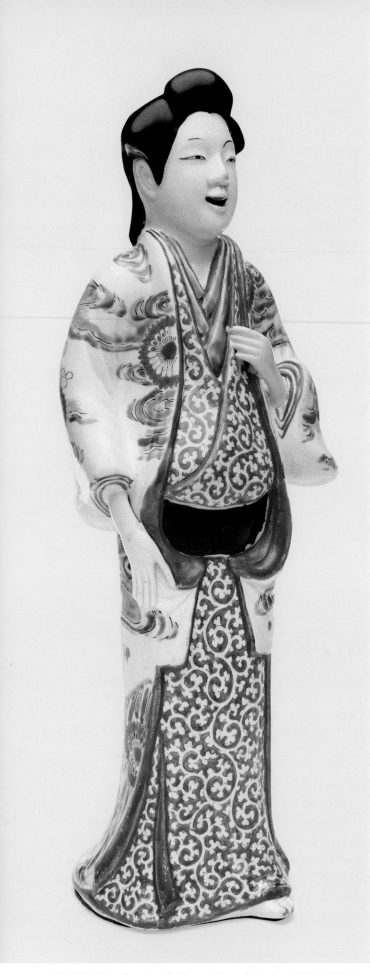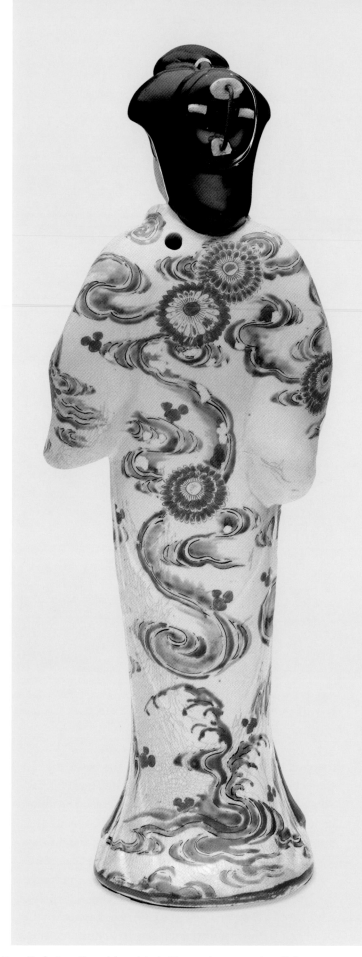

FIG. 272. Standing Female Figure. Edo period, about 1670–1690. Japan, Saga Prefecture. Porcelain painted with overglaze enamels, with traces of gold (Arita ware, Kakiemon style). H. 15½ x W. 6 x D. 5 in. (39.4 x 15.2 x 12.7 cm). Asia Society, New York: Mr. and Mrs. John D. Rockefeller 3rd Collection, 1979.239

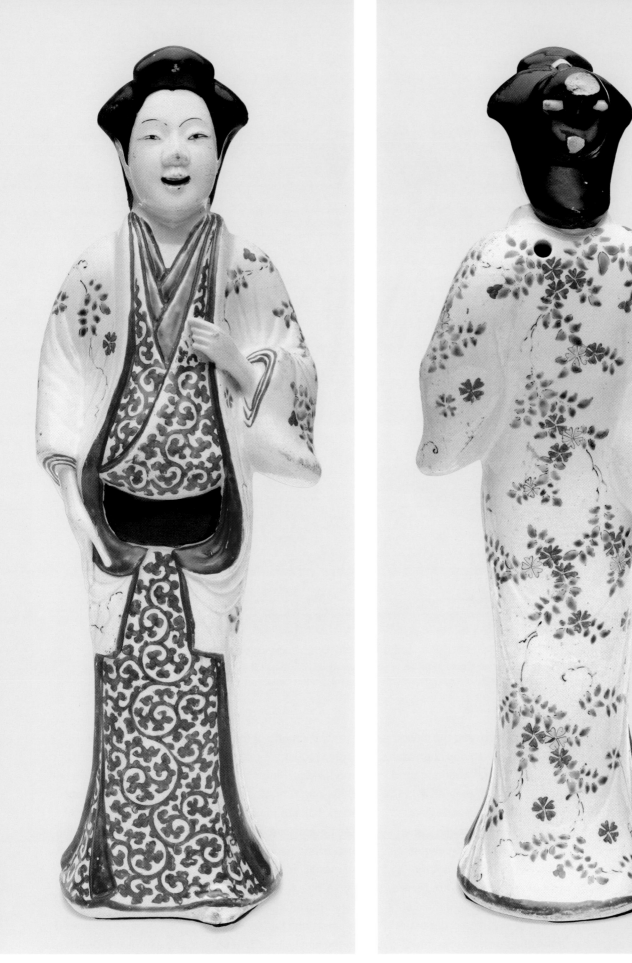

FIG. 273. Standing Female Figure. Edo period, about 1670–1690. Japan, Saga Prefecture. Porcelain painted with overglaze enamels (Arita ware, Kakiemon style). H. 15½ x W. 6 x D. 5 in. (39.4 x 15.2 x 12.1 cm). Asia Society, New York: Mr. and Mrs. John D. Rockefeller 3rd Collection, 1979.240

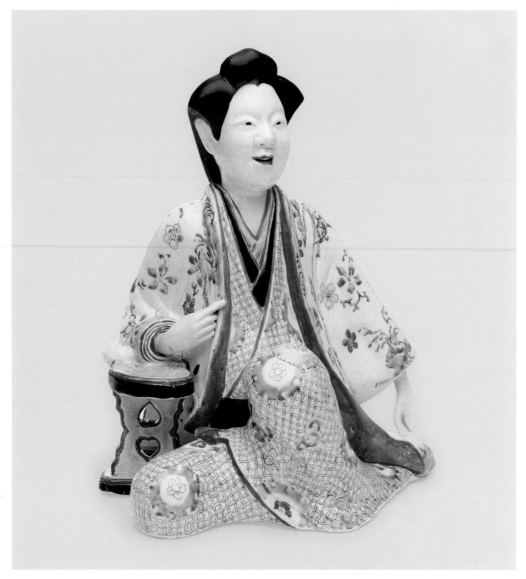

FIG. 274. Seated Female Figure. Edo period, about 1670–1690. Japan, Saga Prefecture. Porcelain painted with overglaze enamels, with traces of gold (Arita ware, Kakiemon style). H. 10½ x W. 9 x D. 9 in. (26.7 x 22.86 x 22.86 cm). Asia Society, New York: Mr. and Mrs. John D. Rockefeller 3rd Collection, 1979.241

Kanbun era (1661–73), when this coiffure and the loose outer robe and black sash were popular among courtesans. The hairstyle, with the hair pulled up and wound around an ornamental pin, is believed to have originated at court.

Both of the standing women wear red-and-white inner kimonos that are decorated with a scrolling vine motif, commonly called *karakusa* or Tang arabesque because it is believed to derive from eighth-century Chinese traditions. On one figure the background is red and the arabesque is white, while on the other the colors are reversed. The outer coat of one woman is decorated with wisteria while that of the other woman is painted with chrysanthemums that have fallen on swirling waves. With the exception of the designs on their clothing, these two figures appear to be identical.

The kimono of the seated woman is decorated with a red lattice pattern on which are multicolored floral medallions. Plums and floral wheels are painted on her outer garment. Seated women such as this are much rarer than standing figures. The bodies of all three of the figures were produced using press molds, and the heads and hands were slip cast for greater delicacy of modeling.

Molds that could have been used to produce such beautiful female figures, as well as some of the many animals and fantastic creatures made, were excavated in the late twentieth century in the enamelers' quarters at Arita. It has been suggested that unlike other Japanese porcelains, these sculptures could have been both molded and painted in this area.

A family of mandarin ducks **(FIG. 275)** represents another popular type of molded ceramic figurine. The drake and duckling are painted in shades of red, green, blue, and yellow, while the hen is a dark brown. Although these three sculptures have no function, it has been suggested that the appearance at Arita of porcelain ducks might be linked to the Kyoto tradition of making incense boxes in the shapes of ducks and other birds. Another possible source is the mandarin ducks that were often used as a symbol of marital happiness—a theme with Chinese prototypes—in Japanese art.

Two lion-dogs **(FIG. 276)** are painted in a bravura manner in shades of blue, yellow, red, and green. Lion-dogs of this type (*koma-inu*) are generally used as guardians at the entrances of Shinto shrines and Buddhist temples, and the pairing of two such creatures, one's mouth open and the other's closed, was most likely imported to Japan from China. The earliest extant sculptures of this theme date from the Heian period and are made of wood. Ceramic versions are known to have been used since at least the thirteenth century. One such pair is known to have been presented to a local shrine in Arita in 1692, and examples, some of which are embellished with astonishing gilt mounts, are in European collections. Beautiful women, ducks, and lion-dogs were exported to Europe as exotic examples of the art of Japan, and it is unlikely that their imagery was well understood there. This is particularly true in the sculptures of women, which were often identified as men in early western publications on Japanese porcelains.

The only products of the Arita kilns that were made exclusively for use in Japan are Nabeshima wares, which were made primarily as presentation pieces. Noted for producing dishes and plates in three basic sizes and in matched sets of twenty or thirty, the Nabeshima kiln was a private concern, established and patronized by the Nabeshima family.

Little is known about the early history of the Nabeshima kiln. Recent excavations have questioned the longstanding belief that the first Nabeshima kiln, which is said to have produced blue-and-white wares, was constructed at Iwayagawachi in 1628. Questions have also been raised regarding the belief that a second kiln operated in the Nangawara Valley from 1654 to 1674. The only kiln firmly associated with the production of Nabeshima wares was located at Okawachi; it is believed to have begun operation around 1675 and to have been most active in the late seventeenth and early eighteenth centuries.

One small dish in the Collection **(FIG. 277)** has a design of flowering cherry trees with two curtains painted

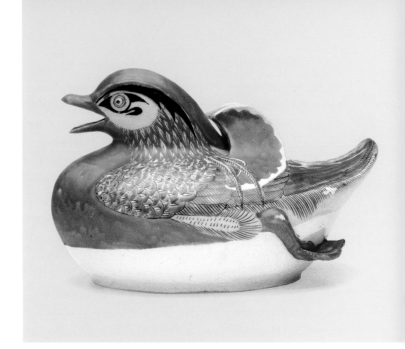

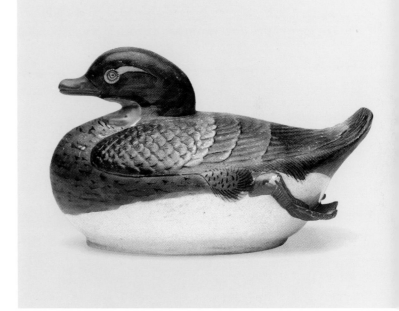

FIG. 275. Three Mandarin Ducks. Edo period, late 17th–early 18th century. Japan, Saga Prefecture. Porcelain painted with overglaze enamels, the hen with glaze and brown enamel on biscuit (Arita ware, Kakiemon style). Drake, H. 4½ x L. 7⅝ x W. 4½ in. (11.4 x 19.4 x 11.4 cm); Hen, H. 4¼ x L. 7¼ x W. 4¼ in. (10.8 x 18.4 x 10.8 cm); Duckling, H. 2¾ x L. 4¾ x W. 2¾ in. (7 x 12.1 x 7 cm). Asia Society, New York: Mr. and Mrs. John D. Rockefeller 3rd Collection, 1979.242.1-3

in underglaze blue with bands of brown and green glaze. The combination of the brown and green glazes attests to the technical proficiency of the Nabeshima ceramists, for these colors have different melting points and therefore require separate firings. The flowering cherry trees and festive curtains decorating the dish are motifs that were also used in contemporary textile designs. This theme may refer to the custom of temporarily erecting curtains at blossom-viewing picnics to give some privacy to those eating and drinking beneath the cherry trees. The slight irregularities in the shape of the dish and the fact that the iron-brown and green glazes run over the edge onto the exterior in some areas suggest that this is an early example of Nabeshima ware. The use of a broad wash technique, known as *damizome*, for the underglaze blue pigment also indicates an earlier period of production. The form of this dish, which has a raised foot and rounded

profile, is derived from the form of traditional lacquered food bowls, and is a standard Nabeshima shape.

The perfectly regular body of a dish decorated with dandelions **(FIG. 278)** suggests that it dates to the late seventeenth or early eighteenth century. Unlike other Japanese porcelains, whose decoration was painted freehand, the designs on Nabeshima wares were applied with carefully controlled, inked transfer patterns. In this technique, designs that appear to have been drawn on the ceramic were inked and applied to its body, leaving behind a faint outline. This outline was then traced in cobalt blue and the ceramic was dipped into a transparent glaze and fired at a high temperature. Enamels were used to paint details—such as the orange-red dandelions and multicolored leaves on this dish—over the glaze, and the piece was refired. This laborious method is based on the *doucai* technique developed in China during the

FIG. 276. Two Lion-Dogs. Edo period, late 17th century. Japan, Saga Prefecture. Porcelain painted with overglaze enamels (Arita ware, Kakiemon style). Each, H. 11⅝ x L. 10¾ x W. 5¾ in. (29.5 x 27.3 x 14.6 cm). Asia Society, New York: Mr. and Mrs. John D. Rockefeller 3rd Collection, 1979.238.1-2

FIG. 277. Dish. Edo period, 17th century. Japan, Saga Prefecture. Porcelain painted with underglaze cobalt blue with iron-brown and green glazes (Arita ware, Nabeshima type). H. 1⅝ x Diam. 7¾ in. (4.1 x 19.7 cm). Asia Society, New York: Mr. and Mrs. John D. Rockefeller 3rd Collection, 1979.248

fifteenth century. It was not used for the painting of other porcelains from Arita, probably because such a painstaking method was not appropriate for the production of large quantities of ceramics for domestic use or export. Dandelions have no known cultural or literary association in Japan, and similarly the charming flowers on this dish and two small dishes, one with a design of fern and rhododendron leaves and the other decorated with waves and water plants, are typical of the interest of Nabeshima artists in humble images such as weeds and vegetables **(FIGS. 279 AND 280)**.

A dish that is delicately painted on the interior with two pomegranate branches **(FIG. 281)** is an example of larger-size Nabeshima wares. The composition is fairly spare and spacious. The comb pattern on the foot and the coins with ribbons on the exterior are painted in underglaze blue; they are typical motifs for the exteriors of Nabeshima porcelains.

The relationship between Japanese porcelains that have been classified as Kutani wares and certain porcelains made at Arita is one of the most interesting issues in the history of Japanese ceramics. Kutani-style porcelains

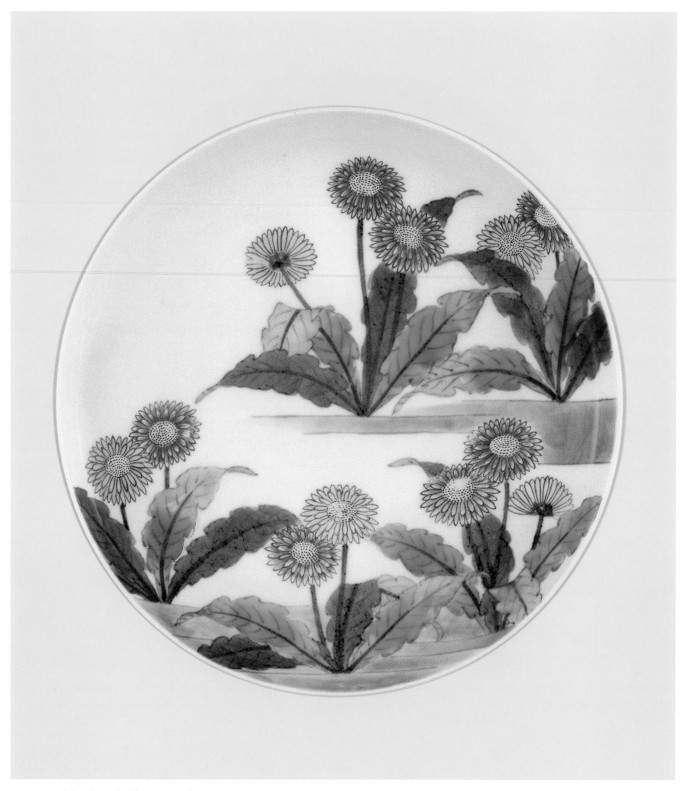

FIG. 278. Dish. Edo period (1603–1867), late 17th–early 18th century. Japan, Saga Prefecture. Porcelain painted with underglaze cobalt blue and overglaze enamels (Arita ware, Nabeshima type). H. 2 x Diam. 7⅞ in. (5.1 x 20 cm). Asia Society, New York: Mr. and Mrs. John D. Rockefeller 3rd Collection, 1979.249

Opposite top: **FIG. 279.** Dish with Design of Waves and Water Plants. Edo period (1603–1867), early 18th century. Japan, Saga Prefecture. Porcelain painted with underglaze cobalt and overglaze enamels (Arita ware, Nabeshima type). H. 1⅝ x Diam. 5¾ in. (4.1 x 14.6 cm). Asia Society, New York: Gift of Richard Oldenburg in honor of Mrs. Blanchette Hooker Rockefeller, 2015.11

Opposite bottom: **FIG. 280.** Dish with Design of Fern and Rhododendron Leaves. Edo period (1603–1867), early 18th century. Japan, Saga Prefecture. Porcelain painted with underglaze cobalt and overglaze enamels (Arita ware, Nabeshima type). H. 1½ x Diam. 5³⁄₁₆ in. (3.8 x 13.2 cm). Asia Society, New York: Gift of Richard Oldenburg in honor of Mrs. Blanchette Hooker Rockefeller, 2015.10

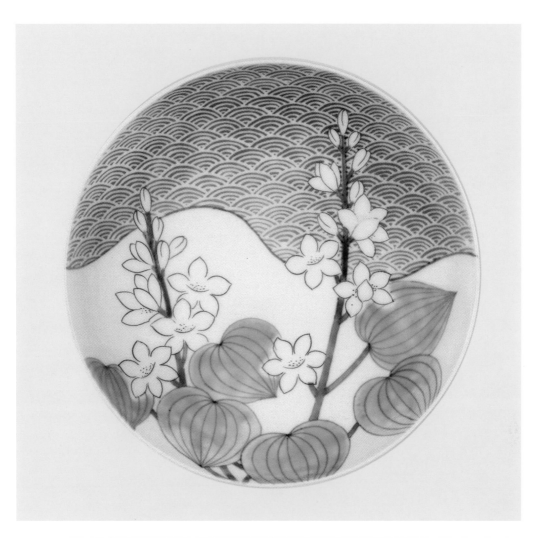

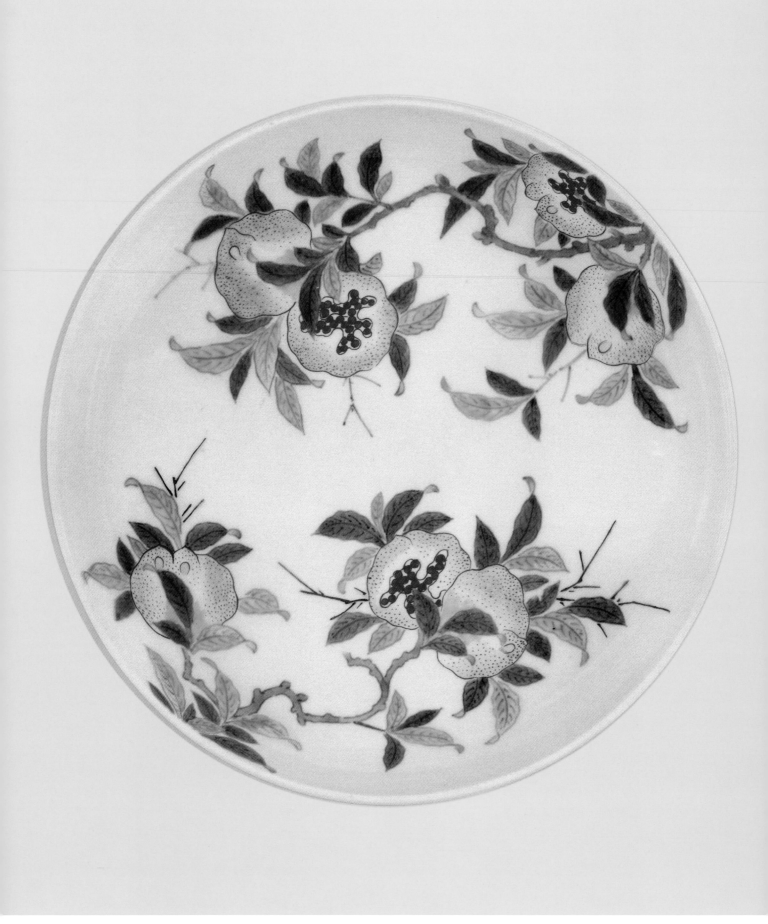

FIG. 281. Dish. Edo period, late 17th–early 18th century. Japan, Saga Prefecture. Porcelain painted with underglaze cobalt blue and overglaze enamels (Arita ware, Nabeshima type). H. 3⅜ x Diam. 11⅜ in. (8.6 x 28.9 cm). Asia Society, New York: Mr. and Mrs. John D. Rockefeller 3rd Collection, 1979.250

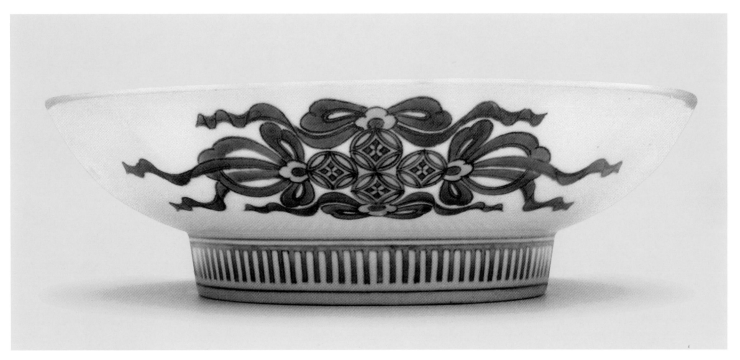

Alternate view of **FIG. 281.**

are characterized by their distinctive palette that combines deep shades of blue-black, green, purple, and yellow to create bold designs that often cover the entire surface of a piece. Archaeological excavations at Kutani and in the area around Arita have raised several questions regarding the relationship between the so-called Kutani wares and early Japanese porcelains with Imari-style decoration. Excavations in 1970, 1971, and 1974 of kilns in Kutani Village suggest that sometime around 1655 to 1658 these kilns were producing green-glazed stoneware (often called celadons), blue-and-white wares, and wares with a distinctive brown or black glaze known in Japan as *tenmoku*. There is little evidence, though, that these kilns produced the type of wares that are called "Old Kutani" (*ko-kutani*) in current literature.

There is a certain amount of evidence to suggest that Kutani-style wares were produced in Arita. The bodies of Kutani-style wares are similar to those of Arita porcelains, and it has been speculated that the bodies may have been produced in Arita and then sent to Kutani for overglaze painting. The palette and type of decoration of the earliest Arita porcelains with overglaze decoration are strikingly similar to those found on mid-seventeenth-century ceramics that were at one point classified as Kutani wares—for example, the gourd-shaped bottle discussed earlier in this essay **(FIG. 262)**—making it difficult to distinguish the early examples of the so-called Kutani style from other early enameled wares. Moreover, excavations in Arita have provided evidence of the production of Kutani-style wares in that province. Shards of dishes

with the dark blue-black glaze that is characteristic of the Kutani style have been excavated at the Yambita kiln site in Arita. There is some evidence that the Maruo kiln in Arita, which is known to have exported green-glazed wares to Southeast Asia, may have produced Green Kutani-style porcelains during the mid- to late seventeenth century.

Two footed dishes and a shallow bowl illustrate the style of decoration found on "Green Kutani" (*ao-kutani*) wares, characterized not only by their color but also by the density of their designs. The center of one of the footed dishes **(FIG. 282)** is decorated with two blades of grass and a green leaf set against a yellow background filled completely with black clusters of radiating pine needles. Wavelike patterns set against a dark green background decorate the interior of the rim. The exterior is painted with designs in black on bands of yellow and dark green. Purple, pink, and blue chrysanthemums with yellow and green leaves decorate the center of the second footed dish **(FIG. 283)**, while the interior of the rim is divided into bands of alternating colors over which waves and needles have been painted in black enamel. Pine needles painted in black against a green background decorate the exterior of the base, and there are leaves painted in black and blue enamel on the exterior of the cavetto.

The decoration of the interior of the shallow bowl **(FIG. 284)** consists of a complicated checkerboard pattern of designs encircled by a field of pine needles. Wavelike patterns are painted in brown enamel against a yellow background on the exterior. The character for "good

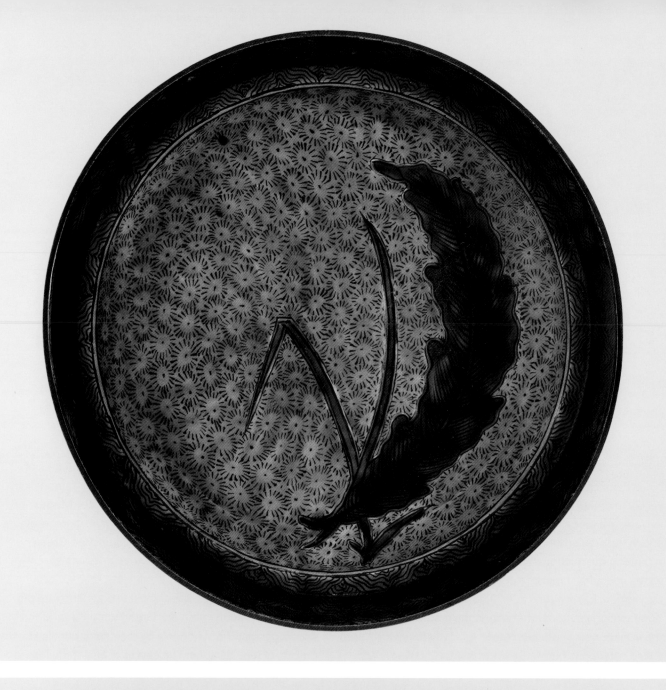

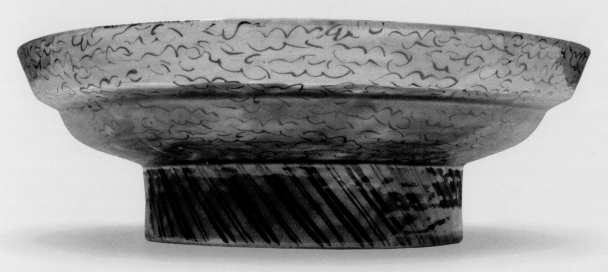

FIG. 282. Footed Dish (interior and exterior). Edo period, mid- to late 17th century. Japan, Saga Prefecture. Porcelain painted with overglaze enamels (Arita ware, Kutani style). H. 4 x Diam. 12¼ in. (10.2 x 31.1 cm). Asia Society, New York: Mr. and Mrs. John D. Rockefeller 3rd Collection, 1979.245

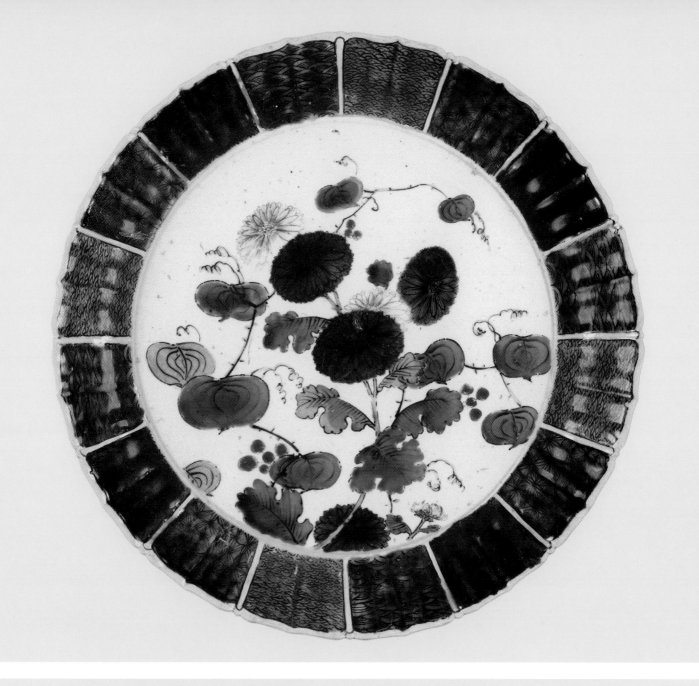

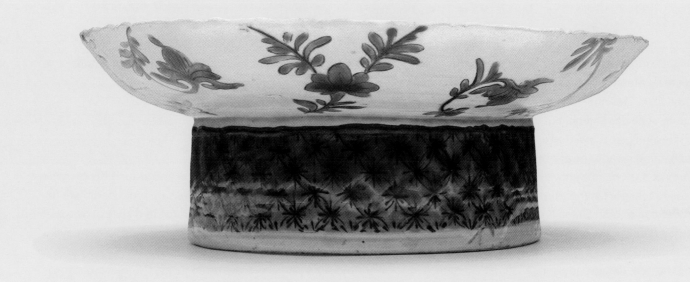

FIG. 283. Footed Dish (interior and exterior). Edo period, mid- to late 17th century. Japan, Saga Prefecture. Porcelain painted wtih overglaze enamels (Arita ware, Kutani style). H. 4 x Diam. 11½ in. (10.2 x 29.2 cm). Asia Society, New York: Mr. and Mrs. John D. Rockefeller 3rd Collection, 1979.246

FIG. 284. Shallow Bowl. Edo period, late 17th–early 18th century. Japan, Saga Prefecture. Porcelain painted with overglaze enamels (Arita ware, Kutani style). H. 2¾ x Diam. 13¼ in. (7 x 33.7 cm). Asia Society, New York: Mr. and Mrs. John D. Rockefeller 3rd Collection, 1979.247

wishes" or "happiness" (*fuku*) is written in black enamel against a green rectangular background on the underside of the dish. This character often appears on wares with Kutani-style decoration, but the reason remains unclear.

Several pieces painted in the Green Kutani style have been found in Indonesia, and it has been suggested that wares of this type may have been made specifically for trade to that part of the world. This could explain the production of both Green Kutani-style pieces and green-glazed wares at the Maruo kiln, as each type would have been produced for a specific market. The bold shapes and the rich, dense patterning that mark ceramics decorated in the Green Kutani style have also been linked to the taste reflected in the screens and textiles produced during the Momoyama period in Japan, raising the

possibility that a domestic market for Green Kutani-style wares also existed.

Two Kyoto Potters

A ceramic industry developed in and around Kyoto in the sixteenth century, and the stoneware produced there for the domestic market differ in shape and style of decoration from the better-known contemporaneous porcelains from Arita made primarily for export. Both Kyoto wares and Arita porcelains are often painted with overglaze enamel pigments. This technique appeared in both places around 1640, and its use continues to be a hallmark of the Kyoto pottery tradition. Unlike the anonymous artisans

who made Arita porcelains, many of the potters working in Kyoto, such as Nonomura Ninsei and Ogata Kenzan, played important roles in the culture of the city and were renowned as artists during and after their lifetimes.

Nonomura Ninsei (active ca. 1646–77) was born Tsuboya Seiemon in Tamba, a province noted for its production of rugged utilitarian wares. Very little is known about his life. He arrived in Kyoto around 1647 and probably already either had important connections or some fame as he was permitted to establish a kiln, called Omuro, near the south gate of Ninnaji, an important Buddhist temple. He took the artist-name Ninsei around 1566; the first syllable of this name derives from that of the temple. Ninsei had close ties to Kawamori Sowa (1585–1656), one of the most renowned tea masters of the time, and Ninsei's ceramics, called Omuro wares, played an important role in Sowa's tea ceremonies and other cultural gatherings. Ninsei's works are thought to embody the concept of *kirei* or "refined beauty" favored by Sowa.

The shape of a storage jar used for tea leaves **(FIG. 285)** illustrates Ninsei's ability to make refinements to well-known forms. The jar is taller and narrower than most storage jars of this type, and the shape of the shoulder and four small lugs of this jar reflect those of much smaller tea caddies used to store powdered tea during the tea ceremony. This innovative shape is one of the most famous designed by Ninsei, and only ten or so examples are extant, the majority in Japan. Most have individual names, a measure of the esteem in which they are held. Used to store tea leaves that have been gathered in the spring, these jars would have been opened during a special ceremony in November when new tea leaves were used for the first time.

This jar is made of a reddish stoneware that has been partially covered with a milky white glaze filled with minute crazing. A seal reading *Ninsei* is impressed into the unglazed base. Overglaze enamels were used to paint the seven mynah birds, bamboo, and rocks on the jar. One mynah bird sits on the ground while the other six fly above. The birds appear to be quarreling, and their placement over the entire surface of the jar singly and in groups creates a sense of movement that is unusual for painting compositions on ceramics. Touches of silver (now tarnished) were added to the wings of the birds, enhancing the richness of the surface. In Japan, mynah birds can symbolize those who defy political corruption, although it is not clear if that was the artist's intention in this case.

The ceramics of Ogata Kenzan (1663–1743) are as famous and as highly regarded as those of his mentor, Ninsei. Kenzan was the younger brother of the famous

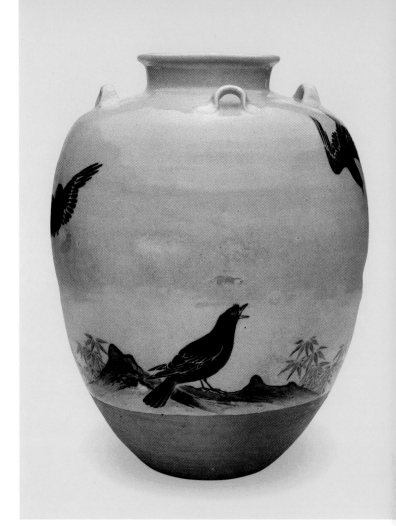

FIG. 285. Nonomura Ninsei (active ca. 1646–77). Tea Leaf Jar. Edo period, 1670s. Japan, Kyoto Prefecture. Stoneware painted with overglaze enamels and silver (Kyoto ware). H. 12 x Diam. 9½ in. (30.5 x 24.1 cm). Asia Society, New York: Mr. and Mrs. John D. Rockefeller 3rd Collection, 1979.251

painter Ogata Kōrin (1658–1716). Born into a prosperous family of clothiers who catered to the Kyoto aristocracy, and educated in many disciplines, Kenzan spent his youth at the artistic colony of Takagamine, which had been established by the potter and calligrapher Hon'ami Kōetsu (1558–1637). At Takagamine, he studied pottery with Kōetsu's grandson Kōho (1601–1682) and with Ichinyū (1640–1696), head of the fourth generation of Raku potters.

In 1688 Kenzan established his first kiln at his home in Omuro Village to the south of Ninnaji and Ninsei's kiln. Kenzan's close friendship with Ninsei is reflected in the fact that in 1699, Seiernon, Ninsei's son, gave Kenzan his father's private technical manual (*densho*) on the art of pottery. In the same year, Kenzan built a kiln at Narutaki, a few miles northwest of Omuro. He began to use the name Kenzan (northwest mountain) when he opened this kiln.

Kenzan's work at Narutaki was characterized by his close collaboration with his brother Korin, who painted the designs on several sets of dishes, some of the most innovative ceramics in Japanese history. Projects of this

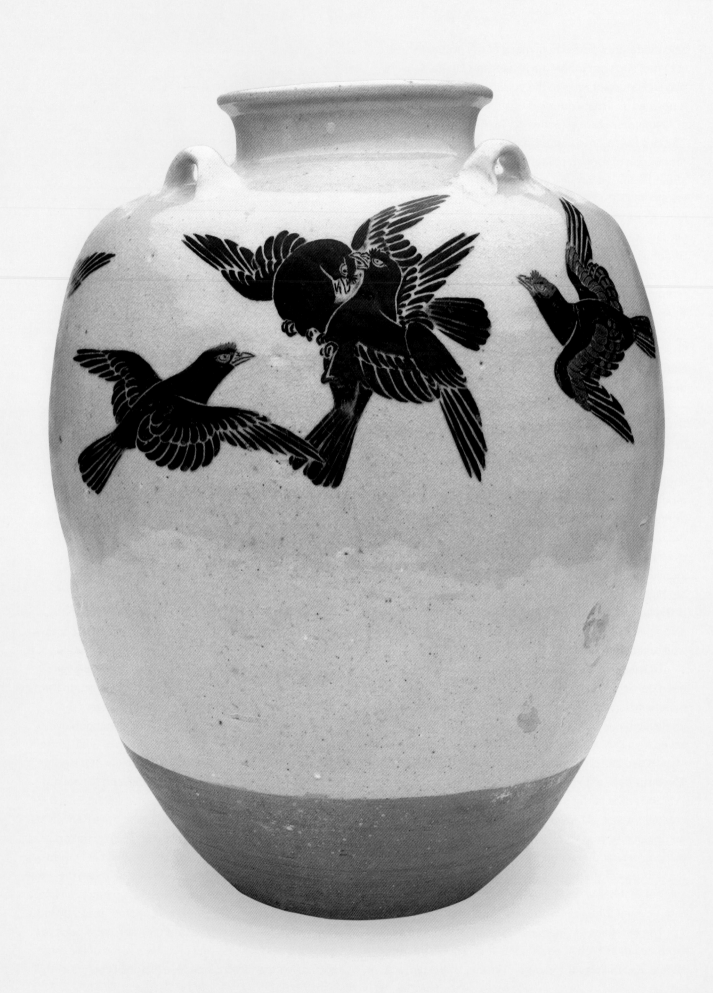

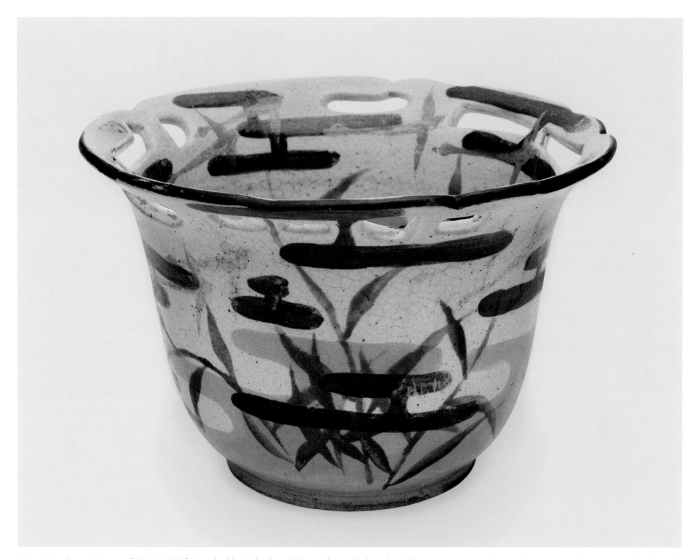

FIG. 286. Ogata Kenzan (1663–1743). Bowl with Reticulated Rim. Edo period, early 18th century. Japan, Kyoto Prefecture. Stoneware with pierced design and painted with underglaze slips, overglaze enamels, and gold (Kyoto ware). H. 4⅞ x Diam. 7½ in. (11 x 19.1 cm). Asia Society, New York: Mr. and Mrs. John D. Rockefeller 3rd Collection, 1979.252

sort seem to have ended in 1712, when Kenzan once again moved his kiln (probably for financial reasons) to Nijō Chojiyamachi, a commercial ceramic district in metropolitan Kyoto. Kenzan left Kyoto in 1731 and continued to make ceramics in Edo until his death in 1743.

The style of the signature on the base of the Kenzan bowl in the Collection (FIG. 286) indicates that it was made around 1712, probably at the Chojiyamachi kiln. The deep shape and pierced open work, a Kenzan innovation, are seen in several bowls produced at this time. Here, the

shape of the bowl has been incorporated into a design of bamboo growing along the misty banks of a river found on both the exterior and interior of the piece. The bamboo and river banks are painted in overglaze green and black, respectively, against a background of white and tan slips that cover the entire surface. Wild geese painted abstractly in gold pigment fly above. Images of transition, geese are traditional symbols of both spring and autumn in East Asian art and literature.

Opposite: Alternate view of FIG. 285

CONTEMPORARY COLLECTION

Michelle Yun

SOUTH ASIA

South Asia's modern and contemporary art movements have largely been defined by the region's shifting socio-political climate. The emergence of modern art in India and Pakistan coincided with the Indian Independence Act of 1947. This Parliamentary Act by the United Kingdom partitioned British India along sectarian lines and separated the southern, predominantly Hindu area, now known as the republic of India, from the northern, predominantly Muslim area, which became Pakistan. In Afghanistan and Iran, ongoing regime changes have had the unfortunate effect of hindering the development of a flourishing contemporary art community.

Afghanistan

Afghanistan's shifting political status following a 1973 coup that dethroned King Zahir Shah, and the Taliban's more recent rise to power in the 1990s, has had a significant impact on the country's political, religious, and cultural standing, and has impeded the development of a stable infrastructure for contemporary art. Modern Afghan art was initially modeled on European modernist painting, after a royal decree in the 1920s granted Afghan artists permission to study abroad. This progressive initiative allowed the returning artists to contribute their newfound knowledge toward the development of a formalized art system and was instrumental in the later establishment of the country's first official art education program, the Faculty of Fine Arts at Kabul University, in 1975. The subsequent decades of Russian, American,

and Taliban occupation slowed the production of avant-garde contemporary art until after 2001, when Afghan artists began to engage more fully with the international art community. Shortly thereafter in 2004 the Center for Contemporary Art Afghanistan (CCAA) was founded in Kabul and became the primary forum for exhibiting contemporary art. The Center also became notable for its support of women artists through its Center for Contemporary Art for Women and as one of the leading training institutions for young artists.

Rahraw Omarzad has been instrumental in the development of contemporary art in Afghanistan in his roles as an artist, curator, and art educator. He founded *Gahnama-e-Hunar*, the country's only art magazine, which was published from 2000 to 2004; established the Center for Contemporary Art Afghanistan (CCAA); and served as a lecturer at the Faculty of Fine Arts at Kabul University. The artist's multidisciplinary practice centers on sociopolitical issues particular to Afghanistan and specifically the local street culture of Kabul. Omarzad was born in 1964 in Kabul and studied drawing and painting at the Faculty of Fine Arts for three years. During the tumult of the 1970s Omarzad turned to video and photography as mediums that could more directly convey the social turmoil around him. His 2005 single-channel video *The Third One* **(FIG. 287)**, formerly titled *Opening*, explores the contentious and restrictive plight of women in Afghan society. As with many of Omarzad's video works, *The Third One* was created through a collaboration between the artist and students from the CCAA. The video depicts a woman dressed in a *chadri* (also referred to as a *burqa*

Opposite: Detail of **FIG. 292.**

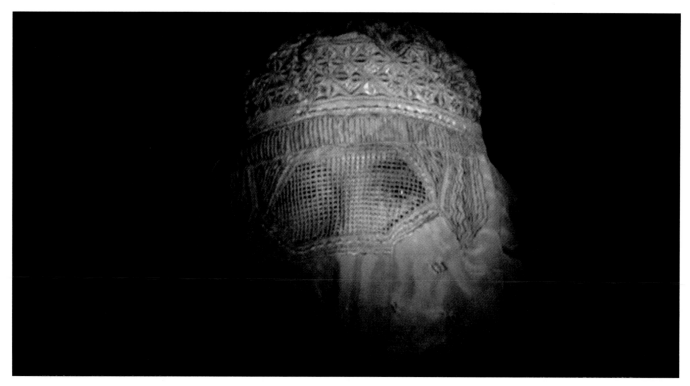

FIG. 287. Rahraw Omarzad. *The Third One*, 2005. Single-channel video with sound. Duration: 11 minutes, 31 seconds. Asia Society, New York: Asia Society Museum Collection, 2010.3

by Muslims in other regions) that covers her entire body with the exception of her eyes. She is sequestered in a windowless space and becomes further separated from the viewer by a black cloth that is suspended by an unidentified person. The accompanying soundtrack—a vaguely sinister, intermittent hammering sound—enhances the feeling of unease. An unidentified hand begins to cut holes into the cloth with large sewing shears, and the woman proceeds to embroider the holes with floral patterns. When the woman is handed the scissors she casts them to the ground, apparently unable to free herself from the constraint of the cloth. Her reluctance to cut away the restricting barriers of the black cloth and her own *chadri* is meant to signal the crippling effects a dictatorial regime has on the psyche.

India

The events surrounding India's independence in 1947 spurred the development of a modern painting movement led by the Progressive Artists' Group, founded in the same year, which announced itself to the world one year later through the Bombay Progressives Art Exhibition in 1948. This avant-garde movement was formed by a core group of artists including K. H. Ara, S. K. Bakre, H. A. Gade, Maqbool Fida Husain, S. H. Raza, and Francis Newton Souza. They and their contemporaries, including

V. S. Gaitonde and others, embraced the international phenomenon of European modernism as a direct rebuke of the conservative figurative aesthetic of the Bengal School of Art. The Progressives' dialogue with the international avant-garde was facilitated in part through Rockefeller Foundation–funded trips to New York City and other international destinations. The trajectory of this movement was bright yet brief and the group dissolved by 1956. Following this first wave of post-Independence activity, the next generation of artists, including Ranbir Kaleka and Nalini Malani, have continued to contend with the reverberations that came in the wake of India's independence and establishment as a postcolonial nation by working through a range of experimental mediums. More recently, political and economic reforms begun in the 1990s enabled India to develop a free market economy that allowed the country to have greater influence on the global stage. This phenomenon has inspired a new generation of contemporary Indian artists to examine the effects of globalization on their home country, including the rise of right-wing fundamentalism, the consequences of increased urbanization, and the development of a seemingly insatiable consumer culture.

Shilpa Gupta is a rising star of the younger generation of artists from India. Her diverse practice spans the divide between real and virtual worlds in an attempt to decode the mechanisms by which people, places, and ideologies are defined and categorized, and fill the subsequent gaps

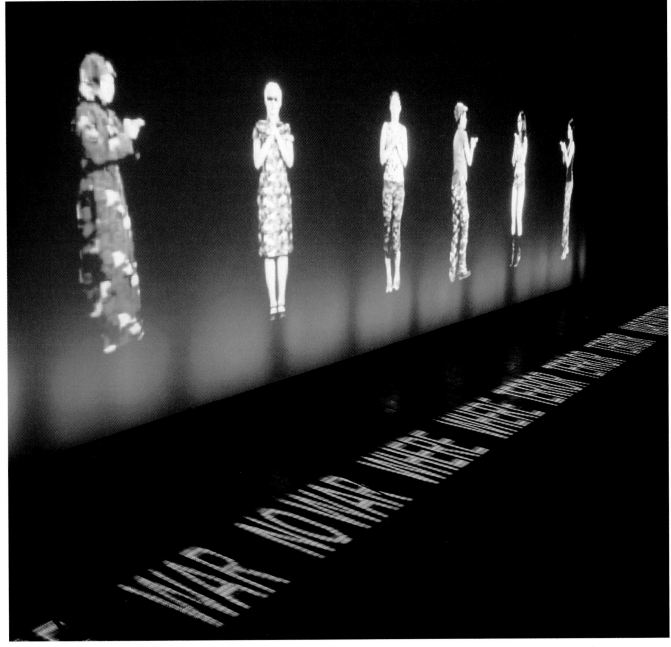

FIG. 288. Shilpa Gupta. *Untitled (War on Terror)*, 2004–5. Interactive video projection with sound. Duration: 8 minute interactive loop. Asia Society, New York: Gift of Mr. and Mrs. Harold and Ruth Newman, 2011.13

in translation that occur in language, nationhood, identity, and religion. The artist was born in 1976 in Mumbai and received a BFA in sculpture at the Sir Jamsetjee Jeejebhoy School of Art in 1997. Shifting the primary status of her artworks from object-based commodity to participatory experience, Gupta creates situations that actively involve the viewer. Her interdisciplinary practice includes sculpture, video, interactive computer-based installations, and performance that reflect a consumerist culture that is increasingly engaged with social media, the Internet, and technology. *Untitled (War on Terror)*, 2004–5 **(FIG. 288)**, is an interactive video installation that features seven women, dressed in camouflage and lined up against a

dark background, who represent a range of age groups. The viewer is provided with a computer mouse with which he or she can select a "leader" to initiate a series of exercise movements that the other six characters follow. The characters are encouraged to keep in sync by a projected scrolling number feed on the floor and an accompanying soundtrack of various female voices intoning exercise instructions. Gupta's appropriation of camouflage in this work plays on its alternate associations as a uniform of war and an ironic fashion statement. Her women at-the-ready allude to the commodification of modern warfare and society's willingness to be pacified and ultimately controlled by the media and technology.

FIG. 289. Ranbir Kaleka. *Man with Cockerel*, 2001–2. Two-channel video with sound. Duration: 29 seconds. Asia Society, New York: Purchased with funds donated by Carol Appel, 2011.1

Ranbir Kaleka's paintings, photographs, and video works share an underlying element of mystery. The artist was born in Patiala, Punjab, in 1953. He received a degree in painting at the College of Art, Punjab University, in Chandigarh in 1975 and an MA from the Royal College of Art in London in 1987. The artist first established himself as a neo-expressionist painter in London and it was only upon his return to India in 1998 that he began focusing on video and new media. Kaleka's painterly video art aesthetic produces a dreamlike sensibility that the artist uses to offset his often surreal and psychologically loaded subject matter. *Man with Cockerel*, 2001–2 (FIG. 289), is a two-channel video work that meditates on desire and dispossession. The vertically oriented format features an elderly man wading in a river grasping a rooster. The rooster is a recurring image in the artist's work and an association with his childhood. The man's image is mirrored on the water creating a doubling effect. He and

his reflection appear and dissolve, wavering between the status of human and chimera. The man wavers in and out of the frame as he struggles to contain the fowl, his reflection slowly following suit. The gentle current of the river and intermittent appearance of other solitary birds allude to the passage of time. A soundtrack of ambient urban noises grounds the viewer in a populated setting. The repetitive imagery of the man struggling to contain the rooster frames the action as a Sisyphean task that alludes to the futility of satisfying our desires and relegates our yearning for fulfillment to the realm of dreams.

Nalini Malani is one of the most important first-generation new media artists in India. She was born in 1946 in Karachi, before it became a part of Pakistan as a result of the Partition of India, and her experiences growing up in the aftermath of this political schism have been a significant influence on her artistic practice. Malani was trained as a painter at the Sir Jamsetjee Jeejebhoy School of Art in Mumbai from 1964 to 1969 and became known as a pioneer in the 1980s for her deliberate feminist perspective, and later in the early 1990s for her innovative theater and installation projects. Malani's multimedia projects feature the recurring themes of desire, gender, identity, memory, race, and transnational politics, especially in reference to India's postcolonial history of independence. She has created a unique visual language through her drawings, videos, and most notably her video/shadow play installations. Malani's technique of painting on transparent surfaces was inspired by the genre of reverse glass painting, brought to the subcontinent in the eighteenth century by the Chinese. The video/shadow play *Transgressions II*, 2009 (FIG. 290)—a variation of an earlier work called *Transgressions*, 2001—integrates the folk sensibility of traditional shadow plays with new technology to create a mesmerizing projection of colors and imagery. Three videos are projected through four transparent Lexan cylinders that the artist has painted in a technique that references the Kalighat style practiced in Bengal in the nineteenth and early twentieth centuries. As the reverse-painted cylinders rotate, imagery inspired by Edward Said's book *Orientalism* creates an ever-shifting tableau on the surrounding walls. The accompanying soundtrack features a poem written and recited by the artist. Malani often draws upon stories from Hindu and Greek mythology, nineteenth-century literary nonsense writing, and early-twentieth-century experimental theater to create allegories for present-day events. *Penelope*, 2012 (FIG. 291), is a video sketch that references the story of Penelope from Homer's *Odyssey*. It details how she wove and unraveled her burial shroud in Odysseus's

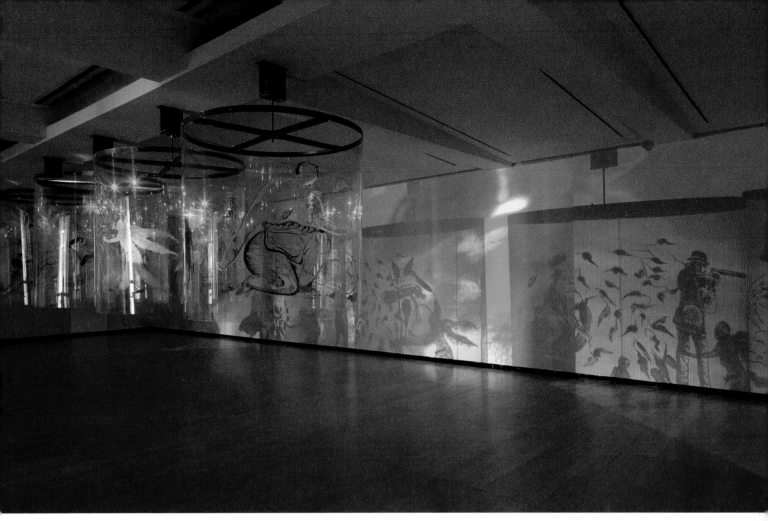

FIG. 290. Nalini Malani. *Transgressions II*, 2009. Three-channel video/shadow play with sound; 4 reverse-painted Lexan cylinders. Dimensions variable; Duration: 20 minutes. Asia Society, New York: Gift of Dipti and Rakesh Mathur, 2010.2. Installed at Asia Society, New York, in 2014.

FIG. 291. Nalini Malani. *Penelope*, 2012. Single-channel stop-motion animation. Duration: 1 minute. Asia Society, New York: Gift of Katherine and Rohit Desai, 2014.9

325

FIG. 292. Shiva Ahmadi. *Lotus*, 2014. Single-channel animation with sound. Duration: 8 minutes, 51 seconds. Asia Society, New York: Gift of Anne and Joel Ehrenkranz, 2015.1

absence in order to avoid her suitors, an allusion to the power of female resourcefulness. Malani's deft use of stop-motion animation highlights the artist's foundation in drawing. The video was commissioned by dOCUMENTA (13) in 2012 to complement her video/shadow play installation *In Search of Vanished Blood*.

Iran

Iran's modern political history has been a major influence on its artistic and cultural evolution. The decades from the 1950s through the 1970s were a time of tremendous societal change in the country and resulted in a burst of artistic activity. The advent of modernism began in the early 1960s alongside a period of great economic, political, and cultural transformation and flourished in the ensuing decades prior to the 1979 Revolution. By the mid-1970s, Tehran, the capital city, had become a cosmopolitan destination on par with New York and Paris. Artists found new patronage especially from the government for exhibitions and festivals, evident in the establishment of galleries such as Galerie Borghese and the Iran-America Society in Tehran in the 1960s; the annual Shiraz Arts Festival, which ran from 1967 to 1977; and later, the creation of the Tehran Museum of Contemporary Art in 1977, which actively acquired both Iranian and interna-

tional art for its collection. In addition to tending to their own art practices, many artists working during this period also functioned as critics, curators, educators, and gallerists in Iran's burgeoning art world. The avant-garde art created during this period was a pluralistic mix inspired by local Shi'ite folk art, pre-Islamic art, and calligraphy, coupled with formal strategies found in western abstraction and conceptual art. This fecund period came to an abrupt end with the 1979 Revolution, which tamped out non-Islamic forms of creative expression. A small, contemporary community continued to function after this point, albeit in a severely limited capacity.

Shiva Ahmadi was born in 1975 in Tehran and grew up in the atmosphere of the country's post-Revolution period. Her paintings and animations offer a critique of contemporary political conflict through the tradition of Persian miniature painting. She received a BA in painting from Azad University in 1998 and immigrated to the United States to pursue advanced studies in art, receiving MFA degrees from Wayne State University in 2003 and the Cranbrook Academy of Arts in 2005. The artist first became interested in politics during the American invasion of Iraq in 2003 and while her compositions most often focus on tensions within the Middle East and between East and West, Ahmadi is ultimately interested in examining the relationship between absolute power and corruption. For the artist, instability and uncertainty

are the only universal constants, and their influence is evident in the ever-shifting dynamics of her complex narratives. *Lotus*, a single-channel video from 2014, was commissioned by Asia Society as part of its *In Focus* series, which ran between 2005 and 2015. This program invited contemporary artists to create a new work in response to a traditional object from the Asia Society Museum Collection. *Lotus*, 2014 **(FIG. 292)**, inspired by two Buddha sculptures from the Collection **(FIGS. 64 AND 82)**, references Ahmadi's 2013 painting of the same title. The viewer is introduced to a bucolic scene that depicts the enlightened Buddha sitting atop a blooming lotus throne, and surrounded by his loyal monkey subjects, who bear offerings of delicate bubbles. As the narrative progresses, the monkeys' bubbles turn into bombs and grenades while their behavior grows violent. As the Buddha begins to participate in the ensuing chaos, his appearance becomes increasingly warrior-like. The landscape changes into a dystopia filled with war and destruction as the once enlightened leader is transformed into a common tyrant.

Pakistan

Pakistan's transition to a postcolonial society following the Partition of 1947 was complicated by the strained relationship between those who supported the development of a democratic state and those who upheld the desire to maintain Islamic law. The unfortunate result was a polarization between East and West Pakistan. The country has remained in political upheaval through the eventual secession of East Pakistan in 1971, to form Bangladesh, and up to the present day. From an artistic perspective, the 1947 Partition spurred a creative exodus of many Pakistani artists to India. Traditional Islamic culture and indigenous folk art became strong artistic influences at this time as well. By the 1950s the city centers of Lahore, Dacca, and Karachi developed formal art councils, and prominent art institutions were established, namely The National College of Arts (NCA), which became the most important incubator of modernist art in West Pakistan. Artists during this post-Partition period were inspired by western, and especially French, modernism due in large part to the influence of the Lahore Art Circle. This group of artists, formed in 1952 and including Shakir Ali and Zubeida Agha, comprised the first generation of artists to receive an art education in the West. These artists merged formal styles learned in Europe with indigenous cultural traditions, including miniature

painting and Islamic calligraphy, to examine politics, religion, and gender, among other issues. After a military coup in 1977, figurative painting and sculpture were discouraged in favor of calligraphy and landscape painting. The revival of miniature painting in the 1980s brought avant-garde art from Pakistan into the international spotlight and paved the way for the acceptance of other conceptual art movements.

The artist Huma Mulji was born in 1970 in Karachi and received a BFA in sculpture and printmaking from the Indus Valley School of Art and Architecture in 1995 and an MFA in New Media Arts in 2010 from the Transart Institut, Donau-Universität Krems in Austria. After returning to Pakistan she was invited to teach at the School of Visual Arts and Design at Beaconhouse National University in Lahore. Mulji's humorous sculptures, photographs, and works on paper offer witty observations on the social and economic disjunctions of postcolonial Pakistan through the appropriation of cultural signs and by highlighting the absurd incongruities of social codes of conduct. *Sirf Tum (Only You)*, 2004 **(FIG. 293)**, *Trespassing*, 2004 **(FIG. 294)**, and *Full Mood Mein*, 2004 **(FIG. 295)**, are all part of the artist's first series of photographic works entitled *Sirf Tum (Only You)*, begun in 2004, in which the artist constructed loaded narratives by posing nude Ken and Barbie dolls together in public spaces around Lahore. The images are meant as a critique of conservative local attitudes in Pakistani culture that condemn public intimacy and displays of affection among men and women. The doll avatars—selected for their identity as secondhand juvenile toys from the West—provide a way of humorously exploring what, if enacted in real life, would translate into dangerously transgressive behavior.

Rashid Rana is known for his conceptual sculptures, videos, and photo composite collages that provocatively deconstruct social histories and cultural disjunctions to reflect the duality of our times. He was born in 1968 in Lahore and received a BFA from the National College of Arts in Lahore and an MFA from the Massachusetts College of Art in Boston. After his studies abroad the artist returned to Pakistan and was the founding faculty member and head of the Fine Art department at Beaconhouse National University in Lahore. The artist frequently incorporates mirror images and geometry, specifically a grid matrix, to structure his works as a means to critique cultural assumptions and illuminate social biases. Appropriation, manipulation, rearrangement, and repetition of images and ideas are also frequent structural tools used by the artist. *Ten Differences*, 2004 **(FIG. 296)**, is a single-channel video that addresses the politics of

FIG. 293. Huma Mulji. *Sirf Tum (Only You)*, 2004. Inkjet print on Heinermuller Photorag. H. 30 x W. 40 in. (76.2 x 101.6 cm). Asia Society, New York: Gift of the Friedman Benda Gallery, 2013.3

FIG. 294. Huma Mulji. *Trespassing*, 2004. Inkjet print on Heinermuller Photorag. H. 30 x W. 40 in. (76.2 x 101.6 cm). Asia Society, New York: Gift of the Friedman Benda Gallery, 2013.4

FIG. 295. Huma Mulji. *Full Mood Mein*, 2004. Inkjet print on Heinermuller Photorag. H. 30 x W. 40 in. (76.2 x 101.6 cm). Asia Society, New York: Gift of the Friedman Benda Gallery, 2013.2

violence and the contentious relationship between the self and "the Other." Due to the complexities of contemporary warfare, it is becoming increasingly difficult to discern between aggressor and victim. The video begins with an image of the artist in profile within a tranquil domestic interior. He is confronted by his mirror image, both selves holding loaded guns at the ready. The standoff quickly escalates into bloodshed and is repeated within the span of a minute. The endless loop of this senseless tragedy soon numbs the viewer into apathy, alluding to our growing indifference toward international violence through the sensationalism and redundancy of war reportage by the media.

FIG. 296. Rashid Rana. *Ten Differences*, 2004. Single-channel video projection with sound. Duration: 53 seconds. Asia Society, New York: Purchased with funds donated by Katherine and Rohit Desai, 2010.1

SOUTHEAST ASIA

Southeast Asia has experienced great social and economic changes throughout the second half of the twentieth century and into the twenty-first century, which has in turn fundamentally impacted the development of contemporary art movements within the region. The artists included in this section largely came of age during times of dramatic political transition in their home countries, which compounded the impact of these societal shifts. Southeast Asia boasts the largest youth demographic in the world; the region's overall population accounts for more than a quarter of the world's total population. Accordingly, the videos and photographs in the Collection from this region highlight the growing disparity between urban and rural spaces, and tradition and modernity as a result of the region's booming youth culture, and the desire of the young to participate on a global platform.

Indonesia

The birth of contemporary art in Indonesia began through a political action, which set the tone for provocative, socially engaged art practices that emerged from the first wave of contemporary artists, and created a structure for subsequent generations of artists to look toward. In December of 1974, at the awards ceremony of the Pameran Besar Seni Lukis Indonesia (The Great Indonesian Painting Exhibition), a group of young artists from the ASRI Indonesian Academy of Art in Yogyakarta staged a performative act of protest that was later termed the Black December intervention. Their action was a rejection of painting in favor of the acceptance of experimental work based on "humanitarian values and oriented towards social, cultural, political, and economic realities."[1] By challenging what they felt to be an outmoded, western definition of fine art, these artists strove to create an interdisciplinary, nonelitist art system and subsequently designated contemporary art-making as a form of activism. From this beginning, the leading contemporary artists of Indonesia have continued to create their work within this subversive construct.

Arahmaiani is considered a pioneer in the field of contemporary performance art in Southeast Asia. The artist was born Arahmaiani Feisal in 1961 in Bandung. She received a BFA from the Bandung Institute of Technology in 1992 after studying first at the Academie voor Beeldende Kunst in Enschede, the Netherlands, and the Paddington Art School in Sydney, Australia. Arahmaiani is best known for her provocative videos, installations, sculptures, and performances that address social and political issues in her native Indonesia in an effort to challenge conservative attitudes toward religion, gender, and class. The artist is represented in the Collection by the single-channel video work *I Don't Want to Be a Part of Your Legend*, 2004 **(FIG. 297)**. This video references the *Ramayana*, a Sanskrit epic in which Sita, Rama's wife, is put through a trial by fire to prove her purity. In Arahmaiani's video, Sita's survival serves as a metaphor for the resiliency and self-sustaining nature of the feminine in the face of oppressive male patriarchy. The accompanying lyrics, written and sung by the artist, underscore the lament of existence under these conditions. This particular video

Opposite: Detail of **FIG. 305**

هل توجد امكانية أخرى لكي لا يجب أن أحمل كلّ محمولة المشكوكت
Is there another possibility for me so that I don't need to
bear the entire burden of a person who must be under
suspicion,

FIG. 297. Arahmaiani. *I Don't Want to Be a Part of Your Legend*, 2004. Single-channel video with sound. Duration: 11 minutes, 34 seconds. Asia Society, New York: Gift of Dipti and Rakesh Mathur, 2015.2

utilizes the traditional shadow-play format of *wayang kulit* to enact Hindu, folk, and Islamic mythology as a metaphor for contemporary political issues in Indonesia.

A younger generation of Indonesian artists often referred to as the "2000 Generation" has continued the tradition of sociopolitical critique established by their predecessors through their response to their experiences growing up during the period of Reformasi (reformation) in the 1990s. This was a tumultuous time of socioeconomic and political uncertainty within Indonesia that included the Asian financial crisis in 1997 and the subsequent fall of the Suharto regime in 1998. These artists often combine local traditions and popular culture to create innovative ways of creating art that poignantly reflects the fluid social landscape around them.

Eko Nugroho embodies the spirit of the "2000 Generation" through a multidisciplinary practice that encompasses drawing, painting, sculpture, installation, video, performance, and street art. Nugroho was born in

1977 in Yogyakarta and received a BFA from the painting department of the Indonesian Art Institute in 2006. His work uses humor to address social issues including the growing disconnect between tradition and modernity within a rapidly urbanizing society, the risk of religious fanaticism, and the breaking of traditional cultural taboos by the younger generation. The artist is also the founder of the radical biannual collaborative zine *Daging Tumbuh* (Growing Tumor), which began circulating in the summer of 2000. Nugroho is represented in the Collection by three single-channel video works, *Bercerobong (Like a Chimney)*, 2002 **(FIG. 298)**; *The Breeder*, 2003 **(FIG. 299)**; and *Let Me Love Me*, 2004 **(FIG. 300)**. The three works exemplify the artist's use of video animation, based on his signature graphic drawing style, to explore the rapidly shifting cultural norms that emerged after the fall of the Suharto regime. These surreal narratives implement imaginary cartoon-like characters whose interactions humorously illuminate the subtle political and social

FIG. 298. Eko Nugroho. *Bercerobong (Like a Chimney)*, 2002. Single-channel animation with sound. Duration: 2 minutes. Asia Society, New York: Gift of Dr. Michael I. Jacobs, 2011.4

FIG. 299. Eko Nugroho. *The Breeder*, 2003. Single-channel animation with sound. Duration: 2 minutes, 20 seconds. Asia Society, New York: Gift of Dr. Michael I. Jacobs, 2011.5

FIG. 300. Eko Nugroho. *Let Me Love Me*, 2004. Single-channel animation with sound. Duration: 2 minutes, 11 seconds. Asia Society, New York: Gift of Dr. Michael I. Jacobs, 2009.2

contradictions inherent in any realignment of power and the subsequent effects on the population at large.

The Indonesian collective Tromarama, founded in Jakarta in 2004 by Febie Babyrose (born in 1985, Jakarta), Herbert Hans Maruli (born in 1984, Jakarta), and Ruddy Alexander Hatumena (born in 1984, Bahrain), mines popular culture to create playful video collages that reflect the country's growing materialistic society. The three artists have backgrounds in design, having met at the Bandung Institute of Technology, and a deep interest in urban culture and music. Tromarama is best known for its low-tech, labor-intensive stop-motion animation techniques. Their early work consists primarily of video installations that capture the rhythmic atmospheres of indie, jazz, and thrash metal music. More recently their focus has shifted to encompass social concerns related to the economic boom and rapid urbanization occurring throughout Indonesia. *Serigala Militia*, a single-channel video from 2006 **(FIG. 301)**, was created as a music video for the metal band Seringai. The stop-motion animation was meticulously created from hundreds of woodcut

panels that were crafted by hand. Beginning in 2008 the collective began developing the visual and audio components of their videos as a cohesive whole, and from 2010 to the present the group has progressively moved toward sociopolitical topics in Indonesian current affairs. *Borderless*, from 2010 **(FIG. 302)**, is a meditation on the types of limitations one encounters in daily life, both societally driven and self-imposed. The work was created from hundreds of embroidered canvases used to animate the video. *Everyone is Everybody* and *Unbelievable Beliefs*, both from 2012 **(FIGS. 303 AND 304)**, take the stop-motion animation process into the realm of the real world. The use of video footage in these two single-channel video works is a departure from the more graphic style of stop-motion animation that the group implemented in earlier works. *Unbelievable Beliefs* was created during a three-month residency in Jakarta and explores the shifting landscape of a city in transformation, while *Everyone is Everybody* is a witty response to the economic boom starting in the 2010s in Indonesia and the development of a new social class with disposable

FIG. 301. Tromarama. *Serigala Militia*, 2006. Single-channel stop-motion animation with sound; music by Seringai. Duration: 4 minutes, 25 seconds. Asia Society, New York: Gift of Dr. Michael I. Jacobs, 2011.3

FIG. 302. Tromarama. *Borderless*, 2010. Single-channel stop-motion animation with sound; sound by monoprint. Duration: 2 minutes, 25 seconds. Asia Society, New York: Gift of Michael & Jennifer Figge, 2014.6

FIG. 303. Tromarama. *Everyone is Everybody*, 2012. Single-channel stop-motion animation with sound; vocals by Yori Papilaya, Lidyawati, Yasmina Yustiviani; music by Hendra Budiman; lyrics by Tromarama. Duration: 3 minutes, 35 seconds. Asia Society, New York: Gift of Mr. and Mrs. Harold and Ruth Newman, 2014.7

FIG. 304. Tromarama. *Unbelievable Beliefs*, 2012. Single-channel stop-motion animation with sound; sound by Bintang Manira. Duration: 2 minutes, 57 seconds. Asia Society, New York: Gift of James Woods, 2014.8

income. In this work, the group satirizes the act of using material objects as a form of self-actualization by animating high-end consumer products in a whimsical musical production.

1. T. K. Sabapathy, "Intersecting Histories: Thoughts on the Contemporary and History in Southeast Asian Art," in *Intersecting Histories. Contemporary Turns in Southeast Asian Art* (Singapore: School of Art, Design and Media, Nanyang Technological University, 2012), 44.

Philippines

Unlike the dramatic formation of the Indonesian avant-garde, Filipino contemporary art developed gradually and has been shaped by the diverse cultural influences imposed on the country through its political past. The long-reaching influence of cultural hybridization goes back to the sixteenth century, when the Spanish colonized the region, and since then the visual arts of the Philippines have been informed by such disparate influences as European religious iconography, East and South Asian

FIG. 305. Jay Yao (Jose Campos III). *Untitled (St. Mary Magdalene Church, Kawit, Cavite)*, 2013. Inkjet print on archival paper; collaborators: Xeng Zulueta and Noel Manapat. H. 66 x W. 44 in. (167.6 x 111.8 cm). Asia Society, New York: Gift of the Hakuta Family, 2015.16

aesthetics along with other cultural exports introduced to the country after its opening to international trade in the nineteenth century, and most recently, western modernism from the nineteenth century to the present. The trajectory of contemporary Filipino art has advanced from this multivalent foundation into a sophisticated and internationally minded milieu that is being used to voice a growing social and political consciousness within the context of the country's identity as a postcolonial Asian nation on the rise.

Jay Yao, who was born Jose Campos III in 1980 in Richmond, Canada, is a Manila-based artist who uses photography to explore the growing socioeconomic disparities of his adopted home. The artist began his career as a commercial fashion photographer and this formative experience influenced his current artistic practice, most notably through his *Homecoming* series, represented in the Collection by *Untitled (St. Mary Magdalene Church, Kawit, Cavite)*, 2013 **(FIG. 305)**. For this ongoing series, begun in 2012, the artist collaborates

with leading Filipino fashion designers to document their clothing designs in the context of their respective home-towns or other provincial locales that have inspired them. The nostalgic tone of these photographs is tempered by the artist's intent to provide commentary on the growing economic disparity between Manila, the country's bustling cosmopolitan center, and the rural communities found across the Philippines. In this photograph, clothing designed by Joey Samson is worn by a local girl from Cavite in the church where the designer worshiped as a child. The crisp, uniform-like outfit emphasizes an idyllic innocence and hope for the future generation of Filipino youth.

Thailand

The establishment of Thailand's modern and contempo-rary avant-garde art movements has been largely centered around Silpakorn University in Bangkok. This university was originally founded as the School of Fine Arts in 1943 by the Italian sculptor Corrado Feroci, renamed Silpa Bhirasri, who is considered the forefather of Thai modern art. Thai avant-garde art has developed in fits and starts, due in large part to the lack of a sustainable patronage base and an inadequate institutional infrastructure, difficulties that have been compounded by political upheaval since the turn of the twentieth century. The grounding of Thai art in western representational art was primarily shaped by the patronage of European artists by the country's monarchs, most notably King Mongkut, followed by King Chulalongkorn in the late nineteenth and early twentieth centuries. Beginning in the 1990s, political and social unrest, and instability have impeded the development of a stronger infrastructure to nurture contemporary art-making practices.

Araya Rasdjarmrearnsook is one of the leading video artists from Thailand. The artist was born in 1957 in Trad and received a BFA and an MFA in graphic arts from Silpakorn University and an MA from Germany's Hochschule für Bildende Künste Braunschweig in 1994. She has been a professor of art at Chiang Mai University since 1987. Rasdjarmrearnsook began her practice as a sculptor and printmaker, but shifted her focus toward video beginning in 1998. Her subject matter is based on dichotomies, such as the relationship between life and death, and the search for autonomy within cultural constraints. More recently her practice has encompassed notions of identity and difference through the lens of class hierarchies and regional idiosyncrasies. *Village and*

Elsewhere: Artemisia Gentileschi's Judith Beheading Holofernes, Jeff Koons' Untitled, and Thai Villagers, 2011 **(FIG. 306)**, is from the *Village and Elsewhere* series, comprising photographs and videos created in 2011. The group of works is meant to highlight the relevance of context in the appreciation of fine art exemplified in this video through Rasdjarmrearnsook's humorous and revealing documentation of a Buddhist monk's "art history lesson." The artist invited a group of children from the Thai countryside to a local Buddhist temple for a lecture by one of the residing monks about two western images, selected by the artist: *Judith Slaying Holofernes* (about 1614–20), by Artemisia Gentileschi, and an untitled lithograph from the print portfolio *Art Magazine Ads, 1988–1989* by Jeff Koons. In this unusual context the works take on entirely different meanings as the monk uses the reproductions as visual aids for a lesson on Buddhist teachings and reverts, during the course of the lecture, to the Five Precepts of Dharma. The ensuing dialogue reveals a myriad of cultural nuances and assumptions between East and West, and among social classes, and opens up the possibility for alternative modes of art appreciation outside a conventional western museological structure.

Vietnam

The cosmopolitan city centers of contemporary Vietnam belie the country's fraught past and the difficulties experienced by its avant-garde artists. Modern Vietnamese art and culture has been imposed upon the Vietnamese by the West beginning with French colonization of the country in 1862 and followed by two Indochina wars: the first resulting in the expelling of the French in 1954 and the segregation of North and South Vietnam; and the second, lasting from 1955 to 1975 and generally known outside the country as the Vietnam War,[1] which resulted in reunification under a communist government. In 1986 the government encouraged *Doi-moi* (renovation), an economic opening up of the country, which spurred dramatic socioeconomic growth in the urban centers of Hanoi and Ho Chi Minh City, and in the process created a socialist-capitalist society with an awkward dual identity. The legacy of an authoritarian and institutional-ized system has had long-reaching ramifications for the creative class. Contemporary Vietnamese artists are routinely subjected to censorship, condemnation, and intimidation by the government. There are not many university programs offering studies in the fine arts

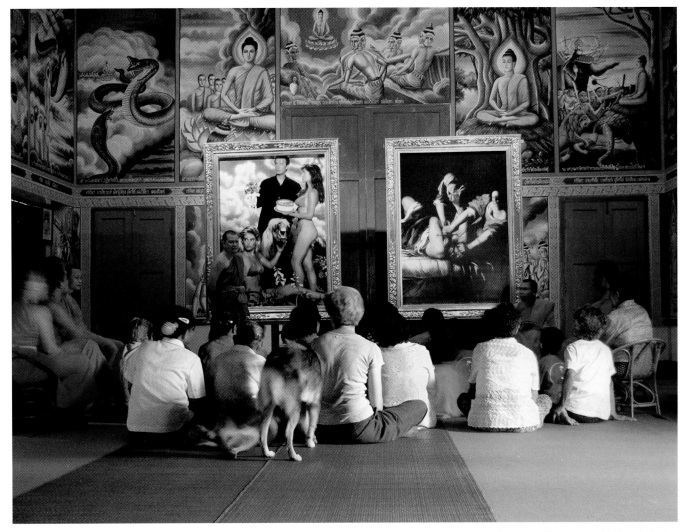

FIG. 306. Araya Rasdjarmrearnsook. *Village and Elsewhere: Artemisia Gentileschi's Judith Beheading Holofernes, Jeff Koons' Untitled, and Thai Villagers*, 2011. Single-channel video with sound. Duration: 19 minutes, 40 seconds. Asia Society, New York: Gift of Anne and Joel Ehrenkranz, 2015.7

and few public institutions where artists may exhibit their work. Despite these hardships, Vietnam has a strong population of Viet Kieu artists—overseas Vietnamese who have returned to establish familial and creative roots. The Viet Kieu have created another layer of complexity in the development of a contemporary art infrastructure; as inhabitants of a third cultural space, their multicultural identity often creates tensions with their native counterparts.

Viet Kieu artist Dinh Q. Lê was born in 1968 in Hà Tiên, a Vietnamese town on the Cambodian border. His family immigrated to the United States in 1978, shortly after the end of the Vietnam War, where the artist remained until his return to Vietnam in 1993. During his time living in the United States, the artist received a BFA from the University of California, Santa Barbara, in 1989 and an MFA in photography from the School of Visual Arts in New York in 1992. Lê is best known for his large-scale photo col-

lages that he creates by appropriating photographs that depict glamorized imagery of the Vietnam War that are then cut up and rewoven together, sometimes with multiple photographs, using traditional Vietnamese basket-weaving techniques. He is represented in the Collection by *South China Sea Pishkun* **(FIG. 307)**, the artist's first video animation. This work was inspired by the mass exodus of American and South Vietnamese troops on the day Saigon fell, April 30, 1975. The term *pishkun* refers to a practice used by the Blackfoot Confederacy in North America to kill roaming buffalo by driving them over a cliff in a panic. Helicopters, initially symbols of American might, are depicted feebly crash-landing into the sea in a similar frenzy of defeat. Through his retelling of history, the artist not only questions the construction of history, but also attempts to initiate a meaningful dialogue about America's role in the Vietnam War and other military conflicts. Lê has become one of

FIG. 307. Dinh Q. Lê. *South China Sea Pishkun*, 2009. Single-channel high-definition 3-D animation video with sound. Duration: 6 minutes, 30 seconds. Asia Society, New York: Purchased with funds donated by Alex, Carol, and David Appel, and Harold and Ruth Newman, with assistance from Shoshana Wayne Gallery, 2011.6

FIG. 308. UuDam Tran Nguyen. *Waltz of the Machine Equestrians*, 2012. Single-channel video with sound. Duration: 3 minutes. Asia Society, New York: Gift of Mitch and Joleen Julis, 2014.1

FIG. 309. Jun Nguyen-Hatsushiba. *Memorial Project Nha Trang, Vietnam: Towards the Complex—For the Courageous, the Curious, and the Cowards*, 2001. Single-channel video projection with sound. Duration: 13 minutes. Asia Society, New York: Gift of Mr. and Mrs. Harold and Ruth Newman, 2008.4. (Left) *History-Xich Lo*, 2000. Inox steel, other metals, and existing cyclo parts. H. 61 x W. 107 x D. 37 in. (155 x 271.8 x 94 cm). Asia Society, New York: Gift of Mr. and Mrs. Harold and Ruth Newman, 2008.6. (Right) *Reflect-Xich Lo*, 2000. Inox steel, other metals, and existing cyclo parts. H. 48½ x W. 104 x D. 37½ in. (123.2 x 264.2 x 95.3 cm). Asia Society, New York: Gift of Mr. and Mrs. Harold and Ruth Newman, 2008.5. Installed at Asia Society, New York, in 2014.

the leaders of the avant-garde art scene in Ho Chi Minh City and has been largely responsible for nurturing the contemporary arts through the founding of Sàn Art, the city's first nonprofit art space, in September 2007.

UuDam Tran Nguyen's multidisciplinary practice is focused on the ramifications of rapid sociopolitical development in Vietnam, especially in relation to power, identity politics, and technological innovation. The artist was born in 1971 in Kontum and was trained as a figurative sculptor. He received a BFA from Ho Chi Minh City Fine Arts University in 1994 and the University of California, Los Angeles, in 2001, and an MFA from the School of Visual Arts in New York in 2005. *Waltz of the Machine Equestrians* **(FIG. 308)** is a witty examination of the social and environmental effects of the rapid urbanization occurring throughout Vietnam. Set in Ho Chi Minh City, the video follows twenty-eight scooter riders literally connected by their brightly colored ponchos and identical face masks, the uniform of the contemporary work warrior, in a choreographed formation whose unified

forward momentum becomes a metaphor for the combined achievements and constraints of urban modernization. The accompanying soundtrack set to Suite for Jazz Orchestra no. 2, Waltz no. 2 by the Russian composer Dimitri Shostakovich provides a theatrical undertone that heightens the drama of negotiating one's way to the office in modern-day Vietnam.

Jun Nguyen-Hatsushiba was born in 1968 in Tokyo, Japan, to a Vietnamese father and a Japanese mother. He received his art education in the United States, earning a BFA from the School of the Art Institute of Chicago in 1992 and an MFA at the Maryland Institute College of Art in 1994 before basing his studio in Ho Chi Minh City. The artist commemorates Vietnam's struggle to move beyond its violent political past and the country's push toward modernization through his use of cyclos (rickshaws), a once popular but now outmoded form of transportation. Nguyen-Hatsushiba has worked with this motif since the 1990s. *Memorial Project Nha Trang, Vietnam: Towards the Complex – For the Courageous, the Curious, and the*

FIG. 310. Phan Quang. *The Disappointment*, 2011. Archival pigment print on paper. H. 35¹³⁄₁₆ x W. 59 in. (90 x 150 cm). Asia Society, New York: Gift of Mitch and Joleen Julis, 2014.2

Cowards, 2001 **(FIG. 309)**, was filmed on the southeastern coast of Vietnam and marked the beginning of a series of underwater videos shot by the artist himself. It offers captivating images of local fishermen pulling cyclos across a craggy seabed. This difficult enactment, along with the outmoded form of transportation, is a metaphor for the daily hardships of the Vietnamese people in the context of the country's struggle with modernization. The video is accompanied by two sculptures from 2000 fabricated from modified vintage cyclos and entitled *Reflect-Xich Lo Cyclo* and *History-Xich Lo Cyclo*.

Phan Quang, a fellow artist based in Ho Chi Minh City, was born in 1976 in Binh Dinh Province. The artist began his photography practice in 2004 and is self-taught. His work examines the increasing influence that mass media and consumer culture have had on

Vietnamese contemporary society, and the disjunction between desire and reality. Quang is represented in the Collection by three photographs: *The Disappointment, Nouveau Riche,* and *Pupils* **(FIGS. 310, 311, AND 312)**. These three photographs are from a series created between 2011 and 2012. In rural areas throughout Vietnam, bamboo cages are used extensively to transport poultry and other small animals. Quang's juxtapositions of urban Vietnamese youth literally lured into these traps by their consumerist desires are meant to underscore the invisible traps that upward mobility and the collective desire for material wealth have introduced into contemporary Vietnamese society.

1. The Vietnam War has also been referred to as the Second Indochina War, and within Vietnam is referred to as *Kháng chiến chống Mỹ* (Resistance War against America).

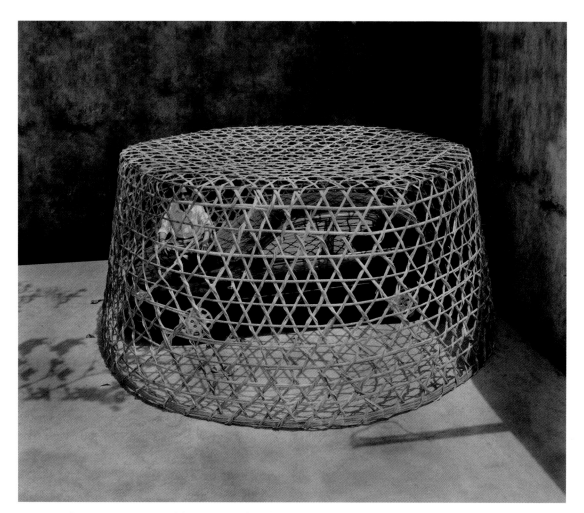

FIG. 311. Phan Quang. *Nouveau Riche*, 2011. Archival pigment print on paper. H. 35¹³⁄₁₆ x W. 53⅛ in. (90 x 135 cm). Asia Society, New York: Gift of Mitch and Joleen Julis, 2014.3

FIG. 312. Phan Quang. *Pupils*, 2011. Archival pigment print on paper. H. 35¹³⁄₁₆ x W. 59 in. (90 x 150 cm). Asia Society, New York: Gift of Mitch and Joleen Julis, 2014.4

EAST ASIA

More than other regions of Asia, the evolution of modern and contemporary art in East Asia has most closely paralleled the trajectory of western modern and contemporary art, due in large part to the relatively close relationship between this region and the West. Artistic development in East Asia did face some setbacks, however, in the form of inter-regional and global conflicts: the second Sino-Japanese war from 1937 to 1945, the Korean War from 1950 to 1953, and World War II from 1939 to 1945. In mainland China the Cultural Revolution, from 1966 to 1976, abruptly halted all cultural activities not in service to the communist agenda and severely curtailed the development of avant-garde art practices. Taiwan has also experienced gaps in artistic production as a result of political strife, notably during the country's period of martial law from 1948 to 1987. East Asia has continued to rise in prominence both economically and politically in the twenty-first century and this elevated stature has brought new attention to the appreciation and connoisseurship of East Asian modern and contemporary art practices.

China

Many first-generation Chinese artists of the twentieth century were sent to Europe by the government to receive an advanced education as part of a strategy to mitigate foreign dominance over China by acquiring western knowledge and technology. Consequently, the modern arts education system in China placed equal emphasis on Asian and western painting techniques taught by both Asian and European professors with a syllabus modeled after the L'École nationale supérieure des beaux-arts in Paris. The second Sino-Japanese War curtailed artistic production, which was further disrupted by the Communist Party's rise to power and the Cultural Revolution. The Cultural Revolution (1966–76) had the most significant impact on the development of modern and contemporary art in China. All cultural production not in service to the party, which championed socialist realism, was forbidden and many artists and intellectuals were persecuted. The death of Mao in 1976 and the end of the Cultural Revolution led to a period of increased openness and experimentation with cultural icons and symbols to reassess and renew political and social ideas. Regional avant-garde art groups came together in what came to be known as the '85 Art Movement, or the New Wave Art Movement, and strove to redefine the role of tradition within Chinese contemporary culture. This period of intellectual liberation was short lived and at the end of the 1980s avant-garde art was again suppressed in the aftermath of the June 4, 1989, crackdown in Tiananmen Square. As a result many artists left the country through

Opposite: Detail of **FIG. 330**

345

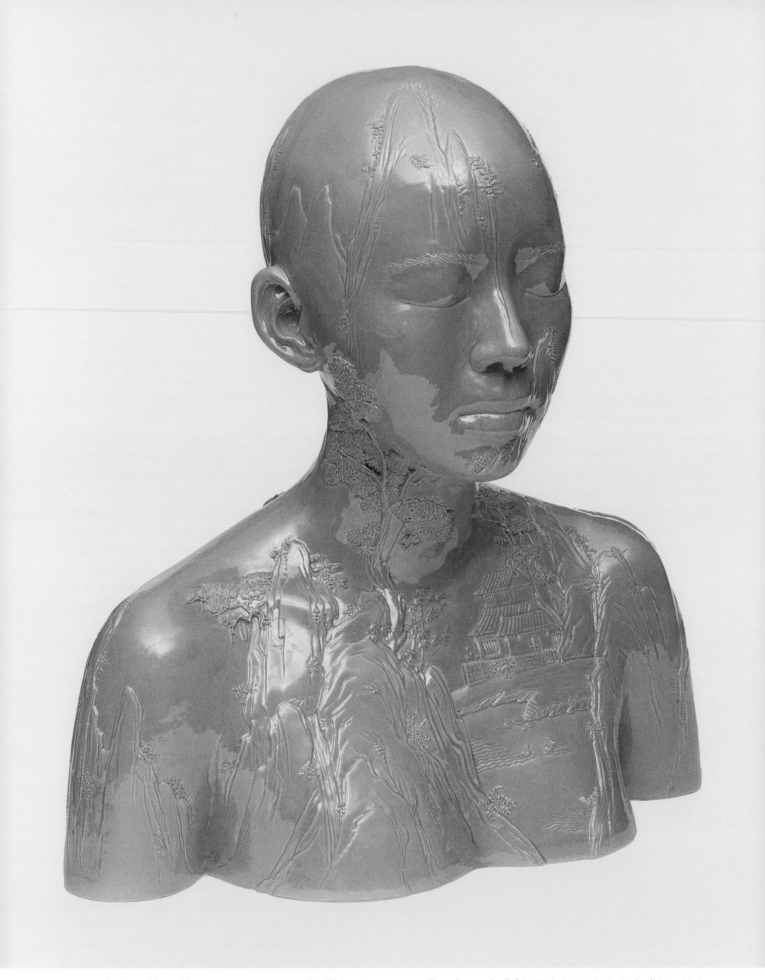

FIG. 313. Ah Xian. *China, China—Bust 57*, 2002. Porcelain with low-temperature yellow glaze and relief. H. 15½ x W. 15½ x D. 7⅛ in. (39.4 x 39.4 x 18.1 cm). Asia Society, New York: Asia Society Museum Collection, 2002.37

student visas or invitations to exhibit their work abroad. By December of 1989 the Party gained control of all publications and exhibitions, forcing the avant-garde movement underground, where performance art, video art, and photography flourished. Mainland and diasporic artists were featured with more regularity in exhibitions in the West, raising the profile of Chinese contemporary art. In 2000 the government relaxed restrictions, which facilitated the development of a commercial art system in China and the creation of a platform for Chinese contemporary art to have a substantial international presence. The generation of artists born after the Cultural Revolution has focused on the dramatic societal changes occurring across the country, especially in urban centers, as a result of China's growing international prominence and the rise of globalism.

Ah Xian's meticulously crafted figurative sculptures use traditional Chinese decorative arts practices to deconstruct the relationship between history, cultural heritage, and identity. The artist was born Liu Ji Xian in Beijing in 1960. Self-trained as an artist, Ah left China for Australia in 1989 to participate in a residency at the University of Tasmania and immigrated to Australia following the events at Tiananmen Square later that year. The artist is best known for his *China China* series comprising forty porcelain busts. Ah's engagement with porcelain was inspired by his desire to use Chinese traditional decorative arts practices to create new cultural forms. The title of the series refers not only to a geographical location but also to the West's associations of porcelain with China, and specifically Jingdezhen, due to the country's role as the primary producer of export porcelain to the West from the sixteenth to the twentieth century. This relationship to place is further emphasized by the fact that the artist exclusively uses Chinese models to fashion his busts. Since 1999 the artist's porcelain sculptures have been fabricated by the artisans working at the kilns in Jingdezhen, Jiangxi Province. *China, China – Bust 57*, 2002 **(FIG. 313)**, is inscribed with traditional Chinese landscape motifs and is rendered in a shade of yellow evocative of the imperial yellow commonly used in the Ming period.

Cang Xin's shamanistic performances and photographs serve as a conduit between the physical and spiritual realms. The artist was born in Suihua, Heilongjiang Province, in 1967. He graduated from the Tianjin Conservatory of Music in 1988 and began his mature art practice as a member of the Beijing East Village collective in the early 1990s. During this time Cang began to integrate photography into his work as a means of documenting his performance projects, as did many of his contemporaries. *Communication Series*, a group of color photographs created from 1996 to 2006 **(FIG. 314)**, depicts the artist licking myriad objects. He began licking domestic items like guns, matches, and currency, and later began to incorporate culturally specific artifacts such as a wine-warming vessel, a Chinese feng shui compass, and even the Great Wall. The artist describes this act of engaging the world with his tongue as a form of exchange. For Cang Xin all things, whether animate or inanimate, are imbued with an inherent memory. His interaction through the tongue represents an internalization of knowledge and an attempt to experience the world through one of our most fundamental means of perception.

Cao Fei is one of the leading artists of China's post-Tiananmen generation. The artist was born in 1978 in Guangzhou and studied at the Guangzhou Academy of Fine Arts, receiving a BFA in 2001. Her artistic practice encompasses video, photography, installation, and projects set in the online virtual world Second Life. A common thread across these various mediums is the disjunction between fantasy and reality, and the disillusionment of China's youth within an increasingly materialistic society. *Rabid Dogs*, a single-channel video work from 2002 **(FIG. 315)**, humorously parodies the pervasive consumerism among China's upwardly mobile middle class and their blindly obedient work ethic, evoking domesticated dogs. Set to kitschy 1980s pop tunes, the video depicts office workers, who are uniformly dressed in the iconic tartan plaid pattern used by the fashion brand Burberry, roaming around an office on all fours. Their faces are painted like dogs in the style of traditional Chinese opera stage makeup, providing a stark contrast between tradition and popular culture. The video exposes the rabid consumerism of these white-collar professionals and how it has turned them into animals pandering to their status-seeking desires. *i.Mirror by China Tracy (AKA: Cao Fei) Second Life Documentary Film*, a single-channel video from 2007 **(FIG. 316)**, is one of her virtual projects set in Second Life. Cao was one of the first of her peers to incorporate the Internet in her work after she became fascinated by the online virtual world Second Life and created an avatar for herself named China Tracy. The video serves as a documentary film of China Tracy's experiences in Second Life, narrated through an on-screen transcript that appears as though typed on a computer. The video explores the increasingly liberal social standards of China's younger generation, especially toward sexuality and the interpersonal relationships made possible through new technologies. The accompanying soundtrack,

FIG. 314. Cang Xin. *Communication Series*, 1999. Color photographs, set of 8. Each: H. 24 x W. 19¾ in. (61 x 50.2 cm). Asia Society, New York: Anonymous Gift, 2008.7a-h

FIG. 315. Cao Fei. *Rabid Dogs*, 2002. Single-channel video with sound. Duration: 8 minutes. Asia Society, New York: Gift of Mr. and Mrs. Harold and Ruth Newman, 2011.8

FIG. 316. Cao Fei. *i.Mirror by China Tracy (AKA: Cao Fei) Second Life Documentary Film*, 2007. Single-channel video with sound. Duration: 28 minutes. Asia Society, New York: Gift of Mr. and Mrs. Harold and Ruth Newman, 2011.9

commissioned by the artist, gives the work a music video sensibility that strengthens its association with popular culture. These two examples of the artist's larger practice reflect her focus on the changes occurring within Chinese society at the dawn of the twenty-first century and the strategies adopted by the younger generation to overcome and escape anxiety-provoking realities.

Chen Shaoxiong's conceptual practice employs a variety of media—including photography, video, installation, and traditional ink painting—to investigate China's complicated relationship with its sociopolitical past and it's rapidly evolving present. The artist was born in 1962 in Shantou, Guangdong Province, and graduated from the print department at Guangzhou Academy of Fine Art in 1984. Chen, Lin Yilin, Liang Juhui, and Xu Tan founded the Guangzhou-based collective Big Tail Elephant Group, one of the leading avant-garde artist groups in China in the 1990s. Beginning in the early 2000s Chen began working with traditional ink painting to create stop-motion animation videos. *Ink City*, a single-channel video from 2005 and the first of these ink animations **(FIG. 317)**, is a contemporary take on traditional Chinese landscape painting created from more than three-hundred individual ink paintings that present a cinematic overview of life in China's urban centers. Throughout his practice, the artist

has been interested in the transience and temporality of modern life. The ambient sounds of the city that make up the soundtrack accentuate the rapidly moving images on the screen, collectively underscoring the fleeting changes inherent in life in contemporary China.

Gu Wenda uses language as a medium to deconstruct meaning, challenge traditions, and examine the outcomes of cross-cultural exchanges. The artist was born in Shanghai in 1955 and graduated from the Shanghai School of Arts and Crafts in 1976. In 1981 he received his MFA from the China Academy of Art, where he subsequently taught from 1981 to 1987. The artist immigrated to the United States in 1987 and shortly thereafter settled in New York; subsequently he divided his time between Shanghai and the United States. *Forest of Stone Steles #13*, 1998 **(FIG. 318)**, continues Gu's play on traditional art practices through the medium of ink rubbings. This series references the Stele Forest, a museum in the city of Xi'an that includes over one thousand stone steles that record important political and cultural moments in Chinese history from the Han through the Qing dynasties. This rubbing is from a series of steles created by the artist between 1993 and 2005 that records the translation of a Tang poem into English and back to Chinese including the misinterpretations that naturally occur between these

FIG. 317. Chen Shaoxiong. *Ink City*, 2005. Single-channel stop-motion animation with sound. Duration: 3 minutes, 1 second. Asia Society, New York: Gift of Michael & Jennifer Figge, Mitch and Joleen Julis, and Mr. and Mrs. Harold and Ruth Newman, 2015.3

versions. His use of translation in this context highlights the fluidity of meaning and the subjectivity of interpretation over time and between cultures.

Hai Bo is best known for his nostalgic photographic images that poignantly capture the passage of time through the shifting sociopolitical landscape of contemporary China. The artist was born in 1962 in Changchun, Jilin Province, and received a degree from the print department of the Jilin Art Institute in 1984. He first came to prominence in the 1990s with a series of photo diptychs that juxtaposed found photographs taken during the Cultural Revolution era with staged photographs by the artist that featured the surviving subjects—whom he had tracked down using the found photographs—positioned to mimic the original. The absence of some sitters and altered features of the survivors amplify a sense of loss and subtly document societal shifts since the end of the Cultural Revolution. Hai continued this exploration of the passage of time in The *Northern* series of photographs, three of which are in the Collection: *The Northern*

No. 6 **(FIG. 319)**, *2008-4* **(FIG. 320)**, and *2008-5* **(FIG. 321)**. The images were taken in the northern Chinese province of Jilin, where the artist spent his youth, and document the isolation and loneliness of the rural countryside. The bleakness of the landscape alludes to the population of mostly elderly Chinese citizens who are being left behind in the midst of the country's economic growth. Hai's melancholic tableaux, often depicting a solitary figure in a desolate landscape, memorialize a marginalized portion of Chinese society that the rest of the country has forgotten.

Hong Lei is one of the leading artists to have emerged from the New Photography movement in China in the 1990s. The artist was born in 1960 in Changzhou, Jiangsu Province, and graduated from the Nanjing Academy of Arts in 1987, where he studied traditional lacquer painting. His lush color photographs are inspired by traditional Chinese painting and serve as a rebuke to the increasing influence of the West on contemporary Chinese art and culture. Hong's still-life compositions evoke the tradition

FIG. 318. Gu Wenda. *Forest of Stone Steles #13*, 1998. Ink rubbing on rice paper. H. 69¾ x W. 38 in. (177.2 x 96.5 cm). Asia Society, New York: Asia Society Museum Collection, 1998.2

FIG. 319. Hai Bo. *The Northern No. 6*, 2005. Color photograph. H. 49¼ x W. 49¼ in. (125.1 x 125.1 cm). Asia Society, New York: Gift of Anne and Joel Ehrenkranz, 2015.4

FIG. 320. Hai Bo. *2008-4*, 2008. Color photograph. H. 47¼ x W. 66⅛ in. (120 x 168 cm). Asia Society, New York: Gift of Anne and Joel Ehrenkranz, 2015.5

FIG. 321. Hai Bo. *2008-5*, 2008. Color photograph. H. 47¼ x W. 66⅛ in. (120 x 168 cm). Asia Society, New York: Gift of Anne and Joel Ehrenkranz, 2015.6

FIG. 322. Hong Lei. *After the Song Dynasty Zhao Ji "Loquat and Bird,"* 1998. Chromogenic print. H. 24 x W. 30 in. (61 x 76.2 cm). Asia Society, New York: Anonymous Gift, 2008.8

of bird-and-flower painting popularized during the Song dynasty. His photograph *After the Song Dynasty Zhao Ji "Loquat and Bird"* from 1998 **(FIG. 322)** is at once an homage to Zhao Ji, and a lament over the loss of traditional values. Zhao Ji, also known as Emperor Huizong (1082–1135), was a Song-dynasty emperor who championed the arts and was himself an accomplished calligrapher and painter of bird-and-flower motifs. As with many of Hong's compositions, the bird depicted in the image is deceased. This imagery has come to embody the artist's pessimistic view toward the death of traditional Chinese culture and creativity in the wake of globalization.

Huang Yan's unconventional reinterpretation of traditional Chinese landscape painting challenges conventional artistic practices and creates a unique dialogue between the body and nature, and past and present. The artist was born in 1966 in Jilin Province and graduated from Changchun Normal University in 1987. In 1999 he began creating photographs that documented traditional landscape compositions in the Song-dynasty style painted onto the human body. *Chinese Shan-Shui (Landscape) – Tattoo*, 1999 **(FIG. 323)**, is an early series of thirteen photographs that depicts a mountain landscape painted on a nude male torso in various poses. The title variously pays homage to the tradition of Chinese landscape painting while also alluding to society's increasing fixation with body art. By using the body as his canvas the artist is attempting to reunite man and nature, which he believes have become estranged from one another in contemporary society.

FIG. 323. Huang Yan. *Chinese Shan-Shui (landscape)—Tattoo*, 1999. 13 chromogenic prints; unique set of 12 prints with 1 MP. Each: H. 47¼ x W. 59⅟₁₆ in (120 x 150 cm). Asia Society, New York: Gift of Ethan Cohen in honor of Professor Jerome A. Cohen and Joan Lebold Cohen, 2012.2.1-13

FIG. 324. Lin Yilin. *Safely Maneuvering Across Lin He Road*, 1995. Single-channel video with sound. Duration: 36 minutes, 45 seconds. Asia Society, New York: Gift of Mr. and Mrs. Harold and Ruth Newman, 2011.16

Lin Yilin is best known for his site-specific performances that use the motif of a brick wall to address the issue of widespread gentrification in urban centers throughout China. The artist was born in 1964 in Guangzhou and received a degree in sculpture from the Guangzhou Academy of Fine Arts in 1987. Lin, Chen Shaoxiong, Liang Juhui, and Xu Tan founded the Big Tail Elephant Group, a progressive performance and installation art group based in Guangzhou in the 1990s. During this period, Lin produced site-specific installations, public artworks, and performances to express his perspective on Guangzhou's swift social and political transformation. *Safely Maneuvering Across Lin He Road*, 1995 **(FIG. 324)**, is a video record of a performance by the artist that highlights the futile—and dangerous—act of moving a wall, brick by brick, across a highly trafficked thoroughfare in Guangzhou, which took him hours to complete. The single-channel video documents the artist moving at a snail's pace and produces a sharp contrast to the active construction sites around him.

Song Dong has been considered one of the leading conceptual artists from China since the early 1990s. His artistic practice comprises photography, installation,

video, and performance art, and often examines ephemerality and the passage of time through the lens of his own experiences. The artist was born in 1966 in Beijing and graduated from the Fine Arts Department of Beijing Capital Normal University in 1989. *Burning Mirror* **(FIG. 325)**, created in Beijing in 2001 at the beginning of the city's ambitious gentrification process in preparation for the 2008 Summer Olympics, highlights the changing urban landscape through alternate depictions of a quiet residential area, a bustling thoroughfare, and a demolition site. By capturing the reflection of the cityscape on a translucent plastic sheet that is then set ablaze, this single-channel video addresses the physical and psychological toll of gentrification on urban residents.

Sun Xun's video animations, drawings, paintings, and site-specific installations consider the lingering impact of the Cultural Revolution on Chinese society and reflect the artist's preoccupation with the subjective nature of history and the disconnect between personal experience and officially recorded events. The artist was born in 1980 in Fuxin, an industrial mining town in northeastern China, part of the first generation of artists born after the end of the Cultural Revolution. He graduated from the print

FIG. 325. Song Dong. *Burning Mirror*, 2001. Single-channel video. Duration: 13 minutes. Asia Society, New York: Gift of Julie Walsh, 2009.1

Above and opposite detail: **FIG. 326.** Sun Xun. *The Time Vivarium*, 2015. Four-channel animation with sound. Duration: 10 minutes. Asia Society, New York: Gift of Mitch and Joleen Julis, 2015.13

department at the China Academy of Fine Arts in 2005 and founded Pi animation studio one year later. Sun's surreal narratives often explore the themes of global history, culture, memory, and politics through the use of animals and other allegorical characters. *The Time*

Vivarium, 2015 **(FIG. 326)**, is a four-channel video animation the artist created in New York as part of a residency at the Sean Kelly gallery. Its title was inspired by Sun's visit to the American Museum of Natural History, during which time he was struck by how the museum's exhibits

were created with a sociopolitical subjectivity that could be equated to the way in which governments spin their cultural histories. The video, set to an instrumental soundtrack by Mahler, incorporates symbolic imagery taken from the artist's larger body of work—including that of movie cameras, megaphones, and real and mythical animals that inhabit an expressionist landscape evocative of Song-dynasty landscape paintings—to allude to the cacophony of China's recent past.

Wang Gongxin is considered one of the forefathers

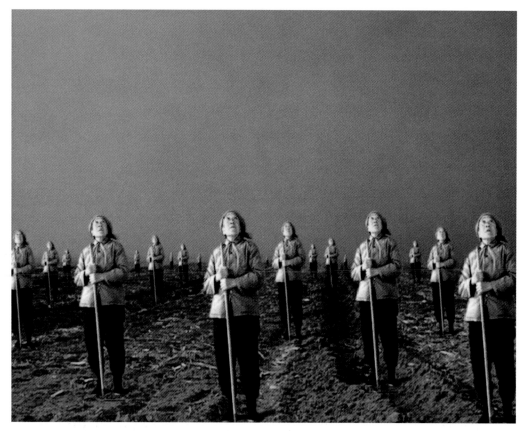

FIG. 327. Wang Gongxin. *My Sun*, 2000. Three-channel video installation with sound. Duration: 7 minutes, 25 seconds. Asia Society, New York: Gift of Mr. and Mrs. Harold and Ruth Newman, 2008.3

FIG. 328. Wang Gongxin. *Always Welcome*, 2003. Two-channel stop-motion animation with sound; four monitors. Duration: 1 minute, 16 seconds. Asia Society, New York: Gift of Mitch and Joleen Julis, 2015.9. Installed at Asia Society Museum, New York, in 2016; **FIG. 15** in the background.

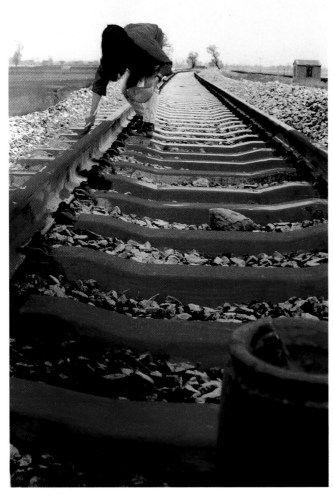

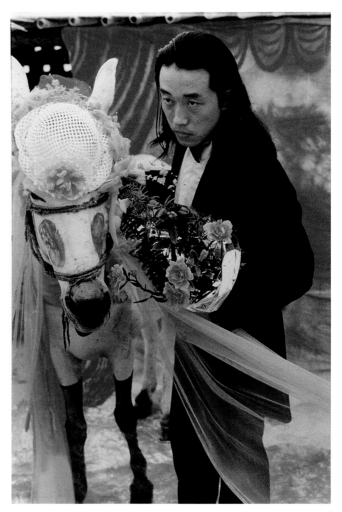

FIG. 329. Wang Jin. *Beijing–Kowloon*, 1994. Chromogenic print. H. 46 x W. 30¾ in. (116.8 x 78.1 cm). Asia Society, New York: Gift of Barry Friedman, 2013.5

FIG. 330. Wang Jin. *To Marry a Mule*, 1995. Chromogenic print. H. 101 x W. 67 in. (256.5 x 170.2 cm). Asia Society, New York: Gift of the Friedman Benda Gallery, 2013.6

of new media art in China. His video installations often humorously take on social and cultural clichés and misconceptions of traditional Chinese culture. The artist was born in 1960 in Beijing and received a BFA from the Beijing Capital Normal University in 1982. The development of his early video works were initiated during a formative period in the 1990s spent in New York with his wife and fellow artist Lin Tianmiao. *My Sun*, a three-channel video installation created in 2000 **(FIG. 327)**, is a surreal rumination on the legacy of the Cultural Revolution and the subsequent rise of individualism in contemporary Chinese society. An elderly peasant woman is depicted sowing a field as a shining light emerges on the horizon. Wang was a part of the generation of Chinese youth who were "sent down" to the country to learn from peasants during the 1960s and his imagery alludes to this memory. Similarly, the artist's use of the light on the horizon is a nod to Mao Zedong and his association with the rising sun in communist propaganda materials. As the woman looks toward the light her image is duplicated

and dispersed across the landscape. She captures the light in her hands where it gradually diminishes and finally disappears. *Always Welcome*, 2003 **(FIG. 328)**, is a humorous video installation that illuminates the shifting meaning of traditional Chinese cultural artifacts in a globalized world. Wang's stone lions play off the disjunction between the West's kitschy associations with these symbols and their longstanding representation of protection and wealth in Chinese culture. Lions are not native to China, but there is a long tradition dating from as early as the third century CE of creating pairs of guardian lions. To this day stone lions are found guarding the entrances to official buildings and temples. Wang's update of the motif through movement and sound is meant to directly engage the viewer and the friendly demeanor of his lions neutralizes the confrontational attitude that these protective sculptures were originally meant to convey.

Wang Jin's multifaceted practice incorporates performance, photographs, and installations to examine the social effects of China's economic growth after the

FIG. 331. Wang Qingsong. *Follow Him*, 2010. Chromogenic print. H. 51⅛ x W. 118⅛ in. (130 x 300 cm). Asia Society, New York: Purchased with funds donated by Cynthia Hazen Polsky and Leon Polsky, 2011.31

Cultural Revolution and the subsequent relationship between commerce and the hierarchies of power. The artist was born in 1962 in Datong, Shanxi Province, and received a degree in traditional Chinese painting at the China Academy of Art in Hangzhou in 1987. Considered one of the pioneers of conceptual and performance-based art, Wang's experimental, often politically charged performances in the 1990s engaged the shifting social attitudes and environmental issues that emerged during that period. The artist's photo documentation remains the primary record for his seminal performances from the 1990s and *Beijing – Kowloon*, 1994 **(FIG. 329)**, in particular

captures a timely moment in the country's political history and the artist's career. This photograph documents a performance in which the artist painted the railroad ties of a new rail link between Beijing and Hong Kong that was being built in anticipation of the impending 1997 return of Hong Kong to China. The political and economic implications of this act highlight China's long-time proprietary hold on Hong Kong that reverberates to the present. Wang's most iconic photograph, *To Marry a Mule* **(FIG. 330)**, created one year later, takes umbrage with the Chinese government on a more personal level. The photograph depicts a staged mock wedding of the artist

and his mule-bride, who dons a hat and stockings. The garish tableau is a sardonic, absurdist commentary and lamentation of the artist's own frustration with being repeatedly denied permission by the Chinese government to visit his wife, who had immigrated to the United States.

Wang Qingsong's heroic photographs depict the shifting social and political mores within contemporary Chinese society largely driven by the country's insatiable consumer appetite. The artist was born in 1966 in Daqing, Heilongjiang Province, and he graduated from the Sichuan Fine Arts Institute in 1993. Wang began working with photography as a means to capture the rapid change occurring around him. The documentary quality of this medium can provide a semblance of truth, which greatly appealed to the artist. To create his large-scale compositions Wang builds elaborate prop-filled sets in warehouses and soundstages. In preparation for his 2010 photograph *Follow Him* (**FIG. 331**), Wang collected dictionaries, books, and magazines about literature, poetry, and law, along with college preparatory materials, over the course of an entire year, and let them molder on their shelves. This massive undertaking is meant as a critique of the current education system in China, which emphasizes the importance of results over true knowledge.

FIG. 332. Xu Bing. *Inside Out New Chinese Art—Calligraphy*, 1998. Ink on paper. H. 30½ x W. 10⅝ in. (77.5 x 27 cm). Asia Society, New York: Asia Society Museum Collection, 1998.3

Xu Bing's ruminations on the indelible relationship between language and society has been an ongoing subject of his work since the 1980s, when he was first recognized for his now iconic installation *Book From the Sky* from 1987. The artist was born in Chongqing in 1955 and received a BFA in printmaking from the Central Academy of Fine Arts in 1981 and an MFA in 1987. In 1990 the artist immigrated to the United States following a residency at the University of Wisconsin-Madison. In 1999 Xu Bing was the recipient of a MacArthur Fellowship in recognition of his contributions to society in relation to his work in printmaking and calligraphy. Xu subsequently returned to Beijing to serve as the Vice President of the Central Academy of Fine Arts from 2008 to 2014 and began to divide his time between Beijing and New York. *Inside Out New Chinese Art—Calligraphy*, 1998 **(FIG. 332)**, is an ink drawing commissioned by Asia Society on the occasion of the 1998 landmark exhibition "Inside Out: New Chinese Art." This work illustrates Xu's square word calligraphy—a writing system that the artist created in which English words are written in a manner that makes them resemble Chinese characters. This cross-cultural fusion of language forces viewers to reassess their preconceived notions about the written language and subsequently about larger cultural assumptions. *Excuse me Sir; Can you tell me how to get to the Asia Society?*, 2001 **(FIG. 333)**, is another commission by the institution in honor of its reopening at 725 Park Avenue in New York City. This multimedia work features four monitors of decreasing size mounted on a metal rod fabricated to resemble a reed. The monitors act as a scrolling marquee that features the following text in the artist's signature square word calligraphy text: *Excuse me, sir, can you tell me how to get to the Asia Society? Get off the number six train at the sixty eighth street stop, go north two blocks, and then make a left and walk to Park Avenue. It is right there. Thank you.* Of this work, Xu likens the identity of Asia Society with the philosophy behind his square word calligraphy noting, "'The Asia Society *in* New York' is a very interesting concept with the sense of 'I am within you and you are within me.' This is the same idea as my use of Square Word Calligraphy characters in this artwork."

Xu Guodong's contemplative sculptures continue the centuries-old connoisseurship of scholar's rocks. Beginning in the Tang Dynasty (618–907 CE) literati scholars began collecting limestone rocks that had a pleasing, contemplative asymmetry or evoked recognizable forms found in nature. Xu was born in Shanghai in 1950, the son of respected landscape rock sculptor Xu Zhiming, who instilled a passion for scholar's rocks in his son. *Garden*

FIG. 333. Xu Bing. *Excuse me Sir; Can you tell me how to get to the Asia Society?*, 2001. Mixed-media installation with animation. Overall: H. 24 x W. 196 x D. 5⁹⁄₁₆ in. (61 x 497.8 x 14.1 cm); Duration: Continuous loop. Asia Society, New York: Gift of Jack and Susy Wadsworth, 2006.1. Installed at Asia Society Museum, New York.

Viewing Rock, 2001 **(FIG. 334)**, a Lingbi stone, which is a type of limestone found in Anhui Province, is a classic example of this literati tradition. The artist often inscribes his stones and he notes, "I engraved inscriptions into the back of the rock. For example, *xiang-shi-shan-zhi* (made by a mountain man who tames rocks). . . . The inscription indicates that in a certain period of history there is only one craftsman who uses his artistic skills and devotes himself to rock sculpting. Through this method, the rock-tamer challenges the traditional aesthetics of landscape rocks in an irreplaceable way."

Yang Fudong is considered one of China's leading video artists from the second generation of artists to come of age after the Cultural Revolution. The artist was born in Beijing in 1971, and graduated from the China Academy of Art in Hangzhou in 1995. Yang is best known for his iconic series *Seven Intellectuals in a Bamboo*

Forest **(FIGS. 335–339)**, comprising five single-channel videos filmed from 2003 to 2007, which explores the journey of seven friends in their quest to reconcile the distance between the utopian ideals of youth with the realities of life in contemporary China. The artist modeled his protagonists after the Seven Sages, a group of idealistic men from the literati class in China during the third century CE who rejected the corruption found in conventional society and withdrew from public life in search of a lifestyle more closely in balance with nature. The artist transposes the Daoist ideas and icons celebrated in the oft-depicted subject *Seven Sages of the Bamboo Grove* to explore the disaffected attitude of contemporary youth in China. Each part of the non-narrative series is presented within very disparate locations to emphasize the disjoined existence of contemporary life: *Part I* **(FIG. 335)** was filmed on Yellow

Mountain, located in China's southern Anhui Province. The setting was chosen specifically for its natural beauty to underscore the estrangement between nature and contemporary society. *Part II* **(FIG. 336)** is set in contemporary Shanghai and centers on interpersonal relationships, especially between men and women as a means to deconstruct the relationship between desire and the societal pressures to refrain from acting on one's impulses. *Part III* **(FIG. 337)** brings the group of seven friends back into the rural countryside to illuminate their attempt to reconcile their relationship to nature with their quest for personal fulfillment. The proceedings in *Part IV* **(FIG. 338)** take place by the sea, where the discourse of individual and philosophical ideologies is shared in the spirit of Daoist practice of *qingtan*, or pure conversation, thought to be practiced by the Seven Sages. The final part of the series, *Part V* **(FIG. 339)** brings the group back to urban Shanghai to face their uncertain futures. The series was shot on black-and-white 35-mm film, which for the artist conveys a sense of temporal distance and introduces the viewer to a pace that is slower than the rushed existence of contemporary daily life. Much like their real-life counterparts, these seven "intellectuals" are in search of an idealized future that remains uncertain and seemingly unattainable.

Zhang Dali's photographs from the 1990s highlight the tenuous dynamic between construction and destruction inherent in urban renewal projects and serve as a critique of Beijing's aggressive gentrification program during that period. The artist was born in 1963 in Harbin and he graduated from the Central Academy of Art and Design in Beijing in 1987. Between 1995 and 1998 the artist created over two thousand photographs documenting his graffiti interventions across the city of Beijing. Zhang created a set of criteria for his compositions. First, the photograph must depict a demolition site with one of the following: a national monument, an imperial palace, or a new construction project. Second, embedded in each image there must be a silhouetted self-portrait of the artist in profile, either carved out of a wall or as a graffiti tag, as seen in *Demolition*, 1998 **(FIG. 340)**. The artist's unique signature is a reminder of the many individual lives that are disrupted in the wake of social and economic progress.

Zhang Huan is best known for the provocative and often physically grueling endurance-based performances that he began during his time living in the Beijing East Village in the early 1990s and continued after his move to New York in 1998. The artist was born in 1965 in Anyang, Henan Province, and received his BA from Henan University

Opposite: **FIG. 334.** Xu Guodong. *Garden Viewing Rock*, 2001. Lingbi stone. Stone: H. 88 x W. 52 x D. 20 in. (223.5 x 132.1 x 50.8 cm); base: H. 26½ x W. 32 x D. 23 in. (67.3 x 81.3 x 58.4 cm). Asia Society, New York: Gift of Jack and Susy Wadsworth, 2006.2

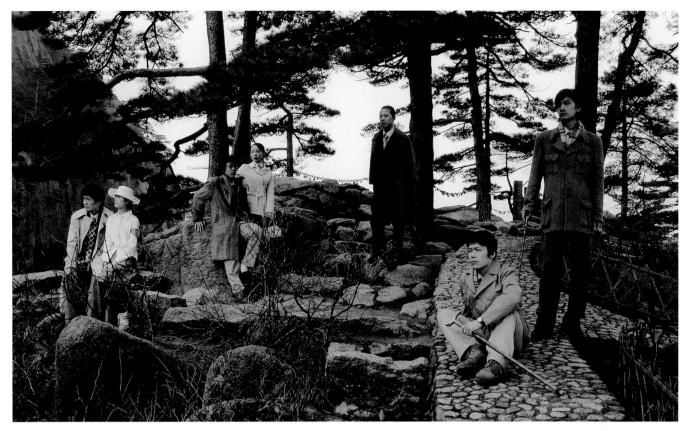

FIG. 335. Yang Fudong. *Seven Intellectuals in a Bamboo Forest, Part I*, 2003. Single-channel video with sound; 35mm black-and-white film transferred to DVD. Duration: 29 minutes, 22 seconds. Asia Society, New York: Gift of Mr. and Mrs. Harold and Ruth Newman, 2011.24

FIG. 336. Yang Fudong. *Seven Intellectuals in a Bamboo Forest, Part II*, 2004. Single-channel video with sound; 35mm black-and-white film transferred to DVD. Duration: 46 minutes, 15 seconds. Asia Society, New York: Gift of Mr. and Mrs. Harold and Ruth Newman, 2011.25

FIG. 337. Yang Fudong. *Seven Intellectuals in a Bamboo Forest, Part III*, 2005. Single-channel video with sound; 35mm black-and-white film transferred to DVD. Duration: 53 minutes. Asia Society, New York: Gift of Mr. and Mrs. Harold and Ruth Newman, 2011.26

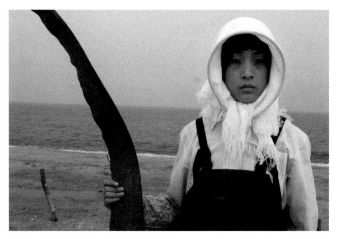

FIG. 338. Yang Fudong. *Seven Intellectuals in a Bamboo Forest, Part IV*, 2006. Single-channel video with sound; 35mm black-and-white film transferred to DVD. Duration: 70 minutes. Asia Society, New York: Gift of Mr. and Mrs. Harold and Ruth Newman, 2011.27

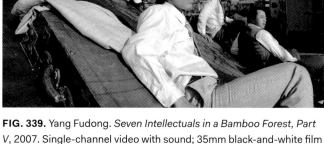

FIG. 339. Yang Fudong. *Seven Intellectuals in a Bamboo Forest, Part V*, 2007. Single-channel video with sound; 35mm black-and-white film transferred to DVD. Duration: 90 minutes. Asia Society, New York: Gift of Mr. and Mrs. Harold and Ruth Newman, 2011.28

in Kaifeng in 1988 and his MA from the Central Academy of Fine Arts in Beijing in 1993. The artist has stated that his very physical performance projects provide a fundamental and direct engagement with society and what began as intimate soliloquies developed into large-scale projects that incorporated the participation of others. The

1997 photographs *To Raise the Water Level in a Fishpond* **(FIG. 341)** and *To Raise the Water Level in a Fishpond (Line Man)* **(FIG. 342)** document one of Zhang's earliest collaborative performances. For this work the artist recruited forty volunteers, primarily recent migrants to Beijing, to collectively raise the level of a local pond by one meter by

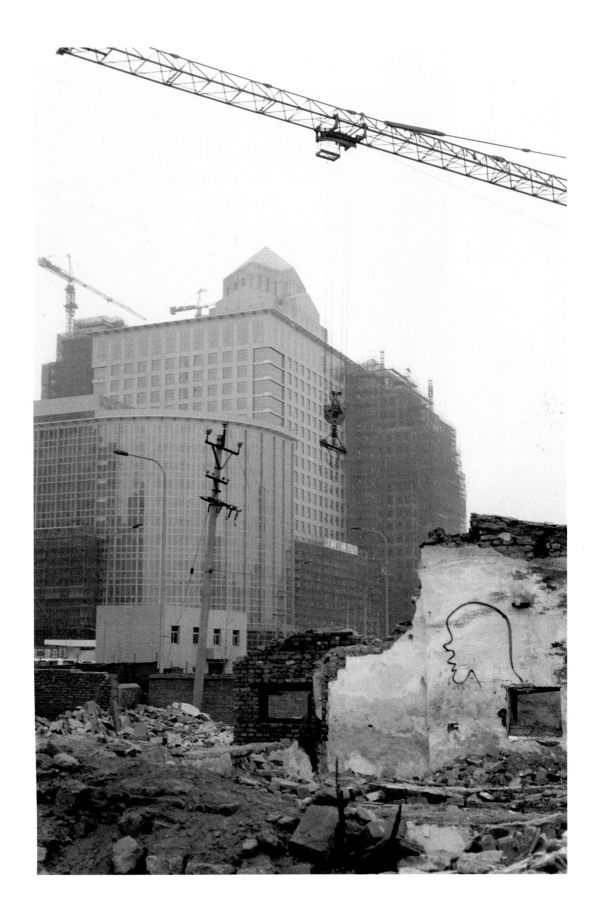

FIG. 340. Zhang Dali. *Demolition*, 1998. Chromogenic print. H. 43⅜ x W. 31½ in. (110.2 x 80 cm). Asia Society, New York: Anonymous Gift, 2008.10

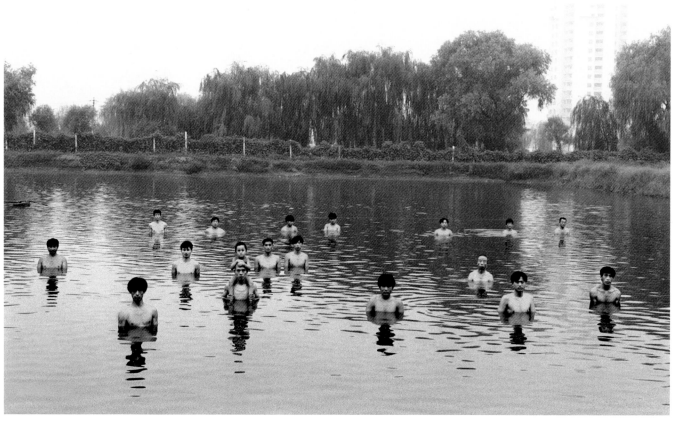

FIG. 341. Zhang Huan. *To Raise the Water Level in a Fish Pond*, 1997. Chromogenic print. H. 41¼ x W. 61 in. (104.8 x 154.9 cm). Asia Society, New York: Gift of Altria Group Inc., 2008.14

FIG. 342. Zhang Huan. *To Raise the Water Level in a Fishpond (Line Man)*, 1997. Chromogenic print; Fuji archival paper. H. 27 x W. 40 in. (68.6 x 101.6 cm). Asia Society, New York: Gift of the Friedman Benda Gallery, 2013.7

FIG. 343. Zhang Huan. *My America*, 1999. Chromogenic print. H. 40 x W. 60 in. (101.6 x 152.4 cm). Asia Society, New York: Gift of the Friedman Benda Gallery, 2013.8

FIG. 344. Zhang Huan. *My America*, 1999. Chromogenic print. H. 40 x W. 60 in. (101.6 x 152.4 cm). Asia Society, New York: Gift of the Friedman Benda Gallery, 2013.9

using their bodies. Upon Zhang's arrival to the United States the artist began to create works that commented on the cultural specificity of his adopted home. A pair of prints from the 1999 *My America* series **(FIGS. 343 AND 344)** documents a performance in which the artist invited fifty-six Americans to disrobe and follow a set of instructions including the directive to stone him with bread loaves. The project was created in response to the artist's difficulty acclimating to his adopted home and is a meditation on the spiritual desolation of contemporary western lifestyles. *My America* is significant as Zhang's first major performance series created in the United States. Like the *To Raise the Water Level in a Fishpond* photographs, the *My America* series demonstrates the artist's engagement with local communities to comment on the cultural specificities of a place.

FIG. 345. Zhuang Hui. *One and Thirty Series*, 1995–6. Gelatin silver print. H. 30 x W. 24 in. (76.2 x 61 cm). Asia Society, New York: Anonymous Gift, 2008.12

FIG. 346. Zhuang Hui. *Bath House Series*, 1996. Chromogenic print. H. 39½ x W. 27 in. (100.3 x 68.6 cm). Asia Society, New York: Anonymous Gift, 2008.11

Zhuang Hui's photographs explore the notion of identity within the shifting sociopolitical landscape of contemporary China through the experiences of everyday citizens. The artist was born in 1963 in the remote town of Yumen in Gansu Province and was inspired early on by his father, a professional photographer, who traveled to remote areas of the country on photography assignments to document the local people until his untimely death when the artist was seven years old. *One and Thirty Series*, 1995–6 **(FIG. 345)**, is a photograph from a series of thirty images depicting the artist with Chinese citizens from all social and professional classes. The straightfor-ward, black-and-white documentary format of the images captures the beginnings of a shift toward a broader socioeconomic spectrum within contemporary Chinese society. In a slightly later group of work entitled *Bath House Series*, 1998 **(FIG. 346)**, the artist documented patrons at a community bath house to emphasize the loss of the social interactions associated with communal life under the communist regime.

Zhang Peili is widely acknowledged as the "father of Chinese video art." Like many of his generation, Zhang's formal training was in painting. However, during the late 1980s he began experimenting with video, initially as a way to record his durational performances. Zhang was born in 1957 in Hangzhou and graduated from the China Academy of Fine Arts in Hangzhou in 1984 with a degree in oil painting. In the 1980s he was a founding member of the Pond Society, an artist collective based in Hangzhou. *Continuous Reproduction*, 1993 **(FIG. 347)**, is an early series of twenty-five gelatin silver prints that depict an appropriated propaganda image of young peasant girls happily working the fields. Each subsequent repetition appears more faded until it has become so deteriorated that the image is unrecognizable. The disintegration of this imagery formerly used to inspire the people to embrace communist ideals alludes to the unsustainability of Mao's utopic vision. *Go Ahead, Go Ahead* **(FIG. 348)**, a two-channel video from 2004, juxtaposes sequences from a vintage Chinese propaganda film and the

FIG. 347. Zhang Peili. *Continuous Reproduction*, 1993. Gelatin sliver prints, set of 25. Each: H. 12 x W. 10 in. (30.5 x 25.4 cm). Asia Society, New York: Anonymous Gift, 2008.13a-y

FIG. 348. Zhang Peili. *Go Ahead, Go Ahead*, 2004. Two-channel video with sound. Duration: 8 minutes, 46 seconds. Asia Society, New York: Gift of Mr. and Mrs. Harold and Ruth Newman, 2011.29

FIG. 349. Zhang Peili. *Scenic Outside the Window*, 2007. Single-channel video projection with sound. Duration: 6 minutes, 43 seconds. Asia Society, New York: Gift of Guy & Myriam Ullens Foundation, 2012.5

Hollywood-produced war movie *We Were Soldiers*, a rumination on the Vietnam War. The artist's intentional removal of footage depicting death or injury results in an aestheticized depiction of combat and xenophobic displays of national military strength. *Scenic Outside the Window,* 2007 **(FIG. 349)**, a single-channel projection, captures the view outside the artist's studio during various weather conditions including fog, wind, lightning, rain, and sunshine. The documentation of these ephemeral moments serves as a marker of time while also prompting the viewer to reassess his or her attitude toward the banalities of everyday life. The artist specifies that the work should be placed opposite from a physical window in the gallery to create a dialogue between experience in real time and a constructed reality.

Zhou Xiaohu's videos and mixed-media animations challenge conventional beliefs and question perception by blurring the distinction between reality and fiction. The artist was born in 1960 in Changzhou, Jiangsu Province, and was trained as an oil painter at the Sichuan Academy of Fine Arts in Chongqing. *The Gooey Gentleman* **(FIG. 350)**, a single-channel video animation from 2002, comments on contemporary sexual relationships and a world in which technology and social media dominate everyday life. The artist humorously explores the complexity of male/female courtship using traditional ink painting on a male and female torso. The stop-motion animation video is accompanied by a deliberately stilted soundtrack of a famous Shanghainese love song. The retro sound is meant to emphasize how antiquated traditional notions of romance may seem in an increasingly high-tech world.

FIG. 350. Zhou Xiaohu. 28 stills from *The Gooey Gentleman*, 2002. Single-channel stop-motion animation with sound; light box. Duration: 4 minutes, 40 seconds. Asia Society, New York: Purchased with funds donated by Christopher E. Olofson, 2012.3

FIG. 351. Zhu Jia. *Never Take Off*, 2002. Single-channel video with sound. Duration: 6 minutes. Asia Society, New York: Gift of Christopher E. Olofson, 2011.2

Zhu Jia's videos and photographs chart the economic, social, and political shifts in China that came about in the wake of the Cultural Revolution. The artist was born in 1963 in Beijing and graduated from the oil painting department at the Central Academy of Fine Arts in 1988. *Never Take Off*, 2002 **(FIG. 351)**, is a single-channel looping video that depicts a Boeing 747 endlessly circling the runway for takeoff. It is an indefinitely delayed gratification as the plane never takes off. The accompanying soundtrack of a plane's ascent intertwined with the canned cabin music piped in for pre-takeoff leaves the viewer in perpetual anticipation.

Japan

The development of modern art in Japan was disrupted by the second Sino-Japanese war, from 1937 to 1945, and Japan's involvement in World War II. Following the reconstruction period, Japanese postwar art underwent a period of great experimentation championed by a number of influential avant-garde movements, most notably the Gutai and the Anti-Art and Non-Art movements of the 1960s and 1970s, the latter including Mono-ha, which incorporated the interdisciplinary practices of painting, sculpture, performance, and installation, and new media art beginning in the 1970s. Concurrent with these movements was the propagation of traditional media such as calligraphy, Japanese-style painting (*nihonga*), and decorative arts. Painting remained a strong influence within these artistic genres culminating in the development of the New Wave

movement in the 1980s. New technologies, as well as a focus on popular culture, especially in the form of anime, manga, and *kawaii* aesthetic, inspired the development of Neo-Pop in reaction to the rigorously conceptual ideas from the previous decades. The continuing influence of traditional Japanese art forms, including *ukiyo-e* prints and *nihonga* painting, has permeated contemporary art vocabularies throughout the postwar period through the twenty-first century.

Makoto Aida's provocative paintings, sculptures, videos, and installations explore psychologically charged subject matter most often relating to sex, violence, war, and politics. The artist was born in 1965 in Niigata Prefecture and moved to Tokyo to study painting at the Tokyo National University of Fine Arts and Music, receiving a BFA in 1989 and an MFA in 1991. Aida's single-channel video, *The video of a man calling himself Bin Laden staying in Japan*, 2005 **(FIG. 352)**, is a humorous parody of the amateur video messages disseminated by terrorists to international media outlets. The artist impersonates one of the world's most reviled terrorists, Osama Bin Laden, as a drunken coward who has sought refuge as a fugitive in Japan. Aida's fictionalized video message reveals that Bin Laden has retired from his life of terrorism and he implores the viewer to leave him alone. Aida's tongue-in-cheek satire is a subtle critique of contemporary Japanese society's apathetic and insular political attitudes.

Chim↑Pom is an artist collective that was founded in 2005 in Tokyo and includes Ellie, Okada Masataka, Inaoka Motomu, Ushiro Ryūta, Mizuno Toshinori, and Hayashi Yasutaka. The group's work engages with contemporary

FIG. 352. Makoto Aida. *The video of a man calling himself Bin Laden staying in Japan*, 2005. Single-channel video with sound. Duration: 8 minutes, 14 seconds. Asia Society, New York: Gift of Mr. and Mrs. Harold and Ruth Newman, 2011.7

social and political issues often using references from popular youth culture. Their interdisciplinary approach includes video, installation, publications, and, more recently, curatorial interventions. *KI-AI 100* (**FIG. 353**), a two-channel video projection from 2011, was created in response to the March 11, 2011, earthquake and subsequent Fukushima Daiichi nuclear plant disaster in Japan. The video was shot in Soma, fifty kilometers from the nuclear plant with the participation of local youths who were working as relief volunteers. *KI-AI 100* means "100 cheers" and refers to the martial arts practice of chanting as a way to collect inner energy before staging an attack. The rousing series of dedications, messages of inspiration, wishes for reconstruction, and sometimes nonsense syllables serve as a cathartic and inspirational act in the wake of tragedy.

Akino Kondoh's multidisciplinary practice includes animation, manga, drawing, and painting executed in a graphic style influenced by her background in graphic design. Her works allude to recollections of childhood memories and feminine adolescent experiences that often take on a surreal, nightmarish quality. Kondoh was born in Chiba in 1980 and she graduated from Tama Art University in 2003. *The Evening Traveling* (**FIG. 354**), a playful black-and-white video animation from 2001/2002, is evocative of the artist's animations in style and content. A young girl takes the viewer on a journey into her imagination through a choreographed dance performance. The protagonist is introduced to the viewer between parted curtains on a stage and the ensuing nonlinear dreamlike sequences alternately morph from a lamp-lit interior to a stage and an urban cityscape through which the protago-

FIG. 353. Chim↑Pom. *KI-AI 100*, 2011. Two-channel video projection with sound. Duration: 5 minutes, 20 seconds. Asia Society, New York: Gift of Dr. Michael I. Jacobs, 2013.1

FIG. 354. Akino Kondoh. *The Evening Traveling*, 2001–2. Single-channel animation with sound; music by CHIKU Toshiaki. Duration: 3 minutes, 56 seconds. Asia Society, New York: Gift of Mr. and Mrs. Harold and Ruth Newman, 2011.14

nist joyfully traipses, accompanied by her reflected and multiplied image to reveal the many facets of her inner life.

Mami Kosemura uses new-media techniques to reinterpret traditional painting practices. The artist was born in 1975 in Kanagawa and she received a Ph.D. in painting from the Tokyo National University of Fine Arts and Music in 2005. Kosemura has created a number of video works in which she examines various methods and styles of artistic production in the history of art from across the world. *Flowering Plants of the Four Seasons* **(FIG. 355)** is focused on the convention of Japanese traditional painting. Kosemura juxtaposes the process of copying directly from nature with the tradition of copying past master paintings to reflect the passage of time, as well as the cycle of death and renewal in nature and art. Inspired by traditional Japanese screen painting, Kosemura created this "moving-painting" installation in her studio by arranging seasonal plants and flowers into a composition emulating classical depictions of *The Four Seasons*. The artist recorded their growth and decay with a stationary digital camera over the course of a year and the resulting photographs were then collaged together to create a moving image.

Through her use of video technology, Mariko Mori illuminates the transcendental forces of nature and the

FIG. 355. Mami Kosemura. *Flowering Plants of the Four Seasons*, 2004–6. Three-channel video animation with sound. Duration: 36 minutes, 30 seconds. Asia Society, New York: Gift of Mr. and Mrs. Harold and Ruth Newman, 2011.15

role tradition and spirituality play in the development of the present and future. The artist was born in Tokyo in 1967 and graduated from the Chelsea College of Art & Design in London in 1992. *Kumano* **(FIG. 356)**, a single-channel video created between 1997 and 1998, was inspired by a dream the artist had after a visit to Kumano in 1997. Kumano has been revered by Shinto and Buddhist devotees as one of the most sacred locations in Japan and has attracted pilgrims since the eighth century. The site serves as the backdrop for the artist to take on the persona of three spiritual deities: a forest fairy, a shaman performing a Shinto ritual dance, and a futuristic hostess who performs a traditional tea ceremony in a Buddhist temple. These personas respectively signify the past, present, and future, and allude to the evolving history of the site in relation to the development of organized religion in Japan.

Motohiko Odani's multidisciplinary practice studies the dichotomy between humankind and nature through the lens of bioengineering technology and the exploration of primal sensations such as desire, fear, and pain. The artist was born in 1972 in Kyoto and received an MFA from Tokyo National University of Fine Arts and Music. A main theme underlying his sculpture, photography, and video work is the mutation of humans and animals. *Rompers* **(FIG. 357)**, a single-channel video from 2003, depicts a young girl happily singing while perched on a tree branch. She is surrounded by woodland animals and insects, and on the surface all seems normal. Upon closer inspection however, the flora and fauna begin to take on a surreal, mutated appearance culminating in the sudden ingestion of an insect by the girl, whose tongue has turned into that of a reptile. The title of the work is a play on the children's TV program *Romper Room* that was televised in the United States from the 1950s to the 1990s and is a humorous view of what the artist sees as the surreal, psychedelic traits found in both children's television and nature.

Yoko Ono's collaborative practice encompasses installation, performance, experimental films, music, and social activism. She has been on the forefront of the avant-garde since the early 1960s when she participated in the fluxus movement in New York. Ono was born in Tokyo in 1933 and spent her childhood living between Japan and the United States. Her pioneering conceptual works have gained greater recognition as performance has become more widely accepted as a fine art form. *Sky*

FIG. 356. Mariko Mori. *Kumano*, 1997–8. Single-channel video with sound; sound by Ken Ikeda. Duration: 8 minutes, 50 seconds. Asia Society, New York: Purchased with funds donated by Carol and David Appel, 2009.3

FIG. 357. Motohiko Odani. *Rompers*, 2003. Single-channel video with sound; sound by Pirami. Duration: 2 minutes, 52 seconds. Asia Society, New York: Gift of Mr. and Mrs. Harold and Ruth Newman, 2011.17

FIG. 358. Yoko Ono. *Sky TV (single) for New York*, 1966/2007. Direct feed closed-circuit TV installation. Duration: Continuous loop. Asia Society, New York: Gift of Mr. and Mrs. Harold and Ruth Newman, 2008.1

TV (single) for New York, 1966/2007 **(FIG. 358)**, is a closed-circuit video installation that transmits views of the sky to an indoor monitor via a live-feed camera. The original work was conceived shortly after the development of the Sony Portapak, the first commercial portable video camera, with the intention of pointing the camera upward to the sky. This presentation in real time captures clouds, passing birds, airplanes, and the heavens, and transmits these fleeting images, allowing the TV monitor to become a window to the universe.

Hiraki Sawa's surreal video works, often set in intimate interior settings, ruminate on the issues of memory, displacement, and migration within the context of psychologically charged landscapes. The artist was born in Ishikawa in 1977 and settled in London where he received a BA from the University of East London and an MFA from the Slade School of Art, University College, London. *Trail* **(FIG. 359)**, a single-channel video from 2005 is set in a dimly lit apartment. The viewer is led by a caravan of silhouetted animals through a dreamscape. The methodical plodding of the procession, executed in the spirit of Eadweard Muybridge's nineteenth-century chronophotography, creates a hypnotic rhythm that lulls the viewer into a dreamlike trance. A soft, music-box-type melody plays as the procession continues its meandering journey across windowsills, faucets, and around the humble objects that life comprises.

Tabaimo's large-scale video installations are inspired by traditional Japanese *ukiyo-e* woodblock prints and contemporary manga comic styles. The artist was born in 1975 in Hyōgo and she graduated from Kyoto University of Art and Design in 1999. *haunted house,* 2003 **(FIG. 360)**, is derived from the artist's own childhood experience of entering a haunted house in an amusement park. The video projector's movement from side to side accentuates a sense of voyeurism in the way it positions viewers to feel as if they are observing everyday actions through a telescope. The ordinary actions depicted in *haunted*

FIG. 359. Hiraki Sawa. *Trail*, 2005. Single-channel video with animation and sound. Duration: 14 minutes. Asia Society, New York: Gift of Mr. and Mrs. Harold and Ruth Newman, 2011.18

house reflect scenes present in everyday life but when paired with the stilted carnival music soundtrack and fleeting images of disturbing events, the work gives a sense of psychological unease, alluding to the anxiety beneath the calm surface of Japanese society.

Koki Tanaka's video projects are revealing vignettes of daily life. Tanaka was born in 1975 in Tochigi and moved to Los Angeles in 2011. A series of looping videos created from 2000 to 2003 are meant to create circular associations between things that at first are seemingly unrelated. Singling out these gestures and actions as significant and meaningful is a philosophical approach toward human cognition. *Moving Still*, 2000 **(FIG. 361)**, is a simple, mesmerizing video of Coca-Cola pouring out of a can that is turned sideways on a table. The never-ending video loop prevents the liquid from completely emptying out of its container, while the title wittily plays on the formats of moving imagery versus still images. Similarly, *Light My Fire*, 2002 **(FIG. 362)**, follows a burning fuse that never fulfills the probability of igniting a blast. *Each and Every*, 2003 **(FIG. 363)**, captures the repetitive actions of a Japanese chef whose seamless multitasking reveals the complexity of his daily routine. *123456*, 2003 **(FIG. 364)**, is Tanaka's representation of a rotating die in a glass that never comes to a stop. Since the die never stops on a number, the artist eliminates the concept of chance and its possibilities. *The Wig*, 2003 **(FIG. 365)**, is an endless

loop of a wig twirling as it is magically suspended in the air. Collectively, these works highlight the beauty and power of seemingly mundane actions and implore the viewer to reconsider the importance of ordinary tasks that one generally tends to ignore.

The Japanese artist collective teamLab is an interdisciplinary group that includes professionals from the fields of art, science, and technology who work with digital media to create artworks that incorporate their various areas of expertise; they refer to themselves as "Ultra-technologists." *Life Survives by the Power of Life*, 2011 **(FIG. 366)**, is a single-channel video that is part of the group's exploration of what they call "spatial calligraphy," an interpretation of traditional Japanese calligraphy in abstract three-dimensional space rendered in the time-based medium of video animation—a realm that the collective terms "Ultra Subjective Space." In this work the Japanese character for "life," written by the contemporary calligrapher Sisyu, is literally brought to life using the motif of the four seasons, a genre that has inspired East Asian artists for centuries, now as a moving image using new technologies developed in the twenty-first century. The word alternately blossoms and withers before the viewer's eyes in an endless cycle of renewal and decay. The specific reference to the four seasons alludes to a longstanding tradition in Japanese painting. This poetic rumination on life and death reflects the resiliency and

FIG. 360. Tabaimo. *haunted house*, 2003. Single-channel video installation with animation and sound; projected on a semi-circular wall with turntable cabinet. Duration: 5 minutes. Asia Society, New York: Gift of Mitch and Joleen Julis, Mr. and Mrs. Harold and Ruth Newman, and Jack and Susy Wadsworth in honor of Miwako Tezuka, former Associate Curator of Contemporary Art, Asia Society, 2014.5

FIG. 361. Koki Tanaka. *Moving Still*, 2000. Single-channel video with sound. Duration: Continuous loop. Asia Society, New York: Gift of Mr. and Mrs. Harold and Ruth Newman, 2011.22

FIG. 362. Koki Tanaka. *Light My Fire*, 2002. Single-channel video with sound. Duration: 3 minutes, 3 seconds. Asia Society, New York: Gift of Mr. and Mrs. Harold and Ruth Newman, 2011.20

FIG. 363. Koki Tanaka. *Each and Every*, 2003. Single-channel video with sound. Duration: 30 minutes. Asia Society, New York: Gift of Mr. and Mrs. Harold and Ruth Newman, 2011.19

FIG. 364. Koki Tanaka. *123456*, 2003. Single-channel video with sound. Duration: Continuous loop. Asia Society, New York: Gift of Mr. and Mrs. Harold and Ruth Newman, 2011.21

FIG. 365. Koki Tanaka. *The Wig*, 2003. Single-channel video. Duration: Continuous loop. Asia Society, New York: Gift of Mr. and Mrs. Harold and Ruth Newman, 2011.23

Opposite: **FIG. 366.** teamLab. *Life Survives by the Power of Life*, 2011. Single-channel digital work; calligraphy by Sisyu. Duration: 6 minutes, 23 seconds. Asia Society, New York: Gift of Mitch and Joleen Julis in honor of Melissa Chiu, 2015.14

FIG. 367. Minouk Lim. *S.O.S.—Adoptive Dissensus (Three-channel version)*, 2009. Three-channel video projection with sound. Duration: 10 minutes. Asia Society, New York: Inaugural Media Art Korea (MAK) Award Acquisition, 2011.30

strength of the human spirit following the 2011 tsunami and the subsequent Fukushima Daiichi nuclear disaster that occurred in Japan.

Korea

The development of modern art in Korea was largely influenced by the period of Japanese occupation from 1910 to 1945 through which aesthetic influences from Japan and the West were introduced. Beginning in the late 1950s, following the end of the Korean War, Korean avant-garde artists focused their attention on western style abstraction, notably realized through the Danseakhwa movement. This movement's aim was to reject realism and embrace abstraction, namely through monochrome painting, with an emphasis on materiality to create a direct relationship with the viewer. This group struggled to establish their practice between an alignment with western avant-gardism and Korean artistic culture. The younger generation has in large part embraced new media technologies, in addition to more conventional modes of artistic production, as vehicles

to comment on the sociopolitical ramifications of the country's rise in the global economy. These include the development of a consumerist culture, urban gentrification, and the effects of globalization on contemporary Korean society and traditional culture.

Minouk Lim was born in 1968 in Daejeon, South Korea. Lim's practice centers on the cultural effects of democratization and industrialization in South Korea, and the resulting marginalization of a strata of society excluded from the country's rise in the global economy in the twenty-first century. Her projects encompass the disciplines of performance, installation, video, music, and writing to draw attention to this disjunction. *S.O.S.— Adoptive Dissensus (Three-channel version)*, 2009 **(FIG. 367)**, is a three-channel video installation that documents a performance the artist staged on March 29 and 30, 2009, for the International Multidisciplinary Art Festival Bo:m in Seoul. Spectators were invited to a night cruise on the Han River to experience the economic prowess of South Korea exemplified by the "Miracle on the Han River," a term coined to describe the policies that were put in place to rejuvenate the country's economy through industrialization and technological development

Opposite: **FIG. 368.** Nam June Paik. *Li Tai Po*, 1987. 10 antique wooden TV cabinets, 1 antique radio cabinet, antique Korean printing block, antique Korean book, 11 color TVs. H. 96 x W. 62 x D. 24 in. (243.8 x 157.5 x 61 cm); Duration: continuous loop. Asia Society, New York: Gift of Mr. and Mrs. Harold and Ruth Newman, 2008.2

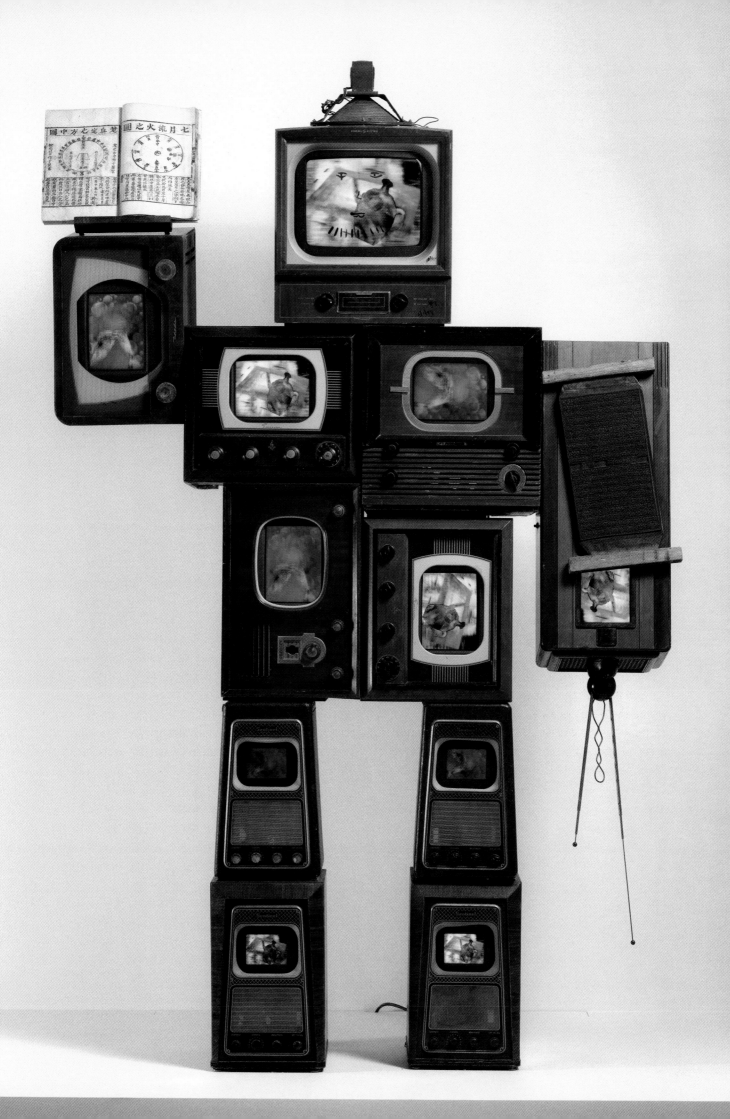

FIG. 369. Chen Chieh-jen. *Factory*, 2003. Single-channel video; super 16mm transferred to DVD. Duration: 30 minutes, 50 seconds. Asia Society, New York: Gift of Mr. and Mrs. Harold and Ruth Newman, 2011.12

after the Korean War, and by the Han River Renaissance Project, which was initiated to gentrify the city's riverfront real estate. The tour encountered a series of seemingly random events—including a demonstration, a couple frolicking at a construction site, and itinerants camping under a bridge—that were actually staged by the artist. The tour is narrated by the ship's captain, who ruminates on the ideals of truth, memory, and humanity. The performance and video installation remind the audience of the power of memory and the history of place, while also cautioning against what may be lost in the race toward urbanization and economic success.

Nam June Paik was a visionary artist, thinker, and innovator. Considered the "father of video art," his groundbreaking use of video technology blurred past distinctions between science, fine art, and popular culture to create a new visual language. Paik's interest in exploring the human condition through the lens of technology and science has created a far-reaching legacy that may be seen in the broad recognition of new media art and the growing numbers of subsequent generations of artists who now use various forms of technology in their work. The artist was born in 1932, in Seoul, and received a degree in aesthetics from Tokyo University in 1956. He moved to Germany to pursue his study of music and then to New York City in 1964. Upon his arrival Paik quickly developed collaborative relationships with a circle of now iconic American artists and spent the duration of his career, which spanned four decades, in the United States. In the early 1980s, Paik focused his energies on creating robots. *Li Tai Po,* 1987 **(FIG. 368)**, is evocative of the series of robots he created that were based on historical figures, such as Genghis Khan, or his friends, who included John Cage and Merce Cunningham. These constructed sculptures were fabricated from found household electronics, such as vintage radios and TV monitors, and were animated through looped video imagery created by the artist, to represent the personality and the individuality of each robot. The relative human scale and handmade quality of these sculptures create an immediate physical connection with the viewer's own body. Nam June Paik died on January 29, 2006, in Miami Beach, Florida.

Taiwan

The issue of identity has been a perennial topic in modern and contemporary art from Taiwan, which has struggled against ruling powers for generations, first with Japan from 1895 to 1945, followed by the implementation of martial law by the Taiwanese government from 1949 to 1987 during the ongoing dispute with the Republic of China over the sovereignty of Taiwan. Aesthetic developments in modern Taiwanese art, led by the Fifth Moon Painting Group and the Eastern Painting Group, largely followed western modernism rather than traditional ink and folk art traditions. In the 1970s the Nativist movement emphasized geopolitical identity issues and encouraged a realignment with folk art and traditional culture. In addition, artists were influenced by American postwar abstraction, pop art, and conceptual art practices. Following the end of martial law, decentralization promoted new liberties for Taiwanese artists and created a pluralistic society that spurred artistic dialogues regarding national identity, cross-straits relations with China, and the ramifications of Taiwan's status as a postindustrial society that continue to reverberate into the twenty-first century.

Chen Chieh-jen's sociopolitically driven videos mine the turbulent modern history of Taiwan. The artist was born in 1960 in Taoyuan. His formative works comprise photography, installation, and performance, and were created during the country's Martial Law period (1949–87). These early works primarily focused on issues relating to precolonial and colonial warfare against China and Japan. After martial law ended, Chen ceased his artistic activity for eight years. Returning to art in 1996, he began collaborating with those relegated to the edges of Taiwanese society. The artist quickly became known for his surreal, durational videos in which he used strategies he terms "re-imagining, re-narrating, re-writing, and re-connecting." *Factory* **(FIG. 369)**, a single-channel video from 2003, examines the social and political evolution of industrialized societies through the lens of marginalized factory workers in Taiwan. Chen filmed former female textile workers as they returned to the Lien Fu Garment Factory, the site where, after two decades of employment, they had been unexpectedly dismissed—the result of cheaper labor abroad. The women silently haunt the interior spaces and reenact their sewing duties at the factory. This documentation is interrupted by government footage from the 1960s showcasing Taiwan's thriving manufacturing industry, highlighting the disjunction between the country's former status as an industrial leader and its shift into specialized, technology-based production.

CENTRAL ASIA

Kazakhstan

Kazakhstan's culture is based on the country's history as a nomadic society and also reflects the significant influence of Russian Soviet sensibilities. The country was established as a republic in 1936 by Russia, which had taken over control of the region in the mid-nineteenth century, and remained under Soviet control until it declared independence in 1991. Art production traditionally has been centered around Almaty, the former capital of the country. The development of a modern art pedagogy was largely informed by the influence of exiled Russian avant-garde painters who began arriving in Kazakhstan in the mid-1930s. By the 1960s this foundation helped develop a Kazakh school of art that attempted to create a distinct Kazakh identity through the lens of socialist realism. More recently, contemporary art from Kazakhstan has gained notoriety following the country's debut at the 2005 Venice Biennale.

Regarded as one of the leading artists from Central Asia, Kazakh video and performance artist Almagul Menlibayeva's surreal narratives often address the

FIG. 370. Almagul Menlibayeva. *Kissing Totems*, 2008. Two-channel video with sound. Duration: 9 minutes. Asia Society, New York: Purchased with funds donated by Mr. and Mrs. Harold and Ruth Newman, 2012.1

uprooting and dislocation of civilizations. The artist was born in 1969 in Almaty and studied at the Academy of Art and Theater in Almaty from 1987 to 1992. Menlibayeva examines the convergence of traditional and contemporary cultures and conceives mythological narratives based on Soviet cultural traditions and the nomadic heritage of the steppes of Kazakhstan. She often uses industrial ruins from the region's communist past during the Soviet era as a backdrop for her work. *Kissing Totems*, 2008 **(FIG. 370)**, is a dream-like narrative that depicts mythological beings from her country's ancestral history.

Shot from the perspective of a little girl who observes a fantastic series of nonlinear actions, *Kissing Totems* is steeped in surreal iconography that interweaves post-Soviet industrial scenery with the cultural heritage of a country in transition. Her imagery of shamanistic practices by a group of female goddess figures alludes to ancient fears and desires that manifest themselves within the anxieties of contemporary life.

AMERICAS

For centuries North America, and the United States in particular, has been a destination for peoples, including Asians, to seek their fortunes or to find political refuge. This quest for individual autonomy has influenced the creative activities of generations of Asian American artists. However, due to the longstanding sociopolitical prejudices faced by Asian immigrants—exemplified in the United States by the 1882 Chinese Exclusion Law, which prohibited the immigration of Chinese laborers and was only repealed in 1943, and the establishment of Japanese internment camps at the close of World War II—Asian Americans were not formally considered an identifiable group until the Civil Rights movement in the 1960s, when a group of University of California, Berkeley, and San Francisco State students asserted their identity as such. While this designation should be understood as one way of considering a group of artists and their works and not an exclusive categorization or designation, reviewing ideas and experiences through the lens of the Asian American experience can provide a compelling perspective on identity, agency, and representation.

Patty Chang first gained notoriety for her endurance-based performances in the late 1990s. Since then she has continued to explore the boundaries between physical and psychological comfort and discomfort. Chang has continued to explore these limits through performance, video, photography, and film. The artist was born in 1972 in San Francisco and received a BA from the University of California at San Diego in 1994. In her single-channel video, *Melons (At a Loss)*, 1998 **(FIG. 371)**, the artist is depicted facing the camera head-on wearing a white

FIG. 371. Patty Chang. *Melons (At a Loss)*, 1998. Single-channel video with sound. Duration: 3 minutes, 44 seconds. Asia Society, New York: Gift of Mr. and Mrs. Harold and Ruth Newman, 2011.10

corset top. She places a plate atop her head and begins to tell the story of a special porcelain plate made in honor of her aunt who had died of breast cancer. As she continues her narrative she wields a large knife and slices open one of the cups of her corset, revealing a halved cantaloupe in place of her breast. Chang continues her soliloquy as she proceeds to scoop out and eat the fleshy fruit in a self-cannibalistic act. In a later work from 2002, entitled *In Love* **(FIG. 372)**, Chang is depicted across two screens variously engaging her mother and father in an intimate kiss. *In Love* is based on an earlier work from 2000, *Untitled (For Abramovic Love Cocteau),* and documents the reversed act of the artist eating an onion

Opposite: Detail of **FIG. 373.**

FIG. 372. Patty Chang. *In Love*, 2001. Two-channel video with sound. Duration: 3 minutes, 28 seconds. Asia Society, New York: Gift of Mr. and Mrs. Harold and Ruth Newman, 2011.11

FIG. 373. Tseng Kwong Chi. *New York, New York 1979 (Statue of Liberty)* from the *East Meets West Self-Portrait Series 1979–1989*, 1979. Selenium-toned gelatin silver print. H. 20 x W. 16 in. (50.8 x 40.6 cm). Asia Society, New York: Gift of Mitch and Joleen Julis, 2015.15

with each of her parents in a manner that is meant to look like a tender embrace. The task of sharing a difficult experience with another person, in this case deliberately ingesting a whole raw onion, serves as a bonding act. The intimacy and perceived taboo of what looks like an act of incest pushes the boundaries of societal acceptance, negating the innocence and purity of the unique bond between a parent and child.

Tseng Kwong Chi was an integral member of the New York avant-garde art scene in the 1980s. During his brief, but prolific career the artist created over 100,000 photographs. Tseng was born in Hong Kong in 1950 and immigrated to New York in 1978, where he remained until his untimely death from HIV/AIDS in 1990. *New York, New York, 1979 (Statue of Liberty)* from the *East Meets West Self-Portrait Series, 1979–1989*, 1979 **(FIG. 373)**, is one of the first works from the series *East Meets West*, which includes more than one hundred self-portraits taken at iconic locations across the United States and Canada from 1979 to 1989. The artist focused on sites that were easily recognizable as tourist attractions. The series was inaugurated in response to President Nixon's 1972 trip to China to initiate an exchange between the East and the West. In the series Tseng is costumed in a Mao suit to reflect his persona as a Chinese "ambiguous Ambassador," a character he created to underscore the association of Asians as "others" in society. This portrait, along with the rest of the series, playfully explores issues of identity and difference, and the fine line between fact and fiction inherent in the photographic medium.

Sze Tsung Leong's photographic practice centers on the documentation of urban architectural sites selected for their specific cultural context. According to the artist,

FIG. 374. Sze Tsung Leong. *Yihao Qiao, Yuzhong District, Chongqing*, 2002. Chromogenic print. H. 40 x W. 48 in. (101.6 x 121.9 cm). Asia Society, New York: Gift of Anne and Joel Ehrenkranz, 2015.8

"[B]uildings are the result of social forces and political power." *Yihao Qiao, Yuzhong District, Chongqing,* 2002 **(FIG. 374)**, illustrates the artist's interest in using the site to exemplify the universal phenomenon of social amnesia through demolition. This photograph captures a traditional district in Chongqing in the process of being razed for new construction. It is part of the artist's *History Images* series, which documents China's rapid urban transformation and the subsequent erasure of tradition and history in the service of the country's quest for economic progress. Leong was born in 1970 in Mexico City and spent his childhood in Mexico, the United Kingdom, and the United States. He studied at the Art Center College of Design from 1987 to 1989, and received a BA from the University of California, Berkeley, in 1993 and an MA from Harvard University in 1998.

APPENDIX: ISSUES IN ATTRIBUTION

DENISE PATRY LEIDY AND ADRIANA PROSER

Refinements over the years in the attribution, dating, and identification of iconography of some of the objects in the Asia Society Museum Collection reflect the growth of scholarship in Asian art history since the initial publications of individual objects and of the Collection. It would be premature, however, to assume that these more recent attributions are in any way final. As knowledge of the subject evolves, it is inevitable that many of the conclusions presented in this volume will also be changed or refined. Moreover, while new studies often answer some questions, they invariably produce others.

This essay, which presents some of the issues that have been raised regarding seven of the objects in the collection, is intended as an in-progress analysis rather than a definitive report. It is expected that many of the questions discussed here will be studied further and that new and perhaps unforeseen answers will be found.

The dating of a large Chinese ritual water basin of the *pan* type **(FIG. 375)** is one of the more perplexing cases in the study of the collection. In the center of the interior is a large quadripartite motif encircled by four animals (a tiger, a dragon, a *qilin*, and an unidentified creature) against a background of swirling clouds and mist. The sides of the interior are decorated with two circular bands containing immortals and real and mythical animals. Smaller bands made up of triangles, which are often interpreted as symbols for mountains, separate the larger areas from each other. Geometric and curvilinear motifs decorate the rim of the basin. The exterior is also filled with large bands containing various animals and spirits against a background of mists and clouds and separated by smaller registers. A large, two-horned dragon with an open mouth, a type that is often termed a "laughing dragon," is found on the exterior of the base.

The immortals and mythological creatures that decorate this vessel derive from the art of the southern state of Qu, one of the most intriguing societies in China during the latter part of the Eastern Zhou period (771–221 BCE). Qu customs, beliefs, and artistic traditions were influential at the Han-dynasty court, particularly during the reign of Emperor Kaozu (206–194 BCE), and a dating of this basin to the early Western Han period (206 BCE–9 CE) is based on the early Han interest in southern culture and traditions, as reflected in its art.

Bronzes with comparable inlaid decoration were fairly common during the Western Han. However, the design treatments on most examples of this type are noticeably more fluid than the motifs on this bronze, which appear static. This rigidity is evident in the stylized stalking postures of the animals in the base of the interior, which do not convey physical motion or power; in the lack of movement in the figures; and in the swirling lines in the background of the basin. The treatment of the dragon engraved on the base of the foot is awkward, particularly the depiction of its front and back legs, which do not compare favorably with other dragons of this type.

A preliminary scientific analysis of the basin was undertaken by the staff of the Department of Conservation and Scientific Research of the Freer Gallery of Art and the Arthur M. Sackler Gallery, Smithsonian Institution, Washington, DC. The basin is composed of a bronze core that has a high content of silver and zinc as well as smaller amounts of tin and lead. This core is plated with silver, which has been engraved and gilded. The high silver content in the composition of the bronze is unusual for

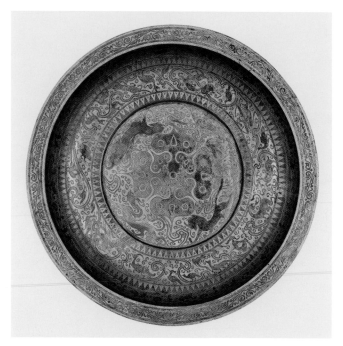

FIG. 375. Water Basin: *Pan*. Possibly 20th century. China. Bronze core plated with silver, the silver engraved and gilded. H. 3 x Diam. 20 in. (7.6 x 50.8 cm). Asia Society, New York: Mr. and Mrs. John D. Rockefeller 3rd Collection, 1979.108

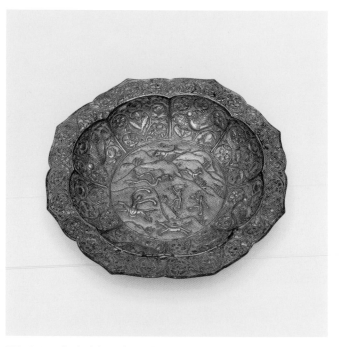

FIG. 376. Lobed Dish. 10th–12th century? North China? Silver-gilt with embossing. H.¾ x Diam. 4⅞ across points in. (1.9 x 12.4 cm). Asia Society, New York: Mr. and Mrs. John D. Rockefeller 3rd Collection, 1979.116

works dating from the Han period. In addition, the chemical composition of the metal is very close to that of several other Han-style bronzes in western collections. Many of these bronzes have been attributed to the hand of a certain Zhou Meike, who is believed to have been active in the region of Suzhou about 1910. However, it should be acknowledged that the works attributed to Zhou Meike tend to have even stiffer decoration than what appears on this basin. At present, it seems that this piece requires further study and that future work is necessary before a final determination can be made.[1]

Preliminary scientific analysis was also conducted on a small silver-gilt lobed dish **(FIG. 376)** by the same conservation department at the Smithsonian. The analysis of this dish, formerly attributed to the Liao period (907–1125), showed a much higher percentage of silver than what is normally found in Tang silver but thought to be reasonable for something of Liao, Sasanian, or other Central Asian origin. However, the contrast in workmanship of the hunting scenes on the foot of the vessel and the floral and bird patterns embossed on the lobed rim is striking, and this combination makes the dish unlike the many Liao metalwork pieces found to date. The overlay of rounded chisel marks, which were applied to bring out the embossed design, also differs from other Liao examples, on which such marks are individually distinguishable and generally linear in application. The simplified figure, animal, and

landscape imagery also do not correspond to characteristic Liao artistry.

A sixth-century tympanum with a paradise scene **(FIG. 377)** has been the subject of scholarly controversy for some time. As noted in the first edition of this catalogue, two types of pictorial depictions are generally associated with the development of Chinese Buddhist imagery: scenes of paradise and of a buddha and/or bodhisattvas descending to Earth to guide the souls of the faithful to paradise. On the Asia Society Museum's tympanum, the hand gesture of the central buddha in the paradise scene indicates that he is preaching. He is seated on a two-tiered lotus pedestal under an elaborate, jeweled canopy. A monk and three bodhisattvas stand to each side of the central buddha, and a figure dressed in the same long, skirtlike garment and scarf as the bodhisattvas kneels at each of the lower corners of the scene. The tympanum is framed with scrolling vines, some of which emerge from the mouth of a thunder monster below, a symbol of the forces of nature found in both Buddhist and funerary art of China.

The shape of this tympanum indicates that it was placed over a doorway to a Chinese-style pagoda. It is difficult to determine which of several possible buddhas and Buddhist pure lands is represented. Both pagodas and reliquary pagodas often had four doors, each facing a cardinal direction, and a buddha would be identified

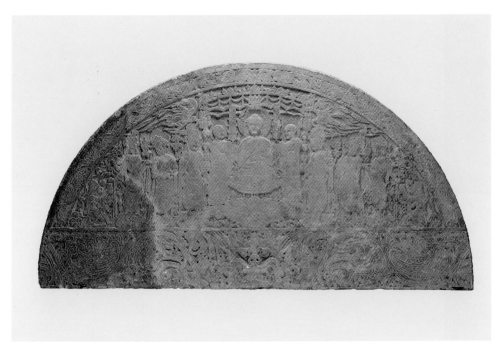

FIG. 377. Tympanum with Paradise Scene. Western Wei period? North China. Limestone. H. 35 x W. 70 in. (88.9 x 177.8 cm). Asia Society, New York: Mr. and Mrs. John D. Rockefeller 3rd Collection, 1979.112

FIG. 378. In the style of Ike Taiga. Bamboo in Mist. Probably 19th or 20th century. Japan. Ink and slight color on paper. Image only, H. 52½ x W. 22⅞ in. (133.4 x 58.1 cm). Asia Society, New York: Mr. and Mrs. John D. Rockefeller 3rd Collection, 1979.215

by the direction he faced. The buddha on this tympanum holds the preaching gesture—in which both hands are raised with the thumbs and the forefingers forming a circle (*dharmachakramudra*)—that is often used to identify Amitabha Buddha in his Western Pure Land. However, this iconography did not become codified until the seventh and eighth centuries.

The combination of different stylistic features in this scene suggests a mid-sixth-century date. The relatively flat treatment of the figures and the overall shallowness of the carving are typical of works dating to the early decades of the sixth century, but the fuller faces of the central buddha and his attendant and the scanty garments worn by the bodhisattvas are typical of slightly later works, from the mid- to late sixth century. The combination of both traits is sometimes found in mid-sixth-century art, particularly pieces that were produced in northwest China under the Western Wei dynasty (535–556), leading to a possible origin and date for this piece. However, a nearly identical piece by a different and more awkward hand is in the collection of the Art Institute of Chicago. Perhaps the Chicago example was made as a copy of the Asia Society piece, or both objects are copies of another model, or they could be two parts of an original four-tympana set from a sixth-century Chinese pagoda.[2]

Several questions also exist regarding a Japanese ink painting entitled *Bamboo in Mist* (**FIG. 378**). The signature

Kasho, an artist-name used by Ike Taiga (1723–1776), one of the most important painters of the literati school (*nanga*), is at the upper right of the painting, following an inscription that reads "clear mist in the upper garden." Two of Taiga's seals (*ike arima no in*; *sangaku dōja*) are impressed beneath the signature. A third seal (*zenshin sōma hōkkyo hō kyūkyō*) is impressed near the bottom of the painting, in the center of the plants.

The painting shows bamboo, with some light stalks and some dark, growing in front of a clump of rocks. The thin, elegant brush strokes used to paint the stalks and the long, narrow leaves are comparable to those in many other images of bamboo attributed to Taiga. The interplay between light and dark shades of ink, found primarily in the depiction of the leaves, is also typical of Taiga's oeuvre. However, the treatment of the stalks as straight, upward lines and the flatness of the leaves distinguish this work from other paintings by Taiga, in which the bamboo tends to sway and bend, moving up and down

FIG. 379. Lakshmi (Kichijoten). Possibly Meiji period. Japan. Ink and color on silk. Image only, H. 46 x W. 21¾ in. (116.8 x 55.2 cm). Asia Society, New York: Mr. and Mrs. John D. Rockefeller 3rd Collection, 1979.208

FIG. 380. Box Cover. Probably Meiji period. Japan. Gold and silver inlays in lacquer on leather. H. 3¾ x L. 13¼ x W. 16¼ in. (9.5 x 33.7 x 41.3 cm). Asia Society, New York: Mr. and Mrs. John D. Rockefeller 3rd Collection, 1979.223

and twisting in the pictorial space. Furthermore, the brushwork in this painting lacks the exuberance and sketchiness that are the hallmarks of Taiga's style. A master painter, Taiga was an extremely prolific artist, and his style was copied by many painters working in the nineteenth and early twentieth centuries, who learned of Taiga's technique from a book explaining his style and methods, the *Taigado Gaho*, published after his death. While it is not possible to identify the painter of this scroll, it is possible that it was painted by one of Taiga's followers who knew the master's work well.

Two other Japanese objects in the Collection, a painting of the Buddhist goddess Lakshmi and a lacquer box cover, illustrate another puzzle in the study of Asian art history. Both pieces are the type of objects currently believed to be Meiji-period reworkings of earlier styles.

Lakshmi is worshiped in Buddhism as the goddess of wealth and happiness. In the painting **(FIG. 379)**, she stands on a lotus pedestal and holds her right hand in the gesture of reassurance. The jewel of wisdom, or wish-granting jewel, rests in her upturned left palm. Lakshmi wears an elaborate multilayered costume, covered with a jacket or shawl, several scarves, and a belt. A fantastic bejeweled and flowered crown is on her head. The clothing and jewelry derive from traditions of Buddhist painting that can be traced to Chinese and Japanese art of the eighth century. These earlier traditions were revived in Japan during the thirteenth century, and this painting has been considered an example of the Kamakura period (1185–1333). Several features, however, suggest a later date: the very detailed, almost fussy treatment of the drapery folds in the sleeves and hemline; the stiff ends of the brocade scarves; and the lack of volume in the figure. An interest in excessive detail is also seen in the depiction of the crown, which has more flowers, garlands, and chains than typical representations of the goddess's headgear in Kamakura-period paintings. The piece's suggested Meiji-period (1868–1912) date is based to a large extent on this interest in detail, which is characteristic of the paintings and especially the decorative arts of the late nineteenth and early twentieth centuries. It should be acknowledged, however, that the art of the Meiji period is not yet well studied. Moreover, although it is fairly common to hear about Meiji-period versions of early works, this material is rarely published, probably because it is assumed that copies are inherently less interesting. This hampers a full analysis of the development of

FIG. 381. Jar. 20th century. Thailand. Stoneware with incised design under glaze. H. 8⅛ x Diam. 7¾ in. (20.6 x 19.7 cm). Asia Society, New York: Mr. and Mrs. John D. Rockefeller 3rd Collection, 1979.92

Japanese art during the Meiji period and of the role played by the studying and copying of earlier styles.

One exception to the gap in scholarship on Meiji-period art is the study of lacquer, and it is well known that artists working in this medium often copied earlier styles in an attempt to revive and master important and difficult techniques. A lacquer cover **(FIG. 380)**, which was presumably once paired with a box, illustrates the use of the *heidatsu* technique, in which pieces cut from thin gold and silver sheets are inlaid in a lacquer base. This technique is believed to have begun as early as the Zhou period (1050–221 BCE) in China, and it was important in Japan during the eighth century.

The decoration of this lid reflects eighth-century prototypes. The floral medallion in the center of the lid is surrounded by four phoenixes, each of which has a branch in its beak. Plants decorate the edges and sides of the cover, and the area between the top and the sides is filled with small circles that were probably intended to represent pearls. Most of the motifs were made from pieces of cut silver and accented by details from gold sheets. As is common in eighth-century lacquerware, the substructure of this lid is leather rather than wood or cloth.

While the motifs are typical of the art of the eighth century, the style of the decoration points to a much later date. For example, the phoenixes' running positions are unconvincing and do not suggest movement, and the composition is static. In addition, the individual elements are treated in a flat, linear fashion that differs from the fully three-dimensional motifs found in eighth-century examples.

The striking shape, body, and glaze of a Thai jar **(FIG. 381)** suggest an association with the Si Satchanalai kilns. The buff-colored body of this jar is decorated with a deeply incised design of rippling lines, covered with a thin, translucent sea-green glaze. The richness of the decoration is typical of the finer examples produced at the Si Satchanalai kilns. Although some scholars attribute this object to those kilns, its origin and date remain enigmatic. Thus far, no other early examples from Si Satchanalai with this shape and rippling patterns have been identified, leading other scholars to suspect this jar is a twentieth-century object.

1. For another discussion of this basin, please see Sherman E. Lee's introductory essay in this volume.
2. For another discussion of this tympanum, please see Sherman E. Lee's introductory essay in this volume.

TRADITIONAL

SOUTH ASIA

Indian Sculptures of the Kushan Period

The Buddhist Heritage of Pakistan: Art of Gandhara. New York: Asia Society Museum, 2011.

Czuma, Stanislaw. *Kushan Sculpture: Images from Early India*. Cleveland: Cleveland Museum of Art, 1985.

Gaulier, Simone, Robert Jera-Bezard, and Monique Maillard. *Buddhism in Afghanistan and Central Asia*. Iconography of Religions, 13–14. Institute of Religious Iconography, State University Groningen. Leiden: E. J. Brill, 1976.

Huntington, Susan L. *The Art of Ancient India: Buddhist, Hindu, Jain*. New York: Weatherhill, 1985.

Lohuizen-de Leeuw, van, J. E. "Gandhara and Mathura: Their Cultural Relationship." In *Aspects of Indian Art: Papers Presented in a Symposium at the Los Angeles County Museum of Art*, edited by Pratapaditya Pal, 26–43. Leiden: E. J. Brill, 1972.

Pal, Pratapaditya. *Indian Sculpture. Volume I, circa 500 B.C.–A.D. 700: A Catalogue of the Los Angeles County Museum of Art Collection*. Los Angeles: Los Angeles County Museum of Art, 1986. In association with University of California Press.

Rosenfield, John. *The Dynastic Arts of the Kushans*. Berkeley and Los Angeles: University of California, 1967.

Sculptures from North India, 5th–7th Centuries

Asher, Frederick M. *The Art of Eastern India, 300–800*. Minneapolis: University of Minnesota, 1980.

Chandra, Pramod. "Some Remarks on Bihar Sculpture from the Fourth to the Ninth Century." In *Aspects of Indian Art: Papers Presented in a Symposium at the Los Angeles County Museum of Art*, edited by Pratapaditya Pal, 59–64. Leiden: E. J. Brill, 1972.

Harle, James. *Gupta Sculpture: Indian Sculpture of the Fourth to Sixth Centuries A.D.* Oxford: Clarendon, 1974.

Huntington, Susan L. *The Art of Ancient India: Buddhist, Hindu, Jain*. New York: Weatherhill, 1985.

Pal, Pratapaditya. *The Ideal Image: The Gupta Sculptural Tradition and Its Influence*. New York: Asia Society, 1978. In association with Weatherhill.

——. *Indian Sculpture, Volume I, circa 500 B.C.–A.D. 700: A Catalogue of the Los Angeles County Museum of Art Collection*. Los Angeles: Los Angeles County Museum of Art, 1986. In association with University of California Press.

Shah, Umakan Premanand. "Western Indian Sculpture and the So-Called Gupta Influence." In *Aspects of Indian Art: Papers Presented in a Symposium at the Los Angeles County Museum of Art*, edited by Pratapaditya Pal, 44–48. Leiden: E. J. Brill, 1972.

Williams, Joanna, G. *The Art of Gupta India: Empire and Province*. Princeton, NJ: Princeton University, 1982.

Zaheer, M. *The Temple of Bhitargaon*. New Delhi: Agam Kala Prakashan, 1981.

Two Jain Sculptures

Pal, Pratapaditya. *Indian Sculpture, Volume I, circa 500 B.C.–A.D. 700: A Catalogue of the Los Angeles County Museum of Art Collection*. Los Angeles: Los Angeles County Museum of Art, 1986. In association with University of California Press.

Shah, Umakant Premanand. *Studies in Jaina Art*. Varanasi: Jaina Cultural Research Society, 1955.

Pala Period Sculptures

Huntington, Susan L. *The "Pāla-Sena" Schools of Sculpture*. Leiden: E. J. Brill, 1984.

——. "Pre Pāla and Pāla Period Sculptures in the Rockefeller Collection." *Apollo* 118, no. 261 (November 1983): 370–78.

Huntington, Susan L., and John C. Huntington. *Leaves from the Bodhi Tree: The Art of Pāla India (8th–12th Centuries) and Its International Legacy*. Dayton: Dayton Art Institute; Seattle: University of Washington, 1990.

Pal, Pratapaditya. *Indian Sculpture, Volume 2, 700–1800: A Catalogue of the Los Angeles County Museum of Art Collection*. Los Angeles: Los Angeles County Museum of Art, 1988. In association with University of California Press.

Proser, Adriana, ed. *Pilgrimage and Buddhist Art*. New York: Asia Society Museum; New Haven: Yale University, 2010.

Stone Sculptures from Hindu Temples

Chandra, Pramod. *The Sculpture of India: 3000 B.C.–1300 A.D.* Washington, DC: National Gallery of Art, 1985.

Desai, Vishakha N., and Dale Mason, eds. *Gods, Guardians and Lovers: Temple Sculptures from North India, A.D. 700–1200*. New York: Asia Society Galleries, 1993. In association with Mapin.

Lippe, Aschwin de. *Indian Medieval Sculpture*. Amsterdam and New York: North-Holland, 1978.

Pal, Pratapaditya. *Indian Sculpture, Volume 2, 700–1800: A Catalogue of the Los Angeles County Museum of Art Collection*. Los Angeles: Los Angeles County Museum of Art, 1988. In association with University of California Press.

Early Sculptures from South India

Gangoly, O. C. *The Art of the Pallavas*. Calcutta: Pupa, 1957.

Nagaswamy, R. "Some Contributions of the Pandya to South Indian Art." *Artibus Asiae* 27, no. 3 (1965): 265–74.

Pal, Pratapaditya. *The Sensuous Immortals: A Selection of Sculptures from the Pan-Asian Collection*. Los Angeles: Los Angeles County Museum of Art, 1978. Distributed by MIT Press.

Sivaramamurta, C. *Kalugumalai and Early Pandyan Rock-Cut Shrines*. Heritage of Indian Art, no. 3. Bombay: Phulabhai Memorial Institute and N. M. Tripathi, 1961.

Bronze Sculptures of the Chola Period

Barrett, Douglas. "A Group of Bronzes of the Late Cola Period." *Oriental Art* 29 (Winter 1983/1984): 360–67.

Chandra, Pramod. *The Sculpture of India: 3000 B.C.–A.D. 1300*. Washington DC: National Gallery of Art, 1985.

Dehejia, Vidya. *Art of the Imperial Cholas*. New York: Columbia University, 1990.

——. "The Persistence of Buddhism in Tamilnadu." *Marg* 39, no. 4: 53–74.

——. *Slaves of the Lord: The Path of the Tamil Saints*. New Delhi: Munshiran Manoharlal, 1988.

Fontein, Jan. "A Buddhist Altarpiece from South India." *MFA Bulletin* 78 (1980): 4–21.

Gaston, Anne-Marie. *Shiva in Dance, Myth, and Iconography*. Delhi: Oxford University, 1982.

Kramrisch, Stella. *Manifestations of Shiva*. Philadelphia: Philadelphia Museum of Art, 1981.

Nagaswamy, R. *Masterpieces of Early South Indian Bronzes*. New Delhi: National Museum, 1983.

Pal, Pratapaditya. *Indian Sculpture, Volume 2, 700–1800: A Catalogue of the Los Angeles County Museum of Art Collection*. Los Angeles: Los Angeles County Museum, 1988. In association with University of California Press.

A Throne for the Image of a Deity

Aitken, Molly Emma. *When Gold Blossoms: Indian Jewelry from the Susan L. Beningson Collection*. New York: Asia Society; London: Philip Wilson, 2004.

Two Mughal Sandstone Screens

Asher, Catherine Blanshard. *Architecture of Mughal India*. New York: Cambridge University, 1992.

Paintings for Mughal, Rajput, and Western Himalayan Courts

Beach, Milo. *The Grand Mogul: Imperial Painting in India, 1600–1660*. Williamstown, MA: Sterling and Francine Clark Art Institute, 1978.

——. *The Imperial Image: Paintings for the Mughal Court*. Washington DC: Freer Gallery of Art, Smithsonian Institution, 1981

Brand, Michael, and Glenn D. Lowry. *Akbar's India: Art from the Mughal City of Victory*. New York: Asia Society Galleries, 1985.

Desai, Vishakha N. *Life at Court: Art for India's Rulers, 16th–19th Centuries*. Boston: Museum of Fine Arts, 1985.

Lerner, Martin. *The Flame and the Lotus: Indian and Southeast Asian Art from the Kronos Collection*. New York: Metropolitan Museum of Art / Harry N. Abrams, 1984.

Pal, Pratapaditya. *Indian Painting, Volume I, 1000–1700: A Catalogue of the Los Angeles County Museum of Art Collection*. Los Angeles: Los Angeles County Museum of Art, 1993. Distributed by Harry N. Abrams.

Welch, Stuart Cary, with Mark Zebrowski. *A Flower from Every Meadow: Indian Paintings from American Collections*. New York: Asia Society, 1973. Distributed by New York Graphic Society.

Temple Hangings

Kumar, Ram. "Picchawais—A Tradition in Ritual Cloth Paintings." *Oriental Art* 32 (Autumn 1986): 284–87.

Skelton, Robert. *Rajasthani Temple Hangings of the Krishna Cult from the Collection of Karl Mann, New York*. New York: American Federation of Arts, 1973.

Buddhist Paintings from India, Nepal, and Tibet

Huntington, John C. "Ge-ge bris: A Stylistic Amalgam." In *Aspects of Indian Art: Papers Presented in a Symposium at the Los Angeles County Museum of Art*, edited by Pratapaditya Pal, 105–17. Leiden: E. J. Brill, 1972.

Huntington, Susan L., and John C. Huntington. *Leaves from the Bodhi Tree: The Art of Pāla India (8th–12th Centuries) and Its International Legacy*. Dayton: Dayton Art Institute; Seattle: University of Washington, 1990.

Losty, Jeremiah P. *The Art of the Book in India*. London: British Library, 1982.

——. "Bengal, Bihar, Nepal? Problems of Provenance in 12th-Century Illuminated Buddhist Manuscripts." *Oriental Art* 35, no. 2 (Summer 1989): 86–96; *Oriental Art* 35, no. 3 (Fall 1989): 140–49.

Pal, Pratapaditya. *Tibetan Paintings: A Study of Tibetan Thankas, Eleventh to Nineteenth Centuries*. Basel: Ravi Kumar, 1984. In association with Sotheby Publications.

Pal, Pratapaditya, and Julia Meech-Pekarik. *Buddhist Book Illuminations*. New York, Paris, Hong Kong, and New Delhi: Ravi Kumar, 1988.

Sculptures from Kashmir

Goetz, Hermann. *Studies in the History and Art of Kashmir and the Indian Himalaya*. Wiesbaden: Otto Harrassowitz, 1969.

Hinüber, Oskar von. "Die Kolophone der Gilgit Handschriften." In *Festschrift Paul Thieme zur Vollendung des 75. Lebensjahres*. Studien zur Indologie und Iranistik 5/6: 49–82.

Huntington, John C. "Three Essays On Himalayan Metal Images in the Mr. and Mrs. John D. Rockefeller 3rd Collection." *Apollo* 118, no. 261 (November 1983): 416–25.

Klimburg-Salter, Deborah. *The Kingdom of Bamiyan: Buddhist Art and Culture of the Hindu Kush*. Naples and Rome: Instituto Universitario Orientali, 1989.

Klimburg-Salter, Deborah E., Maximilian Klimburg, David L. Snellgrove, Fritz Staal, Michel Strickmann, and Chogyam Trungpa Rinpoche. *The Silk Route and the Diamond Path: Esoteric Buddhist Art on the Trans-Himalayan Trade Routes*. Los Angeles: UCLA Art Council, 1982.

Lerner, Martin. *The Flame and the Lotus: Indian and Southeast Asian Art from the Kronos Collection*. New York: Metropolitan Museum of Art, 1984.

Pal, Pratapaditya. *The Arts of Kashmir*. New York: Asia Society; Milan: 5 Continents, 2007.

——. *Bronzes of Kashmir*. Graz: Akademische Druck, 1975.

——. *Indian Sculpture, Volume 2, 700–1800: A Catalogue of the Los Angeles County Museum of Art Collection*. Los Angeles: Los Angeles County Museum of Art, 1988. In association with University of California Press.

Sculptures from Nepal

Deva, Krishna. "Saivite Image and Iconography in Nepal." In *Discourses on Siva: Proceedings of a Symposium on the Nature of Religious Imagery*, edited by Michael W. Meister, 82–90. Philadelphia: University of Pennsylvania, 1984.

Huntington, John C. "Three Essays On Himalayan Metal Images in the Mr. and Mrs. John D. Rockefeller 3rd Collection." *Apollo* 118, no. 261 (November 1983): 416–25.

Huntington, Susan L., and John C. Huntington. *Leaves from the Bodhi Tree: The Art of Pāla India (8th–12th Centuries) and Its International Legacy*. Dayton: Dayton Art Institute; Seattle: University of Washington, 1990.

Khandawala, K. "The Chronology of the Arts of Nepal and Kashmir." *Lalit Kala* 19 (1979): 32–44.

Macdonald, A., and A. V. Stahl. *Newar Art*. Warminster: Aris and Phillips, 1979.

Pal, Pratapaditya. *Art of Nepal: A Catalogue of the Los Angeles County Museum of Art Collection*. Los Angeles: Los Angeles County Museum of Art, 1985. In association with University of California Press.

——. *The Arts of Nepal*. 2 vols. Leiden: E. J. Brill, 1974, 1978.

——. *Nepal: Where the Gods Are Young*. New York: Asia Society, 1975. In association with Weatherhill.

——. "Uma-Mahesvara Theme in Nepali Sculpture." *Boston Museum Bulletin* 66, no. 345 (1968): 85–100.

Sculptures from Tibet

Czaja, Olaf, and Adriana Proser. *Golden Visions of Densatil: A Tibetan Buddhist Monastery*. New York: Asia Society Museum, 2014.

Huntington, John C. "Three Essays On Himalayan Metal Images in the Mr. and Mrs. John D. Rockefeller 3rd Collection." *Apollo* 118, no. 261 (November 1983), 416–25.

Huntington, Susan L., and John C. Huntington. *Leaves from the Bodhi Tree: The Art of Pāla India (8th–12th Centuries) and Its International Legacy*. Dayton: Dayton Art Institute; Seattle: University of Washington, 1990.

Macdonald, A., and I. Y Macdonald, eds. *Essais sur l'art du Tibet*. Paris: Librairie d'Amerique et d'Orient, 1977.

Oddy, W. A., and W. Z Walf. *Aspects of Tibetan Metallurgy*. British Museum Occasional Papers 15. London: British Museum, 1981.

Pal, Pratapaditya. *Art of the Himalayas: Treasures from Nepal and Tibet*. New York: Hudson Hills, 1991. In association with the American Federation of Art.

——. *Art of Tibet: A Catalogue of the Los Angeles County Museum of Art Collection*. Los Angeles: Los Angeles County Museum of Art, 1983. In association with University of California Press.

——. "Kashmir and the Tibetan Connection." *Marg* 15, no. 2: 57–75.

——. "Kashmir-Style Bronzes and Tantric Buddhism." *Annali dell' Instituto Orientale di Napoli* 39 (1979): 253–73.

Reynolds, Valrae, Amy Heller, and Janet Gyasto. *Catalogue of the Newark Museum Tibetan Collection, 3: Sculpture and Painting*. Newark: Newark Museum, 1986.

Rhie, Marilyn M., and Robert F. Thurman. *Wisdom and Compassion: The Sacred Art of Tibet*. San Francisco: Asian Art Museum of San Francisco; New York: Tibet House, 1991. In association with Harry N. Abrams.

Two Bodhisattvas from Sri Lanka

Bronze Bouddhiques et Hindous de l'antique Ceylan: Chefs–d'oeuvres des musées du Sri Lanka. Paris: Association Francaise d'Action Artistique, 1991.

Chutiwongs, Nandana. "Sri Lanka and Some Bodhisattva Images from Southeast Asia." In *Studies in South and Southeast Asia Archaeology*, edited by H. I. R. Hinzler, 68–82. Leiden: University of Leiden, 1986.

Schroeder, Ulrich von. *Buddhist Sculpture of Sri Lanka*. Hong Kong: Visual Dharma, 1990.

Schroeder, Ulrich von. *Indo-Tibetan Bronzes*. Hong Kong: Visual Dharma, 1981.

Woodward, Hiram W., Jr. "Interrelations in a Group of South-East Asian Sculptures." *Apollo* 118, no. 261 (November 1983): 379–83.

SOUTHEAST ASIA

A Buddha from Myanmar

Fraser-Lu, Sylvia, and Donald M. Stadtner, eds. *Buddhist Art of Myanmar*. New York: Asia Society Museum, 2015. In association with Yale University Press.

Green, Alexandra, and Richard T. Blurton, eds. *Burma: Art and Archaeology*. London: British Museum, 2002.

Huntington, Susan L., and John C. Huntington. *Leaves from the Bodhi Tree: The Art of Pala India (8th–12th Centuries) and Its International Legacy*. Dayton: Dayton Art Institute; Seattle: University of Washington, 1990.

Lopetcharat, Somkiart. *Myanmar Buddha: The Image and Its History*. Bangkok: Siam International, 2007.

Luce, Gordon H. *Old Burma, Early Pagan*. 3 vols. Locust Valley, NY: J. J. Augustin, 1969–70. Published for *Artibus Asiae* and the Institute of Fine Arts, New York University.

Zwalf, W., ed. *Buddhism: Art and Faith*. London: British Museum, 1985.

Early Sculptures from Mainland Southeast Asia

Boisselier, J. *Le Cambodge; Manuel d'archaeologie d'Extreme-Orient, Pt. I: Asie du Sud-Est, vol. I*. Paris: A. et J. Picard, 1966.

——. "Notes sur l'art du bronze dans l'ancien Cambodge." *Artibus Asiae* 29 (1967): 275–334.

Brown, Robert. "Indian Art Transformed: The Earliest Sculptural Styles of Southeast Asia." In *Indian Art and Archaeology*, edited by Ellen M. Raven and Karel R. Van Kooij. Leiden: E. J. Brill, 1992.

Bunker, Emma. "Pre-Angkor Period Bronzes from Pra Kon Chai." *Archives of Asian Art* 25 (1971–72): 67–76.

Charoenswongsa, P., and S. Diskul. *Thailande*. Archeologie Mundi. Geneva: Nagel, 1976.

Chutiwongs, Nandana. *The Iconography of Avalokitesvara in Mainland South East Asia*. New Delhi: Aryan, 2002.

Chutiwongs, Nandana, and Denise Patry Leidy. *Buddha of the Future: An Early Maitreya from Thailand*. New York: Asia Society Galleries, 1994. Distributed by University of Washington Press.

Diskul, S. "Development of Dvaravati Sculpture and a Recent Find from Northeast Thailand." In *Early South East Asia*, edited by R. B. Smith and W. Watson. London: Oxford University, 1979.

Diskul, S., ed. *The Art of Srivijaya*. London: Oxford University, 1980.

Dupont, P. *La Statuaire preangkorienne*. Artibus Asiae Supplementum, no. 15. Ascona, Switzerland: Artibus Asiae, 1955.

Guy, John. *Lost Kingdoms: Hindu-Buddhist Sculpture of Early Southeast Asia*. New York: Metropolitan Museum of Art; New Haven and London: Yale University, 2014.

Higham, Charles. *The Archaeology of Mainland Southeast Asia: From 10,000 BC to the Fall of Angkor*. Cambridge World Archaeology. Cambridge, England: Cambridge University, 1989.

Krairiksh, Piriya, *Art in Peninsular Thailand Prior to the Fourteenth Century A.D.* Bangkok: Fine Arts Department, 1980.

——. *The Sacred Image: Sculptures from Thailand*. Cologne: Museum fur Ostasiatische Kunst der Stadt Köln, 1979.

Lee, Sherman E. *Ancient Cambodian Sculpture*. New York: Asia Society, 1969.

Lerner, Martin. *The Flame and the Lotus: Indian and Southeast Asian Art from the Kronos Collection*. New York: Metropolitan Museum of Art and Harry N. Abrams, 1985.

——. *The Lotus Transcendent: Indian and Southeast Asian Art from the Samuel Eilenberg Collection*. New York: Metropolitan Museum of Art and Harry N. Abrams, 1991.

O'Connor, Stanley. *Hindu Gods of Peninsular Siam*. Ascona, Switzerland: Artibus Asiae, 1972.

Suleiman, S. *Sculptures of Ancient Sumatra*. Jakarta: Pusat Penelitian Arkeologi National, 1981.

Woodward, Hiram W., Jr. "Interrelations in a Group of South-East Asian Sculptures." *Apollo* 118, no. 261 (November 1983): 379–83.

Sculptures of the Khmer Empire

Boisselier, J. *La Statuaire khmer et son evolution*. 2 vols. Paris: Ecole Francaise d'Extreme-Orient, 1955.

Bunker, Emma C., and Douglas Latchford. *Adoration and Glory: The Golden Age of Khmer Art*. Chicago: Art Media Resources, 2004.

de Coral-Remusat, G. *L'Art khmer: Les grands etapes de son evolution*. Paris: Vanoest, 1951.

Felten, W., and M. Lerner. *Thai and Cambodian Sculpture from the 6th to the 14th Centuries*. London: Philip Wilson, 1989.

Jessup, Helen Ibbitson, and Thierry Zephir, eds. *Sculpture of Angkor and Ancient Cambodia: Millennium of Glory*. Washington, DC: National Gallery of Art, 1997.

Krairiksh, Piriya. *Khmer Bronzes: A Selection from the Suan Phka Tevoda Collection*. Lugano: Corner Bank, 1982.

Lee, Sherman E. *Ancient Cambodian Sculpture*. New York: Asia Society, 1969.

Lerner, Martin. *The Flame and the Lotus: Indian and Southeast Asian Art from the Kronos Collection*. New York: Metropolitan Museum of Art and Harry N. Abrams, 1985.

——. *The Lotus Transcendent: Indian and Southeast Asian Art from the Samuel Eilenberg Collection*. New York: Metropolitan Museum of Art and Harry N. Abrams, 1991.

Pal, Pratapaditya. *The Sensuous Immortals: A Selection of Sculptures from the Pan-Asian Collection*. Los Angeles: Los Angeles County Museum of Art, 1977. Distributed by MIT Press.

——, ed. *Light of Asia: Buddha Shakyamuni in Asian Art*. Los Angeles: Los Angeles County Museum of Art, 1984.

Woodward, Hiram W., Jr. "Some Buddha Images and the Cultural Developments of the Late Angkor Period." *Artibus Asiae* 42 (1980): 155–74.

——. "Tantric Buddhism at Angkor Thom." *Ars Orientalis* 12 (1981): 57–71.

Sculptures from Indonesia

Bernet Kempers, A. J. *Ancient Indonesian Art*. Amsterdam: Van der Peet, 1959.

Fontein, Jan. *The Sculpture of Indonesia*. Washington, DC: National Gallery of Art, 1990.

Fontein Jan, R. Soekmono, and Satyawati Suleiman. *Ancient Indonesian Art of the Central and Eastern Javanese Periods*. New York: Asia Society, 1971. Distributed by New York Graphic Society.

Lerner, Martin. *The Lotus Transcendent: Indian and Southeast Asian Art from the Samuel Eilenberg Collection*. New York: Metropolitan Museum of Art and Harry N. Abrams, 1991.

Lunsingh Scheurleer, P., and M. Klokke. *Divine Bronze: Ancient Indonesian Bronzes from A.D. 600 to 1600*. Amsterdam: Museum of Asiatic Art, 1988.

Ceramics from Southeast Asia

Brown, Roxanne. *The Ceramics of Southeast Asia: Their Dating and Identification*. 2nd ed. Singapore: Oxford University, 1988.

Charoenwongse, P., ed. *Sangalok sisatchanalai*. Bangkok: Department of Fine Arts, 1987.

Feng Xianming. "Some Problems Concerning the Origin of Blue-and-White Porcelains." *New Discoveries in Chinese Ceramics* 3 (1981): 50–56.

Frasché, Dean F. *Southeast Asian Ceramics: Ninth through Seventeenth Centuries*. New York: Asia Society, 1976. In association with Weatherhill.

Groslier, B. P. "Introduction to the Ceramic Wares of Angkor." In *Khmer Ceramics, 9th–14th Century*. Singapore: Southeast Asian Ceramic Society, 1981.

Guy, John. *Ceramics Traditions of Southeast Asia*. Singapore: Oxford University, 1989.

——. *Oriental Trade Ceramics in South-east Asia: Ninth to Sixteenth Centuries*. Singapore: Oxford University, 1990.

——. "Vietnamese Trade Ceramics and Cultural Identity; Evidence from the Ly and Tran Dynasties." In *Southeast Asia in the 9th to 10th Centuries. Proceedings of a Symposium Held at the Australian National University*, edited by D. Marr and A. Milner. Singapore: Institute of Southeast Asian Studies, 1984.

Hein, D., P. Burns, and R. Richards. "Sawankhalok Kilns: Further Discoveries." *Bulletin of the Art Gallery of South Australia* 39 (1983): 37–47.

Itoi, K. *Thai Ceramics from the Sosai Collection*. Singapore: Oxford University, 1989.

Khmer Ceramics, 9th–14th Century. Singapore: Southeast Asian Ceramic Society, 1981.

Mikami Tsugio, ed. *Sekai toji zenshu* [Ceramic art of the world, vol. 16: Southeast Asia]. Tokyo: Shogakukan, 1984.

Nguyen Dinh Chien. *Handbook of Vietnamese Ceramics with Inscriptions from the Fifteenth to Nineteenth Centuries*. Hanoi: National Museum of History, 1999.

Rooney, Dawn. *Khmer Ceramics*. Singapore: Oxford University, 1984.

Rooney, Dawn F. "A Field Guide to Glazed Thai Ceramics." *Asian Perspectives* 28, no. 2 (1990): 125–44.

Shaw, J. C. *Northern Thai Ceramics*. Kuala Lumpur: Oxford University, 1981.

Thai Ceramics: The James and Elaine Connell Collection. Kuala Lumpur: Oxford University, 1993.

Tingley, Nancy, ed. *Arts of Ancient Viet Nam: From River Plain to Open Sea*. Houston: Museum of Fine Arts, Houston; New York: Asia Society, 2009. Distributed by Yale University Press.

Woodward, Hiram W., Jr. "The Dating of Sukhothai and Sawankhalok Ceramics: Some Considerations." *Journal of the Siam Society* 66, pt. 1 (1978): 1–7.

EAST ASIA

Chinese Bronzes of the Shang and Zhou Periods

Chang, K. C. *Art, Myth, and Ritual: The Path to Political Authority in Ancient China*. Cambridge, MA: Harvard University, 1983.

Chase, W. T., with Jung May Lee. *Ancient Chinese Bronze Art: Casting the Precious Sacral Vessel*. New York: China House Gallery, 1991.

Fong, Wen, ed. *The Great Bronze Age of China*. New York: Metropolitan Museum of Art and Alfred A. Knopf, 1980.

Kuwayama, George, ed. *The Great Bronze Age of China: A Symposium*. Los Angeles: Los Angeles County Museum of Art, 1983.

Rawson, Jessica. *Ancient China: Art and Archaeology*. London: Harper and Row, 1980.

——. "Eccentric Bronzes of the Early Western Zhou." *Transactions of the Oriental Ceramics Society* 47 (1982–83): 11–32.

Whitfield, Roderick, ed. *The Problem of Meaning in Early Chinese Ritual Bronzes*. London: Percival David Foundation of Chinese Art, 1993.

Han Dynasty Bronzes

Erickson, Susan N. "Boshanlu—Mountain Censers of the Western Han Period: A Typological and Critical Analysis." *Archives of Asian Art* 45 (1992): 6–28.

Guo Yong. "Western Han Bronze Vessels Excavated at Youyou Xian, Shansi Province." *Wenwu* 1963, no. 2: 4–12.

Loewe, Michael. *Ways to Paradise: The Chinese Quest for Immortality*. London: George Allen and Unwin, 1979.

Sturman, Peter. "Wild Beasts and Winged Immortals: Early Representations of Landscape in China." *National Palace Museum Bulletin* 20, nos. 2–4 (May/June, July/Aug, Sept/Oct).

Wang Zhongshu. *Han Civilization*. Translated by K. C. Chang. New Haven and London: Yale University, 1982.

Wu Hung. "A Sanpan Shan Chariot Ornament and the Xiangrui Design in Western Han Art." *Archives of Asian Art* 37 (1984): 38–59.

Early Chinese Ceramics

Lovell, Hin-cheung. "Some Northern Chinese Ceramic Wares of the Sixth and Seventh Centuries." *Oriental Art* 21 (1975): 328–43.

Mino, Yutaka, and Katherine R. Tsiang. *Ice and Green Clouds: Traditions of Chinese Celadon*. Indianapolis: Indianapolis Museum of Art, 1987. In cooperation with Indiana University.

Shangraw, Clarence. *Origins of Chinese Ceramics*. New York: China Institute of America, 1979.

Tsiang, Katherine R. "Glazed Stonewares of the Han Dynasty, Part One: The Eastern Group." *Artibus Asiae* 40 (1978): 143–76.

——. "Glazed Stonewares of the Han Dynasty, Part Two: The Southern Group." *Artibus Asiae* 41 (1979): 157–84.

Watson, William. *Tang and Liao Ceramics*. New York: Rizzoli, 1984.

Zhonghua Wu Qian Nian Wenwu Jikan Bianji Weiyuanhui [Five Thousand Years of Chinese Art Editorial Committee]. *Gansu Yangshao caicao* [Neolithic painted pottery: Yangshao painted pottery from Gansu province]. Taipei, 1982.

Sculptures for Tombs

Kuwayama, George, ed. *Ancient Mortuary Traditions of China: Papers on Chinese Ceramic Funerary Sculptures*. Los Angeles: Los Angeles County Museum of Art, 1991. Distributed by University of Hawaii Press.

The Quest for Eternity: Chinese Sculpture from the People's Republic of China. Los Angeles: Los Angeles County Museum of Art; San Francisco: Chronicle Books, 1987.

Shaanxi Provincial Museum and the Tang Tomb Excavation Team of the Liquan County Cultural Education Office. "Tang Zheng Rentai mu fajue jianbao" [Brief report on the excavation of the Tang tomb of Zheng Rentai]. *Wenwu* 1972, no. 7: 33–44, pls. 10–12.

Shaanxi Provincial Museum and the Tang Tomb Excavation Team of the Qian County Cultural Education Office. "Tang Zhanghuai Taizi mu fajue jianbao" [Brief report on the excavation of the tomb of the Tang prince Zhanghuai]. *Wenwu* 1972, no. 7: 13–25.

Wang Xueli and Wu Zhenfeng. "Xi'an Renjiapo Han ling congzang keng de faiue" [Excavation of the pits for funerary objects accompanying a Han mausoleum at Renjiapo, Xi'an]. *Kaogu* 1976, no. 2: 75, 129–33.

Watson, William. *Tang and Liao Ceramics*. New York: Rizzoli, 1984.

Chinese Buddhist Sculptures

Cheng Jizhong. "Hebei Gaochengxian faxian yipi beiqi shizaoxiang" [Some stone sculptures of the northern period excavated at Gaocheng in Hebei]. *Kaogu* 1980, no. 3: 242–45.

Leidy, Denise Patry. "The Ssu-wei Figure in Sixth-Century A.D. Chinese Buddhist Sculpture." *Archives of Asian Art* 43 (1990): 21–37.

Matsubara Saburo. *Zotei Chūgoku chōkōkushi kenkyū* [Research on Chinese Buddhist sculpture]. Tokyo: Kodakawa Kokubunkan, 1966.

Siren, Osvald. *Chinese Sculpture from the Fifth to the Fourteenth Century*. 4 vols. New York: Charles Scribner's Sons, 1925.

Tang and Liao Dynasty Metalwork

Gyllensvard, Bo. *Chinese Gold and Silver in the Carl Kempe Collection*. Stockholm: Nordisk Rotogravyr, 1953.

Juliano, Annette L., and Judith A. Lerner. *Monks and Merchants: Silk Road Treasures from Northwest China; Gansu and Ningxia, 4th–7th Century*. New York: Asia Society and Harry N. Abrams, 2001.

Kelley, Clarence W. *Chinese Silver in American Collections: Tang Dynasty, A.D. 618–907*. Dayton, OH: Dayton Art Institute, 1984.

Rawson, Jessica, "The Ornament of Chinese Silver of the Tang Dynasty (A.D. 618–906)." *British Museum Occasional Papers* 40 (1982).

——. "Tomb of Hoards: The Survival of Chinese Silver in the Tang Periods, Seventh to Thirteenth Centuries A.D." In *Pots and Pans, A Colloquium on Precious Metals and Ceramics*, edited by M. Vickers. Oxford Studies in Islamic Art 3 (1986): 31–56.

Shen, Hsueh-man, ed. *Gilded Splendor: Treasures of China's Liao Empire (907–1125)*. New York: Asia Society; Milan: 5 Continents, 2006.

Watson, William, ed. *Pottery and Metalwork in T'ang China: Their Chronology and External Relations*. London: Percival David Foundation of Chinese Art, 1970.

Ceramics of the Song and Jin Periods

Boqian Zhu. "A Pearl among Greenwares: Guan Ware of the Southern Song." Translated by Roderick Whitfield. *Transactions of the Oriental Ceramic Society* 56 (1991–92): 30–35.

Chen Baiquan. "The Development of Song Dynasty Qinghai Wares from Jingdezhen." In *The Porcelains of Jingdezhen*, edited by Rosemary Scott, 13–32. London: Percival David Foundation of Chinese Art, 1992.

Fan Dongqing. "Early Ding Wares in the Shanghai Museum." *Orientations* (February 1991): 48–53.

Gray, Basil. *Sung Porcelain and Stoneware*. London and Boston: Faber and Faber, 1984.

Imperial Taste: Chinese Ceramics from the Percival David Foundation. Los Angeles: Los Angeles County Museum of Art and Chronicle Books, 1989.

Krahl, Regina. "The 'Alexander Bowl' and the Question of Northern Guan Ware." *Orientations* (November 1993): 72–75.

Li Huibing. "A Re-definition of Ge Ware and Related Problems." *Orientations* (November 1993): 76–78.

Mino, Yutaka, and Katherine R. Tsiang. *Freedom of Clay and Brush through Seven Centuries in Northern China: Tz'u-chou Type Wares, 960–1600 A.D.* Indianapolis: Indianapolis Museum of Art, 1987. In cooperation with Indiana University Press.

———. *Ice and Green Clouds: Traditions of Chinese Celadon*. Indianapolis: Indianapolis Museum of Art, 1987. In cooperation with Indiana University Press.

Mowry, Robert D. "The Sophistication of Song Dynasty Ceramics." *Apollo* 118, no. 261 (November 1983): 394–403.

Traeger, Mary. *Song Ceramics*. London: Rizzoli, 1982.

Vainker, S. "Ge Ware Conference Report." *Oriental Art* 39 (1993): 4–11.

Wang Qizheng, Fan Dongqing, and Zhou Lili. *Ruyao de faxian* [Discovery of the Ru kiln]. Shanghai: Shanghai Renmin Meishu Chubanshe, 1987.

Porcelains of the Yuan and Early Ming Periods

Addis, John. "Hung Wu and Yung Lo White." *Transactions of the Oriental Ceramic Society* 41 (1975–77): 35–57.

Imperial Taste: Chinese Ceramics from the Percival David Foundation. Los Angeles: Los Angeles County Museum of Art and Chronicle Books, 1989.

In Pursuit of the Dragon: Traditions and Transitions in Ming Ceramics. Seattle: Seattle Art Museum, 1988.

Krahl, Regina, John Guy, J. Keith Wilson, and Julian Raby, eds. *Shipwrecked: Tang Treasures and Monsoon Winds*, 77–78. Washington, DC: Smithsonian Institution, 2010.

Liu Xinyuan. "Yuan Dynasty Official Wares from Jingdezhen." In *The Porcelains of Jingdezhen*, edited by Rosemary Scott. London: Percival David Foundation of Chinese Art, 1993.

Medley, Margaret. "Imperial Patronage and Early Ming Porcelain." *Transactions of the Oriental Ceramic Society* 54 (1990–91): 29–42.

———. "Style and Symbolism in Underglaze-Decorated Chinese Porcelain." *Apollo* 118, no. 261 (November 1983): 403–07.

Rogers, Mary Ann. "The Mechanics of Change: The Creation of a Song Imperial Ceramic Style." In *New Perspectives on the Art of Ceramics in China*, edited by George Kuwayama, 64–79. Los Angeles: Los Angeles County Museum of Art, 1992. Distributed by University of Hawaii Press.

Tang Changpu. "Jiangxi Jizhou yao faxian Song Yuan qinghua ci" [Song- and Yuan-dynasty blue-and-white porcelains unearthed at the Jizhou kiln, Jiangxi province]. *Wenwu* 1980, no. 4: 4–9.

Yang Houli and Wen Liangtian. "Yuandai qinghua mudan ta gai ci ping" [A Yuan dynasty *ping* vessel with a pagoda-shape cover and underglaze blue decoration of a camellia]. *Wenwu* 1981, no. 2: 72–74.

Zhang Pusheng. "New Discoveries from Recent Research into Chinese Blue and White Porcelain." Translated by Roderick Whitfield. *Transactions of the Oriental Ceramic Society* 56 (1991–92): 37–46.

Zhejiang Provincial Museum. "Zhejiang liang zhu ta ji chutu Song qinghua ci" [Song dynasty blue-and-white porcelains discovered at two pagoda bases in Zhejiang province]. *Wenwu* 1980, no. 4: 1–3.

Imperial Chinese Ceramics of the 15th Century

Chen Ching-kuang. "Sea Creatures on Ming Imperial Porcelains." Translated by Anthony Hua-tien Lin. In *The Porcelains of Jingdezhen*, edited by Rosemary Scott, 101–20. London: Percival David Foundation of Chinese Art, 1993.

Cort, Louise Allison, and Jan Stuart, with Laurence Chi-sing Tam. *Joined Colors: Decoration and Meaning in Chinese Porcelain*. Washington, DC: Arthur M. Sackler Gallery, Smithsonian Institution, 1993. In association with Tai Yip, Hong Kong.

Imperial Taste: Chinese Ceramics from the Percival David Foundation. Los Angeles: Los Angeles County Museum of Art and Chronicle Books, 1989.

In Pursuit of the Dragon: Traditions and Transitions in Ming Ceramics. Seattle: Seattle Art Museum, 1988.

Lau, Christine. "Ceremonial Monochrome Wares of the Ming Dynasty." In *The Porcelains of Jingdezhen*, edited by Rosemary Scott, 83–99. London: Percival David Foundation of Chinese Art, 1993.

Medley, Margaret. "Re-Grouping 15th-Century Blue-and-White." *Transactions of the Oriental Ceramic Society* 34 (1962–63): 83–99.

———. "Style and Symbolism in Underglaze-Decorated Chinese Porcelain." *Apollo* 118, no. 261 (November 1983): 403–07.

Ceramics of the Late Ming Period

Butler, Sir Michael, Margaret Medley, and Stephen Little. *Seventeenth-Century Chinese Porcelains from the Butler Family Collection*. Alexandria, VA: Art Services International, 1990.

Cort, Louise Allison, and Jan Stuart, with Laurence Chi-sing Tam. *Joined Colors: Decoration and Meaning in Chinese Porcelain*. Washington, DC: Arthur M. Sackler Gallery, Smithsonian Institution, 1993. In association with Tai Yip, Hong Kong.

Curtis, Julia B. "Markets, Motifs, and Seventeenth Century Jingdezhen Porcelain." In *The Porcelains of Jingdezhen*, edited by Rosemary Scott, 123–50. London: Percival David Foundation of Chinese Art, 1993.

———. "Transition Ware Made Plain: A Wreck from the South China Sea." *Oriental Art* 31 (Summer 1985): 161–73.

Idemitsu Bijutsukan [Idemitsu Museum of Arts]. *In Pursuit of the Dragon: Traditions and Transitions in Ming Ceramics*. Seattle: Seattle Art Museum, 1988.

Little, Stephen. *Chinese Ceramics of the Transitional Period: 1620–1683*. New York: China Institute of America, 1990.

Sheaf, Colin D. "Chinese Porcelain and Japanese Tea Taste in the Late Ming Period." In *The Porcelains of Jingdezhen*, edited by Rosemary Scott, 165–82. London: Percival David Foundation of Chinese Art, 1993.

Qing Dynasty Porcelains

Cort, Louise Allison, and Jan Stuart, with Laurence Chi-sing Tam. *Joined Colors: Decoration and Meaning in Chinese Porcelain*. Washington, DC: Arthur M. Sackler Gallery, Smithsonian Institution, 1993. In association with Tai Yip, Hong Kong.

Imperial Taste: Chinese Ceramics from the Percival David Foundation. Los Angeles: Los Angeles County Museum of Art and Chronicle Books, 1989.

Li Yi-hua, ed. *Kangxi, Yongzheng, Qianlong: Qing Porcelain from the Palace Museum Collection*. Beijing: Forbidden City Publishing and Woods Publishing; Hong Kong: Tai Yip, 1989.

Yorke-Hardy, S. "Ku Yueh Hsuan: A New Hypothesis." *Oriental Art* (1949): 116–25.

Landscape Painting in China

Barnhart, Richard M., with Mary Ann Rogers and Richard Stanley-Baker. *Painters of the Great Ming: The Imperial Court and the Zhe School*. Dallas: Dallas Museum of Art, 1993.

Cahill, James. *Hills Beyond a River: Chinese Painting of the Yuan Dynasty, 1279–1368*. New York: Weatherhill, 1976.

Ho, Wai-kam, and Judith G. Smith, eds. *The Century of Tung Ch'i-ch'ang 1555–1636*. 2 vols. Kansas City, MO: Nelson Atkins Museum of Art; Seattle: University of Washington, 1992.

Mowry, Robert D. "*Figures in a Mountain Landscape:* An Attribution to Lou Guan." *Apollo* 118, no. 261 (November 1983): 384–93.

Sturman, Peter C., and Susan S. Tai. *The Artful Recluse: Painting, Poetry, and Politics in Seventeenth-Century China*. Santa Barbara: Santa Barbara Museum of Art; New York: DelMonico, Prestel, 2012.

Jade and Lacquer in China

Rawson, Jessica, ed. *The British Museum Book of Chinese Art*. New York: Thames and Hudson, 1993.

Watt, James C. Y. *Chinese Jades from Han to Ch'ing*. New York: Asia Society, 1980. In association with Weatherhill.

———. *Chinese Jades from the Collection of the Seattle Art Museum*. Seattle: Seattle Museum of Art, 1989.

Watt, James C. Y., and Barbara Brennan Ford. *East Asian Lacquer: The Florence and Herbert Irving Collection*. New York: Metropolitan Museum of Art, 1991.

Korean Ceramics

Griffing, Robert P., Jr. *The Art of the Korean Potter: Silla, Koryo, Yi*. New York: Asia Society, 1968. Distributed by New York Graphic Society.

Kim, Hongnam, ed. *Korean Arts of the Eighteenth Century: Splendor and Simplicity*. New York: Asia Society Galleries / Weatherhill, 1993.

Kim Wonyong, Odazaki Takashi, and Han Byongsan. *Kōrai gudai* [Korean prehistoric and ancient periods]. Sekai tōji zenshū [Ceramic art of the world] 17. Tokyo: Shōgakukan, 1979.

Rogers, Mary Ann. "The Mechanics of Change: The Creation of a Song Imperial Ceramic Style." In *New Perspectives on the Art of Ceramics in China*, edited by George Kuwayama, 64–79. Los Angeles: Los Angeles County Museum of Art, 1992. Distributed by University of Hawaii Press.

Mino, Yutaka. *The Radiance of Jade and the Clarity of Water: Korean Ceramics from the Ataka Collection*. Chicago: Art Institute of Chicago; New York: Hudson Hills, 1991.

Mowry, Robert D. "Koryo Celadons." *Orientations* 17 (May 1986): 24–39.

Xu Jing. *Xuanhe fengshi Gaoli tujing* [Illlustrated description of the Chinese embassy to Korea during the Xuanhe period, 1124]. In *Congshu jicheng chupien* [Primary edition of collected works of ancient texts], chap. 32. 1937.

An 18th Century Korean Buddhist Painting

Horioka, Chimei. "Bosuton Bijutsukan no Chōsen Butsuga ni tsuire" [Concerning the Korean Buddhist paintings in the collection of the Museum of Fine Arts, Boston]. *Ars Buddhica* 83 (1972): 53–59.

Kang Woo Bang. "Ritual and Art During the Eighteenth Century." In *Korean Arts of the Eighteenth Century: Splendor and Simplicity*, edited by Hongnam Kim, 79–98. New York: Asia Society Galleries / Weatherhill, 1993.

Kim, Hongnam. *The Story of a Painting: A Korean Buddhist Treasure from the Mary and Jackson Burke Foundation*. New York: Asia Society Galleries, 1991.

Moes, Robert. *Korean Art: From the Brooklyn Museum Collection*. New York: Universe, 1987.

Two Early Japanese Sculptures

Inokuma Kanekatsu. *Nihon no genshi bijutsu* [Early arts of Japan]. Tokyo: Kodansha, 1979.

Miki, Fumio. *Haniwa*. Translated and adapted with an introduction by Gina Lee Barnes. New York: Weatherhill; Tokyo: Shibundo, 1974.

Pearson, Richard J. *Ancient Japan*. Washington, DC: Smithsonian Institution; Tokyo: Agency for Cultural Affairs, Government of Japan; New York: Braziller, 1992.

The Rise of a Great Tradition: Japanese Archaeological Ceramics from the Jomon through Heian Periods (10,500 B.C.–A.D. 1185). New York: Japan Society; Tokyo: Agency for Cultural Affairs, Government of Japan, 1990.

Japanese Buddhist Art

Brinker, Helmut, and Hiroshi Kanazawa. *Zen Masters of Meditation in Images and Writings*. Zurich, Artibus Asiae Publishers, Supplementum, 1996.

Covaci, Ive, ed. *Kamakura: Realism and Spirituality in the Sculpture of Japan*. New York: Asia Society Museum; New Haven: Yale University, 2016.

Harris, Victor, and Matsushima Ken. *Kamakura: The Renaissance of Japanese Sculpture*. London: British Museum, 1991.

Ishida Mosaku. *Shōtoku Taishi sonzō shōsei* [Collection of images of Shōtoku Taishi]. Tokyo: Kodansha, 1976.

Itō Shirō. *Koma-inu* [Lion Dogs]. *Nihon no Bijutsu*, no. 279. Kyoto: Kyoto National Museum, 1989.

Kamakura Jidai no chōkōku [Kamakura-period sculpture]. Tokyo: Tokyo National Museum, 1975.

Kuno Takeshi. "Daibusshi Zen'en to sono sakuhin" [Daibusshi Zen'en and his works]. *Bijutsu Kenkyu* 240 (May 1965): 1–17.

Kurata Bunsaka. *Hōryū-ji: Temple of the Exalted Law; Early Buddhist Art from Japan*. Translated by W. Chie Ishibashi. New York: Japan Society, 1981.

Miyama Susumu, ed. *Kamakura no chōkōku, kenchiku* [Kamakura-period sculpture and architecture]. *Nihon bijustu zenshu* [Compendium of Japanese art] 12. Tokyo: Gakuso Kenkyusha, 1978.

Mori Hisashi. *Sculpture of the Kamakura Period*. Translated by Kathleen Eickmann. New York: Weatherhill; Tokyo: Heibonsha, 1974.

Nishikawa Kyōtarō and Emily Sano. *The Great Age of Japanese Buddhist Sculpture A.D. 600–1300*. Fort Worth, TX: Kimbell Art Museum; New York: Japan Society, 1982.

Okazaki Jōji. *Pure Land Buddhist Painting*. Translated and adapted by Elizabeth ten Grotenhuis. New York: Kodansha International; Tokyo: Shibundo, 1977.

Rosenfield, John. *Japanese Arts of the Heian Period: 794–1185*. New York: Asia Society, 1967.

Rosenfield, John. M. "The Perfection of Japanese Sculpture." *Apollo* 118, no. 261 (November 1983): 426–29.

Rosenfield, John, and Elizabeth ten Grotenhuis. *Journey of the Three Jewels: Japanese Buddhist Paintings from Western Collections*. New York: Asia Society Galleries / Weatherhill, 1979.

Shimada Shūjirō, ed. *Chōkoku* [Sculpture]. *Zaiga Nihon no Shiho* [Japanese art treasures in foreign collections] 8. Tokyo: Mainichi Shinbunsha, 1980.

Tezuka, Miwako. "A White-robed Kannon in the Asia Society." *Orientations* 29, no. 11 (December 1998): 43.

Yoshida Hiroshi and Kikutake Jun'ichi. *Kōrai Butsuga* [Koryo Buddhist painting]. Tokyo: Nihon Keizai Shinbunsha, 1981.

Paintings of the Muromachi Period

Miyajima Shin'ichi and Satō Yasuhiro. *Japanese Ink Paintings*. Los Angeles: Los Angeles County Museum of Art, 1985.

Nihon no suibokuga [Japanese ink painting]. Tokyo: Tokyo National Museum, 1989.

Shimada Shūjirō and Iriya Yoshitake, eds. *Zenrin gasan chūsei suibokuga o yomu* [Painting colophons from Japanese Zen milieu]. Tokyo: Mainichi Shinbunsha, 1987.

Shimizu, Yoshiaki, and Carolyn Wheelwright, eds. *Japanese Ink Paintings from American Collections: The Muromachi Period*. Princeton, NJ: Art Museum, Princeton University, 1976.

Tanaka Ichimatsu. *Nihon kaiga shi ronshu* [Collected essays on the history of Japanese painting]. Tokyo: Chūōkōronsha, 1966.

Watanabe Akiyoshi, Kanazawa Hiroshi, and Paul Varley. *Of Water and Ink: Muromachi Period Paintings from Japan 1392–1568*. Detroit: Detroit Institute of Arts; Honolulu: Honolulu Academy of Art; Tokyo: Agency for Cultural Affairs, Government of Japan, 1986.

Weigl, Gail Capitol. "The Reception of Chinese Painting Models in Muromachi Japan." *Monumenta Nipponica* 35, no. 3 (1980): 257–72.

Kanō School Paintings

Buckland, Rosina. *Golden Fantasies: Japanese Screens from New York Collections*. New York: Asia Society, 2004.

Cunningham, Michael R., with Suzuki Norio, Miyajima Shin'ichi, and Saito Takamsa. *The Triumph of Japanese Style: 16th Century Art in Japan*. Cleveland: Cleveland Museum of Art, 1991. In cooperation with Indiana University Press.

Go-Hōjō shi to tōgoku bunka [The Go-Hōjō family and Eastern culture]. Yokohama: Kanagawa Kenristu Hakubutsukan, 1989.

Kanda, Christine Guth. "Watanabe Shiko's Irises." *Bulletin of the Cleveland Museum of Art* 71 (September 1984): 240–51.

Murase, Miyeko. *Byōbu: Japanese Screens from New York Collections*. New York: Asia Society, 1979. Distributed by New York Graphic Society.

Murase, Miyeko, with Gratia Williams Nakahashi and Stephanie Wada. *Jewel Rivers: Japanese Art from the Burke Collection*. Richmond, VA: Virginia Museum of Fine Arts, 1993. In cooperation with the Mary and Jackson Burke Foundation.

Ohta Dōkan Kinen bijutsu ten: Muromachi bijutsu to Sengoku gadan [The Ohta Dōkan Memorial art exhibition: Art of the Muromachi and Sengoku periods]. Tokyo: Tokyo Metropolitan Teian Art Museum, 1986.

Shizuoka Prefectural Art Museum. *Kano-ha no kyojin tachi* [Great master of the Kano school]. Shizuoka: Shizuoka Prefectural Art Museum, 1989.

Takeda Tsuneo. *Kanō Eitoku*. Translated and adapted by H. Mack Horton and Catherine Kaputa. New York: Kodansha International; Tokyo: Shibundo, 1977.

Rinpa Paintings

Guth, Christine M. E. "*Varied Trees*, An I'nen Seal Screen in the Freer Gallery of Art." *Archives of Asian Art* 39 (1986): 48–61.

Hōitsu Kachōga fu [Edo Rinpa and artists surrounding Sakai Hoitsu]. 5 vols. Kyoto: Shikōsha, 1979.

Kokkasha, ed. *Kōetsu sho Sōtatsu's kigin-dei-e* [Kōetsu's calligraphy and Sōtatsu's painting in gold and silver ink]. Tokyo: Asahi Shinbunsha, 1978.

Mizuo Hiroshi. *Edo Painting: Sotatsu and Korin*. Translated by John M. Shields. New York: Weatherhill; Tokyo: Heibonsha, 1972.

Murase, Miyeko. "Fan Paintings Attributed to Sotatsu: Their Themes and Prototypes." *Ars Orientalis* 9 (1973): 51–77.

———. *Japanese Art: Selections from the Mary and Jackson Burke Collection*. New York: Metropolitan Museum of Art. 1975.

Murashige, Yashushi, ed. *Rinpa*. 4 vols. Kyoto: Shikōsha, 1978.

Ono Tomoko. "Sakai Hōitsu no gafu tenkai to sono tokushoku" [Special features in the development of Sakai Hōitsu's painting style: new evidence and a reevaluation of Edo Rinpa]. *Bijutsushi* 38, no. 2 (1989): 134–50.

Rosenfield, John, Edwin Cranston, and Fumiko Cranston. *The Courtly Tradition in Japanese Art and Literature*. Cambridge, MA: Harvard University, 1973.

Four Japanese Woodblock Prints, 1790–1900

Lane, Richard. *Images from the Floating World: The Japanese Print*. New York: G. P. Putnam's Sons, 1978.

Leiter, Samuel. *Kabuki Encyclopedia: An English-Language Adaptation of the Kabuki Jiten*. Westport, CT: Greenwood, 1979.

Meech, Julia, and Jane Oliver, eds. *Designed for Pleasure: The World of Edo Japan in Prints and Paintings, 1680–1860*. New York: Asia Society / Japanese Art Society of America, 2008. In association with University of Washington.

Narazaki Muneshige and Kikuchi Sadao. *Utāmarō*. Translated by John Bester. Tokyo and Palo Alto: Kodansha International, 1968.

Suzuki Jūzō. *Shārāku*. Translated by John Bester. Tokyo and Palo Alto: Kodansha International, 1968.

Thompson, Sarah E., and H. D. Harootunian. *Undercurrents in the Floating World: Censorship and Japanese Prints*. New York: Asia Society Galleries, 1991.

Japanese Stonewares

Ceramic Art of Japan: One Hundred Masterpieces from Japanese Collections. Seattle: Seattle Art Museum, 1972.

Cort, Louise Allison. "Japanese Ceramics and Cuisine." *Asian Art* 3, no. 1 (Winter 1990): 9–38.

———. *Seto and Mino Ceramics*. Japanese Collections in the Freer Gallery of Art. Washington, DC: Freer Gallery of Art, Smithsonian Institution, 1992. Distributed by University of Hawaii Press.

Ford, Barbara Brennan, and Oliver R. Impey. *Japanese Art from the Gerry Collection in the Metropolitan Museum of Art*. New York: Metropolitan Museum of Art, 1988. Distributed by Harry N. Abrams.

Fujioka, Ryōichi. *Shino and Oribe Ceramics*. Translated and adapted by Samuel Cromwell Morse. Japanese Arts and Library Series. Tokyo and New York: Kodansha International, 1977.

———. *Tea Ceremony Utensils*. Translated and adapted by Louise Allison Cort. Arts of Japan 3. New York: Weatherhill; Tokyo: Shibundo, 1973.

Meech, Julia. "Notable Japanese Ceramics." *Apollo* 118, no. 261 (November 1983): 430–38.

Nihon tōji taikei [Survey of Japanese ceramics]. 28 vols. Tokyo: Chūōkōronsha, 1989–90.

Shimizu, Yoshiaki, ed. *Japan: The Shaping of Daimyo Culture 1185–1868*. Washington, DC: National Gallery of Art, 1988.

Varley, Paul, and Kumakura Isao. *Tea in Japan: Essays on the History of the Chanoyu*. Honolulu: University of Hawaii, 1989.

Japanese Porcelains

Arakawa Masa'aki. "Kan'ei Baroque bunka to ko-kutani ishō" [Baroque culture of the Kan'ei era and designs on old Kutani wares]. *Kobijutsu Rokushō* 6 (1992): 50–63.

Ayers, John, Oliver R. Impey, and J. V. G. Mallet. *Porcelain for Palaces: The Fashion for Japan in Europe, 1650–1750*. London: Oriental Ceramic Society, 1990.

Ford, Barbara Brennan, and Oliver R. Impey. *Japanese Art from the Gerry Collection in the Metropolitan Museum of Art*. New York: Metropolitan Museum of Art, 1989. Distributed by Harry N. Abrams.

Hizen no iro-e: sono hajimari to hensen ten [Exhibition of polychrome: Porcelain in Hizen, its early type and change of style]. Arita: Saga Prefectural Museum of Kyūshū Ceramics, 1991.

Jenyns, Soame. *Japanese Porcelain*. London: Faber and Faber, 1965.

Nakagawa Sensaku. *Kutani Ware*. Translated and adapted by John Bester. New York: Kodansha International; Tokyo: Shibundo, 1979.

Seattle Art Museum. *International Symposium on Japanese Ceramics*. Seattle: Seattle Art Museum, 1973.

Two Kyoto Potters

Kawahara Masahiko. *The Ceramic Art of Ogata Kenzan*. Translated and adapted by Richard L. Wilson. New York: Kodansha International; Tokyo: Shibundo, 1985.

———. "Early Kyoto Ceramics." Translated and adapted by Louise Allison Cort. *Chanoyu Quarterly* 32 (1982): 31–46.

Meech, Julia. "Notable Japanese Ceramics." *Apollo* 118, no. 261 (November 1983): 430–38.

Sato Masahiko. *Kyoto Ceramics*. Translated and adapted by Anne Ono Towle and Usher P. Coolidge. New York: Weatherhill; Tokyo: Shibundo, 1973.

Shimizu, Yoshiaki, ed. *Japan: The Shaping of Daimyo Culture, 1185–1868*. Washington, DC: National Gallery of Art, 1988.

CONTEMPORARY

SOUTH ASIA

Afghanistan

Ahmady, Leeza, Iftikhar Dadi, and Reem Fadda. *Tarjama/Translation: Contemporary Art from the Middle East, Central Asia, and Their Diasporas*. New York: ArteEast, 2009.

India

Dalmia, Yashodhara, and Salima Hashmi. *Memory, Metaphor, Mutations: Contemporary Art of India and Pakistan*. New Delhi: Oxford University, 2007.

Indian Highway. London: Serpentine Gallery, 2008.

Kapur, Geeta. *Contemporary Indian Art*. London: Royal Academy of Arts, 1982.

Knox, Gordon, Peter Nagy, and Johan Pijnappel. *Icon, India Contemporary: Atul Dodiya, Anita Dube, Ranbir Kaleka, Nalini Malani, Raqs Media Collective, Nataraj Sharma*. New York: Bose Pacia, 2005.

London, Barbara, Gayatri Sinha, and Paul Sternberger. *India: Public Places/Private Spaces; Contemporary Photography and Video Art*. Newark: Newark Museum, 2007.

Pijnappel, Johan, and Betty Seid. *New Narratives: Contemporary Art from India*. India: Mapin, 2007.

Poddar, Sandhini. *Being Singular Plural*. New York: Guggenheim Museum, 2012.

Poshyananda, Apinan. *Contemporary Art in Asia: Traditions/Tensions*. New York: Asia Society Galleries, 1996.

Sambrani, Chaitanya, Kajri Jain, and Ashish Rajadhyaksha. *Edge of Desire: Recent Art in India*. London: Phillip Wilson, 2005.

Sinha, Gayatri, ed. *Expressions and Evocations: Contemporary Women Artists of India*. Mumbai: Marg, 1996.

Sood, Pooja. *The Khoj Book 1997–2007: Contemporary Art Practice in India*. Noida: Harper Collins, 2010.

Yap, June Teckcheng. *No Country: Contemporary Art for South and Southeast Asia*. Hong Kong: Asia Society Hong Kong Center, 2013.

Iran

Amirsadeghi, Hossein, ed. *Different Sames: New Perspectives in Contemporary Iranian Art*. London: Thames and Hudson, 2009.

Daftari, Fereshteh, and Layla S. Diba, eds. *Iran Modern*. New York: Asia Society, 2013.

Gumpert, Lynn, and Shiva Balaghi, eds. *Picturing Iran: Art, Society and Revolution*. New York: New York University Grey Art Gallery; London: I. B. Tauris, 2002.

Grigor, Talinn. *Contemporary Iranian Art: From the Street to the Studio*. London: Reaktion, 2014.

Keshmirshekan, Hamid. *Contemporary Iranian Art: New Perspectives*. London: Saqi, 2013.

Taylor, Meg, ed. *Safar/Voyage: Contemporary Works by Arab, Iranian, and Turkish Artists*. Vancouver: Museum of Anthropology at the University of British Columbia, 2013.

Pakistan

Ali, Salwat. *Journeys of the Spirit: Pakistan Art in the New Millennium*. Karachi: FOMMA, 2008.

Dalmia, Yashodhara, and Salima Hashmi. *Memory, Metaphor, Mutations: Contemporary Art of India and Pakistan*. New Delhi: Oxford University, 2007.

Hashmi, Salima. *Hanging Fire: Contemporary Art from Pakistan*. New York: Asia Society Museum, 2009.

———. *The Eye Still Seeks: Pakistani Contemporary Art*. Haryana: Penguin India, 2015.

Wille, Simone. *Modern Art in Pakistan: History, Tradition, Place*. New Delhi: Routledge, 2015.

Yap, June Teckcheng. *No Country: Contemporary Art for South and Southeast Asia*. Hong Kong: Asia Society Hong Kong Center, 2013.

SOUTHEAST ASIA

Indonesia

Archer, Anita, Bryan Collie, Louise Joel, and Mikala Tai, eds. *Closing the Gap: Indonesian Contemporary Art*. Melbourne: Melbourne International Fine Art, 2011.

Arndt, Matthias, ed. *Sip! Indonesian Art Today*. Berlin: Distanz, 2013.

Ciclitira, Serenella. *Indonesian Eye: Contemporary Indonesian Art*. Milan: Skira, 2011.

Datuin, Flaudette. *Women Imaging Women: Home, Body, Memory—Artists from Indonesia, Philippines, Thailand and Vietnam*. Manila: Cultural Center of the Philippines, 1999.

Hafiz. *10 Years of Video Art in Indonesia, 2000–2010*. Jakarta: Division for Video Art Development, 2011.

Kam, Garrett. *Modern Indonesian Art: From Raden Saleh to the Present Day*. Bali: Koes, 2006.

Lenzi, Iola, and Tash Aw, eds. *Negotiating Home, History and Nation: Two Decades of Contemporary Art in Southeast Asia, 1991–2011*. Singapore: Singapore Art Museum, 2011.

Merali, Shaheen. *Spaces and Shadows: Contemporary Art from South East Asia*. Berlin: House of World Cultures, 2005.

Sam, I-shan, and Alexander Supartono. *Afterimage: Contemporary Photography in South East Asia*. Singapore: Singapore Art Museum, 2014.

Supriyanto, Enin. *Refresh: New Strategies in Indonesian Contemporary Art*. Singapore: Valentine Willie Fine Art, 2008.

Tatehata, Akira, and Tsutomu Mizusawa. *Asian Modernism: Diverse Developments in Indonesia, the Philippines, and Thailand*. Tokyo: Japan Foundation Asia Center, 1995.

Poshyananda, Apinan. *Contemporary Art in Asia: Traditions/Tensions*. New York: Asia Society Galleries, 1996.

Yap, June Teckcheng. *No Country: Contemporary Art for South and Southeast Asia*. Hong Kong: Asia Society Hong Kong Center, 2013.

Philippines

At Home & Abroad: 20 Contemporary Filipino Artists. San Francisco: Asian Art Museum, 1998.

Benesa, Leonides V. *What is Philippine about Philippine Art? and Other Essays*. Manila: National Commission for Culture and the Arts, 2000.

Datuin, Flaudette. *Women Imaging Women: Home, Body, Memory—Artists from Indonesia, Philippines, Thailand and Vietnam*. Manila: Cultural Center of the Philippines, 1999.

Francisco, Francis. *Without Walls: A Tour of Philippine Paintings at the Turn of the Millennium*. Pasig: Winrum, 2010.

Lenzi, Iola, and Tash Aw, eds. *Negotiating Home, History and Nation: Two Decades of Contemporary Art in Southeast Asia, 1991–2011*. Singapore: Singapore Art Museum, 2011.

Merali, Shaheen. *Spaces and Shadows: Contemporary Art from South East Asia*. Berlin: House of World Culture, 2005.

Ocampo, Manuel. *Bastards of Misrepresentation: Doing Time on Filipino Time*. Berlin: Freies Museum Berlin, 2010.

Sam, Ishan, and Alexander Supartono. *Afterimage: Contemporary Photography in South East Asia*. Singapore: Singapore Art Museum, 2014.

Subido, Kristina T., and Emmanuel Torres, eds. *Conversations on Philippine Art*. Manila: Cultural Center of the Philippines, 1989.

Tatehata, Akira, and Tsutomu Mizusawa. *Asian Modernism: Diverse Developments in Indonesia, the Philippines, and Thailand*. Tokyo: Japan Foundation Asia Center, 1995.

Yap, June Teckcheng. *No Country: Contemporary Art for South and Southeast Asia*. Hong Kong: Asia Society Hong Kong Center, 2013.

Thailand

Datuin, Flaudette. *Women Imaging Women: Home, Body, Memory—Artists from Indonesia, Philippines, Thailand and Vietnam*. Manila: Cultural Center of the Philippines, 1999.

Lenzi, Iola, and Tash Aw, eds. *Negotiating Home, History and Nation: Two Decades of Contemporary Art in Southeast Asia, 1991–2011*. Singapore: Singapore Art Museum, 2011.

Merali, Shaheen. *Spaces and Shadows: Contemporary Art from South East Asia*. Berlin: House of World Culture, 2005.

Poshyananda, Apinan. *Contemporary Art in Asia: Traditions/Tensions*. New York: Asia Society Galleries, 1996.

Sam, Ishan, and Alexander Supartono. *Afterimage: Contemporary Photography in South East Asia*. Singapore: Singapore Art Museum, 2014.

Silpasart, Chayanoot. *From Message to Media*. Bangkok: Bangkok University, 2007.

Tatehata, Akira, and Tsutomu Mizusawa. *Asian Modernism: Diverse Developments in Indonesia, the Philippines, and Thailand*. Tokyo: Japan Foundation Asia Center, 1995.

Yap, June Teckcheng. *No Country: Contemporary Art for South and Southeast Asia*. Hong Kong: Asia Society Hong Kong Center, 2013.

Vietnam

Bui, Nhu Huong, and Hau Tuan Tran. *New Vietnamese Art in the 1990s*. Hanoi: Fine Art Publishing House, 2001.

Dao, Mai Trang, ed. *12 Contemporary Artists of Vietnam*. Hanoi: Gioi, 2010.

Datuin, Flaudette. *Women Imaging Women: Home, Body, Memory—Artists from Indonesia, Philippines, Thailand and Vietnam*. Manila: Cultural Center of the Philippines, 1999.

Fan, Joyce, and Siuli Tan. *Post-Doi Moi: Vietnamese Art after 1990*. Singapore: Singapore Art Museum, 2008.

Lee, Sarah, and Nhu Huy Nguyen. *Essays on Modern and Contemporary Vietnamese Art*. Singapore: Singapore Art Museum, 2009.

Vietnam: Destination for the New Millennium: the Art of Dinh Q. Le. New York: Asia Society, 2005.

Yap, June Teckcheng. *No Country: Contemporary Art for South and Southeast Asia*. Hong Kong: Asia Society Hong Kong Center, 2013.

EAST ASIA

China

Ai Weiwei and Feng Boyi, eds. *Fuck Off*. Shanghai: Eastlink Gallery, 2000.

Ai Weiwei, Xu Bing, and Zeng Xiaojun, eds. *Black Cover Book*. Beijing: privately published, 1994.

———, eds. *White Cover Book*. Beijing: privately published, 1995.

——, eds. *Grey Cover Book*. Beijing: privately published, 1997.

Andrews, Julia F., and Kuiyi Shen. *A Century in Crisis: Modernity and Tradition in the Art of Twentieth Century China*. New York: Solomon R. Guggenheim Foundation, 1998.

——. *The Art of Modern China*. Berkeley: University of California Press, 2012.

Chang Tsong-zung and Li Xianting. *China's New Art, Post-1989*. Hong Kong: Hanart TZ Gallery, 1993.

Chiu, Melissa, ed. *Zhang Huan: Altered States*. New York: Asia Society; Milan: Charta, 2007.

Chiu, Melissa, and Zheng Shengtian. *Art and China's Revolution*. New York: Asia Society; New Haven and London: Yale University, 2008.

Clark, John. *Chinese Art at the End of the Millennium*. Hong Kong: New Art Media Limited, 2000.

Fei Dawei, ed. *'85 New Wave: The Birth of Chinese Contemporary Art*. Beijing: Ullens Center for Contemporary Art, 2007.

Gao Minglu. *The Wall: Reshaping Contemporary Chinese Art*. Buffalo: Albright-Knox Art Gallery, and University at Buffalo Art Galleries; Beijing: Millennium Art Museum, 2005.

——, ed. *Inside Out: New Chinese Art*. New York: Asia Society; San Francisco: San Francisco Museum of Modern Art, 1998.

Groom, Simon, Karen Smith, and Xu Zhen. *The Real Thing: Contemporary Art from China*. Liverpool: Tate, 2007.

Ha Thuc, Caroline. *After 2000: Contemporary Art in China*. Hong Kong: Mars Interntional Publications, 2015.

He, Juxing, ed. *Moving Image in China: 1988–2011*. Shanghai: Minsheng Art Museum, 2011.

Lemonnier, Anne. *Alors, la Chine?* Paris: Centre Georges Pompidou, 2003.

Lu Peng. *A History of Art in 20th-Century China*. Milan: Charta, 2010.

Martin, Jean-Hubert, ed. *Magiciens de la terre*. Paris: Editions du Centre Pompidou, 1989.

Obrist, Hans Ulrich. *Hans Ulrich Obrist: The China Interviews*. Hong Kong: Office for Discourse Engineering, 2009.

Pollack, Barbara. *My Generation: Young Chinese Artists*. Tampa: Tampa Museum of Art, 2014.

Sans, Jerome. *China Talks: Interviews with 32 Contemporary Artists by Jerome Sans*. Hong Kong: Timezone 8, 2009.

Silbergeld, Jerome, ed. *Humanism in China—A Contemporary Record of Photography*. New York: China Institute Gallery, 2009.

Sullivan, Michael. *Art and Artists of Twentieth-Century China*. Berkeley: University of California, 1996.

——. *Modern Chinese Artists: A Biographical Dictionary*. Berkeley: University of California, 2006.

Szeemann, Harald, and Cecilia Liveriero Lavelli. *La Biennale di Venezia: 48th Esposizione Internazionale d'Arte*. Venice: Marsilio, 1999.

Wu Hung. *Chinese Art at the Crossroads*. Hong Kong: New Art Media Limited, 2001.

——. *Exhibiting Experimental Art in China*. Chicago: David and Alfred Smart Museum of Art, University of Chicago, 2000.

——. *Making History: Wu Hung on Contemporary Art*. Hong Kong: Timezone 8, 2008.

——. *Remaking Beijing: Tiananmen Square and the Creation of A Political Space*. Chicago: University of Chicago, 2005.

——. *Transience: Chinese Experimental Art at the End of the Twentieth Century*. Chicago: David and Alfred Smart Museum of Art, University of Chicago, 1999.

——, ed. *The First Guangzhou Triennial: Reinterpretation; A Decade of Experimental Chinese Art (1990–2000)*. Guangzhou: Guangzhou Museum of Art, 2002.

Wu Hung and Christopher Phillips. *Between Past and Future: New Photography and Video from China*. Chicago: David and Alfred Smart Museum of Art, University of Chicago; New York: International Center of Photography; Göttingen: Steidl, 2004.

Wu Hung and Peggy Wang, eds. *Contemporary Chinese Art: Primary Documents*. New York: Museum of Modern Art; Durham, NC: Duke University, 2010.

Yang Fudong: Seven Intellectuals in a Bamboo Forest. New York: Asia Society, 2009.

Yu Hsiao Hwei, ed. *Hou Hanru: On the Midground*. Hong Kong: Timezone 8, 2003.

Japan

Aida, Makoto. *Painting for Joy: New Japanese Painting in 1990s*. Tokyo: Japan Foundation, 1999.

Allen, Matthew, and Rumi Sakamoto, eds. *Popular Culture, Globalization and Japan*. London and New York: Routledge, 2006.

Chong, Doryun, Michio Hayashi, Kenji Kajiya, and Fumihiko Sumitomo. *From Postwar to Postmodern, Art in Japan, 1945–1989: Primary Documents*. New York: Museum of Modern Art, 2012.

Elliott, David, and Tetsuya Ozaki. *Bye Bye Kitty!!! Between Heaven and Hell in Contemporary Japanese Art*. New York: Japan Society, 2011.

Favell, Adrian. *Before and After Superflat: A Short History of Japanese Contemporary Art 1990–2011*. Hong Kong: Blue Kingfisher, 2012.

Kashiwagi, Tomoh. *NIHONGA Painting: Six Provocative Artists*. Yokohama: Yokohama Museum of Art, 2006.

Lloyd, Fran. *Consuming Bodies: Sex and Contemporary Japanese Art*. London: Reaktion, 2002.

Matsui, Midori. *The Age of Micropop: The New Generation of Japanese Artists*. Tokyo: Parco, 2007.

Munroe, Alexandra. *Japanese Art after 1945: Scream against the Sky*. New York: H.N. Abrams, 1994.

Murakami, Takashi, ed. *Little Boy: The Arts of Japan's Exploding Subculture*. New York: Japan Society, 2005.

Phillips, Christopher, Noriko Fuku, and Linda Nochlin. *Heavy Light: Recent Photography and Video from Japan*. New York: International Center of Photography; Gottingen: Steidl, 2008.

Roppongi Crossing 2010: Can There Be Art? Tokyo: Mori Art Museum, 2010.

Yamaguchi, Yumi. *The Power of Japanese Contemporary Art*. Tokyo: ASCII, 2008.

Korea

Chiu, Melissa, and Michelle Yun. *Nam June Paik: Becoming Robot*. New York: Asia Society, 2014.

Gim, Jonggil, Sumil Kang, Chinghwan Kho, Chandong Kim, Sunyong Lee, and Jinsang Yu. *100.art.kr: Korean Contemporary Art Scene*. Seoul: Ministry of Culture, Sports and Tourism of the Republic of Korea, 2012.

Jin, Whui-yeon. *Coexisting Differences: Women Artists in Contemporary Korean Art*. Elizabeth, NJ: Hollym, 2012.

Kim, Miki Wick. *Korean Contemporary Art*. New York: Prestel, 2012.

Lee, Sohl. *Being Political Popular: South Korean Art at the Intersection of Popular Culture and Democracy, 1980–2010*. Seoul: Hyunsil, 2012.

Taiwan

Chen, Shulin. *Artist Navigators: Selected Writings on Contemporary Taiwanese Artists*. Taipei: Taipei Fine Arts Museum, 2007.

Chen, Shulin, and Tzuyun Wang. *Artist Navigators II: Selected Writings on Contemporary Taiwanese Artists*. Taipei: Taipei Fine Arts Museum, 2008.

Gao Minglu, ed. *Inside Out: New Chinese Art*. New York: Asia Society; San Francisco: San Francisco Museum of Modern Art, 1998.

Liu, Yunghao. *Mind as Passion: A Video Art Exhibition Featuring 17 New-Generation Artists from Taiwan and Japan*. Taipei: Taipei Fine Arts Museum, 2009.

Pai, Feilan, and Hsupu Liu. *Art Island: An Archive of Taiwan Contemporary Artists*. Taipei: Taiwan Contemporary Art Link, 2009.

Yang, Alice, and Lin Yuhsiang. *Tracing Taiwan. Contemporary Works on Paper*. New York: The Drawing Center, 1997.

Yao, Leechun. *Reborn: Salute to 1980s; An Exhibition of Performance Art in Taiwan*. Taipei: Body Phase Studio, 2007.

CENTRAL ASIA

Ahmady, Leeza, Iftikhar Dadi, and Reem Fadda. *Tarjama/Translation: Contemporary Art from the Middle East, Central Asia, and Their Diasporas*. New York: ArteEast, 2009.

Elliott, David. *BALAGAN!!! Contemporary Art from the Former Soviet Union and Other Mythical Places*. Berlin: Momentum, 2015.

——. *Between Heaven and Earth: Contemporary Art from the Centre of Asia*. London: Calvert 22, 2011.

Merewether, Charles. *East is West: Three Women Artists*. Singapore: Earl Lu Gallery, 2012.

——. *Lost to the Future: Contemporary Art from Central Asia*. Singapore: Institute of Contemporary Arts Singapore, 2013.

Misiano, Viktor. *Art from Central Asia: A Contemporary Archive*. Bishkek: Kurama Art Gallery, 2005.

Misiano, Viktor, and Jari-Pekka Vanhala. *Time of the Storytellers: Narrative and Distant Gaze in Post-Soviet Art*. Kiasma: Museum of Contemporary Art, 2007.

Sorokina, Yuliya, and Japarov Ulan. *Muzykstan: Media Generation of Contemporary Artists from Central Asia*. Almaty: Asia Art +, 2007.

The Tamerlane Syndrome: Art and Conflicts in Central Asia. Rome: Skira, 2005.

AMERICAS

Chang, Alexandra. *Envisioning Diaspora: Asian American Visual Arts Collectives*. Beijing: Timezone 8, 2008.

Chiu, Melissa, Karin Higa, and Susette S. Min, eds. *One Way or Another: Asian American Art Now*. New York: Asia Society Museum, 2006.

Desai, Vishakha N., Margo Machida, and John Kuo Wei Tchen. *Asia/America: Identities in Contemporary Asian American Art*. New York: Asia Society Galleries / New Press, 1994.

Yang, Alice, Jonathan Hay, and Mimi Young, eds. *Why Asia? Contemporary Asian and Asian American Art*. New York: New York University, 1998.

GLOSSARY

abhayamudra: *see* reassurance, gesture of.

Amitabha Buddha: the buddha of infinite light or life, who presides over the pure land known as Sukhavati, or the Western Paradise.

animation: a rapid display of sequences of static imagery that creates the illusion of movement.

anime: a style of Japanese animation that is often characterized by colorful graphics, vibrant characters, and fantastical themes.

Avalokiteshvara: the bodhisattva of compassion, the most popular deity in the Buddhist pantheon. He is worshiped in a wide array of forms, some with different names (for example, Khasharpana Lokeshvara), and is identified by the small image of Amitabha Buddha in his headdress.

avant-garde art: an art form that is innovative, experimental, or that explores new forms or subject matter.

avatar: 1) in Hinduism, an incarnation of a deity, primarily in its descent to Earth; 2) in the realm of technology, an on-screen image that represents a user in a game, in a virtual world, or on the Internet.

bhumisparshamudra: *see* touching the earth, gesture of.

bird-and-flower painting: a genre of traditional Chinese ink painting that originated in the Tang dynasty (618–907). Dominant subject matter includes flowers, birds, fish, and insects.

bodhisattva: an enlightened being in Buddhism who postpones his attainment of nirvana in order to assist the enlightenment of others.

Brahma: the Hindu god of creation.

buddha: "one who awakened"; an enlightened being in Buddhism, an embodiment of divine wisdom and virtue. *See also* Amitabha Buddha, Maitreya, Shakyamuni Buddha.

Buddhism: religion founded in India during the fifth century BCE based on the teachings of Siddhartha Gautama, who is revered as Shakyamuni Buddha. A wide range of Buddhist sects have been and are practiced throughout Asia.

chadri: a female garment that covers the body from head to foot. Traditionally worn by women in Islamic countries.

chakra: "wheel"; an attribute of the Hindu god Vishnu; in Buddhism, the wheel of the law.

charity, gesture of (*varadamudra*): gesture in which the hand is lowered with the palm facing out.

chromogenic print: alternately known as a C-print, a C-type print, or chromogenic print. A photographic print made from a color negative that is exposed to chromogenic paper. This type of paper contains three different layers of emulsion, or light-sensitive colloid, that produce different colors (cyan, magenta, and yellow) when exposed to light.

closed-circuit video: use of a video camera or cameras to transmit a signal to a specific location on a limited viewing platform (for example, a monitor).

conceptual art: a type of art first defined in the 1960s, and most commonly associated with the 1960s and 1970s, in which the idea or concept behind the work is more important than the finished, physical object.

cyclo: a three-wheeled pedaled or motorized vehicle traditionally used in Southeast Asia as a taxi.

Daoist: a practitioner of Daoism, a religious tradition, based on the philosophical writings of Laozi in the sixth century BCE, that stresses living simply and in harmony with nature.

dharma: a moral or religious law or duty.

dharmachakra: "wheel of the law"; a symbol of Buddhism, especially of Shakyamuni Buddha's teachings and his first sermon, in which he set in motion the wheel of the law.

dharmachakramudra: *see* preaching, gesture of.

dhoti: a skirtlike garment.

dhyanamudra: *see* meditation, gesture of.

doucai: "joint colors"; a ceramic technique in which a design is outlined with underglaze cobalt blue and then carefully painted with overglaze enamel colors.

Durga: a form of the supreme goddess in Hinduism.

earthenware: low-fired ceramic made from many types of clay, usually fired at temperatures between 600°C and 1150°C.

feng shui compass: also called a *luopan*; a magnetic compass historically used in China by feng shui practitioners to determine the direction of an architectural structure or object.

Ganesha: an important deity in the Hindu pantheon, revered as the bringer of good fortune. He is the elephant-headed son of Shiva and Parvati.

Ganga: the Hindu goddess personifying the river Ganga (Ganges).

gelatin silver print: a photographic print made from a black-and-white negative that is exposed to gelatin silver paper. Gelatin silver paper is coated with a layer of light-sensitive silver salts suspended in gelatin that produces a positive image when exposed to light.

glaze: a colored or transparent glassy coating containing silica, applied to the surface of a ceramic to make it impervious to liquids and to enhance its appearance.

greenware: broad term for ceramics with greenish glaze, often called "celadons" in the West.

Hinduism: a term encompassing a wide range of related religious practices and beliefs in South Asia. Three major deities—all of whom appear in many different forms—are Shiva (principal in Shaivism), Vishnu (principal in Vaishnavism), and the supreme goddess, who is most commonly known as Devi or Parvati.

Jainism: a faith that follows a series of twenty-four *jinas* (or *tirthankaras*), beings who have attained perfect knowledge.

Kalighat-style painting: a style of watercolor painting developed in the nineteenth century in India by artists in the Calcutta marketplace and primarily sold to pilgrims visiting the Kalighat temple. These paintings are characterized by broad brushstrokes, simplified forms, and bold colors suitable for mass production. The compositions usually depict popular Hindu deities but sometimes include subject matter from contemporary life.

kaolin: the key ingredient in porcelain, a white clay free of ferrous impurities, that fires white.

kawaii: a Japanese cultural style that emphasizes the quality of cuteness, often incorporating bright colors and characters that have a childlike appearance.

Ketumati Pure Land: an earthly paradise that Maitreya will preside over when he descends as a buddha.

Krishna: "the dark one"; one of the avatars of the Hindu god Vishnu.

Karttikeya: a Hindu god, a son of Shiva and Parvati; also called Skanda or Kumara.

lakshana: an auspicious physical mark on a bodhisattva or buddha indicating an advanced spiritual state. Shakyamuni Buddha has 32 major *lakshanas*; the most frequently depicted are the *urna* and *ushnisha*, broad shoulders, webbed fingers, and full lips that appear to have been stung by bees.

lalitasana: *see* relaxation, posture of.

Lexan: a brand name for polycarbonate resin, a type of durable plastic.

Lokeshvara: *see* Avalokiteshvara.

lotus posture: *see* meditation, posture of.

Mahayana: "Great Vehicle"; a principal branch of Buddhism encompassing a wide range of practices and beliefs. Tends to stress the importance of bodhisattvas. Based on a canon of texts in the Sanskrit language.

Maitreya: the buddha of the future; worshiped as a bodhisattva in this age and as the buddha of the next. As a bodhisattva, he presides over the Tushita Pure Land; as a buddha, he will rule over Ketumati Pure Land.

manga: a genre of comic books, originally developed in Japan, that is characterized by stylized colorful art and often includes adult themes.

Manjushri: the bodhisattva of wisdom; often depicted as a youth.

mandala: a cosmic diagram used in Asian religions as an aid to meditation or as an area devoted to ritual purposes.

mandorla: an almond-shaped halo surrounding a figure to indicate its holiness.

meditation, gesture of (*dhyanamudra*): a gesture in which both hands of a seated figure rest in the lap, palms up, one over the other.

meditation, posture of: a stable, seated posture with bent legs, one crossed over the other. In this publication, the term includes the lotus and half-lotus postures and the diamond posture (*padmasana, vajrasana, vajraparyanka,* and *sattvaparyanka*).

miniature painting: a genre of Indian painting characterized by its small size and naturalism, a style that accurately depicts its subjects and is rooted in European Renaissance art.

mixed-media animation: an animation created with a combination of different media or materials (*see* animation).

Modernism: a term referring to a sensibility in western arts and culture beginning in 1850 that rejected the styles of the past and emphasized innovation and experimentation of forms, materials, techniques, and subject matter that more accurately reflected modern society. Beginning in the middle of the twentieth century, the influence of Modernism extended to non-western countries.

Muchilinda: a serpent demigod who sheltered the Buddha from a rainstorm with his hood.

naga: a snake or serpent deity.

nihonga: a term describing paintings created with traditional Japanese materials and techniques.

nirvana: the ultimate goal of the Buddhist path, in which perfect knowledge is attained and the cycle of earthly rebirths is transcended.

overglaze: a form of ceramic embellishment in which enamels (low-fire glazes) and sometimes metallic pigments are painted on top of the glaze on a fired piece, which is then refired at a lower temperature to fix the design.

Parvati: a form of the Hindu goddess Devi; the consort of Shiva.

pishkun: a Native American term for cliff formations historically used to hunt and kill bison. Native hunters herded and drove the bison over the cliffs to their deaths.

pop art: a type of art, first made in the 1950s and 1960s, inspired by popular and commercial culture.

porcelain: a ceramic ware that has a high proportion of kaolin and is fired at high temperatures, usually about 1280°C and upward. After firing, it is very hard, white, vitrified, and translucent.

Prajnaparamita: "perfection of wisdom"; personified by an important goddess in Buddhism; also the name of an important group of texts.

preaching, gesture of (*dharmachakramudra*): a gesture signifying "turning the wheel of the law" in which, generally, both hands are held at chest level, with the tips of the thumb and forefinger of the right hand touching and forming a circle with the forefinger and thumb of the left hand.

reassurance, gesture of (*abhayamudra*): a gesture in which the hand is raised to shoulder height and shown with the palm open and fingers pointing up.

relaxation, posture of (*lalitasana*): a posture in which one leg is folded and resting on a seat while the other hangs downward.

reverse glass painting: a genre and technique in which paint is applied to one side of a piece of glass, and the finished image is viewed through the unpainted side. This type of painting was a popular export item from China during the eighteenth and nineteenth centuries.

sancai: "three colors"; a Chinese term referring to ceramic ware with variegated lead glazes of a limited palette.

Shakyamuni Buddha: the name given to Siddhartha Gautama (about 563–483 BCE) after he achieved enlightenment and became a buddha, an "awakened one." The Buddhist religion is based on his insights and teachings. He is represented in many different ways in Buddhist art. In this publication, he is referred to as "the Buddha."

Shingon: a Japanese sect of Esoteric Buddhism.

Shiva: "auspicious"; one of the three principal gods of Hinduism; the god of destruction and re-creation.

single-channel video: A video or new-media work that presents one information source through a playback device in a single display mode.

Skanda: *see* Karttikeya.

slip: a dilute mixture of clay and water, sometimes with pigment, applied to the body of a ceramic object as a coating or to create a design.

stoneware: a strong ceramic ware fired between 1150°C and 1300°C. Unlike porcelain, stoneware is not translucent.

stop-motion animation: a motion-picture technique in which objects are photographed in a series of slightly different positions so that, when the images are seen sequentially, the objects appear to move (*see* animation).

Sukhavati: the Western Pure Land, over which Amitabha Buddha presides.

sutra: in Buddhism, a text attributed to Shakyamuni Buddha.

Tantrayana: *see* Vajrayana.

taotie: a mythical creature often appearing in the art of the Chinese Bronze Age.

Tara: an important goddess in Buddhism; at times worshiped as the consort of Avalokiteshvara.

teaching, gesture of (*vitarkamudra*): a gesture in which the thumb and index finger from a circle while the other fingers of the hand are extended.

terra-cotta: a coarse clay fired at a low temperature.

Theravada: "Way of the Elders"; one of the major branches of Buddhism. Tends to stress the historical nature of the Buddha. Based on a canon of texts in the Pali language.

three-channel video: A video or new-media work with three different information sources that use three playback devices to present the work in three display modes.

Three Friends of Winter: a theme in Chinese literature and painting. The Three Friends of Winter—pine, plum, and bamboo—flourish under adverse conditions and symbolize virtues of the scholar-gentleman: longevity, perseverance, and integrity.

touching the earth, gesture of (*bhumisparshamudra*): a gesture in which the right hand reaches toward the ground, palm down. Usually seen in representations of Shakyamuni Buddha's victory over the demon Mara.

Tushita Pure Land: the abode of all buddhas before their final rebirths on Earth; primarily associated with Maitreya.

two-channel video: A video or new-media work with two different information sources that use two playback devices to present the work in two display modes.

ukiyo-e: literally, "floating world"; popular genre of Japanese paintings and woodblock prints, of which two important themes are beautiful women and Kabuki theater actors.

underglaze: a form of ceramic embellishment in which pigments are painted on the surface before being covered with glaze (usually transparent) and fired to fix the design and glaze.

urna: the tuft of hair between the eyebrows of the Buddha (*see lakshana*).

ushnisha: the bump at the top of the Buddha's head, sometimes represented as a knot of hair or a turban, referring to his superior wisdom (*see lakshana*).

vajra: a pronged implement used in rituals or as an attribute of a Buddhist or Hindu deity.

Vajrayana: the "Diamond Path"; also known as Tantrayana or Esoteric Buddhism. This branch of the religion is characterized by an expanded pantheon of deities and by a reliance on incantations and rituals. Many doctrines are based on a group of texts called *tantras*.

varadamudra: *see* charity, gesture of.

Viet Kieu: "overseas Vietnamese"; Vietnamese people living in the diaspora, outside Vietnam.

Vishnu: one of the three principal gods of the Hindu pantheon. He descends to Earth as different avatars—most frequently as Krishna and Rama—in order to restore the balance of the universe.

vitarkamudra: *see* teaching, gesture of.

wayang kulit: a theatrical performance originating in Indonesia, featuring shadow puppets traditionally created from leather.

wucai: "five colors"; ceramic decoration consisting either of a combination of underglaze blue and overglaze enamels or entirely of overglaze enamels.

INDEX

Illustrations are indicated by page numbers in *italics*.

Z

PHOTOGRAPHY CREDITS

All images of the Asia Society Museum Collection are by Synthescape and courtesy Asia Society, unless otherwise noted.

All artworks in the Contemporary Collection are copyright the artist, unless otherwise noted. All images representing the Contemporary Collection are courtesy of the artist, unless otherwise noted.

Fig. 56: Otto E. Nelson; fig. 98: (front) Susumu Wakisaka, Idemitsu Museum of Arts, Tokyo, (back) Lynton Gardiner; figs. 128 and 175: Lynton Gardiner; figs. 254 and 368: Bruce M. White, 2014; fig. 287: Courtesy of the artist and the Center for Contemporary Art Afghanistan; figs. 290 and 309: Eileen Costa, courtesy Asia Society; fig. 292: Courtesy of the artist and Leila Heller Gallery; figs. 297 and 306: Courtesy of the artist and Tyler Rollins Fine Art; fig. 307: Courtesy of the artist and Shoshana Wayne Gallery; figs. 315 and 316: Courtesy of the artist and Vitamin Creative Space; fig. 317: Courtesy of Pékin Fine Arts; fig. 322: Courtesy of the artist and Chambers Fine Art; fig. 325: Courtesy of the artist and Pace Gallery; fig. 326: Courtesy of the artist and Sean Kelly, New York; figs. 328 and 333: Perry Hu, courtesy of Asia Society; figs. 335–339: Courtesy of Yang Fudong, ShanghART Gallery, Shanghai, and Marian Goodman Gallery, New York; fig. 340: Courtesy of Pékin Fine Arts; figs. 342–344: Courtesy of the artist, © Zhang Huan Studio, courtesy Pace Gallery; figs. 348 and 349: Courtesy of Syncro Services Inc.; fig. 351: Courtesy of the artist and ShanghART Gallery, © Zhu Jia / ShanghART Gallery; fig. 352: Courtesy of the artist and Mizuma Art Gallery, Tokyo; fig. 353: Courtesy of the artist and MUJIN-TO production, Tokyo; fig. 354: Courtesy of the artist and Mizuma Art Gallery, Tokyo; fig. 356: Courtesy of Mariko Mori Studio, Inc., © Moriko Mori Studio, Inc.; fig. 357: Courtesy of the artist and YAMAMOTO GENDAI, Tokyo; fig. 358: John Bigelow Taylor; fig. 359: Courtesy of the artist, Ota Fine Arts, Tokyo and James Cohan, New York; fig. 360: Courtesy of the artist and James Cohan, New York; fig. 366: Courtesy of the artist, © teamLab, courtesy Pace Gallery; fig. 369: Courtesy of the artist and Long March Space; fig. 373: © 1979 Muna Tseng Dance Projects, Inc., New York; fig. 374: © Sze Tsung Leong, Courtesy Yossi Milo Gallery, New York;